Julia Frey was educated in the United States, Mexico and France, and earned her Ph.D. from Yale University. An expert on nineteenth-century French literature and culture, she also trained for years in Paris as an artist and printmaker. She has taught at Yale, Brown, Sarah Lawrence and the University of Colorado, where she is Associate Professor of French. She is the author of *Writers and Puppets in Nineteenth-Century France*, and prepared the first edition of Flaubert's *La Lutte du Sacerdoce et de l'Empire* (1837). She is working on a book of criticism: *Venus Betrayed: Sexual Economics in French Erotic Fiction*. She divides her time between New York, Boulder and Paris.

A 'magisterial new biography ... Toulouse-Lautrec could not have found a more persuasive champion than Julia Frey.' Joan Smith, *Independent on Sunday*

'Julia Frey's massive biography, nearly 600 pages, spells out in detail, but she puts it most beautifully in context ... in this superbly documented book. Julia Frey made the serendipitous discovery of Toulouse-Lautrec family letters, previously unknown to historians, 10 years ago. Never have documents been better served, as if Lautrec, so loved in life by his friends, so adept at getting his own way with them, has once again struck it lucky. Not much else in his life was lucky, which is all the more reason to celebrate this biography.' Sister Wendy Beckett, *Sunday Express*

'Julia Frey has written a detailed study of his personal and family life, making use of over 1,000 unpublished letters and much other material. It brings him to life in a way never done before. Once you start, you simply cannot put the book down.' Paul Johnson, *Sunday Telegraph*

'A mass of new material and generous collection of colour plates which emphasise Lautrec's miraculous perceptions, pitiless but never bitter, and his unrelenting quality of light.' Fiona MacCarthy, *Observer*

Henri de Toulouse-Lautrec dressed as a Japanese, c. 1887

Julia Frey

TOULOUSE-LAUTREC

a life

PHOENIX GIANTS

A PHOENIX GIANT PAPERBACK

First published in Great Britain in 1994
by Weidenfeld and Nicolson

This edition published in 1995 by Phoenix,
a division of Orion Books Ltd,
Orion House, 5 Upper St Martin's Lane, London WC2H 9EA

Copyright © 1994 Julia Frey

A CIP record for this book is available
from the British Library.

ISBN 1 85799 363 2

Filmset by Selwood Systems, Midsomer Norton
Printed and bound in Great Britain by
Butler & Tanner Ltd, Frome and London

CONTENTS

BLACK AND WHITE
ILLUSTRATIONS

COLOUR PLATES

for Ron

TOULOUSE-LAUTREC

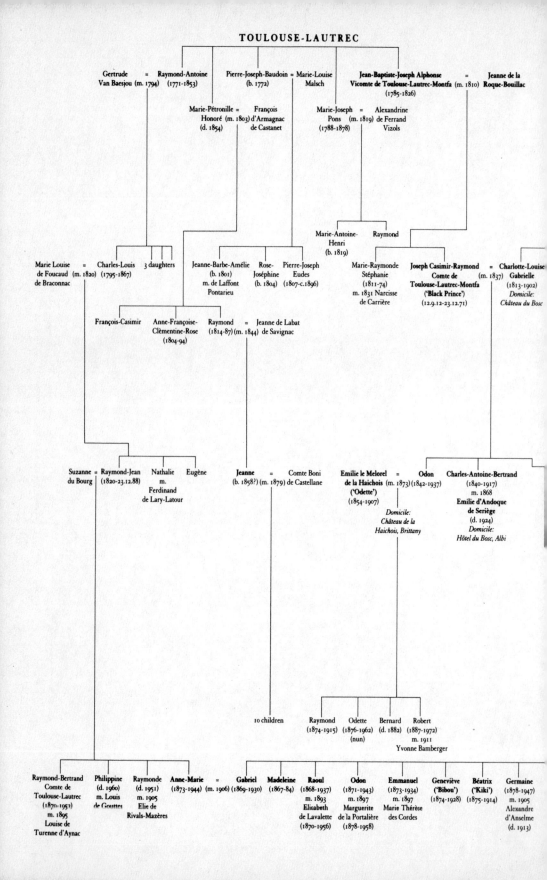

Gertrude Van Baesjou (m. 1794) = Raymond-Antoine (1771-1853)

Pierre-Joseph-Baudoin (b. 1772) = Marie-Louise Malsch

Jean-Baptiste-Joseph Alphonse Vicomte de Toulouse-Lautrec-Montfa (m. 1810) = Jeanne de la Roque-Bouillac (1785-1826)

Marie-Pétronille Honoré (m. 1803) (d. 1854) = François d'Armagnac de Castanet

Marie-Joseph Pons (m. 1819) (1788-1878) = Alexandrine de Ferrand Vizols

Marie-Antoine-Henri (b. 1819) Raymond

Marie Louise de Foucaud (m. 1820) = Charles-Louis (1795-1867) 3 daughters

Jeanne-Barbe-Amélie (b. 1801) m. de Laffont Pontarieu Rose-Joséphine (b. 1804) Pierre-Joseph Eudes (1807-c.1896)

Marie-Raymonde Stéphanie (1811-74) m. 1831 Narcisse de Carrière

Joseph Casimir-Raymond Comte de Toulouse-Lautrec-Montfa ('Black Prince') (12.9.12-23.12.71) (m. 1837) = Charlotte-Louise Gabrielle (1813-1902) *Domicile: Château du Bosc*

François-Casimir Anne-Françoise-Clèmentine-Rose (1804-94) Raymond (1814-87) (m. 1844) = Jeanne de Labat de Savignac

Suzanne du Bourg = Raymond-Jean (1820-23.12.88) Nathalie m. Ferdinand de Lary-Latour Eugène

Jeanne (b. 1858?) (m. 1879) = Comte Boni de Castellane

Emilie le Melorel de la Haichois ('Odette') (1854-1907) = Odon (m. 1873) (1842-1937) *Domicile: Château de la Haichois, Brittany*

Charles-Antoine-Bertrand (1840-1917) m. 1868 **Emilie d'Andoque de Seriège** (d. 1924) *Domicile: Hôtel du Bosc, Albi*

10 children

Raymond (1874-1915) Odette (1876-1962) (nun) Bernard (d. 1882) Robert (1887-1972) m. 1911 Yvonne Bamberger

Raymond-Bertrand Comte de Toulouse-Lautrec (1870-1952) m. 1895 Louise de Turenne d'Aynac

Philippine (d. 1960) m. Louis de Gouttes

Raymonde (d. 1951) m. 1905 Elie de Rivals-Mazères

Anne-Marie (1873-1944) (m. 1906) = Gabriel (1869-1930)

Madeleine (1867-84)

Raoul (1868-1937) m. 1893 Elisabeth de Lavalette (1870-1956)

Odon (1871-1943) m. 1897 Marguerite de la Portalière (1878-1958)

Emmanuel (1873-1934) m. 1897 Marie Thérèse des Cordes

Geneviève ('Bibou') (1874-1928)

Béatrix ('Kiki') (1875-1914)

Germaine (1878-1947) m. 1905 Alexandre d'Anselme (d. 1913)

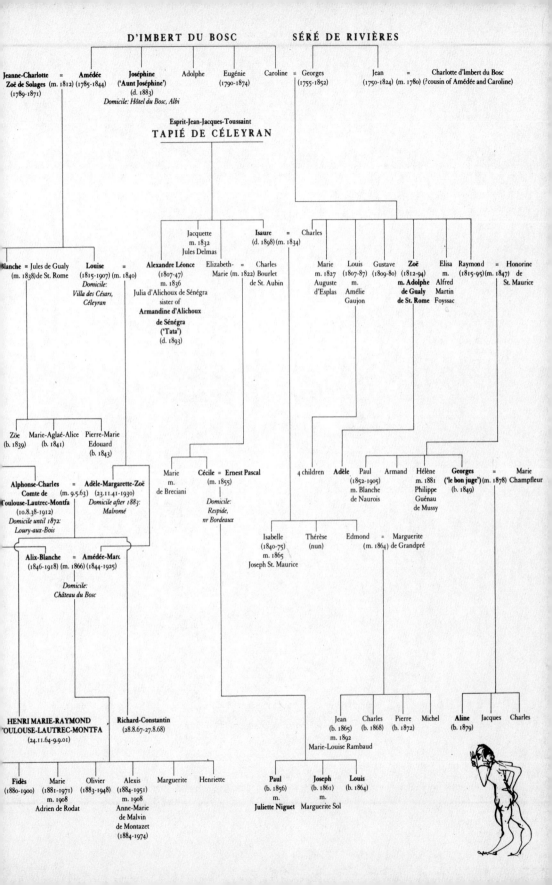

D'IMBERT DU BOSC — **SÉRÉ DE RIVIÈRES**

Jeanne-Charlotte Zoë de Solages (m. 1812) (1789-1871) = **Amédée** (1785-1844) | **Joséphine** ('**Aunt Joséphine**') (d. 1883) *Domicile: Hôtel du Bosc, Albi* | Adolphe | Eugénie (1790-1874) | Caroline = **Georges** (1755-1852) | Jean (1750-1824) (m. 1780) = Charlotte d'Imbert du Bosc (?cousin of Amédée and Caroline)

Esprit-Jean-Jacques-Toussaint
TAPIÉ DE CÉLEYRAN

Jacquette m. 1832 Jules Delmas | **Isaure** (d. 1898) (m. 1834) = Charles

Marie m. 1827 Auguste d'Esplas | Louis (1807-87) m. Amélie Gaujon | Gustave (1809-80) | **Zoë** (1812-94) m. **Adolphe de Gualy de St. Rome** | Elisa m. Alfred Martin Foyssac | Raymond (1815-95) (m. 1847) = Honorine de St. Maurice

Blanche = Jules de Gualy (m. 1838) de St. Rome | **Louise** (1815-1907) (m. 1840) = *Domicile: Villa des Césars, Céleyran* | Alexandre Léonce (1807-47) m. 1836 Julia d'Alichoux de Sénégra sister of **Armandine d'Alichoux de Sénégra** ('**Tata**') (d. 1893) | Elizabeth-Marie (m. 1822) = Charles Bourlet de St. Aubin

Zöe (b. 1839) | Marie-Aglaé-Alice (b. 1841) | Pierre-Marie Edouard (b. 1843)

Marie m. de Breciani | Cécile = Ernest Pascal (m. 1855) *Domicile: Respide, nr Bordeaux*

4 children | **Adèle** (1852-1905) m. Blanche de Naurois | Paul | Armand | Hélène m. 1881 Philippe Guénau de Mussy | **Georges** ('**le bon juge**') (m. 1878) = Marie Champfleur (b. 1849)

Alphonse-Charles Comte de Toulouse-Lautrec-Montfa (10.8.38-1912) *Domicile until 1872: Loury-aux-Bois* = **Adèle-Margarette-Zoë** (m. 9.5.63) (23.11.41-1930) *Domicile after 1883: Malromé*

Isabelle (1840-75) m. 1865 Joseph St. Maurice | Thérèse (nun) | Edmond = Marguerite (m. 1864) de Grandpré

Alix-Blanche (1846-1918) (m. 1866) = **Amédée-Marc** (1844-1925) *Domicile: Château du Bosc*

HENRI MARIE-RAYMOND TOULOUSE-LAUTREC-MONTFA (24.11.64-9.9.01) | Richard-Constantin (28.8.67-27.8.68)

Jean (b. 1865) m. 1892 Marie-Louise Rambaud | Charles (b. 1868) | Pierre (b. 1872) | Michel | **Aline** (b. 1879) | Jacques | Charles

Fidès (1880-1900) | Marie (1881-1971) m. 1908 Adrien de Rodat | Olivier (1883-1948) | Alexis (1884-1951) m. 1908 Anne-Marie de Malvin de Montazet (1884-1974) | Marguerite | Henriette

Paul (b. 1856) m. **Juliette Niguet** | **Joseph** (b. 1861) m. Marguerite Sol | **Louis** (b. 1864)

PREFACE

This biography of Henri de Toulouse-Lautrec was born out of one of those moments every scholar dreams about. I happened to be visiting the Harry Ransom Humanities Research Center of the University of Texas at Austin, to submit my first published edition of the Center's manuscript by Gustave Flaubert: *La Lutte du Sacerdoce et de l'Empire*. Sally Leach, then Acting Director of the manuscript collections, mentioned that I might like to take a look at the Center's recently acquired collection of Toulouse-Lautrec letters. Although like almost everyone, I knew Lautrec's art, both his striking posters and his revealing portraits, my knowledge of his life came entirely from legend. In the first minutes of looking at these letters, I had an experience reminiscent of Sherlock Holmes. Poring with a magnifying glass over pages of faded nineteenth-century handwriting, I suddenly realized that I was learning the real story of Lautrec's life. Abruptly, my years of training as an artist and printmaker came together with my doctorate in French and my research on nineteenth-century manuscripts. Not only was there a need to tell this story, but I was curiously qualified to do so. The passion engendered during that first fifteen minutes of recognition has remained undiminished during the ten years spent researching and writing this book.

These and other letters and documents which had been lost, misplaced or hidden away for many years have only gradually come to light, and contain significant material which was unavailable to previous biographers of Lautrec. A few of them were quoted inaccurately, incompletely or without attribution in early works on Lautrec. Most of them were finally sold, one by one, beginning in the 1950s, by a member of the Toulouse-Lautrec family. They now reside primarily in three places. One thousand or so pages of unpublished letters and documents mostly written by family members, particularly by Lautrec's mother, belong to the Carlton Lake Collection of the Harry Ransom Humanities Research Center at the University of Texas at

Austin. Herbert Schimmel's final edition of the Toulouse-Lautrec *Correspondance*,[1] consisting of nearly 700 letters, was published in the original French in 1992. Another 350 pages of still unpublished letters by family members and others who knew Lautrec were also put at my disposal by Herbert Schimmel before his personal collection was sold. Finally, fifty or so letters which still belong to the Toulouse-Lautrec heirs were generously supplied to me in photocopy by Georges Beaute, with the permission of their owner, Nicole Tapié de Céleyran. I have been fortunate enough to be the only researcher to have access to all these documents.

When brought together, these documents provide a far more complete and objective view of Lautrec than has ever been available before. From them we learn many details of the artist's childhood, his illnesses, and his interactions with those around him, professional relations as well as family and friends. As the letters were not intended for posterity, they do not glamorize the personalities involved, and a network of ambivalent relationships unfolds in them. They also supply a context to explain many previously recorded but seemingly incomprehensible events in his life. Time after time Lautrec's adult behaviour has roots in his childhood: his exhibitionism, his alcoholism, his transvestism, his obsession with parrots, his ambiguous relations with women.

The absence of accurate information about Lautrec has led to flawed analyses of the artist's character, maladies and motivations, and of the role played in his development by his mother, his father and others. It is time now to update and correct previously published works on Lautrec. Although I do not systematically state each error in order to rectify it, I have attempted to clarify all the misapprehensions, intentional as well as accidental, which have accumulated over the nearly one hundred years since Lautrec's death. Notes at the end of this book give the documentation supporting each claim, and are designed for use by further researchers in the field. In cases where I believe the anecdotal or circumstantial evidence is probably true but cannot be proved, I say so in the text. Predictably, the truth is more complex, and far more interesting, than the inventions and exaggerations.

[1] Paris, Gallimard, 1992. The English-language edition (*The Letters of Henri de Toulouse-Lautrec*, Oxford, 1991) is not recommended for French speakers.

A Note on Usage

As the sheer number of notes would have made note references intrusive in the text, I have followed the system of identifying the note by text page and 'the words to which it refers. In addition to these notes, all direct quotations are sourced, and all works by Lautrec are identified by their catalogue numbers in Dortu and Wittrock (see Bibliography), where these exist.

To avoid confusion, in quoted letters the writer's underlining for emphasis has been preserved. Italics in quoted matter signify that the word was written originally in English, not French. Original French titles of works of art, music and literature are used throughout, and are translated where necessary on first mention. The French (and British) convention of referring to floors of buildings beginning with 'ground', then 'first', etc., has been used for consistency. Birth and death dates of all persons mentioned in the text, where known, are given in the index.

ACKNOWLEDGEMENTS

I have had the good fortune to have the support of individuals and institutions who have generously put their experience, their collections and their funding at my disposal. I have also had, at every stage of the preparation of this book from the earliest proposal to the final draft, numerous and excellent readers, many of whom have spent long hours discussing my work with me. They are my teachers and my students, my colleagues, friends and family. Some are specialists, others are intelligent lay readers. It has been a pleasure for me to incorporate their suggestions and observations into my text. I have tried to note these observations when I felt they changed my thinking, but many influences that are not specifically documented are nonetheless there. It is with affection and gratitude that I acknowledge the following persons and institutions for their assistance in the preparation of this book.

Institutions: Archives Nationales, France; Bibliothèque Nationale, France; Chicago Art Institute; Columbia University; Erindale College, University of Toronto; Institut de France; Metropolitan Museum of Art, New York; Musée Toulouse-Lautrec, Albi; Musée du Louvre, Cabinet des Dessins; Musée d'Orsay; New York Institute for the Humanities, New York University, Biography Seminar; New York Public Library, Allen Room; Rijksmuseum Vincent Van Gogh, Amsterdam; San Diego Museum of Art; Sarah Lawrence College; Sheridan College of Art, Canada; The National Endowment for the Humanities; The University of Colorado at Boulder, Council on Research and Creative Work, and Graduate Council on the Humanities; The Harry Ransom Humanities Research Center of the University of Texas at Austin.

Individuals (in alphabetical order): Jean Adhémar; Sandy Adler; Hazel Barnes; Georges Beaute; Sarah Ben-Susan; Tina Berke; Austin Bloch, M.D.; Cameron Bloch; Philippe Brame; Richard Brettell; Victor Brombert; Riva

Castleman; Phillip Dennis Cate; Beverley B. Conrad, M.A. and Stephen E. Conrad, M.D.; Benjamin J. Conroy; Alfred and Nell Dale; Nora Desloge; Elizabeth Evans; Rhonda Garelick; Joan Halperin; Christopher Hewitt; Anna Hobbs; Marni Kessler; Jared Klein, M.D.; Carlton Lake; Sally Leach; Eunice Lipton; Jacques Magné; Pamela Marcantonio; Gary May, M.D.; The Very Reverend J. Anthony McDaid; Jean Méric; Mildred Mortimer; Gayle B. Murray; Arturo Nagel and Thérèse Bolliger; Linda Nochlin; Pat O'Meara, M.D.; Fieke Pabst; Sue MacDougall Palmer; George Plimpton; Katharine Bloch Rasé, M.S.W.; Anne Roquebert; Ann Scarboro; Herbert Schimmel; Robert Simmons; Marcelle Thiébaux; Richard Thomson; Marcus Verhagen; Bogomila Welch-Ovcharov; Guy Weelen; Gwen Wells; Suzanne Zavrian; Adek Zylberberg.

Particular thanks are due to the familial heirs of Toulouse-Lautrec's legacy: the Vignaud, Tapié de Céleyran, Rodat and Toulouse-Lautrec families; to my fellow members of the University of Colorado Research and Creative Work Faculty Seminar, especially Paul Levitt, Hardy Frank, Elissa Guralnick and Ed Rivers; to fellow members of the N.Y.U. Biography Seminar, especially Aileen Ward; to my husband, Ronald Sukenick, who read the book in draft form at least twice; and especially to the students who participated in my University of Colorado seminar, *Zola, Toulouse-Lautrec et la Belle Epoque*, Spring, 1993, all of whom read this book in manuscript form and gave me their comments, suggestions and corrections: Brad Anderson, Caroline Cohen, David Lapham, Lynda Supino, Marguerite Burke, Nathalie Eddy, and Tim Taylor.

Naturally the long hours spent on this book by Allegra Huston, Editorial Director at Weidenfeld & Nicolson, Celia Levett, the world's most meticulous copy-editor, Douglas Matthews, who prepared the index, Martin Richards, the designer, and Michael Millman, Senior Editor at Viking Penguin U.S.A., not to mention the support and patience of my agent, Phyllis Wender, are of inestimable value to me, and can only really be recompensed by the book itself.

I would like particularly to express my debt to Roger Shattuck who certainly unintentionally, and at times I think unwillingly, has served as a model and mentor for me over all these years.

Boulder, Colorado
December 1993

THE CRISIS

On Tuesday, 3 January 1899, Henri de Toulouse-Lautrec was expecting to have dinner with his mother. At the age of thirty-four, the artist regularly ended his afternoons getting drunk in a Montmartre bar and afterwards almost always went to his mother's for dinner. Before going to her Paris apartment at 9, rue de Douai, at the foot of Montmartre, he would take a horse-drawn cab from whatever bar he was in to the avenue Frochot, a private road. At the gate, he had the coachman ring for the concierge, who opened the carriage gates so the cab could drive up the cobblestone slope to the house at the end, number 15. There he at last got out and, using a cane, painfully dragged his tiny, deformed body up to his studio on the second floor. For unknown reasons he had taken to living there instead of in his charming apartment at number 5, whose nine windows looked out on tree-tops. In the studio, in the falling darkness, he would bathe and change his clothes before taking another carriage to his mother's, less than two blocks away.

On this day, as Lautrec dressed for dinner, his right hand was shaking and hampered by a large bandage. Even lighting the gas lamp in the studio was a struggle. He had put his hand down on a hot stove, receiving a burn that would not heal for several weeks.

The burn made it hard to bathe and dress, but Lautrec had developed a compulsive need to be clean. Art is dirty work. If he wasn't smelly with linseed oil and turpentine from his painting, his hands were stained with the greasy *korns* (inksticks) and *tusche* (inks) he used to make lithographs, or black from drawing with charcoal. In addition, his mother, the Comtesse de Toulouse-Lautrec, had little tolerance for the sartorial eccentricities that marked him out in Montmartre. His garb could be astonishing by turn-of-the-century standards of good taste. A portrait done the year before by his

friend Edouard Vuillard showed him in a floppy hat, bright yellow trousers, a red shirt and a large red and white plaid kerchief.

Even under his clothes, Lautrec dressed strangely, insisting on wearing layers of underwear, knitted longjohns and extra undershirts, no matter what the weather. Was he, like other advanced alcoholics, using this padding as imagined protection from the hostile gaze of others?

A skilled doctor, looking at his body moulded by the underwear, would immediately have understood a number of things about the crippled artist. Silhouetted in the studio lamplight, his physical appearance verged on the monstrous. He had a normal-sized torso, but his knock-kneed legs were comically short, and his stocky arms had massive hands with club-like fingers. His slope-shouldered, muscular body hid fragile bones, knotted by healed fractures. On at least two occasions in his adolescence, they had broken almost without cause. From childhood, his shuffling limp had forced him to use a short cane he called his '*crochet à bottines*' – his button-hook.

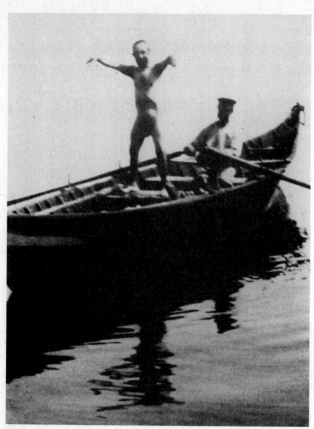

Bathing with a family friend, Viaud, c. 1899.

He showed other marks of abnormal physical development: very large nostrils, a thickened tongue, bulbous lips, a lisping speech impediment, a characteristic sniffle and an unfortunate tendency to drool.

Standing unsteadily in his underwear in the half-light, Lautrec might have appeared comic, or merely grotesque, except for the expression in his eyes. Well aware that they were unusually large and his only beautiful feature, he had developed the habit of taking off his pince-nez to gaze at a woman who interested him. They were such a dark brown that there was no difference in colour between the iris and the pupil and the effect was to intensify his gaze. They were quick to reflect his fluctuating moods, for his emotions were intense and easily visible. Melancholy and hostility could abruptly replace hilarity or tenderness. Though he hid behind a verbal barrier of witticisms and repartee, he was easy to offend.

Because of his handicap, Adèle de Toulouse-Lautrec tended to be over-protective of her son. She had always considered him her special

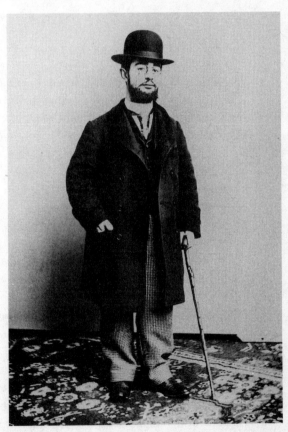

Standing, with his cane, 1892.

G. C. A., Paris 794 Montmartre. — La rue Pigalle — Nouvelle Athènes.

Two views of Montmartre soon after Lautrec's death.

'burden' and he remained so in her eyes even as an adult. But their relations were not easy. She seemed to encourage infantile behaviour from him, ambiguously giving in to his whims, then provoking his rages with attempts to control him. In 1898, she had rented an apartment in Paris so she could be close to him. This apartment, only a few blocks from Montmartre, where his own studios were always located, was described by a relative as being 'at the extreme limit of a neighbourhood where she could decently live'.

For Lautrec, freedom was just across this border. In Montmartre, he had found his own territory, a land his mother didn't like to enter. High on a hill the Parisians called a *butte*, it was known among artists for buildings which could be rented cheaply. A haven for the socially marginal, Montmartre was covered with steep footpaths, winding up and down the *butte* between the Place du Tertre and the Place Pigalle. At both the top and the bottom of the hill could be found clusters of *bals populaires* (public dance halls) and *cafés chantants* (singing cafés) where working-class clients gathered to sing along with a piano-player or pay by the dance to polka on a creaky dance floor. The seamstresses and factory girls went there on Sunday afternoons to meet their beaux at Le Moulin de la Galette and L'Elysée-Montmartre, places Lautrec and other artists would make famous in their paintings. In the

882. Montmartre qui s'en va — Le Maquis en 1907

evenings, women who listed their profession as 'actress' would dance the *cancan* and other intentionally shocking *quadrilles* at Le Moulin Rouge. There young girls from the provinces, hoping for fame, could be found high-kicking, occasionally without bloomers, for an audience which included not only their boyfriends and pimps, con-artists and the local representative of the police morals squad, but also painters and musicians, slumming aristocrats and rich bourgeois. The latter were often accompanied by chic mistresses, known as *demi-mondaines*, who added a titillating aura of satin and jewels to their explorations of working-class vice.

Lautrec painted this world as compulsively as other artists paint the landscapes of their beloved home countries, but his 'landscapes' were nearly always interiors. He himself was a well-known figure in these interiors and was considered to be virtually part of the uninterrupted show in the dance halls, where he watched and drank every evening.

Although, at least when he was sober, he did not brag in any systematic way, the dance-hall public knew vaguely that Lautrec was 'some kind of count'. His courtly behaviour made him stand out from the working-class clientele around him. Even in the most disreputable establishments, Lautrec maintained a reckless, aristocratic stance and a spontaneous generosity which came from the *noblesse oblige* of his upbringing.

His friends there would nonetheless have been astonished to learn that alongside his public debauchery, Lautrec lived in almost daily contact with his extremely conservative family, wealthy southern aristocrats whose *ancien régime* pedigree was widely recognized. He was particularly close to his pious, Catholic mother. The Comtesse de Toulouse-Lautrec, whom Lautrec called 'Maman' to her face and 'Adèle' behind her back, liked to think of herself as his major source of emotional and social support, an idea her son also promoted, perhaps for his own reasons. 'I long more and more to see you in Paris,' he had written to her in 1897. 'The evenings are empty indeed for us old bachelors.'

This statement was partly true, but it was partly cover-up. His relationship with his mother was a conflict he never resolved. *'J'ai deux vies'* (I have two lives), he said to a friend. His *'pauv' sainte femme de mère'* (poor sainted mother), as he liked to call her when she was not present, presumably did not know about his 'other life'. His letters to her are full of relatives and châteaux, inheritances and sporting events, horses, wines and carriages.

And yet his outrageous public behaviour was an open secret. His life in the nightspots and brothels was a form of rebellion against the control Adèle exerted on him and against his very real dependence on her. He knew that it pained her to hear of his spending time in dubious, if not illicit, company, and she was even more offended when he took his younger male cousins with him, exposing them to the same corruption. That world was the polar opposite of the stable, Catholic existence she led herself and would gladly have imposed on him, had she been able. Adèle was surely as dependent on her son as he was on her. Despite her martyred attitude about Henry, as she called him, her own life centred around caring for her unpredictable and unconventional son.

Adèle's over-decorated salons were full of knick-knacks and sombre Louis XV furniture, with family arms engraved on the silver, and formed a startling contrast to Lautrec's bohemian quarters, just a few minutes' walk away. In 1897, he had rented lodgings in the avenue Frochot, a sloping tree-lined walkway with a guard and locked gates that closed it off tightly from the nearby Place Pigalle.

A friend once described Lautrec's studio as messy and dirty with a huge fifteenth-century oak coffer, dumb-bells to strengthen his arms, artist's equipment, costumes and hardly any place to sit. There were just two stools, a divan and a couple of straightbacked chairs. Instead of a bed, as in all his studios, he kept a mattress on the floor, dressed up with material

from Liberty's, the famous London shop, and a bearskin instead of an eiderdown.

The studio revealed much about his interests, habits and state of mind. Prominently placed, one at each end of the room, were two tables. One, near his easels, was a marble-topped café table with wrought-iron legs. It was cluttered with empty drinking glasses, dried-up paint cups and an accumulation of curious objects: a Japanese wig, a ballet slipper, a woman's high-buttoned shoe, photographs, the score to a popular song and reproductions of classic art works. The other, a long table near the door, was set up as his 'cocktail bar'. A mass of bottles stood there in disarray, along with the heavy glasses which had held drinks brought up from Père François' bar on the corner. On this January evening, the bottles and glasses were mostly empty with sticky dregs in the bottom. Occasionally he would hobble over to the table, leaning on his small cane, to pick up each bottle, one by one, in the hopes of finding a leftover finger of rum somewhere. He would pour it into one of the thick-bottomed glasses and drink it down, not bothering to wipe his dripping moustache.

There was a platform for posing models and a stepladder so he could climb up to reach his canvases. But here, unlike in his earlier studios, there was no work in progress. The easels were empty. Cartons and boxes had been stacked around. Lithographic stones lay on the floor.

Everything in the studio had an abandoned look. Nothing was hanging on the walls. His paintings were leaning against the wall in orderly rows. Only the drab backs of the canvases were visible. Lautrec, it seemed, no longer wanted to look at the faces of his paintings. The desperate gaiety of the high-kicking dancers, the pale, garish whores, the elegant society ladies sitting at their pianos and the trim carriages in the Bois de Boulogne gave him no pleasure now. All the energy of Belle Epoque France, its showy richness and the frenzied abandon of its *déclassés*, was turned to the wall.

Lautrec's health had only really begun to decline the preceding year. He was suffering from an advanced case of alcoholism and probably from tertiary syphilis. He looked puffy and swollen. He began having heavy nosebleeds. In his earlier drinking days, he had ridden joyously in a fashionable dog-cart up the Champs Elysées to the Bois, ritually stopping at every bar; but now he seldom had the energy to leave his own neighbourhood. Once the leader of the gang, he no longer encouraged his friends to dress up in costumes and take photographs of one another. He didn't even have to hide brandy in the hollow cane he was rumoured to carry in case he needed a drink between bistros. Père François' bar was right across the street.

It was the first time since his childhood that Lautrec was not working. Early in 1898, he had written to his mother that he was in a 'rare state of lethargy ... The least effort is impossible for me. My painting itself is suffering...also no ideas.' He had always been meticulous about the commercial aspects of his work, but now, even where going out for business was concerned, he increasingly missed appointments. 'A thousand excuses for not showing up last night,' he wrote to his publisher Alexandre Natanson at *La Revue blanche*, 'I fell asleep before getting dressed and only woke up at an inappropriate hour.'

Nonetheless, tonight as usual, Lautrec would have dinner with his mother. He buttoned a clean white shirt and stiff collar over his layers of undershirts, pulled pressed woollen trousers over his bulging, almost feminine buttocks and completed his costume with a silk waistcoat, a woollen jacket and a soft cravat. He replaced his wide-brimmed felt hat with a bowler.

As he finished dressing, a knock came at his door. He opened it to find Berthe Sarrazin, his mother's housekeeper. Lautrec's mother, she told him, had gone with his uncle, Amédée Tapié de Céleyran, to the other end of France, to her family home in the town of Albi, near Toulouse. She had told no one in Paris except her servants that she was leaving, nor did she give any reason for her trip.

Over the years Lautrec and his mother had developed a love-hate relationship in which each continually tried to dominate the other. Until the evening of 3 January, their power struggles had always been disguised by a veneer of well-bred politeness.

Now, as Lautrec's behaviour had become more disturbing, his Uncle Amédée had persuaded his sister simply to abandon the situation entirely. Unwilling to confront her son herself or even to tell him why she was leaving, Adèle had asked her housekeeper to tell Lautrec she had gone. She also asked Berthe to write every day during her absence to tell her how her son was doing. Thus it came to pass that Berthe Sarrazin, an uneducated, self-effacing family servant, would provide posterity with a daily account of Lautrec's life over the next six tragic weeks. She and a number of other people, some of whom he scarcely knew, were keeping careful watch on him, writing to his mother about his every word and action.

The first of Berthe's letters to the Comtesse de Toulouse-Lautrec, dated 4 January 1899, reports what happened next with striking simplicity: 'I told him that Madame had left. He was very angry. He swore and pounded the floor with his cane. He took a carriage. He came to the house; he rang the

bell so hard he almost broke it. The concierge told him there wasn't anyone there. He didn't even say a word.'

Only a pattern of building intensity in their conflicts can explain Adèle's abrupt departure when her son visibly needed help or the outburst it provoked from him. In the succeeding weeks, Henri de Toulouse-Lautrec would endure a major psychological crisis, ending with a nervous breakdown and institutionalization. With the apparently superficial event of his mother's departure, Lautrec's grasp on reality crumbled. In his mind, he had been totally abandoned, left without any love or support in an aggressive and hostile world. In order to understand how his mother's approval or condemnation had become the dominant influence not only in Lautrec's life, but in his work, let us turn back to the time of his birth.

HENRI MARIE RAYMOND MONTFA, VICOMTE DE TOULOUSE-LAUTREC

M̂onfa

Henri de Toulouse-Lautrec, or Henry (the spelling his mother affected), was born before dawn on a black November morning in 1864 while a violent autumn storm raged over the pink brick city of Albi, fifty miles northeast of Toulouse. In his family's townhouse, such a storm can be a spectacular event, for the Hôtel du Bosc is built into the ramparts of the medieval city, and some of its windows actually pierce the old town walls to look out onto the open plain. When sheets of rain sweep across the walls, water floods through the closed louvred shutters of the house and under the double french doors, pouring onto the warped wooden floors of the salons and bedrooms.

Adèle, in labour in one of the bedrooms, must have been disturbed by the inevitable rush of servants trying to stem the flooding by putting cleaning rags against the doors and mopping up the wet floors by lamplight. The chaos caused by the storm probably also heightened the uneasiness of her husband, mother, mother-in-law and aunts, all awaiting the first child of the new generation, the heir of the Toulouse-Lautrecs.

For the event to carry the full symbolic weight of her identification with him, the baby should have been born the evening before, on Adèle's twenty-third birthday, but he finally came at 6 a.m. on 24 November. He seemed a perfectly normal baby, though not a very big one.

His mother had chosen the Hôtel du Bosc in Albi, one of her extended family's numerous estates, as the place to spend the final weeks of her pregnancy and to give birth. There, she could be cared for by both of Henry's grandmothers, who happened to be sisters. Adèle had married her first cousin Alphonse, and Henry was their first child. With hindsight, the fool-hardiness of a marriage between first cousins seems evident; but at the time, the rules of the Roman Catholic Church were not rigidly fixed, and first-cousin marriages were not strictly forbidden. Even if they had been, a wealthy

and powerful family like the Toulouse-Lautrecs could have applied for and received Papal dispensation. To a family like Henry's, there appeared to be good reasons for marrying one's cousin: not only did it assure that one's mate had as noble a bloodline as oneself, but it also kept property and inheritances within the family, instead of dispersing them. His father triumphantly took the baby down to the town hall the next afternoon to prove that his son had been born alive and to make his name official: Henri Marie Raymond de Toulouse-Lautrec-Montfa. It was a fine name for the eldest son of an eldest son: Raymond for Alphonse's father, Marie for the Virgin and Henri for Henri V, Comte de Chambord, the legitimate (if exiled) heir to the throne of France. The Toulouse-Lautrecs were ardent monarchists and had not abandoned hope that the nation would recognize the error of its ways and return power to the king by divine right.

Toulouse, Lautrec and Montfa were all place names. The fact that Henry had three of them was an indication of the importance of his origins. His forebears had been the lords of three lands: the great city of Toulouse, the small town of Lautrec, some twenty miles south of Albi, and the *commune* (parish) of Montfa, whose château was three or four miles east of Lautrec. Henry himself, God willing, would one day be the Count of Toulouse-Lautrec.

Although as cousins Adèle and Alphonse had known each other all their lives, the marriage was an obvious misalliance of temperaments. Euphemistically, the family described Adèle as an 'angel' and Alphonse as 'dashing'. The reality was somewhat more complex.

Until his marriage at the age of twenty-five, Alphonse had been a career officer in the cavalry. After graduating from France's most prestigious military college, Saint-Cyr, he had reached the rank of second lieutenant in the mounted Lancers. He was an avid horseman, the pride of his regiment for his jumping and success in the steeplechase. Fiercely competitive, barrel-chested and strong, he had the thick black beard and hawk nose of his father.

His bright brown eyes, however, had the expression not of a hawk, but of a charming, intelligent squirrel, reflecting a flaw in the image of this model of courage. Alphonse, or Alph, as Adèle called him, was totally, maddeningly undisciplined, completely unable to plan for the future or to complete the projects he undertook. In addition, he was such a resolute non-conformist that life in the military quickly became constitutionally impossible for him. Before he gave up his career, he spent one hundred and thirty-two days in the guardhouse for offences such as sketching, playing frivolous tunes on his bugle and being out of uniform.

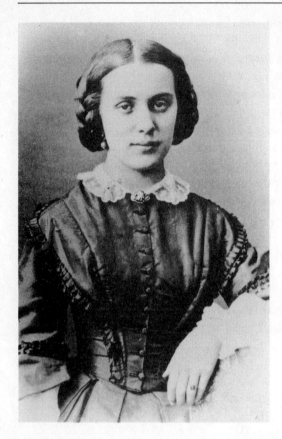

Adèle de Toulouse-Lautrec as a young bride.

Before he married, the unruly, handsome young nobleman had lived a life of riding, racing and weekends in Paris. Around his native Rouergat countryside, he had a reputation for being able to wear out three horses in a single day. The women he seduced, it was said, were not women of his own social class, but barmaids and farm girls, who did 'not mix love into matters of copulation'.

Alphonse once described his marriage to Adèle as resulting from the 'impetuosity of impulse' and, even after his son's death, spoke of the passionate love which had produced the child against his better judgment. Calling his son the 'fruit of the violent passion of real lovers', he added that he and his wife were not of the same 'moral class' and should never have been married. Later Henry himself would say irreverently, and somewhat improbably, 'My mother couldn't resist a pair of red riding trousers.'

Henry's mother was three years younger than her husband and probably

Alphonse de Toulouse-Lautrec
as a young man.

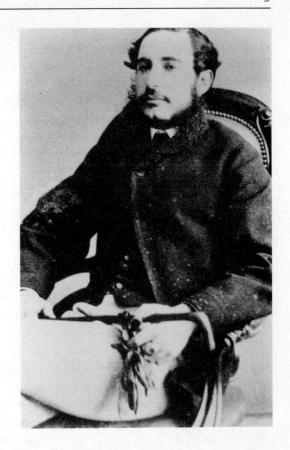

had looked up to him throughout her childhood, but she could hardly be said to be much like him. Adèle had all the qualities defined as ideal by the Roman Catholic Church: 'piety, gravity, devotion to duty [and] the bringing up of children, resignation, acceptance of one's lot and finding consolation from prayer'. As a bonus, she was pretty, modest, reserved, and a meticulous manager of household and funds. However, when antagonized, she retreated into icy dignity and sanctimonious, martyred silence. It was predictable that neither member of the couple would long be able to appreciate the qualities of the other.

The Catholic Church at the time supported a double standard in marriage which condoned exactly the behaviour of both Alphonse and Adèle. The 'madonna or whore' dichotomy, which marked the mentality of the entire era, led to frigid wives who, like Adèle, sought emotional consolation in the confessional and to a quasi-legitimization for husbands of adultery and prostitution. One of Henry's characteristics as an artist would be to render

the human qualities of the women on both sides of this division, concretely discrediting the split images of women provided by his culture.

Alphonse, typical of many men in France at the time, countered his wife's self-righteous piety with a combination of male chauvinism and outspoken anti-clericalism. 'Believe me,' he is supposed to have once said to his nephew's wife, 'it is better to be a male toad than a female Christian.' As he grew up, Henry was to be profoundly aware of this polarization between his parents. His ambivalence about the roles each of them expected him to play would be a major formative influence in his own life.

Although to outsiders it might have seemed strange that Adèle had chosen to have her baby at what was officially her Great-Aunt Joséphine's home in Albi, her decision reflected her nomadic status in the Toulouse-Lautrec family. For legal purposes, Alph and Adèle stated that they lived with Alph's parents in the Château du Bosc (also known as Le Bosc), some thirty miles to the north of Albi, and individually each owned property of different sorts; but they didn't really have a home of their own. They moved around from château to hunting lodge, townhouse to Paris pension, both together and separately all their lives. Great-Aunt Joséphine, who lived full-time in the Albi mansion, at over eighty years old was accustomed to family visitors who came to stay for weeks or even months at a time. *Bébé* Henry and his mother lived there for the first three and a half months after he was born while his father, grandmothers and other relatives came and went.

Almost immediately after his son's birth, Alphonse left Albi for a hunting lodge he rented at Loury, many miles to the north, in the Loire Valley. He did not even return at Christmas but instead sent a twenty-pound boar's haunch, with 'an enormous foot' still attached. Alphonse used riding and hunting as a way of escaping from things he didn't wish to confront. Part of a dedication written inside the cover of a book on hunting he gave to his son for the latter's eleventh Christmas explained his feelings: 'should you, one day, encounter the bitterness of life,' he wrote, 'first the horse, then the hound and the hawk will be precious companions and help you to forget things a little.'

After several months' absence, Alphonse announced to his family that he intended to live at Loury full-time. Emotional ties were intense in this family, and his mother, Henry's Grandmother Gabrielle, wrote to her sister, Henry's Grandmother Louise, who was also his godmother, in great distress:

Alphonse wants to leave Le Bosc and go to live elsewhere. He's unhappy with himself, so he takes it out on everything around him. He refuses to listen to reason.

Adèle can't talk to him at all. You can't possibly imagine this kind of mental aberration, nor all he's putting us through. He's dominated by one thought – he wants to shatter our life together and do without everybody. He must be very unhappy to think such ideas are the solution.

Any attempt to escape family pressures was severely judged. However, Alphonse prevailed. Henry, who grew up in a household where his father was almost always absent, formed a dual opinion of Alphonse, reflecting both his mother's resentment of her inattentive husband and his own fascination with his missing father's glamour.

Alphonse, ignoring his family's disapproval, excelled in what he personally admired. He devoted his full attention to organizing a complete hunting apparatus at Loury, hiring a professional huntsman to train his dogs and lead the chase. Hunting was more than a sport to him. He adored animals and protected them all, even those he hunted. He was known to call off a hunt if it was not being conducted in accordance with the rules that gave the quarry a fair chance to outwit the hunters. It was not unusual for him to come back from hunting carrying a dog over his shoulders because it had been wounded or was simply exhausted. He mixed beans into the mash of the eighteen dogs in his hunting pack to help their digestion and prepared for them beds of fresh ferns to keep fleas away.

Another hunter, M. de Montesquieu, recounted an anecdote which showed that Alphonse at times pushed his love of animals so far that it was incomprehensible to his friends, exasperating and alienating them. As the story went, Alphonse once invited him to shoot duck. After hiking for miles in extremely hot weather to reach an isolated lake, M. de Montesquieu loaded his gun and prepared to fire at the teal and other ducks they had flushed from the water, when Alph stopped him, saying, 'My dear fellow, please don't shoot. These birds are the delight of my eyes, and if you shoot you'll frighten them and they might not come back.' Montesquieu presumably never hunted with him again.

Alph's two unmarried brothers, Charles and Odon, visited him often to hunt at Loury, and there is some evidence that Adèle and Henry would have been able to move with Alphonse to Loury if Adèle had insisted, but she chose not to. Surrounded by her kin in Albi, Adèle was learning that she got along quite well without Alph. This was fortunate because his neglect of her, particularly in contrast to his love of animals, was so flagrant that it took on almost mythical proportions. Family legend has it that he took her to Nice on their honeymoon and disappeared. She was convinced that he must

somehow have been killed and, grief-stricken, returned to her mother's. There she received a two-word telegram from Alph at Loury: 'Send ferrets.' Another story claims that the week after their marriage, Alphonse returned to his cavalry post as required and, when the weekend came, went to Paris on leave. There a friend ran into him in a restaurant and said, 'I'm eager to meet your new wife. I presume she's here with you.' 'My wife?' said Alph going pale. 'Oh, my Lord, I have to leave at once! I completely forgot I was married!' In a third story, he is supposed to have boarded a train, leaving Adèle standing on the station platform. As she had no money with her, she had to persuade the railway company to send her home.

In one verifiable incident from Henry's childhood, Alph instructed Adèle to bring their son to meet him at the train station in Orléans, so they could travel together to Paris. But by now, Adèle had learned to ignore his demands when they inconvenienced her. Since going first to Orléans involved changing trains and complicated scheduling, she decided to go straight to Paris. When she and Henry arrived, they found Alph already at the hotel. He had apparently revised his plans without informing them. 'If I'd listened to him,' she wrote to her mother, 'I'd still be waiting in Orléans.'

The Toulouse-Lautrec side of the family had a reputation for producing eccentrics, and both Alphonse and later his son Henry fully lived up to that reputation. Alphonse delighted in collecting and dressing up in exotic costumes. 'This is my Circassian helmet,' he wrote to his mother, sending her a sketch of it, 'exactly the same shape as the towers at Le Bosc, decorated with red cloth, trimmed with gold, which floats in the wind as the knight gallops.' Once Alphonse came down to lunch at the Château du Bosc dressed in a Scottish plaid, with a ballet dancer's tutu in place of the kilt.

Alphonse had the habit of keeping rather exotic animals as pets. He was particularly attached to birds of prey: falcons, ospreys, hawks and owls. The family loved to tell the story of the time he gave an elegant lady a ride to the Opéra in his splendidly appointed, high-wheeled carriage, manoeuvring it rapidly and easily through the streets of Paris. His passenger quickly realized that everyone was noticing them. This made her blush at first; but as the ride progressed, she began to be flattered by the looks, then to gaze proudly around, accepting the attention as her due. Only when she got down from the carriage in front of the theatre, did she realize what the onlookers had been staring at: under the rear axle were suspended several cages full of owls and falcons, swinging gaily as the carriage moved through the streets. Alph had hung them there so his hunting birds could 'get some fresh air'. People around him were both charmed and outraged by his tranquil defiance of

convention, behaviour encouraged by the combination of great wealth and complete unaccountability.

Alph had two modes of being: he was either intensely, dramatically present and demanded everyone's attention, or he had 'gone hunting', sometimes sending very depressed letters back to his family, as his mother had remarked when he suddenly decided to live in seclusion at Loury. This strong bi-polarity resembles manic-depressive behaviour. When the depressions hit, he preferred to disappear.

Henry in the meantime was thriving in Albi. His Grandmother Gabrielle described him as 'graceful and pink-cheeked', sleeping in the same bed with

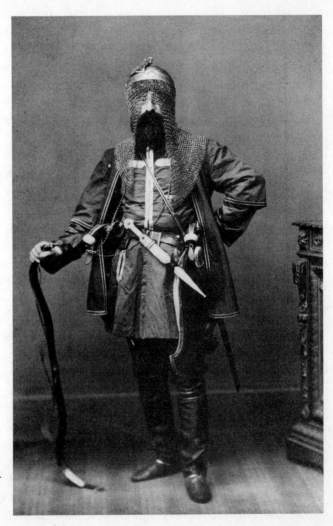

Alphonse de Toulouse-Lautrec dressed in Circassian chain mail.

his mother and already showing an energetic, laughing disposition. He had developed, she observed, 'the family's excellent stomach, capable of digesting nails'. Otherwise, throughout his childhood his health was fragile. He was continually suffering from colds and other respiratory troubles, which may have been side effects of his still unrecognized congenital disease. He was not, however, a complainer, consistently directing his attention to pleasure and amusement.

By the time Henry was four months old, Adèle had introduced him to the nomadic existence she found normal, travelling from family home to family home: from Albi to Uzès, to Vindrac, to Narbonne, to Céleyran, to Le Bosc, in each town visiting his grandmothers and great-grandmothers, aunts and great-aunts in their numerous estates and châteaux. The accepted hypocrisy, at least for the present, was that despite his odd behaviour, Alphonse loved his wife and child. When Henry was six months old, his father saw him for the second time: 'Alphonse finally arrived yesterday after at least a dozen countermanding letters,' Adèle wrote. 'Naturally he's ecstatic over his son and his progress. We gave him his six months' weighing together: ten pounds, six ounces, a fair weight for a baby ... or a turkey.' Occasionally thereafter, Alphonse would show up where his son and wife were staying, but more often he would get there when they had left, having been delayed by a detour through some out-of-the-way city to look at a horse or a dog he might wish to buy.

Although Henry had begun to 'talk' (Adèle said his first words were '*ba-ba*') at six months of age, he was seventeen months old before he took his first steps, not late enough to worry about, but unusual enough to notice. The first sign that anything might be abnormal about his physical development had come at the end of May 1865, when Henry was six months old. In a letter, Henry's Grandmother Gabrielle said that the family doctor, M. Seguin, had reassured them about the 'dear child's' foot while warning them that it shouldn't be neglected. Since Henry couldn't yet walk, it is unlikely that he had an injury. From that time on, ignoring a nagging anxiety that all was not quite right, his mother would try to attribute his smallness, fragile health and slow growth to dietary or nervous problems. The importance of the doctor's visit, however, should not be discounted, for at that time in France, particularly in the provinces, even wealthy people did not ask for a doctor unless they believed something was very wrong.

In October 1865, after living apart from his family for nearly a year, Alphonse suddenly asked Adèle to come with Henry to live at the hunting lodge at Loury. He had everything ready for them, he said, and had even

hired a cook; but Adèle kept finding excuses not to go. In fact, she delayed reuniting with Alphonse for another year, preferring to live at Le Bosc even when she and Henry were the only ones there. One of the reasons she resisted moving to Loury was that her marriage had suffered some sort of public damage. The incident was apparently so humiliating that neither Adèle nor anyone else ever said in writing what it was, even though everyone in the family probably knew. It was referred to indignantly in letters the women in the family wrote back and forth in the summer of 1866. Great-Aunt Joséphine wrote to Adèle's mother, Henry's Grandmother Louise, in May that she was very worried about Adèle. A letter from Henry's Great-Grand-mother Jeanne du Bosc was more detailed, but curiously inexplicit: 'a dagger-thrust to the heart could not have caused me more pain. I've lived too long to have to see such things happen in my own family … our dear Adèle deserved far better treatment. I can't imagine the sad life she's going to lead at Loury.'

Whatever it was, it happened while Alphonse and Adèle were both at the wedding of Alix, Alph's sister, and Amédée, Adèle's brother, in January 1866. Returning to Le Bosc, Adèle wrote to her mother: 'My father-in-law and his sons are occupied with their habitual pleasures, hunting and fishing, but I believe I see in [them] a trace of sadness.' With her traditional reserve and understatement, she mentioned her problems only indirectly: 'Moreover, except with my mother-in-law, I remain completely silent, and I live from day to day, praying God to arrange everything for the best.'

While Adèle was at the wedding, Henry suddenly found himself aban-doned for two months to the care of his paternal grandparents. Adèle had planned to be away only for the weekend, when her mother's father-in-law died. Perhaps not realizing how traumatic a lengthy separation from a small child could be, she delayed her return to Le Bosc, going instead to help her mother settle the estate. This first unexpectedly long separation, possibly exacerbated by his father's constant absences and the tensions he may have sensed between his parents, began a pattern Henry would repeat throughout his life. At each separation from his mother, even as an adult, he tended to fall into depression and occasionally despair.

Under pressure from Alphonse and perhaps from the rest of the family to move to the Loury hunting lodge, Adèle finally acquiesced. In any case, she had few options. Divorce was impossible. A career would have been almost unthinkable. She had made an unhappy marriage; now her responsibility was to be heroic in adversity – to prove her worth through prayer and loyalty

and to be a perfect mother to her son. In doing what was expected of her with a meticulousness that amounted to a vengeance, she could at least provide a living contrast to her husband's irresponsibility and neglect. Where he was grandiose, she was modest. Where he was impatient, she was long-suffering. Where he was headstrong and egocentric, she was devoted – if not to him, at least to her position of moral superiority. In mid-August, when Henry was nearly twenty-one months old, she finally moved with him to Loury, feeling very sorry for herself.

Alphonse clearly had gone to some effort to make Loury a home for his wife. The hunting lodge was not only isolated practically half a mile through the forest from the nearest house, but massive, sparsely furnished and very rugged. Alph decided that since he was having a new dog kennel built, he would also have a room in the house refurbished as a formal salon. He wanted Adèle to feel comfortable 'receiving ladies'. He had bought her a good piano. Soon he bought her a coupé to ride in from the train station to the lodge to facilitate the many visits to relatives she continued to make.

That autumn, Alph took Adèle and Henry on a gala trip to Paris. They went to the Opéra and Adèle did all her clothes shopping for the winter, leaving her infant son with his maid at their hotel in the rue de Richelieu.

Henry was thriving. 'He's perpetually trotting about,' Adèle wrote to his Grandmother Gabrielle, 'very funny in his first pair of trousers. In the garden he likes the flowers a little too much, and if we let him, he'd overdo the "harvest". He's been wearing the pretty red wool stockings you sent him, which (he says) make him look like a baby partridge. When his maid comes to get him he yells orders at her: "To the kennel, Maid! To the stable, Maid!" I can't scold him, he lives with the whippers-in and the dogs, and has absorbed that language.'

Alphonse exuberantly participated in the household activities, which was not entirely to Adèle's liking. She described his interest in cooking with resentment: 'Alphonse caught an enormous salmon in the Loire. This mas-todon is worth having mounted, but Alphonse wants to eat it, preparing it himself, as it should be done. Thus it's been marinating for five days and my husband spends each day inventing a new sauce, which humiliates the chef. Henry is ecstatic and would happily abandon alphabet and catechism to observe the culinary fantasies of his father.'

For a child just learning to explore his environment, Loury was a mys-terious wilderness. Surrounded by deep woods, it remained primarily a hunting lodge even after the family had moved in. There were almost always other hunters visiting, and Henry must have found it fascinating to watch

the men mounting their horses in the courtyard at dawn while the whipper-in tried to control the frenzied dogs, releasing them only after the call to hunt was sounded on a curved horn. The hunters would gallop off, following the baying through the wide avenues which had been carved for kings in the royal forest two hundred years before.

As the riders entered the woods, the little boy could see the low-hanging branches slap at their faces, showering them with wet twigs and leaves. When they came back at the end of the hunt, bits of vegetation would still be caught in their hair and clothing, and the top half of their bodies would sometimes be soaked from the rain, even though their thighs and buttocks had been steamed dry by the heat of the horses.

That September, they did not bag much in the way of venison or boar, but their hunts on foot, with beaters to flush the game, sent them home with partridge and pheasant for dinner every night. There was so much rain that Henry had to wear wooden shoes to keep his feet dry, which meant stationing someone at the door to put them on him as he scampered out of the house and to nab him and take them off again when he came back in. There were so many mushrooms in the woods that, so Adèle wrote to her mother, they were 'living on them'. But the humidity that made Loury a paradise for mushrooms was hard for her to adapt to, coming, as she did, from Languedoc, 'the land of dryness'.

Despite Alph's attentions, Adèle disliked Loury. She strove to civilize some small territory in her husband's world. The first summer, she tried to make the place homey, laying flowerbeds and planting strawberries around the house. She seemed to want above all to establish routine and stability. She was completely uninterested in the hunters, except to be irritated when they affected her daily schedule and interfered with her own needs, which centred around caring for Henry and rigorous religious practices – beginning each day by attending Mass and observing Catholic rituals such as fasting until dinner on Fridays. If the hunt was particularly arduous, the men sometimes didn't return until well after dark, and she would get very hungry. She wrote to her mother asking if it was not permitted to have a snack in such a case. She added wistfully that as she was always busy, she didn't have time to be bored, but 'that doesn't mean that my heart and mind are not frequently very far from here'.

Even in the wilderness, she had already begun her son's religious training, and she announced proudly that Henry, who was twenty-two months old, was very good when his nurse took him to vespers. She took refuge from Alph's anti-clericalism in signs of piety in Henry: 'A little while ago,' she

wrote to her mother, who, unlike her husband, understood the importance of such events, 'he was improvising a prayer on the cross of my rosary: <u>Good night little Jesus, I give you my little heart.</u>'

In one of her weekly letters to Alph's mother, Gabrielle, Adèle related an incident that puts the distance between herself and Alph into perspective and makes her martyred attitude more understandable. She said that they were replanting the lawns. They had been 'horribly ploughed up by the nasty wild boar, which I <u>finally</u> managed to have shut up in the kennel. I hope it'll seriously injure some dog, and they'll do away with it. It's a dangerous animal for whom I feel no affection.' Alph must have brought home a young or wounded boar to make a pet of it. Boars are savage fighters and have been known to kill not only dogs, but men. Some years later a large male did rip open five of Alphonse's hunting dogs, which had to be sewn up 'like *galantines*' (boned stuffed chickens), keeping him and his friends from being able to hunt for several weeks. For Adèle, whose son could no longer play in the garden because of the boar, it must have seemed that Alphonse was more concerned about following his whims than making a safe environment for Henry.

As winter set in, Adèle's mother wanted to know how her daughter's marriage was going. Adèle's answering letter said, 'Dear Mama, you would like to know, and it's legitimate, exactly what my relations are with Alphonse ... but frankly, don't you believe there are things that shouldn't be put in writing? I can tell you only that I do my best to try to make our household as comfortable as possible for him and I think he is grateful to me for this. Henry will be the link between us, thank the Lord.'

Adèle devoted herself to the child, fixing him a special diet because she found game and wild boar too rich for him, keeping him amused when he developed yet another bad cold and couldn't go out. 'It takes looking at a lot of pictures to keep him happy,' Adèle noted, adding, 'My *gros chéri* is as sweet as can be with me, and that helps me to bear many things.'

Before he was two, Henry was surely aware of the struggle between his parents and of the need somehow to reconcile their personalities, poignantly symbolized by contrasting images: the wild boar in the garden and the nightly vespers in the chapel.

In a generous gesture, Adèle had offered all Henry's baby clothes, including his beautiful christening robe (embroidered, in keeping with his royal lineage and name, with *fleurs de lis*), to her sister-in-law and first cousin, Henry's Aunt Alix, who was pregnant with her first child. 'After all,' Adèle said, 'it's

possible I'll never need them, except for Henry's children.'

She must have been surprised a month later to discover that at the very time she wrote that letter she was pregnant again herself. This pregnancy may explain why, despite the trouble between them and his flagrant lack of interest in his son, Alphonse had been so eager to have Adèle and Henry invade his masculine retreat at Loury. It is quite possible that Alphonse wanted another child.

Alphonse was an expert judge of animal perfection: he owned, trained and bred dogs, horses and birds of prey. He was quite aware of the risk of deformity associated with inbreeding and may have sensed very early, even from Henry's birth, that there was something wrong with the normally proportioned, but very small, baby. Alphonse's abrupt disappearance a few days after Henry was born and his refusal to see the child again for six months indicate more than simple lack of interest. In a close-knit family like the Toulouse-Lautrecs, such behaviour, although not unthinkable, was seen as distinctly anti-social. Doctors have noticed that fathers – particularly competitive, athletic fathers – are highly sensitive to any physical abnormality in a child, sometimes even before the abnormality has been recognized. It is not rare for the father to avoid contact with the child, particularly when that child is a son. If Alphonse insisted that Adèle move to Loury, it may have been because he was hoping to produce a second child, a healthy son who would be able to ride and hunt with him.

On both Christmas and New Year's Day Alphonse and his friends went hunting as usual. 'I spent a very solitary January first,' Adele wrote in her New Year's letter to Alph's mother. 'The bad weather kept me close by the fireplace. Thank goodness my Henry was there, so happy to own a new wooden horse, a fat [toy] musician cat and a train set, that his gaiety cast a ray of sunshine onto my sad thoughts. I've aged at least twenty years in the past twelve months. I feel like an old lady with no beauty in my life ... I ask only to watch Henry grow up. My life is completely concentrated on him; this is what I'm thinking this evening by the fire.' She did not mention her pregnancy. As it advanced, she appeared less than overjoyed at the prospect of a second child. In any case, she wanted a daughter.

Answering her mother's request for suggestions for gifts, Adèle remarked that sending another toy to Henry was of little use: 'he's not spoiled for playthings and the ugliest one makes him happy until he manages to take it apart.' She herself preferred to have money, 'to convert into useful things', and also requested twenty pounds of chocolate, which they used at the rate of more than a pound a week. In closing she mentioned that '*Bébé* asks for

paper and pencil as soon as he sees me sit down at my desk. Unfortunately, he can't yet wish you <u>Happy New Year</u> legibly.'

Adèle used the birth of Alix's baby, Henry's first cousin, Madeleine, in February 1867, as an excuse to take Henry to Albi, then on to her mother's estate at Céleyran, where they stayed for three months. She was nearly six months pregnant in April when they did the entire journey in reverse, returning in high spirits to the hunting lodge despite twenty-one hours on the train, loaded down with truffles, goose-liver pâté, artichokes and the first asparagus from Henry's grandmother's garden.

Such trips required amusing Henry at length with stories, particularly, as he requested, 'about horses'. Like every child, Henry was fascinated by tales of knights and ladies, battles in armour and holy crusades. But in his case, the stories were said to be true, and his own forebears were the heroes. Truth, particularly where family history is concerned, is always relative, and there is some evidence that he heard vastly different versions of the family history, depending upon which parent was telling it.

Despite their nomadic life, the Toulouse-Lautrecs were by no means rootless. His family was descended from a secondary branch of one of the oldest and most prestigious families in France, the Toulouse dynasty, which had ruled the regions of Toulouse and Aquitaine a thousand years before he was born. The Counts of Toulouse were almost like kings. At their most powerful, they ruled an enormous region that included Languedoc, Rouergue, and Provence – the whole southern part of France – and maintained this control, despite innumerable wars with rival factions, for five hundred years. Over the generations their genes produced a series of leaders whose physical strength, mental energy, audacity and violent ambition made one Count of Toulouse after another famous throughout the land.

Adèle no doubt told her son the story of her favourite Toulouse ancestor, Raymond IV, who led his personal force of one hundred thousand men (a massive army for the time) on the first crusade to the Holy Land and was largely responsible for capturing Jerusalem for the Christians in 1096, making it a feudal state under French sovereignty. Raymond IV was buried there, and his second son stayed in Asia Minor where his descendants ruled the area around Tripoli for generations.

Another Count of Toulouse, Raymond VI, had taken the side of the Albigensian heretics, accused of Satanism by Pope Innocent III in 1209. When his youngest brother Baudouin aligned himself with the Pope, Raymond, furious, tricked him into an ambush and had him brought to Montauban, condemned to death and hanged from the limb of a walnut tree.

In the appalling fanaticism on both sides of this conflict – which, like all 'holy wars', used religion only as a pretext in what was essentially a struggle for economic control of the region – the Toulouse family was excommunicated by the Pope on ten separate occasions. The Toulouse nobles responded to one excommunication by stringing up the legate 'who so impudently brought them his Holiness's writ'. It was said that Alphonse had remarked nostalgically to an archbishop at dinner one night: 'Ah, Monseigneur, the days are gone when the Counts of Toulouse could sodomize a monk and hang him afterwards if it pleased them.' The conflict ended in a religious and civil war which devastated and depopulated the domains of Toulouse and finally obliged the once-powerful Counts of Toulouse to pay allegiance to the French Crown. The fierce and independent status of the family changed, and their territories became known as Languedoc, the largest province of France. In Albi, while the memory of the heresy was still fresh, the spectacular Cathédrale Sainte-Catherine was built with thick red brick walls and fortress-like ramparts in case the population ever decided to rebel again.

Baudouin de Toulouse, who before his untimely death had married Alix, Vicomtesse de Lautrec, in 1196, united the two noble families which would form Henry's direct lineage. In the thirteenth century they acquired the name and estates of Montfa, creating the combined name Toulouse-Lautrec-Montfa, which was used from the fifteenth century on.

Baudouin's murderous elder brother, Raymond, was himself married five times, the fourth time to Joan of England, daughter of King Henry II and sister of Richard the Lion-Heart. Ironically, that branch of the family died out in 1271, and its estates and titles were merged with the French Crown, but the younger branch thrived. Although by right and by order the Toulouse-Lautrecs occasionally served at the Royal Court in Paris, they seemed to prefer to stay in the Languedoc, strengthening their own possessions and developing a legendary prowess as hunters.

The Counts of Toulouse-Lautrec may have provided the noble titles, but it was Adèle's side of the family, the Imbert du Boscs, who had accumulated most of the wealth which permitted Henry's parents to live in the style to which they were accustomed. Though not as high-born as the Toulouse-Lautrecs (the Imbert du Boscs were only barons), the family was well respected and known for being exceptionally conservative and pious, not to mention for producing excellent businessmen, who shrewdly acquired lands, vineyards, townhouses and châteaux. Under Napoleonic law, inheritances were split equally among the children, and these properties had been

sub-divided from generation to generation, but they still amounted to a considerable fortune. When Adèle's grandfather had died the year before, her mother had inherited at least eight estates, including the domaine of Céleyran with its three thousand five hundred acres of farmland and vine-yards, and the spectacular, palatial Villa de César where she lived just five miles from the Mediterranean. When Henry was a child, there were other family properties at Le Pech Ricardelle and Sainte-Lucie, and townhouses in Narbonne and Béziers.

As an adult Henry could expect to inherit some of those estates, as well as his father's title of count. Throughout his childhood, his family, both consciously and unconsciously, prepared him to assume this heritage. None-theless, the child's peaceful existence on what were essentially large farms was quite different from the exploits of the great Toulouse dynasty.

Country nobles such as the Toulouse-Lautrecs were closer in many ways to their farming neighbours than they were to royalty. Henry's family was perhaps even more profoundly snobbish than its forebears precisely because it could no longer equal their glory. In their letters to each other, the Toulouse-Lautrecs often expressed a condescending distrust of anyone personally unknown to them: this included people of other social classes, nationalities, races, religions and political persuasions. An individual was immediately considered to be of more value if he was one 'of our world', and many decisions in young Henry's life were made on that basis. His family was greatly chagrined when, as an adult, Henry insisted on having friends from all social classes.

In the meantime, preparations were being made for the existence of yet another Toulouse-Lautrec. This time Alph was not even present for the birth. He stayed at Loury while Adèle, seven months pregnant, took Henry with her to finish her lying-in at the Albi mansion, free from household responsibilities and surrounded by other members of the family. Grand-mother Louise was nervous about how Henry would react to the new baby because Adèle still slept with the two-and-a-half-year-old in the same bed.

On 28 August 1867, Adèle's second son was born and named Richard after Richard the Lion-Heart. Henry, who was nearly three, was allowed to go to the christening. When he was an adult, he frequently repeated an anecdote from that day as proof of his early vocation as an artist: as the guests were leaving the chapel, the small boy noticed that each one was signing the register and immediately insisted upon being allowed to sign it himself. 'But you don't know how to write yet,' someone pointed out. 'That's all right,' he answered without hesitation, 'I'll draw an ox!' In later years, relatives would

insist that this incident really took place when he was four, at the christening of his cousin Raoul Tapié de Céleyran, and that he did not draw an ox, but a cow. Whether or not Henry exaggerated the story, it is certain that by the time he was three he was no longer satisfied with just looking at illustrations in books. He already wanted to make his own drawings. 'He's a great sketcher,' reported Grandmother Gabrielle, 'and we consume quantities of paper and pencils.'

Suddenly Henry had to learn to make use of his limited internal resources, for his brother supplanted him as the focus of family attention. Richard was not a healthy child. Adèle had a severe fever just after the birth and lost her milk. To make things worse, the family agreed with her opinion that her own poor health was to blame for Richard's frailty. Alphonse, writing not to Adèle but to his mother, suggested that if a good wet nurse were required, they shouldn't hesitate to go out and hire one, since Adèle couldn't do the job. Although the wet nurse was hired, and Richard was 'less pale', he was constantly ill. The family naturally concentrated its attention on him instead of on Henry. 'It makes me want to cry,' Adèle wrote to her mother on Henry's birthday in November. She did, however, take the time to say that her elder son had finished his third year 'in flourishing health' and that he now liked his little brother so much that Adèle was afraid he'd suffocate him with caresses, 'although he has almost as frantic a passion for the long-horned nanny-goat who gives her milk to his younger brother'.

At first Henry seemed to adjust well in spite of everyone's preoccupation with Adèle and her sick baby. At his grandparents' château, where they were living until the baby was better, there were many people around to give him attention. In October, his Grandmother Gabrielle had described him as joyous and easy to deal with, enchanted to be at Le Bosc and sleeping soundly. A month later she admitted he was getting 'a little rowdy, having been with the servants a lot'. He responded to his change in status in the family by developing a game which both his mother and his grandmother thought was charming – no doubt a factor in its longevity as an amusement. He would put on a blue and white hooded wool Moroccan burnoose that his Aunt Alix had left at Le Bosc and announce that he was his cousin Madeleine. 'He is very good when he is dressed up like that and speaks as softly as he possibly can.'

'He refuses to be called anything but Madeleine, and corrects us all when we say <u>Henry</u>, or refer to him in the masculine,' Adèle noted a few days later, adding wryly, 'That will have the advantage of teaching him grammar.'

A month later, the game persisted. 'Decidedly, Henri thinks only about Madeleine,' Grandmother Gabrielle wrote to her daughter, Henry's Aunt Alix, 'and when you call him Henri, he always answers by saying, "I'm Madeleine." He is very funny and wants me to tell you that you don't have any Madeleine any more, that she's at Le Bosc.'

As winter approached, it was decided that Adèle, Henry and Richard would stay on with Alph's parents at Le Bosc until spring, while Alphonse continued to live and hunt at Loury. Once again, it would be nearly a year before Henry lived with his father again.

Grandmother Gabrielle had inherited the spacious, comfortable Château du Bosc from her father, and she and Henry's grandfather Raymond, Comte de Toulouse-Lautrec, lived there in the provincial elegance traditional to wealthy French *hobereaux*, a word which originally meant falconers, but had come to refer to minor country nobles.

Originally built as a fortress, the château is so proportioned that its towers and four storeys seem almost low compared to the breadth created by its outbuildings, stables, kennels and the small chapel which was built during Henry's childhood. The low ceilings and red-painted wooden sills and shutters give the rooms a warm, homey feel. During Henry's childhood, each room was heated by a fireplace, one of which, in the guards' room, where the arms of the Comtes du Bosc had been inscribed in 1521, was wide enough to hold an entire deer on a spit.

The men of the family and their male guests hunted almost every day, staying home only when the weather was too inclement. They assembled each morning on horseback in the enormous courtyard, to be led by Henry's grandfather, whom some people called the 'Black Prince', known for his unsmiling taciturnity.

At Le Bosc the table was set from eight in the morning on, for one never knew when the hunters would return, ravenous for 'hot and cold beverages, salt victuals and sweet, meat pâté in crust, venison, cold cuts, game birds in wine jelly, perfect goose livers in their golden fat larded with truffles, butter and cheeses, preserves and honeys'.

Generations of game trophies – heads, antlers, horns and cloven hooves – hung on the walls. And generations of children had played with the worn playing cards, talked to the grooms in the stables and gone out to the kennels to see the new puppies.

Henry seemed as happy at his grandparents' as he had been at Loury. He loved running freely around the big, draughty house in his red stockings even when it was snowing outside. He had grown so noisy and active that

his grandfather had nicknamed him 'Tapajou' (rowdy), in the *occitan* dialect of Languedoc which they all spoke more or less fluently along with standard French. While Henry slid down the polished corridors in his socks, the rest of the family took refuge from the cold in the salon, where they had put the dining-room table, and kept the fire burning all day long. Grandmother Gabrielle gave Henry an alphabet book, and Adèle began teaching him to write.

Although Richard seemed better, there was a constant air of anxiety in the household. Fear of sickness wove uneasily through all families in the nineteenth century. The causes of disease were often not known, and explanations verged on the magical. For example, Grandmother Gabrielle was convinced that a thunderstorm at Le Bosc had 'given' toothaches to four adults, and that the death of the child of friends was caused by 'a temper-tantrum thrown by the nurse, which gave the child convulsions'. When there was a chimney fire at Le Bosc, Adèle theorized that she developed a serious

Henry about aged three (c. 1867).

inflammation because of her panic during the fire. She also attributed an attack of vomiting Henry had once had at Loury to Alphonse, who had 'yelled for Germain [the gamekeeper] in a thunderous voice while the poor little thing was eating his soup'.

Illness was seen as punishment which struck mysteriously and uncontrollably, defying all precautions. People died suddenly and inexplicably. Tuberculosis took the young, influenza took the old, and cholera swept France in annual epidemics that wiped out the weak and the poor. In 1872, a third of the twenty-year-old men called up for military service were excused for deformities or infirmities, including rickets, consumption, hernias, rheumatism, skin diseases, goitre, scrofula, convulsions, paralysis and 'precocious debauchery' (possibly venereal disease).

Despite her education and fortune, Adèle felt painfully unprotected against the arbitrary nature of illness. Someone was always sick in the Lautrec household, often with ailments which could not be treated. She was extremely vigilant about her children's health and particularly avoided taking them to places where there was known to be disease. In early August 1868, it was finally decided that eleven-month-old Richard was well enough to go to Loury for the first time. But when Adèle arrived with the two children after more than a year's absence, she was shocked to discover that

Château du Bosc, near Naucelle, Aveyron.

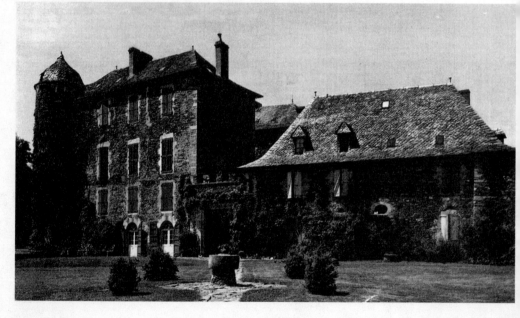

she had not been warned of an epidemic of intestinal disease, perhaps cholera, in the region. The cook caught it and left, and the huntsman was also ill with it. Richard, already a frail child, fell ill.

All of them, Adèle and Alphonse, Rosalie the maid and their nearest neighbours, took turns caring for Richard night and day. Henry's distraught parents, sick themselves with exhaustion and fear, sat helplessly by the cradle of their younger son. Adèle prayed for a miracle, bargaining with God, begging Him to take her instead of Richard, but the miracle did not come. After being desperately ill for eleven days, Richard died on the night before his first birthday.

'The unsaid things in my letter will tell you more than the words I cannot seem to find,' Alphonse wrote to his mother the following morning. 'I have no plans. My wife, whom I have left free [to leave Loury and the marriage if she desires], is so shattered with grief and lack of sleep that it would be unthinkable for her to travel ... I have just written to my mother-in-law to ask her to come – may her presence bring us some comfort in our sadness.'

When Adèle was able to write herself, she was struggling to accept Richard's death without losing her faith in God. At least, she said, God had given her the resignation to bear 'without complaining, and without dying ... the most cruel test in this sad world ... I could never have believed this sacrifice would be so painful ... but God has his views which are not our own.' Piously submissive even in her grief, she went back and crossed out the last phrase, correcting it to 'which are not obscure like our own'.

'My poor Henry tried hard to console me, when he saw me crying,' she wrote, continuing, 'Alphonse has been so good to me during this ordeal. I'll never forget it, and the memory of this will make many things easier to bear ... He has offered to let me travel anywhere I like, but I would never have the courage to come back to Loury if I left now, to sleep in the room where I watched my child die, to hear the church bells that tolled for him!'

Briefly reunited in grief, the family healed as best it could. Henry's Grandmother Louise encouraged her daughter to tour the countryside and go looking for mushrooms in the woods. Alphonse grieved in his own way, throwing himself into frenzied hunting, one day bringing back sixteen pieces of game. Suddenly, his remaining son seemed more precious to him, and he paid more attention to Henry's games and baby comments. Adèle prayed and tried to resign herself to her loss although she commented, after an

Henry as an adult, dressed in an altarboy costume, with his friends Anquetin and the Greniers, c. 1888.

excursion to Paris two months later, that in all the city what she noticed most were 'the beautiful one-year-old babies'.

She had dressed herself and Henry in mourning with characteristic thrift: she sold her raincoat to a friend before buying a black one. But she found Henry's natural vivacity very restorative. She was amused by two predilections he developed: he was fascinated by caged or trained animals, by the bird-tamer in the Jardin des Tuileries as much as by the Jardin d'Acclimatation (children's zoo) in the Bois de Boulogne and, curiously for so young a child, he very much liked going to restaurants. All his life, two of Henry's favourite haunts would be zoos and restaurants.

At the time Richard died, Henry was too young, of course, to understand death or, after a year or two, even to remember anything much about his brother. For him, life had returned to normal. He was rid of the sibling who had usurped his mother's attentions. In a general sense, he was also rid of the nearly forgotten father who had briefly reappeared in his life when they went to Loury at the beginning of Richard's illness. Alphonse, faced with his wife's grief at the loss of a child, could think of

nothing better to offer than to let her travel anywhere she chose.

Whatever Alphonse's hopes had been when he remodelled Loury for Adèle, it seems obvious that he had now abandoned any idea of attempting to have further children with her. His first son was small and slow to develop. His second son was dead. He strongly suspected that by marrying his first cousin he had produced genetically inferior offspring. In the family, it was said that since he believed he was going to end up creating *une cour de miracles* (a freak show), he preferred to 'abstain'.

As Henry's fourth birthday approached, three months after his brother's death, Adèle was proudest not of his learning to read and write, but of his progress in piety. According to her, what he liked most at the time was to go to the neighbours', where they had an altarboy costume he could wear. She was already having him memorize prayers in Latin. 'We are digging away at the Credo, it's harder than the Pater and the Ave.' In another letter, Adèle noted, 'He's convinced that the devil, to talk to Eve, took the form of a parrot.' Henry had seen parrots at his great-grandmother's house in Vindrac, including 'Vert-Vert', a parrot belonging to one of his great-aunts, which, it was rumoured, had travelled from South America on a pirate ship, learning to 'swear like a Templar'. Henry's childhood sketchbooks contain numerous drawings of parrots, which for unknown reasons had become a personal emblem of evil to him, even at this early age.

Adèle, who could not imagine leaving the marriage, continued to live at Loury. Alphonse moved into a separate part of the house and hired an English couple to keep house for him. Adèle was pleased – she hoped Henry would learn English by playing with their children. This left Henry and Adèle in the rest of the house as the basic family unit, exemplifying the assertion of the French philosopher Alain that the real couple in the French family is the mother and child, not husband and wife, and that the love between mother and child is the only real love.

Although Henry was fortunate – in an era when children were frequently shunted into the care of servants and allowed to join the adults only for a few minutes after dinner – to have a mother who enjoyed his company, the intensity of such a relationship was not without its responsibilities. His mother did not hesitate to point out to him her own sufferings: 'The poor little thing said to me, when he saw I'd spent all day in bed, "Maman, I want to take back the cold I gave you!"'

Adèle, sad and disappointed by the unmet expectations of her marriage, used Henry as a companion for her loneliness, a focus for her devotion and a pretext for the few pleasures she would allow herself. Everything she did

was for his well-being, but her definition of what was good for him quite often coincided with what she felt like doing herself. Thus, he was seen to benefit from long visits to his grandmothers, stays at health spas, and trips to Paris at the time of the autumn fashion showings.

The responsibility of managing even a small property like Loury made Adèle anxious. One suspects that, feeling out of control of her money and, at a more profound level, of her marriage and her life, she displaced her anger onto her servants. Predictably, this was a strategy which worked against her. Households such as hers simply could not function without a large, cooperative staff. Even in a hunting lodge like Loury, it took cooks, cooks' helpers, chambermaids, scullerymaids, laundresses, valets, coachmen, grooms, stableboys, gardeners, groundsmen and gamekeepers to keep things in order. In the nineteenth century, without the concerted efforts of a team of underlings, the aristocratic and even the middle-class French household would have foundered, awash in a sea of unmade beds and unwashed linen, its meals uncooked, its lamps untrimmed and unlit, its fireplaces cold and its grounds overgrown. Servants were involved in every aspect of daily life and privy to all the family's activities and secrets. They had a peculiar status in the power structure of the house, both trusted and feared, depended on and disdained, loved and at times exploited.

For perhaps half the year for the next two or three years, Adèle lived reluctantly at Loury. When they were with Alphonse, traditional expectations prevailed, and although they kept separate quarters, Adèle acted as mistress of his household. This was in no sense a minor role, for often guests coming for the hunt would send ahead servants, horses and as many as eighty dogs. Both people and animals had to be housed, fed and allowed to set up their own microcosm within the Loury routine. Adèle's job was to organize meals, see that the game Alph and his guests shot was properly butchered and hung, and direct the functioning of an elaborate community. Adèle resented this role, which she called 'the life of a galley-slave for those who do not share the pleasure of the hunt' and expressed her frustration by endlessly complaining and finding conflicts with the servants. In one case, two maidservants had quit because she refused to raise their salaries from 150 francs to 250 francs a year. 'The prospect of spending several days alone with the servants on strike was not very amusing,' she wrote to her mother. She explained her refusal by saying, 'I cannot subscribe to this exaggerated blackmail.' It is hard to know how unreasonable the maids' demands were. Around the same time Adèle's mother had hired a cook at 300 francs a year, and Adèle's own income was 2,500 francs per month.

However, Adèle's sense of overwork and isolation was not entirely unjustified. Her conflicts with the servants, her irritation at Alph's demanding eccentricities and financial irresponsibility were based on real problems. When a cook got drunk and wrecked the entire kitchen, it was Adèle who had to fire her and supervise the chambermaid drafted in, despite her inexperience, to make the sauces. 'I have to be careful not to ask Alph's opinion, for if I do, we don't have dinner until ten o'clock, while he is making sure that everything is perfect.'

In the same letter in which she complained of striking maidservants, Adèle thanked her mother for sending her a 4,000-franc supplement, which was separate from the 25,000-franc dowry Alphonse was already receiving in instalments. Since her dowry agreement required that Adèle's monthly allowance also be paid directly to Alph, the frequent supplements from Louise were precious. In 1865, she had asked her mother not to tell Alphonse that she had inherited some extra money. Adèle wanted exclusive access to it in case she needed it for her own personal use. Presumably, if Alph knew about it, he would try to control how she spent it. Secret money from her mother was Adèle's way of maintaining some independence, applying pressure on Alphonse and later having power over her son Henry.

The income of the whole family, Imbert du Boscs and Toulouse-Lautrecs alike, came largely from their properties, particularly from tenant farming and vineyards. No one in the family worked for a salary, of course, but all at times were called on to administer the family holdings in one way or another. Alphonse was a constant cause of conflict because he systematically refused to attend to detail yet often insisted on making outrageous demands in family matters involving business or property. Adèle quickly realized that he was unlikely ever to take responsibility for the actual business of their material existence. Decisions regarding property, lawsuits, the disposition of inheritances, etc. inevitably caused problems. She learned to handle such matters by trying to avoid confronting or even consulting her husband on them: 'I thought I had been insistent when I asked you not even to consider counting on Alphonse,' she wrote to her mother on one occasion many years later, in relation to the disposition of a family property. 'If we can act without Alph, it will be far better ... he wants to finish with all this ... above all, avoid making him deal with the preliminaries, which as you know, are even harder for him than making a decision ... to ask Alphonse to set things up himself is impossible.'

As a young bride, Adèle had learned that any serious decisions would have to be up to her, and that in the constant affairs of inheritances and

shared estates, she would be forced to appease all the disgruntled relatives who were inconvenienced by her husband.

Henry's annual visits to his grandparents at Le Bosc were almost the only contact he ever had with other children. As time passed, his aunts and uncles were producing a numerous accumulation of cousins for him to play with. The younger generation tumbled through the hallways and courtyards, inventing endless games. They visited the kitchen where a dog was harnessed to turn the spit with the roasting meat, the meat locker where the venison was hung, the steam-filled washhouse where all the linens were washed by hand. The barns, gardens, stables and fields were all fruitful territory for their escapades. Their enchanted forest was the nearby wooded area they called 'La Gravasse'. Henry – 'kind-hearted and full of the devil' as his Grandmother Louise described him – was the eldest and often the ringleader. He showed no particular interest in sports or in rough play but loved organizing his cousins to do things of an artistic nature. His particular pride was a puppet theatre they set up on the landing of the floor reserved for them at Le Bosc. In another elaborate project, he and his cousins laid out a miniature 'Bois de Boulogne' in the gravel of the driveway, where they pushed their toy carriages, raced wooden horses and aligned their lead soldiers with military precision.

The summer of 1869 was a typical one for Henry. Not yet five, he was eager to learn to ride. In a letter to her mother, Adèle added a postscript from him asking her to bring him a horse when she came back from the spas. 'You mustn't count on disinterested affection,' Adèle commented.

His favourite playmate now was Madeleine, the cousin he had so happily impersonated the year before. 'Madeleine and Henry get along much better now that they've thought up the idea of getting married,' Adèle wrote from Le Bosc. No doubt reflecting that marriage had not improved her relations with her own cousin Alphonse, she added cynically: 'however, the method is not always infallible'. Henry gave Madeleine a paper newspaper band for an engagement bracelet.

The weather at Le Bosc was burning hot, and the children were allowed out of the house only before ten in the morning or after five in the afternoon – and only into the shade. The thick-walled stone château became an oven, and to combat the discomfort, the children were given frequent cool baths. This was a luxury only the very rich could enjoy. Since the château had no running water, taking a bath involved setting up a large metal bath in the bathroom (which closely resembled a normal room, except that it had a drain

to take away dirty water) and calling servants to fill the bath with pails of water. In the summer, at least, the water didn't have to be heated over the kitchen stove after it was drawn from the well.

All the cousins who were old enough to swim had the additional pleasure of hiking through the dried-up fields and down the steep ravine which led to the Viaur River, whose water, according to Adèle, was easily 85 degrees Fahrenheit. 'Climbing back up is hard, but the good it does us is delicious,' she remarked.

Henry's great-grandmother de Toulouse-Lautrec visited that summer and brought a pet monkey with her. In the family she was nicknamed 'Monkey's Grannie', and from his earliest days, Henry was occasionally taken to see her at Vindrac, her property midway between two other family estates, where she was frequently found, draped in fringed Indian shawls, wandering around the small manor with Julia the spider-monkey sitting on her shoulder. Later, when she had grown senile, she insisted that a place be set beside her at the dinner table for Julia to whom everyone had to be exceedingly polite.

However, at Le Bosc, Adèle did not appreciate the charm of such a house guest. She wrote to her mother that she and Grandmother Gabrielle 'made so few advances to Miss Monkey that it was understood that her presence in the house would be less than agreeable, and she's been relegated to the greenhouse, where the pigeon and Martine [probably a pet ferret] keep her faithful company'.

Interest in all kinds of animals was also part of the family artistic tradition, for when the weather was bad, children and hunters alike would gather by the fire in the salon and devote themselves to sketching, painting with watercolours and modelling wax figures. The subjects were almost always animals. Henry's childhood sketchbooks show parrots, falcons, owls and monkeys, dogs dressed in costumes and innumerable sketches of horses. The prints and paintings on the walls at Le Bosc were representative of the realism fashionable at the time: family portraits and scenes of 'le sport' – an English word used to describe riding on horseback, whether it was hunting or racing. As he got older, Henry endlessly copied riding prints as models of the kind of art he wished to do.

In the autumn of 1869, a minor incident led to a major change in his level of sophistication. Adèle began their trip north to Loury as usual, taking her son to visit various family members and friends, but she began to worry because she had had no word from Alphonse. When she got to Orléans, where he usually picked her up in the coupé, she found a letter from him telling her to leave again immediately and go to Paris. A cook at the hunting

lodge had come down with smallpox, and Alph didn't want Adèle and Henry to be exposed. All three of them had been vaccinated against smallpox with the newly developed vaccine when Henry was born, but the fear of epidemics died slowly. Like many people, the Toulouse-Lautrecs weren't convinced the vaccine would really work and, having lost one child, they had no intention of taking any chances. Alph told Adèle to wait in Paris with Henry until he came to get them, which he would only do when he was convinced all danger of contagion was past.

On her husband's orders, Adèle took Henry to the Hôtel Pérey, a *pension de famille* where they lived for the next two months. Henry, who had already visited Paris twice before, would now learn to live in a city. Their arrival was less than auspicious: Adèle was irritated that her plans were changed, that it was raining hard when they arrived in Paris and that they had to wait an hour for their bags, but she found the Hôtel Pérey most interesting. It was very international and at the dinner table she could hear Russian, English and 'American' spoken: 'to me it feels like being inside a huge twittering birdcage. A few *Miss* have the courtesy to murder a little French with me.' She and Henry were the only French people present.

Alph's brother Odon had discovered the hotel, which was run by a Protestant. This made Adèle somewhat uneasy. Disconcerted by the strangeness of another religion, she felt at times as if she had to defend her Catholic purity from the nefarious influences of the other guests at the hotel. At least once she was obliged to ask a Protestant guest at Pérey (as they called it) to stop trying to convert her. And on Fridays and other fast days, she had to arrange to take meatless meals at a nearby Catholic restaurant.

Still, Pérey had advantages, and over the next twenty-five years or more members of the Toulouse-Lautrec family stayed there often. Located at 5, Cité du Retiro in the eighth *arrondissement*, it was in one of the most fashionable districts of Paris. It looked out on a quiet, private courtyard which before the Revolution had been the mews where Court carriages were kept, and it felt like a private property, far from the noise and bustle of the rue du Faubourg Saint-Honoré, located at the other end of the courtyard through an archway. Adèle's spacious room on the first floor had three windows looking out onto the mews. The food was delicious, the servants were polite, the Péreys had a six-year-old daughter for Henry to play with and, best of all, the hotel was only a three-minute walk from the Church of the Madeleine, where Adèle scrupulously went to Mass every morning – perhaps in penance for living among the infidels.

Alphonse wrote a letter during the Christmas season which showed elo-

quently how different his life was from theirs: 'The woods had been very well "done" ... in two hours the dogs had downed and strangled a red-coated beast which made a charming hunt. The next day my mare was injured in the forelegs and will need ten days of rest. Odon, out with his dogs, took a fall on Paroli, who is also limping ...' He continued in the same vein for six pages, finally ending with 'I'm asleep on my feet, and in excellent health.'

Adèle and Henry were excited by the adventure of being in Paris alone, but she mostly kept him in the hotel, reading the *Bibliothèque Rose* (Pink Library) by the Comtesse de Ségur and the *Mémoires d'un Ane* (Memoirs of a Donkey). Henry, at five, could already read for fifteen minutes at a time, all by himself. Adèle also bought him a simplified illustrated Bible, which she read carefully to check its accuracy before she would let him read it. She admitted, however, that he couldn't really read much except the text under the drawings. They were both sorry when, at the end of November, Alph came to take them back to Loury.

As soon as they arrived, they were all revaccinated against smallpox just to be on the safe side. There had been a number of cases of the disease in Loury, and the community was taking strenuous measures to combat it. In nearby Orléans, six hundred people lined up to be vaccinated with serum taken directly from a calf that had developed antibodies to cowpox, a closely related disease.

Compared to Paris, life at Loury seemed slow, immersed in the seasons, the rituals of hunting and the chores of everyday life. Sitting by the fire during the cold November rains, Henry was now beginning to read the Bible 'passably' well. However, despite his mother's influence, he was developing his own characteristic interests: 'The word concupiscence intrigues him strongly,' Adèle wrote to her mother, including with her letter a portrait of a wild boar Henry had drawn.

As winter and spring passed, the only activity in the house was the arrival of each new hunter who came to visit Alph. When the men were out hunting, Adèle ate alone. Although Henry usually was fed by his nurse, Adèle sometimes let him sit at the table with her so mealtimes didn't seem so long. 'He's delighted. He races as fast as he can to get his chair.' She was pleased to be taking Henry to Le Bosc for the summer.

On 19 July 1870, all normal existence was abruptly disrupted. Napoleon III declared war against Prussia, even though the country was largely unprepared. As it happened, Adèle and Henry were at Le Bosc, where Henry was recovering from jaundice, and Alph was at Loury. The Toulouse-Lautrecs

were somewhat protected by their wealth and insular way of life, but the war made movement around France difficult, if not downright dangerous, so each branch of the family stayed where it happened to be. At Le Bosc, practically the only subject of conversation was the war. Henry's Uncle Odon insisted upon being given a commission in the army even though he could have paid someone to replace him. He became a courier, which had 'the advantage or the disadvantage (his father is of the latter opinion) of keeping him out of combat,' Grandmother Gabrielle wrote.

In less than six weeks, it became apparent that the war was a lost cause. On 1 September, Napoleon III tried to reverse his mistake by surrendering, an act which was considered a betrayal of the nation and caused an enormous outcry. On the 4th, he was overthrown and the Third Republic was proclaimed. The new government, moved by spirited but unrealistic nationalism, refused to capitulate. On the 17th, the Prussians laid siege to Paris. Although the situation was hopeless, as one of the bitterest winters in thirty years set in the Parisians submitted 'with grim gaiety' to the lengthening months of bombardment, cold and famine. Large areas of the Left Bank were flattened by shells. It was not long before people were forced to eat the animals in the zoo and even rats. Starvation and cholera, which spread rapidly in the weakened population, caused many deaths.

In the countryside, where people had access to farms, things were not so difficult, but the war was still dangerous. When Loury was overrun by Austrian lancers, Alphonse decided to rejoin his family in the south. Before he left, he said, he had been able to hear cannon fire from the battles of Orléans and Arthenay. The rural population was tense and frightened, and somehow as he travelled he was mistaken for a spy. He was very nearly thrown into the Loire – the peasants had already called for a cart to haul him off – but he managed to talk his way clear and finally arrived safely at Le Bosc. A few weeks later, Adèle and Alphonse learned that Loury had been pillaged, not by enemy soldiers, but by the townspeople; one of the maids wrote to say that she had seen Henry's toys and baby clothes on the village children.

Adèle, Henry and Alph huddled together at Le Bosc, with Grandfather Raymond de Toulouse-Lautrec, Grandmother Gabrielle and Henry's Uncle Charles. They were virtual prisoners in the house, for at times even horses couldn't get through the deep snow. The infrequent letters from Odon at the front were passed from person to person.

Loury, now abandoned, changed hands several times, being used first as a military hospital, then as quarters for 'those odious Prussians'. Trapped at

Le Bosc, everybody felt claustrophobic, anxious and bored. 'You can imagine,' Adele wrote to her sister-in law, 'how cheerless our life is. The hunters don't like the snow. Henry is beginning to find his imprisonment long, especially since he is kept from playing and quarrelling with his cousins ... We are in real anguish over the outcome of this great gamble. Will it be the salvation of France, or the *coup de grâce*?'

The government was in disarray, and communication was extremely difficult. Private citizens quickly realized that outfitting the army and taking care of those deprived by the war had become the responsibility of those individuals who could still share what they had. Adèle and the other women knitted socks for the conscripts. Grandmother Gabrielle had decided to give a woollen-blanket, a flannel undershirt and two pairs of socks to each man from the district who left for the war. A family friend from Loury wrote to Alphonse to say she was destitute. The Prussians had swept through the region twice, and after the second invasion she was literally threatened with starvation. She asked if he could send her some money. 'The truth is,' Adèle wrote to her mother, 'without a miracle, we are almost lost.'

The 'almost' was optimistic. By the New Year, defeat was certain, even to die-hard French patriots. In her next letter to her mother, Adèle wrote, 'we hardly have the morale to wish each other Happy New Year when all we can see is public and private misery. The horizon of 1871 looks very black ... As Odon says, the most heartbreaking thing is that we haven't the faintest chance of winning.' Snow had been alternating with heavy frosts since Christmas, and even crowded around the fireplace everyone was very cold. Requisitioning had caused prices to skyrocket, so they were trying to scrimp. Chocolate and other sweets had entered the category of 'great luxuries', and even sugar cost 2 francs a pound. They used chestnuts as a sweetener, went without sugar and ate mostly soups. It snowed for twenty-four days. 'How the poor soldiers and prisoners must be suffering!' Adèle wrote to her mother.

Beyond the isolation of Le Bosc, chaos prevailed. At the front in dense fog on 10 January, Uncle Odon's battalion accidentally fired on its own men at two hundred yards. The shooting went on for a quarter of an hour. Luckily the soldiers' aim was bad.

On 28 January, Paris capitulated, and the Prussians demanded a punitive war indemnity equal to one billion dollars at the time. In the extreme political instability that followed, the Parisian working classes, aided by a mutinous military, began the popular uprising which became known as the Paris Commune. In the end, the rebellious workers were suppressed with the help of the National Guard. When the fighting finally ended in the summer of

1871, nearly forty thousand people had been shot, imprisoned or exiled, not by the occupying Prussian armies, who sat by quietly and watched, but in a civil and class war between Frenchmen.

The Toulouse-Lautrecs were appalled that the working classes had dared to rebel. Seventy-five years after the French Revolution, they were still unregenerate royalists. Adèle had expressed her fear of anarchy even before the end of the war, and the Commune reaffirmed the family's royalist convictions. Alph was not alone in believing that the man Henry was named for – Henri V, Comte de Chambord – was the legitimate and most able ruler of France. Faced, as they saw it, with the clear failure of democracy, monarchists were convinced that only a king by divine right could successfully lead the French. Such a belief had the advantage of confirming the Toulouse-Lautrecs' sense of innate superiority. If the king were king by divine right, then they, too, must deserve special benefits as a result of their aristocratic birth.

Although France was slow to recover from the war and the Commune uprising, the household quickly returned to normal. The Toulouse-Lautrecs shifted from the emergency mode created by the war to a renewed preoccupation with the close focus of their own lives. That summer, Henry and his cousins went for their first trip to the seashore to take the waters at Cabanes-de-la-Nouvelle on the Mediterranean coast, not far from Céleyran, where they were staying.

Taking health baths was the new fashion. Grandmother Louise had gone to Lamalou-les-Bains for her holiday, and Aunt Alix had taken Henry's great-grandmother on a brief excursion to nearby Saint-Pierre, with the result that her faithful companion, Miss Monkey, over-excited by the noise and tumult of the ocean, urinated all over a visitor's book. A family friend, Paul de Lamothe, was also there, not for his own health, but to give health baths to his black mare. Henry and Madeleine managed to have thirty baths each.

Alphonse, for his part, spent the summer at Loury, attempting to repair the ravages of the occupation and make the place habitable again. He apparently was unaware that Adèle did not intend to return to live at the hunting lodge. She had enlisted Odon to try to persuade Alph to let her at least take Henry and live in Orléans, where she wouldn't feel so isolated. When he would not allow it, Adèle decided to return to Le Bosc, to stay with Alph's parents until the matter could be settled. There, she reported, Henry was in fine form, playing loudly with his cousins, proud that he had received a letter from a friend and could answer it himself without help, proud even that he

was now old enough not to eat meat on Fridays. She did not mention to Alph that Henry, who had not seen his father for nearly a year, tended to become intensely attached to any male figure of authority in the vicinity, including both a boat captain he had befriended and his swimming teacher. He cried at separation from each of them.

3

HENRY

Henry de [signature]

The death of a brother, the privations of wartime, illnesses such as jaundice, all marked Henry's childhood despite its privilege. The men around him, primarily his paternal grandfather and his uncles, served as role models in the absence of his father. He watched them hunting and managing their properties, caring for their horses and dogs, playing with their children and grandchildren, tending to their employees and telling stories of their hunting and war exploits in the evenings by the fire. There was no reason to think his life would not be substantially the same as theirs. In December 1871, Adèle, who had used the disruption of the war to settle more or less permanently with her in-laws at Le Bosc with Henry, was expecting the usual calm of a country winter after the harvest, when they would all have more free time.

However, two days before Christmas, there was a tragic accident. Henry's Grandfather Raymond, the Black Prince, ignoring the very cold weather, had gone out as usual with his huntsmen and dogs, and at lunchtime was on the trail of a hare. He sent his men back to the château to eat, saying he would continue to track the hare alone and that they weren't to hold lunch for him. At dusk, the dogs came back without him, and the family grew very uneasy. Although the men searched as well as they could in the darkness, they found no sign of the lone hunter. It is said that Henry kept urging his mother to have them look in the valley of the Viaur River, but it was too steep and icy to negotiate in the dark. The next morning, when it was light enough to continue the search, it was in that ravine at the foot of a cliff that they found his grandfather's frozen body. The Black Prince had apparently slipped on ice-covered rocks while hunting in the underbrush, probably not even realizing how close he was to the cliff's edge, and had fallen down the uneven rock face, breaking a leg, to lie conscious but helpless, caught between boulders at the edge of the river. He must have tried to blow his hunting

horn to call for help, for it lay bloodstained on the ground beside him.

The pain of this unexpected loss was intensified for Henry's mother and grandmother because the Black Prince, anti-clerical like his son Alphonse, had not been given the last rites of the Catholic Church before he died. To their relief, some six months later, a relative wrote to them that according to a Mother Superior she had consulted, his soul had been saved anyway, since he had surely had time to repent, make his confession and return to God before dying.

Henry was almost certainly present when the men carried his grand-father's body into the courtyard. He must have been marked by the women's grief and the heroic quality of the death. He knew from family stories that his grandfather's own father had also died in a hunting accident, thrown from his horse at the age of thirty-seven. The lesson to be learned from such events was that life was full of risk. Anyone, grandfathers and baby brothers alike, could have an accident or fall ill. In the face of such uncertainty, the only path worth following was the one dictated by his own will. Henry was becoming headstrong.

But so were all the men of his grandfather's lineage. They had always been known as relentless hunters, black-bearded, sexually demanding, hot-tempered, fierce-willed and fearless to the point of foolhardiness. Para-doxically, they were also characterized by a certain aesthetic sensitivity. For three generations, Henry's forebears had shown a marked artistic talent. His great-grandfather, Jean-Joseph de Toulouse-Lautrec, had done a number of small but excellent family portraits. Naturally, as a nobleman, this talent served him only as a hobby. It would have been unthinkable for him to be a professional artist.

Henry's father Alphonse, and his uncles Charles and Odon, were typical of their bloodline. They were intelligent and talented, if eccentric, men. All were skilled amateur artists and went through periods of intense artistic activity. One rainy April, when Henry was a child, Charles and Odon, unable to hunt, turned the living room into a painting studio. 'You should see your brothers, who are doing watercolours with a veritable furor. Charles has done a boar kill where there are a mere sixteen dogs, two or three horses, gamekeepers, hunters,' Grandmother Gabrielle wrote to her daughter Alix. 'It's a little chaotic ... Odon is more restrained in his numbers of characters and animals and succeeds better with his colours ... For three days, they have been literally swimming in watercolour, which seems to attract them infinitely more than wax. They invent landscapes, they struggle for the right tones. In the end I am astonished by their results.'

As she pointed out, her three sons were alike in their tastes: 'When my sons kill a woodcock,' she observed, 'the bird affords them three pleasures: those of the gun, the pencil and the fork.'

Adèle's brother Amédée had a different sort of influence on Henry. He and his wife Alix, Alph's only sister, were the other first-cousin marriage in the Toulouse-Lautrec family. Now that Adèle and Alph were estranged, Alix and Amédée had become Adèle's primary allies and intermediaries in dealing with her husband. Amédée was much like Adèle: reserved, conservative, long-suffering and extremely pious. The father of most of Henry's numerous cousins, he was the male figure most often present during Henry's childhood, disciplining and correcting his nephew as if he were one of his own sons. He was a reasonable and stabilizing influence in Henry's early childhood despite his own eccentricities: during thunderstorms he would make his entire family sit on chairs set on large panes of glass, according to his theory that, as glass does not conduct electricity, they would be safe there if lightning struck.

Alphonse himself was not often present, and his prolonged absences were punctuated by brief entrances of increasing theatricality. He had begun to wander continually, following the hunting and racing seasons across France. He grew more grandiose and more eccentric, tending to develop numerous elaborate projects, any one of which would take a lifetime to put into effect. His choices, when he finally made them, seemed based on whim more than reason, leading him, for example, to travel without warning to Lyon because he had heard there was a band of gypsies there, or to plan to raise two lion cubs at Montfa, a run-down château near Albi, which his father made over to him in 1869 and which he used intermittently as a hunting lodge. Henry continued to be of two minds when he thought about his father. On one hand, it was impossible to compete with Alph: 'Where Papa is, one is sure not to be the most remarkable,' he once commented to his Grandmother Gabrielle. He was proud of his father's bearing, his handsomeness, his horsemanship, his arrogance, even his eccentricity. However, Henry was well aware of the disdain his father engendered in the family, and he himself was growing more and more to suspect Alphonse of being an exhibitionistic but harmless fool. As an adult he would say: 'The Count, my father, has always done his partying on *café au lait*,' suggesting that his deeds were substantially inflated in the telling.

At last after lengthy pleading, seven-year-old Henry was given a horse and riding lessons. This, in the family, was the first proof of manhood – his first step towards joining the hunters on their daily rides. His Grandmother

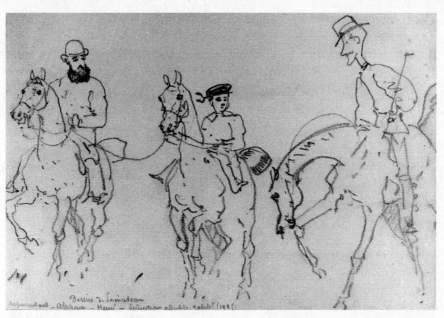

René Princeteau's drawing of himself (right), Henry and Alph on horseback, c. 1871.

Gabrielle remarked on his recklessness: 'he is still too young to go hunting, though with his pluck and skill he would not baulk before obstacles far beyond his capability.' She also spoke of his growing passion for art: 'When he is unable to go out he spends all his free time drawing or painting in water-colour, supervised by his Uncle Charles.' Plagued by frequent illnesses, Henry often had to be kept in, but he remained cheerful and energetic. Grandmother Gabrielle, who was often depressed, commented, 'with such a high-spirited fellow around, how could we persist in being gloomy?'

He was very small for his age, and a pronounced lisp, which had seemed charming in a two-year-old, unfortunately persisted. In addition to the colds, flus, toothaches and rashes of normal childhood, Henry must also have suffered from pain, deformity or weakness in his legs because in May 1872 Adèle took him to Lourdes to pray for a cure.

The 'miracle' at Lourdes had taken place fourteen years earlier in 1858, in a grotto where a fourteen-year-old peasant girl announced that the Virgin Mary had appeared to her on several occasions. Miraculous cures were attributed to the waters of a spring in the grotto, catching the fancy of both religious believers and those attracted to the supernatural. There were so many visitors that in 1867 the French national railway decided to build a

spur to the site, and by 1872, one hundred thousand pilgrims a year were visiting the holy grotto, asking the Virgin for help.

Alph, who held little stock in miracles, decided abruptly that if Adèle really refused to live at Loury, rather than hovering around religious sites, she should go with Henry to Paris, where he could get expert medical treatment. 'If my own pleasure were the only consideration, I'd infinitely prefer to be at Le Bosc,' Adèle wrote to her mother. 'But I think it's right to give in to Alphonse's wishes.'

Henry himself didn't want to move to Paris. His horse was at Le Bosc. Adèle consoled him by saying he could ride in the goat-carts that plied the Champs Elysées, and that later in the summer he would be able to ride his cousin Raoul's 'velocipede horse'. Bicycles were the newest rage in France. In May, they moved to the Hôtel Pérey full-time, accompanied by a sort of great-aunt, Armandine d'Alichoux de Sénégra.

Henry's beloved 'Tata' (Auntie; or sometimes even 'Tata Didine'), as he called her, was not a blood relative, but the sister of Grandmother Louise's dead husband's first wife. Tata had never married and had lived with her brother-in-law's family since her sister's death some thirty-five years before. Adèle was very fond of her, and Henry, who adored her, insisted that she play card games for hours on end. She was so shy and intimidated by Paris that she refused to enter the salons or the dining room at Pérey. The idea of facing forty strangers over the dinner table was too much for her. Instead, she walked to a relative's for lunch and dinner every day.

The first few weeks were difficult. Adèle and Henry played tourist, despite almost continual rain. They went out daily into the bustle and wetness, walking on the slippery planks laid along the edges of the roads to protect pedestrians from the relentless mud. Adèle's long, full skirts were inevitably spattered and bedraggled by the time they got home. In addition, the streets could be dangerous, for horses galloped everywhere, bearing riders or pulling cabs, delivery wagons and carriages. The Parisian Industrial Exhibition of 1872 was in full swing, and Henry struggled to walk from the hotel along the Champs Elysées to the Grand Palais de l'Industrie to see the painting and sculpture.

Adèle, who had taken him to Lourdes to pray for divine intervention and had spoken in letters of his going out for his daily *promenade* in a carriage, rather than walking or on horseback, as would be normal for a seven-year-old boy, finally referred in writing to his symptoms in a letter to her mother-in-law in mid-May 1872. She was clearly terribly worried, worried enough to move to Paris for Henry's health, yet she discreetly referred to his medical

problems only in the vaguest terms, saying that he was exhausted after a long walk or that she hoped that exercise would 'make him less stiff'.

To strengthen his legs, she took him nearly every day to a gymnasium which by good fortune was next door to the hotel. He seemed to take real joy in going there, for Adèle wrote to his Grandmother Louise: 'he runs, jumps, climbs with little boys his own age . . . This establishment is very well run; they pay special attention to the needs of each child. I can see that Henry is improving.'

To her surprise, one day Alphonse arrived on horseback from Loury, stabling his mount at the hotel. They got along unexpectedly well and began socializing with the other guests at Pérey, appearing together at meals and in the salon. As things seemed to be going well, Adèle decided to send Henry to school for the first time in his life. As an experiment, she enrolled him for the last two months of the school year in the youngest class at the Lycée Condorcet. He went there for two hours in the morning and two more in the afternoon. His mother was eager to see how he would do since until then he had been educated entirely at home and almost entirely by herself with a little help in Greek from the Abbé Peyre, who lived on Grandmother Louise's estate at Céleyran. 'Decidedly, my dear schoolboy has a happy disposition, for he's accepted all this gaily,' she wrote to her mother. But she couldn't help adding, 'whereas I myself am completely overwhelmed'.

Adèle's reason for sending Henry to school, she said, was to teach him to be ambitious and competitive with boys his own age. However, after only five days, it became clear that he was too unaccustomed to the system to keep up. Changing her plan, Adèle sent him instead to work with a private tutor who held small classes every evening from four to six. 'It's much more expensive than the school, but Henry is learning to follow in a classroom, to listen to a teacher; I make him study in the mornings at the hotel, and will continue to do so until classes start again in the autumn. At that point we'll have to come back to Paris.' Henry was doing a sort of introduction to the ninth form, the class he would enter in September, which was at the right level for his eight years.

For the time being there was almost a sense of family unity. Alph was perfectly disposed, so long as he had his horse, to remain with his wife and child in Paris. He seemed really to enjoy, for example, taking them both to the Grand Prix at Chantilly.

A trip to the Chantilly *pelouse* or racetrack was an exciting outing for everyone. The town, stables and spectacular white-lace castle were located next to a deep, cool forest some twenty-five miles north of Paris. Alph rented

a small landau carriage to take them. Chantilly was where the most elegant races were held, and the season was crowned by the Grand Prix, held in late May. Crowds of spectators and bettors, rich and poor alike, surrounded the grassy track. Elegantly dressed women in pale gowns strolled with their husbands or lovers dressed in dark frock coats. The sandy paths were raked and sprinkled with garden hoses every morning to keep down the dust. The women carried parasols, and there were huge red umbrellas posted on the velvety lawns for people to seek shelter from the sun. Those willing to leave the racetrack walked and sat in the shadowy woods. Before each race tense sportsmen and trainers gathered at the stables, while bookmakers stood by the betting windows crying out their odds. To see the races, spectators clambered onto high wooden grandstands, with private boxes for the affluent. Each jockey wore a brilliant silk cap in an identifying colour: orange, mauve, pink, blue, purple, turquoise. The races were very short, only a few minutes each, marked by a crescendo of voices urging on their horses, crying 'Bravo!' and 'En avant!', the cheers of the winners mixing at the end with the disappointed murmurs of the losers.

Adèle and Henry were astonished by the excitement and glitter. 'We saw a horse earn 78 thousand francs in five minutes! What I liked best were the brilliant crowds, which had turned out in the superb weather. My cousin [Madame Albert de Naurois] had one of the most extraordinary dresses there, which is saying quite a lot. I saw all the Princes of Orléans who had been installed in the ex-Imperial Tribunal ... What crowds! What splendour! Last year could never have happened!' Adèle wrote to her mother-in-law, referring to France's 1871 defeat at the hands of the Prussians.

In Paris, Adèle and Alph went around together making visits after six o'clock dinner, systematically paying their respects to everyone they knew, while Tata babysat with Henry at Pérey. There was no further discussion of medical treatment. They were caught in the social obligations of living in Paris.

In their world, life in the city was a succession of significant rituals: visiting cards, weddings, funerals, horse shows, the Opéra, the races, charity bazaars, exhibitions, yachting and country weekends. Alph was an old hand at the Paris routine and seemed to enjoy it, riding daily in the Bois de Boulogne, going to the Jockey Club in the evening to see his friends. But Adèle, despite her abstract fascination with high society, was uncomfortable when actually confronted with it. Even the social activities she agreed to participate in, obligatory visits to acquaintances, made her feel insecure and anxious; had she forgotten someone, hurt someone's feelings? From time to time, she

would have dinner with relatives, but if the occasion were too elegant, she preferred to stay at home with Tata and Henry. By the beginning of summer, she was eager to leave Paris. The weather was already hot and she'd somehow managed to get bitten in the hand trying to protect Henry from a dog fight. 'Now that's bad luck,' observed Grandmother Gabrielle, 'when we all spend our lives surrounded by dogs, to go to Paris to get bitten.'

The choice of where to take a holiday created a crisis between Henry's parents, although, in point of fact, since Henry's birth they had never spent the holidays together. This year, 1872, Adèle's first choice was Arcachon, a resort favoured by the old aristocracy on the Atlantic coast near Bordeaux. She was particularly adamant because her mother-in-law and cousin Alix were going there, too, and they could share lodging costs. Alph himself leaned towards more elegant, fashionable locations, that year pushing for the family to take their holidays at Boulogne with an Englishman he had met. In the end, however, Adèle got her way and went to Arcachon with Henry, and Alph went back to Loury as usual. Henry spent his summer in a beach-side chalet with his Aunt Alix and her children, 'running wild', as his mother put it, and learning to swim with cork waterwings. She was perturbed to see how undisciplined he was getting ('he's a real devil'), and she worried more than once about how she was going to get him under control again 'after too much liberty'.

He may have been rebelling in part against the clumsiness and stiffness of his gait, which were increasing and becoming more noticeable. He was particularly humiliated that he had taken a bad fall at the home of family friends, scraping all the skin off his nose in front of children he didn't know well. His memory of the incident was so strong that he referred to it in a letter to his cousin Madeleine some two years later.

That autumn saw Henry and his mother settled into what she called their 'new existence', accompanied by Lolo, the canary Henry's new aunt, Uncle Charles's wife, Emilie, had given him to take back to Paris. He had bought it a little cage and planned to buy its food with the money his mother would give him for getting good grades. Before long he acquired several more canaries, named respectively Lolotte, Lolichon, etc., and known collectively as 'les Lolots'.

Henry now went to school every day with other boys his age, including his cousin, Louis Pascal, who was in the same class. 'Henry is happy with his new life,' Adèle wrote to Grandmother Gabrielle. 'He insists on getting to school before the second bell sounds and does his homework

with enthusiasm. He is most impatient to know his rank in class; they have a competition every Saturday. So far he has already brought home two high marks, which makes him hope he won't be one of the worst. Louis Pascal studies hard and is very competitive; he's an excellent classmate for Henry.'

The Lycée Condorcet, as it was called after 1871, was unusual for a state-run secondary school. All its students were day students, and came in general from privileged milieux. A former student later commented that his life there was a happy mixture of classical education and family life in Parisian society. He also mentioned that the school made sure all students received prizes in a timely fashion: 'Thus you found yourself named good in Greek essay, good in Latin discourse, after having spent your time, to all appearances, at becoming good at billiards.' Known as the 'most intellectual' of the Right-Bank schools, it was also attended by a number of boys, notably Marcel Proust, who later were members of the Parisian avant-garde. Several of them, including Tristan Bernard, Aurélien Lugné-Poë and Alexandre Natanson, were to become Henry's friends.

Henry's enthusiasm for school was obvious in a note he wrote to his old Greek tutor, the Abbé Peyre, to ask about the distinction between two words: 'Monsieur l'Abbé is begged by his *crottin*-eating pupil to tell him whether one writes Γνωτι σεαυτον or Γνωθι σεαυτον. All my respects. Henri de Toulouse-Lautrec.'

Crottins – literally horse-manure – were small round brown sweets, and were a speciality of the region where his Grandmother Louise lived. The Abbé passed on the hint, and his grandmother took to sending packages of *crottins* to Paris on special occasions. In December, Henry was still getting good grades (third one week and eighth the next out of a class of thirty-five students), 'except that he has a lot of trouble sitting still and gets some bad marks for that'.

Adèle spent her time going to Mass every morning at the Church of the Madeleine, fretting over Henry's frequent colds and continuous runny nose and visiting her relatives, particularly Louis Pascal's mother Cécile, a first cousin who had also recently moved to Paris.

One of Adèle's important tasks in Paris was going shopping for her mother and mother-in-law, her cousin Alix and all of Alix's children. True prestige to women from the provinces meant owning the latest Paris gown. 'Please tell Alix that ... here a lot of brown, and above all bright blue are being worn. The hats are sailor-hats, worn all the way at the back of the head, with the pompom always behind.'

Alph stayed at Loury, which, since it was located in a national forest, he

had always leased from the French government. Although officially his lease had expired the preceding year, he had been given permission to continue to hunt for another year as a war indemnity for destruction done by the Prussian occupation. He was trying to reconstitute his hunting retinue after the ravages of the year before, a somewhat unrealistic project given the temporary nature of his hunting privileges. He knew he would have to sell or store all his furniture and move out of the lodge at the end of April 1873, but he insisted on remaining at Loury as long as he possibly could. Such behaviour was typical of Alphonse. He refused to accept circumstances he disliked, even when he was powerless to change them. Similarly, if he felt he had made a mistake, he did anything he could to renege on the agreement. The year before, when war broke out, he had sold his eighteen dogs. Now, not liking the hunt without them, he tried to get them back by returning the money. The new owners were not receptive to renegotiation, and finally he was forced to repurchase the ones he wanted at a loss. In a more dramatic example, in 1894, some twenty-three years after their father's death, Alph apparently tried to renegotiate part of an inheritance with his brother Charles.

Despite Alph's absence, Henry was eager to please and impress his father. Just after Christmas, he wrote to his Grandmother Gabrielle, asking her to send him a book on falconry, written in English, which belonged to his father: 'Papa wants me to translate a chapter ... as a present to him, and you can understand that I want to make him happy. We waited in vain for him to come at Christmas, but he says he'll come for the New Year.'

'I'm not bored in school,' he wrote to his other grandmother a few days later. 'I've found good friends there and I'm getting good grades. We often go to school with my Pascal cousins. Louis is a good fellow, although he brags a bit. We have a good time on our days off.'

In his letter to Grandmother Louise he was cheerful. But he was beginning to take an apologetic and self-deprecatory tone when writing to Grandmother Gabrielle, his father's mother, which henceforth would characterize almost all of his letters to her. He had broken out in some sort of very itchy bumps, and in writing to her he emphasized his blemishes: 'unfortunately I have pimples which make me spend a lot of time scratching them.' It was as if he felt she would inevitably compare him to his father, and he was showing her that he already knew that he was the loser in the comparison.

The bumps prevented the holiday from being very happy for him. 'They itch day and night, and he's got them everywhere,' Adèle added in a note attached to his letter. He was kept indoors for two days of his precious five-

day holiday. 'I would have liked him to be better rewarded for his hard work. He got an honourable mention when the grades were reviewed at the end of the year. It's not much, but still ...' He was tenth in the class and his cousin Louis was eleventh. Adèle was proud that Henry was succeeding so well, considering that it was his first experience of school, but curiously, she was getting into the habit of denigrating him too. To *her* mother, she seemed to judge him far more severely than he deserved: 'I beg you, dear Maman, to be indulgent with Henry's letter; he wants so much for you to get it by January 1st.' In another letter she mentioned how embarrassed she was to have a relative see Henry and Louis coming home from school 'all smudged with ink'.

By March he was first in his class for two weeks running, and at Easter he was placed fourth overall in a class of forty, many of whom were much older than he. His enthusiasm and sense of humour returned. In closing a letter to Grandmother Louise with kisses for the relatives, he added, 'I'd gladly ask you to kiss the Abbé Peyre for me, but you wouldn't do it.'

Just before school finished, in June 1873, Adèle decided to go with Alph to Brittany for Odon's wedding. She left Henry, possibly for the first time since he was two years old, with Tata, who came to Pérey to stay with him until school was over. Although they had a good time, and Henry even got the top mark in his class for a Latin composition, he wrote Adèle a letter which expressed such intense longing that one is reminded of the other time during his infancy, when she left for another wedding and didn't come home for two months:

My dear Maman,

When I asked you not to go, I had no idea of how much it hurts to be separated from one's mother. I need you every minute, and will feel much better when I can see you again. In the meantime, you can be sure that I'm studying as hard as I can to please you ... I am alone with the Lolots in my room, since I haven't finished my homework, and very sad I can't be with you. I haven't had time to write any English. Yesterday I was thrown up against the railing of the school staircase by Madame Michel's son. M. Montoy insisted that I go and complain to her, and she punished him. This morning we went to high mass. Goodbye my very dear and beloved Maman.

Your dear Coco, H. de T. Lautrec

Adèle's 'Coco', at the age of eight and a half, had learned to express himself

in writing with both passion and subtlety. That summer, as the eldest cousin in his extended family, he would take on the responsibility of chief correspondent with his Grandmother Louise and begin to use the wit and quirky originality which would mark his adult verbal style as well as his art: 'As I am writing, Gabriel is being wicked; Aunt Alix is threatening to put him into the frog prison.'

In the autumn of 1873, he wrote to her about a visit to his cousin Louis Pascal, whose family had now moved to Bordeaux, where M. Pascal had been appointed *Préfet* of the Gironde, the *département* where Bordeaux is located. Henry's observations on the trip were thoroughly his own: 'At Agen we picked up a family whose little boy had a hat just like the Shah ... All evening we set off firecrackers, joked around and toured all the enormous salons of the Prefecture. Louis told me he misses Paris.' Adèle's letter of the same date gave more details. According to her, Henry and Louis were tearing the place apart. They had even been caught smoking Uncle Ernest's cigarettes. Henry received some paternal authority from Louis' father. Unlike Alphonse, Ernest Pascal lived at home with his wife and three sons and had always taken active responsibility for their discipline and education. Henry, whose standing as a cousin did not spare him, was punished exactly as Louis was for such sins as insubordination and smoking.

As Henry had noted, the Pascals lived well, maintaining sumptuous quarters wherever they were stationed. Visiting them was an important event to both Adèle and her son.

Louis Pascal would remain one of Henry's closest friends even when they were adults. Blond and blue-eyed – a marvellous physical specimen with a generous, childlike air and an expansive smile – Louis, a year older and more advanced in school, at first seemed to dominate his frail, dark and increasingly unattractive cousin. At this time Henry's relationship to Louis was that of a faithful sidekick going along with Louis' escapades. Henry assumed a deferential role with Louis, somewhat parallel to the curious, subservient role Adèle played with Louis' parents. Whether intentionally or not, when she visited them Adèle behaved like a poor abandoned wife going with her sickly son to visit the glamorous house of elegant cousins whose family was happy and intact, delighted to be wined and dined by them and to have the chance to get out and have some fun. 'My lodgings are magnificent,' she wrote to her mother, adding, 'I am a little disoriented by the noise of the big city.'

That this was a role, however, is clear because privately she was highly

critical of her cousins' lifestyle. Although Cécile was one of Adèle's few friends and Adèle admitted that she was impressed by the gorgeous salons and carriages, the dinner parties, boxes at the theatre, balls, and formal evenings that made up Cécile's life, she wrote confidentially to her mother predicting disaster and comeuppance for her cousin's pride. These predictions would be confirmed twenty years later, in 1892, when the Pascals were forced into bankruptcy.

Henry was still in Bordeaux with his mother when school began, an indication that formal education was not considered very important in his family. When he finally went back to classes, he was two months late. 'Henry was welcomed at school like a student who has already proved himself, which made us both very proud, not even to mention the beautiful prize books!' He had made some friends although he missed Louis.

They were living again at the Hôtel Pérey, where Alph also stayed intermittently, as did Uncle Odon and his new wife Emilie, whom everyone called 'Odette'. As the hotel's reputation became known in the family, even distant cousins began using it as their Paris base. At times, Henry's extended family occupied a whole floor in the hotel.

Another addition to their family circle was the artist René Princeteau, a family friend from Libourne, near Bordeaux, who was living at Pérey while his Paris studio was being remodelled. The son of a wine merchant, Princeteau had been born deaf and dumb. However, he had been carefully trained, both by his mother and by specialists, and had learned to lip-read and then to speak. He was quite fluent, although his voice did not sound exactly normal, and he had great disdain for other deaf-mutes who could not talk as he did. He was very sociable and even went dancing, explaining that he could 'hear the music in his stomach'. He was well educated and had learned a number of skills, including gymnastics and horsemanship. He had intended to become a sculptor but, while studying at the Imperial School of Fine Arts in Bordeaux, had changed his interest to painting. Quite well known as a society animal painter ('I never paint a horse worth less than 20,000 francs,' he is supposed to have said), over the years Princeteau was commissioned to do several portraits of Toulouse-Lautrec men on horseback. Although Princeteau was vain and snobbish – he was always exquisitely dressed in a frock coat and top hat – he was sympathetic to others' frailties and handicaps. Henry, whom Princeteau called 'Le Petit', adored him. 'His great pleasure in the evening is to ask M. Princeteau to do drawings for him,' Adèle wrote to Grandmother Gabrielle, and Uncle Odon made the same observation: 'he is stimulated by M. Princeteau, who ... has had the kindness to draw him

an album of sketches, each prettier than the last, and which make it a precious object to keep.'

School holidays were almost the only variation from the routine of school, gym, tutoring and life at Pérey. That Christmas he and Adèle went to the 'American' circus, where he saw lions in a cage and 'eight elephants who walked on their heads'. There were also puppet shows, the Jardin d'Acclimatation, the Jardin des Tuileries and the ongoing excitement of walking the *grands boulevards* looking into shop windows where, he wrote to his cousin Madeleine, 'there are so many dolls you wouldn't know which one to choose'. He was apparently unusually charming for a boy of his age, and people responded to him warmly. His Uncle Odon, who was not given to kind words, wrote that Henry was 'more and more sweet-tempered and delights the Pérey salon society'.

As Henry was taking English at school, Adèle hired a tutor for him and for herself. Miss Braine, a young Irishwoman, quickly became a fast friend of the family and a major source of moral support and comfort to Henry over the next difficult years. She was fond of them both, and when she went outside Paris to give lessons, she picked bouquets of field flowers for Adèle and brought bunches of fresh pimpernel for Henry's canaries. She also brought them books in English, and Adèle thought that Henry learned much faster with her than at school. Adèle was soon also making progress, enjoying reading in English and hoping to converse with the American and English visitors at Pérey in their own tongue. Even when Henry was an adult, Miss Braine continued occasionally to work for Adèle as a sort of private secretary, possibly a tactful way the Toulouse-Lautrecs found of giving her money, for she had a difficult time earning a living.

In the middle of the 'uproar' caused by the numerous relatives occupying Pérey in February of Henry's second year in Paris, Adèle wrote proudly that he was now first in his class in handwriting as well as Latin, French and English. 'It would be perfect if he hadn't got <u>covered</u> with extra assignments for having misbehaved with his classmates during class.' Henry himself saw it all with a lot of humour: 'I have a French teacher who wheezes like a <u>grampus</u>, and an English teacher who takes <u>snuff</u> and gives us homework with stories about <u>cotton</u> and <u>thistles</u>; despite all this, I like them both very much.' He ended the year with first prizes in Latin prose, Latin translation, French grammar and English grammar, as well as honourable mentions in recitation, history, geography and arithmetic.

As spring came in 1874, Alph, forced despite all his resistance to give up Loury, came to Paris and took over his son's training in riding. They went

to the Duphot riding stables where he could supervise Henry's ring work. Adèle approved, hoping that riding would develop and fortify her son. 'He is hardly growing at all, and at school has already been nicknamed "Petit Bon-homme" [little fellow].' Alph also took him back to Chantilly on a number of occasions, usually for the races, although once the whole family rode there in an open carriage to follow the hunt, led by the Prince de Joinville. Henry loved the crowds and excitement and the liberty of being with the men. Alph left him free to 'go wherever his curiosity might lead him', appointing a meeting place under a tree for when it was time to go home.

These experiences gave Henry a much-needed taste of independence. Adèle herself was too timid even to ride in a lift: 'Those contraptions make me seasick, I prefer to use my legs,' she wrote to her mother. Cautious and self-denying, she systematically deprived herself of any pleasures which might interfere with her duty to her son. For example, when the Péreys gave a ball for their daughter's eleventh birthday, Adèle declined the invitation, writing of her reasons to her mother: 'As I accurately foresaw that the dancing would last until three in the morning, I starred there by my absence. How would I have been able to go to school on Friday?' After more than two years in Paris, Henry's fearful mother still would not let him make the fifteen-minute walk to school unaccompanied.

She was most concerned about his religious education. The competition for a 'good church' was so fierce that she had signed up Henry, who was now nine, to take his first communion two years in advance. That spring of 1874, he went to confession and kept Lent for the first time, eating no meat for three days. Unfortunately, he was coughing a lot, so Adèle didn't force him to hold out for the whole forty days. When Henry began his catechism classes that autumn, she was ecstatic. She wrote to her mother, 'Pray for your godson, dear Maman, so he will profit from them and make progress in the knowledge of God, so much more necessary than that of school.'

'Although it seems absurd to say this when one leads a Parisian life,' Adèle added, she was feeling sad and isolated. The biggest advantage of her life, she said, was that it left her no time to think, adding piously, 'Can one complain of being judged worthy of bearing a heavy cross?' As was her habit, she was vague about what exactly her cross was.

Henry's cross, however, was growing apparent. Daily new symptoms accumulated. His bones were not developing properly, and this caused him more and more discomfort. Never a whiner, he now complained of cramps and sore joints and increasingly of terrible toothaches. These toothaches may not have been caused by decay at all, but by pressure from his sinus cavities

which, as he grew, were becoming malformed, another symptom of his congenital malady. Of course dentistry at the time in France was still fairly primitive. Oral hygiene for most was a toothpick and a glass of water, and no one thought of going to the dentist except to have a tooth extracted when it was rotten beyond saving. Although Henry owned a toothbrush, he would be plagued all his life by toothaches. That summer he wrote about a visit to his Uncle Odon's summer house at Le Haichois in Brittany: 'I would have had a bully good time but those cursed toothaches made me see everything crooked. The place where I felt the best was in my bed. Still, thanks to a bandage tied around my jaw, I could go and watch the cows, and finally thanks to Addison Water and ether in my ear, I made it safe and sound to Arcachon.'

Otherwise, he was a tough, uncomplaining child, and despite his letter to his mother about being pushed at school, he tended to concentrate on the exciting, active side of his existence. He longed to appear more physically able than he really was. For example, later that summer in Arcachon, he was obviously having a wonderful time roughhousing with his Pascal cousins. To his great envy, his older cousin Joseph could climb a tree to get up to the first-floor balcony to Adèle's bedroom. This feat impressed Henry so much that by the time he wrote about it to his Grandmother Gabrielle, the perpetrator of this stunt was 'on' (one) – a vague pronoun that could be interpreted as 'we'. He still liked horseback riding best of all his activities. Nonetheless, at least part of the stay in Arcachon was spent taking the health baths. He had taken twenty-three when he wrote the letter.

In November, Henry and his mother headed for Paris, hampered briefly by a train derailment, 'thanks to a stupid ox which decided to get itself spread all over the tracks'. Although Henry was only slightly injured, on the left thumb, possibly by being jarred in his berth when the train stopped, Adèle managed to extract maximum sympathy for the injury, mentioning the event in at least three letters to different people between 22 November and 1 December: 'It's cured now, but it complicated my duties, since everything had to be done for him, like a baby.' In view of the fact that every pimple or toothache was treated like a major event, it is surprising that the growing evidence of Henry's real handicap was not given more attention.

Back at the Hôtel Pérey, they calmly took up their routines, and the school year began with deceptive normality. 'My big boy went joyfully back to school, and received four prizes,' Adèle wrote to Grandmother Gabrielle. 'You can imagine how happy he was to see all the professors in wigs and togas, as required by the new law! His own [teacher], who is as short as he is fat, is particularly elegant.' The 'new law' had been formulated to give the

national education system a little more credibility and the teachers were expected to wear the long robes and wigs previously only worn by university professors. In the 1870s, the possession of a *baccalauréat* – a secondary-school diploma – was an exclusively male and mostly aristocratic or upper-middle-class prerogative. In order to go to school, a young man had to have the wealth and leisure not to work. Henry was expected to earn his '*bac*', but for him to be taught in a state school made Adèle nervous. He might be subjected to the pernicious influence of radical professors. The state-run schools had the perhaps well-deserved reputation of being hotbeds of atheism and liberal politics, and professors in general were often allied with republican, even populist, political groups. Consequently, Adèle was relieved after some investigation to learn that many of the professors in Henry's school were good Catholics.

The scholar himself was more interested in the beneficial effects of Nozeran chocolate drops, sent by his Grandmother Louise for Christmas. 'He finds that the sweets help him to do his essays ... in my room, of course, because at school they would be contraband.' He was as irreverent and irrepressible as usual, writing amusing letters to various relatives: 'My dear Aunt, I have decided to write to you in the guise of a spider. Maman thought it was a nasty creature to confront you with, but I pointed out to her that with your beauty you could ensnare the hearts of all who came your way, just as the spider ensnares all the flies.'

During the Christmas holidays, Henry went to see Robert Houdini, the conjurer-magician who, he wrote to his cousin Madeleine, 'made some little boys like me disappear, also some birds like Lolotte'. Around the same time, Adèle was trying to teach him the value of money. He got coins for each good grade at the end of the week, and his Grandmother Louise gave him money for Christmas to spend as he wished, but Adèle supervised his purchases, as she said, 'to make him reflect carefully, so as not to have any regrets'. However she pointed out, 'I have to admit that he is just as quick to empty [his purse] into the hand of a beggar as into that of the man who sells barley-sugar or pictures.'

Unfortunately, all these commonplace considerations suddenly seemed irrelevant. Shortly after his tenth birthday, he had begun to have severe pains in his legs and thighs, a symptom consistent with hairline fractures, microfractures produced in abnormal bones by normal activities such as walking or getting up from a sitting position. Although intermittent 'growing pains' which go on for a period of one to three months can be normal in growing children, Adèle thought it best to have Henry checked

again. Before Christmas, she had taken him to Neuilly, a fashionable town on the outskirts of Paris, to see a man named Verrier who ran a private clinic in his home. Little is known of Verrier, who had a reputation for treating joint problems but may not have been a doctor at all. Adèle had heard that he had had success in curing an Alsatian girl with symptoms similar to Henry's. Verrier's diagnosis was that Henry's legs were weak and he needed more exercise.

Now, in early January, Henry was again suffering intense, though intermittent, pain. Adèle rushed back with him to Neuilly for a further consultation with M. Verrier. While conceding that the holiday had somewhat strengthened Henry's legs, Verrier said that they were not yet at the 'desired point', and on 15 January Adèle made the momentous decision to take Henry out of school and hospitalize him full-time at M. Verrier's home.

Neither Henry nor Adèle ever described in their letters exactly what the treatments were. Apparently they were a combination of manual and mechanical stretches, where Henry's legs were pulled and manipulated while he lay still. There is a fair possibility that he was placed in traction several hours a day while his legs were stretched with weights, to make them longer.

Adèle had been afraid that Alph or other family members might oppose her, but to her relief they supported her decision. Grandmother Gabrielle explained their point of view in a letter to Henry's Aunt Alix: 'Interrupting his studies is minor given his intelligence, and health comes first ... The child's marvellous disposition, it seems to me, should give the treatment even more chance of success ... [Adèle and Alphonse] are luckier than other parents, who lack the financial means to profit from scientific progress, and must watch their dear ones languish before their eyes.'

Optimism surrounded the project at the start. Everyone believed that in time M. Verrier would succeed in getting Henry's legs to grow and that it was worth the emotional stress of separating Henry from his mother and making him live in Verrier's house, where he was not allowed to walk any farther than the garden, if in the long run he would be normal and live like other boys. Adèle's first letters on the subject were cheerful:

The doctor is pleased with his 'subject', and Henry is even more pleased with his social standing. He's very proud to have a pretty little room all to himself and plays host with the most comical grace. I should mention that the entire Hôtel Pérey has been to visit him, and I am very touched by these marks of friendship.

Henry has the complete run of the house and the pretty garden; he's only obliged

to stay lying down twice a day, during his treatments, but it's not at all painful or boring, for he reads amusing books. He's working passionately at his English, thanks to the visits of Miss Braine, who has also begun giving lessons to the doctor's daughter, a charming little girl of eleven. She's making her first communion this year, and I'm going to try to send Henry to catechism at the Neuilly church, so he won't be held back for a year. But it's not easy ... we have to go there in a little carriage and last Sunday it was impossible to drive Henry to Mass because the weather was so awful.

Adèle began organizing her life around the new demands posed by Henry's ill health. She continued to live in Paris at Pérey, but every day, rain, shine or snow, she went out to Neuilly to spend two or three hours with her son, taking a horse-drawn public omnibus or a train the first part of the way and the newly installed tramway for the last part of the trip, in order to save money. She felt the treatment and lodging costs for Henry were very high. Although she could no doubt have afforded a private carriage for her trips from Paris (Alphonse, for example, stabled a horse in Paris, even though he did not live there full-time), she was unwilling to indulge in what she considered an unnecessary luxury. Unyielding with her servants and disapproving of her spendthrift cousins, she managed her own life with self-denial and frugality.

Her daily visits to Henry, she pointed out, took an hour and a half each way. When she got there, she generally took him out to the Jardin d'Acclimatation, a fair distance from Verrier's. There he would look at the animals and play carefully on the swings and other playground games.

The family was impressed that Henry never complained. He even appeared 'content with his fate'. His health was generally good, and they were waiting for the judgment of a physician cousin, Dr. Louis Raymond (whom Adèle respectfully called Dr. Raymond instead of using his first name), before trying to decide if the treatment was actually causing any improvement. They had ordered a large tricycle for Henry, so he would be able to ride to the Jardin d'Acclimatation. According to M. Verrier, the tricycle wouldn't fatigue his legs too much, and it was important not to stress them. Adèle was pleased because she hoped Henry would also be able to ride to his catechism classes: 'I cannot afford to hire a carriage to go to the church three times a week. It's enough to pay for Sunday.'

After some delay, Tata had come back to Paris to help Adèle take care of Henry, which according to Adèle made him 'jump with joy'. Within two weeks after Henry was installed at Verrier's, Alphonse also returned to Paris,

concerned about Henry's condition. He even suggested that he and Adèle take lodgings nearer to their son, possibly near the Arc de Triomphe, and they planned to move at Eastertime. The child's illness had generated a sense of mobilization, of productive activity, as Alphonse and Adèle banded together to cure the fragile boy.

At the end of a month, the doctor declared that the treatment was working well. 'I want it to so much that I don't dare to believe it,' said Adèle cautiously. When their cousin Dr. Raymond finally came to visit Henry on 8 March, he also was 'very satisfied' with the boy's progress, so Alphonse, reassured, left Paris again, to go hunting. Adèle took Henry out every day on his tricycle, although she was forced to lodge an official complaint with the Paris park authorities before he was allowed to ride it into the Jardin d'Acclimatation to see the animals. As Henry never tired of going there, Adèle complained she was beginning to know it 'by heart'. On Easter Sunday Henry was allowed to go back to Paris to visit his parents at Pérey for a few hours. 'The proof that he's happy at Neuilly is that he went back there without complaining, even though he was delighted with his day off and being spoiled by everybody.'

Alphonse had returned to Paris for Easter from a huge hunt, jubilant that he had ended the season by taking three stags. The autumn before, he had found a new hunting lodge at Grignon, not far from Orléans in a sparsely populated, densely forested area. He planned to make it his permanent residence, so he could hunt in all seasons, both on foot and on horseback, but he was discovering how isolated it was. Loneliness in combination with his concern over Henry's health may have precipitated his suggestion that he and Adèle live together again in Paris.

Unexpectedly, the weeks at the clinic stretched into months. Henry wasn't allowed to go back to school that year. Adèle wrote to her mother that she couldn't even make plans for the summer because Verrier wouldn't tell her when her son would be well: 'If I knew that Henry's treatment was still going to be a matter of months (the Lord only knows) ...' Verrier was restricting Henry's movement more and more. The only outing he was permitted after Easter was a trip to the 1875 Grand Prix at Chantilly with his parents in late May. Despite the hot weather Henry was delighted to be free, lost in jockey fantasies, sure he would soon be back on horseback.

In June, the Verriers' daughter had her first communion, accompanied by great celebrations. Adèle attended the luncheon given for friends although she refused to go to the banquet that evening. Henry, who lived in the house, of course went. Already, aged ten, he had discovered the pleasure that alcohol

gave him, and Adèle tried to control him: 'I strongly recommended sobriety to Master Henry, who would be happy to toast the health of his friend Louise a little too often.'

Adèle, as impatient as Henry, again pressed M. Verrier to give her a date when Henry would be better, but he postponed. Then he postponed again. At first he said that she would be able to take her son south with her at the end of August, something Henry was eager to do, as he wanted to see his cousins. But shortly afterwards M. Verrier and Dr. Raymond decided together that if Henry left at all, it would have to be for a spa, preferably at the seaside. Adèle was disappointed at this announcement, but resolutely began making plans. 'I will submit to anything, except to putting Henry back at Neuilly after the holidays; above all this has to be over.'

Yet, desperately worried about her sick child, she grasped at any straw to believe the cure might work. A month later she wrote exactly the opposite: 'I'll never decide to take Henry away so long as I can still hope for some improvement; it's working, but it's slow. You might say he's getting the wait treatment.' Henry did seem to be improving a little. He was no longer required to ride his tricycle everywhere, but was able to walk an hour and a half without tiring. His general health was excellent, and he was feasting on the grapes and peaches Adèle brought him every day, 'even though fruit is not exactly given away in the Paris markets'.

After much hesitation, in mid-September Adèle decided at last to go on holiday by herself to Le Bosc and Céleyran, leaving Henry at Neuilly for his treatments: 'I am very impatient to begin my little trip even though my heart is already heavy at leaving my Henry. However, he is quite reasonable and understands very well that I too need to see my maman again,' she rationalized. Alphonse had agreed to stay in Paris to take care of his son.

During the month Adèle was gone, Henry wrote her a whole series of letters, some of them, like the following, in English, which he was studying assiduously with Miss Braine:

My dear Mama,

I have received Marraine's [Godmother's] letter yesterday. We could not go out today because it rained very much. Miss Braine brings me *décalcomanies* [transfers] and I do them well. M. Verrier does all he can for you may be satisfied on your arrival. I am very happy. I will do all I can for you may be satisfied. We have just taken a little groom for the pony. Goodbye my dear mamma, I kiss you very much, and everybody too.

Your loving son, H. de T. Lautrec

my kiss

Another letter in English written during the same period and signed 'Coco de Lautrec' announced that his Greek teacher was pleased with his work and ended by saying, 'If I had wings, I should go to see you, but I have no.' Although they do not show the same wittiness as his letters in his native tongue, they reveal two important motivating factors in his personality: an intense desire to please his mother and an optimistic and cheerful attempt to accept his lot.

He again expressed his loneliness, this time in French, to his Grandmother Louise: 'If I could leave my legs here, and go off in an envelope (just to give you and Maman a kiss) I would do it.' It was depressing to stay in bed most of the time. Although he was trying valiantly to be a good sport, he missed his mother, his cousins, the animals at Le Bosc, everyone. He and Alph had spent so much time at the Jardin d'Acclimatation that they had befriended the falcon-keeper, another reminder of the excitement that lay outside Verrier's, for Alph had promised to teach Henry to hunt.

When Adèle got back, Alphonse, before leaving for Grignon, told her he had decided that she had to get Henry out of Verrier's clutches. Although she agreed that the improvement in her son's health was minimal and was worried about the destructive effect of long confinement on the spirit of the eleven-year-old boy, she agonized over what decision to make: 'My position is difficult, since I'm forced to fight to prolong something that I find so painful to endure.'

By the end of the autumn, Adèle had decided to ignore Alphonse's opinion. She accepted the experts' decision that Henry must not leave Neuilly in the near future and began setting up tutors for lessons and catechism so he wouldn't fall behind. 'Henry ... has accepted his need to stay at Neuilly with good humour; he has even developed a great friendship with his teacher – of course each Greek lesson ends with another hand of cards.'

Alphonse, predictably, was insulted and angry, and Adèle was nervous that when he returned to Paris he would force her to take Henry away from Verrier's. Alph's brother Odon was taking his side in the affair and decided to go to Neuilly to judge Henry's progress for himself: 'The treatment seems to me to be lasting an awfully long time.'

That Christmas, Alph decided not to come to Paris, possibly because of his frustration at being unable to influence Henry's treatment, but he did send a book to his son, in bed in Neuilly. It was a treatise on falconry, with a dedication that said in part: 'Remember, my son, that life in the open air and in the light of the sun is the only healthy life; everything which is deprived of liberty deteriorates and dies quickly.' Clearly it was true for himself but it

seems cruel of him to have dictated this to a bedridden child. Perhaps he hoped that by encouraging Henry himself to insist on leaving Verrier's, he would force Adèle and the doctors to listen to him. Around the same time, Henry began to feel extremely dispirited. It was difficult enough staying in all the time without being at the centre of a conflict between his parents. His self-image may have begun to reflect the invalidism imposed upon him. In a letter to his Grandmother Gabrielle, he said, 'I am not very eloquent.' He also mentioned that he felt 'unlucky' not to be at Le Bosc with his cousins for Christmas, and that he didn't know when he might see her again. He was lonely in Neuilly. Even the falconer at the Jardin d'Acclimatation had gone away for the holidays. He was, however, allowed to go to Paris with Adèle to see Princeteau's huge painting of Washington on horseback, *Washington, 19 Octobre 1781*, before it was sent off to Philadelphia for the United States centennial celebrations in 1876.

Alphonse also seemed depressed, writing to his mother from the forest of Grignon that if he weren't expecting two friends to come and hunt with him, he would have moved out long ago. Despite his isolation, he continued to make elaborate preparations for the hunt and described to her a man he'd hired who could raise three hundred partridges, trap foxes and be a coachman if necessary. He himself admitted he was being unrealistic. 'In the past I'd have been so happy with such a helper, because all my friends would have enjoyed his diverse talents. But today, for whom am I going to organize all this?' It must have been hard for him to accept that his son might never hunt with him. Stoically, he tried to put Henry's situation in perspective: 'At the Jardin d'Acclimatation, Henry is watching falcons being trained to hunt pigeons and cormorants being trained to fish. It seems to me that he has more amusements than many do; so much the better for the poor child.'

Grandmother Gabrielle thought it would do Alph good to go to Paris occasionally. She encouraged him to take painting lessons from René Princeteau. She considered Alph the most talented of her three sons and thought that concentrating on art would distract him from 'the disappointments of the hunt'. Henry, after focusing on school for the preceding year or two, was also beginning to show artistic inclinations again. After riding Toby, the baby elephant at the Jardin d'Acclimatation, he drew its portrait and sent it to Grandmother Gabrielle, commenting that 'baby' Toby was well over five feet high.

He had now been a virtual prisoner for a year and two months. For an eleven-year-old, the change must have seemed permanent. He was only

allowed to go to Paris occasionally to visit his mother overnight at Pérey. Even when the Seine flooded Neuilly he stayed at the Verriers', inviting Adèle to take a turn around the garden in a rowboat. He was eager for any excuse to get outside, insisting on going to the Jardin d'Acclimatation in rain and snow. 'The dear child is more and more anxious to come back to me,' his mother wrote. Although Adèle and Dr. Raymond had begun negotiating in March for Henry to come home, Verrier continued to baulk. He obviously didn't want Henry to leave Neuilly, even though the child had made no concrete progress whatsoever. He insisted that the boy still needed his daily treatments.

Unable to find any medical solution to her son's plight, Adèle attempted to provide for his future by the two means she herself believed in: religious faith and financial security. Making a commitment to the Church was theoretically the great crossroads of every Catholic child's eleventh year. Henry learned his catechism at the Catholic church in Neuilly not far from Verrier's since his knees were too stiff, she said, to make the trip to Paris often. However, he was able to make his first communion on 12 June 1876, at the Eglise Saint-Louis d'Antin in Paris. It was also in this year that she arranged a guardianship for Henry, in the case of her death. He would henceforth have the income from their property at Le Pech Ricardelle near Céleyran if he needed it.

Perhaps it is just coincidence, but the situation finally began to resolve after Alphonse paid a two-day visit to Henry in Paris in early April. Possibly under his influence, Adèle was reluctantly beginning to admit that Verrier might be a quack, prolonging useless treatments for financial gain. She managed to corner Dr. Raymond, who declared himself 'as satisfied as he could possibly be. He said that the results have been obtained and that special treatments will only have to be continued for a few more months.' At last! Dr. Raymond promised to use his influence with M. Verrier to get him to teach Adèle how to handle Henry's treatments herself, and Adèle reconciled herself to leaving the child at Neuilly until the end of June, when she and Alph would take him to the 'liberty and good air' of Le Bosc.

After mobilizing Adèle and Dr. Raymond by registering his disapproval of Henry's continuing treatments, Alphonse, as usual, had left town when the time came to deal with the practical details of actually getting Henry away from Verrier. Instead he was off fishing for pike and hunting wild duck at a pond he had rented not far from Grignon. Characteristically, he had now developed a technique of catching pike and trout by firing a rifle into the water: 'Naturally the bullet cannot hit closer than a few inches from

the fish, which is killed instantly. The commotion in the water is so strong that the fish cannot survive it.'

Alone, Adèle did not have the courage to confront Verrier: 'The latter would like to discourage me and keep his lodger, and I'm forced to turn a deaf ear, which I find most difficult.' At last, aware that her son could not by any stretch of the imagination be considered cured, in late June Adèle simply left with Henry for the south, against Verrier's wishes.

Henry could hardly believe he was out again after eighteen months of confinement. He hated having to continue his treatments with his mother every day, but except for that requirement, he was on holiday. He wasn't even asked to do much studying, although he continued his Greek with the Abbé Peyre and was learning to serve at Mass as an altarboy. His high spirits vindicated Adèle's decision to take him away from Verrier. She was now sure that leaving Neuilly had done him no harm at all. Firm evidence of how quickly his boyish energy and humour were restored comes from one of the letters he sent his mother while she was in Albi visiting Great-Aunt Joséphine later that summer.

'This morning I went with Papa, hunting for Grésigue [a falcon], who had perched at the top of a tree and didn't want to come down ... I've been having fun building a hippopotamus trap, and I'm going to build one to catch the mouse. Thursday I went all the way down to the bottom of Vergnasse creek (I think that's the name) ... P.S. Please bring me back four drawing-board pins for spares.'

He also commented that his cousin Béatrix had 'lost some of her *guincharderie* [splay-leggedness]'. This was a telling remark, for Béatrix Tapié de Céleyran (usually called 'Kiki'), Henry's godchild and one of his favourite cousins, was just learning to walk, sliding around the house in her bedroom slippers. This may have been when her family first became aware that she, too, was handicapped.

Henry was 'wild with joy' to be in the château in the country and to spend his summer playing and fighting with his cousins the way he always had. Although he was now forced to walk with a cane, he manoeuvred fairly well and made up in masterminding imaginative pranks what he lacked in mobility. Alphonse, staying at Le Bosc for a time that summer, was attentive to his son. He had developed a new hobby. Inspired by the trained cormorants he had seen with Henry in the Jardin d'Acclimatation, he had ordered two of the sea fowl sent from Bordeaux. Alph took Henry with him to teach the huge black birds to dive for freshwater tench in the fish hatchery. Once,

accompanied by Adèle, they even tried them out on the trout at Castelpers, a town on the rushing River Céor some five miles from Le Bosc. The locals must have found this new fishing method quite extraordinary, and it is likely that part of Alph's pleasure came from his ability to amaze his audience.

But summer was short. Alph did not stay long, and most of Henry's cousins left again for school in October. As the cold weather set in, he was reduced to babying his aunt's toddlers, who were too young to go to school, and 'taking' Nounou, their nanny, for a walk, pushing the baby carriage. Even Adèle soon thought better of having Henry spend the winter at Le Bosc. She decided to take him back to Paris, enrolling him once more in the private classes which Henry's *lycée* teacher, M. Montoy, offered in his home outside normal school hours.

They moved back to their habitual room in the Hôtel Pérey and installed the cage of 'Lolots' in its place by the window. Henry had classes in the morning with M. Montoy and studied at the hotel in the afternoons, supervised by his mother. Despite having been out of school for a year and a half, he was doing well in his subjects and writing whole essays in English. His professor assured Adèle that if he went back to school, he would be able to catch up with his class. But Adèle was absorbed by a dozen peripheral concerns. In fact, she didn't want him to stay in class all day, even if it would mean his catching up more easily, because it was inconvenient for her to fetch him late in the afternoon. She also felt that the extra hours of class cost too much: 200 francs (in today's terms over £400) a month.

Adèle's behaviour towards Henry was frequently influenced by this kind of ambivalence. In addition, she was often not sure exactly where his best interests lay. For example, although she was eager to consult Henry's uncle Dr. Raymond about the boy's congenital illness, she now refused to contact him until Henry recovered from a bad sprain because she wanted to be sure the doctor saw Henry at his best. She and Henry continued to maintain some relations with Verrier; although he was no longer responsible for Henry's treatment, everyone kept up the pretence that they were all good friends. In early December, Henry even went for the weekend to Neuilly. Verrier and his family were delighted to see him and insisted he come back the next week. Years later, as an adult, Henry got word that Verrier would like to have him to lunch. But by then he was clear on his answer: 'Not likely,' he remarked to his mother.

When Dr. Raymond finally inspected his nephew, he agreed with Verrier that although Henry's joints were still weak, they were 'as good as could be expected'. Such perhaps intentionally vague answers were unsatisfying. Adèle

could see for herself that her son's walk was far from perfect. And although he seemed to be trying to reassure her, Dr. Raymond also warned that Henry shouldn't be put in a position where he could get hurt in the playground. He recommended that when school finished in the spring, Adèle take Henry to the spa at Barèges, where the waters were recommended for joint disease.

Despite his continued muscular weakness and occasional injuries, Henry remained energetic and full of enthusiasm, throwing himself into life as if he had no illness. He had numerous friends in M. Montoy's private class. There were three boys his age, including a Russian aristocrat. Also, his cousin Louis was in Paris, as his father had lost his job in Bordeaux, confirming Adèle's prediction that the Pascal family was headed for trouble. Henry was overjoyed that Louis was being tutored by M. Montoy too. Somehow Louis had fallen a year behind Henry in his studies, in spite of all Henry's delays. Adèle noted wistfully that Louis was 'very big and very strong'.

Christmas the year Henry was twelve was typical: Alphonse's absence, Henry's New Year letters to his grandmothers, and Adèle's denigrating comments: 'I'm sending his letters on to you,' she wrote to her mother, 'even though to me they seem not only late but uninteresting.' Grandmother Louise sent Henry his yearly supply of *crottins* and money, possibly to help pay his tutor. In his thank-you note he wrote that although the sweets hadn't yet arrived he was 'already sharpening his teeth'.

Doctors continued to try different treatments on Henry, but Adèle was discouraged. No matter how she tried to deny it, it was sinking in that Henry was crippled. Occasionally, however, this knowledge was too painful to accept. Her depression had to give way to unrealistic if cautious optimism: 'My worry about Henry is over, for the moment at least. Heavy applications of tincture of Arnica stopped the shooting pains which were making it almost impossible to walk. I hope all this will work itself out with growth, but you understand that I still have some concerns.'

Henry, of course, hated the constraints – hated not playing with other children because he might get hurt, hated not being able to go on his own to see his cousin Louis, hated having to confront the realization that every time his pain retreated, a new pain came to take its place. It is understandable that he should become fixated on immediate pleasures like chocolate.

As the winter passed, his freedoms began to be severely curtailed again. His physical condition was deteriorating noticeably, preventing him from spending a full day at his tutor's, not to mention going to the *lycée* as planned. In addition to what his mother called sprains, Henry had serious pain in his knees. At times he could not walk at all. Since there was no

clear diagnosis, it could not be known that his malady was taking its normal course.

There have been frequent attempts in medical circles to identify the form of dwarfism Henry had developed. Two French physicians, Lamy and Maroteaux, even gained a certain fame in 1962 by identifying a particular form of dwarfism, pycnodysostosis, as 'Toulouse-Lautrec's disease', but as they based their diagnosis on caricatures he had drawn of himself rather than on the numerous accurate photographs of him which still exist, it is important to discount their claims. Henry in fact did not have the characteristic symptom of pycnodysostosis, which is an unknitted anterior fontanelle or soft spot. Although posthumous diagnosis is always risky, experts on endocrine disorders say that Henry was probably suffering from a genetic mishap which caused fragility at the growth end of bones, hindering normal bone development and causing pain, deformation and weakness in the skeletal structure. The most eloquent evidence that his illness was hereditary is the fact that compared to the crippling suffered by at least three of the fourteen children born to his aunt and uncle, his own case was mild. The other three were true dwarfs. Henry's godchild, Kiki, along with two of her sisters, Geneviève, called 'Bibou', and Fidès, would be badly deformed. Kiki would have to walk with crutches, and poor Fidès would never walk at all, being confined her whole life to a large wicker baby carriage. In addition, his cousin Madeleine suffered from pain and weakness in her legs. The maladies of all five children were probably caused by the doubling of a recessive gene which, true to Mendelian law, appeared in one out of four offspring of a couple who were both carriers. Since both sets of parents were first cousins from the same family, the conditions for such a genetic pairing were, unfortunately, ideal.

As he entered adolescence, Henry's long bones began to atrophy at the joints where the adolescent growth spurt would typically manifest itself. As the oldest child of his generation, he was the first to suffer such symptoms, and naturally no one in the family had any idea what was wrong. The anxiety of not knowing what to expect took its toll.

'I'm still very worried about Henry's soreness,' Adèle wrote to her cousin Alix in February 1877, when Henry was twelve. 'It now seems to have moved to his ankle and greatly hinders him. I went back to see the *grand docteur* [Dr. Raymond], who says it's caused by nerves and is still prescribing arnica. Now, more than ever, he's recommending that I do the sulphur baths.' Adèle's use of the pronoun 'I' shows how strongly she identified with her son's malady. She often referred to his sufferings and medical treatments in

an ambiguous way, as if it were unclear whether they were happening to her or to him.

Henry, however, was not unclear as to who was disabled: in a letter to Grandmother Gabrielle written to thank her for sending him a book on sport and physical fitness (a choice which shows that she had decided to support her son Alphonse by 'tactfully' encouraging Henry to use willpower to overcome his handicaps), Henry referred to his illness concretely, if without self-pity: 'I have more free time the last few days, because Maman has had me leave my teacher's so I can take the electric brush treatments that

Henry and his extended family at the Château du Bosc, c. 1895. Henry is at left. Seated centre are his two grandmothers, the sisters Gabrielle du Bosc de Toulouse-Lautrec (left) and Louise du Bosc Tapié de Céleyran (right). Adèle is standing behind them. To the left is her first cousin, Cécile Pascal; to the right is Louis Pascal, Cécile's son. On the far right, standing, is Alix de Toulouse-Lautrec Tapié de Céleyran, Alphonse's sister. Her husband, Adèle's brother Amédée Tapié de Céleyran, is standing behind Adèle, with his hand on her shoulder. The three handicapped cousins in this photo are Geneviève (Bibou), seated middle row third from left, Béatrix (Kiki), standing with crutch under her right arm (second row, third from right), and Fidès, in the large baby carriage at right.

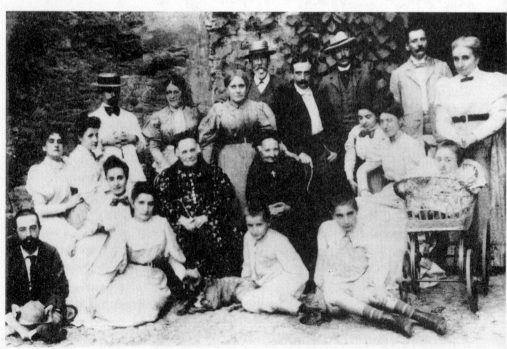

once cured my Uncle Charles.' The electric brush treatments appear to have been some kind of mechanical massage of his legs or possibly applications of mild electric shock to stimulate his circulation. 'I am very frustrated to be lame in the left leg now that the right one is well. Let's just hope that it's only a reaction to my treatment, as Dr. Raymond says it is. I already feel better.' The use of electricity was just becoming known in society at large, and it was widely considered to be a panacea for most of the world's problems. Both Henry's father and his Uncle Charles received electric brush treatments at different times for sporting injuries.

Henry was eager to forget his ailments, to focus on the world around him. He and Adèle went that winter to the circus with Odon's eldest son, and to see *Le Malade Imaginaire* by Molière with Louis Pascal and his brother Joseph. In his private classes, Henry was progressing rapidly in contrast to his cousin Louis. According to Henry, M. Montoy was threatening to throw Louis out of the class since he wouldn't study. Louis and Henry were still inseparable, but as they approached adolescence, their respective roles were shifting, taking on the characteristics that would mark their friendship as they entered adulthood. Henry was now the instigator in their pranks and games and Louis the follower.

Interestingly, Henry's response, as he began to feel himself the superior, was to become tenderly protective of his weaker cousin. He was sorry when Louis was held back in school. As time passed and Louis showed himself to be substantially less able than Henry to cope with the stress and competition of the world around him, Henry worried and suffered for him. Now Louis, like his cousins Kiki and Madeleine, was under his protection. The humanity and sensitivity he showed to Louis were part of his growing awareness of suffering – both his own and others'. But it was developing in parallel with other, defensive tactics: the increasingly self-deprecating irony and wit that showed in his letters.

Henry's increasing maturity, coupled with his first freedom in nearly two years, led him to look for more amusement and stimulation. Although that year Alphonse seldom came to Paris, Charles, the elder of Alph's two brothers, had also moved into Pérey for the winter of 1877 and was a great companion for Henry. They talked and read together and drew pictures. Uncle Charles was childless and extremely fond of his eldest nephew. The two had a long history of writing amusing letters back and forth between Paris and Albi, and Charles had always followed Henry's artistic and intellectual development with great interest. When he was in Paris, he took the boy to art shows and horse races.

Uncle Odon, his father's other brother, had also moved to Paris. He lived in an apartment not far from Pérey which, to Henry's delight, was just upstairs from a bird-seller's, where he could buy things for his canaries. Odon and his wife were raising three children and numerous dogs, thus greatly increasing Henry's social contacts. In fact, socially, life in Paris for Henry was now much like the country. He and his mother were surrounded by family, and outings always involved other relatives. Occasionally even Alphonse came back, although he was always a source of tension: 'Henry is better since the last "*petit flacon*" the doctor gave him. That makes me doubly happy, because I was afraid that Alphonse might arrive and find him sick.'

Adèle did not openly express her resentment at Henry's new attachments to his uncles and cousins or at his increasing passion for visits and outings, but a conflict was developing. Her own life was centred on one thing: her duty to her son. The more he tried to stretch, the more she wanted to hold him back. She was obsessed with the progress of his illness: 'I've decided he mustn't ever go out in damp weather – it's so bad for him – and I've had to dismiss the teacher.' According to her, the fatigue of studying was too much for her frail son. 'The doctor says that the reaction and the pain are just caused by nerves, but while we wait for good weather to come and cure him, the poor child can only walk leaning on someone's arm. His ankle isn't swollen, but so stiff he says it feels as if he has a wooden foot. Could this be a growth crisis? Let's hope so. I am ready to do anything to end all this, even to put him back at Neuilly for a month.'

All the old doubts about Verrier's competence were falling away. Adèle was ready to try anything to save her son, even at the expense of her own physical health: 'The other treatments Henry had exhausted me so much that I was really afraid to put him back in the hands of M. Verrier, but it's important not to be hard-headed, and the worst would be not to have tried [the new treatment] in time.' However, she was no longer willing to send Henry away. Instead, she hired Verrier to come every morning to Pérey to massage Henry's shins. Verrier managed to add to Adèle's fears by insisting that the boy have complete rest. He was not allowed to walk at all – he was even carried to the dinner table for his meals and into the salon at Pérey in the evenings. 'I'm calmer now that Henry is in treatment. I simply didn't know where to turn, watching his walking deteriorate day by day.'

Although she must have sensed that being forced to stay in bed again was just as great a torture for Henry as his actual physical suffering, her letters concentrate on the impact his illness was having on her own life: 'I assure you that the regime is hard on both of us!' she wrote to her mother, 'perhaps

more even for me than for Henry, who is happy to amuse himself reading or drawing, loves the visits from Louis and, so long as he remains sitting, doesn't suffer at all.'

Adèle was beginning to be irritable about Henry's illness. She was both mortified and distressed to have to turn again to Verrier for help after once dispensing with his services. She also felt that his visits were an imposition: they interrupted her day. In addition, she resented spending so much money. The carriages she had to hire whenever Henry wished to go anywhere were frightfully expensive, 'but it's not worth it to walk'. When he tried to walk even as far as around the Church of the Madeleine, he had to lean so hard on Adèle that her arm would be sore by the time they got back. She couldn't think of travelling alone with him if he continued to walk so badly. She didn't know whether to be fearful or hopeful, since Henry's pains came and went unpredictably. In short, life seemed to her one long martyrdom.

A side effect of her role as Henry's long-suffering protector was that it forced her at last into open conflict with Alphonse: 'To complicate my troubles, I'm trapped between M. Verrier, who insists on taking Henry to Neuilly, Dr. Raymond, who is opposed, and Alphonse, who wants to fire all the doctors and cure his son on horseback!' She was praying for help from God, and her wish was granted. Alphonse stopped coming to Paris. Henry remained in her hands.

Henry appeared philosophical about all the things that were happening to him. Pragmatically, he had found an activity which could be done from his bed – stamp collecting. He also sketched and did watercolours lying on a chaise-longue. As the boy moved towards manhood he was intelligent enough to realize how far he was from meeting the Toulouse-Lautrecs' expectations of a man. While he was bedridden, his father was off hunting woodcock at Grignon, and even Uncle Odon went from Paris to Chantilly twice a week to hunt on horseback with the Duc d'Aumale.

When Henry began to show a little improvement, Verrier came only every other day. On the alternate days he gave Henry 'very time-consuming, not very amusing' exercises to do, flexing his feet and putting traction on his legs with straps. 'His walk is still awfully flawed, but we were so low before that I've regained a little morale,' his mother wrote just before Easter 1877. Henry also had a good many peripheral health problems, most markedly a tendency to develop respiratory ailments, which were aggravated by staying in bed. In early April that year he caught a chill which made him very ill for three nights, ending with an abscessed right ear and a burst eardrum. Although he would be deaf in that ear until the eardrum healed six weeks later, Adèle

tried to see the bright side of things: 'The good thing about it is that he sweated so much that the pains in his shins have disappeared!'

As the months passed, the extended family was unfailingly attentive to the sick child. His cousins came often to Pérey to amuse him. Louis occasionally spent the whole day playing with him and even waiting on him. Uncle Odon lent Adèle his carriage and team to take Henry and Louis on rides around the Bois de Boulogne. Sometimes his young son Raymond went, too. Princeteau came to visit Henry at Pérey and was closely involved with all the Toulouse-Lautrecs: in his new studio he was doing a painting for Uncle Charles, and Odon, Odette and Raymond were posing for portrait sketches.

By now everyone had a theory on what was wrong with Henry. Grandmother Gabrielle thought he had rheumatism. Adèle clung to the idea that it was either nerves or growing pains, and Alphonse claimed Henry was sickly because Adèle and the doctors babied him too much and didn't oblige him to be physically active. Of all the family, in the long run Alphonse would show the least denial. In later years, he openly admitted that he believed Henry had a hereditary ailment and chastised himself for not having restrained himself when he fell in love with his first cousin.

Fortunately, the patient himself remained cheerful. That same April, he wrote a thoroughly lighthearted letter to his Grandmother Gabrielle about the wedding of a cousin:

I have to confess that [it] seems most extraordinary to me ... to have a new cousin at noon who wasn't one at 8 a.m. I wish I were sitting beside Uncle Charles to keep him from getting sick on truffles!!!!!! I've been a lot better for the past four days, and can get around inside the house ... Louis Pascal and I have founded a theatre with sixty actors. We have a lot of fun with it. My canary de Béon is sitting on three eggs, which portends an increase in our family ...

Your respectful grandson

In another letter, written about the same time to his cousin Madeleine, he elaborated on the puppet theatre he and Louis had constructed, built on the model of their old puppet theatre at Le Bosc. The sixty puppets were each about seven inches high and supported from below with wire rods. Plays he had been to and the military ceremonies he saw in the streets furnished his imagination with plots. It was the boys' primary amusement during the rainy Paris winter.

Henry said he was proud of Madeleine's 'portrait' of Kiki, the goddaughter the two of them shared, and hoped that (like 'Delon's' representation of them

in her drawing) Kiki's fingers were going to be long, so she could 'play the piano well and charm me in my old age'. He assumed his responsibilities as godfather to his niece gravely and kept a photo of her in his bedroom. 'Henry is very proud that his goddaughter is so beautiful,' his mother wrote to Alix. 'You would think he believes he had something to do with it.' He was always eager for news of 'his girl'.

Everyone in the family was impressed with Henry's morale. Odon, preoccupied by the seizures and other signs of severe neurological difficulty in his own son, Raymond, took time to remark on it to Grandmother Gabrielle: 'Poor Henry can barely walk enough to get around his room with the help of a cane ... Thank goodness the child finds many resources to bolster his spirits. He is always joyous – drawing, painting and watching the growing chick presented to him by Lolichonne, a.k.a. Mademoiselle de Béon.'

Henry still lisped and had developed chronic sinus trouble. To compensate for the postnasal drip caused by his misshapen sinus cavities, he had taken to interrupting his speech with a repetitive sniff. Adèle treated his terrible sinus headaches with quinine. No one realized yet that the headaches were probably exacerbated by nearsightedness. He only began to wear glasses, a pince-nez with a ribbon attached to his buttonhole, in late adolescence.

By mid-May, the headaches were so severe that Henry woke up crying at four in the morning. As soon as he was able to travel, he and Adèle left Paris for Barèges, a spa high in the Pyrenees towards the Spanish border. The journey, like all travel at the time, was arduous, even though they broke it with a visit to Céleyran on the Mediterranean coast. From Céleyran they took a train to Lourdes, where they stopped overnight, then another train, and finally a stagecoach pulled by a team of four horses, which took nearly four hours up a steep trail to reach Barèges. The Pyrenees were high and arid, the vegetation sparse, and the mountainsides marked by deeply eroded ravines. Barèges, only half a mile below the treeline, was practically uninhabitable during the winter. Even in July, when they were to arrive, the weather was said to be extremely variable.

Adèle hoped the waters would stop Henry's pains and 'consolidate' him. Barèges' fame came from hot sulphur springs whose mineral content was so high that the water felt almost oily to the touch. People with health problems both drank and bathed in the waters, believing they were good for healing rheumatism and joint disease, wounds and surgical scars, as well as scrofula, gout, skin diseases, syphilis, tuberculosis, anaemia and certain nervous conditions. People spoke of almost miraculous cures, and Adèle held high hopes

that Henry at last would come to the end of his mysterious 'growing pains'.

On their overnight stop at Lourdes, they put the weight of prayer behind Barèges' reputation, spending one whole Sunday in the grotto, waiting for a miracle. Henry's letter to his Aunt Alix, describing the experience, showed a healthy dose of humorous irony: 'We didn't forget to mention you to the Holy Virgin. Sunday at vespers we sang very well and a priest read us the story of a woman who was miraculously cured. But he ruined his sermon by adding that since the event the "miracle" had gained twenty pounds.' Lourdes, despite the earnestness of their intent, had something of the aura of a street fair. They ended their day of praying with a long ride in a landau through the winding streets of what was in large part a religious tourist trap. Even the guidebooks of the time warned that it was 'good to agree on the price in advance'. Henry and his mother stayed at the elegant Hôtel de la Grotte. Although Adèle thought the hotel was in a perfect location, she told her mother-in-law later, 'they take you for everything you're worth'. In fact, she observed, 'travelling in the Pyrenees, you have to resign yourself to [being cheated]; it's considered part of the cure'.

Adèle's resignation in the face of acts of God did not extend to her purse. She decided she was not going to get taken again. The day they arrived at Barèges, she cancelled their reservations at the Hôtel de l'Europe because she thought it was too expensive. They moved across the street into a boarding house called the Maison Gradet and had their meals sent in from the nearby Café Richelieu. Proud of her decision, she announced: 'We are housed grandly, with *balcon sur rue*.'

The Toulouse-Lautrecs took over Barèges as they took over all their holiday spots en masse, all going to the same place at the same time. Aunt Alix had come with her two eldest children, Toto (Raoul) and Henry's favourite, Madeleine. Uncle Amédée arrived within a few days, with their brother, young Gabriel, in tow. The group was then joined by Henry's great-aunt, Blanche de Gualy de Saint-Rome, and an elderly cousin from Brittany, Marie de Toulouse-Lautrec. All the cousins, adults and children alike, joined in the routine of the health spa. The ritual involved daily trips to the elegant marble 'Thermal Establishment', where there were hot springs for drinking and bathing and even swimming pools. A military hospital and a hospice for the poor adjoined the baths. Clients were assigned to springs of different mineral content, depending upon the severity of their symptoms.

Henry's specific treatment called for cold showers every day and special high-pressure hot showers every evening, which left him so weak that he had to be wrapped in towels and brought home in a wheelchair, to be put to

bed for the night. It was so cold at Barèges they had to sleep under woollen blankets.

He did seem to be improving: he clambered eagerly up and down the wooden steps that adorned the steep forested hillside which loomed, as his mother repeatedly said, 'almost over our heads', keeping his balance with a steel-tipped cane. Every other day the whole family went out into the 'pretty woods' on donkey-back, which Henry and Madeleine loved. When they came down, they topped off the outing with the spa's speciality: hot sulphur spring water with a raw egg broken into it. The doctor they had consulted at the baths was most attentive to everyone and assured Adèle that two seasons at Barèges 'would make a man' of Henry. The cost of the treatments was 12–15 francs a day. They stayed for two months, which would make the cost of treatments just for Henry and Adèle, not counting room and board, around 1,800 francs. Frugal Adèle must have believed it was worth it.

In an enthusiastic letter written at the end of the summer, her cousin Marie said: 'Henri has made visible progress, and his good Doctor, as persevering as Adèle herself, is planning to make a big, handsome man of him – just as his face and his name require. I'll also add his intelligence, for the boy is overflowing with it.' Even in this casual letter by a distant cousin, the family's high expectations of Henry's heritage as a Toulouse-Lautrec came through. His cousin went on to comment on his sense of humour: 'Blanche and I had a terrific time egging him on. When she saw us laughing, Adèle stopped worrying about what she called his stupid remarks, but which sometimes contained so much wit ... Barèges was depressing afterwards ... We even missed Henri's riding crop; the big house seemed very lonely to us without any whips cracking.'

At the end of the summer of 1877, after a full round of baths, Adèle and Henry did not go back to Paris. Instead they went to Le Bosc for a long visit. They spent the autumn there with Grandmother Gabrielle, Uncle Charles and his wife, Emilie, leading the life Henry had often longed for. As the baths had been judged a success, he was allowed to go riding again with Urbain the footman, but only when the weather wasn't too cold. When he had to stay in, Uncle Charles, encouraged by his nephew's enthusiasm, gave him lessons in drawing and watercolour painting.

This was Henry's first attempt to discipline his art work. Charles trained Henry by getting him to do what any artist would, to learn his trade by copying the works around him: prints, illustrations from magazines, small bronzes on the side-table at the château, not to mention works by Charles

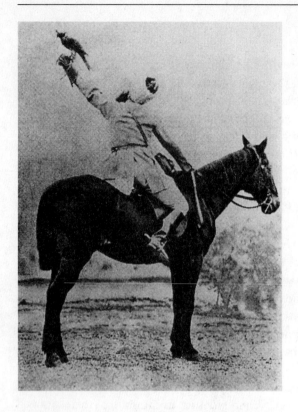

Alphonse de Toulouse-
Lautrec with a falcon,
c. 1877.

himself and by Princeteau. From the works which remain, it looks as if
Henry chose his models more for their subject than for the style of their
execution. He was almost exclusively interested in 'sporting scenes' and
animals, particularly horses in motion. Throughout the next year, Henry
produced a number of works based on paintings exhibited at the Salons and
probably reproduced in the illustrated magazines of the period. That year,
for example, Henry did a painting, *La Calèche* (The Open Carriage), and
two drawings which closely resembled parts of a painting exhibited in the
Salon d'Automne by Edmond-Georges Grandjean. Henry's attempts to copy
these works do not show genius, but they do show effort. He was diligent
and working hard.

 That autumn, from far away in Paris, his father sent a photograph of
himself in Persian costume, mounted on his horse Paroli, with a falcon on
his wrist. 'It will make a mate to the photo of Odette dressed as an *Egyptienne*,'
Grandmother Gabrielle remarked. 'In the future, our descendants will think
their forefathers were a little strange,' she prophesied. Alph's photo must
have made a huge impression on his son, for two years later, in 1879, Henry

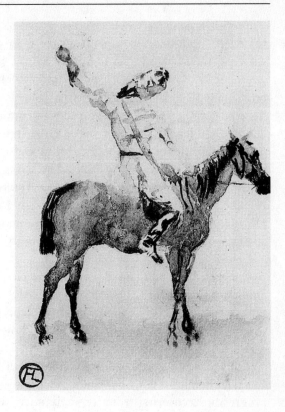

Comte Alphonse de Toulouse-
Lautrec en fauconnier,
watercolour, c. 1879.

copied it for one of his first portraits. Alphonse had not sent the photograph
to Henry, however, or even to Adèle. He had addressed it to his brother
Charles.

As Alph chose to spend the winter 'living happy in Grignon', as Adèle
put it, hunting on foot with the Count of Bethune (while the Countess
followed on horseback), Uncle Charles in his turn became a father-substitute
to Henry. Like Alphonse, Charles went off hunting hares and woodcock
every day, keeping game on the family table. But in the evenings he sat down
and worked conscientiously with his nephew – supervising his drawing and
reading with him.

Although he was like Alphonse in loving the hunt when he could be active
and art when he had to stay indoors, Charles' character was far calmer and
less eccentric than his elder brother's. Devoted to his wife, Emilie, and
to God and family in the classic French sense, Uncle Charles was a true
conservative. He lived the life that was expected of him and had a strong
sense of duty. He believed that his brother's child had a real gift that needed to
be encouraged and did not hesitate to influence Henry's artistic development.

'Henri is painting [woodcocks] in watercolours,' Grandmother Gabrielle recorded, 'and Charles is painting them in oils, while they wait for the skewers. Henri is fine, he is utterly happy, and would love to spend the winter at Le Bosc. He wants to see how we make sausage.' 'I've never seen him so happy ... [he] paints and rides Gazelle at playtime.' As usual, when the cold weather set in, it began to rain continually, making Le Bosc dark and chilly. Henry's presence had a good influence on the household. 'His happy disposition is such that he continues to be cheerful even when he has no playmates. Sometimes he forces us to shake off the black thoughts caused by the critical situation in France.' The Toulouse-Lautrecs were distressed because the Republican party had won a majority in the Chambre des Députés the month before, defeating a monarchist movement and dashing any hope that Henri V, Comte de Chambord, would be called to the throne of France.

Concentrating on more cheerful matters, Grandmother Gabrielle announced in a letter to her daughter, Henry's Aunt Alix, that she found her grandson's appearance was improving: 'Henri is looking better, especially in the face. I was telling him that his nose is showing a tendency to refinement. You'll find him more handsome.'

Adèle was not so convinced as Grandmother Gabrielle that staying at Le Bosc was best for them. She felt that Henry was not making enough concrete progress in recovering from his symptoms: 'without being in pain the way he was before, [Henry] is more and more unwilling to walk, and I don't dare to push him, because of the damp. Perhaps the absence of his cousins is partially the cause, and he sticks as close as he can to Charles to do paintings and drawings.' She may also have found it difficult to tolerate the closeness developing between Henry and Charles or Henry's new independence from her, riding, playing and drawing without turning to her for everything he needed. And she herself disliked the wet, chilly weather at Le Bosc.

In February, when the worst of the winter set in, Adèle decided again to take Henry to a spa, this time to Amélie-les-Bains. Once there, when it was too late, Adèle regretted her decision. The hotel was full of a distinctly ill-looking clientele, the view from the window was dreary and without sunshine, and dinner was served at 5 p.m. Their rooms were heated by the pipes from the inhalation rooms at the underground springs, which passed through the walls to the roof, giving the entire hotel a pervasive odour of rotten eggs. Within a week, Henry developed a high fever and for five days they thought he had typhoid, until he came down with the rash that identified his illness as a simple case of measles. Still, he was miserable, sweating, exhausted and

insomniac, and he began having violent nosebleeds. These caused terrible anxiety, since they were not part of the normal pattern of measles, and on at least one occasion they were so severe that Henry fainted. They couldn't know, of course, that – like his severe headaches, his sinus trouble and his vulnerability to respiratory infection – the nosebleeds were related to his abnormal physical development.

Although Adèle complained about the expense of the doctors who had seen Henry, he quickly recovered under their care, remaining only somewhat thin and pale. Even before he could get up he had bought a box of 'marvellous watercolours which he contemplates with pride while waiting to use them'. It was not long before he set up shop in the inhalation room, drawing the imitation Greek statues that decorated the underground grottoes. A few days later he and his mother were going out together for a daily walk. As they prepared for their departure, in early March, the doctor who had treated Henry gave Adèle a written medical report on her son's condition. Fawning and flowery, his letter was what might be expected from the kind of doctor who treated the frequently hypochondriac patients at health spas:

Madame,

... Your young son is charming in every way, and because of the intensity with which he engages others, I am in sympathy with all you predict for him. He absolutely must be cured and be made into a strong, straight boy ... He'll recuperate faster with an active regimen than by pharmaceutical means. It's probable that his general health will recover once he gets out of this adolescent growth crisis. Once his body is strong, his intelligence will make short work of the school time you think he has lost. But I strongly advise that the dear child's health be considered your primary concern, and become the reward for a mother's devotion.

With hindsight, it is obvious that the doctor's already guarded optimism about Henry's recovery was influenced by his professional need to feel that he could help the boy and by his desire to reserve some hope for Adèle. Did she believe his predictions? It must have been difficult, no matter how strong her desire, since by now Henry's health problems were almost constant.

Alphonse was shown the doctor's letter. Although he may have been pleased to notice that the spa doctor concurred with his own opinion that Henry should lead a more active life, he was disdainful of all the doctors, spas, and fretful activity. It was obvious to him that nothing was doing any good. From Paris, he sent his 'reasoned observations on the subject of Henry' in a letter to his mother, Henry's Grandmother Gabrielle:

Since he came back from Amélie in a far worse state, I have been holding out for a choice quite opposite to the wishes of the Gentlemen Doctors of the Baths who would be happy to draw and quarter their patients – water gymnastics. The high phosphate diet offered by fish bones, in combination with the healthy amusements of the beach, where the air is always pure, seems preferable to the stagnant, humidity-laden air of the gorges of the Pyrenees, which are either stifling hot or glacially cold. Louis Raymond is entirely of the same opinion.

The tone of Alph's letter is far more realistic than that of the 'Gentleman Doctor of the Baths'. Rather than hope for miracles, Alph was pushing to strengthen Henry's bones through diet and his muscles with exercise – to give the boy some real resistance against what was more and more clearly a progressive condition. He was planning, he said, when the weather got warmer, to take Henry to Arcachon, or perhaps another beach resort, to get him back into shape through swimming. Had he really wished to take Henry to Arcachon and insisted on doing so, Adèle would not have resisted. However, he made no move to enforce his opinion.

Always an iconoclast, Alphonse liked to contradict the conventional wisdom on any problem, to feel that his was an entirely original and dia-metrically opposite position. However, he rarely acted on his own proposals or actually involved himself with the attendant practical difficulties. This had the advantage of allowing him to believe he was right no matter what happened. If the family followed his advice successfully, it was proof of his superior wisdom. If they refused to follow his advice and did not succeed, he was able to withdraw disdainfully, as if to say 'I told you so'.

Faced with Alph's ambivalence about enforcing his dictates, Adèle found herself in a now habitual, if not entirely comfortable, position. She knew she was bound to follow her husband's orders, but she also knew no one would oppose her if she did not. As usual, she made her own decision.

In early April, when they left the spa at Amélie, Henry's mother took him to her own mother's home. Henry's Grandmother Louise's Céleyran estate, the Villa de César, as it was known, was a lovely eighteenth-century building with a red-tile roof. Less than five miles from the Mediterranean, it was located on a sandy plain on the outskirts of Narbonne, a pre-Roman harbour which had silted up at the beginning of the fourteenth century. It had some sixty rooms, built in classic Mediterranean style, with white stone walls and wrought-iron balconies. Enormous three-storey wings coming forward on either side of the main building focused the visitor's attention on the huge balcony-roofed portal that was the main entrance and formed a sheltered

central terrace, which was decorated with a fountain. The huge private park surrounding it, several hundred acres in size, whose entrance road was nearly a mile long, was planted with aloe, mimosas, parasol pines and orange trees in pots. The sandy walkways were bordered with palm trees and low-growing tropical plants, giving the grounds a bare, almost desert-like look which emphasized the size of the house. In front of the villa was a huge reflecting pool, and lost among overgrown cypresses in the park was a large lily pond with a bridge that bore a striking resemblance to the one at Giverny, Monet's home. The sea, although not visible from the house, was close enough to hear.

Henry was overjoyed to have the chance to play with his nine cousins for the first time in nearly two years. With Raoul, his ten-year-old cousin, he became passionately involved in collecting miniature carts and carriages and competing to see who could have the best sets. This was the first in a series of curiously obsessive hobbies Henry would periodically develop throughout his life, and it took on surprising importance for him.

The month-long visit was far too short for Henry, and he was furious with disappointment when Adèle decided to move on to Albi, particularly because he had not had a chance to place his latest order with the merchant who supplied the little toy carriages. Back in Albi, he begged Grandmother Gabrielle to help him influence his cousins to make sure he got the models. She did her best, writing to Alix: 'He asks his cousins to place his order as soon as possible. I presume that you aren't going to hitch up the horses just for that.'

It is not known why Adèle was so eager to take Henry away from his playmates. Certainly Albi was a frustrating environment for him. His grandmother found his thirteen-year-old enthusiasm irritating. The hot southern *autan* wind was blowing black clouds across the sky, parching the earth and making everybody short-tempered and moody. It was both too hot for Henry to go out in the sun and stifling inside. He felt like a prisoner cooped up in the Albi townhouse. Each time he opened the french doors to the outside, his grandmother made him stop because the flies came in along with the wind. She complained about his boyish disorder: 'all the furniture is covered with bags of biscuits. It's embarrassing when I see visitors coming upstairs.'

Henry and Raoul wrote to each other often, exchanging cards with printed images of characters in popular children's stories: 'Dear Raoul, I'm sending you Scipion and M.J. Pomerac. You send me M. Bobson, which I need. And tell Madeleine if Augé doesn't have the carriages ready on Thursday she should give him my address.'

He longed to be at Céleyran where there were children to play with, where his canaries had a new brood of chicks, where he could collect toy coaches. At Albi, he complained, his only entertainment was going to Mass and planning his summer stint at the spa at Barèges.

Although Alphonse had written to Adèle repeatedly that he was on his way to Albi to take Henry to the seaside, he didn't arrive for nearly two months, and even his arrival – accompanied by a pet screech-owl – didn't provide much diversion for Henry. Once Alphonse realized no one was going to humour his wishes, he announced he would leave again. Then, maddeningly, he vacillated and lingered on at Albi on a variety of pretexts. Grandmother Gabrielle considered her own son as troublesome as Henry.

The whole household seemed ill-humoured as they began to get ready for the summer move to the Château du Bosc. Grandmother Gabrielle would make the six-hour trip in the carriage with Adèle and Henry, leaving the dogs and horses to Alphonse, who would come along on his own.

4

LE PETIT

Before Henry and his extended family were ready to leave Albi for the summer, something happened that changed everyone's lives, abruptly putting their petty irritations into perspective. On Monday, 13 May 1878, Alphonse, Adèle and Grandmother Gabrielle were sitting in the salon when M. Seguin, their Albi doctor, arrived. Alphonse abruptly ordered Henry, who was sitting nearby, to come and greet the doctor. The child hurried to comply, using his cane to push himself up from his low chair. Suddenly the cane slipped on the waxed floor and he fell, breaking his left femur.

Many adolescents break bones, but this break was provoked by a very minor incident, and the bone which broke was one of the strongest bones in the body. It was apparent to everyone that this injury was abnormal and almost certainly had the same cause as the pain, weakness and stiffness from which Henry had been suffering for nearly six years.

Once again his family responded with the kind of supportive unity that always knitted them together in times of crisis. Grandmother Gabrielle gave up complaining to take charge of organizing the house around Henry's needs. The doctor, whose presence that afternoon Alphonse later called 'a sort of irony of destiny', set the leg, using as a splint a heavy cardboard box which had arrived that day.

Two days after the accident, on 15 May, Adèle filled in the details to her cousin Alix in Céleyran: 'Henry is doing as well as possible: no fever or local inflammation. Slept well last night. Just sharp nervous contractions in his thigh, but not too often, and a liquid tranquillizer stops them.' Characteristically, she felt that she herself was the person to have suffered most: 'What a burden on top of my other worries. The load seemed heavy enough already, but God obviously didn't agree, and one must submit as best one

can ... This blow ... completely stunned me; there is no better expression. Henry wonders what his cousins are going to think, and wishes he could have all of them around his bed.'

Reports on Henry's progress went from Albi to Céleyran almost daily. Mail service was fast and reliable in nineteenth-century France and letters arrived by train and stagecoach within twenty-four hours. People wrote numerous letters every day almost as they would use the telephone a generation later. By the next day, 16 May, three days after the fall, Henry was 'sleeping well, eating with appetite, chattering gaily'.

Alphonse was distraught to have been the inadvertent cause of his son's fall and took an active role in caring for him. The day after the accident, he telegraphed Dr. Louis Raymond in Paris to be sure that he approved of the way M. Seguin had set the leg and to see if they needed to consult a local specialist. To Alix, Grandmother Gabrielle wrote admiringly of his zeal: 'Tonight I want poor Alphonse to go to bed because for the last three nights he's been getting up at midnight and staying with Henri until morning.' She continued the latest news, saying:

Last night for the first time, Adèle stayed with Henri in the evening until midnight and slept like a log, she said, until eight. She's doing well, and now that she sees how calm Henri is, has completely recovered from the shock, which hit both of us like a bolt of lightning. Charles is spending a lot of time with Henri, who is constantly asking for him, to rub his heel, where sometimes he has shooting pains, an inevitable side effect of all fractures. Because of its location, Henri's fracture is the simplest kind. We've installed a trapeze above his bed. He uses it to pull himself up, so we can arrange his cushions.

Her next report came two days later: 'Henri continues ... not to suffer, to eat, and to sleep like a log, all night long. In the daytime he sings, laughs, reads, or listens while being read aloud to.' His aged Great-Aunt Joséphine climbed laboriously up the stairs twice a day to play with him, and Grandmother Louise was on her way from Céleyran to help out. His Céleyran cousins sent letters and games, and the whole town of Albi now knew about his accident and was expressing sympathy: 'They stop one in the street to ask how he's doing,' Grandmother Gabrielle said.

On 20 May the temporary splint was removed, and a semi-permanent 'appareil' (apparatus) was fixed onto his thigh. It was a series of braces and splints with adjustable padding and straps, designed to hold his leg immobile from above the break to below the knee. The day after that, Adèle supplied

her sister-in-law Alix with the details of the operation, saying that the change
to the final apparatus had taken

three agonizing hours ... how lucky that Maman wasn't there to share our anxiety.
You can be sure that both patient and observers suffered as much as on the first
day. But everything seems to be fine. The bone didn't move; there's just a little
inflammation. The new apparatus, chosen on the advice of Dr. Raymond, seems to
fit well. It took more than two days to assemble it, with all the improvements
Alphonse and M. Seguin managed to think up. My poor Henry was most cour-
ageous, but you can imagine that the whole process was very painful and he had an
exhausting bout of cramps.

Perhaps the most interesting detail of this letter, written a week after
Henry's fall, is a brief reference to the accident itself. In it, Adèle implies that
Henry's broken leg was caused by an event that bears no resemblance to the
fall described by both Henry and Alphonse. Her allusion doesn't go into any
detail; she presumed that her cousin Alix already knew the story. The entire
reference, translated word for word, is as follows: 'You can imagine that I
regret that my poor Henry ever happened to put himself across the beam
[*soit venu se mettre en travers de la poutre*]. Emilie claims that your mother
admitted to her that she couldn't bear to have it installed, because she was
convinced that it would be the last thing she ever did.'

What could this reference possibly mean? The language is somewhat
ambiguous in French as well as in English. Adèle says neither that Henry
climbed on the beam, nor that he tripped over it. Yet she unambiguously
regrets that he ever came to be on top of it. Alphonse's and Henry's accounts
of the accident state simply that Henry slipped getting out of a low chair
and fell. Neither mentions a beam, and even if there were a beam involved,
it is hard to understand what it would be doing in the salon. The rafters
in the salon are not exposed, and it is improbable that Grandmother
Gabrielle would have left a ceiling beam lying around on the salon floor,
even if she thought putting the last beam in place would be a bad omen.
At worst she would have left the beam on sawhorses in the ground-floor
carriage house. In addition, the Albi house was not new – or even being
remodelled.

Could Adèle have decided to alter the facts of the incident, saying that
Henry had really fallen while climbing on a rafter, a normal childhood
accident which could easily cause a broken bone? In any case, persistent and
entirely unsubstantiated rumours attribute Henry's broken bones to being

dropped by his nurse, a fall from a horse, or an incompetent doctor whose treatment of the break left Henry permanently crippled.

Two days later, still unable to write himself, Henry dictated a slangy letter to his cousin Raoul which gave no details of the accident at all:

Dear Raoul,

I have to depend on Maman to write to you, and you better believe it's no fun. Like they told you, I broke my left ham-bone. They've tied me into a rig and all I have to do now is hold still, 'cause my leg doesn't hurt at all. I'm sending you my photograph, and I hope you'll like it. Give it to your Maman or hang it by your bed in a little frame. When you get my letter Madeleine is going to be busy getting herself fixed up to go and see M. Ferlus. Ask her for me to ask Augé exactly where he's ordering the sledge and the brougham from. When you learn the address hurry up and send it to me. Grandmother is fine and Rosette keeps me company by telling me about the canaries. Tell everybody that my leg doesn't hurt at all and that I'm anxious to start classes again and most of all to run around. Give my love to everybody and especially to my little Finet [Béatrix, also known as Kiki] and give her some good advice: not to break her little paw.

Your cousin Henry – Broken-Paw!!!

Henry's good humour in the face of adversity and his intense desire to get on with his previous occupations (in this case his collection of miniature carriages and the fantasy games he played with his cousins) show even more strongly in a second letter included in the same envelope. Also in Adèle's handwriting, and obviously dictated by Henry to Raoul, it bears the title: 'Letter from Monsieur Fogg to Monsieur Tapié'. In turn, it covers each of Henry's dealings with the outside world, beginning: 'Ennery has broken his leg. We were most touched by the swift arrival of all our friends, and have kept only the nigger and M. Pomerac, as there wasn't enough room [a reference to the cards with images of Scipion and M. J. Pomerac in his previous letter to Raoul]. We thought M. William would need his two assistants.' The letter goes on to talk about the new canaries at Céleyran: 'Ennery was very pleased to hear about the marriage and about the birth of Mademoiselle Irene. Where are the newlyweds living?' Next he listed his newest possessions: 'Isidore bought us two doll's-houses, one made of china and the other of lead. At the fair we also bought three horses, a domestic servant, a typewriter and a little carriage that needs repairing. We have had the carpenter make us three beds, two big and one little.' It ends by summing up present and future plans:

As soon as Ennery is well we'll head straightaway to classland, pulled by all three horses at once. M. J. Pomerac is giving his most expert care to our dear patient, who has decided not to devour him, given his resemblance to an old codfish. We are planning to repaint Dorniska. Among the new horses are a bay, a white and a chestnut. The new groom is named John and can stand alone. How lucky! Please accept, M. Tapié, my most distinguished sentiments; I hope your neck is better; present my respects to the Mother Superior,

<div style="text-align: right">Philéas Fogg, Esq.</div>

In this letter Henry divided himself into two characters – Ennery, who was laid up with a broken leg, and Philéas Fogg, the laconic and phlegmatic hero of Jules Verne's *Around the World in Eighty Days*. Old Fogg was perfectly capable of action but refused to leave his room, living a completely ordered existence, always doing the same thing at the same hour. On two occasions, however, he was moved to extraordinary heroism: once to save the life of a manservant, and the other to save the life of the woman he later married.

The Mother Superior in the letter was Henry's cousin and Raoul's sister, Madeleine. The nicknames Henry had for everyone, including himself, were part of family tradition. Practically all the children were nicknamed as they were born, and Henry had borne a series of nicknames, including 'Petit Bijou' (little jewel), as Grandmother Gabrielle liked to call him, 'Bébé lou Poulit' (pretty baby in Gascon dialect), 'Coco' and 'Ninette'.

The next letter from Philéas Fogg (in Henry's handwriting this time) was to Madeleine: 'Madame Mother Superior, Ennery is better. We have bought a donkey and put together a cart like a dogcart. Tell the Moujik [Uncle Amédée] that his daughters will be able to take rides in the donkey-cart which this is the portrait of.'

Henry insisted he was not bored, but he again urged Madeleine to find out where Augé was getting the toy carriages, and in a subsequent letter to Raoul he returned insistently, even dictatorially, to the theme of the toy carriages:

Augé told me that he would send me a brougham and a dog cart ... and now you allude to a landau. Write to him quite distinctly that if he doesn't send me the kind of two-wheeled surrey I asked for I don't want any others (unless you yourself can find me a light two-wheeled one), and if there aren't any, then I want a horse-drawn one with four wheels. I want yellow and black harness and a dog cart. Don't forget ... with two wheels if possible. Tell Godmother [Grandmother Louise] to arrange

this for me. Send your own carriages as an example, and tell me something about the landaus.

Philéas Fogg.

In context, the irritable tone of this letter is not surprising. The thirteen-year-old, after bearing up under two or three years of futile treatments, was in far worse shape than ever before. Since his time at Verrier's, he had consciously determined not to complain about his ailments but to remain cheerful and amusing. Now, although he did not complain, his frustration was expressed in material demands. He began to insist on satisfying all his fancies. If he was thwarted in his desires he became almost despotic. This contradiction marked his personality for the rest of his life.

He continued to exhibit great stoicism and discretion in discussing his physical limitations, lightened by a sense of play and an astonishing talent for rapid humour and wit. But his friends and equals began to accuse him of having a distinctly tyrannical manner and a conviction that all his whims should be granted. Henceforth he always insisted on the best of everything, constant entertainment and the loyal attention of everyone near him.

Grandmother Gabrielle reported realistically on his progress twelve days after the accident, on 25 May. His basic health was 'marvellous' and his leg 'as good as could be expected. But we'd better be armed with patience and resignation, because it's going to be slow. In any case let's hope that he won't be any more crippled than he was before his accident ... I can hear Adèle trying to sing Toto Carabi [a Gascon song?] and give breakfast to Henri, who is laughing as hard as he can.'

Now lying in bed, alone for hours at a stretch, he turned for solace to the drawing he had always loved. Until now he had used it largely to manifest boredom, filling the margins of his schoolbooks with caricatures and illustrations. Only with Uncle Charles, the year before, had he begun taking his artistic talent seriously. Now he filled notebooks with drawings of all sorts, including one sketch of himself, lying in bed sketching.

The rig on his leg was supposed to be removed on 24 June, forty-two days after the accident. Alphonse, although he had left to visit family friends, had promised to be back in time for the procedure. Henry, remembering how much it had hurt to put on, was very nervous about having the brace taken off. He told Grandmother Gabrielle that he'd be happy to leave it on another six months so long as it didn't hurt, and his Great-Aunt Joséphine wrote to his other grandmother that he was 'in no hurry to be taken out of his cage'.

When the time came, Alphonse, predictably, was nowhere to be found. The family later learned that he had decided it was more important to attend the funeral of a 'cormorant or falcon relation', as Grandmother Gabrielle sarcastically put it, than to continue the support he had lavished on his son immediately after the accident.

The night before the brace was removed, Henry was so nervous he couldn't sleep. Even after it was over, his Grandmother Gabrielle was convinced that his problems were not finished: 'I think it'll be a long time before Henri will be able to walk a little, since he's horribly fearful and doesn't want anybody to touch him. He misses his apparatus and would put it back on in no time ... We can't know when he'll be able to be moved anywhere.' But Henry surprised her by his tenacity and grit. As soon as the operation was over, he began singing and whistling 'like a blackbird' again. Within just a few days he was able to walk with the doctor and his mother on each side of him as 'living crutches'. At the end of June, when he wrote to his cousin Raoul, he didn't even mention his leg:

My dear Tapié,

Write and tell us how your new carriages are. We have made some beautiful blankets and are going to make a beautiful stall for the brougham horse. M. Pomerac and Scipion left on the two o'clock train. M. Bobson is going to come, I think with M. Johnson Solticof. John will be the servant of the new arrival. Ennery farts all day long because he eats too many beans. Good evening.

Fogg.

A week after Henry's leg brace had been removed, Adèle gave her mother a fairly complete medical report. Henry could now have walked with crutches, but since they had to be built to order and hadn't yet arrived, she and Marie the maid were letting him lean on them. He was quite irritable, so they were trying hard to cheer him up, giving him his meals, for example, in a room off his bedroom, so he had a chance to get up and 'changer de l'air', even though he was not well enough to go downstairs to the dining room. Despite his impatience and bad humour, he had no pain from the leg, and it no longer cramped during the night as it had while healing. In fact, the broken leg looked so much like the other, she said, that 'you wouldn't be able to tell them apart, if he could lift it and put his weight on it. Like all the other doctors, M. Seguin admits that my poor Henry is a mystery for medical science, uniting strength and weakness in contradictory ways.'

Soon he was getting around on crutches, going for rides in the country in carriages, and standing alone 'exactly like a china doll!' his mother remarked. M. Seguin was clear, however, that Henry must not return to the baths at Barèges until the break was completely consolidated. Henry was very disappointed, because he had been hoping to meet up with his friend Charles Castelbon, and his Grandmother Gabrielle and all his cousins had already made plans to spend part of the summer there.

Once again he had to look forward to a summer of invalidism and lone-liness, trapped this time in the Albi house with only his mother and his Great-Aunt Joséphine for company. Alphonse had never shown up, and Henry's only other ally was Urbain, the footman, who carried him up and down stairs and was helping him to walk again as he got better. He warded off despair with a mixture of bravado, humour and imaginative banter. In midsummer, he wrote a good-humoured, tongue-in-cheek letter to his Grandmother Louise that seems to capture his physical and emotional state:

I thank you for your unanimous good wishes relating to the holy day of my great patron the famous Saint Henri (which parenthetically is also my own). But if you were to wish to make my cup run over with joy – and my overexcited imagination has already filled it to the handles just knowing that I have not fallen one iota in your affectionate esteem – you would, via the channel of your spoken word, transmit the following carefully weighed request to Monsieur the Abbé Peyre: that I would very much like him to intimate to my bony cousin the strict order to be so kind as to send me by post a tiny epistle in which he would give me some news of the personnel at Céleyran and of the childish vehicles which Augé, a Narbonne mer-chant, has received the order to have sent to me from the capital of France.

Now, it is my honour to inform you that in person and in flesh and bone, I was brought in a chariot drawn by fiery steeds, to the metropolitan cathedral of the Albigensian city for the purpose of there consuming the audition of divine service. For the nonce, having now given you this news of a gallows nature, considering that it deals with the improvement of my gallop system, I will inform you about the relative constipation undergone by my person as a result of the merciless mastication of a certain sweet confected of the fruit of the quince-tree. Having nothing further to relate to you, I shall take the liberty of placing a tender kiss on your right cheek, all the while praying you to do the same in my name for everybody else.

Your crutchy godson, Henry de Toulouse.

This adolescent letter contains all the elements that would mark Henry's character as an adult: wit, punning, scatology, visual imagery, grandiosity, complete absence of self-pity backed by self-deprecating humour, obsessive

and dictatorial demands along with real tenderness and affection. At thirteen, Henry's personality, although it reflected elements of each parent, was typically his own.

As the summer progressed, so did Henry's healing. He spent long days in the narrow triangular garden which had been newly installed on the roof of the ground floor of the Hôtel du Bosc, extending out over the ramparts of the old city. Soon he could walk with two canes. He spent a lot of time with Great-Aunt Joséphine, his only real companion. They had developed a series of elaborate ongoing jokes and games, despite the two-generation difference in their ages. That summer she 'flattered' him, as Adèle put it, by framing some of his growing accumulation of art work. Did this provoke a new desire in Henry – the desire to be recognized as an artist? He also sent a watercolour to the friend he had met the year before at the Amélie spa, Charles Castelbon.

By August, his cousins were back from Barèges, and he was well enough to plan a visit to them at Le Bosc, a six-hour trip if the weather was good. It was arranged that he would ride in his grandmother's comfortable *berline* carriage, famous for its elegant team of four matching grey horses with foxtails dangling from their reins. The morning they were to set out, Alphonse arrived unexpectedly, armed with cages of goshawks and sparrowhawks for hunting. The scene which followed was so characteristic of Alph's behaviour that it warrants a full description. Preoccupied with moving dogs back and forth between Albi and Le Bosc, he demanded that everyone concentrate on resolving his hunting problems. Only then did he turn his attention to his son. Although he had shown no interest in the case since shortly after the accident and had not returned as promised for the removal of Henry's apparatus two months before, he now dictated what must be done: 'His first word was that Henry must not be taken to Le Bosc, that he had to go and spend a few days in Vindrac [where, coincidentally, Alph needed to pick up some hunting dogs], then eat fish at the seaside.'

Although Adèle was unwilling to contradict her husband's orders, Grandmother Gabrielle was not intimidated. She took immediate action, calling the doctor in to decide what was truly best for Henry. By noon the 'wind had changed'. Adèle and Henry would go to Le Bosc as planned. '[Alphonse] came in like a madman, now he's calmed down,' his mother remarked laconically. Defeated, Alph took his dogs and birds and left, imposing his will one last time by insisting that the others take with them to Le Bosc two of his animals: a horse named Bibi and a tame marten named Zybeline. 'Decidedly,' Grandmother Gabrielle commented, 'we'll soon be competing

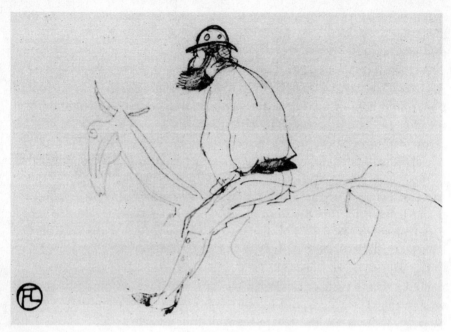

Alphonse de Toulouse-Lautrec, à cheval, *1896*.

Self-caricature, riding on a drawing pencil,
c. 1882.

with the [zoo at the] Jardin d'Acclimatation. My poor son's head is completely
unbalanced. I used to say that he had never been a child. Well, it was only
delayed. What a pity for it to come at the age of forty.'

Although he saw Alphonse only rarely, Henry had a number of personality
traits that seemed modelled on his father. Like Alphonse, he had an infantile
quality characterized by extravagant, theatrical, rebellious behaviour. His
drawing and sketching, his dressing in costumes, his love of animals and

horses, his need to be the centre of attention – all replicated his father's traits. But unlike Alphonse, Henry had also had the experience of long months of confinement. Perhaps that bred in him a tenacity his father would never show.

By coincidence, Henry and Adèle had left Albi just in time. Great-Aunt Joséphine was informed that she would be expected to house troops in the townhouse during the military exercises to be held in the region. This perturbed everyone in the family, for she naturally had no choice about whom she would lodge. The best one could hope for was well-bred officers with orderly men. They did well to worry: eighteen thousand soldiers were billeted in Albi during the summer and autumn of 1878. The troops ranged out over the countryside for miles around, practising various war games and generally disrupting life in the villages and farms: trampling fields and crops, requisitioning foodstuffs and other supplies, and seducing the local girls.

Henry was disappointed that no soldiers were billeted out in the country at the Château du Bosc, where he, Adèle, his Aunt Alix and Uncle Amédée and his nine cousins all spent the autumn with Grandmother Gabrielle. He was fascinated by the war games and filled a whole notebook with sketches of cavalry, artillery and drum and bugle corps. For the first time he began to use live models. He had bought paints, and now he struggled on his own to learn to use them. From his sketches he developed his first truly original oil paintings, at least nine of which still remain. All his training the preceding winter with Uncle Charles had involved working strictly from paintings and sculptures by other masters, dutifully signing them with both his own name and the name of the painter of the original. Striking off on his own now, doing paintings of living models informally observed, he showed his growing artistic independence and maturity.

In high spirits again, he swung his crippled leg around the garden and the courtyard balancing on his two canes, played with his cousins 'without fighting', as Adèle noted, and ate 'for four'. He was almost well enough to get around without crutches, although he was not allowed to go to Lamalou-les-Bains for Grandmother Louise's saint's day in late August: 'the personage who had the unfortunate idea of breaking his leg can't be there to offer his wishes with his big ugly voice,' he wrote to her, proud that it had finally changed. He was three months shy of fourteen years old.

Probably because of his malady, Henry's physical and sexual development was very slow. Now, although he remained small, signs of manhood were

beginning to appear – dark facial hair, a new deep voice, a big Adam's apple. But the other traits he was developing were troubling. His nose and lips were growing disproportionately large compared to the rest of his face. In combination with his pince-nez, his lisp, and the long thread of saliva that occasionally dripped from his pendulous lower lip, they made his overall appearance less than prepossessing. From a very attractive child, Henry was turning into a spectacularly unattractive adolescent: small, dark, hairy, ugly. '*Il n'est pas joli,*' Grandmother Gabrielle commented. Henry echoed her in a description of himself that accompanied a self-caricature he drew a year later. 'Look at that figure, totally lacking in elegance, that fat *derrière*, that potato-nose. It's not pretty.'

Adèle, watching her frail but charming child grow into a malformed, unattractive adolescent, tended to focus her thoughts on his happier child-hood. That summer, her fixation surfaced in an almost grotesque souvenir. She had a ring made for herself, set with Henry's first four baby teeth.

Although he continued to threaten to take Henry to the seashore, Alphonse was too busy hunting to come to Le Bosc. Henry and his cousins had the whole menagerie to play with: two dozen dogs, the horses in the stables, Zybeline, the tame marten, and the whole 'colony' of canaries. Apparently Rosette, the maid, had brought them from Céleyran to Le Bosc, a terrific chore when one imagines transporting three or four cages of them for twenty-one hours by train and horse-drawn omnibus. Henry trained Zybeline to go on walks with a chain as a leash, which Grandmother Gabrielle found most amusing: 'He carries her on his arm and looks exactly like a little organ grinder – he only needs to learn the songs.'

Winter set in early that year in the Aveyron, with snow making it difficult to get around and demoralizing everyone. Henry was no doubt lonely as his cousins had left for school, and he was now the only child at Le Bosc. For Henry's grandmother, it was reminiscent of the winter her husband had died by falling into the frozen ravine. In the nearby hamlet of Sauveterre, the mayor rounded up all the men in the vicinity for the yearly wolf hunt. This caused Uncle Charles to beat a swift retreat to Albi, on the pretext of needing to have some clothes made. 'Keep his secret for him,' Grandmother Gabrielle confided to her daughter Alix, for she knew that the annual carnage was a nightmare for Charles. And yet the wolves were a menace, particularly in the years when winter came early, for as they grew hungrier, they grew bolder, scavenging in the farms and attacking the livestock. When freezes were exceptionally long and bleak, the wolves had been known to surround the Château du Bosc at night, howling in the darkness.

Henry aged about fourteen.

At the beginning of December, Henry and Adèle abandoned Zybeline, the canaries and the wolves to Grandmother Gabrielle and went to spend Christmas at Céleyran, stopping first at Albi. Henry went with his aunt to pick up his cousins from their boarding school in the nearby town of Sorèzes, where a Catholic priest and distinguished educator, the Père Lacordaire, was preparing all the boys for their exams. In an irreverent letter reporting on that trip, he verified his cousins' accusations that their preceptor had an unbearable body odour: 'The whole time I didn't smell anything except the moleskin upholstery of his armchairs, but when he took us into the study, he leaned on my shoulder, and then!!! ... aromas.' He illustrated this detail with a drawing of a nose and the French word '*Parfums*'.

In Albi, Henry had received a thorough medical examination from M. Seguin, the doctor who had set his leg. He found him 'better than he expected in general', Adèle reported, 'but he's looking for any way of strengthening the poor paw, which Henry is still fearful about putting his weight on.'

According to Adèle, the doctor urged her to take Henry to Nice and, despite 'all the worries of the voyage', Adèle decided that Henry's health and appetite were good enough for him to take the thirteen-hour 'Rapide' to the Côte d'Azur. Alphonse, writing from Paris, where it had been snowing for twenty days without interruption, tried to persuade her in his usual contrary fashion to take Henry instead to the winter resort at Pau, where the waters were supposed to be beneficial to those with 'nervous' diseases. As usual, she never seriously considered his suggestion, saying she was 'afraid of the Pyrenees'.

Nice, a pre-Roman port famous for its mild climate, had been conquered in turn by Romans, Saracens, and Sardinians, not to mention the Italians and the French, who had passed it back and forth a number of times. After 1860, when Italy handed Nice over to France for the final time, it became known as one of the most fashionable winter spas in Europe.

By the time Henry and his mother arrived there in 1879, and through the first third of the next century, Nice was the refuge of a wealthy international set, particularly of chronic invalids. It was divided into two sectors – the Old City (which Adèle described as 'unhealthy and inhabited by the poor and the dirty') and the City of Foreigners. The 'season' in Nice began just after the New Year, with horse races in January, Carnaval and masked balls in February, and ended with the sailing regattas in March or April.

Henry wrote a report on his new territory to his cousin Madeleine shortly after they arrived in mid-January:

My dear Deloux,

... the Promenade des Anglais ... is magnificent. It runs along by the sea and you can watch tartans, cutters, etc., etc. The harbour is splendid compared with anything I've seen up to now. There are quite a few merchant vessels and an English yacht that is a veritable jewel. They rent boats for sightseeing, but Maman is afraid to get in them ... The food is all right but dinner is too long, even though there are five waiters in tails lined up to serve it. One of them is very funny and skips all the time. They are going to have a ball next week. We are eating excellent tangerines, but the Nice oranges are as bad as the ones I used to play with ...

Your graceful cousin
Henry de Toulouse Lautrec

The weather that winter was not dry and balmy, as it was supposed to be, but hot, wet and exceedingly muddy. 'Cold weather is unknown here, but we have far too many rainy days,' Adèle remarked. Just when Henry was

eager to be outside all day long, pursuing his new passion for boats and ships, the damp and a bad cold forced him to stay in his room amusing himself with his stamp collection. He was as obsessive about it as he had been about his toy carriages. At the hotel there were also frequent balls and concerts. 'The dancing goes on very late, but we leave early,' Adèle reported. 'Each guest has to pay. Henry makes his investment up at the buffet.' And they did go out occasionally: to Mass in a carriage, and to visit the pretty port of Villefranche on the coast between Nice and Monaco, where Henry was attracted by a heavily armed, high-masted American frigate coming into the harbour under full sail. He was pleased that the tutor his mother had hired was a sailor. 'He's excellent,' Henry wrote to his Grandmother Louise, 'twenty years old, and goes seagull hunting. He'll be racing in the regattas.' For Adèle, an essential element was that Henry's tutor not be too expensive, as during the 'season' Nice was known as one of the most costly resorts on the Riviera.

According to her, the food at the pension was good and she was the only one who liked the weather, refusing to build a fire in her room and leaving the windows open. 'The English women in the salon insist on having both fireplaces lit,' she complained. 'I am forced to use a fan.' She had found a church where she liked the priest and, by means of a generous contribution to its building fund, had already begun negotiating with him for special dispensation from Lenten eating restrictions, 'for he understands my situation here. It's already hard enough for me [to arrange a meatless meal] on Friday ...!' All in all, despite her constantly negative evaluation of things, she seemed to be enjoying herself. 'Alph is bored [in Grignon], sitting by his fire, while all around him trees are breaking under the snow,' she gloated. She had even overcome her cautiousness enough to agree to take a boat to Monaco with Henry and an old friend from the Hôtel Pérey, M. Lévi.

Although Henry was not allowed into the gaming rooms at the casino because he was too young, M. Lévi placed five francs for him on the roulette wheel as a consolation prize and, to Henry's delight, doubled it. Adèle, who found Monaco charming, noted primly: 'The sad faces of the gamblers are like false notes in the harmony of this tiny Paradise. Many suicides are hushed up by bribing the Nice newspapers! ... For me the sight of gambling is not at all immoral; it's merely sad.'

Fortunately, after a month of solid rain, the weather cleared briefly in mid-February, just in time for Carnaval: 'Everybody has been working on the splendid Carnaval,' Adèle wrote to her mother. 'Windows and balconies

along the parade path are being rented out for as much as 200 francs ... I've managed, with some difficulty, to find one to rent and shall have the pleasure of offering a place in it to Madame Moss. You understand that I couldn't pay such insane prices.

'Everybody has to wear a mask made out of metal screening to be protected from the confetti and from the flowers with which people have furious battles,' she went on, referring to the popular new invention for Mardi Gras at Nice. In its earliest version, confetti was made of tiny bits of crumbled plaster and was heavy enough to be flung with some force. Thus such masks were a real necessity for the revellers. 'Henry is half crazy with excitement and is much more interested in getting his teacher to teach him how to build a confetti-thrower than in studying his Greek.'

Adèle and Henry enjoyed Carnival enormously. 'We, too, participated in a few of the pranks, which are always in good taste, thank goodness,' Adèle announced. 'One senses that there are well-bred people under the disguises, which is not true everywhere.' Protected by their masks, they fearlessly threw kilos of plaster confetti on passersby and received quantities in return. Henry's tutor went costumed as a Pierrot, in white silk and cashmere. Adèle reported all the details of their holiday, even to the fate of their friend who dared to go outside in his top hat: 'It was transformed into an accordion. During Carnival people only wear caps.'

From their rented window, they watched the battle of the flowers and the donkey race down the Promenade des Anglais. Henry seemed stronger now, and he was walking farther than he had before. He walked from their Pension Internationale at 8, Promenade des Anglais, all the way to the sumptuous Villa Bermond, nearly a mile away, 'but he's still heavy to drag around, in spite of the abundance of benches here. You ask me if he's nimble: it would be going too far to use that term to describe him, but he's doing as well as can be hoped for the time being, I think. As soon as the weather turns good, I'll try the hot sea baths.' She had arranged for Henry to take a number of baths in the hot, iron oxide-rich water provided by a beach-side health spa. The bathers undergoing the treatment dived into the heated 'waves' together, but only on sunny days. Henry appeared to like the treatments. He was particularly charmed by the English girl from his hotel who took her baths accompanied by her Scottish terrier.

Around the end of March the season at Nice closed with a week of sailing races. Henry, who spent most of his free time drawing boats and sailors, was very excited. Despite the foul weather, he managed to drag Adèle out to watch a large number of the races and the celebrations accompanying them.

'He had a lot more fun than I did,' she complained. 'He was completely unaffected by the sea wind which froze us on the grandstands.' She compensated by insisting that he take his hot baths and every other day a seawater rubdown, although as usual she resented the expense. The high point of regatta week for Henry was going one Sunday to visit the French fleet at Villefranche. They were invited on board to meet the commander of the frigate *La Couronne*, and they also got to tour the flagship, where Adèle commented, 'Henry got along pretty well with the inevitable gymnastics aboard; I see real progress there.' At the end of the season, Adèle was still optimistic that Henry had gained great benefit from the baths: 'He's regained his small swimming abilities and comes out of the waves looking like a redskin, hot and full of appetite.'

From Nice they went to Albi. Alphonse was off in Brittany, acquiring more cormorants and small goshawks to add to his aviary, but Henry and Uncle Charles worked on Henry's new hobby: building model ships. Grandmother Gabrielle was pleased to see how improved he was: 'Henri's so much better. He and Charles spend all day building boats; I don't know which of them is having more fun.'

At the end of June, Adèle and Henry set off for the baths at Barèges, where they had passed the summer of 1877, again via Lourdes, to pray for a miracle. This time, however, Barèges had lost its charm. The Maison Gradet, where they were staying for the second time, was almost empty. Unmelted snow cut off the road to the mountain so they couldn't go out of town, and the people they met were boring. There were never more than twenty people in the dining room at dinner, and Adèle wrote that she and a friend, Mademoiselle Duplessis, were the only women in the salon in the evening: 'You can imagine how animated it is!' They would have liked to leave, but Adèle was determined that they should take an entire course of treatments.

Henry, now nearly fifteen, fought the boredom of Barèges by writing silly letters to his cousin and godchild, Kiki, then four, and too young either to read or to write. As her side of the correspondence was carried on by her eleven-year-old brother Raoul, Henry used the opportunity to tease and insult him shamelessly.

'My dear little rabbit-catching critter,' Henry wrote, addressing himself to Kiki using the formal *vous*:

There's only one fault I have to find with you and that's your choice of a spelling teacher, for he is a person with very little brains and if you don't believe it, run your little rabbit-catching paw over your brother's head and see if you don't feel a great

big hole; it's so deep you'll be afraid of falling to the bottom; and now you ask me what connection there is between this big hole and your spelling teacher's brains. Here is the answer: the brain is a kind of gut that produces intelligence, it's in the head; there should be this brain I'm talking about instead of the enormous hole that scares you so, and that's why your dear spelling-master isn't smart!!!! ... We go riding on donkey-back and if you want to pretend to do the same get up on your spelling teacher's back; don't be afraid if you hear sounds like firecrackers going off, donkeys do it all the time; to correct this defect you just look brave and hold your nose. That's the rub. There's a Prussian king here and I'm sure that if you were at Barèges you'd quickly wring his neck, even if he weren't a rabbit.

He ended by sending his fondest regards to his canaries and kisses to her (but not to 'the other', probably meaning Raoul).

The major amusement of Barèges, given the unseasonably cold and rainy weather, was donkey rides, and Henry managed to lure Adèle and her friend Mademoiselle Duplessis all the way past the snowline. 'I was wrong,' his mother whined, 'to let myself be dragged on one of those climbs into avalanche territory. For me, the beauty of the view is no compensation for the perpetual horror of falling and the arduousness of the path, when there is one!'

Henry spent much of his free time painting. He was 'in ecstasy over a complete set of oil paints he ordered from Paris on Charles's specifications. He's regretting that Gordon [his setter] isn't here so he can paint his beloved features.' He went everywhere with his paintbox. He was very distressed when news came from Le Bosc that his marten Zybeline had died before he got a chance to paint its portrait. Luckily he had found some friends at Barèges, including two dogs.

Then on Monday, 21 July, out walking with his mother, Henry fell again, this time into the dried-up bed of a gully no more than a few feet deep, and broke his other leg. Alphonse described the incident later in a letter: 'While his mother went to get a doctor, Henri, far from bemoaning his misfortune, sat with his hands rigidly supporting his injured thigh.'

As with his first accident, not everyone would be told the truth. Care was taken, for example, not to upset his very elderly maternal great-grandmother. She was told he had a 'sprain'. The famous apparatus from the first break, so carefully refined and perfected by Alph and the doctor, was located at the Albi hospice, where fortunately it wasn't being used, and sent post-haste to Barèges, to be recycled back to its original owner, this time for his other leg.

'Physically, we are not suffering,' Adèle wrote to her mother-in-law on

Sunday, six days after Henry's fall. In fact, she went on, she was the only one suffering:

Henry is doing marvellously well, not in pain at all, eating and sleeping well except sometimes for a little agitation, which stops with a spoonful of potion. I have to say that his courage has not failed him for a second and he knows how to give some to me. The hospital's splint has been perfect until now; I don't know if the one coming from Albi will replace it or not. He can sit up on the edge of his bed, eat, read and write a little thanks to a sort of iron tablet used to protect his injured limb. Alphonse telegraphed yesterday from Rennes to say he was arriving after an involuntary delay; he will decide with the doctors which apparatus will be the final choice.

Two things are significant in this text: the extent of Adèle's identification with Henry's injury, and her willingness to let Alphonse make a major decision about the quality of her son's care, even though he had been unable to manage his own life well enough to get to Barèges earlier than a week after the accident.

The rest of the letter was devoted to an enumeration of her own state. Her resiliency, she admitted, was at rock bottom. She could well understand the shock her misfortune had been to her loved ones, but she wanted them to know how consoling it was to have their moral support, 'when one has a sad life like mine. I admit it, as for morale, I am totally flattened, I can find no better expression. It had never occurred to me that I should ever have to face such a trial again!'

Although he had broken the other femur this time, in strictly physical terms Henry was not as badly hurt as the year before: 'The Doctor says there's no more danger of inflammation and that everything will go as fast as possible – he comes twice a day ... for the time being all we need is patience ... My poor Henry says: "How happy I would be if after 40 days of trouble, I could just walk as well as I did before."'

One of Henry's friends during this new ordeal was a 'most good-natured' boy his own age who came to cheer him up as he lay in bed. Adèle announced proudly that the boy was the grandson of the painter Jean Honoré Fragonard. Only later did Grandmother Gabrielle refer to Henry's friend in her typically brutal way as the 'little hunchback Fragonard'. She was also the only one ever to point out that Etienne Devismes, another friend Henry had made that summer, was forced to get about on crutches, or that Charles Castelbon, Henry's pen pal of the year before, was also crippled. One of her roles in the family seemed to be as the one person who didn't mince words. It was in

character for the rest of his family to avoid mention of the embarrassing reality that Henry and his playmates were handicapped. Spas tended to attract primarily boys with ailments, and it is understandable that Henry might feel at ease with someone whose experience was similar to his own.

In spite of Adèle's admonitions, Grandmother Gabrielle came to Barèges almost immediately after learning of Henry's fall, arriving just after Alphonse, who had been delayed again, this time by the near loss of a wheel on the stagecoach: 'They were four miles from Luz in the direction of Pierrefitte, so everyone set off on foot towards Luz, except for an old English woman, who, not wishing to leave her baggage unguarded, begged Alphonse to stay with it. So he gave her a big pistol to defend herself with in case of attack.' Grandmother Gabrielle sent off a medical report to Alix, who was still in bed after the birth of her tenth child, Henry's cousin Fidès:

Henri's doing as well as possible, he's looking excellent, eats with good appetite, sleeps well, doesn't hurt and hasn't hurt. He's as merry as a lark and as proof, told me a little while ago that one of the main attractions at Barèges was breaking your leg ... When I got here Alphonse had just gone to sleep in Angeline's [the servant's] bed. We're hoping he'll turn it over to me soon. In the meantime, I'm sleeping behind [a screen in] Adèle's alcove. No way of finding anything else, everything's taken or booked, the season is beginning ... The simple gutter-apparatus is working so well, and M. Armieux and M. Guyard, his aide who will take his place, were so adroit, so skilful that Henri hardly suffered at all. After about an hour [spent fitting him with the apparatus], these gentlemen, plus M. Vergès and a male nurse, were able to carry him back to his bed all by themselves, on a large cushion. It is easy to imagine the procession that sad hike made through the streets.

In a letter to his Grandmother Louise, written about the same time, Henry joked about his new cousin, suggesting that she be nicknamed 'Fifi', and adding: 'I hope you'll excuse this word-play, but I don't have many things to keep my brain busy.' He referred to his accident in curiously self-accusatory terms: 'I'm sure I will make you happy by saying that I am as well as possible, and that I'm not in pain. I'm not too bored, either, and I hope that you aren't worrying too much about me, for I don't deserve it, being so clumsy.' He signed the letter 'Your clumsy godson. Henri de Toulouse.'

Two weeks after the accident, Grandmother Gabrielle wrote to her sister Louise: 'You realize that unfortunately Henri is the hero of Barèges, and everybody is interested in him. Each visitor goes to great lengths to cheer him up, and he has almost too many visits, but he's not complaining. Yesterday he

began doing watercolours again and painted a plough-horse which has real physiognomy.'

Everybody agreed: Henry's good humour would pull him through. Even his extremely ill-tempered and hypochondriac Great-Aunt Blanche wrote to her sister about 'Henri, whom I love so ... his disposition, so admirable and so easy to deal with, will help him more than any other thing to bear this repeated ordeal, so hard to take, especially at his age.'

As it had the first time, his splint was supposed to come off forty days after it was put on, around 1 September. The footman, Urbain, was planning to come down from Le Bosc to accompany Henry on the trip home from Barèges. And M. Vergès, a former Zouave (French soldier in the African legion), who had been the person to lift Henry out of the ditch when he fell, was willing to act as his manservant and travel with him once the splint was off. Adèle was very pleased to hire him: 'He's strong and dextrous,' she added.

For the time being, Henry was somewhat cheered because the 'little hunchback' had given him a puppy and, as his mother observed, because he was drinking Vin de Quinquina (a sweet wine laced with quinine) to increase his appetite.

At times, despite his desire to keep up the courage his Uncle Odon had told him he expected of him, he felt overwhelmed by self-pity: 'I am indeed alone all day long. I can read a little but end sooner or later by getting a headache. I draw and paint for as long as I can, until my hand becomes weary.' For the first time, Henry showed an awareness of a woman as beautiful and of his own ugliness in contrast: 'and when it is dusk I begin to wonder whether Jeanne d'Armagnac [one of his cousins] will come and sit by my bed. She does sometimes and I listen to her but lack the courage to look at her, so tall and so beautiful, and as for myself – I am neither of these.' He signed his letter 'Monsieur Cloche-Pied' (Mr. Peg-Leg).

The painful comparison implicit here with *La Belle et la bête* shows a wistful longing. Increasingly, he would seek to deaden it by barricading himself behind humour, self-indulgence and painting. Years later, in an illustration of a modern version of that fable, he showed *la bête* as big and bear-like.

Henry, whose formal spa activities were limited to drinking one glass of mineral water daily, was working on one of the model ships he had been building with his Uncle Charles. It had been sent from Le Bosc to Barèges, and he had enlisted his friend Etienne Devismes to help him rig it as authentically as if it were full-size. When Devismes had to go back to Arcachon

before they finished the project, Adèle told Henry's Grandmother Louise that he was 'in despair'.

As mother and son waited impatiently for the leg to be declared healed, Adèle also was feeling deprived of social contacts: 'So many people have left, or are leaving, while for no good reason, I am stuck here in Barèges!' She complained to her mother, 'It's all well and good to talk about blindly submitting to the will of God; when I think about the uselessness of my troubles, I'm awfully discouraged.' She was also very worried about money. An outbreak of the phylloxera mite which was ravaging the vineyards of France had struck one of their wine-producing properties, Ricardelle, and was threatening to destroy one of her major sources of income. 'Henri's care costs so much,' his Grandmother Gabrielle observed.

On 3 September 1879, Henry wrote a first letter to his friend Etienne Devismes: 'On Monday the surgical crime was committed, and the fracture, so admirable from a surgical point of view (but not, be it understood, from mine), was laid bare. The doctor was delighted and did not bother me any more until this morning. Then, this morning, under the shallow pretext of making me stand up, he let my leg bend at a right angle and made me suffer atrociously.'

Because Devismes was also crippled, and possibly the only person who could really understand what he was going through, Henry's letters to him are far more truthful about his feelings than the tough, funny, uncomplaining ones he generally wrote to his cousins at Céleyran. He did not have to protect Devismes from feeling guilty as he did his 'normal' relatives. After commenting to Devismes on 'my fat clumsy paws', he briefly expressed the despair Adèle had perceptively recognized: 'If you were only here five little minutes a day! How easy it would be for me to contemplate my future sufferings with equanimity!'

He quickly moved on to less painful topics. He needed Devismes' advice on their unfinished model boat: 'I pass the time making hatchways (the bobstays and shrouds kept me busy scarcely half a day). But wouldn't it be better to make the ramming-block out of brass instead of wood, and should it be painted or merely varnished? ... Must the sheet be unhitched from the jib in order to change it?'

Theoretically, once the splint was off, Henry would be able to go back to Le Bosc within ten days. The doctor was thinking of putting a rigid cast, a 'silicate bandage', as Grandmother Gabrielle called it, on the leg, so Henry could travel home with less uncertainty, but she, for one, was sceptical: 'I'm

able to wait that long [before leaving]; however, I don't have the slightest illusion that he will be able to make such a long trip so soon.' The apparatus was taken off yesterday,' Grandmother Gabrielle wrote a few days later, 'the bone has knit perfectly, the knee is supple and pain-free, but to be prudent, the doctor doesn't want him to walk before fifty days after the accident, which will take us to the twentieth. Today they're going to put him in a wheelchair.'

Adèle was chafing to leave Barèges but, haunted by the fear that Henry's bones might continue to break, she decided to be extremely careful about moving him so long as there was the slightest chance of provoking another accident. Both her mother and Tata had written, offering to keep her company and help out, but Adèle refused, full of martyred self-righteousness: 'We surely will figure out how to bear a little loneliness; it's not new for us ... pray God to let us leave this frightful place quickly.' She remarked ironically that they had had a letter from Henry's Uncle Charles, who was on holiday in Venice, and that they found it 'so cheering to see people who are having a good time. For our part we have the dry south wind and exhausting heat. The doctor can't talk without sucking on a vial of heat-potion. Alphonse writes that it's cool at Le Bosc.'

She described Henry's slow improvement: 'He's in great need of fresh air to revive his appetite and his colour, but first he has to be able to move that poor leg without pain. This morning the doctor wanted to get him to stand up (while holding him, of course), and it gave him a terrible cramp. We're going to have to be patient for a few more days before trying walking. In the meantime we're going to have fortifying massages.' Grandmother Gabrielle added more details:

His ankle isn't swollen, but so stiff it looks like a wooden leg. His knees are fine. Among a thousand other things we're going to try the famous electric brush. For bathing, we wrap his thigh in an oiled compress, to protect it from the water. In Barèges I was impressed by a young Englishman who arrived, carried in like a formless bundle, and several little girls, also carried in, and now they all walk and trot. Let's hope our dear Henri will do the same.

When Grandmother Gabrielle finally left, Adèle and Henry hit a new low. Although the hot weather broke, they were beset by cold rainstorms. There was snow on all the mountaintops. 'We haven't been very cheerful. Henry remarked to me that although *Bonne Maman* didn't make much noise, without her we have become depressingly becalmed,' Adèle reported.

When the weather cleared, Henry could at last go out in a little cart pulled by his new nurse, the Zouave, who carried him 'like a child' in and out of doors and even gave him a haircut. Working on the details of the trip home, she wrote to her mother: 'We have crutches, but he's still unwilling to walk and can hardly lift the broken leg; I understand the phenomenon and am patient with him, for it's a matter of a few weeks. If the weather is good enough to go out for walks his strength will come back a lot more quickly. That's another reason for hastening our departure, for winter is beginning here.'

When at last they left Barèges to move to Le Bosc, life, already slow, slowed even more, but this time peacefully. Henry was healing gradually, much as he had from the first break, with no great leaps or improvements. Winter came early and was bitterly cold. The fireplace in the *grand salon* burned night and day, but even in the cold Henry and his mother went out every day for a brief walk – first on crutches, then with two canes. He also painted every day. In early December, when he was stronger, they moved to Céleyran, where the Tapié cousins had moved in early autumn, to profit from the milder climate.

The devastating phylloxera insects were still rampant in the region, and the grapevines at Céleyran were struck as well. No treatment seemed to work. Among the family, illness – particularly chest colds and other respiratory ailments – was also a problem that winter. In a house that size (the seventeen or so members of the family were cared for by more than thirty servants), any illness swept through the ranks. M. Vié, the family doctor, came continually that winter, but remedies were primitive: chest plasters for colds, herbal teas for digestion, quinine, taken orally for fever and used in rubdowns for seizures, and a combination of iron, meat broth and donkey's milk to build up anyone whose health was fragile. For a change, it was not Henry who was the centre of attention, but his godchild, Kiki, who was having seizures two days out of three. She also was developing worrying problems with her legs.

As they were helpless to stop any of the evils afflicting them, either dwarfism in their children or phylloxera in their vineyards, to a certain extent the family remained philosophical. Kiki's father Amédée hunted woodcock for the dinner table. Grandmother Louise went off on religious retreats 'to sanctify herself', and Alix, when she was not trying vainly to 'consolidate' one or another of her sickly children, searched feverishly for servants and English nursemaids to keep the household functioning. Henry, whose only obligation was to continue his lessons with the Abbé Peyre, was most pre-

occupied by the new litter his dog Belle had just given birth to. Since all the cousins in his own age group were away at school, he was somewhat lonely in the Céleyran mansion. When he learned that they were not studying hard enough and might not be allowed to come home for Christmas, he wrote a mock-furious letter that nonetheless showed how much he missed their companionship:

You can understand how upset I am, and I'm writing to push you to do your best so this punishment won't come about, and then how happy we'll be! ... We would have the most amusing card games: we'd play *chemin de fer*, we'd have secret signals; what wouldn't we have!!! While, if you *acagnardissez* [Gascon for 'fool around'], if you continue to do nothing but bad workmanship, as they say, they're going to leave you at the school, where you'll be bored, and your mother will be ashamed, and what about me!!! And if you get into the habit of behaving like this, what's going to happen to you? Are we going to have to come and see you at Carnival, on Saint Cécile's day, on Easter and maybe even at the summer holidays!! I assume you won't let that happen to you when you realize that with a few more times around the dictionary, everything will go just fine, the way your cousin wants it to.

In early January, Henry and Adèle left for Nice since Adèle thought a second season might ensure that Henry was completely healed. The 1880 season seemed much less active and amusing than the previous year. Henry, struggling with his schoolwork, particularly German, which he hated, spent most of his free time on his art, doing mostly watercolours of ships and sailors.

At Carnival they were joined by Henry's Uncle Odon and Aunt Odette. Odon reported on Henry's health to Grandmother Gabrielle: 'We were astonished by the progress in Henry's walk. He was very spry on the long route back from the Corso. Unfortunately, he's very deformed, but always cheerful and very busy with drawing – an art in which I find he's taken great strides.'

Henry continued to write to his friend Etienne Devismes: 'I say we were broiling because two days ago (on account of Carnival, I suppose) the Eternal Father opened the celestial floodgates all the way; I could almost have sailed the cutter in question out in the garden ... My obsession with the [model] navy has died down a little, but it's mostly changed its form; painting has replaced it. My room is full of things which don't deserve even to be called *croûtes* [daubs]. But it passes the time.'

Henry himself had recognized his serial obsessions with carriages, stamps

and model boats and, in his letter to Devismes, he referred to his changing enthusiasms as *'furias'*, an accurate observation on the intensity of his interest in them. For the rest of his life he would be subject to periods of violent attachment to one interest or person, abruptly tiring of the most recent passion, to take up a new one with the same force. Unlike his other pursuits, however, painting would remain a constant, a foundation for almost everything else that attracted his attention.

In a later letter to Devismes, he elaborated on his frustrations as an artist:

You tell me you'd like to see one of my masterpieces or attempts. I'd like to send you something good, and what's worse, I don't know what of. You're going to think that my menu has a lot of choice – well, no; you can only select horses or sailors; the first are more successful. As for landscapes, I'm totally unable to do even the shadow of one; my trees are like spinach and my sea looks like anything you want to call it. The Mediterranean is the devil to paint, precisely because it's so beautiful.

Henry was aware that his *'charissime* [sic] Etienne', possibly the first real friend he had had outside his own family, was suffering as much or more than he was:

Even though you laugh about it, my dear friend, you wouldn't believe the enormous impression your accident has made on me. You tell me you've been suffering for three long months – when I had had enough after only forty days, and half the time I wasn't in pain. Oh, how I would have liked to have been able to keep you company, if I'd been sure of being able to amuse you even a twentieth, a hundredth as pleasantly as you made the time pass for me in Barèges. Do you remember our famous shrouds, hawsers, blocks and bobstays?

In June, Henry and Adèle returned to Le Bosc via Céleyran. Although his handicap had not improved, Henry was relaxed and healthier than he had been in months. He amused himself by painting all the family pets and writing gleeful letters to his Great-Aunt Joséphine, but addressed to her dog, 'Miss':

Dear Madam,

As your nice letter yesterday announced, maternity's joys are yours once again. There you are, once again the head of a family, grave responsibilities weighing down your curly little head. What care you will have to lavish on these warm and rosy little creatures, feebly stirring their tiny little paws at the bottom of your basket. I'm

sure your nice Mistress and Mélanie will help you with this difficult task and that they will make as much and even more fuss over your children as you yourself. I also know you must have a crazy urge to eat the aforesaid Mélanie when she wants to touch your progeny and that the echoes of your G-r-r-r- G-r-r-r-rs will resound in the living room.

So, first of all, I implore you not to eat all of the above-mentioned Mélanie and to leave at least a little piece of her to care for your nice Mistress; second, to lick your babies very thoroughly, so that the good people of Castelnau will be able to raise their heads to heaven and say, amid tears of emotion, 'Oh Lord, they're just like their Mother!'

In closing, I send you my heartfelt congratulations, and pray you to lick your Mistress' hand for me.

I squeeze your little paw.

<div style="text-align: right">Henri de Toulouse-Lautrec</div>

p.s. Remember to give my best to Flavie, Mélanie and Benjamin.

Henry, now sixteen, was fine-tuning a successful way of adapting to his life, finding autonomy and perspective through his sense of humour and his art, talking about his emotional and physical suffering only to those like Devismes who could understand it. Amusing, heavily illustrated letters to friends and family were becoming his forte. The most spectacular of these was done in the winter of 1880–81 during one last, fruitless visit to Nice for his health.

To amuse himself on the trip down and to maintain his resources of enthusiasm, humour and self-deprecating irony during their first weeks there, he created an illustrated diary, which he called his *Cahier des Zig-Zags* and mailed to Bordeaux to amuse his ailing cousin Madeleine, who had been sent there to study and to receive treatment for developing problems with her own legs.

He put his feelings on paper in a delightfully heavy-handed journal which shows a fine sense of the ridiculous and includes numerous skilful caricatures of the people around him:

19 January – Forgive me, my dear cousin! Laziness and still more the bad weather have tied my hands!! Rain, splish, splash, mud, mire, botheration, all of these have been bestowed on us lavishly by the Eternal Father. Disgusting, isn't it? … To continue … It's not very gay here … At the table I stare at the Armenian and pass the mustard to Mademoiselle Lecouteur. It's almost as lively as a convent.

His description of a dance a week later included detailed commentary on his fellow dancers:

Wednesday, 26 January. – After an unpropitious start, some money has been collected, and there is going to be a dance this evening. I shall try to tell you about it ... We went to dress. You can imagine what a serious matter it was, I looked almost clean ... Downstairs again. People were already in the salon. There were two young Englishmen, magnificent, who have the room next to ours; their two sisters, exactly like umbrellas dressed in pink, were invited too, as well as a little Miss in blue with red hair ... I went into the hall. The orchestra was there, a piano (belonging to the hotel), a cello, and a violin ... Oom-pa-pa, the dance began with four women dancing. We began to hum the tune, it was useless (two of the Misses who live in the hotel, the most enthusiastic dancers of all, were ill) until a bevy of innocent young beauties swept onto the floor; among them Mlle Lecouteur (aged 35), Miss Armitage (a female chimpanzee, a clergyman's sister, fifty winters old), and Miss Ludlow (who laughs like a hen and whose age is midway between the ages of the other two).

It would be easy to say that Henry was being insolent and mean, but probably he was just trying to write a funny story for poor Madeleine. He knew from personal experience what she was going through.

In the same journal, he described what was possibly his first experience of drinking himself into a stupor, at a wedding party to which he had been invited:

Madame, having made me sit at her right, ordered me four different things to drink. At first I protested, but M. Feltissoff would not listen. So I began to drink a little. M-m-m-m. Pretty good, eh? You know, it's only the first glass that counts. It went down very nicely ... There were toasts. To the newlyweds! Oh, Mme Viroulet! By that time things were so boisterous that M. Morgan and M. Virtain kissed Mme Viroulet. Eugene danced like a monkey, M. Lévi cried Hip, hip, hurrah! and I had a raging headache.

A little later I went very sheepishly to bed. It was no use. Oh, I felt very queer. I was beginning to ask myself if that would last long when suddenly a frightful upheaval answered the question for me. You can imagine! I'll spare you a recital of the pretty names Maman called me.

As a reward for finally settling down with a tutor to prepare for his secondary-school examinations, Adèle let him order an elaborate easel and all sorts of art supplies from Paris. 'He's most proud [of it], and I'm most

Self-caricature, vomiting, from the Cahier des Zig-Zags, *1881.*

happy with the encouragement he's been getting from M. Suermondt, who is a true connoisseur of painting and in general very sparing with compliments.' No matter how much he joked about life at the pension or the people inhabiting it, the only thing that seriously occupied Henry was his art. Everything around him was food for his passion, transcribed into his sketchbooks and thence onto his canvases. When he was concentrating on drawing, Henry could also find some merciful distance. He entered a private world, and nothing could touch him, not his father's neglect nor his mother's whining, nor the fact that no matter how much he might wish to hold one of the 'umbrella' maidens in his arms, he would never be able to dance.

That winter in Nice, bored and writing letters to Madeleine, Henry seemed set to follow the path his parents would have wished. Although they never said so in writing – such things were discussed in private, late at night – it seems obvious that if Henry were to be incurably crippled, they hoped he would live passively on one of their many properties, beloved and loving, surrounded by relatives and pets, protected by the tight armour of family ties. A peripheral benefit of this cloistered life was of course that he would be more or less out of sight and that his handicap would not be paraded around to humiliate those bearing his family name. They had the money to keep him safe at home. However, they were soon to discover that they did not have the power.

5

LOST

LOST

H enry was almost grown up now: nearly seventeen. He would take his *baccalauréat* exams in the spring of 1881. At the time the baccalaureate was the gentleman's proof of education and he was not expected to go any further. At the end of the season in Nice that spring, instead of returning to Le Bosc, he and Adèle moved to Paris, 'to see what we can . . . organize for next winter'.

Henry's family had looked on his art as a fortunate talent, important because it substituted for the riding and athletics Henry could no longer do, a hobby that distracted him from the physical and psychological discomforts of his handicaps. But for nearly a year Henry had been insisting that he wanted to make art his life. Now his parents began to look at his talent as a possible source of real happiness for a son who was not going to have many other options. His role models, Princeteau and Uncle Charles, men who loved art and took their own art seriously, led the ranks of the adults proclaiming that he showed exceptional promise as an artist. Adèle and Alphonse really had no choice except to listen. To refuse him further training would not only be a terrible disappointment for him but would also be ignoring his real gifts. They were eager to discover what school or atelier would be best for him.

In Paris, Alphonse took great interest in the affair, inviting Princeteau and the other artists who had studios in Princeteau's courtyard to see his son's work and comment on it. Princeteau found that 'Le Petit's' drawing had improved so much that sometimes he couldn't tell Henry's sketches from his own. According to Adèle: 'Princeteau was literally in ecstasy at the sight of [Henry's] masterpieces. That is more than it would have taken to put my little man in seventh heaven, and his Maman is happy to see him happy.'

Everyone agreed: Henry had great talent. Even his grudging Uncle Odon said so: 'Henri is full of enthusiasm for painting, and everyone is encouraging

him to take it up as a profession. The truth is that he has really extraordinary predispositions for it, and he would do well to cultivate them. He's doing much better with his legs, though I'm sorry that he hasn't grown at all. He is still very funny and cheerful.'

Adèle made frequent reports on the progress of Henry's artistic decisions: 'All Alphonse's and my time is still taken up with Henry, and since each person gives us different advice, it's becoming more and more cumbersome; what we have to do is to choose an atelier, professor or Ecole des Beaux Arts for next year ... Alphonse is very preoccupied with the final decision we have to make, and the Ecole des Beaux Arts seems to have a chance of winning.'

Adèle herself was not so much concerned that Henry have good art training. It was far more important to her that he be exposed to the beneficial influence of someone from his own social class: 'There [at the Ecole des Beaux Arts] Henry would find a comrade in the younger brother of Monsieur de Chanterac, who entered this year. He is considered to be a gentleman from every point of view, although,' she couldn't help adding, 'he has had the misfortune to have lost one eye.' Another possibility was the private atelier of the academic painter Alexandre Cabanel, a teacher at the Ecole des Beaux Arts, who directed the annual Salons.

Henry himself seems to have been almost unconcerned with the decision. The heady independence of living in Paris as 'the aspiring artist' was enough. He thought only of leaving the hotel immediately after breakfast to go to see Princeteau, whose atelier was almost next door. According to Adèle, Princeteau, whom Henry called 'René', was spoiling him rotten and even gave him the key to his studio as if he were an equal. To Henry it must have seemed as if the world had turned around. Suddenly life was rich and full in this, 'the best of Parises', as he called it. Every morning by half past eight he was working under Princeteau's close supervision: 'The first study,' Adèle reported, 'was the portrait of a monkey. The turbulent model decided to eat a tube of paint, which upset Henry, who had three of the coachmen in the courtyard hold it down and give it a glass of oil. Now he's copying a painting by Princeteau.'

The crippled boy and the middle-aged deaf-mute had grown close over the years since the distinguished artist had begun supervising Henry's schoolboy sketches. Princeteau had struggled courageously to overcome his handicap and live normally among normal people, adding to his importance as a role model for Henry. Now Princeteau began giving him serious training. His influence was so apparent in Henry's drawing that years later the French

critic Arsène Alexandre, studying the sketchbooks master and pupil had worked in together, observed: 'Only a certain hesitation and inexperience characterize the pupil's work, and sometimes one must look twice to determine which is which.'

In Princeteau's atelier Henry learned what a professional artist's life was like. Unlike Henry's father and uncles, Princeteau earned his living with his art, selling paintings, taking on commissions and exhibiting regularly in all the major shows. He expected his 'studio nurseling' to exhibit the same kind of professionalism, sometimes assigning Henry tasks relating to the preparation and research for his own work. Henry was pleased and proud, for example, when Princeteau asked him to trace a drawing of 'a pack of hounds holding a young boar by the ears'. Princeteau commented in his letters on the progress of the 'budding painter': 'The young H. de Toulouse-Lautrec is working valiantly in my studio and has been making miraculous progress. He mimics me like a monkey.' In 1914, as an old man with a faulty memory, he wrote a brief description of Henry's work with him: 'At the age of fourteen in 1879 [sic] he copied my sketches. He copied my painting of a cavalry officer on rounds so remarkably well that it gave me cold chills. The copy is in the Château de Malromé.' When he realized that he had taught Henry as much as he could, he pressed him to move on to other teachers.

Although he remembered some of the dates wrongly, Princeteau's account agrees with Henry's own account of the experience: 'I had got so I could easily paint those little scenes ... but I was incapable of doing a portrait. Princeteau advised me to learn to draw and to work in [a portrait artist's] atelier.'

Henry, who was preparing for his baccalaureate exams, had also been going over his schoolwork with Louis Pascal's tutor. Adèle was afraid all the glory of having his artistic talent recognized would go to his head and he would never pass the 'bac': 'all the artists in the neighbourhood come [to Princeteau's studio] to talk and praise Monsieur Henry, who has even gained the admiration of the two Messieurs du Passage!' she said, referring to brothers who were friends of Alphonse, one of whom, Charles, was a sculptor and painter of sporting scenes. 'They are predicting an unbelievably glorious future for him, and I think the diversion of the Greek professor will be helpful in calming his imagination a little.'

Henry and his cousin Louis intended to take the 'bac' together in July. 'So, here we are in Paris for two months,' Adèle announced ruefully. She hated to miss summer at Le Bosc, but, as she commented: 'It would be really too bad to interrupt Henry's studies – artistic in the morning and serious in the

afternoon.' Henry, although still interested in the details of daily life back on the farm, had different views on the subject, as can easily be seen from a wildly enthusiastic letter he wrote to his Uncle Charles around the same time:

I ... wanted to write to you about my own offspring – for I have one – that is to say a palette. I'm as inflated as Gambetta in his balloon [Léon Gambetta, as a political stunt, had escaped from Paris in a hot-air balloon during the Prussian siege in 1870] when I think of all the compliments that have been paid me. *Blague à part* [no kidding], they took my breath away. Princeteau was raving, du Passage was in tears, and Papa didn't understand what was going on at all. We have been discussing every possibility, even, just imagine, Carolus-Duran [a fashionable portrait painter]. Finally, this is the plan I think will work the best. Ecole des Beaux Arts, Cabanel's atelier, and hanging around at René's studio. I've done a portrait of Louis Pascal on horseback. Well, I'm rambling on, and I hope that makes you happy, because it's you who kindled the artistic spark in me. Princeteau has a painting in the Salon which is getting a lot of attention. It reproduces, enlarged and modified, the painting we did at Le Givre.

Please tell Grandmother and Aunt Emilie how ecstatic I am, give them a kiss for me. Everything's fine. See you soon under the parasol and on the folding stool at Le Bosc. What sketches we'll make!!!

Your nephew Henri

Alphonse, whose enthusiasms rarely lasted for long, was losing interest in the project of choosing a school for Henry. He made repeated threats to go to Orléans to see how his horses were doing, though he did not actually leave Paris. True to form, he went out and bought a mare, which he promptly rode off to watch the Grand Prix, leaving Henry and his cousin Louis in Paris alone, even though he had promised to take them to the races at Chantilly and Auteuil.

Even as July grew unbearably hot, Henry continued his routine in Paris: painting in the mornings, studying for the '*bac*' in the afternoons. The only real interruption in his routine was the celebration of the 14 July *fête nationale*. The holiday had been reinstated as a nationwide event after the fall of Napoleon III, in 1871, although Henry's family refused to celebrate the date, since it commemorated the taking of the Bastille. The Toulouse-Lautrecs considered the celebration of a populist uprising to be not only a dangerous approbation of the rise to power of the French working class but also downright unpatriotic.

Despite all Adèle and Cécile's attempts to use social and political influence

to get permission for Henry and Louis to take their exams at the same time, and as early as possible (so Adèle could go to Le Bosc for the summer), the boys weren't scheduled to go before the judges until the end of July. Adèle was worried: 'They aren't used to systematic study, and that's an enormous factor.' She was absolutely right. When they took their exams, both boys failed. Henry, who had failed because of a bad result in French, showed his usual bravado by referring to himself as 'Henri de Toulouse-Lautrec, *Retoqué ès Lettres*' (Reject of Letters).

Adèle handled their defeat (for she considered it hers as well as Henry's) by leading Henry off with his cousin Madeleine and a swarm of Madeleine's siblings to cleanse him at another spa, Lamalou-les-Bains, for the month of August. Madeleine and Henry immediately despised the place.

Psychologically, Henry had reached a crossroads. The spring in Paris, the recognition for his art, the joy of working on it every day under the supervision of Princeteau, had made him realize he was no longer merely floating, following his mother from place to place without purpose. He raged at the boredom of the resort and longed to be back in the atelier. Rescue came from an unexpected source: his friend Etienne Devismes wrote requesting his help in illustrating a story Devismes had written. Touched by the honour his friend paid him, he answered humbly:

Dear friend,

You must think me very ungrateful if you believe that I have forgotten the patience with which you used to sit by my bedside. I have left Paris, having failed in French recitation for the degree of Bachelor of Letters. I received your pearl in prose only the day before yesterday. Here I am in a miserable desert of red earth, although the landscapes could pass for Bagnols. I am eager to get to work, but I want to be sure to get the feeling of your story. You are really too kind to take notice of my poor pencil, which will do what it can, you may be sure; nevertheless I hope to be able to produce something on the subject of *Cocotte*. I shall try to be quick about it.

In a second letter, written a few days later, he elaborated on how he felt about almost everything in his life at that time:

Are you at Barèges? That is the question that haunts me in my bath, in my bed and on my walks. Truly, all the hideousness of this nasty place vanishes like a smudge of charcoal in a puff of wind when I think of the hours you were good enough to pass at my bedside.

You will say that I am turning sentimental; nonetheless this is nothing but the truth.

At present I am at Lamalou, a resort whose waters are impregnated with iron and arsenic (mildly, the doctor says), for the purpose of soaking myself internally and externally. It is much drearier than Barèges, *quod non est paululum dicere* [which is saying a lot], but at any rate one does not break one's shanks here (at least I haven't succeeded in doing so yet). Our winter in Nice ended badly on account of my aunt's illness. I took advantage of the delay to continue my sea baths. I had no less than fifty of them, in time I was able to jump out of a boat I was paddling about. This will demonstrate two things:

1st. That my locomotor extremities show considerable improvement.

2nd. That I have recovered my fondness for the sea and by the same token for little boats. At this very moment I am negotiating for the construction of a six-foot wherry; the provoking part of it is that all of those I have seen have very broad hulls and ride low in the water, while I want mine to be very slim.

But I see that I am chattering away like an old magpie, so, reiterating my request to be told what style of painting you require to conform to your 'inspiration' (it's frightfully cheeky of me and I must get to work), I clasp your hand heartily.

When Henry finished the twenty-three India ink drawings for *Cocotte* he posted them off to Devismes with the following letter, written on stationery with the letterhead 'Etablissement Thermal de Lamalou l'Ancien (Hérault)':

My dear friend,

I have done my best and am sending you by this post twenty-three drawings, one of which is in duplicate because of an accident. Perhaps the sketches are a little too animated, but it seems to me that the text is no less lively. Poor *Monsieur le Curé*! As I am entirely at your service, write to me if you want any modifications and return to me, if you please, any drawings that you cannot use. If you want an altogether new set of drawings, I am your servant, so happy am I that you have cast a glance at my rudimentary inspirations.

I have tried to draw realistically and not ideally. It may be a defect, for I have no mercy on warts, and I like to adorn them with stray hairs, to make them bigger than life and shiny.

I don't know if you can control your pen, but when my pencil starts to go I have to give it its head, or crash! Dead stop.

Well, I have done my best, I hope that you will be indulgent. What joy if . . ., but one must not count one's chickens before . . .

Farewell I clasp your hand cordially . . .

The budding painter, H. de T.L.

This was one of the few times Henry ever described his approach to his art, and it gives a vivid description of what was rapidly becoming his mature style. All his life his work would be characterized by speed of execution, enthusiastic line and an uncontrollable tendency to make his subjects' 'warts' stand out. Devismes apparently was pleased with the results, warts and all, for Henry's next letter to him responds to Devismes' praise:

I thought I had gone a little mad when I read your generous and charming letter. I never expected such kindness: that you should accept my miserable sketches and thank me for them into the bargain. And you are most conscientious with regard to my drawings. Use any of them you like. I suggest especially the head with the rats, the anchor and the skull surrounded by helmets. One in particular might be eliminated, the sentimental cottage. The others *ad libitum*. I know that you will choose well, and am only too happy if a single one pleases you. I am returning your manuscript, which I kept in case there were more sketches to be made.

Well, I am thrilled, delighted, mad with joy, at the idea that perhaps your prose will brighten up my sketches like a display of fireworks, that you offer me a helping hand along the difficult road of public recognition, and finally that I have been able to contribute a little to an old friendship which only improves with age.

Henry's drawings were considerably more interesting than Devismes' adolescent story about an old mare which hears the trumpets of her old cavalry regiment as it is going past and gallops into the ranks with a priest on her back.

Once more at Le Bosc, now that the *Cocotte* drawings were done, Henry and Louis were preparing to go to Bordeaux to take their '*bac*' exams a second time, on 17–18 November 1881. Henry passed with flying colours, and his Great-Aunt Joséphine was so proud of what Adèle called 'our success' that Henry said that pleasing her made him even happier than his laurels. Via his mother, he sent a message to his younger cousins at Céleyran: 'Tell them that they're not wasting their time [by studying] because the examinations are terrible. Anybody who doesn't do good classwork will never pass the "*bac*", and anybody who doesn't have the "*bac*" will be obliged to serve five years as a simple soldier instead of one year of voluntary service.' Louis Pascal, who had failed, was not reassured. Only four candidates out of twenty had passed.

Henry wrote a more uninhibited version of his success to Devismes on 22 November 1881, four days after the exam: 'the jury in Toulouse accepted me, in spite of the nonsense I uttered in my replies! I used quotations

from Lucan that never existed and the professor, wishing to appear erudite, received me with open arms. Well, it's over now.'

He seemed to be truly exhausted by the whole experience and wrote as much to his mother: 'my letter is colourless, like my ideas, which are absolutely drained after the tension of the exams.' He signed it 'Your son, back from the grandeurs of this world [a quote from Voltaire] and above all from those of the baccalaureate.' Now he could get on with more important things.

Henry's point of reference to the world was consciously visual. From Céleyran, before they left for Paris for the winter, he wrote: 'It's freezing here, but the sun is so hot and bright that we're not suffering. Which proves that you feel cold more in your eyes than in your back.'

At a very young age, Henry had shown himself to be an acute observer of movement, an inclination that may have come as a psychological response to long immobilization. This skill showed in his accurate memory of people and animals in motion and his ability to transfer remembered movement onto paper, creating there the freedoms he didn't have in life. As early as his funny notebooks in Nice, Henry had shown that he observed things and events for their anecdotal content as well, finding in them unexpected truth or absurdity. Now he was becoming aware of the subliminal, emotional influence of the visual: in this case, the fact that one could feel hot or cold at the same temperature, depending on the visual elements of the situation.

Once they got back to Paris early in 1882 and were again settled in the Hôtel Pérey, things fell into place quickly. Henry immediately returned to his habit established the year before of spending all his free time at Princeteau's. The painter was living and working in his new studio in a courtyard at 233, rue du Faubourg Saint-Honoré, putting the finishing touches on a huge painting for the Exposition Universelle of 1882. He and the other artists in the 'grande cité d'artistes' provided a stimulating atmosphere for the seventeen-year-old.

One of them, Charles du Passage, transmitted to Henry his own excitement about the first stop-action photographs, taken by a physiologist, Etienne-Jules Marey, in a laboratory setting the preceding autumn. The photos had finally revealed the true gaits of horses. Du Passage was preparing a series of drawings from the experiments, and Henry, basking in reflected glory, took pride in announcing to his father that du Passage's drawings had been published in the 16 April 1882 issue of La Vie moderne, a popular artistic and literary journal. The photographs themselves were not published until

1887, by which time an English photographer, Eadweard Muybridge, had already received credit for the discoveries.

John Lewis Brown, a French-born sporting painter of English parentage, was also a part-time resident in the same courtyard, although Henry didn't meet him for some time. Lewis Brown was well known as a painter of hunting scenes and military compositions and was one of Alphonse's favourite artists. All these companions in the *cité*, which included the lesser-known artists the Count de Ruille and Busson, were 'painters of sporting elegance, frequenting the important circles [clubs] – the Volney, the Epatant – and assiduously exhibiting at the Salon des Artistes Français'. In addition, all of them were well-born and had independent incomes.

The only one to gain serious recognition also seemed to be the odd man out, being of neither noble birth nor independent means. Jean-Louis Forain had little interest in sporting scenes. His themes, like those of Edgar Degas, whom Henry was yet to meet, were social realism: dandies, horses at the racetrack, scenes from courtroom trials, stage productions, and the world of nightlife: dancers, actresses and *demi-mondaines*. Forain, of all the artists in the *cité*, in the long run would have the strongest influence on Henry's subject matter.

Born in Reims in 1852, Forain was best known for his skilful, humorous illustrations in the periodicals where Henry himself would later publish his drawings. His fame as an ironic and witty caricaturist, who signed his work 'Zut' (Phooey), grew as much from the way he treated his subject matter as from the fluid quality of his line. His chosen target was the manners and morals of contemporary society, and he attacked the hypocrisy and petty meanness of the middle classes with bitter humour and spare, powerful drawings so strong that he became his generation's successor to Honoré Daumier. He had been extremely poor at the beginning of his career and was well known for the bitterness of his personal as well as his artistic manner.

Alphonse apparently was friendly with Forain and owned some of his work, which he admired greatly. By one account he was supposed to have saved Forain's scanty personal possessions from being seized for non-payment of debts. Although Henry's mature style bore no resemblance to Forain's, he was greatly impressed by the older man's economy of line and rebellious, often ribald irreverence for the pretensions of respectable people.

Three months after he returned to Paris – in March 1882 – the final decision about Henry's art training was made: he would apply to study in the studio of Léon Bonnat, one of the most famous portrait painters in

France, and also apply to the Ecole des Beaux Arts in order to enter its competitions while working at Bonnat's. Bonnat had painted an important portrait of Victor Hugo after he returned from exile in 1879, and he would be called to Victor Hugo's home again on 22 May 1885, to paint the great novelist and national hero on his deathbed.

Monsieur Bonnat, as he was always called, was known as 'the favourite painter of millionaires'. His artistic success had come early and easily. In 1882 at the age of forty-nine, he had already received the highest honour an artist could earn in France at the time – he had been made a member of the Institut de France. He had also been awarded the Grand Cross of the Légion d'Honneur and was commissioned by the government to paint 'Republican statesmen and positivist philosophers'. This immense fame had led him to feel very pleased with himself. As a personality, he was rigid, profoundly conservative and egomaniacal although capable of joviality and even joke-telling when he was among people he considered his equals. Short in stature, he wore built-up shoes, held his head unnaturally high and, when he spoke, bellowed in a strong southern accent unchanged by twenty-five years of living in Paris. He spent a large part of his impressively large income on his personal collection of art, which he later bequeathed to the museum in his home town of Bayonne.

For twenty years from about 1870 to 1890, a portrait by Bonnat ranked with a dress by Worth, a hat by Virot, shoes by Hellstern, sweets by Boissier or a dinner at Voisin as a prestigious example of conspicuous consumption.

Bonnat had far more requests for portrait commissions than he would accept. 'If you want to be painted by Bonnat,' wrote one of his con-temporaries,

it is necessary to prepare yourself by prayer, fasting and every conceivable kind of austerity, for a portrait by Bonnat is a serious matter. Then, when you are thoroughly soaked with the importance of the step you are taking, you order a 'portrait-by-Bonnat' dress – there are special styles approved by him. Get yourself recommended by a general, a minister or an ambassador, and then and only then will M. Bonnat consent to paint you, standing stiff as a board, bright as crystal and lit from above.

Bonnat was an academic painter *par excellence*. His work was austere and considered impeccable by the standards of the Salon des Artistes Français. He was not interested in innovation. As far as he was concerned, the canonic conventions of Beaux Arts training – the rule of three (to calculate proportions), precise draughtsmanship and technical accuracy – were the

bastions of real art. His loyalties were to the traditions of French painting. He considered the Impressionists, whose first exhibition had been held eight years earlier in 1874, to be 'humbugs and revolutionaries' – upstart frauds and troublemakers who were trying to discredit the good name of art.

Adèle wrote excitedly to her mother about the prospect of Henry's studying with Bonnat:

He's Madame de Gironde's favourite artist, and it seems to us that Henry will have more advantages and fewer inconveniences working with him than at the Ecole des Beaux Arts. Moreover, he can always change if things don't go well. Be sure to pray for us, Maman, at this important time which could decide the future of your grandson. He seems to me to be eager to set to work seriously. We've been to ask Notre Dame des Victoires for her blessing.

Although Princeteau agreed to visit Bonnat to discuss his young protégé, the real decision about Henry's training had been made by Henry's parents less on artistic than on social grounds. Through Ferréol Roudat, an Albi goldsmith who frequently made jewellery for the family, Henry's parents had met an Albi banker named Rachou, whose younger brother Henri had been working in Bonnat's studio for a couple of years and was one of his favourite pupils. It was Henri Rachou, a 'known quantity' of good family, whose character and background they had been able to establish and who would subsequently become one of Henry's closest friends, who actually arranged to have Henry introduced to Bonnat. This social wariness may have been reciprocal. As Bonnat's southern origins and snobbery were almost as great as those of Henry's family, it is possible that Rachou also used Henry's Toulouse-Lautrec pedigree to guarantee his entry into the high temple of Bonnat's studio.

Adèle's report of the first meeting gives some detail about what was involved in entering the atelier of a great master:

On Monday, Princeteau went to meet the great painter Bonnat, and on Tuesday morning, Henry, greatly moved, was accepted into his atelier as a pupil. He had been asked to bring some samples, if not of his talent, at least of his aptitudes, and Princeteau had chosen the portrait of Germaine. Who would have believed that the little puppy would do her cousin such a favour? Because of the holidays, Henry won't begin at the atelier until after Easter. He's not too upset since he's already spending most of his time at Princeteau's studio, and the neighbouring artists encourage him and lend him their models.

Henry's account to his Grandmother Gabrielle quoted Bonnat's reaction to the portrait of Germaine 'sucking her thumb. The Master stared at the perpetrator and the work, and said to me, "Have you done drawing?" "That's the only reason I've come to Paris." "Yes," he said. "You have some sense of colour, but you would have to draw and draw." '

Henry spent the Easter holidays planning enthusiastically for the beginning of his studies. 'It seems that Bonnat's atelier is composed exclusively of young Americans,' his Aunt Odette wrote to her mother in a wry tone. 'At least my young nephew is a native and can immediately begin getting to know his way around.'

Just before he was to start at Bonnat's, Henry, his mother and his cousin Louis all were hit by the flu that was epidemic in Paris that spring. Henry's bout kept him in bed ten days and left him with a terrible cough. Consequently Adèle delayed his entrance into the atelier by a week. Ateliers were notably unhealthy places. Large, draughty rooms with high windows and no insulation, they were crowded, sometimes with thirty or forty young aspirants at their easels. Usually the atelier was badly heated by a coal-burning stove whose metal chimney, rising through the centre of the studio, might glow red-hot, radiating heat violently to those seated near to it, but hardly reaching the far corners of the room. In addition, they were filled with the fumes of paints and solvents, the dust from charcoal and coal and the hunks of soft white bread the pupils used to erase their drawings.

A new arrival at the hotel had caught Henry's attention: by improbable coincidence, another deaf-mute artist, this time an American named Harry Humphrey Moore, who had just arrived from San Francisco via Japan. He was accompanied by a huge collection of Japanese *objets* and a young American art student named Watson, who joined Bonnat's atelier the same day as Henry, 17 April 1882. Tradition held that the newest student in an artist's atelier be subjected to a certain amount of public humiliation and sometimes even physical trials, but the fact that two boys came in together, in combination with Henry's support from Rachou, who may have prepared his fellow students for the unconventional physical appearance of their new comrade, eased the transition.

Henry had begun his career as an artist, and as Princeteau commented in a letter: 'He is very proud, and ecstatic to be free in the world of art.' He was eager to work seriously and determined not to get discouraged by difficulties. At least the initiation was over, and Adèle wrote in relief to her mother: 'all in all it was limited to a lot of off-key singing around the newcomers, who had been hoisted up on high stools, and a big punch, which they paid

for. Henry and Mr. Watson leave every morning at a quarter to eight, full
of enthusiasm. Since there are two models a day, this week Henry chose
the one who poses in the morning. But the studio is so far away that he
eats lunch in a restaurant before coming back. Today he'll stay there all
day.'

The new atelier represented much more than just art lessons for Henry.
Now that he was going to Bonnat's, Henry felt the thrill of having an
experience that was entirely his own. The atelier was, he announced, off-
limits to anyone but Bonnat's students. No one from his family could go
there.

Superficially, the change in his level of independence was not apparent at
first. Henry still lived with his mother at Pérey and still went off early every
day to paint. He spent frequent afternoons with his cousin Louis Pascal,
attending prestigious sporting functions. Princeteau, who loved such things

Léon Bonnat, Le Vieillard,
c. 1882.

as much as they did, sometimes took them with him to the races at Chantilly or at Auteuil. That spring Henry was even allowed to follow one of the Duc d'Aumal's famous hunts at Chantilly in a carriage. In his work at home, he was still using Princeteau's training, painting small canvases of horses. Princeteau, whenever he was in Paris, stayed at Pérey, and they saw each other daily, even eating dinner *en famille* at the hotel or in restaurants, accompanied by Adèle. 'Princeteau is truly Henry's godfather as far as artistic life is concerned,' Adèle enthused. 'He's perfect for him.' It was as if she hadn't noticed that Henry was no longer going regularly to Princeteau's. Although Bonnat's studio was less than a mile from Princeteau's, to Henry they represented two different worlds: the world of his parents and the world he was going to make his own.

Adèle may have needed to believe that Princeteau continued to play his role *in loco parentis* as her son came under the dangerous influence of

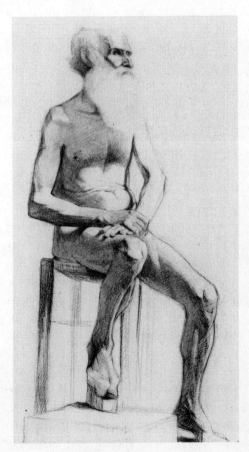

Henry's académie of an old man,
c. 1882.

bohemians and artists, but Princeteau's dominion was becoming more and more tenuous. Now that Henry was no longer his pupil, the two artists became more like friends.

'There is so much to see,' Henry wrote to his Uncle Charles that spring about the art exhibition at the Exposition Universelle, 'I'll mention the Portrait of Puvis de Chavannes by Bonnat, the Fourteenth of July Holiday by Roll, the last moments of Maximilian by J-P. Laurens.' Although he did not mention Manet's famous painting *Un Bar aux Folies-Bergère* in the same exhibition, ultimately Henry's work would be far closer to Manet than to the academic artists he seemed to favour in 1882.

That March, the seventh exhibition of the Impressionists had opened at 251, rue Saint-Honoré, just three blocks from Pérey and a block from Princeteau's studio. Like their first, in 1874, and the five following, it was greeted with outrage from 'official' painters such as Bonnat, ridicule from the public at large and intense interest on the part of a growing minority of admirers, who took pleasure in making their viewpoint public.

Is it possible that Henry chose not to see the works of the controversial artists? There is no question that Bonnat would have considered a visit to their camp a mark of absolute heresy. Henry would later learn that his fellow students had already been slipping off to investigate the new art movement, but his own work from that year shows no such influence. He dutifully copied the live models and plaster casts Bonnat provided, creating sombre charcoal drawings where the emphasis was on perspective and not on fluidity of line. His paintings became far darker than the works he had done with Princeteau, and his drawing, although more accurate and less sketchy, was also far more stiff. The works, which show a lack of confidence and a struggle to exert control over the medium, reflect a conflict that working at Bonnat's had created in him. He needed to do two things at the same time: to acquire artistic discipline and to adapt to sudden freedom in his other activities.

As he pulled his crippled legs into a horse-drawn cab each morning to go from the fashionable rue du Faubourg Saint-Honoré to the studio in proletarian Montmartre, he entered his 'other life'. Both the privileges and the controls imposed by being a Toulouse-Lautrec abruptly lost their power.

Psychologically and sociologically, Montmartre was a total liberation from the constraints of life with Adèle. Bonnat's *atelier libre* in the Impasse Hélène was not far from the Place de Clichy, where dance halls and cafés attracted the art students when they had finished their work. The atelier provided models, and students generally paid by the class. Henry, on his own for the first time in his life, came and went as he pleased, ate lunch with his friends

from the studio and could even go out with a bunch of fellow *rapins* (art students) to a café for a drink at the end of the afternoon.

Montmartre was not like the rest of Paris. Although the village had been legally incorporated into the city limits in 1860, it retained its own identity. This was due partly to its location, on a steep hill which isolated it geographically from the flatter parts of Paris, and partly to the fact that the rocky hillside was hard to build on and had only five springs of fresh water, making it of little economic interest to the city at large. To the visitor, it felt like a trip to the country, for the hillside was covered with tangled undergrowth and dotted with windmills, gardens and vineyards. In fact, Montmartre was so separate from the rest of Paris that until 1871, Parisians had to pass through a gate and pay a toll in order to enter the area.

Unlike much of Paris, which was still rigidly bound by social barriers and codes of politeness and dress, Montmartre was a stronghold of bohemianism. Previously it had been notorious as the most dangerous village in the region, known for at least three hundred years as a place where illicit activities and riotous dissipation were tolerated. It was used as a hideout by criminals of all sorts. For generations it had been subjected to attempts at police regulation to control the drunks, prostitutes and outlaws who flourished in its taverns. At various times it had been illegal for Montmartre's taverns to have cards, dice or gambling paraphernalia, to sell drinks to inhabitants of the village or to stay open after eight o'clock in the evening. One law even prohibited public houses from having a back door – presumably to facilitate police round-ups of the criminal element. In the eighteenth century, at one Montmartre tavern there were ten murders in a single week, and respectable citizens avoided the village entirely, forcing some of the thieves and pick-pockets into retirement for lack of victims.

Towards the end of the eighteenth century, Montmartre subsided into quiet village life. Most of the worst dens were closed, and the few dance halls and bars that survived were neighbourhood haunts, unknown by outsiders. When Baron Haussmann modernized the rest of Paris, it was not touched. It had almost no paved roads, just steep dirt footpaths. The buildings were small and low. Plumbing consisted largely of outhouses and water carried home in buckets. Heat was from fireplaces and wood or coal stoves. The inhabitants were some of the poorest people in Paris, gleaning a meagre living, when they found work, as factory hands, day labourers and market gardeners.

It was only in the late 1870s, shortly before the time that Henry began working at Bonnat's, that the artists, poets and musicians, whose traditional

hangouts had been Montparnasse and the Latin Quarter, began to migrate to Montmartre for the cheaper rents. Montmartre's briefly working-class base was again losing its homogeneous quality; the isolated, unpoliced hillside again began attracting illegal and socially subversive activities, particularly prostitution. In the scaffolded shadow of the unfinished domes of the Basilica of Sacré-Coeur bare-headed, shawl-clad streetwalkers could be had for a few *sous*, or sometimes just by giving them a place to sleep overnight. Bars and dance halls opened everywhere and quickly came to cater to a growing population of bohemian artists and writers who had moved to the neighbourhood to get away from the stifling, bourgeois domination of the rest of Paris. The unsupervised, rundown atmosphere of the *butte* was a major factor in attracting bohemian elements, but in a predictable reversal, the cafés which opened to serve them also began to draw in an element of the despised bourgeoisie, attracted precisely because the area was forbidden territory, slumming with the seamstresses and *apaches* (slang for street thugs who wore a characteristic costume of striped sweater, bandana and beret) in the cabarets and dance halls. Such nightspots became a melting pot of the least and the most fashionable, elbow to elbow. Henry and his fellow student artists, for example, who were mostly of affluent and upper-middle-class background, mixed happily with the working-class and unsavoury population. Henry, possibly looking to shock, described it to his Grandmother Louise as unsafe for his mother, 'a neighbourhood which retains its cut-throat character. Friendly jokers attack women alone and empty ink down their ... necks. It's in charming taste.' Henry's Uncle Odon was aware that his nephew appeared to be rejecting his own social class, and wondered if it were wise: 'Henri is rarely around,' he wrote to Henry's other grandmother, 'since he spends his life at the atelier in a neighbourhood not often frequented by people from our world. Will a true talent be revealed by this?'

Henry was captivated by Paris, partly because for the first time in his life he had many friends – not just his cousins, but young men his own age, with whom he had in common the excitement of art and of Paris, a passionate interest in their own work, the sharing of models and tools.

Before he had gone to Bonnat's he had very little experience of people outside his family: just a few boys in school and his friendships with boys as crippled as himself, Etienne Devismes and Charles Castelbon. But now he was suddenly a member of a group of young men who worked together at Bonnat's every morning and frequently gathered, two or three together in the afternoons, to work in one artist's garden or another's studio space. And

what joined him to them was not family or illness, but his work: he was a legitimate member of a group united by conviction and commitment.

The studio was his 'other' family – a family consisting only of brothers, for women who wished to work in an atelier were obliged to meet separately from the men in special sessions at the Académie Julian. The experience was not only exhilarating but curiously reassuring. Henry quickly learned, for example, that some of his fears of rejection could be forgotten. Despite his physical limitations, his shortness and the overall peculiarity of his looks, he quickly captured the favour of many of his comrades, his wittiness and exuberant good humour going far to compensate for his oddity.

Soon he was something of the studio comic, leaping onto the high stool he called his 'donkey' each morning like a cowboy two-handedly mounting his horse from behind, playing practical jokes with everyone else, joining in loudly to sing the bawdiest songs. More important, he was serious about his work. His fellow art students could see that in spite of his handicaps, his wealth, his snobbish name and his aristocratic manners, he took his art more seriously than anything else in life.

An art student at Bonnat's traditionally began with drawing – painstakingly copying engravings, particularly of individual parts of the human body (ears, feet and the like), proceeding to drawing whole heads and figures, and finally to drawing from plaster casts. When the young artist had acquired enough skill, he moved on to *académies* (figure drawings from nude models in classic poses), and finally to painting. Henry's fellow students watched him struggle, as he copied antique and Renaissance works in the atelier, to render the classic proportions and rigid perspective Bonnat required in academic figure studies and portraits. Where skill was concerned, Henry was eager to push himself to perfection. Adèle worried. 'Henry is working frenziedly and tires himself out with this constant activity,' she observed.

Henry hadn't in the least lost his enthusiasm for art, but it was hard making the transition from pampered invalid whose work had already been much complimented to being just one boy among others. It must have pained him to admit to Princeteau that Bonnat had said, as Princeteau later reported to Adèle, that 'his painting was peculiar in colouring. He also told him that he drew like a child.' Henry faced Bonnat's criticisms bravely and made no attempt to hide his difficulties from his family. 'I am certainly not regenerating French art,' he wrote to his Uncle Charles, 'but am struggling hard to accomplish something on an unlucky piece of paper which has done me no harm at all, and on which, believe me, I am doing nothing that is good

... I hope things will improve eventually; as it is I am pretty wretched.' Despite the excitement and the discipline of the studio, which he approved of and worked hard to follow, this life was very unfamiliar to him. And there were problems.

Bonnat was cold and aloof by nature and had taken an instant dislike to Henry. He hated what might be called Henry's looseness: not his appearance or manners necessarily, but the lack of rigour and the free-flowing character of his line. 'His haughtiness prevents any questions,' Henry wrote to his Uncle Charles in another letter. 'Would you like to know the kind of encouragement Bonnat is giving me? He says: "Your painting isn't bad, it's very *chic*, but all in all it's not bad, but your drawing is downright atrocious." So you have to pluck up your courage and start again – and get out the bread crumbs!' He illustrated his comments with a little cartoon showing himself and Bonnat. Bonnat developed such an aversion to the younger painter and his work that many years later, after Henry's death, when the Friends of the Luxembourg Museum acquired one of Henry's portraits, *Léon Delaporte au Jardin de Paris*, Bonnat was instrumental in convincing the museum to reject the donation. A member of the museum council later wrote, 'Bonnat exhibited a kind of personal hatred for Lautrec: whenever his name was mentioned ... Bonnat flew into a rage.' The portrait is now in the Ny Carlsberg Glyptotek in Copenhagen.

Although he could not manage to please Bonnat, Henry was working hard and learning a lot. At least he knew that if his teacher gave him a compliment, it was because he deserved it. Henry seemed to appreciate this toughness.

That first year, Henry made three lifelong friends who would expose him to a new world of artistic ideas and to a new lifestyle. All were students at Bonnat's: Henri Rachou, Louis Anquetin and Albert Grenier.

Rachou was also a friend of Princeteau's. As the one who introduced Henry into artistic life, Rachou felt responsible for the younger, and distinctly more eccentric, painter. He himself was accepted by Bonnat and later would become the *massier* or chief assistant in Cormon's studio, to which he and Henry moved later that year.

Later Rachou described his friend in the following way:

His most striking characteristics, it seemed to me, were his outstanding intelligence and constant alertness, his abundant good will towards his devoted friends and his profound understanding of his fellow men. I never knew him to be mistaken in his appraisal of any of our friends. He had remarkable psychological insight, put his

trust only in those whose friendship had been tested and occasionally addressed himself to outsiders with a brusqueness bordering on asperity. Impeccable as was his habitual code of behaviour, he was nevertheless able to adapt it to any milieu in which he found himself. I never found him either over-confident or ambitious. He was above all an artist, and although he courted praise, he did not overestimate its value. To his intimate friends he gave little indication of satisfaction with his own work.

Rachou had already been at Bonnat's for a year. Louis Anquetin, three years older than Henry, began the same spring that Henry did. As Henry and Anquetin became friends, Anquetin took Henry under his wing, protecting him from the humiliations that might otherwise have made the gross verbiage and brutal hazing typical of *rapins* an unendurable torture.

In return Henry developed an exaggerated esteem for Anquetin, whom he nicknamed 'Mon Grand' (big guy). Anquetin was everything that Henry was not: tall, strong, almost handsome, and overbearingly self-confident. 'All teeth and curly locks', standing nearly head and shoulders taller than most of the atelier students, he was said to resemble Michelangelo. As an artist, he received early recognition, showing in the Salon des Indépendants in 1883, and during his early years in Paris it was generally conceded, even by his masters and fellow students, that he was an innovative and imaginative painter. He did very successful works in the Impressionist, Pointillist and later the Cloisonist modes but did not follow any school of painting for long. Despite a striking facility with both line and colour, the quality of his work was inconsistent and frequently derivative, particularly as his friends advanced and he did not. At the beginning, Henry admired him greatly, believing that Anquetin's imitations of Impressionist landscapes showed true artistic genius and were far better than his own work. Around 1886, Anquetin did an oil painting of Henry in the Impressionist style and several drawings of him. His work remained interesting for a few years, but after 1893 he produced little of significance, devoting himself to what he called '*le retour au métier*' (the return to craftsmanship), imitating and supporting the work of Peter Paul Rubens. Nonetheless, Anquetin was a most appealing comrade, passionate about his work and about life, happy to play, to laugh, to seduce women, to feel intensely, even intensely sad. Henry and Anquetin formed the core of a band of friends who continued to spend much time together for more than ten years.

The third important friend Henry made in Bonnat's studio was Albert Grenier, a rich, easy-going young man whose parents had wanted him to be

a boat-builder, but who instead had decided to take up painting. His work, apparently 'an abundant production in a luminous, realistic Impressionist style', is difficult to find, which makes it difficult to judge his talent, but he had a significant influence on Henry's beginnings in Paris, for he and his pretty girlfriend, whom everyone knew as Lili Grenier, opened their home to Henry and other students at Bonnat's, creating an atmosphere of play and camaraderie which made them the headquarters of this close group for several years.

Adèle and Alphonse, far away in the fashionable part of Paris, lived as usual, apparently unaware of how different Henry's existence was becoming. For the time being, they were both at Pérey, going out as a couple, making their rounds after dinner in the carriage which Alph had brought, along with his horses, from Orléans, leaving their calling cards at the doors of family and aristocratic friends, having tea in elegant salons, attending formal dinners and receptions several times a week.

Alph rode daily in the Bois de Boulogne, joining the crowd of horsemen and horsewomen every morning and often returning to the Bois in the afternoon, in a carriage, to see and be seen in the procession of elegant horse-drawn vehicles – coupés, dog-carts, landaus, broughams, phaetons and victorias – that paraded through the Allée des Acacias so the stylish wives and mistresses of the fashionable and aristocratic could show off their dresses and the expensive harnesses of their beautifully matched teams.

At the end of each day Henry, his hands and usually his face covered with paint, plaster and charcoal from the atelier, hung up his filthy work clothes and returned dutifully to the Hôtel Pérey, where he bathed and, once presentable, dined and usually spent the evening with his parents. As Adèle was perpetually worried about bad influences on Henry in the studio, he carefully restricted his comments about his artistic life to what he wanted her to hear: 'Henry naturally has a lot to say about his new life, which he is taking more and more seriously. If you take his word for it, he needs to be in Paris year-round, and since he's right from a lot of points of view, I'm afraid our holiday is going to be very short. Bonnat wants to get rid of most of his students, and to manage to be one of the chosen few is going to take a lot of hard work.'

Adèle was wary as she saw Henry planting the seeds of more independence. Although she complained about the sacrifices required of her by his career, she had no intention of leaving him in Paris alone: 'Henry is more and more involved in his vocation, and received compliments from the severe

Bonnat and from his assistant Ferrier. I cannot refuse to let him come back in October, but how short our holidays are going to be!'

In the end she refused to listen to Henry's requests to stay in Paris to work on his artistic projects, and around the middle of July insisted on taking him off to the despised Lamalou-les-Bains, where he and Madeleine had been utterly unhappy the preceding summer. Apparently the decision to have Henry submit to a check-up with the Lamalou doctor was her own. 'Dr. Privat finds us both so healthy that he considers our season at the spa to be merely a wise precaution. Henry is delighted [to hear it], for he had bragged that he would make him admit as much. Since the doctor has promised to find him a perfect example of a drunken *clochard* [tramp] to paint, my son is bearing his misfortune patiently.'

Painting the locals was Henry's favourite occupation that summer, reflecting his new awareness of the Naturalist movement in literature and its artistic counterpart, Social Realism, which tended to focus on the lowest members of the social hierarchy. The minute he got back to Le Bosc from Lamalou, he set up his studio and began getting colourful models from the nearby countryside to pose for him. His first model was the 'shrimp woman'. 'A fine type to reproduce,' chided his Grandmother Gabrielle, irritated by his adolescent liberalism. 'It's she who's going to be astonished when she finds out what we want of her.'

Being 'home' was so totally different from his newfound existence in Paris that it is no wonder that Henry took refuge in his painting. It was one means of keeping his priorities in perspective. The accumulation of domestic details which were the focus of life at Le Bosc slowed the pace of existence to the minute scale of a world where only family and farming mattered. Since the death of his grandfather, Grandmother Gabrielle had developed into an able manager of the property and the tenant farmers who worked it, but at table there was talk of little else.

To make things worse, it rained so much that everyone had to stay in. Henry managed to get his Uncle Amédée to pose for him, along with the shrimp woman again and Miquelou, the child of a neighbouring tenant farmer, who wriggled all the time. Henry, disgusted, persuaded Pierre the huntsman to pose next. Since there wasn't anything else to do, everybody hovered in the studio Henry shared with his Uncle Charles to watch: 'Henry studies every head he encounters, looking for willing models, paying them an average of 75 centimes per sitting. Kiki will no doubt pose for him,' said Grandmother Gabrielle.

At the end of the summer he had painted and drawn a quantity of

portraits, not only of his paid models, but also of anyone in his family or anyone working at the château whom he could persuade to pose: his mother, both his grandmothers, Uncle Charles, Uncle Amédée, and various cousins. His charcoal portraits of family members particularly showed the effect of his new training. The figures are in studied perspective and the volumes are clearly indicated and stand out with shading. The likenesses are good when compared to family photographs but feel stiff and lack any indication of the vitality of the models. The paintings are heavily shadowed and dark, using academic chiaroscuro techniques.

While Henry painted, the rest of the family was wrapped up in the division of property. The near certainty that phylloxera would destroy the vineyards at Ricardelle, a property long owned by Henry's parents, had led his Grandmother Louise to offer to buy another property elsewhere for her daughter Adèle. Alphonse, for his part, had decided to give up his hereditary right, as the eldest son and heir to the title of the Count of Toulouse-Lautrec, to the Château du Bosc. Instead, Alph sold Le Bosc to his sister, Henry's Aunt Alix, who, with her husband Amédée, had been trying to buy it from Alph since at least 1865. Although the sale was logical, for Alix now had ten children and lived all year round in the region, while Alphonse no longer wished to live on the property, preferring his hunting lodge, the decision contained a hidden barb. Legally, the Château du Bosc, when Alphonse decided to give it up, should have gone to Henry. And although eighteen-year-old Henry had already made the decision to live and work in Paris, this act felt like a betrayal to him, particularly because, even though Alphonse was usually elsewhere, Henry and his mother continued to live at Le Bosc nearly every summer, and Adèle in particular was strongly attached to the place.

Part of Henry's sense of hurt must have been that he was not even told of the decision at the time. It was only later, in 1884, that he learned that Le Bosc was considered someone else's home and that henceforth he would always be a guest: 'Papa finally told me that Le Bosc was my Aunt's and that we were out. You know my opinion on the subject. Useless to keep repeating it.' The hidden lesson of Alphonse's disinheriting him was not lost on Henry: by selling the property that should have been his, his father had symbolically rejected him.

Henry's expectation had always been that at Alphonse's death he would in turn become the Count of Toulouse-Lautrec. The inside front cover of one of his childhood sketchbooks contains numerous practice signatures, including, in letters so tiny it takes a magnifying glass to read them, the words 'Monsieur le Vicomte' – Henry's official title until he should become

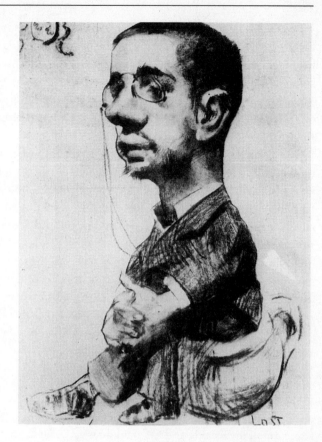

Self-caricature in
charcoal, signed 'Lost',
1882.

count. But around this same time Alphonse began trying to persuade Henry to use a *nom de plume*. He seemed particularly concerned that the glorious Toulouse name not be 'misused' by his son, whose art he possibly already found suspect.

A number of Henry's portraits from the summer of 1882 are signed not 'Toulouse-Lautrec', but 'H.T.L. Monfa'. At least one – a caricature of himself sitting on a chamberpot – is signed 'Lost', a bilingual pun based on the name Toulouse, 'to lose', and quite probably a comment on how it felt to be denied use of his name. These were the first of a series of pseudonymous signatures Henry would try out over the next few years.

That summer of 1882 removed Henry's last illusions about being the pride of the Toulouse-Lautrecs. He was forced to confront the difference between their lifestyle and the life he had already chosen. Although the choice was his, he was obliged to recognize that the family was ambivalent about his choice. Adèle and Alphonse had encouraged him to study art and to take it

seriously, but it was slowly dawning on them that he might not simply paint fashionable pictures as a pastime, and it never occurred to them that he would become a world-class artist. A man who devoted himself uninterruptedly to succeeding as a skilled craftsman was an embarrassment to a family for whom the only acceptable career was the military, diplomacy or managing one's estate. That the trade he had chosen was a bohemian one only made matters worse.

For their handicapped child to show strength of character, and above all to insist upon leading a life of his own, was to reject their wisdom, traditions and good will. And even that summer, although no one was yet admitting to Henry that he was out of the entail in terms of the family property, he surely sensed that something was going on and wondered why he felt so much in disfavour.

In the middle of his holiday, Henry received the news he had been fearing. Bonnat had been named a professor at the Ecole des Beaux Arts and had decided to close down his own teaching atelier completely. Although he possibly took a few selected students to the Ecole des Beaux Arts with him, Henry was not among them. Henry immediately wrote to his father to let him know:

My dear Papa,

Bonnat has let *all* his pupils go. Before making up my mind I wanted to have the consensus of my friends, and by unanimous agreement, I have just accepted an easel in the atelier of Cormon, a young and already celebrated painter, the one who did the famous *Cain Fleeing with his Family* at the Luxembourg. A powerful, austere and original talent. Rachou sent a telegram to ask if I would agree to study there along with some of my friends, and I have accepted. Princeteau praised my choice. I would very much have liked to try Carolus, but this prince of colour produces only mediocre draughtsmen, which would be fatal for me.

And after all, it's not as if we were getting married! And the field of masters is hardly used up.

We're about to leave for Respide, where we expect to stay only a few seconds if I am going to get back to work again. In my search for success, it would please me to have your approval on a choice which is based, not on any prejudice, but on serious considerations.

It is obvious that Henry had no intention of permitting Alphonse to keep him from doing what he wished. Although his letter is polite and he asks for his father's approval of his decision, the decision has already been made, and

there is no hint that it might be reconsidered. He needn't have worried. In Alph's eyes, Henry was taking no artistic risks. Fernand Piestre, known as Cormon, was no Impressionist. He was a very successful academic painter, nearly as well known for being a good teacher and for producing good artists from among his students as he was for his own art. The painting Henry had referred to, which illustrated a verse in Victor Hugo's epic poem, *La Légende des Siècles* (The Legend of the Ages), had been exhibited in the 1880 Salon des Invités of two years before. Acceptance into this annual exhibition of contemporary art was the official mark of success for a painter. That year, Cormon's painting had been considered one of the finest in the Salon, leading the French government to purchase it.

Oddly, despite Henry's decision to continue his studies at Cormon's, rather than returning to Paris promptly in the autumn he stayed at Respide, the Pascal cousins' country estate near Bordeaux, until two months after Cormon's atelier opened. Adèle obviously did not feel it was important for Henry to hurry back to his art training and may even have intentionally provoked the delay: 'Henry is having so much fun that he's practically forgotten the atelier – particularly since he's been assured that his easel is waiting for him at Cormon's.'

When they finally decided to go to Paris, near the end of November, Henry did find his easel waiting for him, along with many of his friends from Bonnat's. Thus he already felt like one of the boys. In fact, it was Cormon who in some ways was the newcomer, for although he had trained numerous students, he had never opened a formal studio before. Anquetin and Rachou, along with other students from Bonnat's, had persuaded him to take the risk by accepting all Bonnat's pupils who wished to come.

Cormon's atelier was located at 10, rue Constance, not far from where Bonnat's atelier had been. Henry adjusted quickly to the change. Cormon, younger and more personable than Bonnat, belonged to a more liberal and popular group of painters who were known as the *juste milieu*. Its painters combined elements of the academic and the avant-garde so as to appear both solidly founded and fashionable. Almost all the radical Impressionist painters had come from the strict tradition of academic training. Despite their development of revolutionary artistic theory, they had not abandoned all traditional concerns, which meant that Henry and other art students of the time probably did not perceive the Impressionists as an abrupt break with what the young artists knew. In painters from the *juste milieu*, they could easily see the influences of both Impressionism and academic painting.

Cormon, to his credit, had developed an artistic domain all his own. He painted great biblical and historical tableaux, based on preparatory drawings from life, posed in his studio. Now he was working his way back in time from the Old Testament to prehistory, painting landscapes peopled by pretty adolescent models dressed in animal skins and working with primitive tools. His students had nicknamed him – probably as much for his emaciated, bony appearance as for his scientific, even archaeological fascination with prehistory – 'Père la Rotule' (Daddy Kneebone). They liked him very much. He was straightforward and unaffected, and he loved to joke around. Although he had won a number of medals and honours, he refused to take his status seriously. The day he received the Légion d'Honneur, the highest civilian award given by the French government, he took a toy sword and led a parade of his friends and students through the streets in the rain, protected from the damp by a student holding an open umbrella over his head.

On Friday, 1 December 1882, Henry penned a report on life at Cormon's to his Uncle Amédée:

Here we both are, back to business once again – you with your inventions and me with my plumb line. My affairs are chugging along pretty well. Cormon seemed happy to take me in. My drawings pleased him most, particularly (excuse my saying so) Odon with his hands in his pockets, otherwise called *Raou plaou plaou* [presumably a funny nickname]. Princeteau had preferred *The Bat*, and Rachou, *Uncle Charles* leaning on a table ... My new boss ... often drops in on us and wants us to have as much fun as we can painting outside the studio. I still haven't seen Bonnat. I wonder if I ever will!!!! Since I already knew all my fellow-students, there's been no initiation.

He ended his letter with his usual slightly impertinent charm, saying 'I shake your hand majestically by the forefinger'.

Henry now spent every morning with thirty other young men, painting in Cormon's atelier. According to one of Henry's fellow students Cormon's atelier held an assortment of eclectic props for students to draw and paint, including armour, all kinds of fabrics and embroideries, a variety of copies of old masters on the walls and even a gold Buddha. Twice a week Cormon himself would appear and go from easel to easel, criticizing each student's work. He particularly seemed to like the work of Henry's friend Anquetin and even hung some of his paintings on the walls of the studio.

It was not so easy for Henry to find a new mentor. Already rejected by Bonnat, Henry, perhaps to make the separation easier, had himself openly

rejected Princeteau's influence. Although he still sometimes worked at Prince-
teau's atelier in the afternoon, he made fun of his former teacher's frailties to
friends from Cormon's, saying: 'Princeteau is a deaf-mute, but he doesn't
want to admit it ... He's very proud of being able to talk, and makes fun of
other deaf-mutes. He's charming, but his painting is old-fashioned.' As late
as 1885 he was still making disparaging comments about Princeteau to his
mother, observing that Princeteau had 'become a hypochondriac, but very
sweet all the same'. By being negative about Princeteau Henry may have
eased his guilt about moving beyond his mentor, since, if he was a 'bad'
protégé, his mentor was better off without him.

However, Henry had only been at Cormon's a month before he began to
have misgivings about the quality of the teaching he was receiving there.
When he wrote to his Grandmother Gabrielle at the New Year, he told her
that he was working hard morning and evening, but he was wondering if
he hadn't lost ground by switching ateliers. He had quickly realized that
Cormon was not demanding enough and that Bonnat, despite his bad temper,
had been a more useful teacher to him. He reported on his new environment
to his Uncle Charles:

I am getting to know Cormon, who is the ugliest and thinnest man in Paris. All on
account of necrosis. They even say he drinks. Cormon's comments are far milder
than those of Bonnat. Whatever you show him he warmly approves. It will surprise
you, but I like this reaction less. Indeed the lashes of my old master's whip put
ginger into me and I didn't spare myself. Here, on the other hand, I feel a little too
relaxed, and have to make an effort to produce a conscientious drawing when
something not quite as good would do just as well in Cormon's eyes. In the past
two weeks, however, he has shown signs of a new approach and has expressed
dissatisfaction with several pupils, including myself. So now I am hard at work
again.

Henry, proud of his new Parisian sophistication, also reported on the
exhibitions he had seen, showing by far the most respect for the 'official' Salon
des Artistes Français. He sneered at the other shows: 'The Watercolourists,
pitiful; the Volney, mediocre; and the Mirlitons, tolerable. You see that I clear
the deck with perhaps a little too much abruptness, but they don't deserve
anything better.'

Training at Cormon's, much like training at Bonnat's, focused on Renaiss-
ance laws of perspective, the use of classical pyramid composition of the
image, chiaroscuro shading and realistic rendering of the physical elements

portrayed. The formal stages of learning to paint, like learning to draw, went in precise order: copying heads from old masters, then portrait studies of live models, ending with full-scale figure studies. The technique which was emphasized in the training of novice painters was called the *ébauche* (sketch), a preliminary painting, usually of a head, which although it could be the base for a completed work, was most often considered a final work in itself. It was characterized by colour limited to earth tones and by areas of light and dark which were brushed in rapidly to emphasize the dimensionality of the work and the effect of the light, guiding the eye of the viewer through the general movement of the composition. Academic painters in general were preoccupied with absolute control over the scenes they were painting. They worked almost exclusively in their studios with grey north daylight, carefully planning the organization of space in their canvases, using either totally neutral or elaborately detailed background elements, and models who sat immobile for long hours.

However, Cormon was far more flexible than Bonnat in what he would accept as appropriate atelier painting style: 'Nothing can remain stationary in this world,' he said. 'Everything changes and must change. A school [of art], therefore, cannot stand still. It must be subject to transformation if it is to endure; and having regard to this fact, I consider it an excellent thing that each of us watches his neighbour, profits by his progress, seeks to correct his own weaknesses and to assimilate what may advantageously be absorbed.'

Since he had given them permission to explore, the *rapins* took their teacher at his word and worked as hard outside the studio as in. In addition to the training he provided by forcing his students to draw from classically posed models and plaster casts, he also encouraged them to work from nature, a method used by academic painters as well as the Impressionists, and, of course, to go to museums and exhibitions. Henry's friend Henri Rachou later documented this influence on Henry: 'He often accompanied me to the Louvre, Notre-Dame, Saint-Séverin, but, much as he continued to admire Gothic art, he had already begun to show a marked preference for that of Degas, Monet and the Impressionists in general, so that even while he was still working at the atelier, his horizon was not bounded by it.'

Henry's independence, possibly strengthened by his sense of entitlement as an aristocrat from a family with a tradition of eccentricity, kept him quite free as an artist. He welcomed classical training to acquire the skills he needed, and his work quickly began to show an expertise in perspective and draughtsmanship; but his need to establish his own sense of independent identity, both from his family and from his training, kept him from feeling

philosophically bound to observe the limits of classical taste, and he was intrigued, rather than annoyed, by accidental effects of light and movement. In his later work he would repeatedly focus, for example, on the bizarre distortions of his models' faces made by stage footlights.

Neither Henry's awareness of Cormon's limitations as a critic nor his original intention to study at the Ecole des Beaux Arts as well kept him from settling comfortably into the atelier. He ended up staying for five years. As he absorbed Cormon's teachings, his self-confidence and enthusiasm increased. Nothing could keep him from going every day to the atelier, a cheerful haven where he was sure of the friendship and respect of his comrades. 'His gaiety serves him as a passkey, at the atelier and everywhere else,' his mother noted.

When Cormon was not there, the studio was left under the direction of the *massier*, whose job it was to maintain a semblance of order. Often, despite the *massier*'s attempts to calm things down, the boys would behave outrageously, bragging about their sexual exploits, singing obscene songs at the top of their lungs and generally disrupting all atelier work. Henry, accustomed to his family role as gangleader and master of witticisms, threw himself into the uproar with a vengeance: 'Oh, how I should like to find a woman who has a lover uglier than I am!' he would yell. True to his style, he called attention to his ungainliness before others did it for him.

At the end of the day, Henry would hobble from the atelier down the curved rue Lepic, escorted by friends taller and stronger than himself, to explore the artists' bars springing up at the foot of the *butte*: La Grande Pinte, Le Plus Grand Bock or L'Auberge du Clou. He was becoming a connoisseur of alcohol. He liked to go in the twilight to *étouffer un perroquet* (literally: choke a parrot – a Montmartre expression meaning to down a glass of green absinthe, commonly known as a *perroquet*). Absinthe, a bitter liqueur made from the poisonous wormwood plant, was already known to be dangerous, but was only legally prohibited in France in 1915. It is ironic to see the parrot of Henry's childhood, his infant emblem for evil which had haunted his sketchbooks, reappear in the form of a liqueur – a symbol of his downfall. The image of the diabolical parrot and, by extension, the evil green of absinthe, seemed to have special importance for him, even in his art. He later said to a friend, 'Do you know what it is like to be haunted by colours? To me, in the colour green, there is something like the temptation of the devil.'

He was quickly gaining a reputation for being willing to taste anything.

He described the flavours of the 'American' cocktails which were growing fashionable in Paris by comparing taste to vision. They were, he said, better than the tail of a mere rooster (cocktail), 'like a peacock's tail in the mouth'.

'I would like to tell you something of what I am doing,' he said to his Grandmother Gabrielle in an undated latter which must have been written during his first year or so in Paris, 'but it is so special, so "outside the law". Papa, naturally, would call me an "outsider" ... I have had to make a great effort, since, as you know as well as I, I am against my will leading a truly bohemian life and am finding it difficult to accustom myself to this milieu. I am particularly ill at ease on the Butte Montmartre in that I feel myself constrained by a whole heap of sentimental considerations which I simply must put out of my mind if I am to achieve anything.'

It is sure that Henry did not make the change from aristocratic invalid to full-time artist without ambivalence, nor would he ever completely adopt the bohemian way of life. But the 'sentimental considerations' that he claimed limited him were probably related to guilt about upsetting his family. Although for the time being he continued to live with his mother at the Hôtel Pérey, he had begun using the studios of friends for his afternoon work. His decision not to work any longer at Princeteau's atelier represented a final break with his mentor's artistic influence, although the two maintained friendly relations and continued to go together to circuses and other performances. After some convincing, Adèle had agreed that Henry really needed a studio of his own beginning the next year.

Many of the men who studied in the atelier had rented their own work space in the cheap, run-down buildings of the *butte*. After spending the mornings at Cormon's they would hire models, usually young Italian girls they had met at the *marché aux modèles* in the Place Pigalle, and take them back to their studios for painting sessions that sometimes ended in orgies. Although at first Henry apparently did not participate in his fellow students' debauch, and there is no hard evidence as to his initiation into their activities, it is certain that within a very few years he was eagerly experiencing brothels, vulgar sexual displays in dance halls and scandalous art student balls. Full of his new decadence, he signed a letter to a friend 'La jeune pourriture' (the young rotter), but naturally he avoided discussing this part of his life at home.

In the winter of 1882 or spring of 1883, Henry produced one of the first paintings which showed a breakthrough from atelier training to a style of his own. This striking work, *Etude de nu* (Study of a Nude, Plate 1) in which the naked model, probably hired from the Place Pigalle, was posed still

wearing her black stockings, reflected the conflicts caused in him by incompatible needs and desires. Although posing a nude model in black stockings was part of the current mode in erotic art, Henry painted her in a way that rendered her minimally seductive – slouching, with one arm hiding her breasts and mouth. Her mixture of vulnerability, even shyness, and sensuality is typical of the ambivalent emotions about women that now began to characterize his work.

When was it that Henry was actually introduced to women as sexual beings? Having grown up in a household of women as pious and reserved as his mother, aunt and grandmothers, he had learned early that women were of two types: the women one could admire and women of the sort his father had somewhat indiscreetly favoured over his mother. Now that he was in Paris, he was confronted with the contrast. Cormon had three mistresses, and many of his fellow students at the atelier had seduced shopgirls. Nor would it take him long to hear from the other *rapins* that some of the models they hired were not particularly rigid about the circumstances in which they would take off their clothes. But he might naturally have been afraid of being rejected for his almost comical appearance or even for his inexperience. He knew that because of these, plus the risk of hereditary dwarfism, probably no woman of his own social class would choose him as a mate and that the chances of his making a conventional marriage were slight. Most boys in France at the time received their sexual initiation in a brothel, going there after school when they were fourteen or fifteen years old. But Henry had never really gone to school. By the time he was fifteen he was already permanently crippled, and he had always lived under the close supervision of his mother.

One of his friends at Cormon's later bragged that it was he who could claim responsibility for Henry's loss of virginity. It may well be true. If it did not happen as he described it, it very likely happened in a similar manner. According to Charles-Edouard Lucas, aware that Henry was covering up his fear and embarrassment with a layer of crude jokes and obsessive sexual references, he arranged for a young model named Marie Charlet to seduce Henry. According to him, she was an ideal choice because at the age of sixteen, she was already brutally experienced. A victim of incest at the hands of her alcoholic father, she had survived by living on her own, working as a model and occasional prostitute, protecting her emotions behind a stance of uninhibitedness, nymphomania, and a salacious curiosity about the unknown. She would sleep with anyone. It is likely that Henry had no illusions about what he could expect from a

sexual alliance. But now, at least, he knew how and with what kinds of women to find pleasure.

Cormon's was an easy ride in a horse-drawn cab to the newest catalyst for creative energy on Montmartre. The *cabaret artistique* called Le Chat Noir (The Black Cat) had opened in December 1881 at 84, Boulevard de Rochechouart, a dozen blocks from where Henry worked every day. Located in a former post office, it was decorated in the lugubrious, early seventeenth-century style known as Louis XIII and cluttered with all kinds of unusual objects. Most interestingly, the walls were hung with paintings and drawings done by artists who actually went to the cabaret. The works could be purchased by interested clients, if the owner, Rodolphe Salis, was in the right mood.

The original large room of the post office had been divided in two by a curtain. The front half was reserved for clients coming in from the street. The rear was called the Institut, after the prestigious group of intellectuals and artists who belonged to the closed membership of the Institut de France. It was reserved for the cabaret's regulars, who used it as a meeting place. In the front room beer was 60 centimes. In the back room, brandy was 20. The walls of this room were decorated by some of the major artists of Paris, including Henri Pille, Henri Rivière, Puvis de Chavannes and Carolus-Duran. In time, Henry's work would appear in the albums where Le Chat Noir kept drawings done by its clients.

Immediately after opening Le Chat Noir had begun to attract the painters, illustrators, journalists, playwrights, performers and poets who typically haunted the cabarets, dance halls and theatres of the Butte Montmartre.

What was the magic that drew everyone to one café? Rodolphe Salis and his second-in-command, the poet Emile Goudeau, had developed a gold mine by providing as entertainment in their cabaret – the clients themselves. There was an organized programme of readings, singing, recitals and plays which were performed gratis by the artistic talents who frequented the place. At one point an upstairs room even included a large screen with a stage behind it, where elaborate nightly performances of shadow puppets were held. In order to assure a high quality of performance, Salis had induced Goudeau, in exchange for a job managing the cabaret, to relocate the activities of a private club he had created, the Hydropathes (a name intended to imply an aversion to drinking water), from the café they usually frequented on the Left Bank up to Salis' Chat Noir in Montmartre. The Hydropathes were a remarkable group of young writers, poets, composers and musicians only

slightly older than Henry. In addition to Goudeau, its members included many who would have enduring fame: François Coppée, Paul Bourget, Anatole France, Catulle Mendès, Charles Cros, Raoul Ponchon, Aristide Bruant and Sarah Bernhardt. Their activities had been celebrated in Murger's *Scènes de la vie de bohème*. Among the artists who were members, André Gill, Adolphe Willette, Henry Somm and Jean-Louis Forain frequented Le Chat Noir. Goudeau was responsible for establishing literary soirées every Friday and Saturday and what he called the *'absinthes littéraires'* on Wednesdays. These were times when true performances were held with Salis introducing the writers, musicians or poets before they took the stage. Henry and his friends went regularly to see and converse with the generation of Montmartre artists that had just preceded them.

Salis himself was one of the attractions of his café, for his dynamic, even grandiose, personality set the tone for the cabaret's activities. He had tried (and failed at) a number of occupations before achieving celebrity as a shrewd bar-owner, but he preferred to think of himself as an artist. At one point in his career, although he had abandoned the Ecole des Beaux Arts and been rejected by the Salon, he painted landscapes for several months in the forest of Fontainebleau, improbably costumed in a scarlet cloak, a huge wide-brimmed hat with a plume and a long sword like one of the three musketeers. In Paris, he was prone to exhibitionistic publicity stunts.

In January 1882, Le Chat Noir had begun to publish its own newspaper, also called *Le Chat Noir*. This four-page weekly printed works and drawings submitted by the cabaret regulars. Following the policy established in the cabaret, it did not pay its contributors. Its principal illustrators over the twenty years of its existence were Willette, Somm, Henri Rivière, Henri Pille, Uzès, Théophile Alexandre Steinlen and Caran d'Ache. The newspaper came to represent the 'spirit of Montmartre': sarcastic, even macabre humour and satire aimed at the bourgeois political and economic establishment. Here many of the anarchist theories that Henry's family found most frightening were expounded and glorified, but so were all sorts of silliness. On the cover of the 22 April issue of the magazine, Salis published his own obituary, announcing his own suicide. The reason given was that he had become convinced that Zola's latest, and wildly successful novel, *Pot-Bouille*, had been plagiarized from his own, of course unpublished, work. The readers were invited to attend his funeral, which he led himself, dressed in a gold costume.

One of the pleasures of being an artist was that one did not always have to be serious. Although the mornings at Cormon's provided Henry and his

friends with a central core of artistic theory and practice, and they often worked in the afternoons, electricity was unknown in their studios at the time, so it was difficult to work after nightfall, unless one liked the way gas lighting and oil lamps coloured the canvas. In short, they managed to find lots of time to play, and if they weren't around to march in Salis' funeral procession, it was strictly an oversight. They went wherever anything was happening.

A lot of their discussions took place in cafés. The tradition of the literary salon as an intellectual proving ground had begun to die down somewhat at the end of the eighteenth century. Although the intellectual 'chapels' held in various homes still had enormous impact on certain writers and literary movements, the café had begun to democratize the marketplace of ideas. Anyone could go to a café, and each man paid for his own drink. There the discussions went on endlessly, providing both social contacts and an exchange of information vital to an artist who otherwise might work totally isolated in his own studio. 'You kept your mind sharp,' Claude Monet remarked about café conversations, 'mutual stimulation made it easier for you to follow a course of disinterested artistic research; you stored up a stock of enthusiasm that for weeks and weeks sustained you until your ideas achieved a definitive form. You always left better steeled, your will-power firmer still, your thoughts clearer, more distinct.'

The cafés became the decor for many paintings of the time. At least one artist, André Gill, opened his own cabaret, which he called Lapin Agile (Agile Rabbit), a pun on *là peint A. Gill* (A. Gill paints there), and decorated with his own work. Other cabarets, cafés and *bals* in the *quartier*, notably Le Chat Noir and later Le Mirliton and Le Moulin Rouge, hung their clients' paintings on the walls. Sometimes these paintings in turn portrayed the café or cabaret where they were hung.

For the younger artists, it was exciting to have the chance to hobnob with or at least sit at the next table to the greats of the preceding generation – Monet, Renoir, Degas – as they drank beer and talked at the cafés of Montmartre, particularly at Le Guerbois and La Nouvelle Athènes, where Erik Satie played the piano and Verlaine could often be found slumped in a corner. As the competition intensified in the *quartier*, with arty new places opening all around them, even the older neighbourhood cafés began redecorating, often in imitation Gothic style with stained-glass windows. Around the time Henry first began to work at Cormon's, La Grande Pinte in imitation of Le Chat Noir began hanging the work of artists who frequented it. It was not long before many of the other cafés did the same. In 1882, as he began

working at Cormon's, Henry did not realize the importance the cafés would have in his life and work. Not only would much of his art have as subject matter the people and activities of the Montmartre café and cabaret scene, but these same cafés would provide him with an important source of exhibition space.

Observing the more experienced artists around him, Henry was ambitious and eager to make his way in the world of professionals. At Christmas he had discussed his professional aspirations with his Grandmother Gabrielle:

Did I lose anything when I switched from Bonnat to Cormon? I should be tempted to answer, 'No'. The truth is that while my new boss does not yet have the astonishing prestige of my old boss, he is contributing to my training all the freshness of his youthful illusions, a talent that bids fair to carry off the medal of honour [at the Salon] this year, and tremendous kindness. With that kind of help one can go much farther than I probably will. In any case all morning and afternoon I devote myself to brushing something or other.

Then he added the real news: 'I have a work ... or at least a picture in Pau. So now I'm an exhibitor.'

Armed with an introduction from a comrade at the atelier, he had had a small painting accepted for a group show in Pau in February 1883. 'The era of exhibitions opened wide at the beating of my wings,' he wrote gleefully to his Uncle Charles as the show opened. The painting, titled *Un Petit accident*, may have been a scene with country peasant women, for he elaborated: 'I sent loyal Uncle Albert into the Aveyron countryside to buy me some blue skirts: mended, faded and well-worn ... They are wildly successful.'

Politically, things were very tense in Paris in the spring of 1883. After Gambetta's death in January and the arrest of Jérôme-Napoléon Bonaparte for conspiracy to take over the government two weeks later, a new government had been formed. Despite a new law outlawing pretenders to the throne, both anarchists and socialists were trying to recruit working-class support against the democratic regime, which was thought to be too conservative, and there seemed to be signs of an impending popular uprising. Adèle, always an alarmist, was trying to decide where to retreat in case of a general revolt. After considering the South of France, she finally made contingency plans to leave the country entirely and go to Brussels. 'I had thought of going to London, but it seems that dynamite already controls things there ... Pray for us Maman, and for France. What a sad moment for all of us.'

Perhaps the most significant aspect of this fear, expressed by several members of the Toulouse-Lautrec family, was that it symbolized their aristocratic conviction that the working classes were unpredictable, violent barbarians. This naturally increased their discomfort with Henry's growing tendency to leave the realm of acceptable social contacts and become intimately connected with people they did not know and who were not of the same social class.

Henry had at last decided to move out of the Hôtel Pérey, where his father and Princeteau were living. On the advice of Rouilat, an atelier friend, he 'moved [his] pillow', probably to a sublet at 37, rue des Mathurins, not far from his old secondary school, just at the limit of the respectable neighbourhood near the Church of the Madeleine, edging towards Cormon's atelier in disreputable Montmartre. 'The hard part was finding a place that wouldn't frighten Princeteau, who wanted me to go to the Hôtel Pivert in the Passage de la Madeleine. He's still at Pérey, where I go every evening to change for dinner about half-past six. I carry off Louis with me to sleep.'

'My work is going well,' he wrote to Adèle about the same time. 'I'm finishing the portrait of d'Ennery [Gustave Dennery], who very obligingly posed for me. Cormon is a little worn out by being on the Jury [for the Salon] which finished on Saturday.' Unfortunately, Henry's painting was refused, 'thirty-eight votes to two'. It is possible that his work already showed too much Impressionist influence to be tolerated by a Salon jury. In a letter to his mother the same spring, he referred to Manet's death in April, writing: 'Long live Manet. An Impressionist storm is blowing in the atelier. I'm ecstatic, since I've long been the lightning rod for Cormon's thunder.'

He was forced into an increasingly dual existence. No matter how intense his interest in his work and his new life in Montmartre, he was perceived by his family to have his primary obligation to them, and he generally met this responsibility, particularly where his mother was concerned. On or around 20 March that year, for example, the two of them were walking in a Paris street when they were somehow thrown to the ground by a carriage. Henry was mostly bruised, but Adèle was badly injured. Henry took charge, organizing his mother's care and intentionally hiding from her his own possible concussion. She developed a high fever, which caused the doctors to fear that she might have peritonitis. A few days later, Henry wrote a note to his Uncle Amédée, in a hurried, telegraphic style: 'Better and better, her bed can be changed, she's cheerful and talks freely. We're saved. Thank you dear God!! Bulletin of no use. Will write ... Your nephew Henri.'

Shortly afterwards, Henry was able to return to the atelier. In the after-

noons, Henry and his friends now often went to the galleries and clubs where exhibitions were held. That spring, disguised, as he described it, 'as a journalist, or rather as a gallant idler', Henry systematically visited not only the Salon but the Première Exposition de la Société Internationale des Peintres et Sculpteurs at the Georges Petit Gallery, 8, rue de Sèze, the annual shows at two fashionable private clubs: the Cercle Volney and the Club Mirliton, as well as the Society of Watercolourists' annual show, a one-man show of Eugène Boudin's work at the Durand-Ruel gallery and an all-woman show held in protest by women artists who had been refused entry into the all-male exhibitions. He wrote a lengthy criticism of the artists in each show. This article was published only after his death and was probably not originally intended for publication. Quite possibly its audience was his Uncle Charles.

His likes and dislikes as an eighteen-year-old art student appear to have been strongly guided by his family's taste in art, leaning mostly towards 'official' art. He was thoroughly aristocratic, for example, in his disdain for the new method of choosing the painters to be allowed to exhibit in the annual Salon. In the years preceding 1883, one artist, Alexandre Cabanel, had virtually controlled the selection of the jury for this show, officially known as the Salon des Invités. As a strict academician, he naturally chose jurors who supported his definition of good art, that is to say, art in the academic Salon tradition. In 1883, however, the newly founded Société des Artistes Français, which consisted of those artists who had been accepted at least once by the Salon, insisted that the majority vote from their membership decide the composition of the jury. This democratization of the Salon seemed to offend Henry. He preferred the Salle Petit international show, which had been limited to twelve painters, only three of whom could be French. There he contrasted the 'real value' of Giovanni Boldini's stylized society portraits to the 'brush-wiping' of John Singer Sargent. A few years later he probably would have been astonished at his youthful bad judgment. Boldini, an Italian whose portraits were extraordinarily popular with wealthy aristocrats and international-class *demi-mondaines*, had developed a trademark style. He used a hasty, easily identifiable brushstroke which the Duchesse de Clermont-Tonnerre once described as 'spattering his canvas with the point of a virtuoso brush and putting deliberate black splashes which seemed to have been thrown by angry cuttle-fish'. Yet it was Sargent whom Henry accused of commercialism. 'Do you wish to sell, Mr. Sargent?' Henry wrote. 'Certainly the manner in which you "wipe" your paintbrush is marvellous, but, really, international art will hardly regenerate itself at the

enthusiastic contact of your brush.' He might well have addressed the same remark to Boldini.

Both Princeteau and Cormon had exhibited in the *cercles* that year. Elegantly attired, Parisian high society attended these private club exhibitions no doubt as much to be seen as to see. 'What a mob!' Henry observed. 'Lots of people, lots of women, lots of nonsense! The jostling is done with gloved hands, wielding tortoise-shell or gold pince-nez, but it's jostling nonetheless.' Princeteau's work was at the Cercle Volney, and Henry's comments are distinctly opinionated: 'It seems to me that M. Princeteau appreciates the exhibitions at the *cercles* for what they are worth. He submits the first sketch that comes to hand and still comes out in the top ranks, and honourably.' Henry's comments on his newest master, intended to be in praise of his realism, come across as impertinent: 'another old man by M. Cormon, whose somewhat dubious pose is redeemed by the perfection of his hands. A portrait of a young girl by the same painter is the last word in the study of anaemia, the bloodshot eyes, the mealy skin; all rendered with a sincerity which should serve as a lesson to many and to our best painters. It is for you that I say this, M. Carolus-Duran.'

Henry gave the exhibition by the women of the Société des Abandonnées, whom he referred to as 'the forsaken ones', the same attention he gave to the other shows. It was the only show for which there was no admission charge, he noted. He described several of the artists as attempting to ' "virilify" their brushes … The curious thing is that these ladies rarely do well without exaggerating the energy of their procedures. I have not seen a single canvas here that is truly feminine.' Was this a compliment or a criticism? Henry didn't yet know much about women and quite possibly had no experience whatsoever with a woman who was a professional artist. He did, however, know both the attachment and the resolute will of his 'forsaken' mother.

Henry made unexpected progress towards autonomy in the spring of 1883 because his mother herself became autonomous. Using money from her own mother, Adèle decided to purchase a lovely old château not far from Bordeaux, near a village called Saint-Macaire, where she intended to live. Restored by Viollet-le-Duc and surrounded by a large park, the château of Malromé was only about ten miles from Respide, the estate where Louis Pascal's family lived. Now, although she would continue to spend her winters in Paris and frequent holidays with her family, Adèle was no longer a nomad. She explained the purchase to her mother in emotional terms:

You know, dear Maman, that it wasn't I who changed the conditions of my life at the beginning of my marriage. But after twenty years, was it reasonable to keep on vainly grieving and not try to make the best of it? We had to guarantee this 'chez nous' for ourselves. Alphonse of course insists that he will never live there, so far from the 'deserts' [i.e., the isolated forests where hunting was good], but there will certainly be many things to attract him, and lots of space for his clutter.

The security of Malromé satisfied a deep need in Adèle, who henceforth considered it her personal refuge from the world. Henry would often join her to spend holidays there, but Alphonse, as he had predicted, showed no interest in it, and it is possible that he only visited once or twice.

As summer began in 1883, Adèle was impatient to go to Malromé, to get the house ready to live in. However, she was unwilling to leave Paris without Henry, and his holiday plans were still up in the air. He liked Cormon's very much, and Cormon was planning to choose a larger atelier. Like the other students at the atelier, Henry was supposed to wait until Cormon told them his plans before making any of his own. The one he chose was at 104, ·

Henry and his mother in the garden at Malromé, c. 1893, photographed by Maurice Guibert.

Boulevard de Clichy, a few blocks down the hill from the rue Constance studio. There Henry would continue to work over the next four years, until 1887.

In mid-July, Adèle finally managed to drag Henry away from his art to begin what would become her annual visit to Malromé. She left him at nearby Respide, where he went boating and touring with his cousins Louis and Joseph Pascal, while she bought furniture. 'I'm not sorry to see him rest a little from his beloved atelier,' Adèle confided to her mother. Even when on holiday, Henry remained very involved with his art, and by the time they had finished with business at Malromé and settled down in Céleyran for what was left of the summer, he was working frenetically again, painting a whole series of portraits of the peasants who worked on his grandmother's estate.

On 1 September, he wrote to a comrade at Cormon's, Eugène Boch, to find out if Cormon would be in Paris when Henry returned on 1 October, who else would be back and if the new atelier was going to be finished, 'ready to shelter our young skulls, simmering with boiling inspiration ... I'll spare you the story of my bovinities in the sun with a brush in my hand and a spectrum of spinach, pistachio, olive or shit-coloured spots on my canvas. We'll have plenty of time to talk.'

The paintings he did that summer show both the effects of the training he was getting and the self-confident development of a fluidly personal style. The 'spots' he refers to are of a distinctly Impressionist cast, showing that his palette, at least, was responding to the influence of the forbidden school of painting or to its influence on his *juste milieu* teacher. His portraits of the workers at Céleyran, and particularly of a young farmhand named Routy, are almost tender, poignantly rendering his models' discomfort and embarrassment at being painted (see Plate 2). He also did the first of a series of oil portraits of his mother, reading on a garden bench in the shade, with her eyes downcast and a sort of halo of colour around her head.

Another portrait of Adèle, painted the same summer, is perhaps the finest he ever did of her (Plate 3). It shows her at breakfast in her new château at Malromé, but there is nothing of the countess about her. The pastel colours of the thinned-down oil paint highlight the finely drawn, careworn features of an unassuming, gentle, sad-looking woman, looking gravely down at her coffee cup. Again, around her head, is a pale halo of backlighting.

That September he did a different, but charming, work of art: an illustrated journal of his Uncle Amédée's attempt to kill the phylloxera at Céleyran with a chemical flooding treatment he called submersion. Henry's

'Whew! It lives!' In the final drawing of the Submersion *series, 1883, Henry shows a dance of celebration when the phylloxera mite seems to be vanquished. He and his Uncle Amédée are in the corner, watching the scene.*

humorous account of a tragic, losing battle to save Céleyran's vineyards depicted Uncle Amédée as a tyrannical general and was full of absurdities and puns. In his drawings, he represented himself several times, observing or sketching the action. These journals for the family prefigured one of the professional forms his art would later take: illustrating books, sheet-music and theatre programmes.

In early October, Henry went on to Paris to get back to his work, staying one last time at Pérey but without parental supervision, leaving Adèle at Malromé for her 'beginnings as a *châtelaine*'. By the time she arrived in Paris in the second week of October, he had become so involved with his own life that she was almost offended. She resented the fact that he was in Montmartre from eight in the morning until dinnertime, but she did not oppose his decision now to rent a studio. 'He's barely ever at the hotel ... he's looking for an atelier of his own because he's going to have to rent one to work in ... Cormon wants Henry to work in the afternoons on his own. It's going to be expensive, but Henry's future comes before anything else.'

Henry's first studio was a sublet from an artist who was visiting Algiers: 'Henry is enchanted with his atelier where he works all afternoon with two

friends whom he has invited to join him. He has taken over to it all his drawings and all the canvases which cluttered up the Hôtel Pérey.'

Perhaps as a reaction to her growing sense of abandonment, Adèle tried to involve herself with Henry's art – however, she did so in ways he must surely have found distracting and irritating. She even tried to help with his projects: 'Right this minute, Henry has gone to see his master, Cormon, to hand in a sketch based on Solomon's Song of Songs. This assignment, which was given to everyone in the atelier, necessitated a lot of negotiations with Le Bosc to have my Bible sent to us.' Her assistance, of course, was always well-meaning and generous, and thus impossible to refuse.

The fact that Henry himself owned no Bible is perhaps significant. He was ambivalent about religion. The combination of Adèle's scrupulous Catholic training and Alphonse's casual dismissal of and even disdain for all things religious was bound to be reflected in him. Although he had no use for ecclesiastics as an adult, and even caricatured one in 1898 by drawing him as a blue-faced baboon, his memories of the faithful teachings of the Abbé Peyre at Céleyran during his childhood and his grudging acknowledgement in the 1890s of his mother's 'saintliness' were markers of the impact of his early religious training. After he moved to Paris, he showed almost no interest in religion, although one Sunday in 1884 he wrote to Adèle, 'I've just come out of one o'clock Mass. That civilized me a little, for I hardly ever leave my hillside.' According to his family, before dying he confessed and received the last sacraments. Even if he had ceased to be a practising Catholic, it is unlikely that he would make an issue of it on his deathbed.

Inexorably, Henry continued to create his own life. Around the middle of January 1884, he proudly moved into a different studio in the rue Lepic. It was just around the corner from Cormon's old studio and not too far from Rachou's studio in the rue Ganneron, which he sometimes had shared in the afternoon. The new studio was truly his own. He himself had chosen the furnishings and rugs for the twenty-eight-foot long room, including a 'marvellous Chinese drapery' paid for with money he had received for Christmas. He was to manage the budget himself, receiving a monthly allowance for household expenses. To offset the annual rent of 1,100 francs, he had sublet the bedroom of the studio, since he was expected, as in the past, to sleep at Pérey. However, he was at the hotel less and less frequently. Although he saw less of Adèle, he still spent a lot of time with his cousins Paul Pascal and Gabriel Tapié de Céleyran, who were both in Paris that winter.

Adèle was at a loose end. Alphonse was in Albi, and Henry was never home. In addition, the entire Hôtel Pérey was moving across the courtyard

to a modern building with a lift. Henry dutifully spent his Sundays with her, since there weren't any models at Cormon's, but his heart wasn't in it. Uncharacteristically disoriented, Adèle spent more time with Odon and his wife. Finally, as she had when her marriage to Alphonse was foundering after the death of their son Richard, she found a resource in religion. She began doing volunteer work in a charity hospital in Belleville, one of the poorest neighbourhoods in Paris, work she would continue over the next several years.

In February 1884, Henry's cousin Madeleine died at the age of seventeen. Like Henry, Madeleine had not been growing normally and had trouble walking. A year of special treatments in Bordeaux had made no difference. Although she had been suffering for several years, and her death was not unexpected, it was a harsh blow for Henry and Adèle: 'Poor little Madeleine,' Adèle wrote. 'It's not she who is to be pitied, since she has reached the goal we are all dragging ourselves towards, through so many thorns . . . let us pray for her or with her for the grand family reunion there where we won't leave each other again – other joys are so rare in this world. Henry joins me in sending you all his affection; we speak very often of Céleyran, and I assure you that Henry is far more upset than he wants anyone to know.'

Adèle left shortly after for Céleyran, although she waited until Princeteau arrived in Paris, so Henry wouldn't be without supervision. His only surviving letter to her during this trip makes a plaintive demand for money that would become a repeated theme with him for the rest of his life: 'p.s. Please send money to pay landlord. It's better not to let it wait. Mail it to me at Aunt Emilie's.' He had been in his own studio less than three months and already he seemed unable to manage his finances. Although there is no firm evidence to show what kind of monthly allowance he received from his family at this time or how much freedom he had to spend it, money henceforth became an issue between him and his parents. It can't be known if they withheld the necessary funds as a means of controlling him or if he was simply extravagant and unable to keep track of his own bills or both. The fact that he later kept his artistic financial records with meticulous care indicates that his chaotic handling of his living allowance sprang at least in part from psychological causes. Fifteen years later his affairs would be in such disorder that his creditors began turning directly to Adèle to pay his debts.

Despite the inevitable frustrations with his work, Henry continued to go to the atelier with unflagging enthusiasm. That spring he also shared some reflected glory because both his masters and his fellow students won prizes in the Salon, which was held in the Palais d'Industrie from 1 May to 20 June.

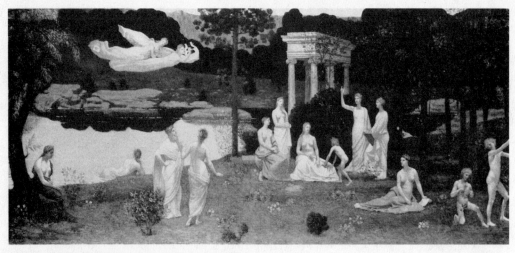

Puvis de Chavannes, Le Bois sacré, *1884.*

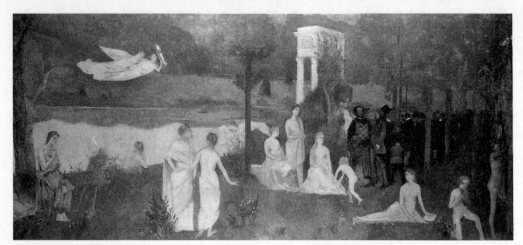

The parody of Puvis de Chavannes' Le Bois sacré *by Henry and his atelier friends, 1884.*

Princeteau's 'big ox', whose real title was *Boeuf labourant* (Steer at Plough), had won a prize, which enchanted him and Henry both, and Cormon had entered a thirty-foot-long canvas which won a place of honour at the opening. It came in second in all three rounds of voting, 'which is really very glorious for a young grand master', Adèle explained. Henri Rachou, Henry's friend from Albi, also had won a prize.

Princeteau was 'very busy with tiny paintings which he sells for their weight in gold', Adèle observed, and having so much success that they almost never saw him. He was working in a studio up under the roof in the new

Hôtel Pérey, to which he 'hoisted himself', as Adèle put it, in the elevator. Around the same time, probably influenced by Princeteau's new interest in pastoral and peasant-class subject matter, Henry also painted a number of cows. Like many of his works at the time, they were what he called 'traités en pochade', sketches with a loose quality rather than finished paintings.

Six months before, Henry had signed his New Year letter to his Grand-mother Louise: 'H. de Toulouse-Lautrec, *artiste en faux bois*', referring to the interior decorating techniques of painting imitation wood grain or marble on woodwork. Now the title proved prophetic, for with some friends from the atelier, he decided to create an imitation grove. Their attention had been attracted at the Salon by the large (thirty-five and a half by eighty-two inches) allegorical painting, *Le Bois sacré cher aux arts et aux muses* (The Sacred Grove, Beloved of the Arts and the Muses), by Puvis de Chavannes. Henry and his friends immediately made the pretentious, outsize canvas a subject of ridicule and collectively painted a monstrous parody of the painting, even larger than the original, which they titled *'Le Bois sacré' parodie du panneau de Puvis de Chavannes du Salon de 1884* ('The Sacred Grove', Parody of a Painting by Puvis de Chavannes Shown in the 1884 Salon).

Painting parodies was not unusual at the time. A number of Anquetin's works, for example, were parodies or pastiches of works by others. Too clearly based on well-known works to be plagiarism, these paintings were considered a sort of witticism, an artistic game. In 1893, for example, Anque-tin did a painting called *La Danse au Moulin Rouge*, which broadly pastiched elements of two of Henry's best-known works: an 1890 painting called *Le Dressage des nouvelles* (Training the New Girls) and an 1893 poster of the dancer Jane Avril. Other works from the same period, by Louis Valtat for example and, as shall be seen, by Henry himself working alone, also pastiche the art around them.

Although the *Bois sacré* parody was presumably a collaborative effort, completed in two afternoons by a team of painters from Cormon's atelier, it was Henry, more audacious than his peers, who was brave enough to sign it. With hindsight, looking at the body of Henry's work, this sarcastic visual commentary on the original painting can be seen as a statement of what would henceforth be his position about art. Puvis de Chavannes' subject was the eternal tranquillity of the unchanging domain of the arts. The *rapins'* painting opposed to that point of view the one that contemporary art should deal with contemporary life and with the realities surrounding the artist. Thus into their representation of the timeless woods they introduced a clock that read five minutes past nine and a whole procession of nineteenth-century

trespassers, many of whom are identifiable as Henry's friends. Anquetin is wearing checked overalls and standing next to his friend, the critic and writer Edouard Dujardin. Maurice Barrès, a friend of Dujardin's who had moved to Paris the preceding year and who would become enormously well known as an anti-naturalistic, nationalistic writer, journalist and politician, is represented wearing a top hat, standing next to someone who might be Bonnat. Henry, probably painted by himself, is shown from behind, facing the parade of his friends in a posture indicating that he is urinating. The parody makes a number of other ironic changes from the original which are, overall, whimsical rather than scathing. The style of this painting is a good imitation of the flat, clearly defined, pastel-coloured shapes of Puvis de Chavannes and bears little relation to the sensitive line and colour of the oil wash portraits Henry had done at Céleyran the preceding summer.

Why did Henry choose Puvis de Chavannes as the object of his mirth? His taste in art remained conservative, and he had commented in the past that he appreciated the work of this classical, academic master. However, he was probably growing very tired of the fashionable allegorical style that Cormon also favoured. Cormon had his pupils do studies on biblical and mythological subjects and apparently had asked Henry to paint a series of allegories of the Golden Age (*Le Printemps de la vie*), but Henry balked at painting young girls and boys frolicking with lions and leopards, 'and with bronzed rattlesnakes', he added in a reference to the artificiality of Cormon's studio poses.

In June, Henry received a singular honour. Cormon asked him to join himself and Rachou, who was ten years older and had just won a medal at the Salon, to collaborate on the illustrations for a magnificent edition of the works of Victor Hugo. The commission of 500 francs, equivalent to about £1750 today, seems enormous for a nineteen-year-old. No doubt this mark of favour went far to make Henry feel better disposed towards Cormon's 'historical' style. Although Cormon was said by one source to think that Henry would never attain 'the upper reaches of art', Adèle confirmed the commission in a letter to her mother-in-law:

For the time being Henry has decided not to prepare the Beaux Arts' competition, since he doesn't have enough time, but on the other hand, he has received a most flattering task from his master Cormon ... To give you an idea of the artistic luxury of this edition, each complete set will cost the collector 6,000 francs! This detail will give you an idea of how thrilled and happy Henry is, feelings shared moreover by his father and his Uncle Charles. The bad part is that if his work is accepted by the

publisher, we will be dominated by this huge work for an unlimited time. If Rachou also ends up doing some of the drawings, I would do my best to take the two artists to Malromé to work during the worst of the heat.

Through the month of July, they stayed in Paris, in spite of the heat and the presence of cholera. Adèle took the precaution of eliminating fruit and ice from their diet, since she was slightly sick with intestinal problems. 'As for Henry,' she commented, 'he's astonishing, always running and working.' However, there were serious problems with the commission. 'Unfortunately, despite all his effort, the work is not advancing much,' Adèle elaborated. '... Even though the drawings he does have been approved by the artists, they have to be accepted by the most peevish editor possible, and to date nothing has been printed. Henry has tried having them redrawn in ink by special draughtsmen, even if it eats all his profits – that's not the question for the moment. But either they are so clumsy that they change the character of the work, and Henry is furious, or else they're not right for some other reason; to sum it up, we're not getting anywhere, and the work is supposed to be finished by the end of September ... I've promised Henry we'll stay until the cholera drives us away. Where in France is there a place safe from it?'

They finally left Paris at the end of the month, leaving Alphonse behind at the Hôtel Pérey, where for two months his bags had been packed and he had been announcing each morning that he would also leave. Apparently he couldn't decide whether he preferred to go to Orléans, Mont Dore or the Château du Bosc.

Adèle was happy to have Henry at Malromé 'breathing the air of the fields a little', but his project continued to degenerate. 'Henry came very close to breaking off completely with his publisher, which would have been regrettable from many points of view, and would have had only the advantage of giving us our freedom. The first engraving has been printed, and he's planning to do the easiest ones here and go back to Paris when it becomes necessary.'

The next day, the whole thing fell apart. Adèle announced the bad news bitterly to her mother:

The time we spent roasting in Paris, with the anxiety about cholera to boot, was all for nothing: the great project which kept us there has been definitely cancelled, as of this morning ... I was very worried when I got the letter, because I was afraid Henry would be sorry he had left Paris. Happily, he's been more philosophical than

I, and says that Cormon's approval is all that matters to him and that he doesn't give a d— about the rest. It's still too bad to have worked so hard for nothing.

Henry bounced back quickly from what, despite Adèle's euphemism, was a rejection of his drawings. His two desires were to work on his painting at Malromé and to have fun on his holiday. His cousin Louis was at nearby Respide, and the two families immediately began going back and forth, eating meals together, planning elaborate outings, going rowing and learning archery, using equipment Alphonse had sent. 'We've settled down to our little routine,' Adèle wrote to her mother nearly a month later. 'In the mornings Henry has been painting me, surrounded by our beautiful hortensias.' She continued her description of the sittings in another letter: 'Lately my artist hasn't been leaving me enough time to go to Verdelais, since the study he's doing of his Maman requires early morning light.'

When Cormon's opened again, Henry returned to Paris, leaving Adèle in the south.

6
TRÉCLAU

Tréclau

Henry returned to Paris in October 1884 for his third year at Cormon's. Now almost twenty years old, he was in Paris alone and free of supervision possibly for the first time in his life. The transition appears to have made him feel very insecure.

Having had his drawings for the Victor Hugo project rejected, he was nervous about showing Cormon his work from the summer, but Cormon was very friendly when he glimpsed him in passing. When they finally had time to discuss the summer's work, Henry wrote to his mother that Cormon 'rather congratulated me, even while making me feel my ignorance. That cheered me up a little. At least we weren't wasting our time.' He added, 'The one Cormon liked best was the big *navet* [literally 'turnip' – slang for a bad painting]. That surprised me.'

Temporarily, until Adèle returned to Paris, Henry had arranged to stay with his atelier friend, Grenier. He ended up living there for several months and later stayed with the Greniers off and on over a period of two years. At the time, Henry perceived the living arrangement at the Greniers' as only temporary. From his letters, it seems as if he intended to return to Pérey with Adèle when she came back; however, except for brief visits to her château at Malromé, he would never live with her again. From now on he would always live and have his studios in Montmartre. Even after he finally set up an apartment of his own on the *butte* with a friend, he remained close to the Greniers, seeing them often, visiting them in their country house and sharing models with Grenier in the city.

For Henry the Greniers' spacious apartment at 19^{bis}, rue Fontaine was his first taste of unlimited freedom. Although he had established his own studio the preceding spring, except for one brief period he had always gone back to the Hôtel Pérey to sleep at night. Now he realized that, practically speaking, it was a great advantage not to have to leave the *butte* to go home when

he left Cormon's atelier. Just getting around was fatiguing for him, and everything he really wanted – friends, the stimulation of other artists, models, studios to work in, not to mention the excitement of Pigalle nightlife – was all right there. The trek on foot and by tram back and forth from the Hôtel Pérey had been hard on him, often making him too tired after dinner with his parents to go back up the hill for evening activities.

He also discovered that it was much more fun to live just at the foot of Montmartre and to have friends to see any time he wanted to. There were a lot of painters' studios at 19bis, rue Fontaine. Edgar Degas lived on the fourth floor and had his studio on the ground floor.

Albert Grenier, who came from Toulouse and had an independent income, was supposed to have talent, but he did not appear to be very concerned about his own art. What he liked was the lifestyle of an artist. In his studio, a friend observed, '*la flânerie* [wasting time] often took the place of work.'

Grenier's girlfriend was an artist's model of some fame. Lili, who was only twenty at the time Henry met her, was the daughter of prosperous art and antique dealers in the rue Chaptal. She probably abandoned her own name when she began to live openly with Grenier, possibly to appease her family, who may well not have approved of her career and independence. Apparently she had been 'discovered' by the Princesse Mathilde Bonaparte, Napoleon III's cousin and an amateur painter, who had asked her to pose. The reputation of Lili's plump beauty, her white skin, red hair and sensual mouth spread quickly. In short order she had posed nude for some twenty artists, including Degas. Lili was herself quite well-to-do and owned two country houses in Villiers-sur-Morin, where she regularly invited all their friends. She was somewhat haughty and liked to order people around. This amused Henry. '*Lili la Rosse*' (Tough Lili) he called her, punning on her red hair (*rousse*) by using an adjective that was part of his colourful Montmartre vocabulary. *Rosse*, a slang noun for a horse, specifically an old nag, had taken on the adjectival meaning of bitchy, bad-tempered, brutal or vulgar. In Montmartre it was used admiringly, to imply tough, street-wise and unsentimental.

Henry's friends later said that, living in their apartment, he fell in love with her, although there is no firm evidence either that this was true or that she responded. As the mate of his friend, she was an irresistibly safe target. He did not have to run the risk of being rejected, since it would not have been appropriate for her to accept him as a lover under the best of circumstances. Instead, she became his first woman friend – warm and protective. She is said, for example, to have taken his hand whenever they crossed the street.

This maternal treatment was a mixed pleasure. On one hand, he could enjoy her company without any attendant sexual responsibilities, but on the other, it must have been painful for him to live with a couple and feel their intimacy. One evening he is said to have remarked to Mademoiselle Dieterle, a singer and dancer at the Théâtre des Variétés who was a friend of Lili's, 'Why is it, my dear friend, that the happiness of others makes us feel as if we have been robbed?'

Friendships with highly attractive but absolutely unavailable women became a pattern in his life. With them, he could be himself, bask in the glory of being with a beautiful woman, particularly of accompanying her in public, and live *almost* the existence of a real lover.

The Greniers' apartment was a place of laughter and enthusiastic camaraderie. The couple loved to play and tended to gather their friends around them. Almost all of them, it appears, were men. Lili was very flirtatious, and that, in combination with her striking appearance and the energy she put into enjoying life, attracted a cluster of admirers, each hoping to seduce her. She tended to cultivate actors while Albert's friends came primarily from Cormon's atelier. In the evenings, along with Henry, they went out together in groups to Le Chat Noir, the dance hall at Le Moulin de la Galette or the rowdy *cabaret dansant*, L'Elysée-Montmartre.

On other occasions, they would all dress up in costumes and go off to masked balls which were Paris's newest fad. Before they went out, they participated in another fad – taking photographs of each other in their costumes, grouped in amusing tableaux. Henry was central in these activities. He had always loved dressing up, and in the Greniers' salon he devoted his creative energy to inventing new personae. In a way he was even making his self-presentation into a work of art. Photographs of the time show him dressed as a Japanese, an Arab muezzin, a choirboy, a common labourer and a Spanish dancer.

Henry's love of costumes was closely related to his lifelong penchant for showing off. Since his earliest childhood, amusing relatives by doing animal imitations or wearing his aunt's Moroccan burnoose and calling himself 'Madeleine', Henry had behaved in conspicuous ways – perhaps modelling himself after Alphonse's attention-getting behaviour or, with more complicated motives, trying to distract attention from his flaws through his talents as a comedian. Now that he was unattractive, he seemed to try even harder to attract attention to himself.

In the autumn of 1884, Henry discovered that his new-found freedom could run up against unexpected limits. This made him uncharacteristically

irritable. First the cholera epidemic broke out again in Paris, and everyone had to avoid going out in public. 'Our gang is dead. I go to bed at nine o'clock. A pox on Cholera!!' he wrote. Then the concierge of his building announced that he was leaving 'to become an oyster-monger'. Henry, more than a typical tenant, had counted on the man to perform the physical tasks of everyday living: bringing firewood and water, starting fires, lighting lamps, carrying in meals. To him this departure meant that he had to consider changing studios after all the energy and love he had devoted to finding and furnishing this first studio of his own in the rue Lepic. 'I'm going to try to find a new place, but it's not easy,' he wrote to Adèle at Malromé. It would be two years before he found a permanent studio.

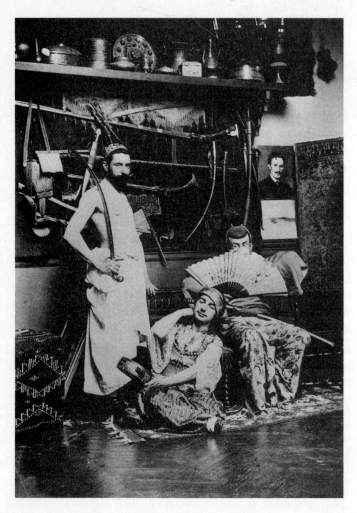

Henry (front) dressed as a gypsy dancer, c. 1884. An atelier friend, Claudon, is at left.

Henry dressed in bath towels as an
Arab muezzin, c. 1898.

In addition, Henry was not getting along with his family. Living with the
Greniers did not mean Henry had broken off constant contact with his
relatives. Alphonse was in Paris, as were Henry's cousins Louis Pascal and
Gabriel Tapié de Céleyran, although the latter would soon leave for Lille to
begin his medical studies. Perhaps because of the intensity of his new
freedom, which may have made him feel guilty, Henry tended to be overly
disturbed by what he perceived as rejections from his family. He was
offended that Gabriel left Paris without saying goodbye, particularly since
Gabriel was going to be busy with medical school for many years. Also that
autumn he learned of the sale of Céleyran. His Grandmother Louise's health
was too poor for her to maintain the estate and it had ended up being sold to
strangers. This, in combination with the sale of the Château du Bosc to his
Aunt Alix, upset him disproportionately. He may have felt that his birthright
was slowly being eroded. Around the time he learned that Céleyran was lost,

Henry wrote to his mother that he had accidentally missed seeing his Uncle Odon's family when they were in Paris and commented ironically that they were going to be so angry at him that 'they're capable of disinheriting me'. He asked his mother for more information: 'Have you been officially cut out of the family pot? Did you just sink into absolute silence or was there a discussion, and how did it go? Write to me with all the details, because I don't know what my position should be, and don't want to say the wrong thing.'

Adèle, living at Malromé, pressed Henry to write to her about his progress in art. He complied, but with a strange lack of enthusiasm:

I thought I had talked to you about how my *navets* made out with Cormon. – It seems I was mistaken. He thought my oxen were bad, the little Laffittes O.K., and the one on the grass, good. To sum up, it's all weak compared to the landscapes Anquetin brought back. Everybody is impressed. They are done in an Impressionist style which does him great honour. I feel like a very small boy beside workers of that temper ... I've got back into the routine which will last until spring – then, perhaps, I'll do some strange things. It's still vague.

What 'strange things' might he do? Implicit in his letter were both a commitment to the routine of the atelier and envy of the independence Anquetin was manifesting in his work. Henry was probably feeling that he, too, should be doing innovative work, pressing forward as an Impressionist rather than just learning academic painting methods, but his ideas were not clear. He seemed oddly fatigued and depressed for a twenty-year-old. He may also have been worried about making Adèle feel she was now unnecessary in his life, or that he was too successful in his new world. In the same letter he added: 'I haven't had the energy yet to go to the shirtmaker. The very idea of leaving the *butte* makes me tired. It's so nice in the evening in the warm atelier at Grenier's. You'd do a good deed if you knitted me a stocking cap and some slippers. The café bores me, going out is too much trouble, there's only sleeping and painting. I'm stopping because I'm getting boring ...'

Later the same autumn, when there was trouble at the atelier in the form of rebellion from *rapins* who questioned Cormon's authority as an 'academic' artist, Henry immediately began to sound more cheerful. He was obviously intensely involved with atelier politics. Any form of excitement, he was learning, stimulated him out of his lassitude:

There's been a revolution at the atelier. Cormon threw out the *massier* and named

another. All this has excited us more than you would believe. Rachou is our boss –
I think I've already told you. I must be getting senile, for it's been five days since I
left the *butte*. I'm painting a woman whose hair is absolute gold. My drawing for
Le Figaro isn't completely finished, but it's coming along. Whew. I just ate lunch on
the run and am headed for work.

The model whose head was 'absolute gold' was probably Carmen Gaudin,
whom he portrayed in many paintings between 1884 and 1887 – an aston-
ishingly long loyalty to one model, where Henry was concerned. He appar-
ently first saw her in the street. He was with Rachou, who persuaded her to
model for Henry even though she had never posed before. First attracted to
her by her bleached-orange hair and *rosse* look, Henry, who had imagined
that she would be a 'terrific bitch', was very surprised to find her sweet,
punctual and discreet. He later learned that she had a lover who beat her up
regularly. Carmen became well known among the artists of Montmartre,
posing for at least six separate portraits for Henry and modelling as well for
Cormon and for the Belgian portrait painter, Alfred Stevens.

Henry had begun what would become a habit for him. He had a red-
headed model. His sudden *coups de foudre* (love at first sight) for red-heads
would become practically a trademark. He told his atelier friends that he
preferred red-haired women because they had a particular odour that he
found arousing.

In the atelier, Henry was enlarging the scope of his friendships. He had
now made firm allies of two brothers, Adolphe and Joseph Albert. A third
brother, Henri Albert, became the French translator of Nietzsche and the
Paris editor of the German art magazine *Pan*, where Henry published in the
1890s. Adolphe Albert, better known as 'Dodo', was primarily interested in
printmaking and lithographic techniques, including experimenting with
monotypes – single-copy prints made by pressing paper against a still-wet
painting, often done on a non-porous surface. His inventions in these fields
would earn him some minor fame, and very probably he was one of the
people who encouraged Henry himself to get involved with printmaking
around 1891.

Adolphe's brother Joseph, who sits in the foreground of Henry's 1889
painting *Au Bal du Moulin de la Galette*, had a far more conservative artistic
temperament than Henry. Joseph, who painted mostly landscapes, had also
worked at Bonnat's, which possibly was when the two men met. He later
worked with Puvis de Chavannes and exhibited in the official Salon from
1887 to 1889. Unlike the majority of the *rapins* in the studio, he refused to

wear the wide-brimmed hat, velvet jacket and flowing scarf that were the trademark of an artist at the time. Joseph dressed, on the contrary, something like a bank clerk, rejecting even the obligatory bohemian beard for a neatly trimmed moustache and the musketeer's cape for a three-piece suit. He loved Degas' work, and encouraged Henry to study it too.

In 1884, the influence of Impressionism in the atelier, despite Joseph's admiration for Degas and Anquetin's landscapes in an Impressionist mode, remained discreet. Students continued to do academic work at Cormon's and did experimental studies only at home. Nonetheless, Henry's work increasingly showed the influence of Impressionist techniques. His palette was lightening up from the *clair-obscur* (the use of highlighting and shadow to indicate relief in a two-dimensional work) of Bonnat's training. The works he did outside the atelier were far lighter and more colourful than conventional training would allow. François Gauzi, a fellow *rapin* at Cormon's, noted that in the atelier also Henry was unconventional. He tried hard to stick to classic drawing techniques, 'to copy the model precisely, but in spite of all his efforts, without attempting or even wishing to, he distorted, exaggerating what seemed to him essential details in such a way that the whole character was often changed'.

As the winter of 1884 drew on, Henry began preparing for the *concours des places*, a competition in which the entire atelier would be ranked individually according to 'degrees of merit' by 'a jury made up of the greatest known artists, Benjamin Constant, etc.' The best students might be admitted to the Ecole des Beaux Arts. Writing to his mother, he again sounded frustrated and negative:

Here horrible fog, suffocating trams and red noses. It's totally depressing. We're up to our necks in the *concours* – it's too crowded to work. There are too many people. It's simply more of a nuisance than most weeks ... I've been going everywhere to see effects; in the evening it's terrible going to bed at 2 a.m. knowing you have to get up at 8 and by candlelight, and what for??? ... I'm doing O.K., and I feel like working. To heck with the rest. I kiss you like a disillusioned old man.

Yours, Henri

Why did 'going to see effects' keep Henry up till 2 a.m.? It's possible that he was using the need to study the contrasting effects on darkness of different kinds of light, including moonlight, gaslights and footlights, as an excuse for staying out late. One also wonders why, at the age of twenty, Henry felt like a 'disillusioned old man'. Was it only coincidence that eighteen years earlier

when Henry was just two, his mother, aged twenty-five, had written to her mother-in-law that she felt like an old lady, with no beauty in her life?

'Not much to say,' Henry wrote to Adèle. 'Life goes on. Atelier in the morning where Rachou is criticizing our work, and he's not kind, the brute. Afternoon working outside at Rachou's [whose studio, coincidentally, was in the same building as Bonnat's personal studio], and the evening in the bar where I finish my little business.' Henry's routine was now habitual and would not change substantially for years: after a morning's drawing and painting, he and friends – often Rachou – ate lunch in a restaurant or café in Montmartre and then spent the afternoon working on their own projects in one or another's private studio. When the weather was warm enough, they worked outside. If he had no visitors to see his work, as the end of the afternoon came and the light grew dim, Henry would retire for drinks to a bar or café. He tended to frequent the same one for months or even years on end, going there every afternoon about the same time and befriending the proprietors and bartenders. That winter, and at intervals for years, it was the Café Américain in the rue Royale, where, for example, he met a journalist who showed one of his drawings to the publisher of the Conty guidebook series. 'I'm just about to be given a commission ... Maybe this will be the lucky break I've been dreaming of,' he wrote to his mother, adding: 'This just to show that if good luck comes while you're sleeping, sometimes it comes while you're drinking.' However, Henry's drawings, if submitted, were never used.

At dinnertime he met his mother or some other relative – Alph, Odon and Odette or Louis Pascal. Generally they ate at the Restaurant Lucas-Carton, as they had since his childhood. One of the best restaurants in Paris, it had the advantage for Henry of being within walking distance of the Café Américain. After dinner, he and Louis Pascal, if he was there, would go back to Montmartre to meet Henry's friends and go out to some nightspot to drink and watch the show. Curiously, it was here that Henry often did his real creative work. Gauzi described a notebook that he carried with him in which he made hundreds of tiny, very quick sketches.

His sketches were rapid and simplified, practically mere notes, to catch a gesture or movement, a facial expression, the interplay of two bodies, a striking colour relationship. From these sketches he eventually took many of his finished works, sometimes getting models to duplicate the pose he wanted to draw, sometimes taking a photograph to work from, sometimes merely developing his sketch until it became a highly refined, complex

research, usually worked out in oils. He was surprisingly productive. He developed the habit of working one image over and over until the results satisfied him. This not infrequently produced a whole series of drawings, several canvases and a print reproduction, all based on the same outline with small changes.

Artistically and socially, by Christmas 1884 Henry seemed to have established an autonomous existence, but the separation from his family was less successful than it appeared. He continued to be both preoccupied by and alienated from them. He seemed hostile to everyone in the family except his mother, whom he missed. Adèle's commitment to Henry was unquestioning and unjudgmental. She never complimented his work, never said whether or not she personally liked it, and may never have asked herself the question. She supported him not because she wanted him to be an artist but because he was her son and deserved to succeed at whatever he wished. At times, to both Henry and herself, she felt like his only supporter, for as he showed himself to be more and more committed to his artistic life, he was inevitably more at odds with the expectations of the Toulouse-Lautrecs.

'So, you think Louis is looking well,' he wrote to Adèle disdainfully. 'Well, good for him. I wrote to him to explain why I didn't see him before he left. Papa is going to leave?? Let him leave.' Again, Henry seemed depressed and angry. 'My life is sombre. I'm churning around pitifully and haven't seen Cormon yet.' By then he was back at work but in considerable turmoil. In his next letter he said, 'The studio is in revolution, we want to name a *massier*. They'd like me to take on that boring job, and I stubbornly refuse,' adding, 'I haven't replied to Louis and won't. I find it terribly provoking the way most of the family insist on making fun of me. Luckily you have several votes on that ballot.' Louis had grown up into a handsome, blond ladies' man. 'I'm told you enjoyed my handsome friend Louis's charming ways and patent-leather shoes. You ought to find him an heiress and throw her into his arms. He's not much good, I'd say, for anything else,' Henry had remarked to his Grandmother Louise a year earlier. Louis ended up getting a job in a government banking agency.

In late December, Adèle decided to come back to Paris from Malromé. Although there is no record of her motives, it seems likely that she was worried about Henry's low morale. He was so eager to see her that he even went south to accompany her on the train, and apparently her presence had a salutary effect. Writing to Henry's Grandmother Gabrielle after the twenty-hour train ride, Adèle commented how impressed she was by her son's self-discipline: 'He's much more committed than his mother and went

off to his beloved atelier straightaway as soon as lunch was over.'

Adèle had refused to live in the newly remodelled Hôtel Pérey probably because the rooms had increased in price, so Henry had booked her into the nearby Hôtel Métropolitain. He himself continued to live at the Greniers', finally introducing Albert (but not Lili) to Adèle. 'He brought [Grenier] to dinner yesterday,' she reported to her mother. 'He seems a fine young man and, unfortunately for Henry, is moving shortly to another apartment. He has an independent income of 25 thousand francs, which is a pretty penny for an artist.' Henry's was not quite two-thirds of that.

Paradoxically, even Adèle didn't get along with her son that winter. Her presence interfered with his new freedom. She herself considered the season in Paris a trial, a new martyrdom in her son's best interest, for now he left her neglected, ill-at-ease and at a loose end. She struggled to bring him close to her again, but it was obviously difficult. Luring him to Sunday Mass and conventional art exhibitions in the windy, rainy weather, she came down with a bad cold, which developed into a routine of nervous fatigue, insomnia and digestive troubles, which she described to her mother: 'Every evening, almost at the same time, I would have an attack.' Finally she 'allowed' Henry to arrange for a doctor. The doctor seemed to agree with Adèle that the trouble was 'nervous'; that she was not really ill, just anaemic, and that she'd caught a chill.

It is possible that she was reacting physically to the anxiety she felt when confronted with the distance which had developed between her and Henry. Although she could not know what he was doing, he was not with her nearly as much as she might have hoped. Bravely, she made excuses for him: 'It's been snowing for two days. Henry comes to see me as much as he can, but today it's so hard to get around that I'm not really expecting him.' Into the spring, her health remained poor, and her life was made unpleasant by neuralgia and boils. Henry was less and less available, explaining his evening absences as occasioned by work. 'Henry ... had spent the preceding night as Cormon's delegate, counting the vote for the painting Jury at the Palais d'Industrie. It was big business for those young people,' his mother said, repeating his excuses.

Around Easter 1885, the competition which would decide Henry's ranking in the atelier, for which the *rapins* had been preparing for three months, reached its final stages. However, it had to be deferred, according to Adèle, because a model 'suddenly fell so ill during the third session that [she] had to be taken to the emergency room. This [competition] is an important business for Henry's future ... And just his bad luck, Henry has

been ordered to report for medical review for the military at the exact time the *concours* is scheduled to start again. I've had to take steps to request a delay, and I hope I will manage to.' Adèle's motherly endeavour was successful. The military physical was delayed until 25 April, and Henry continued the competition without further interruptions.

At this time, he wrote a letter to his Grandmother Louise which related his frustrations with his art:

I don't believe it, I don't believe it!!! ... I have to play deaf, to beat my head against the wall! yes, and all that for an art that evades me and perhaps will never appreciate all the trouble I've gone to for it ... Maman has just read your nice letter to me; she finished by offering me a lovely trip with you and I have to refuse. The truth is that I'm just getting back into the groove at the studio, after floundering around miserably for three long months. Moreover, the July competition is facing me!! I don't have a minute, a second, to myself, not even my Sundays, when I have to get dressed up and visit influential people. Ah, dear Grandmother, you'd be wise never to get involved with painting. It's as difficult as Latin, when you take it seriously! Which is what I'm trying to do.

Before he completed the atelier competition, Adèle decided to leave again to go to Céleyran to help Henry's Aunt Alix close down the château, which had been sold the preceding autumn, and to pack up all their possessions. The two women were depressed by the sale and felt the buyers had cheated them. To make things more final, even the chapel at Céleyran had been deconsecrated. Adèle said she didn't have the courage to go back inside and that whenever she drove by it she felt like crying. She seemed somewhat consoled when Henry wrote that he was finding Sundays very long without her and wished he could be 'in the greenery for a while'.

Although no record of Henry's ranking among the students at Cormon's remains, he wrote to Adèle with the results of his military physical: 'The committee declared me *impropre au service* [unfit for military service].' As his disability was easily visible, he hadn't had to produce a medical certificate and was allowed to go before the military service board out of turn, 'alongside some Auvergnats with smelly feet'. He celebrated by staying up till six in the morning at a party given by Léon Mayet, a fellow student at Cormon's. When he went home he was, as he put it, 'rather tired'.

At last in mid-spring, Henry seemed more cheerful. He wrote to Adèle in Malromé, full of atelier news and his plans to come south for the summer, bringing with him a friend whom he described in the following exuberant,

but probably disconcerting fashion: 'A remarkable fellow, fan-shaped chest, the arse of a rabbit, you have to have seen him naked ...' In a later letter he continued in a more conventional vein:

The weather has turned good again, which is letting me get a lot of work done ... Everybody is pushing hard to get ready for the Salon, Bordes, Rachou, etc. The latter just got a portrait commission for a very pretty price. I'm telling you all this because I hope it interests you. I may bring you two guests instead of one. You should collect the young girls in the vicinity and teach them to pose a little, so all we'll have to do is get on with it.

This letter precipitated a surprising crisis. In a second letter and even a third, Henry tried to appease his mother:

I must be most evil for you to write me such cruel things. I refuse to be angry in return. I think the rain is responsible for your bad humour. What you say on the subject of my friends makes me feel that you must think I'm very stupid, if you really believe me capable of introducing wolves into your pigeon coop. I simply wanted to be helpful to a charming, very well bred fellow, whom you certainly would not have had any reason to complain about. We'll be working as hard as we can, and doing honour to your wine. What more can you want?

What could have caused such a violent reaction from Adèle? There were at least two items in Henry's proposal which may have offended her. First of all, an invasion of art students into her private hideaway no doubt rendered her son's 'other life' altogether too concrete. She was quite sure that she disapproved of most of his new friends, particularly since their names and families were unknown to her. She seems to have made an exception in the case of Grenier, who was from Toulouse and wealthy. It is also likely that the idea of hunting up female flesh for the artists to use was entirely too suggestive of sexual activity for her to tolerate. Her understanding of what went on between artists and their models was probably very close to the truth. The whole situation must have reminded her of Alphonse's reputation for seducing any women who came within his range, particularly servant girls and farmers' daughters. If Henry had given any thought whatsoever to how Adèle would react to his showing up with an uninvited friend, not to mention his asking her to act as a procuress, he could have easily predicted her feelings. One can only assume that he thought her more naïve than she was, that 'doing honour to wine' and other spirits had impaired his judgment

or that he was unconsciously provoking her, as her anger would ease his guilt at leaving her for his new life. Perhaps he merely thought he had nothing to lose by trying, and that if Adèle chose the models, she wouldn't be surprised to see them coming and going from the house at odd hours.

She was obviously not to be appeased, because Henry finally delayed the trip, all the while insisting that his request was a reasonable one. Instead he stayed in Paris, whence he pointedly wrote to her that he spent all his time working, 'which hardly gives me anything new to tell you'.

Finally, in June he organized a brief holiday with friends at Taussat-les-Bains, near Arcachon on the Atlantic coast. There they stayed together in a country house belonging to Robert Wurtz, a doctor whose portrait Henry would paint a few years later. When he got back to Paris at the end of June, he lived in Grenier's apartment and, having sublet his own studio, shared the studio of Emile Ottoz, a friend from Cormon's.

In mid-June, Adèle herself returned to Paris, staying at the Hôtel Métropolitain until the end of July. All three Toulouse-Lautrecs were in Paris at once, a rare occurrence. Alphonse, who had been leading his own existence in Paris for some time, seeing Henry only occasionally, was in his usual mode – announcing regularly that he was leaving town, but making 'his departure more problematic every day by piling Caucasian trinkets on top of Persian ones', as Adèle put it. Alphonse's need for the exotic led him to make two sorts of collections: people and knick-knacks. Although he himself did not travel to the strange, wonderful places he dreamt of, he was irresistibly attracted to those who did. As he had enjoyed talking to the American couple at Pérey who had returned from Japan with a collection of *japonaiseries*, now Alphonse had developed the eccentricity of following travelling circuses in order to learn the customs of the exotic foreigners who performed in them. Henry in turn would 'collect' exotic beings. He reportedly spent a whole season in the company of an explorer, fascinated that the man had eaten human flesh.

When Adèle left for Malromé, Alph began pressuring Henry to move into the Hôtel Métropolitain with him, presumably because he thought Montmartre was too dangerous for his son. By insisting on protecting Henry, it seemed as if Alphonse again was implying that Henry was unable to look after himself.

In any case, as far as Henry was concerned, the Hôtel Métropolitain in the rue Cambon was too far from Cormon's. Going back and forth would have been exhausting. 'And as for wanting me to give up my studio, I don't think so – I'm too wary for that,' Henry wrote to his mother late that summer. In

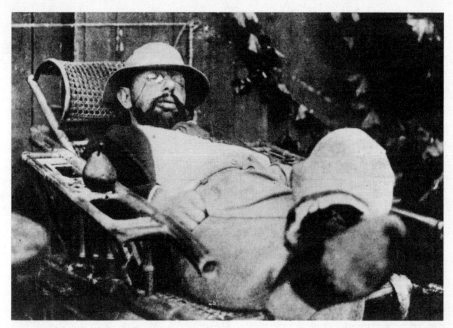

Henry asleep on a chaise longue, c. 1896.

the same letter, he expressed a renewed depression about his work: 'I'm dutifully finishing a piece and yet I'm frustrated. For I realize that working outside is an astonishing thing, and resting in the shade is a pleasure of the gods ... Struggling causes me to work frantically without producing anything of value – maybe it would be better to relax.'

Henry's increasing mood swings make it seem as if his morale and his physical health were both being affected by his new way of life. He was already aware of how necessary alcohol was to his self-confidence, how he looked for 'occasions to celebrate'. He referred to 'working' at the bars in the evenings, and as he did so, he also drank, probably to excess. In another letter to his mother written at about the same time, he mentioned what would become characteristic behaviour: 'Sunday my meal at the Nabob's was so copious that after dinner I began to snore. That's a fine thing!!' It was not unusual for him to drink so much that he dozed in public – at least two photographs were taken of him sound asleep.

From his letters it seems clear that his self-esteem was low and that he was feeling demoralized. As his anxiety increased, he turned back to Adèle for support. 'Now it's my turn to browbeat you a little for your silence,' he wrote to her. 'I was just about to telegraph you to find out what's become of

you. I wrote to Grandmother Louise to wish her a happy Saint's-Day. It was totally by accident that I remembered. I've been a little hampered by the weather, in working outside ... Maybe your letter got lost?' In the power struggle between Henry and Adèle, when one expressed need, the other withdrew. Now it was Adèle's turn to neglect Henry. A few days later, he wrote to her again: 'Have you broken your arm or have you forgotten the existence of your offspring? A little note, s.v.p. to let me know. Everything's fine here, I'm working hard.'

When 'the rains came' in September, he took off to Lili Grenier's country place at Villiers-sur-Morin, twenty-five miles from Paris, in the Brie region. Although it wasn't far away as the crow flies, getting there required taking a train to Esbly, then a horse-drawn coach for another hour, to the valley of the Grand Morin. Grenier and Lili loved organizing visits from friends, who frequented the bar at Père Ancelin's inn on the church square, not far from their house. Henry went there repeatedly over the next few years.

'It's quite cool out in the country,' Henry wrote to his mother when he got back. 'Paris is black and muddy, which doesn't keep me from trotting around the streets chasing down musicians from the Opéra, whom I attempt to charm so I can slip [backstage] into that temple of the arts, and of boredom. It's not very easy.' The 'musician from the Opéra' may have been Désiré Dihau, a distant cousin of Henry's from Lille, of whom Henry would do several portraits. As the composer and bassoonist at the Opéra de Paris was an intimate of Edgar Degas, Henry may even have cultivated Dihau in order to have better access to Degas. Of all the artists a generation ahead of Henry, it was Degas whom he was growing to admire the most.

Henry had probably already met Degas in the courtyard the elder artist shared with the Greniers. Lili had modelled for one of the master's *femmes au tub* and could easily have introduced them. Degas' work would now become the primary visual influence on Henry's own work, and Henry frankly copied the subjects and techniques of his chosen mentor. The number of Henry's works, even through the early 1890s, which make direct visual reference to Degas is quite astonishing. The borrowings are so open and obvious that they cannot be considered simple imitation but rather a kind of development of and tribute to Degas' art. Unfortunately, Degas in person was never to be accessible to Henry. Known for his misanthropic disposition and his devastating criticisms of other artists, Degas never showed any particular interest in Henry and probably was unresponsive to the boy's friendly approach. Thirty years Henry's senior, slowly going blind, and living in increased isolation, he had a spinsterish quality which may have been

offended by Henry's exuberantly non-conforming style. Degas seemed unaware of Henry's repeated attempts to pay him homage in his art and, if anything, appeared offended by Henry's use of the same subjects.

Henry's insistent borrowing from Degas' subjects and techniques in the face of Degas' dislike for both him and his work is reminiscent of his previous artistic rejections by Alph, Bonnat and, to a certain extent, by Forain, who had shown no interest in Henry's art. All his life, Henry would seek Degas' approval, and cling valiantly to any positive comment Degas made. But Henry also adapted and changed Degas' ideas, often taking them further and in different directions.

Back at Cormon's atelier in the autumn of 1885, Henry found two new students who interested him: Emile Bernard and François Gauzi. Gauzi, who came from the Languedoc just as Henry did, had arrived in Paris from Toulouse, where he had been studying art. Rachou, who had introduced Henry to Bonnat, now introduced Gauzi to Cormon. Gauzi was an excessively skinny, tall youth with a sparse black beard. He joined the group of southerners, including Rachou, Grenier and Henry, who worked in the atelier. He and Henry became good friends, sometimes even sharing a model. Henry, who frequently asked friends to pose for him, used Gauzi himself as a model in at least three works, one of which was painted from a photograph. Gauzi was lighthearted and not very serious about his art – he would not make a lasting reputation for himself – but he was extremely kind and provided a sort of anchor for Henry during the next few years.

Emile Bernard, on the other hand, was an energizing force. Only seventeen years old, Bernard was small and slight with long, straggly dark hair and large dark eyes (see Plate 8). He compensated for his slightly feminine appearance by impudent and contentious behaviour. Cormon, who loved energy and intelligence in his students, was tolerant of this, perhaps because Bernard was considered a prodigy. Before arriving at the atelier, the boy had already 'run the gamut of art', attempting works in all styles from medieval tapestry to Impressionist landscapes. He had considerable talent and quickly convinced the entire atelier that his high opinion of his own artistic worth was merited and that he would go far, although compared to Henry he never gained wide public attention. Such self-confidence and charming insolence could not help but attract Henry. Bernard, however, was somewhat puritanical. In 1893 he would join the Rosicrucians, a mystical religious sect. Shocked by the rowdiness of the studio *rapins*, in 1885 and 1886 he refused, for example, to join Henry, the Greniers and Anquetin in their nocturnal revels. However, it was with Bernard and Anquetin, the two egomaniacs of

the atelier, that Henry would form an inseparable trio, engaging in countless escapades both inside and outside the studio.

One of his new eccentricities was hunting odd game. He went off late that autumn with Anquetin, 'hunting crows' in Normandy, writing to his mother: 'I'm here to tell you my ears are cold and I'm drinking a lot of cider. The country is fairly powdered with frost but still has its charms. Monsieur and Madame Anquetin are delightful as always.' He was planning to go off again soon, he said, after equally inedible prey, to Le Crotoy to hunt seals. There is no evidence that these treks into nature had any influence on his own painting. Since his summer paintings in Céleyran in 1883, he had never done another landscape, although he often posed models outdoors. Making plans to go to Malromé that autumn, he wrote to Adèle: 'Try to get Kiki there if you can – use all your diplomacy, and realize how pleased I'm going to be to be able to have fresh air and work both together.'

For the first time in years, he spent Christmas with his family, ending up at the Château du Bosc, 'which for the time being is far from resembling Sleeping Beauty's castle, considering the number of young males who are cutting up in its long corridors', he wrote in his New Year letter to his Grandmother Gabrielle. The cousins spent their time taking photographs of the farm animals and of each other, including the cook, 'who seems to fancy himself a knockout, the way he poses in front of the lens'. Henry, who had just turned twenty-one, made a number of studiedly casual allusions to his adult status, referring to being forced to go outside with the other men to smoke his pipe: 'we circle the courtyard together in a group, like an exhibition of Shouberskis (the only stove on wheels, which can be bought at Place de l'Opéra for one hundred francs)' and mentioning that his New Year wishes came to her out of his newly bearded mouth.

On 10 June 1885 at midnight, something had happened that indirectly had a profound effect on Henry's reputation. In another of his astonishing processions, Rodolphe Salis ('Malice', as another artist nicknamed him) had moved his Montmartre cabaret, Le Chat Noir, about five hundred yards down the Boulevard de Rochechouart to a better location where the neighbourhood was not so rough. Accompanied by cooks, waiters and musicians, as well as friends, customers and hangers-on, Salis carried all the furniture and fixtures from the old Chat Noir to the new one. By moving, he left the old location empty, and the cabaret which replaced Le Chat Noir would be the first place where Henry's works would hang permanently in public.

The old post office which had formerly been Le Chat Noir was taken over

by Aristide Bruant, who had already made his reputation at the cabaret singing songs he wrote himself. Bruant renamed the cabaret Le Mirliton (toy whistle or doggerel verse). Although in style it was the polar opposite of the fashionable Club Mirliton whose annual art shows Henry had criticized at length as an eighteen-year-old, in this Mirliton, too, artists' works hung on the walls. Hanging on the cabaret walls, these portraits, often of prostitutes, were quite unlike the family portraits in bourgeois drawing rooms, and were one of Bruant's ways of thumbing his nose at the middle class.

Bruant wanted Le Mirliton to be totally different from Le Chat Noir. Its general tone was rough benches and greasy tables, resolutely working-class. Inside, the cabaret no longer had the cluttered decor of Le Chat Noir, with its Louis XIII furniture. The space was set with a clearing in the centre for the musicians and performers. However, Salis had inadvertently forgotten

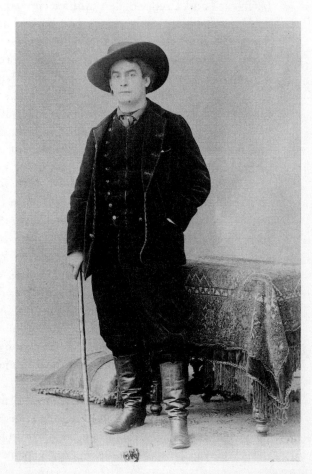

Aristide Bruant, c. 1886.

one of the Louis XIII chairs, and Bruant nailed it to the wall over the door. When Salis sent someone to get it back, Bruant refused to give it up. Instead he wrote a song about it, and the 'Refrain de la chaise Louis XIII' became a theme song of the establishment.

Although, like Salis, he was fully aware of his image, Bruant had a different style. Rather than trying to increase his prestige through snobbishness and affectation, he attracted attention with violently sentimental populism. He became so famous in Paris in the late 1880s that Emile Zola used him as a model for a character in his novel, *Paris*.

Fourteen years older than Henry, Bruant was a tall, flamboyant man whose face bore a perpetual five o'clock shadow. He affected the costume of a bohemian artist: a wide-brimmed black hat, red flannel shirt, black corduroy jacket and trousers and heavy sewer-cleaner's boots. To go out, he added a black cape and a red woollen muffler, draped over one shoulder (see Plate 4). His expression was sneering and bitter, but he had charismatic energy and a very loud voice. Someone who had been in the army with him once described him as singing a marching song so rousingly that it 'would make a paralytic get up and march. You would think he had swallowed a trumpet.'

Although not a native Parisian, Bruant had declared himself the spokesman of the underprivileged urban masses. His songs were described as telling 'the woes of the cold, the ragged and the homeless, the anger of the exploited and the hungry, the ongoing disappointment of those whom bad luck and human injustice have condemned to a life of crime – the oldest product of human misery'.

As an adolescent, Bruant had supported his family, working at a string of jobs – in a lawyer's office, with a jeweller, for the railroads – and continued to support them after he decided to use his native poetic talents to write cabaret songs. These were comic, vulgar, sentimental and full of Parisian argot. He quickly became immensely popular. Written in the coarse, cynical jargon of the working class, the songs declaimed the sadness and deprivation of life in the slums, the brothels, the prisons and particularly in the *zone* – the urban wasteland created around the periphery of Paris under the Baron Georges E. Haussmann, prefect of the Seine during the Second Empire. Many of the songs were named after the different sectors of this belt of shacks and empty lots.

To understand the political impact of Bruant's popularity, one has to understand the changes in Paris under Haussmann. By 1885, Paris was a 'new city'. It had been rebuilt and opened up following the elaborate plans designed by Haussmann and Emperor Napoleon III himself, who personally

instructed Haussmann on many of the details. Instead of a congested medieval town with a few impressive palaces, Paris was now an open, urban metropolis, crisscrossed by large, tree-lined avenues with classical perspectives. For the first time, it could be traversed efficiently (by troops, if necessary), and the wide new streets formed a perfect theatre to display the elegant comings and goings of the rich. Those of all nations who had the means and the leisure gathered there to play. The City of Light was becoming known as the pleasure capital of the world, and it was in this new city that the 'Belle Epoque' was born.

Haussmann had also seen to the establishment of new water supplies and drainage systems which removed foul odours from the city. New parks had been constructed, both in the centre and on the outskirts of Paris. The most notable of these was the Bois de Boulogne at the end of the Champs Elysées, which was now the final destination of the extended morning parade through the city by the leisured class. Rich and fortunate Parisians circulated in it freely, seeing and being seen. Its working-class counterpart, on the eastern boundary of Paris, was the Bois de Vincennes.

The rebuilding had destroyed a number of decaying neighbourhoods, forcing their poverty-stricken inhabitants to the outskirts of town, where they lived in a squalid *zone* of tenements and hovels which had none of the modern amenities Haussmann had so proudly installed for the bourgeoisie. Without proclaiming his intentions, he had effectively isolated the undesirables from the leisured class. In what was now called *la ceinture rouge* (the red belt), sewage ran in open ditches and water had to be brought in buckets. These dreadful slums, which included Montmartre, sheltered beggars, prostitutes and outlaws, and were full of disease and suffering. Nonetheless, they developed their own social life which for bourgeois and aristocratic Parisians had a seductive, if distant, glamour all its own. When the rich grew tired of their own games, by ironic reversal, it was they who would invade the 'red' neighbourhoods, slumming in the working-class *bals* and *cafés concerts*, where one could have a drink and listen to a populist singer like Bruant, braying out his songs about the suffering of the poor.

Bruant was well aware of the disparity in the clientele of his cabaret, and he built its reputation on this contrast. One could rub elbows there with thugs and prostitutes. But any outsider ventured there at his own risk. Outside the cabaret hung a sign: 'THE MIRLITON – RENDEZVOUS FOR THOSE SEEKING TO BE ABUSED.' Inside, the clients were taunted mercilessly.

It is said that Bruant did not originally intend to alienate his rich clients, but that the day he opened the cabaret, only three customers came. Haunted

by the 1,000 francs he had borrowed to open up, and mentally comparing that sum to the total receipts for the day – 7 francs – he bravely sang his entire repertory of songs to an almost empty house. And when one of the customers insisted that he keep singing, he lost his temper: 'What? What's that? Who's that idiot complaining?' He began yelling. The next day the same man came back with a number of friends, and they all waited expectantly while Bruant sang. When he didn't insult them, they looked disappointed, and one of them said, 'What, no bouquets today?' Bruant suddenly realized that the customer had come back with his friends not for the songs, but for the unexpected experience of being yelled at. From then on, it was Bruant's policy to be as ill-tempered and inhospitable as possible.

One client described the experience of gaining admittance to the cabaret:

Bruant ran the Mirliton on the principle that the more difficult a pleasure was to obtain, the more it was valued. One could not just go inside as one did at an ordinary café or pay for a seat as one could upstairs at the Chat Noir. On the contrary, Bruant enjoyed leaving people outside, standing in the street, while he examined them from behind a little barred window – a joke which he prolonged, in our case, for so long that I was sure that he didn't like our looks and was going to send us away.

In the cabaret, as Bruant described it himself, 'From ten o'clock at night until two o'clock in the morning he would recite lamentable verses with rousing and vindictive choruses, in which he prevailed upon the whole audience to join. Between-times he extolled the army, hobnobbed with Academicians, bullied cads, ridiculed fools, execrated those in power, treated grand-dukes like cossacks and referred with familiarity to kings.'

Henry was fascinated. Le Mirliton was like a sideshow; there was always something going on. He and his friends became regulars almost from the beginning and joined boisterously in the choruses. Bruant capitalized on his now famous disdain for his clientele. His songs were deliberately insulting:

Tas d'inachevés,	What a bunch of wimps,
Tas d'avortons,	A pile of dead meat,
Fabriqués avec des viandes veules.	You look like aborted muck.
Vos mères 'avaient donc pas de tetons,	Is it because your mothers didn't have teats,
Qu'elles n'ont pas pu vous faire des gueules?	That you don't even know how to suck?

The only drink at Le Mirliton was beer, served in very small glasses called

galopins, and it wasn't very good beer, either. Since Friday evenings at Le Mirliton were considered especially fashionable, Bruant used them as a pretext to raise the price of a *galopin*. Then after singing, Bruant would sit down with a table of well-dressed bourgeois who had come up to Montmartre to rub elbows with the low life, and order one for himself, putting it on their bill.

Although (or perhaps because) it was less intellectual than Le Chat Noir, Le Mirliton was frequented by a number of artists and writers, including Théophile Alexandre Steinlen (who sometimes used the pseudonym Jean Caillou, the French translation of *steinlen* – pebble), Georges Courteline and Oscar Métenier. Bruant published their work, as well as work by Forain and other popular illustrators, in the magazine *Le Mirliton*, a periodical he published 'very irregularly about twenty times a year' and sold at the cabaret.

Bruant seemed particularly interested in Henry, who was too odd to be a simple tourist and whose sketches of Le Mirliton Bruant liked. When Henry came into the cabaret, Bruant, it is said, sometimes stopped his chain of insults and songs to announce, 'Silence, Messieurs, here's the great painter Toulouse-Lautrec with a friend, and a bastard I don't know.' Henry and other friends from Cormon's all began doing paintings using Le Mirliton as setting. Henry did two works based on Bruant's now legendary Louis XIII chair, putting himself and his friends Anquetin and Gauzi into them. Bruant published the later work, *La Quadrille de la chaise Louis XIII à l'Elysée-Montmartre* (The Quadrille of the Louis XIII chair at the Elysée-Montmartre), done in 1885, as the cover illustration for *Le Mirliton* on 29 December 1886.

Another popular nightspot which attracted Henry and his friends, Le Moulin de la Galette, was a truly working-class dance hall located high on the *butte*, up the steep rue Tholozé very close to Henry's studio in the rue Lepic. The atmosphere was vulgar and brutish, full of local colour, but with a layer of dirt and an undercurrent of danger which made many uncomfortable. It catered unpretentiously for shop-girls and factory workers, prostitutes and their pimps, day labourers and thugs on a night out. When there were arguments, and there often were, the *apaches* and toughs went out into the dark back streets to fight it out.

The area of Montmartre near Le Moulin de la Galette had retained its bad reputation from the preceding century, and at night the dance hall was considered to be a place where a curious artist might get more trouble than he'd asked for. However, on Sunday afternoons the clientele at Le Moulin de la Galette changed, particularly during the warm weather, and its glass-walled ballroom and gardens were filled with a mob of young people flirting

and dancing under the trees. The girls were apprentice milliners, errand-girls, laundresses and seamstresses. Around them clustered artisans, counter-clerks and office-boys. To go on the dance-floor for a waltz cost two *sous*.

The windmills at Le Moulin de la Galette were real and had once ground wheat for the village of Montmartre. Now wafer-thin cakes called *galettes* were sold there. A contemporary description makes the place come alive:

We stood in line at the ticket-window with many other people, and paid the fifty centimes admission. (Women: twenty-five centimes.) In the cloak-room a stout older woman relieved us of our hats and canes and asked each of us for two *sous*. We went up the long entryway, its walls covered with paintings of flowers and garden scenes, and entered the large ballroom. What a brilliant spectacle of light and life! From what at first seemed a confusing mass of sounds, light and movement, different elements bit by bit began to separate themselves out. The dance floor was full of dancers, and the girls unveiled generous amounts of attractive anatomy. At the far end of the ballroom a huge orchestra on a sloping platform was the high point of the roar. The walkway, separated from the dance floor by a wooden railing, was full of bareheaded, laughing girls and smooth-faced boys with caps or straw boaters. They wore trousers that were tight around the knees and very short haircuts. Everybody wandered around in small groups, or watched the dancers, or drank at wooden tables.

Nobody dressed up. Women sometimes went in their house slippers, and men didn't bother to wear collars.

Even though Le Moulin de la Galette wasn't Henry's favourite, he went there often between 1885 and 1889, and did a number of studies of people dancing, walking around or seated at tables. Gauzi later described his first visit to Le Moulin de la Galette with Henry in 1888:

At the time Renoir, who had a marked influence on Lautrec, was exhibiting his painting *Bal au Moulin de la Galette* [1876] at the Durand-Ruel gallery. Lautrec knew this painting and he had been so impressed by it that, wanting to try the same subject, he dragged me one Sunday afternoon to this dance hall ... First we checked out the handkerchief-sized garden, where the wooden mill's black mass and per-manently immobile arms rose high in the air. The view over Paris was splendid: to the west were the hillsides of Saint-Cloud and Mont Valérien, with a fortress sitting on its top like a lump of sugar. This panorama was only barely interesting to Lautrec, who liked to see things close up, so he was much more attracted by the drinkers ... There we ran into some friends from Cormon's and sat down together in front of a salad-bowl of very sweet hot wine, flavoured with powdered cinnamon and cloves.

Lautrec declared: 'Here the only thing you can drink is hot wine; it's a sacred tradition.' And I think it's the only place he ever drank any. As he drank the hot mixture, he tried to figure out which tables had pimps sitting with their *daronnes* [girls]. There were some, naturally, but it wasn't easy to recognize them ... they looked exactly like the common mortals who frequented the place. We were obliged to resign ourselves to guessing, and soon a friend, who insisted he knew who was who, told us we were wrong.

The *quadrille* they danced at Le Moulin de la Galette was not the presentation of professional dancers that could be seen elsewhere, but a sort of disorganized amateur chorus line where everybody could dance. And when the skirts were lifted high for the *chahut* (the high-kicking part of the *quadrille*), they revealed not fancy lace ruffles, but everyday underwear. However, the best dancers quickly acquired a reputation and a following of fans. They soon moved on to clubs that paid them.

Three of the most famous *quadrille* dancers – La Goulue (The Glutton), La Môme Fromage (The Cheese Kid), and Valentin le Désossé (Valentin the Boneless) – all got their start at Le Moulin de la Galette. The most famous

Le Moulin de la Galette, c. 1885.

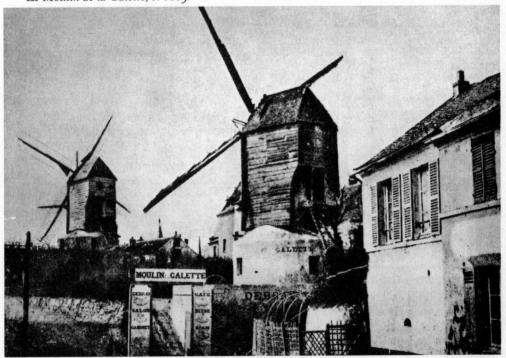

*Publicity photo of La Goulue,
c. 1889.*

Right: *Cha-U-Kao, c. 1889.*

of these, for a number of years, was La Goulue. Like many of the cabaret dancers, she had acquired her nickname as a descriptive term. It was given to her by the regulars at the dance hall, who said she was willing to try anything and showed a voracious appetite for all life's pleasures, particularly food and drink. On occasion she was known to wander around the room emptying customers' glasses.

La Goulue's real name was Louise Weber, and she had arrived fresh from the farm to make her way in Paris, where she had started out as a dancer in the Cirque Fernando aged about sixteen. A stocky strawberry blonde with a reputation for audacity, she was described variously as 'a strange girl, with a vampire's face, the profile of a bird of prey, a tortured mouth, and metallic eyes, who danced always with definite gestures' and as having 'the face of a strong-willed, dirty-minded baby and a brash provocative stare'. Yvette Guilbert, a cabaret singer who later became even more famous than La Goulue, remembered seeing her when she herself was not yet performing:

La Goulue was pretty and amusing to watch in spite of a certain vulgarity – blonde with bangs hanging down to her eyebrows. Her chignon, piled high on the top of her head like a helmet, ended in a single coil firmly twisted at the nape of her neck to ensure that it would not fall down while she danced. The classic *rouflaquette*, or

ringlet, dangled from her temples over her ears, and from Paris to New York, by way of the dives of London's Whitechapel, all the wenches of the period imitated the style of her hair and the coloured ribbon around her neck.

La Goulue danced very well, with provocative gestures, not hesitating to end a number, for example, by turning her back to the audience and flipping her skirts over her head to show her bottom, clad in lacy bloomers.

Thanks to her, the *quadrille* changed its character from a sort of square dance to a real show and became known as the *quadrille réaliste*, in honour of its lower-class dancers whose dancing was unprofessional, thus more real. It had started as the *cancan* (an onomatopoeic word meaning scandal or gossip), a line dance where the dancers, who were just clients, kicked in unison. But now it took on an exhibitionistic character. It had become primarily a dance for women, who were called *chahuteuses* (rowdies), and who dressed in street clothes and hats because the laws permitting floor shows were very restrictive and specifically prohibited the wearing of costumes by the dancers. However, it didn't take much imagination to get around the regulations: the women merely lifted their skirts as they danced, revealing as much as sixty yards of lacy petticoats, black silk stockings and black satin slippers. Rather than making any attempt to dance in measured unison, each

dancer tried to outdo the others, adding her own special steps, her own way of bending, turning and leaping. It was not unknown for La Goulue or another of the dancers to kick her leg so high that, while revealing the bunches of pink ribbons tying her drawers at the knees, she knocked a spectator's top hat off his head. The dance typically ended as the women slid to the ground in splits, with their skirts spreading out in a circle around them.

With time, the dance evolved even further into the *quadrille naturaliste*, presumably after the Naturalist literary movement which often portrayed the brutal, unpleasant realities of life among the lower classes. The name change implied degenerate vulgarity, and the dance lived up to its name.

Henry, who loved spectacle, particularly liked La Goulue. He was charmed by her outrageousness. Perhaps he identified with her insatiable appetite for pleasure of all sorts. His drawings captured her silhouette, her affectations, her arrogance. He caught not only her body language, but also her impertinence, her pretensions and a painful hint of what she would become as an old woman (see Plate 5). These drawings, developed into paintings and later a poster, had double impact. Because La Goulue was so famous in Montmartre, Henry became known as an artist who painted Montmartre faces. And as his art became more renowned, her reputation spread, both in and outside Montmartre. Everyone soon recognized La Goulue, and long after she gave up dancing, Henry's works kept her memory alive in the eye of the viewer. Henry literally made a legend of her. She herself, however, would never have more than the slightest awareness of the debt she owed to the dwarfed painter. Many years later, when she was interviewed on the subject of her friendship with him, she repeatedly referred to him as 'Toudouze'.

La Goulue, having started at Le Moulin de la Galette as an amateur, made her debut at L'Elysée-Montmartre as a professional dancer late in 1885 or 1886. Forty-five years earlier, L'Elysée-Montmartre had been the first dance hall to open in Montmartre. In 1880, it had moved from its original address on the Boulevard de Clichy to 80, Boulevard de Rochechouart, almost next door to Le Mirliton.

The Elysée had the most disreputable reputation of any of the clubs on the *butte*. A year or so before, a waiter from Le Chat Noir had been murdered, apparently by someone who wanted to reduce competition with the Elysée. Henry, intoxicated by the scent of danger, was drawn there by the potential for the unexpected, both onstage and off. The show at L'Elysée-Montmartre was elegant, and La Goulue was queen of the dancers. Usually she danced with other women who were not so famous, to fill out the *quadrille*. Now

she was accompanied by her 'sister' (actually her housemate, possibly a lesbian lover), La Môme Fromage, and other dancers with nicknames like 'Grille d'Egout' (Sewer Grating, because of her widely-spaced upper teeth), 'Nini Patte en l'Air' (Foot-in-the-Air), 'Miss Rigolette' (Giggle) and 'Rayon d'Or' (Sunbeam). One of Henry's favourites over the years was a gymnast, Cha-U-Kao (a nickname based on *chahut-chaos* or 'noise and chaos', the name of another dance).

Only one man, Valentin le Désossé, attained something of the same fame, but he apparently was not paid. Like the girls, he was considered to be part of the establishment, but they were now professional performers, while he had maintained his status of talented amateur. He was a tall, angular man who always wore a top hat, even while dancing. He had received his nickname, meaning boneless or double-jointed, because when he danced – which he did with amazing agility – he looked as if his legs were made of rubber. Like La Goulue, his almost caricatural silhouette, cadaverously thin, with long skinny legs and top hat tilted forward on his brow, became a trademark of the dance halls he frequented. According to Gauzi, 'the ladies of the *quadrille* considered it an honour to dance with this skeleton-like character'.

Valentin, like Henry, led a double life. His real name was Jacques Renaudin, and he is said to have come from an upper-middle-class family. During the day he held a regular job. Some said he was a wine merchant; others reported that he was a cashier for his brother, a government notary. In any case, like Henry's father and most of the Parisians who could afford teams and carriages, it was his custom in the mornings to ride horseback in the Bois de Boulogne. Sometimes he even took La Goulue with him in his carriage, 'tipping his hat gravely to the habitués of the Bois' as he passed. One morning, so the story goes, Henry and a friend were riding in the Bois in a carriage when they saw Valentin. 'Don't say anything to him,' warned Henry. 'He doesn't like to blow his cover.'

At L'Elysée-Montmartre, the *quadrille naturaliste* had been commercialized to the *quadrille érotique* on publicity flyers, and it was so scandalous that the police department sent the supervisor of public morals, a man named Courtelat du Roché, to make sure the dancers stayed within the limits of decency. A photographer who moonlighted as an inspector for the vice squad at night, Courtelat du Roché was known in the nightclubs as 'Père la Pudeur' (Daddy Decency). When occasionally he caught a daring young woman without underwear, he threw her out of the dance hall until she came back 'dressed decently; the Elysée was not a brothel'.

A popular novel of the time described the dancing:

With her right foot held straight up as high as her hat, Grille d'Egout, her pretty high-topped shoe in one hand, showing off her well-made calf, her long red stockings and her bloomers whose wide lace trim was gathered above her knee, revolved slowly while the crowd yelled with enthusiasm . . . La Goulue, dressed as a milkmaid, leaped around like a little goat, her milk-can clanking at each bounce. The brass was playing stridently off-key. As the gallop started, the frenzied musicians seemed determined to rival each other in noise-making, and a saturnalian gale carried off the leaping dancers, vibrating to the cymbal clashes, making the floor rock under their frenetic heels.

Until now, Henry had generally been doing portraits in the way Bonnat had trained him – life-size head and shoulder studies of faces, where such indicators as body language and costume were largely absent. But beginning in 1885, Henry began to do more partial-body and full-length studies or tableaux, sometimes with more than one person. In these works, the elements of social consciousness became as important as psychological representation, and in combination created a storyline. His portraits of Carmen Gaudin over the years are a good example of this change. He started by painting a series of portraits of her head and shoulders, showing her distrustful, suspicious expression (see Plate 9), but as his style changed, he moved to paintings showing her posing in character: in *La Blanchisseuse* (The Laundress), working as a laundress leaning on a table to rest her back, or in *Boulevard extérieur* (City Limits) as a prostitute, looking out for clients in a doorway. Carmen, who was not known to be a prostitute, managed to embody the character from Bruant's song so perfectly, and the accuracy of Henry's observation was so subtle, that without any obvious pointers her fatigue and anxiety lead the viewer immediately to understand her purpose. This ability to dissect his models' emotions has been compared to the newly discovered concept of experimentalism – a form of rigorous observation which marked scientific experiments in the nineteenth century; however, Henry probably came by it from long practice. Living with an unexpressive mother and a missing father, he had been trained since childhood to interpret the nuances of unstated feelings.

Henry was not alone. Many artists had begun to show social awareness in their work, reflecting the popularity of Emile Durkheim's newly elaborated theories of sociology. All over France the mid-1880s were marked by an increased interest in popular culture, and Montmartre itself was the centre of a populist political movement raising awareness of its poverty-stricken inhabitants. The Realist school, pervasive in French art and literature since

the 1850s, had already declared that art should represent without falsification. Even Bonnat, it was rumoured but never proved, had achieved the realistic Christ in one of his crucifixion paintings by nailing a real cadaver to a cross and propping it up in his studio as a model.

Now, slowly, not only the Impressionists but artists as diverse as Jean-François Raffaelli, Degas, André Gill (who had just died of tertiary syphilis in the insane asylum at Charenton), as well as journalistic artists like Forain working in the time-honoured tradition of Honoré Daumier, were defending their conviction that all subjects were appropriate for art and that artistic concerns included painting the scene as it really appeared rather than editing out 'non-pictorial' elements. It was important to show that beauty resided in the supposedly commonplace and ugly, while carefully avoiding sentimentality in the treatment. This work included paintings as diverse as Gill's portrait of a madman, which had caused a scandal in the 1882 Salon,

Carmen Gaudin posing for
Boulevard extérieur, *c. 1886.*

Boulevard extérieur, *1886.*

and Monet's later studies of the effect of changing light on haystacks.

Part of this concern came from an increasing social consciousness in the forty years since the 1848 revolution and an awareness that suffering and injustice had to be dealt with by society as a whole. The avant-garde in this case had been literary, and writers as dissimilar as Victor Hugo and Emile Zola had chosen as subject matter human suffering and social injustice.

Beginning in press illustrations and becoming more pervasive, the subject matter of visual art had also been changing. Formal work remained conventional for longer, but in drawings to be reproduced in newspapers and magazines the most frequent topics were everyday life or subjects of popular interest, like cabaret and dance-hall scenes. A lot of public attention was focused at the time on what the middle class perceived as the scandalously relaxed morals of the working classes under the Third Republic. A woman no longer had to be represented in an idealized setting in order to be seductive. Drawings of streetwalkers had become a commonplace in the popular press. Although more slowly, in painting, also, scenes from the everyday life of the poor were becoming acceptable.

Illustrations showing the plight of the poor were frequently requested by the popular journals for which Henry was just beginning to draw. Although Henry doesn't seem to have been politically concerned, as Bruant was, with social justice *per se*, he was more deeply touched than he liked to show by the individual tragedies of those he knew personally. One winter he wrote to his mother while visiting his friends the Greniers at Villiers-sur-Morin: 'I have begun a small head of a boarder at the inn where I painted the panels. She is in the last stages of consumption, but very pretty. I am sorry that I cannot bring her to Malromé to paint her and eventually see her buried.'

His newest works were a synthesis of what it was like for him to live in Montmartre: bohemian disrespect for the traditional values he had learned from his family, a mix of sexual fascination and sympathy with the outcasts of society, a whiff of anarchy and rebellion just under the surface of the growing interest in commercialism that marked both the *quartier* and his own art.

Anquetin and Bernard had also begun using Naturalist subject matter. At Cormon's, each *rapin* was eager to develop his own *patte*, his own distinct style. Together, visiting galleries, sitting around discussing art in cafés, working on *académies* in the atelier and on their own paintings in their personal studios, they tried to make their way through the maze of possibilities. Whom should they imitate? Where was the true avant-garde? Were

they willing to abandon the establishment? Degas, Renoir and Cézanne were thriving. Forain's and Raffaelli's work was published in the newspapers.

New theories were there for the younger artists to explore. In addition to their Naturalist subjects, three experimental concepts in style interested them: the application of pure pigments directly to the canvas as opposed to mixing colours on the palette, the rejection of chiaroscuro effects and, above all, working from nature, in natural light, as opposed to setting up scenes in the studio.

Henry was not a theorist in any general sense, but the conversations among the students at Cormon's were focused on theory, and he could not help but be influenced by what he saw, heard and read. He remained very divided. In 1885 he still desired the conventional forms of recognition: admission to the Ecole des Beaux Arts, winning the Prix de Rome, having a picture accepted by the Salon – in short, rewards his family would be proud of and which would lead to further rewards: well-paid portraits and official commissions or, with time, a professor's chair at the Ecole des Beaux Arts. But he was full of contradictions.

Perhaps Henry's greatest strength as an artist was that he remained responsive to each influence, as time passed incorporating many elements – photographs as poses, Divisionist colour theory, Japanese perspective, Social Realist reportage of contemporary life, for example – into his own increasingly individual style. To his credit, neither popular fashion nor academic rules impressed him much. Although he was passionate about working outdoors at this time, he was not at all above posing a scene in his studio or taking a photograph of it to fix the image before painting from the photo. And although he did dozens of paintings in Montmartre gardens, he was equally interested in the effects of artificial light, particularly gaslight and the brutal footlights illuminating the stage in the *cafés concerts*.

What interested him most was making a public impact. 'I hope you mailed my sketch off to the big newspaper,' he wrote to his mother from Normandy that autumn. In August he had prepared a drawing for *Le Figaro*, but Rachou had convinced him that it was not good enough to submit. He was eager to get some work published in magazines and newspapers, as Forain, Steinlen and other artists he admired had done. He felt that no matter what the qualities of his work were, if he did not have widespread recognition, no one would even know he existed. He was becoming very preoccupied with getting publicity in all its forms. One of his letters written about this time refers to an interview with a journalist that fell through: 'Ah, Dayot really set us up; we sat around all evening at the Café de Bordeaux, we paid for

our own dinner, and Deforges finally came over very late to tell us that ...
well, the excuse was weak ... we spent the whole evening in the same ten-
square-yard area. Too bad for us.'

It was in his illustrations for the popular press that the subject matter of his
work changed most. Bruant had raised Henry's social consciousness by several
notches. Henry's pieces intended for publication were typically on the kinds of
subjects Bruant treated in his songs. Until now Henry had struggled to achieve
an accurate representation of reality; now he added an anecdotal element of
social criticism. Although an awareness of social ills was common among the
progressive intellectuals and avant-garde artists of the day, Henry did not
choose his subjects for humanitarian reasons. He was working for the publicity
he desired and consequently he chose subjects which were likely to attract
attention and please those in power. Henry was no more a 'Naturalist' than a
member of any artistic movement. Except for his newspaper and magazine
work or his illustrations of texts written by others, he probably never had a
didactic intent. What he was attempting was more like reportage.

After a long search, Henry had finally found a permanent studio at 27,
rue Caulaincourt (now number 21), on the southwest corner of the street, up
a steep hill from the Place de Clichy. It had a separate entrance on the rue
Tourlaque at number 5–7, and Henry used the building's two doors, as well
as its two addresses, interchangeably. Much of the building was occupied by
artists and models, and his friend Gauzi moved in as well. It would provide
unusual sources of inspiration as Henry befriended those around him, par-
ticularly Federico Zandomeneghi, a hunchbacked Venetian painter and
protégé of Degas. 'Zando', despite his deformity, was a most dramatic charac-
ter who wore a musketeer's cape and defended his artistic theories by yelling
his arguments. He was painting circus subjects, and Gauzi later said that it
was Zando who taught Henry to view such subjects through a cropped
frame, as in a photograph, choosing an angle that showed only part of the
subject which extended beyond the edge of the canvas.

The new studio was a huge room on the top floor of the four-storey
building. A narrow staircase ran up one wall to a balcony near the high
ceiling. Off the balcony was a smaller room. In time Henry filled both of
them with an extraordinary collection of junk, canvases and art supplies. He
also set up a formal bar on a table in the large studio downstairs. 'Here
Lautrec mixed for you, often against your will, with the deftness of an expert,
all kinds of cocktails – far too many cocktails, alas!'

His mother now lived most of the year at Malromé, usually only coming
to Paris in late autumn or around Christmas for shopping, concerts and other

seasonal pleasures of the capital. During her brief stays in Paris, Henry put himself at her disposal, particularly because she habitually arrived with stocks of truffled foie gras, chocolate, and wine from her own vineyards.

Seeing too much of Alph, on the other hand, was always unpleasant for Henry, especially since Alph systematically refused to give him any money. On 24 April 1886, for example, he wrote to his mother: 'If Papa doesn't come across with my rent (which he doesn't look like doing) I am counting on you. I'll telegraph you "*Send Money*", but only in case of emergency, which will mean to send the necessary 335 francs, 33 centimes by telegraph (to 27, rue Caulaincourt).'

In addition, Alph's odd ideas could cause problems. While Henry had been looking for the new studio, Alph had decided that they should purchase one and live together. However, Alph's idea of a studio was an elegant apartment on the Champs Elysées near the Arc de Triomphe. 'I took pains to explain to him that it would never be more than a salon,' Henry wrote to his mother.

Henry, who now openly referred to his father as 'Alphonse', disdained the 'salon' Alph's studio would have become, but in fact his own studio had become the centre of his social life. First of all, given the difficulty he had getting around, it was far more convenient for him to receive at home than to go out, particularly during the winter months. In addition, he was proud of having his own studio, concrete evidence that he was no longer just a *rapin*, but a serious artist with a career. He liked having his friends and family visit him there. Jammed as it was with memorabilia, *objets d'art* and his paintings, it served as an extension of his personality. There he showed his work, had his friends model for him and mixed everyone drinks.

It was not long before Henry had the idea of holding open house on Fridays at the rue Caulaincourt studio and inviting people to drop in. Probably as a result of his propensity for hard liquor, this quickly became a weekly bash. According to Gauzi, the place was mobbed, sometimes by people who were not necessarily Henry's friends at all, but who hoped to profit from him or who came for the sideshow – to drink his extraordinary 'American' cocktails and to make fun of him behind his back. Henry didn't seem to care, and the studio parties went on for a number of years.

Surprisingly, Henry was very successful socially. One thing that appears repeatedly in his letters and accounts by contemporaries is that he had close friends and that he had a good time with them. If he was depressed, it was ostensibly about his work or his health. Although his romantic life remained a secret or at any rate separate from the rest of his contacts, he loved to go

out with groups of people. These friendships with men, both intense and superficial, were a source of great pleasure to him. People liked him. Henry was funny but not cruel, and he managed to disarm their shyness about his disabilities by laughing about them himself.

While he worked at Cormon's in the mornings, Henry poured forth a continuous stream of songs and funny remarks. His favourite songs, of course, were Bruant's populist ballads, and among them, he liked those with lewd and scatalogical references. The last verse of 'Au Bois de Vincennes' particularly pleased him:

Aussi l'soir quand ils sont partis,	And when they're gone, when it's pretty late,
On trouv' des cous d'poulets rôtis,	You can find selected bites of cake,
Des restes d'desserts assortis,	Sardine cans and broken plates,
Et d'porcelaine;	And bottles in the dark;
Et des boît' à sardines, des litrons,	As well as necks of roasted birds,
Des p'tits Journals et des étrons	Old magazines and human turds
Au Bois de Vincennes.	In Vincennes Park.

Montmartre's characteristic slang, which served almost as a code, permitting people from the neighbourhood to identify each other, had immediately fascinated Henry. Since his first days on the *butte* he had larded his conversation heavily with Montmartre expressions learned in the streets. Gauzi commented that although Henry loved slang, had memorized all Bruant's songs, and would even recite comic monologues he had learned by heart, the mixture of aristocratic French and gutter-slang on his tongue was not vulgar, but good-naturedly humorous.

Although there are no recordings of Henry's voice, it is likely that he had the high resonant twang common to most dwarfs. Later his friends would describe his way of speaking as oddly individual: in addition to his native southern 'Gascon' accent, full of regional dialect (*trempadou* for bathing, *poutous* for kisses), his voice was marked by a mixture of lisping, sniffing, and drawling which seemed infantile and made his witticisms all the more amusing. Henry was becoming as skilled at verbal quips as he was at line-drawings in charcoal, and he loved to laugh at his own jokes.

His characteristic vocabulary over time was adopted by those who knew him and found it funny. He tended, for example, to eliminate verbs entirely, using instead a concise noun phrase to sum up his impression of something. He referred to many things with words which had a special meaning for

him, which was confusing when one first met him. However, a friend commented that 'once you understood the precise meaning of those pithy formulas which he used to decorate his conversation, they glowed in his thinking like spotlights, making you aware of its complexity'.

For him a certain sort of feminine grace became 'Fontanges' – a reference to one of the most touching of Louis XIV's mistresses, Marie-Angélique de Scorraille de Roussilles, Duchesse de Fontanges, a lovely ivory-skinned, red-haired girl who died in childbirth at the age of nineteen. A high-class prostitute Henry knew had also adopted the name. He described a dandy by saying, 'A useless sapphire adorned his *sinistra*,' and referred to an overweight, wrinkled, provincial relative as a 'pachyderm *in partibus*'.

He had *tics de langage*, endlessly punctuating his sentences with the word *'hein?'* (eh?) or referring to almost any action as a *'technique'* (which he pronounced in a funny way, exploding the consonants: 'tek-nik'). According to one friend, everything had its technique for Henry: he referred to the way an actress's husband mounted guard in her dressing room as 'jealousy tek-nik'. Women dyed their hair red in the 'Venetian tek-nik'.

He referred to all preparatory work – sketches, observations, studies, etc., even merely watching a woman who interested him – as *'travaux d'approche'* (defensive manoeuvres), and after the night he fell drunk down a flight of stairs and broke his collarbone, he called all potentially dangerous situations 'clavicle-bones'. Anything that fell into the category of bad art he called *'roup'*, from *roupie* (snot), and it was often these things he liked best – putting an absurd lady's hat into several paintings, or wanting to amass a collection of ridiculous works of art.

He developed a series of personal proverbs with which he replaced everyday stock phrases. Instead of casting pearls before swine, he referred to 'giving jam to policemen'. When something was to be kept a secret, he'd gravely warn his friends, 'mustn't tell it to the concierge'. If someone irritated him, he called them a *'ouax rababaou'*, an onomatopoeic epithet imitating the sharp, yipping bark of a fox-terrier. But it was the term 'moustache' which had the most elaborate explanation. Maurice Joyant, who later would be Henry's art dealer, recounted this anecdote:

Once a friend of ours, Louis de Lasalle, a poet killed during the war, had come along with us sailing in the Baie de Somme, saying he adored the sea and sailing boats. Athletic, proud of his muscles, quite handsome, he had a magnificent handle-bar moustache which he painstakingly curled, wrapping the ends each evening so it would hold its shape. Lasalle had asked Lautrec to paint his portrait, and he had

agreed to do so long before, on the condition that Lasalle shave his moustache.

As we came out into the deep swell of the open sea, our passenger, wearing brand-new, elegant sailing togs, quickly became seasick, and soon his moustache was drooping pitifully. 'Moustache, moustache,' Lautrec kept yelling throughout the whole trip on the rough sea, 'Moustache,' taunting him for hours ... I don't know if Lasalle, exasperated, finally shaved his moustache, but Lautrec never did his portrait.

Henceforth Henry used the word 'moustache' to describe someone whose affectations and petty vanities were sure to result in a humiliating come-uppance.

To his friends Henry presented a garrulous, witty exterior. To his mother, he repeatedly admitted fatigue and depression, saying that he was unhappy and a bad son. She, as much as his friends, may have required him to play a particular role to meet her own needs.

In Paris in the spring of 1886, there was a lot of snow. Working in draughty studios, Henry developed 'tonsil tribulations' that would last until July. His health overall seemed frail, although his symptoms were those of fatigue and low resistance, not of recurring bone weakness. The time of unexpected bone breaks was over. Despite some chronic pain caused by his distorted limbs and difficult, limping gait, the agonizing muscle cramps and aching joints of his childhood had passed. His condition had stabilized. His real health problems were other: for at least two years he had been drinking excessively, and it was around this time that Henry very probably contracted syphilis. One widely repeated story relates that after his sexual initiation through the good graces of atelier comrades, word got out that he was frequenting a certain prostitute known on the *butte* as Rosa La Rouge, after a woman in a Bruant song. Henry was warned that she had syphilis, but either it was too late or he was unable to control his impulses – the same ones that led him to compulsive drunken nights followed by early mornings hard at work.

There was no cure for syphilis at the time, and it spread uncontrolled at all levels of society, particularly among prostitutes and those frequenting them. The disease was badly understood, and when the first lesions had healed, many people thought they were no longer contagious. Men con-tracted syphilis in brothels, then gave it to their unsuspecting spouses, who transmitted it to their unborn children. One theory even suggests that Henry's dwarfism may have been caused by congenital syphilis, which his mother presumably had caught from Alphonse, who was extremely likely to have been infected. The disease could have caused fragile bones and

growth problems. Although there is no evidence that either Alph or Adèle suffered from it, the number of people who had syphilis in the nineteenth century must have been far greater than any official statistics. Twenty-five percent of those infected eventually died of the disease.

Henry's friends repeatedly stated that he had contracted syphilis. Sylvain Bonmariage, who had met Henry through Gabriel Tapié de Céleyran, claimed in 1947 that Henry was a *'martyr du sigma'* ('martyr to the Big S', or syphilis). Presumably Henry's cousin Gabriel was Bonmariage's source of information. Bonmariage also quoted Edgar Degas' opinion, as expressed to him, that Henry's representations of women in art stank of syphilis (*'ses femmes puent la vérole à plein nez'*). Henry's friends said that a friend from Toulouse, Henri Bourges, who was then finishing his medical training in Paris, treated Henry as best he could.

Henry's family, predictably, always denied that he could have had the disease at all. Just as they explained Henry's crippling through broken bones, Adèle and the rest of his family always explained Henry's behavioural anomalies as being caused exclusively by his alcoholism. Did she really not suspect that Henri Bourges was treating him for syphilis? Two things are certain. One, that if he had syphilis, he might have gone to great lengths to hide this information from Adèle, and two, that the disease was extremely common. Some of the best writers and artists of the century died of it, and as one of its victims, the novelist Gustave Flaubert, said in his *Dictionnaire des idées reçues* (Dictionary of Commonplaces), 'Everybody has it more or less.'

Henry's chronic fatigue, causing him to fall asleep at parties and to feel too tired even to leave the house, may have been a side effect of syphilis, as well as of drinking. Later, Henry's friend Bourges wrote in a treatise on syphilis: 'More than anyone, the syphilitic requires a sufficient number of hours' sleep ... he cannot overwork his intelligence and abuse his mental activity with impunity.' Henry, the *fêtard*, the party-lover, who had always had numerous intestinal and respiratory infections, was taking serious risks with his health.

In March 1886, an odd new student came to work at Cormon's. A slight, hunched, clumsy man with unexpectedly large hands and a strange stare, Vincent Van Gogh had just come to Paris after a series of depressing experiences. He had worked as a Protestant missionary in the coal fields of Belgium, living in poverty and painting in greys and blacks to represent the colourless life of the workers, breaking with his family and painfully studying art on his own. A voracious reader and obsessive painter (sketching fifty heads of

peasants in preparation for *The Potato Eaters* of 1885), he had left the Antwerp Academy, where he had tried for a few months to study, to come to Paris to live with his brother Théo, his closest ally. Théodore Van Gogh managed the smaller of two branch boutiques of the Goupil gallery, which had been bought in 1884 by Boussod et Valadon.

Since Van Gogh had declared that he wanted to spend a year drawing from nude models and plaster casts of classic sculpture, Théo had registered him at Cormon's. Despite the students' rebelliousness, and fortunately for Van Gogh, Cormon continued to tolerate independence and eccentricity in his students. The *rapins* perceived Van Gogh as a curious, excessive man, out of place among them because he was ten years older. Often morose and withdrawn, he worked silently in the studio, ignoring their banter, then suddenly breaking into unsettling loquaciousness, engaging anyone near him with abrupt intensity. On those occasions he would launch into stuttering outbursts of bad French, loudly declaiming his theories on line and colour, and hissing through badly fitting false teeth.

Rembrandt, Delacroix and the Impressionists were his latest discoveries, and under the influence of the lighter palettes surrounding him in Paris, he was leaving behind his former sombre drawings and paintings and, like Henry and his friends, experimenting with colour applied directly from the tube. He was excited, almost intoxicated, with art, and he had a touching but somehow inappropriate wish to share his enthusiasm. 'And his dreams, oh, what dreams!' Emile Bernard later wrote. 'Gigantic exhibitions, philanthropic communities of artists, founding of colonies in the South of France; moreover, a progressive invasion of the public domain in order to re-educate the masses to the love of art which they knew in the past.'

Many students came to Cormon's from other countries, but Van Gogh seemed especially foreign. Gauzi recorded his reactions to him, as did A.S. Hartrick, an English painter who also entered Cormon's that year. Hartrick described Van Gogh as 'weedy' and 'pinched'. He did not fit in easily with the lighthearted pranks of the atelier, and his own seriousness and determination were almost a guarantee that the other students would not take him seriously, although Bernard observed that he 'did not condescend to notice those who were laughing behind his back'. Hartrick commented: 'I fancy the French were civil to him largely because his brother Théodore was employed by Goupil and Company and so bought pictures.' His branch of Goupil (as everyone still called it despite the change in ownership) was almost the only Paris gallery receptive to younger artists. 'Frankly,' Hartrick continued, 'I confess that neither myself, nor any of those I remember of his friends,

foresaw that Van Gogh would be talked of specially and considered a great genius in the future.'

No one in the atelier considered Van Gogh to be crazy in the conventional sense of the word, but they were aware that he was unstable. Gauzi commented that Van Gogh only wished to be left alone and that the others were careful not to play tricks on him – they were a little afraid of him. 'If, when we were talking about "art", anyone insisted on disagreeing with him, he lost his temper in a disconcerting way.'

Henry and Van Gogh worked with the others in the studio, using the same models. A number of their drawings are of identical plaster casts from slightly different angles. Despite their dissimilar personalities, the two men became friends. Van Gogh expressed admiration and enthusiasm for Henry's work and encouraged Théo to buy and hang some of it in his gallery. Early in 1887, Henry did a portrait of Vincent Van Gogh (Plate 6), employing some of the Dutchman's own techniques. In this work, Henry not only used pastel, an unusual medium for him, but imitated the multicoloured hatching and comma-like strokes which distinguished Van Gogh's style. The portrait seems to be almost a homage to Van Gogh's art as well as his person. Henry

Engraving showing the original Goupil gallery in the rue Chaptal, c. 1860.

quite possibly traded this portrait to Van Gogh in exchange for Van Gogh's spring 1887 painting, *Vue de Paris*.

Henry's work was changing, reflecting influences far beyond Cormon's atelier. He, like Van Gogh, used Impressionist colour and brushstrokes in much of his 1886–7 work. He was influenced by Georges Seurat's exploration of the theory that colour is more luminous when applied pure to the canvas in dots of juxtaposed complementary colours, so that it has to be mixed by the eye of the spectator. Henry's work would henceforth employ strongly contrasting colours, frequently applied unmixed.

In May 1886, the weather was hot and stormy. Henry wrote to his mother that he was working happily. He remarked that Cormon had been pleased when Henry brought in his outside work to be reviewed in one of the Sunday sessions and mentioned in passing that the annual atelier competition would be judged the next Wednesday. His ambivalence about the atelier prizes showed in his attitude: he wrote that he was preparing paintings for the competition, but that it was of no importance to him. As Cormon had been pleased with his work outside the atelier, he probably felt approval of his own experiments was more important than the success of his versions of conventional academic work.

For over three years Henry had patiently completed Cormon's assignments of legendary biblical and mythological subjects. Now he began to ridicule them to his friends. It was, as he had said in a letter to Adèle, a time of revolution at the atelier. Emile Bernard, in the atelier only since November, had already begun stating his outrage at Cormon's conservatism. Henry, for his part, was growing more and more intolerant of 'painterly' techniques and of artists who cared more about how the paint was applied than the effect of the finished work.

He intentionally toned down his work, both in terms of the thickness of the paint and the use of glazes. Perhaps as a result of his growing disdain for the kind of painting which won prizes at the official Salons, he developed an absolute hatred for varnished painting, for any surface which was falsely sealed and glossy. He may have perceived the varnish and affectation of such works as similar to the hypocrisy and sentimentality which coated bourgeois social conventions.

He believed that the surface of the painting should be discreet. As early as 1880 he is said to have sought a flat, non-glossy surface in his work, painting with a brush dipped in black ink on a piece of cardboard. In order to subdue the shine of oil paint, he now adopted a technique he had seen the artist Jean-François Raffaelli use, of painting with greatly thinned oils on bare cardboard

or raw canvas, producing a flat, almost powdery surface which greyed the effect of the colours and looked something like pastels when it dried. Now his paintings were often reduced to line-drawings with a colour wash. Hartrick had noticed Henry's use of this technique very early. 'Lautrec was an artist of very marked individuality and, I should say, had one of the best artist brains in Paris...I can still remember vividly how novel and interesting his work looked to me among those of others in the studio. He was painting in turpentine on cardboard, using a very liney method of drawing ... No one else attempted this method at the time, though many copied it later.'

Henry was cultivating his own characteristic style. Unlike Emile Bernard, for example, who was eager to invent a style that was as yet completely unknown, Henry was not attempting a revolution in art. His *patte* had been visible in his earliest drawings. But he was moving on from the solid base of training he had received from Bonnat and Cormon – accurate perspective, realistic volumes, copies of old masters and living models. He obviously believed in the value of careful draughtsmanship, and he would continue to draw *académies* for practice until 1887. There is even one *académie* dated some ten years after that. In his work outside the studio he was doing primarily portraits of friends in informal poses, often in his ordinary work environment, sometimes in 'Social Realist' poses. While retaining his basic allegiance to realism he experimented with subject, style and technique, trying the methods his friends were trying and adopting them permanently only when they fulfilled his own stylistic needs.

In the late spring or summer of 1886, his new project was to go to the avenue de Villiers, where he was doing drawings in the atelier of a young sculptor whom he did not identify, but described to his mother as being 'a most handsome boy', ironically adding, 'irreproachably well-bred'. Henry appears to have been intermittently interested in three-dimensional work, for in 1885 he had written to his mother that he was working on sculpture in the studio of the famous sculptor Carrier-Belleuse, where earlier Auguste Rodin had trained, and that summer sent a 'small bronze' to his seventeen-year-old cousin Raoul. An academic painting of a studio model he submitted to the Cormon competition that spring, titled *Le Polisseur de marbre* (The Marble-Polisher), and a series of academic drawings from plaster casts of sculptures are the closest direct references to sculpture in his surviving work.

He showed far more excitement about getting a commitment from Jules Roques, publisher of a somewhat risqué popular newspaper called *Le Courrier français*, to print some of his drawings, the first of which, *Gin Cocktail*, appeared in the issue of 26 September 1886. Henry worked hard on the

drawing. Disappointed with the resulting reproduction, he redid it several times.

Popular magazines in Paris in the 1880s, rather than using photos or engravings of paintings, often had a stable of paid artists whose drawings they published regularly, using typographic reproduction techniques. The journals which attracted Henry were the ones which published the Montmartre artists – Henri Pille, Henry Somm, Léon-Adolphe Willette, Steinlen and a number of other illustrators who, somewhat older than Henry, lived on the *butte* and drew its denizens and their life. Most famous for working in black and white, their striking illustrations were becoming synonymous with the Belle Epoque. The big magazines, *Le Fin de siècle* (sic), *La Vie parisienne*, *Le Figaro illustré* and *Le Courrier français*, were joined by smaller-circulation magazines published by cabarets, such as *Le Mirliton* and *Le Chat Noir*. All had in common a bold populist tendency and an interest in the erotic.

Did Henry choose *Le Courrier français* as a place to publish his drawings or had he submitted work to the publishers of the entire spectrum of popular literature? In any case, his association with this particular magazine was not surprising because *Le Courrier français* published Forain's work and Henry showed every sign of wanting to attract the same audience. Perhaps he even wanted to associate himself with Forain's prestige which, although limited, was high among connoisseurs of Montmartre. It is said that Forain did not reciprocate Henry's admiration, but Henry was more influenced by Forain than is generally supposed.

To begin with, Forain, whom he had met in the days when Forain's studio was in the same courtyard as Princeteau's, was the only one of the popular illustrators with whom he had anything like a personal acquaintance. He had maintained contact with the older artist, whose reputation came from his relentless portrayal of the Paris underworld of pimps and prostitutes, which he represented in india ink drawings with scathing titles. Many of Henry's early drawings on the same subjects closely resembled Forain's in style and ironic social content although he never wrote captions for them. Henry may have felt the influence of Forain's work partly because he knew Alphonse admired him. At one time Forain had done a watercolour sketch of Alphonse which Henry kept in his studio and showed proudly to visitors.

Being published in 1886, not only by Forain's publisher, but in the same issue with an illustration by Willette, who was much more famous, made Henry very proud. He did not seem aware that Willette was essentially a commercial illustrator whose subject matter was social commentary,

particularly 'Parisian' (i.e., big city) morality. Willette's drawings fell into the domain of frivolous erotica and, despite their popularity, their reputation as art was less important than their interest as ephemera.

For Henry, publishing his work had a double edge. On the one hand, he held such recognition up to his family as objective evidence of his success as an artist. On the other, he was aware that his public image embarrassed them, and that they probably didn't consider drawings published in the popular – or even worse, bohemian – press proof that he was a famous artist. However, one way of resisting his family's control was to make a public figure of his person. Rather than attempting to remain anonymous as he made his nightly rounds of the Montmartre cabarets, he usually took with him Louis Pascal or some other relative or family friend. The very small artist, seated night after night at the same table in the same *caf' conc'*, sketching the floor show and the customers while the stack of coasters from his drinks accumulated in front of him, was bound to attract attention.

As Henry sought more recognition, Alph clamped down even more strongly on Henry's use of his family name. Henry had signed works 'Monfa' (not Montfa, the spelling on his birth certificate) as early as 1882. Now, in 1886, for the first time he began using the pseudonym 'Tréclau' (an inversion of Lautrec), which he also wrote 'TREclau' and 'Tréclo'. The phonetic resemblance of this name to the expression *très clos* (very closed) is unmistakable. He used this signature for a year or more on all his work, including on a portrait of his mother that he did at Malromé that summer which was exhibited in Toulouse in May 1887. In at least one work, he actually painted out his own signature, painting 'Tréclau' on top of it. He said in a letter to his Uncle Charles that he had 'permanently adopted' the *nom de plume*, but no one was fooled by it. An art critic writing in *La Dépêche de Toulouse* in June 1887 referred to his 'transparent pseudonym'. By 1888 he abandoned it to sign his work 'HTLautrec', 'Lautrec' or simply 'HTL'.

Henry resented Alphonse's insistence that he not use the family name as strongly as he had resented his disinheritance from the Château du Bosc. Once again, Alphonse, although he obviously loved Henry and devoted considerable attention to his adult son, showed that at some level he was ashamed of him, believing that Henry's appearance, behaviour, and the kind of art that he did were so great a betrayal of the house of Toulouse that Henry must be prevented from revealing his relationship to the family. It is a sign of strength that Henry did not permanently submit to Alphonse's demands and in the end insisted on reclaiming at least the Lautrec portion of his birthright – not only signing his works, but having his posters

promenaded, signature and all, through the streets on horse-drawn movable billboards.

The issue of name was not minor to noblemen like Henry and Alphonse. In their social class a man's name was considered to be the immortal part of him which would live on. All other elements of his person, including individual talents and achievements, were generally perceived to be manifestations of a lower, temporary nature, unworthy of real concern. It was not unusual, for example, for a young aristocrat who had no illusions about his looks, intelligence or other assets to propose marriage to a great beauty or, even more commonly, to the daughter of a fabulously rich American, confident that he was offering a commodity of equal value: his name. In the world of the Toulouse-Lautrecs, 'all individual misfortune was considered bearable, so long as it did not touch the reputation of the family name'.

There is no question that Henry was preoccupied by his name. Once he signed a portrait 'Henri IV' and on another occasion signed a drawing 'H. Quatre'. Since these could not be references to his now dead legitimist namesake Henri V, Comte de Chambord, perhaps they were a comparison between himself and Henri IV, the Renaissance King of France, famous for his amorous exploits. On another occasion, Henry's family was profoundly embarrassed when during an alcoholic binge he explained to the police, who were called because he didn't have the money to pay for his hotel room, that he was the Count of Toulouse. The issue remained unresolved throughout Henry's life. Many years later, in an 1899 newspaper commentary, a journalist accused him of irresponsibility in refusing to take a 'plebeian pseudonym' because neither his lifestyle nor his art did honour to his famous ancestors.

Still, Henry's ambivalence about his role in the world was most often expressed with irreverence and good humour. He liked to provoke and shock those around him – members of his family or others. A painting he did in 1886 showed an artist (presumably himself) from the rear, working on a canvas. Written on the canvas was the sentence: *'Oh! que ce pet pue!'* (Wow! does that fart stink!). A cloud of smoke was depicted churning from the artist's *derrière*.

Henry spent the summer of 1886, when he was twenty-one, alone in Paris, working. In late May, since the Greniers were going to be out of town for the summer, he moved back into their apartment, probably from Rachou's place at 22, rue Ganneron. Saying he needed time to paint, he refused himself the pleasure of going off to Nice with Anquetin, but although he was disciplined enough to deprive himself of clearly defined distractions like

trips and outings, and even though he remained alone by choice, he felt abandoned. He consoled himself with drink. '*Me voilà* [Here I am],' he wrote, 'completely orphaned.' He referred to his art as a '*sale métier*' (foul profession) and vacillated about staying, planning briefly to go to see the Greniers ('at the risk of leaving again if I don't work'), then to go with another atelier friend, Roger Claudon, to Cernay, near Rambouillet, where they would hire a model and work in the country.

In late July, in the midst of leaden hot weather, Henry caught tonsillitis for at least the third time that year. His way of dealing with his illness seemed eccentric at best. He wrote to Adèle that he was working 'out in the sun' as much as possible. 'I'm somewhat cooked,' he wrote. He even developed a brief artistic interest in painting suntanned models. He mentioned that he had been forced to abandon a study because his model, whom he had posed sitting on the grass without a hat or a parasol, got sunburned and refused to continue. He apparently continued his interest in painting nudes outdoors into the autumn, for in a letter written after a visit to Grenier that October, he remarked that it had been too cold for a model to pose nude on the grass. A family anecdote, surely from a later period, has it that he also offered to paint the infant child of his cousin Raoul, if only its mother would let him put it outside without a bonnet long enough for its skin to turn the colour he wanted. His offer was rejected.

Henry's rakish behaviour, as well as his eccentricities, were hard on his mother. When he and Grenier went to visit Adèle late that summer at Malromé, she and Tata were scandalized by the 'absolutely terrifying' quantity of food and drink the two young men consumed. Kept in day and night for four days by a continual storm when they were eager to paint and go rowing and be outdoors, they persuaded Louis Pascal to visit them and did his portrait, filling Malromé with their talk, cigar smoke and lively enthusiasm. 'My clean laundry is getting wet and my young men are cursing the rain,' said Adèle. She too posed for a portrait reading in the salon at Malromé (Plate 7), but the posing was long and frustrating because her son insisted that the light be perfect: sunshine from nine to eleven in the morning, even though raging storms were keeping them all awake at night and making the 'sky so black' that Henry couldn't finish paintings he'd already begun. She both liked and was irritated by his presence. He and Grenier complained so of the cold that she finally relented and had fires built in the salon in the evenings. She referred obliquely to Henry's drinking several times, remarking on one occasion that the Armagnac was disappearing 'far too fast' and commenting that Henry was frenetically active, but indecisive and unable to

get down to work: 'Naturally [his plans] are far from clear, and at the moment he's doing a lot more fidgeting than working.' On a trip with her to Le Bosc, Henry insisted on smoking so much he had to be placed at the other end of the hall from Grandmother Gabrielle. He spent most of that visit with his Uncle Charles, finishing the huge model clipper they had begun years before when Henry was convalescing from one of his broken thighs.

In mid-October, after more than two months in the south, Henry suddenly announced that he 'urgently' needed to be in Paris for his work and departed immediately, taking with him a puppy named Robby. Henry, like all the Toulouse-Lautrecs, loved dogs, but it quickly became obvious to him that having a puppy in the city was a lot of trouble and that he was unwilling to give it the care it needed. In his first letter to Adèle after his return to Paris, he declared Robby to be a pearl of a dog, looking exactly like a fat rat and already learning to growl. He promptly made two paintings of it, but nonetheless mentioned in passing that he had parked the puppy 'for the winter' at Lili Grenier's place in Villiers-sur-Morin. In a subsequent letter he responded to Adèle's request that he return the dog to her by explaining: 'I can't send you the dog because a young beauty took it from Eustache.' He sent her its portrait instead. However, henceforth he repeatedly sent his mother puppies, and once a kitten, almost as consolation for his absence.

That autumn, Henry's mood was lightened by participating in an 'incoherent' art show. Four years before, in 1882, a popular playwright, Jules Lévy, had jokingly organized an exhibition he called the Exposition des Arts Incohérents, exhibiting works by people who 'didn't know how to draw'. This show was such a success that it became an annual event and began holding its exhibitions, not in Lévy's personal apartment as at the beginning, but in space rented in the spectacular Galérie Vivienne, a two-storey glass-covered pedestrian mall of cafés, restaurants, shops and offices across the street from the Bibliothèque Nationale. Most of the exhibitors were journalists and caricaturists from the popular press or actors, actresses and other performers who had no art training. Soon a group of Chat Noir habitués, including Willette and Henry Somm, began calling themselves the Incohérents. Le Courrier français had become the mouthpiece of the Incohérents and had devoted a whole issue to their work in 1885. This 'anti-group' challenged the establishment and specifically the strait-laced Salon des Artistes Français through humour and absurdity – incoherence, in a word. Its iconoclastic exhibitions took place intermittently over the next nine years, despite an 1887 announcement that the group was dead. To be precise, it was not a consistent group at all, but rather a phenomenon. It received enormous

press coverage, described by the satirical journal *Gil Blas* as rejecting 'the decaying, the depressing, the morose, the symbolists and the anarchists' in favour of what *Le Figaro* called '*la vieille gaîté française*' (old-time French gaiety), 'tweaking the nose of pessimism,' as *L'Illustration* put it. Although all its manifestations were accompanied by joyous tomfoolery, it was rare for an artist to exhibit more than twice. Many of the best entries were based on puns or social commentary and prefigured Dada and Surrealist works which a larger public would consider world-shaking thirty to fifty years later. Entries in the Incohérents' show included one by the comic monologuist Coquelin Cadet, titled *Sarah Bernhardt en robe blanche* (Sarah Bernhardt in a White Dress), which consisted of a white board with a straight piece of fishing line mounted on it, a reference to the legendary thinness of the actress.

In 1885, led by Lévy, the Incohérents added to the entertainment aspect of the exhibitions by introducing frequent costume balls. In 1886, a Café des Incohérents, which had no official relation to the exhibitions, marked the popularity of the concept by opening up at 16^{bis}, rue Fontaine across the street from the Greniers' apartment. That was the year that Henry and other friends from Cormon's decided to exhibit in this show. He waited impatiently to hear if his submission had been accepted for the third annual exhibition. 'I ... have nearly got an entry at the Eden,' he wrote to his mother in early October, referring to the Eden-Théâtre where the show would be held. On 17 October, when it opened, Henry's entry was hung as number 232. Now lost, it was called a landscape, an 'oil painting on emery paper'. Henry titled it after a working-class Paris suburb: *Les Batignolles* – $3\frac{1}{2}$ *B.C.*. Although no description of this work remains, the very title, declaring the painting to be a pre-Christian-era description of the neighbourhood around the Place de Clichy near Cormon's studio, indicates that Henry probably painted a parody of Cormon's caveman tableaux, but inhabited by the street types common to his own neighbourhood in 1886. It was painted – so far as the public was concerned – by 'Tolav-Segroeg, a Hungarian from Montmartre, [who] has visited Cairo and lives with one of his friends, has some talent and proves it.'

At last, Henry had found a spiritual home. Constitutionally incapable of joining any theoretical school of art, he found his closest philosophical match in the Incohérents, who refused to be a school at all, who had no consistent membership, and who thumbed their noses at all 'serious art'. Like them, he was devoted to using any idea he found enriching, to ridiculing hypocrisy and pompousness wherever he found it, and above all to breaking rules, to having fun, to making a spectacle of oneself and of life, and to partying as often as possible.

When he returned to Cormon's in November, Henry found the atelier 'in revolution over money matters'. He wrote to Adèle that Cormon was despondent and penniless. In addition, over the past year, the *rapins*, led by Emile Bernard, had begun openly confronting their teacher over questions of artistic theory. In the spring of 1886, Cormon, attempting to assert his authority, had briefly expelled Emile Bernard for insubordination. Bernard, attempting to modernize the classical mode of the atelier, had painted wide red stripes on his canvas where he should have represented the drab backdrop before which models posed.

Bernard's father was so dismayed that he took his son back to their house in the Parisian suburb of Asnières and threw his brushes into the fire. Stuck in Asnières, Bernard set up another studio, where he was joined for a month by Van Gogh. However, by the autumn of 1886, Bernard had wheedled his way back to Cormon's, where he was still causing trouble. Henry's own tendency now was to withdraw from conflict at the atelier, to work more and more on his own, where he could remain cheerful and drink as he worked.

He asked Bernard to pose for him at his studio and in twenty sessions produced a portrait which reflected his friend's intelligence and impatience – the feeling of barely restrained anger in his narrow adolescent shoulders and his alert, rat-like face (Plate 8). Bernard, in turn, made pencil caricatures of Henry, showing him painting in his studio, wearing a bowler hat, pince-nez and pointy goatee.

All his friends at Cormon's were moving in new directions. Van Gogh took Henry with him to the paint shop of Julien (Père) Tanguy at 14, rue Clauzel – a fair hike from the rue Caulaincourt. In the afternoons a group of young painters including Van Gogh and Bernard regularly gathered in the back room of Tanguy's shop to discuss art. At this time they were particularly interested in Japanese perspective, which Degas and others had been using in their work for at least ten years, and Van Gogh had begun collecting the Japanese wood-block prints which had been flooding Paris since the 1870s. Though he had almost no money, he had bought a number of them on credit from Siegfried Bing, who had one of the first galleries of Japanese art in Paris. Van Gogh's energy was remarkable. In January 1887, he persuaded a former mistress, artists' model Agostina Segattori, known as La Ségatori, who ran the Café Tambourin in the rue de Clichy, to allow him to set up an exhibition of Japanese prints on the walls of the café and to decorate the café itself by painting it with Japanese motifs. Henry, who in December had invited Van Gogh to the unveiling of some of his own works

on permanent exhibition at Bruant's Le Mirliton, no doubt attended the Café Tambourin exhibition. He liked the café, where the walls were already hung with tambourines decorated by the café's patrons, mostly poets and artists. It was in the café that he had done his pastel portrait of Van Gogh that spring. Henry also painted circus motifs on a tambourine around the same time, which may have joined the others on the walls.

Like the other *rapins*, Henry had distanced himself from Cormon. He continued to work at the troubled atelier despite the increasingly frequent outbreaks of resistance, but his work and his affirmation of his talent were now coming from sources outside. His two best friends soon left the atelier entirely. Bernard went off to Normandy and Brittany, where at Pont-Aven he met Paul Gauguin. Until 1883 the latter had only painted as a hobby, but by July he and Bernard had set up a new 'school' of painting, L'Ecole de Pont-Aven, identified by works in which areas of colour were surrounded with unbroken outlines. Henry's friend, the critic Edouard Dujardin, dubbed the new style *Cloisonnisme*, since it was reminiscent of the coloured enamel of cloisonné jewelry.

Anquetin, who was the other primary force in the anti-Cormon faction, also decided to leave the atelier early in 1887. Abandoning the Impressionist experiments which had made his reputation in the atelier, and brief alliances with Pointillism and Cloisonism, by 1889 Anquetin returned to painting traditional mythological and allegorical themes in classical styles. This painter, whom Henry had praised to the skies only a year before, was turning out to be at best a skilled imitator – doing excellent pastiches of styles developed by others.

Even after they left the atelier, Henry remained close to Anquetin and Bernard, but artistically there began to be a separation. Henry showed no interest in joining the Cloisonist movement, although he didn't hesitate to use its theories when they suited him. The following year he would employ Cloisonist techniques in *Au Cirque Fernando, l'écuyère* (At the Cirque Fernando, the Bareback Rider).

As the winter lingered, Henry seemed impatient and dissatisfied, even a little ill: 'Personally, I'm not up to the life I would like to be leading, but I'm compensating for it by eating a lot, since my appetite isn't yet affected.' He seemed negative about everything: family, friends and work. He wrote to Adèle that Louis Pascal was being 'very friendly', as if he didn't expect him to be. Alphonse was in Paris, too, and more eccentric than ever. 'He has a little white overcoat which is a real poem,' Henry remarked nastily to Adèle. Henry's friend Paul Leclercq, writing about Henry years later, tells of

meeting Alph, possibly around the same time, and being struck by the fact that Alph was wearing white flannel on a winter evening when it was 'freezing hard enough to split rock'.

Perhaps because Cormon's atelier community was crumbling, Henry had begun to have unexpected moments of intense need for Adèle. Just before Christmas 1886, without warning, he had suddenly arrived at his Uncle Amédée's hunting lodge, Rivaude, in the Loire valley, a four-hour ride from Paris, at nine in the evening, in a rented carriage, making no attempt to explain his sudden decision at five that afternoon to visit his mother. Such abrupt trips to see his family occurred a number of times – in early February 1887 he went to Rivaude again, then down to Albi to visit his Great-Aunt Zoë Séré de Rivières de Gualy de Saint-Rome. On each occasion, Henry returned to Paris a few days later. His mother referred to such trips as *'fugues'* – fleeing. When he was worried about his work, he occasionally felt overwhelmed and chose literally to escape, much as Alphonse did when he felt pressurized. Henry was particularly nervous about the business aspects of his art. For example, after engaging a publisher named Richard to reproduce some of his drawings, he was discovering that Richard was involved in lawsuits 'with everybody. So much the better,' he commented ironically. As usual, he couldn't seem to manage his money, and although he was now settled in the rue Caulaincourt for studio space, his housing was uncertain. He could have slept in the bed in his studio, but he preferred not to. He kept moving around, from Rachou's to the Greniers', and possibly elsewhere – occupying friends' apartments when they were away. Alph was still encouraging Henry to rent a place to live with him. They went together again, as they had the previous summer, to visit a possible apartment but, fortunately from Henry's point of view, even Alph didn't like it.

Despite their superficial bohemianism, Henry and his *rapin* friends had a surprisingly affluent lifestyle. Although they lived in very cheap quarters in Montmartre, and Henry himself was always short of cash, they were almost all the sons of well-to-do families, supported by parents or private incomes. They all could afford to eat well and drink plentifully in the cabarets and to spend weekends and even entire seasons away when they wished. Henry, who found the weather depressing in Paris and kept developing bad colds, cheered himself by focusing on the busy social life he led with his friends both in and out of town. Caught in a perpetual conflict between his escapist tendencies and a genuine desire to work, he succumbed more and more often to the invitations, letting his work slide.

He wrote gaily about organizing an impromptu orchestra which played

one night in Le Chat Noir so 'the people' could dance, adding that they didn't get to bed until five in the morning. The *Chat Noir Guide* of 1887 mentioned that a drawing by Henry called *Retour des Courses* (Return from the Races) was one of forty-five drawings on display in an album in the Salle des Fêtes (Banquet Room), which shows his artistic involvement with Le Chat Noir as well as with Le Mirliton.

The *cafés concerts*, or *cafés chantants* as they were also called, were all the rage now. Set up on the Chat Noir/Mirliton model, these small theatre spaces, where the audience sat at tables and drank while songs and skits were presented on a small stage, were springing up all over Montmartre. Henry and his friends developed the habit of following a favourite singer or dancer from *caf' conc'* to music hall as the performer moved from place to place.

Montmartre was becoming an area for property speculation. The neighbourhood was being cleaned up, shops and cafés were opening everywhere and lots of money was suddenly being made in the picturesque artists' quarter. People from all over Paris poured in for the exhibitions and costume balls given by the Incohérents. The popular journals had begun competing in the presentation of these elaborate masked balls. Henry and his friends attended them en masse in outrageous costumes, then based paintings on them.

Henry's work as well as his life was coming to be centred on the dives of Montmartre. Although he admitted his work was suffering because of his late nights, he also realized that these were the scenes that sparked his imagination. Increasingly the subjects of his paintings were the denizens of this electricity-lit night world, although the models for such scenes were usually his friends. Henry seemed particularly to like the paradox of having perfectly respectable friends play the roles of prostitutes, pimps, and alcoholics so convincingly that if it were not for photographs showing the close likeness of his works to his friends in the same poses, the viewer would never suspect that the works were not drawn as a slice of life. In 1887, for example, a *rapin* friend, Frédéric Wenz, who studied at Cormon's, sat for a portrait and a series of works in which he posed as an obscene soldier, rubbing his crotch as he approaches a woman drinking alone. These studies came to be known as the *Artilleur et femme* (Artilleryman and Woman) series (see Plate 10). The works, all made from one original pose, are especially interesting not only because they show Henry's use of potentially shocking subject matter, but also stylistically, as an example of Henry's imaginative use of copies of the same image. In them he used techniques, including tracings and monotypes created by pressing paper against the still-wet paint of an

earlier version, to duplicate the images. From the wet oil sketch, Henry created several works developed on separate pages which he first pressed against the wet image, before drawing and painting over the mirrored outlines. The complete series is an unusual example of his creative process, revealing the energy and flexibility with which he worked out an artistic problem.

Gauzi remembered once seeing a drawing in Henry's studio of Wenz, possibly an unused study for the *Artilleur et femme* series. According to Gauzi, Henry showed it to him to express his disdain for the banal 'classical painting' of allegorical subjects done at the Ecole des Beaux Arts, saying: 'Mars and Venus, what a joke! Take a look at that.' Henry's version of the Mars–Venus allegory was of the artilleryman pulling up his trousers.

The subject of venal love was integrating itself into the anecdotal content of his work. Often now his cabaret scenes focused on the clients and their interactions with one another, particularly when these showed sexual tension. Encounters between men and women became a subtext of a great deal of his work from 1886 onwards.

Henry also began hiring prostitutes to model for him. He commented to Gauzi that he found them far more relaxed and less worried about their appearance than other models, especially his well-bred friends and family members. One of his early prostitute portraits was of a Montmartre woman known as Fat Maria, Venus of Montmartre. Her face is coarse, her expression sardonic. Although Fat Maria is merely the portrait of a nude, not specifically identifiable as a prostitute, the 1887 drawing *Deux Pierreuses* (Two Streetwalkers), closely related visually to the *Artilleur et femme* series, is unambiguously a drawing of prostitutes.

This drawing marks an important change in his work. Henry, like Forain, Degas and Daumier before him, now began to portray 'fallen women' in many works. His first acknowledged drawing of a prostitute was done to illustrate Bruant's song 'A Saint-Lazare' (written in 1886). The woman in that drawing could be almost any working-class woman, but the lyrics of the song are about a syphilitic prostitute who has been imprisoned to keep her from infecting her clients, and the model resembles the woman who posed for *Artilleur et femme*. The poses in his new portraits left no doubt as to the occupation of the women, although, as formerly, the models for these works were not necessarily themselves prostitutes. Frédéric Wenz's girlfriend Jeanne, known as Jeanne Wenz, although they were not married at the time, posed for some of these works, particularly for a portrait called *A la Bastille, Jeanne Wenz*, which showed her dressed as a waitress in one of the *brasseries*

à femmes, establishments where the serving was done by women who were widely acknowledged to sell sex on the side. Bruant, no doubt attracted by the risqué theme, hung the painting on the wall of Le Mirliton.

Henry was suddenly discovering that he had a certain artistic following, particularly at Le Mirliton where, over the next three years, Bruant decorated the walls with a number of his drawings and paintings. Bruant's clients were not art collectors, perhaps, but for a very young artist, any public recognition was a substantial factor, particularly since Bruant occasionally introduced Henry from the stage. Over the next year, Henry did several more illustrations for Bruant's song covers or for his magazine, *Le Mirliton*. His favourite red-headed model Carmen Gaudin posed for some of them, and Jeanne Wenz posed for at least two.

Surprisingly, given the variety and inventiveness of both Henry's amusements and his art, he had a hard time adapting to change. He had a tyrannical streak. It was not uncommon, when people either intentionally or inadvertently refused to cooperate with his plans, for him to take it very badly, especially where his art was concerned. He complained constantly about his models. Gauzi observed:

For him, there was only one goal: to complete the work as he had begun it. If for any reason he believed the result was going to be compromised, he dropped the whole thing. He couldn't bear for a model to stop once he had begun drawing or painting from life; it got him off track. Then he'd give up ... When he started portraits or studies with live models, he always finished them with the model before his eyes. If for any reason the painting was interrupted, he turned the canvas to the wall and abandoned it. Lord knows how many works he left unfinished!

'My model is threatening to leave me,' Henry wrote to his mother. 'Being a painter is truly hard. If my ultimatum is rejected I won't have anything left to do.' Gauzi described the time Henry refused to finish a portrait of him because he had lost the yellow and white checked waistcoat he was wearing to pose in. 'How do you expect me to go on with your portrait without your yellow waistcoat?' Henry said. 'It's absolutely impossible; it changes everything ... You have to understand that the accessories are an integral part of the picture; if they change, the atmosphere vanishes. No! I can't continue that portrait, but I'll start another one.' The bust he painted of Gauzi in 1886 or 1887 showed him wearing a white shirt and no waistcoat.

The same kind of incident ended his long and fruitful relationship with Carmen Gaudin, around 1887, even though he considered her his best model.

She was extremely reliable, always arrived on time, held poses without moving, was quiet and reserved. Above all, she had wild orange hair. 'To tell the truth,' Gauzi recorded, 'she had dyed it yellow, but Lautrec had nothing against artificiality; he almost preferred it to reality.' About six months had passed without his needing her, when she turned up in the studio looking for work. In the interim she had let her natural hair grow out. 'She's got brown hair now!' Henry remarked. 'You understand, she's lost all her appeal.'

In March 1887, Henry began to share the apartment of his physician friend, Henri Bourges. It was at 19, rue Fontaine, next door to the Greniers. There he slept and ate his meals, while working as usual in the rue Caulaincourt studio – an arrangement the two friends kept up for the next six years. This was the first time Henry had really chosen to roost somewhere. Until now he had used his studio as a base and – always in a temporary fashion – stayed at night with one friend or another, but without actually having an official residence as well as a studio address. The decision was a good one, as he hated living alone and Bourges' housekeeper Léontine took care of the everyday organization of their meals and laundry. Although Henry could be fanatical about the details of reproducing one of his art works, organizing photographers, printers and publishers, verifying their work and making them do it again when he did not like the results, he seemed temperamentally unable to deal with even the most basic aspects of everyday living. His finances were invariably a disaster.

Henri Bourges was deeply entrenched in Henry's Montmartre world, and the two were equally assiduous in seeking excitement in the nightclubs, but the young doctor nonetheless served as a sort of middleman between Henry's life as an artist and his family. Also from the south, Bourges had the respect and even the trust of the Toulouse-Lautrecs. Alph would later consult him for an injured shoulder, and Adèle felt relieved to know Henry was in the care of someone who was in a position to watch over his health.

Adèle may still have worried if Henry was ever going to amount to anything. 'I left Henry ... busy with his friends' paintings for the Salon,' she noted. She must have wondered why he wasn't chosen for the Salon himself. From the admiration which marked his first analysis of the Salon, Henry had grown profoundly ambivalent about it. He knew that his family per-ceived having a painting accepted by the jury of the Salon as the surest measure of artistic success. This year, as every year, his Uncle Charles wanted him to write a personal critique of the Salon, since he couldn't come up from

Albi to see it himself, but Henry's account, if he wrote it, is lost. All Henry's masters – Princeteau, Bonnat and Cormon – showed annually in the ultra-conservative exhibition, although this year Princeteau hadn't finished his painting in time and so had nothing to enter. But at this stage of his development, Henry's preoccupations were in many ways anathema to strict academic painting – if he had submitted a serious work to the Salon, it would have been rejected, not for lack of artistic skill, but on theoretical grounds.

At the time, anyone who wished to make it in the official world of French art had to exhibit in the annual Paris Salon des Artistes Français. Despite the existence of the Société des Artistes Indépendants, which was just beginning to gain credibility, and the Salon des Refusés of 1863, there was still only one Salon. However, even there, strict divisions were beginning to fade. Although the Impressionists were still outcasts, among Salon painters compromises were appearing. Paul Albert Besnard, until then an academic painter and decorator who had won the Prix de Rome, exhibited a painting at the 1886 Salon which showed a woman who was half blue and half yellow, representing, as he explained, the effect of moonlight on one side and light from a gas lamp on the other. He was soundly rejected by traditional artists and Impressionists alike although Henry liked his work.

Henry himself actually submitted another work to the Salon in either 1886 or 1887, but since he felt he could not submit any of his serious work, which was too radical, he chose, as he put it, 'to fool' the selection jury by hastily painting a perfectly conventional still life of a camembert cheese, which he submitted under a pseudonym, imitating some of the parodies exhibited in the 1886 Incohérents. When it was rejected he was furious that his joke had backfired. This otherwise unimportant incident is significant as a symptom of Henry's predicament. Although he realized that the Salon's official definition of art did not agree with his own, he still felt the need to prove that he could succeed by its standards. He wanted to be able to reject the Salon. That the Salon should reject him – even when he had not seriously attempted to do a good painting – was an offence to his self-importance.

As if to confirm the gulf between himself and Henry, Cormon in 1887 won the Médaille d'Honneur at the Salon for his painting *Les Vainqueurs de Salamine* (The Conquerors of Salamis). '*Les Vainqueurs de Salaminette*', as Henry absurdly chose to call it, was hung in the most prominent place in the exhibition, directly opposite the entrance. The huge canvas showed naked women waving palm branches and dancing for the victorious Greek army.

Although the *rapins* made much of Cormon's prize ('We gave him a ridiculous silver palm frond, which he accepted, very touched') and held a party for him, the studio's days were numbered. Within a month, Cormon closed his atelier completely. Henry's academic training was over.

TOLAV-SEGROEG

After Cormon closed his atelier, Henry, now nearly twenty-three, was on his own. There is no evidence that he resented this: in fact, given the turmoil reigning in the atelier over the preceding year, he probably welcomed the chance to work alone. His life and art were already so far removed from the world of the Salon that it is almost surprising that he had stayed so long or showed so much concern for the opinions of academic artists. In 1887, in two shows, one in Toulouse in May and one organized by Vincent Van Gogh in the late autumn, he exhibited paintings that Cormon and the Salon jury would surely have rejected. Henry's focus and recognition increasingly came from unconventional, populist or avant-garde subgroups: theatre people, cabaret singers and dancers, musicians, writers and other artists.

In the Toulouse exhibition Henry showed two works. One was the portrait of Adèle he had done the preceding summer at Malromé (Plate 7). The other was his portrait of Gauzi. Both works were in a modified Impressionist style which, as Jules de Lahondès, the art critic of *Le Messager de Toulouse*, noted, was closely related to the work of the *juste milieu* painter Besnard. De Lahondès felt that Henry 'should not be encouraged ... Most visitors surely recoiled in horror when they came close-up to that violet hair, the lemon-yellow [brush] marks which look like chopped vegetables.' However, he gave Henry credit for using the techniques successfully: 'when you back up three or four steps, to the distance from which one generally looks at a portrait in a living room, you realize that this apparent barbarism is calculated, that the profile takes on form and density despite the vibrations of the brush – that the red-currant silk of the armchair plays its note in this careful harmony, and even in the reciprocal exaltation of the yellow and purple.'

This, so far as is known, is the first published criticism of Henry's art.

Grandmother Gabrielle had reacted predictably to his decision to show in Toulouse, where the family name was at stake. When she first learned that her grandson had works in the show, she had expressed interest tinged with concern: 'I'm pleased with his choices because I was a little afraid that through love of art he might be falling into a style which would not be appropriate among well-bred people. There are nuances which the ateliers seem not to notice, and I would like to hope that my grandson's brush, when he decides to show his work in public, will always be in good taste.'

Although she herself had voiced the family's inevitable concerns, her reaction to an outsider's criticism of Henry was outrage: wasn't he going to respond to the critic's 'bloodthirsty' attack, to defend himself 'after that scathing article'? In private she wondered to Henry's Aunt Alix if it wouldn't discourage Henry, after so many years of working, to have had such a fiasco, and what his parents were going to think. She was particularly sad for them – having a son who attracted public disapproval:

If there could only be a turn-about in the opinion of this [Impressionist] school – still unknown and a little strange; it would be fortunate ... I would have preferred that the critic not be one of our own kind! You can show the article to Charles, but I won't be the first one to mention it to your mother-in-law [Henry's Grandmother Louise], Alphonse or Adèle. Maybe it would have been better for our dear Ninette to have stuck to pencils and charcoal, which don't cause any discussion and which are exactly his style.

Encouragement came fast after criticism, for Adèle reported glowing praise of Henry from Charles du Passage, whose studio Henry had frequented when he first began painting with Princeteau as a teenager. According to her, Henry had run into du Passage and his brother at the *vernissage* of an important show – possibly the 1887 Salon – and had been 'bombarded with praise'. Charles du Passage paid her a long visit the next day to express his enthusiasm about the progress Henry was making as an artist. Henry had given du Passage a work which the latter had framed and hung at his home in Boulogne. According to du Passage, on ten occasions both collectors and well-known artists had tried to buy it from him. 'It's almost too good to be true,' Adèle said.

Henry, surely aware of both the negative and the positive reactions to his work, wrote humbly but undaunted to his Uncle Charles around the same time, saying: 'All I deserve is a little indulgence and a "Good, young man, keep it up." '

By summer 1887, Paris was blazing hot, giving Henry a 'slight case of neuralgia', but he continued painting, climbing a huge ladder in his studio to work on a large panel, which he said was 'for the circus'. Gauzi later described Henry's rue Caulaincourt studio as having 'a large studio ladder, ten feet tall, and an enormous easel – an indication that large-sized canvases did not intimidate Lautrec'. Now that he had abundant studio space, Henry had begun work on at least two very large paintings of circus themes. Henry's venture into enormous canvases was apparently not of long duration, but for the present he spent many evenings at the circus, sketching the ringmaster, always called 'Monsieur Loyal' in French, the bareback riders – all the panoply of theatre, costume and exoticism which had fascinated him since childhood.

Paris had at least three full-time indoor circuses: the Cirque d'Hiver (Winter Circus) in the Boulevard du Temple; the Cirque Fernando – later called the Cirque Médrano – in a circular wooden building at 63, Boulevard de Rochechouart, near Bruant's Le Mirliton; and the Nouveau Cirque (New Circus) in the more fashionable rue Saint-Honoré, whose exterior was described as looking like a music hall. Inside the Nouveau Cirque, the ring, with its thick padded mattress and red velvet border, was surrounded by rows of orchestra seats, surmounted by a balcony of well-appointed boxes. Behind the boxes was a circular *promenoir* (promenade) where the audience could walk and talk between acts, on the way to the circus café for something to drink. The atmosphere in these small one-ring circuses was comfortable and intimate. The nightly shows were frequented by all classes of people, including elegantly dressed women.

Henry did works based on performances at all three, but according to friends he went most often to the working-class Cirque Fernando, which was in his home territory of Montmartre. He liked being close enough to the performers to see every detail of the acts. He also liked being allowed to go backstage to visit what one of his contemporaries called the 'pretty stables' and to watch the performers getting ready to enter the ring.

The Cirque Fernando was best known for its equestrian and trained animal acts. Henry sketched and painted both the ring and behind the scenes, but it was his paintings of ring work during rehearsals, with only a few spectators in the orchestra and Monsieur Loyal directing the acts, that would take their place among his most famous works. In 1887, the Cirque Fernando closed for the summer on 12 June, before he could finish the large panel he had mentioned to his mother. He said he planned to begin working on it

again the next winter, when the circus reopened. It seems likely that the canvas he was referring to is the huge painting (around fourteen and a half square feet) which is shown in a photograph taken of Henry's studio around 1889 and also in an 1895 painting by A. Voisard-Margerie, *Toulouse-Lautrec et son modèle*. This circus painting, which has disappeared, is now known as the 'lost *écuyère*' canvas. Gauzi said Henry sketched in the figures with his usual ease 'in a trice', indicated the colours in light wash and then, tired from the exertion of working on the high ladder, climbed down to rest and to all appearances totally forgot about the painting. If this was the painting Henry was working on when the Cirque Fernando closed for the summer in 1887, it would expain why he never completed the work. By autumn, he may have become more interested in other subjects.

The painting hung on the wall of the rue Caulaincourt studio until at least 1895. According to Gauzi, it only acquired one further change: 'one day, coming into the studio, I stopped in front of the canvas, dumbfounded. The

Henry in his studio, c. 1889. Both the missing Circus painting and the Puvis de Chavannes parody are visible.

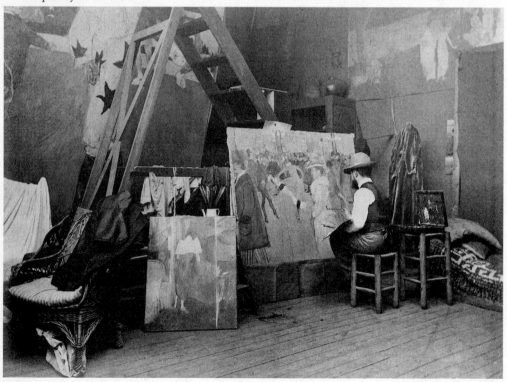

background was covered with a layer of smooth, uniform paint which in no way resembled Lautrec's style. Noticing my astonishment, he said "I had [Maurice] Guibert [an amateur artist friend] finish it. He did it ... like a housepainter; isn't it great?"'

Gauzi said that shortly after, Henry took the painting off its stretcher, rolled it and stored it leaning against the studio wall. It very probably was left behind when Henry moved to a smaller studio in the avenue Frochot in 1897. He did at least five other circus works around this time, and while working on them, he became emotionally involved with one of his models, a woman who would later be famous as a painter in her own right. Suzanne Valadon lived at 7, rue Tourlaque, downstairs from Henry's studio, with her mother and her son, Maurice Utrillo, who also became a painter. The extent of this involvement, however, remains ambiguous. Henry liked discussing sex in general but never in particular and, despite portraying himself in several pornographic caricatures, he left no document of his specific sexual relations. In addition, Suzanne Valadon, who openly admitted having affairs with a dozen or more men, always denied that she and Henry were anything more than close friends. However, she was an unreliable witness. She lied about everything, beginning with her birthdate and the paternity of her son, apparently as much out of disdain for her listeners and the joy of invention as out of a need to disguise the truth. In this she was something like Henry, who was known to invent and embroider anecdotes about himself and to be greatly amused when they came back to him distorted even further from being retold by others. Gauzi described the two as lovers, at least for a time. When all the data are compared, this seems the likeliest assumption. If so, this was one of the few times Henry had an affair with someone who was not already more or less a prostitute.

Valadon was promiscuous, and open about it, but she was serious about her intention to be an artist and, in contrast, very secretive about that. No one yet knew of her interest in drawing, that she had always drawn on 'anything that came to hand, including walls and pavements'. For years, she showed her spare, uncompromising paintings and drawings to no one. Henry himself is said to have found out only by chance, when he dropped in unexpectedly one day and discovered her working on a drawing. Later she said it was Henry who encouraged her and introduced her in 1887 to the man who would become her mentor and firm supporter: Edgar Degas. In later years, Degas showed far more respect for her art than he did for Henry's, supervising her first engravings in 1893 and arranging for her first one-woman show at Ambroise Vollard's print gallery in 1895.

It is possible that Henry had first met Suzanne Valadon long before, one evening in 1882 when the police were called in to stop a bacchanal at Anquetin's studio. Valadon was certainly there, and it is likely that Henry was also present. When he met her, she was known as Marie-Clémentine Valadon, and often called Maria, but according to her it was Henry who, in 1883, when she was eighteen, said, 'You who pose in the nude for old men, you ought to be called Suzanne.' Henceforth she signed all her work with that name.

She and Henry became fast friends, and she often sought refuge in his studio from the crowded lodgings she shared with her mother and young son. She later said she had been hostess at Henry's studio parties. She also said that he bought drawings from her, invited her to his studio to criticize his work, and that they sketched together. According to Gauzi, she was an unreliable model 'who posed when she felt like it' and abused Henry's confidence and good will. She disappeared for days at a time and, when she returned, lied about where she had been, but Henry apparently did not protest. She was his model in a number of works. It is not at all sure, however, that she modelled for his 1887 paintings and drawings showing bareback riders. According to one account, the model for his famous *Au Cirque Fernando, l'écuyère* was an aristocratic bareback rider from the Cirque Molier who had run away with her riding instructor.

Henry's affair with Valadon, such as it was, lasted at least intermittently for several years between 1887 and 1890. According to Gauzi, although Henry and Valadon got on very well in many respects, he was more and more upset by her scenes, her unexplained disappearances and her almost pathological lying. He had confided his problems to Gauzi and finally, one day, things came to a crisis. Henry came to Gauzi's studio very upset, saying that Valadon was downstairs threatening suicide because he wouldn't marry her. The two men rushed to her apartment, where they unexpectedly heard Valadon and her mother talking through the open door: 'You've done it now!' Valadon's mother was saying. 'You've scared him off and he's never going to come back. A lot of good that's done you!' 'He wouldn't go for it. I tried everything!' they heard Valadon reply.

According to Gauzi, Henry never saw or mentioned Suzanne Valadon again, but Gauzi must have been mistaken. Neither of them moved out of the rue Tourlaque, and circumstantial evidence indicates that their lives continued to overlap, at least superficially, for a number of years. In a letter Henry wrote to his mother some ten years later, in May 1896, he referred to a woman he called *'cette pauvre Suzanne'* (that poor Suzanne) who was

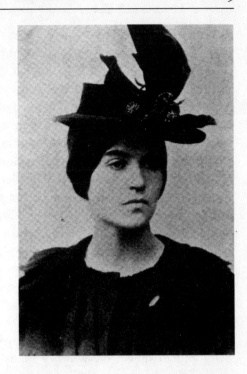

Suzanne Valadon, c. 1887 (aged about twenty-two), in the hat Henry bought for her

pretending to be exotic, but the last name of the woman is not mentioned.

Like Van Gogh, Henry had begun collecting Japanese prints, trading his own paintings and drawings for them with a man named Alphonse Portier who dealt in both contemporary art and Japanese prints and who, by coincidence, lived in the same building as Vincent and Théo Van Gogh, at 54, rue Lepic. Portier also found buyers for Henry's work. A brief note from Henry written on 11 July 1887 confirmed that he had received 400 francs from Portier and asked if he could have another 100 francs 'on account against the Elias bill'. This arrangement continued for a number of years.

Another sign of Henry's growing reputation as an artist came that July. The Belgian painter Théo Van Rysselberghe came to Paris looking for artists to include in the fifth annual show of a group called Les XX (Les Vingt or The Twenty). Les XX, in four previous annual shows, had already made a reputation for showing the most avant-garde trends in art. Van Rysselberghe wrote in excitement to another Vingtiste, Octave Maus, who was preparing the introduction to the fifth exhibition: '*Le petit bas-du-cul* [Little low-arse], not bad at all. The guy has talent! Definitely in the XX. *Has never shown*. – Right now doing very funny things. Cirque Fernando, whores and all that.

Good friends with a lot of people. He's O.K.; he thinks the idea of being in Les XX with the "rue de Sèze" guys and the "rue Laffitte" guys is very *chic*.'

Henry was being invited to show at the fifth XX exhibition, due to open in Brussels in February 1888. The 'rue de Sèze' was a reference to the new gallery that Georges Petit had opened to lure away the most famous artists from the Durand-Ruel gallery, which was at 16, rue Laffitte. Durand-Ruel had held the eighth and last exhibition of the Impressionists and Neo-Impressionists in 1886 at the Maison Dorée restaurant, which was also in the rue Laffitte, featuring the work of Georges Seurat and Paul Signac. Van Rysselberghe was trying to get Monet, Renoir, Pissarro, Sisley, Berthe Morisot, Whistler, Rodin, Seurat and Signac all to exhibit in his XX show. Of that list only Signac actually agreed.

For Henry, this invitation was a recognition that he was considered part of the serious avant-garde. The group of twenty Belgian artists, all of whom had been rejected by the jury of the Belgian Salon, was much more responsive to the younger French artists than was the French art establishment. It was in Belgium and not in Paris that the front line of French painting was now being recognized. Since their first show, five years earlier, Les XX in Belgium had shown the work of many major French painters who could barely get a showing in Paris. One of their principles was to honour almost exclusively experimental works. Perhaps as a *succès de scandale*, their shows had become so popular that on one occasion they had to give out admission tickets. They were very seriously reviewed in the press, but naturally few works were sold. 'For anything new to be accepted,' a supportive journalist wrote in *L'Art moderne* on 26 February 1888, 'many imbeciles have to die.'

Although Henry had exhibited his work before, starting with the Pau exhibition in 1883, he was thrilled to be asked to join Les XX and set to work choosing a series of eleven paintings for the show. He told his mother that Van Rysselberghe and another 'Belgian intransigent' (a reference to the movement calling itself the *Intransigeants* or 'die-hards') had been to see him and had been prodigal with 'alas undeserved praise'.

He got very involved with organizing the fifth XX exhibition and tried to arrange for Forain and the artist-printmaker Dodo Albert, who had recently done a portrait of Henry, to submit work also. It is not clear whether Forain accepted the invitation, but Albert was not asked to submit. Although it seems surprising for Henry to have promoted an older artist such as Forain, whom he considered a sort of mentor, in 1888 Forain remained very poor and known only in a restricted sector of the Paris art world. Louis Anquetin

and Armand Guillaumin, old friends from Cormon's, also showed in Brussels that year.

The letters Van Rysselberghe wrote describing his attempts to organize the exhibition demonstrate that he liked Henry very much and counted on him to introduce him to other artists in Paris. He and Henry were caught up in the enthusiasm and excitement that marked the young art scene throughout Europe. The whole world seemed to be opening up before them – anything was possible.

The excitement of Les XX distracted Henry from Paris's longest hot spell on record. 'For the last few days I've been in a murderous temper,' he announced to Adèle. Between showers, baths and forty-eight-hour visits to the country, he painted outdoors when he could and lived mostly at night. In September 1887, Henry took off to Malromé for his annual visit and spent his work time painting portraits of his cousin Paul Pascal's wife Juliette and of another relative, Aline Gibert. Then he, Louis and Adèle went to Le Bosc for a few weeks. Henry returned to Paris in late October. While he was gone, four of his works were exhibited at the Boussod et Valadon gallery, where Théo Van Gogh worked, making Théo the first art dealer regularly to represent Henry. Alphonse went to see them with his brother Odon, who wrote of his reactions to Grandmother Gabrielle: 'Henry is doing Impressionist paintings, four specimens of which are on exhibition at the big art dealer, Goupil's ... Perhaps he will forge his way in this style, but it's an ugly style. I call that stuff the Zola of painting. I would like beauty better.'

Théo, however, continued to give Henry the support he couldn't find from his family. The following April, he sent a painting by Henry, *Etude de femme* (Study of a Woman), to the branch of Boussod et Valadon in The Hague. In October 1888, Théo sold one of Henry's paintings, *Etude de tête* (Study of a Head), at Boussod et Valadon in Paris. It is easy to guess the implications for Henry of having Théo sell his work. It meant formal acceptance at last by practically the only gallery willing to deal in the work of younger painters, the equivalent of acceptance to the Salon for an academic painter.

Back in Paris in October 1887, Henry threw himself into his bohemian existence. Although earlier that year he had written to his mother that he intended to 'WORK HARD AND TRY NOT TO DRINK', there were repeated signs that his drinking was a problem. In letters to his mother, he blithely excused his failure to answer a special delivery letter because he was out late at a party and gave as his reason for refusing to attend a family gathering 'discretion', because of the 'panic he would have caused'. In her response, Adèle approved

the latter decision, a sign that she was not eager to have the family observe him too closely. Despite his continued habit of dining every night with Alph, Odon and Odette as he often had in the past, Henry found that he felt more at home in his other, bohemian life.

In November 1887, Vincent Van Gogh invited him to participate in an exhibition he was planning. He arranged to have it not in a gallery, but in the upstairs ballroom of a working-class restaurant called Le Grand Bouillon–Restaurant du Chalet at 43, avenue de Clichy, and coined the expression, 'Impressionists of the Petits Boulevards', to contrast his friends with Monet, Degas and Renoir, Impressionists who showed their works in the fashionable galleries on the *grands boulevards* from the Etoile to the Opéra. The ballroom of the restaurant, which had closed shortly before, was a marvellous exhibition area, a huge room lit by high bay windows, but the exhibition was a source of strife. First of all, Van Gogh's friends couldn't get along well enough to exhibit together. They had separated roughly into two groups: the Divisionists (later to be called Pointillists), led by Signac, and the Synthesists (later called Cloisonists), led by Anquetin and Bernard, who had abandoned Divisionism in the spring of 1887. Henry was probably allowed to stay in the group because he professed no theoretical alliances whatsoever. Finally only Van Gogh, Henry, Bernard, Anquetin and a Dutch friend of Van Gogh's named Arnold Koenig were in the show. The avant-garde artists – Pissarro, Gauguin, Seurat, Guillaumin – flocked to see it, but naturally it received no reviews in the press, and the workers who ate in the restaurant made so many complaints about the visitors walking through the restaurant to get to the upstairs ballroom that the owner finally insisted that Van Gogh take the show down. He was exhausted by the experience, which may have influenced his decision to leave Paris for Arles in mid-February 1888.

Suzanne Valadon recalled seeing Van Gogh regularly at Saturday get-togethers at Henry's studio:

He would arrive carrying a heavy canvas under his arm, which he would place in a well-lighted corner, and wait for someone to take notice of him. No one was the least concerned. He would sit down opposite his work, surveying the others' glances and sharing little in the conversation. Finally wearying, he would depart, carrying this latest example of his work. Nevertheless, the following week he would return and commence the same stratagem yet again.

According to Bernard, who had now begun using the pseudonym 'Nemo', Henry exhibited some 'prostitute types' in the Restaurant du Chalet show.

Henry may have shown his recently completed portrait of a woman in heavy make-up, which he called *Poudre de riz* (Rice Powder, Plate 11). Van Gogh liked that particular painting very much, even referring to it in a letter to his brother Théo, who decided to purchase the painting for his personal collection. Van Gogh's 1887 portrait of La Ségatori, *La Femme au Tambourin* (Woman Sitting in the Café Tambourin), is very reminiscent in both pose and style of this portrait. Vincent later suggested that his own *Portrait of the Gardener Patience Escalier* should be hung next to *Poudre de riz* at Théo's:

I do not think that my peasant would do any harm to the de Lautrec in your possession if they were hung side by side, and I am even bold enough to hope that the de Lautrec would appear even more distinguished by the mutual contrast and that on the other hand my picture would gain by the odd juxtaposition, because that sun-steeped, sunburned quality, tan and air-swept, would show up still more effectively beside all that face powder and elegance.

In *Poudre de riz*, Henry played with the contrast between setting and model, showing a white-powdered chorus girl or streetwalker sitting at the café table in his studio, a jar of make-up on the table before her and canvases clearly stacked against the walls in the background. Although Suzanne Valadon may have been the model for this painting, the subject is not she, but a type whose role she was acting. He showed his studio as a background in many paintings to indicate that the poses and costumes of his models were artifice. His subjects, emotionally disassociated from their surroundings, frequently seem uncomfortable and reveal themselves in ways they might not if they had fitted into the setting. Sometimes they appear emotionally blank, posed in profile, turned away from the viewer, lost in thought, or observing someone else in the painting. Sometimes he showed the model looking at him with marked hostility, as if she mistrusted him or resented his intrusiveness (see Plate 9). Is it possible that he provoked negative reactions from his models precisely so they would reveal feelings artists usually do not capture in portraits? He may even have wanted them to mirror his own carefully hidden feelings of alienation and hostility.

In a related series of head and shoulder studies, he had begun to explore a new theme: open-air portraits of pale, over-powdered women, looking like nocturnal birds suddenly exposed to the light. These are not seductive or beautiful studies – the women are generally posed in everyday clothes, without hats, as if interrupted while doing something else. He painted them in the garden of a retired photographer friend, M. Forest, which was across

the street from Goupil's print shop at 9, rue Forest. Père Forest, who was also an avid amateur archer, had a lovely walled garden at the corner of the rue Caulaincourt, just a few blocks down the hill from Henry's studio. Père Forest liked artists, particularly Henry, and often allowed them to use his garden to work in. There was a shed there where Henry left his unfinished canvases, his painting supplies and, it is rumoured, a completely stocked bar.

Over the three or four years that Henry painted in this garden, his subjects, surrounded by greenery and caught in the daylight, often looked tired and pale, coarse and sometimes surly, in stark contrast to the exuberantly green setting. These paintings were his own particular variation on Cormon's admonition to go outside to paint and on the Impressionist credo of painting from nature and in nature. But Henry showed little interest in the garden itself. As he had remarked earlier, 'Landscape is nothing and should be nothing but an accessory to make the character of the figure more intelligible.'

The variety of styles in his work must have impressed viewers. A precise, highly detailed Impressionist-Pointillist style marked the spare, ironic, finely executed portraits of Carmen Gaudin, Vincent Van Gogh and *Poudre de riz*. The more intimate family portraits of his mother and of Juliette Pascal also use Pointillist division of colour but in a looser, softer way, and bear Henry's characteristic unsentimental psychological penetration of his models' characters. The paintings representing circus scenes are markedly different stylistically, executed as rapidly as the action they portray, in loose oil or watercolour drawing, and are his only works of that period showing more than one figure.

The circus works tend to capture their subjects in mid-motion, almost like snapshots. Henry had been very interested when, in 1881 and 1882, Charles du Passage was studying stop-action photographs of men and animals in motion. One critic noted that the different parts of the bodies Henry drew looked as if they had been caught in successive moments of a gesture, commenting that our memory works the same way, reconstituting a body moving from one position to another in its successive stages.

Although it is impossible to date groups of works exactly within the year 1887, it seems likely that Henry worked exclusively on one subject for a period of weeks or months, and then, when he felt he had achieved what he could in that territory, moved on to another interest. Some of the subject matter of his work was now well established and would remain consistent, varying only in stylistic treatment, throughout his life. Repeatedly, he would paint family members and friends, red-headed female models, circus scenes, prostitutes, cabaret and bar scenes and scenes from the streets of Montmartre.

The Impressionists had spawned an ongoing artistic revolution. Young artists spent hours in theoretical discussions, formed schools, collaborated on exhibitions and then regrouped as their ideas developed. In the wake of Impressionism, other schools had formed – notably the Pointillists, who followed Seurat's theory of Divisionism, fascinated by the concept that the eye would automatically blend contrasting dots of pure colour into an intermediary hue, and the Nabis (a word meaning 'prophets' in Arabic, not in Hebrew as is commonly believed), who, in the wake of Gauguin's Cloisonist school, pushed the use of flat areas of intense colour beyond any attempt to portray reality. Henry knew all these artists – some of them were his best friends. Given the attention accorded to theories of art at the time, his independence is quite unusual. It may have been more important to him to affirm his independence – to be free of the burden of his family – than to identify with another group. It is also possible that he perceived his work as merely 'his work'. Rather than committing himself to a particular theoretical stance, he instinctively and consciously adopted ideas from all sources that interested him. He was open to everything, systematically refusing to adhere to a particular medium or school, but happily trying each new technique. Over his career he was involved not only with painting and drawing but also with theatre sets and programmes, sheet-music covers, bookbinding and stained-glass windows. In time he would find a niche in printmaking, never leaving the world of painting, but marking the field of lithography by the originality of his techniques, particularly in poster art.

As Henry underwent artistic changes, he showed the influence of the immense artistic diversity of the 1880s. At last, artists were struggling to overcome the isolation from industry and science they had increasingly suffered since the applied arts and fine arts were separated in the eighteenth century by the Académie des Beaux Arts. Photography had become the art of the masses, joining prints and illustrations in the widely distributed popular press. Now to Henry and his friends, all media, including printmaking and the decorative arts, were considered valid materials for artistic production.

Although Henry continually added elements to his repertory of artistic resources, typically he eliminated none, giving his work diversity and richness. Years after leaving Bonnat's severe academic discipline, for example, and despite Bonnat's stated dislike of him, Henry was overheard loudly defending Bonnat against ridicule from friends who were visiting the Salon. 'But why are all these idiots making fun of him? He's a man who knows how to work hard.' Similarly, although Henry had long since distanced himself from Princeteau's commitment to hunting and racing scenes, the

deaf-mute remained his friend and ally and sometimes went sketching with him to the circus.

Unlike Van Gogh, who did twenty-five self-portraits in Paris between March 1886 and February 1888, Henry's art generally was not introspective. Only two serious self-portraits are known to have existed, and one of those is now lost. The first, done when he was perhaps nineteen years old, shows the young painter looking into a mirror. In the foreground, much larger than his own head, are the objects on the mantelpiece – a clock, candlestick, etc. – as well as their reflections. Comparatively, Henry himself seems small, indistinct and withdrawn, particularly since none of his distinguishing features – neither his beautiful eyes nor his physical deformations – show in the misty head-and-shoulders rendering. The only account of the other self-portrait was left by an English acquaintance, Arthur Symons, who described it as 'Son portrait, par lui-même' (His Portrait, by Himself), saying it 'seizes one almost literally by the throat, so absolute is this creator's image of himself: a face ravaged with nerves, a face that had tragic beauty; a face malignant and diabolical, sinister and sardonic, with the huge mass of tormented hair that straggles across the high forehead; his tenebrous black eyes; his black moustache; the ironical curve of the lips; the virile nose, strong chin; in a word, the pure aristocrat'.

Although he no longer painted self-portraits in any conventional sense, Henry did occasionally include images of himself in his art. In works such as the 1885 black and white grisaille painting of La Chaise Louis XIII au Cabaret du Mirliton (The Louis XIII Chair at the Mirliton Cabaret), he showed himself as an observer, seen in profile or from the rear, watching someone else from the sidelines. These self-images were not exclusively meditations on himself, as self-portraits are for some artists. He was making a statement about his role as outsider inside the painting. This kind of self-consciousness – the need formally to show himself as an observer or voyeur – would appear often in his work from now on. Henry's self-representations cannot be said to be either complacent or vain. His visual commentary on his physical appearance is almost always denigratory. Sometimes his self-images are designed literally to repel the viewer – specifically in the scatological representations of himself on a chamberpot in 1882, for example, or farting in 1886. Later, his self-portraits move to the background of his work, but he still showed himself in contrast to men stronger, taller and handsomer than himself.

His perception of his role was prophetic, since renown would finally come to him not as performer, but as observer – it was for the power of his

observation that he was recognized, for his interior readings, his ability to get below the surface, peeking through flaws in the exterior shell to show the inner being of his models. Although his deformity may have been the image which afflicted him most, and certainly drove him to accept the passivity of the artist-observer rather than the physically demanding life his relatives led as sportsmen, to posterity only his skill at rendering what he had observed would be important. His work would be admired by people who never knew that he was a dwarf.

In late January 1888, Henry packed the paintings he had chosen for his first show with Les XX and shipped them off to Brussels. Then he caught the train to Belgium for the opening on 2 February. Participation in the show was Henry's first official affiliation with the artistic avant-garde. Proudly, he ordered ten copies of the catalogue.

For the XX catalogue, he made a special drawing of a mustachioed clown holding a paper hoop, probably taken from his large circus canvas. Wittily,

Self-portrait, c. 1882–3.

he wrote his initials, H.T.L., in the corner so they could also be read as XX. The titles of the eleven works he was showing were written inside the hoop. The paintings Henry chose to exhibit reflected his work over the preceding year and a half. He showed three of the studies he had done of Carmen Gaudin, the 'Impressionist' portraits he had done of Adèle and Juliette Pascal, and a 'portrait of a man' – possibly the seated portrait of Louis Pascal done in the Malromé garden or a portrait of François Gauzi. Other works in the show were *Etude de face* (Front Study) and *Etude de profil* (Profile Study), the pastel portrait of Vincent Van Gogh he had done in 1887, as well as Théo's purchase, *Poudre de riz*. Finally, Henry showed two circus works, an *écuyère* and a fan painted in watercolours.

Although it has often been assumed that Henry's most famous remaining circus painting, *Au Cirque Fernando, l'écuyère* (At the Cirque Fernando, the Bareback Rider, Plate 12), was included in the 1888 XX exhibition, this seems unlikely on purely stylistic grounds. Painted in thin wash over bare canvas, it is strikingly different from the portraits he exhibited there. Of large dimensions ($40\frac{3}{4} \times 63\frac{1}{2}$ in), it represents a radical change in style from earlier circus works and was Henry's first use of the Cloisonist techniques which Anquetin and Bernard had begun exploring with Gauguin as early as 1887. The thin brushstrokes of *Au Cirque Fernando* are totally dissimilar to the other works Henry showed in Les XX.

It was probably late in 1888 that he painted *Au Cirque Fernando, l'écuyère*. Moving far from the soft edges of his 'Impressionist' works and from the rapid sketchy quality of the two circus works that were shown earlier that year, in this work Henry chose carefully to delineate all the spaces with hard-edged lines, creating a striking composition in which the empty spaces have as much impact as the shapes of the figures. The drawing-like quality, flat areas of colour and use of Japanese-style cropping and foreshortening all move away from the intimacy of his portraits, concentrating instead on the abstract values of movement, shape and colour which within three years would be the outstanding characteristics of his poster work. The painting was purchased by one of the owners of the new Moulin Rouge nightclub, Joseph Oller, and would be hanging in the entrance hall at the club's grand opening in October 1889.

The fact that two of the works Henry showed in Les XX had already been purchased – *Poudre de riz* and *Rousse (Plein air)* (Red-head – Out-of-doors) – attests to Henry's success in his own Parisian territory. When the XX reviews came out, Henry got more praise than any painter in the show, including Whistler, the avant-garde Belgian James Ensor, or Signac, whose

Divisionist experiments were a source of scandal that year.

Henry, unlike the others, a critic said, was not just trying to *épater les bourgeois*, but was a true artist. He was called 'the most interesting of the innovators, because his canvases have a depth the others lack'. The critic for *L'Art moderne* was impressed by his portraits, which he found 'precise and deeply developed; his profiles and full-face studies are more than just studies. Certain strong-willed, mean expressions, certain commanding, sensual mouths, certain lines show his profound analysis which reveals intimate feelings and thoughts.' He was critical too, remarking, 'sometimes very hard lines and too many wine colours negate the effect'. However, another critic, Eugène Demolder of *La Société nouvelle*, liked just that: Henry's 'slightly vulgar energy which rolls in orgies of loud, dirty colour'.

Emile Verhaeren, the poet laureate of Belgium, was also an art critic whom Henry would come to know well and who later bought some of Henry's work. In his review of Les XX, he found important similarities in Henry's and Anquetin's observations of contemporary society. In both artists' paintings, he noted: 'Certain feminine types are shown with depth and decisiveness. Certain kinds of slyness, the chilly enigma of certain glances, the perversity revealed by a particular attitude or posture, are all present. And all of this, contemporary everyday life, is attentively, thoroughly explored.'

It was in February 1888 that Vincent Van Gogh made his move to Arles, to be joined later by Gauguin. Although there is no firm proof that Henry really told him, 'It is in the south that the studio of the future must be set up,' it is likely that Van Gogh discussed it with him. Henry, as a southerner, understood southern light and climate and might have had insights into whether Van Gogh could really find there the ideal community he so desired. It would not have been out of character for Henry to think the south superior to Paris. In March, Van Gogh mentioned in a letter to his brother Théo that he had written to Henry, although that letter, like all letters Henry received, is lost. In June, Vincent asked his brother to ship *Poudre de riz* to him in Arles.

Van Gogh's interest in Henry's work allows the dating of Henry's striking *Gueule de bois* (Hangover) series, for which the model was Suzanne Valadon. The painting and a preparatory pastel were probably done early in 1888, for Van Gogh mentioned the painting of a woman at a table in Henry's studio in an 1888 letter to Théo as 'unfinished', clearly not speaking of *Poudre de riz*, which Théo already owned. The style of *Gueule de bois* is related to

Henry's other 1887 and 1888 works. The model's pose bears such a striking resemblance to Van Gogh's pose in Henry's 1887 portrait of him that it might almost be considered a companion piece. The title apparently was provided by Bruant, who purchased the painting to hang in Le Mirliton alongside Henry's earlier works. Later Henry was commissioned to do an ink and crayon drawing based on the *Gueule de bois* painting to illustrate a story about a prostitute for *Le Courrier français*.

The subject of a woman sitting alone at a table is a repeated theme in Henry's work. Although his early portrait of his mother at the breakfast table is the first example, his later use of the pose tends to place his models in a quite different anecdotal and social context. From 1886 on, in works ranging from *A Saint-Lazare* to the 1899 *La Toilette* paintings, Henry represents a series of women, invariably lower-class if not overtly prostitutes, writing letters, combing their hair, putting on make-up or merely sitting blankly, waiting. Most of these paintings are not done from real scenes, but obviously and artificially posed at the café table in his studio.

Of these women sitting alone, *Gueule de bois, la buveuse* (Hangover, the Woman Drinker) is the most troubling. It is a portrait of a haggard, tough-looking young woman slumped dejectedly at a café table with a glass and a half-empty bottle before her. The theme of the drunken woman was not new, of course, and had been memorialized in Emile Zola's famous *L'Assommoir* of 1877. Henry surely knew both the novel and Degas' oil *L'Absinthe* (The Absinthe Drinker, also called In a Café; 1875–6), as well as Manet's *La Prune* (Plum in Brandy, 1878), but somehow Henry's specific image – a woman alone in a café, nursing her drink – adds a new dimension to the concept because it removes any possibility of accidental drunkenness from the image. He confronts the spectator with a socially unacceptable reality: a young, beautiful woman who appears to be curing her hangover with more alcohol. Women were supposed never to drink too much; to do so was a symptom of irretrievable degeneracy. Only a woman who had lost all sense of self-worth would allow herself to be seen in such a situation. The portrait is unpitying. Henry no doubt had been struck by such a scene in a café, but his rendering is unsentimental. Hangovers were becoming more and more a fact of life for him, too.

Although Henry was beginning to occupy a real place in the Parisian art world, his reputation, both as an artist and as a character, was extremely mixed. Some were repelled by his appearance and his outspokenness, yet he was always surrounded by a group of intensely loyal friends.

Gueule de bois, *c. 1888.*

When Henry went to Bruant's cabaret or to the other bars and cafés he liked, he was greeted as a regular, as a friend, but François Gauzi, commenting on Henry's notoriety, added: 'Lautrec is seen only as a midget – a minuscule being, a gnome, one of Ribera's dwarfs, a drunken, vice-ridden court-jester whose friends are pimps and girls from brothels. He has an appalling reputation which, in part, he deserves.'

Being a fine artist and an accurate judge of character did not keep Henry from outrageous behaviour. His father Alphonse had used hunting and riding to demonstrate his aristocratic prowess: Henry distinguished himself by showing off – his work, his wit, his person.

Although he had removed his self-images from the centre of focus in his art, Henry compensated by making himself the centre of almost every social situation he encountered. He was one of the acknowledged leaders of his group. He had been asked to be *massier* at Cormon's; he was usually the centre of any conversation or party. Perhaps the most psychologically accurate self-portrait he ever painted is the one in the 1884 *Bois sacré* parody, where, although his back is to the viewer, he is urinating in public in full view of all his best friends. Throughout his adult life, he would do what he had done in childhood: *s'afficher*, make a spectacle of himself.

It is true that Henry's odd appearance and behaviour were good

advertising. He said clever things and they were repeated. He did funny things in public places, and people noticed him and remembered him. Perversely, he became notorious in order to become famous, and, by becoming famous, to prove to his family that, though crippled, he was worthy of his name. He began to make himself into a legend, not only by telling stories against himself, but by developing a mythic personality, arrogantly dominating his friends with his scathing remarks. He could not hope to compete with Anquetin in seducing women, perhaps, but he could lead the pack in both eccentricity and debauchery.

Henry's fear of being alone, his need to be with others, to defy his sense of alienation by being part of a crowd, was closely related to his constant search for recognition. Except when actually working, he tended to surround himself with people, as if his sense of self-worth only existed when it was reflected by others. Even when he went out casually, he was almost always at the centre of a group of people. He seemed to attach as much importance to his social prowess, to his ability to be at the right café at the right time, as to his work itself.

Henry was not the first fine artist to earn his reputation, however well-deserved, for reasons not entirely to do with talent. The double role he chose of snobbish aristocrat and *déclassé*, epicure and vulgar drunk, important artist and *fêtard*, was in tune with the time. As Baudelaire, Huysmans and Jarry did in literature, Henry was inventing a lifestyle that was in its own way an artistic creation. Its overt decadence was consistent with the decadence appearing in French art and letters as the turn of the century approached. This tendency to glorify destructive impulses, to revel in them and to reject moral values in favour of heightened sensation may have been a response to that generalized anxiety which appears in populations at the end of each era.

Henry's personal tendency to self-destruction was related to his psychic pain, itself sufficient to motivate him to use pleasure as release from anxiety through sex, alcohol, food and intense relationships with others. Henry lived hard. 'I expect to burn myself out by the time I'm forty,' he commented to Arthur Huc, editor of *La Dépêche de Toulouse*, a journal that commissioned a poster from him. Henry may have reasoned that since he had little chance of conventional happiness anyway, there was no reason not to take risks with his physical and mental health.

An odd repercussion of his sense of ephemerality was his increasing use of easily destructible media. Like his lifestyle, Henry's art focused on immediacy at all levels from his ability to capture movement in mid-gesture to his later understanding of the poster's need to be understood instantly and his

production of art for temporary purposes such as theatre programmes. This extended naturally to the use of short-lived materials and is poignant evidence of his lack of interest in posterity.

Although until now Henry's painting, unlike his drawings, had been largely portraiture, his commissioned illustrations for the popular press were beginning to influence the subject matter of his paintings, too, making them more anecdotal. Rather than simple, neutral portrait settings, Henry's paintings now tended to be placed in a recognizable, self-conscious context. Thus the canvas represents what the artist is actually doing: posing a model in a café scene in his studio – a two-layered social realism which showed his commitment to modernist painting styles and his complete rejection of the academic subjects and poses used by Bonnat and Cormon. Like his new tendency to show his errors in painting and to leave sections of canvas bare, these 'studio' paintings showed his interest in the process of making art. During that spring and summer of 1888, Henry produced a series of paintings in his studio using Naturalist themes suggested by the popular press, Bruant's songs and works by Degas. It was not long before he began systematically using completed oil paintings as preparation for illustrations he intended to publish. The result was that the subjects of interest to the popular press became elevated in his paintings to the level of high art, thus changing not only his distinctive personal style and subject matter but also the conception of appropriate subjects for oil paintings.

Perhaps the most striking element of Henry's art was what he had called in childhood his *furias*, his temporary obsessions with an idea, a person or a place, his need to repeat the same gestures over and over. As with his intense infatuations with people, Henry developed a series of fascinations with different milieux and art forms. His works identify them and show that they followed a pattern: first he would be obsessed with a place, frequent and draw it repeatedly, then lose interest and find a new subject. Thus in turn he was excited by the backstage scenes of young ballerinas at the Paris Opéra, by Bruant's cabaret Le Mirliton and by the working-class Montmartre dance hall, Le Moulin de la Galette. As he was fascinated by animals, he was also fascinated by humans who moved with animal vitality, and his drawings of La Goulue and Valentin le Désossé, as he followed their careers from cabaret to cabaret and finally to Le Moulin Rouge, confirmed his fame among his contemporaries and recorded theirs for posterity. When he lost interest in La Goulue's dancing, he began to do repeated works based on the characteristic movements of another Moulin Rouge dancer, Jane Avril, and then works which played on the trademark style of Yvette Guilbert, a cabaret singer.

He worked with enormous intensity. He sketched everywhere, and if he didn't have paper at hand, he drew on napkins, tablecloths, sometimes directly onto the marble tops of the café tables. He had the same seat at the same table every night in his favourite nightclubs, just as he had always taken the same seat in Cormon's atelier. He loathed moving and rebelled each time he had to change apartments. And he copied the same image over and over, tracing the same lines into drawings, paintings, posters and illustrations.

He now also drank compulsively – daily, hourly. It was this behaviour that most damaged his reputation. His increasingly uncontrolled drinking caused him sometimes to send very mixed signals to the outside world, as he played the fool and scandalized the public. He treated his alcoholism as he confronted his deformity, by making fun of it: 'No, I'm not afraid of getting falling-down drunk,' he is supposed to have said. 'After all, I'm so close to the ground.' Underneath the bravado, he suffered and had real reasons to feel insulted.

According to an acquaintance, one night at Maxim's he had brilliantly made some of his neighbours 'the victims of his wit and the subjects of his sketches. He got up to leave, abandoning on the table a pencil worn down to a stub. Seated, he made a good impression, for his torso was of normal size. But his legs! Standing, he was shorter than he was sitting down. At this point, one of his neighbours called him back to the table, holding out the tiny pencil: "Monsieur, Monsieur! You've forgotten your cane!"'

Henry's obsessiveness, the contrast between his rigidity and his nightly revelry, created a characteristic pattern – a sort of anxious melody, which was his particular song. Its contrapuntal elements were his need for recognition, both approving and disapproving, and the need to balance two worlds in which he was not ever a full member: the world of the Toulouse-Lautrecs which satisfied his wish for a heritage, and the circus/sideshow of Montmartre which fulfilled his need for company and stimulation – for spectacle, lights, sounds, odours and movement – and in which he found a family of a different sort – of outcasts who, however mistakenly, saw him as one of their own.

In that spring of 1888, Henry was still preoccupied with making drawings for reproduction in the illustrated journals which were the arbiters of Paris style and fashion. On 10 March 1888, his drawing *Bal masqué* appeared in *Paris illustré*, a weekly magazine published by Boussod et Valadon. As usual, Henry was very interested in this sexually charged fad. The masked ball and its accompanying reputation for libertine behaviour – a happy combination

of bordello and circus – now began to appear repeatedly in his work and became a long-lasting fascination.

Although it is part of the French cultural heritage to appear in masks and costumes, especially around Mardi Gras, disguises had become popular again in Paris with the balls given by the Incohérents. In addition, the Ecole des Beaux Arts and the three other related schools in Paris (Arts et Metiers, Conservatoire de Musique, Louvre) had begun holding an annual masked ball called the Bal des Quatz' Arts, which was famous for its riotousness. (A hundred years later, this tradition finally became so notorious that it was permanently abolished.) Joining the trend, a number of nightclubs began holding costume balls with elaborate *redoutes* (parades), where the participants promenaded to display their costumes.

Henry's masked ball works were suggested by real situations, for he loved going to balls himself and willingly dressed as a choirboy, gypsy dancer or Spanish señorita, complete with fan, veil and large moustache. Henry did not discriminate – he attended all the balls he could and dragged his friends along with him. His *Paris illustré* drawing showed two friends from Cormon's: Roger Claudon and Dodo Albert along with Dodo's future wife Renée Vert, La Goulue 'and others'.

On 7 July 1888, *Paris illustré* published four more drawings by Henry for Emile Michelet's article 'L'Été à Paris': *La Blanchisseuse* (The Laundress), *Le Côtier de la compagnie des autobus* (The Trace Horse of the Omnibus Company), *Cavaliers se rendant au Bois* (Riders Approaching the Bois de Boulogne), and *Un Jour de première communion à Paris* (First Communion Day in Paris). Reproduced by photorelief in black and white, three of these drawings are done in *manière noire*, where the paper is first coated with black and then the drawing is produced by scratching away the black to create white lines and spaces. This is one of the few times Henry ever used this technique, which is particularly well adapted to producing the strong black-and-white contrasts needed for illustrations on poor-quality paper such as that used in the journals where Henry published. Each of these works in its way reflects Henry's own life as well as a typical Paris street scene.

Cavaliers se rendant au Bois is a scene direct from Henry's Paris childhood, for Alph had often stabled a horse at the Hôtel Pérey for the express purpose of daily rides to the Bois. The morning promenade by carriage or on horseback was a central element of moneyed life during the Belle Epoque and permitted the leisured classes to establish their ranking in the social order by exhibiting the elegance of their horseflesh and the extravagance of their trappings.

The other three drawings in the series, by contrast, are of strictly working-class Paris experiences. *La Blanchisseuse* is one of several studies Henry did in the late 1880s representing the theme, already famous from Zola's novel *L'Assommoir* and Degas' pastels and oils of laundresses, of a struggling woman exhausted by physical labour. This drawing is said to be of Suzanne Valadon, who reputedly had been discovered as a model when she delivered clean laundry to Puvis de Chavannes. Thus Henry's drawing of Valadon as laundress has an anecdotal element and may have been done as something of an inside joke.

Le Côtier de la compagnie des autobus, based on a Bruant song, describes a scene that was common in Henry's neighbourhood and a source of continual noisy disruption for those who, like him, had windows open in summer facing major streets on the big hills. The horse-drawn trolleys, called 'omnibuses', ferried passengers up and down the steep hill of Montmartre, running on steel tracks laid in the paving stones. Going uphill, the trams were too heavy for one horse to pull alone, so an extra horse was kept by a driver at the bottom of the hill and hooked to each tram as it started up the hill. On the way down, the trolley worked up enormous momentum and made a terrible racket, the clattering of its iron-clad wheels competing with the screeching of its brakes, while the spare horse and guide walked down by themselves at a leisurely pace to wait for the next tram.

François Gauzi's account of posing for the last of these drawings, *Un Jour de première communion à Paris*, reveals how Henry worked when doing these illustrations:

Posing for Lautrec was almost pleasurable. He wasn't difficult and never demanded absolute immobility. We talked and the time passed quickly, enlivened by his unpredictable sallies, his funny observations and his good humour. I was supposed to be pretending to push a baby carriage. Since we didn't have one, I posed by leaning my hands on a chair back. After half an hour Lautrec said, 'You can relax for a while, I can do without you.' I sat down and watched him work ... His composition required five characters, and he had only one model, but he had no trouble filling in the four missing figures from memory. He even threw in a horse-drawn cab at the end of the street and some starched shirts in a shop-window. By five, the drawing was done. Lautrec would have been most astonished if I had pointed out to him that his composition was absolutely classical. Though he claimed to disdain 'effects', right in the middle of his drawing there was a white spot, outlined in black, concentrating the light.

Gauzi also pointed out another inconsistency in Henry's working tech-

niques: the same painter who had refused to continue a portrait because the sitter had misplaced his waistcoat, who turned a canvas to the wall unfinished if he had trouble with a model, was perfectly happy to 'transform one of his friends into a worker dressed in his Sunday best and to surround him with four characters drawn from memory'. As long as he was free to do exactly as he pleased, Henry was extremely flexible as an artist. But as soon as he felt some restraint or limitation, his immediate reaction was to baulk and refuse to cooperate.

A few months later, Henry gave the drawing to Gauzi: 'Don't thank me too fast,' he said. 'I tried to get Goupil [Boussod et Valadon] to take it, along with the three others that were published in *Paris illustré*. Even though I only wanted twenty francs apiece I was told they weren't worth anything since they'd already been reproduced.'

Surprisingly, Henry did not seem excited at having finally achieved his goal of being a regular illustrator for the popular magazines. When he wrote to Adèle in the summer of 1888, the tone was lonely and forlorn: 'I have no news of you from anywhere ... What's going on? No doubt more than with me, whose life is flat. If it weren't for showers and work, I'd be bored to death. Bourges is sick, probably will go off to Mont Dore [a spa for tuberculosis patients] "and I will be alone with my dishonour".'

The mention of his 'dishonour', a quote from the then-popular playwright Augustin Eugène Scribe, was supposed to be amusing, but it is revealing. As with the 'impure kiss' he had sent his mother in his preceding letter, Henry seems to be hinting to his mother that he had syphilis: in several letters to his mother he had alluded to both dishonour and a serious malady.

Was he possibly driven by a compulsion to tell her, but hoping she would not get the hint? Or had they discussed his illness in person? In that case, his references were to something she knew to be a fact. If he chose not to tell her, it must have been most difficult, since all his life he had reported on every detail of his health, including stomach upsets. But it would not have been entirely out of character. Throughout his life, Henry refused to admit outright the things his family found upsetting. But he hinted at them strongly, as if he wanted his family to know his faults even though they would disapprove.

He wrote to his mother again, without enthusiasm, the week his *Paris illustré* drawings were published, saying only that the rainy weather was so exasperating that he had once again gone to visit the Greniers in the country. 'I'm better since I've been delivered from Paris and my models,' he commented.

According to reports, Henry's behaviour as a weekend guest was unpredictable. Sylvain Bonmariage, who was also a guest on at least one such expedition, said that, for example, Henry would abruptly announce, '*Je vais changer de cochons*' ('I'm going to change pigs,' a variant of 'changing horses' with a reference to *cochonnerie* – smutty or lascivious behaviour) and go back to Paris in the middle of the weekend. It was Bonmariage's theory that Henry's intense desire to get back to Montmartre was caused by his fascination with the sexual eccentricities of the Montmartre underworld, like an addiction that he couldn't long resist. On this occasion he was back in Paris two days later, saying the trip had been a waste of time and asking his mother to send Grenier some wine in thanks for his kindness.

According to Bonmariage, he and a former student from Cormon's, Henry's friend Claudon, were both at Villiers that weekend. He described Henry catching a huge *barbeau* (carp) and having fun making puns on the word, which was also slang for 'pimp'. Bonmariage claims that on this same visit Henry posed Lili in the garden, although no garden portraits of Lili are extant. Lili was very nervous about posing for Henry and had resisted for a long time. According to Gauzi it was because Henry was now openly copying Impressionist colour techniques. 'To tell the truth, she was wary of the Impressionist painter's terrible paintbrush and was afraid she'd find herself on canvas with her beautiful complexion zebra-striped in dabs of yellow, green or purple.' At length Henry got Lili to sit for two portraits. He also did at least two portraits of Albert Grenier.

The most important artistic event of Henry's numerous visits to the Greniers seems to have taken place this same weekend. Bonmariage, apparently an eyewitness, claimed that Henry did the famous Auberge Ancelin frescos during the two-day visit. His testimony is supported by the strong stylistic similarity between those paintings and an oil on canvas titled *Etude de danseuse* (Study of a Dancer), the only clearly dated work in a series of six or so closely related paintings. It bears the following inscription on the back, signed by Grenier: 'H. de Toulouse-Lautrec. Dancer, study done in the evening, rue Caulaincourt, 1888. We hired model together for a week at his studio. Toulouse did two studies, one standing and this one.' Henry continued to do works on ballet dancers until at least 1890.

The actual date of the Auberge Ancelin works may never be clearly established. Legend has it that when Grenier and his fellow artists went to Villiers-sur-Morin, they often went out to the fields to paint from nature, but since that weekend it was rainy, Henry decided to stay inside in L'Auberge Ancelin, where he could have easy access to the bar while doing his own

nature studies – a series of four wall murals painted directly onto the plaster, representing the ballet at the Opéra de Paris.

It is typical of Henry's unconventional voyeuristic focus that only one of the murals actually depicts what was happening onstage. The other three views are either backstage or into the audience. In the first fresco, the stage manager, wearing a cap with a tassel, rings the bell to call the dancers onstage. In the second, a dancer is having her costume altered in her dressing room, while a well-dressed gentleman looks on. In the third, the spectator looks over the conductor's shoulder to view the ballet chorus, while the fourth shows the audience in the *poulailler* ('chicken-house', or cheapest seats in the upper gallery), including Henry himself, painted in with a workman's cap and an *apache*'s red bandana.

These works are interesting in terms of medium, style and subject matter. Other clearly identified murals by Henry have not been found, and there is no evidence that he had any interest in doing frescos, although a caricature of his cousin Gabriel was found scratched into the plaster of a house visited by Henry in the 1890s. Henry may well have painted on the walls simply because the inn-owner offered him the wall space, or even asked him outright to decorate the *auberge*. There is no reason to think this was a paid commission. It is more likely that he took his pay in drinks.

Stylistically, the paintings are less controlled than much of his other work at this time, showing sometimes uncertain use of line while the diagonals of movement and rapid diagonal brushstrokes are very intense, especially in the chorus fresco. Being small and working on walls in a rather dark space, he may have had some difficulty reaching the areas to be painted or seeing clearly what he was doing, for example. Or he may have done the frescos while downing his salary. They closely resemble a series of ballet paintings he probably did the same year which seem to be almost a parody of those by Degas. In fact, all the paintings from the Auberge Ancelin period have a comic, caricatural quality. In the chorus scene, for example, the diagonal line of dancers neatly divides the work into two triangles, a device Degas often used, but the perspective in Henry's work is crazily skewed. In each of the triangles Henry made an ironic commentary. In the dark background of the upper triangle can just be perceived the leering satyr face of a stagehand watching the dancers from offstage. The lower triangle is dominated by the gesturing hands of the conductor, recalling Degas' affectation of dominating the foregrounds of his ballet paintings with an intrusive fan or the silhouette of a musician. The hands themselves closely resemble a Daumier caricature.

They subsequently reappear in Henry's 1893 poster, *Divan Japonais* (Plate 24).

Later in the summer, Henry made his annual pilgrimage to Adèle's château at Malromé, breaking his visit in late August with a week or two at Arcachon. There he stayed at the Hôtel de France and had the honour of being asked to take the tiller of the splendid yacht raced by Commodore de Damrémont ('the maritime king of Arcachon,' said Adèle) to win the regatta in the yacht basin that day. This was a moment of high glory for Henry, whose interest in sports was most often limited to the role of spectator. He seemed to take a lot of pleasure in succeeding at those sports in which he could participate, primarily rowing and sailing. According to friends, he kept a rowing machine in his studio, which he used to strengthen his upper body. He was an excellent sailor, never seasick, and a good swimmer.

In October, Henry and a friend, possibly Louis Anquetin, were again at Malromé, painting morning and afternoon, getting up early and spending the evening *en famille* with Adèle. She commented to her mother that they were being 'very good': 'in the morning, one of my pairs of oxen poses and, in the afternoon, one of my day labourers.' In passing she remarked that 'even though Henry has chosen a king-sized friend, almost as though he wanted his own smallness to be more obvious', she approved of her visitor from every other point of view.

Clearly Adèle still nervously verified the pedigrees of the friends chosen by her son. Henry, nearly twenty-four years old, continued to keep her busy with his needs, turning to her for shipments of food and wine, payment of bills and help with his family obligations, asking her for example to choose a birthday present for his godchild Kiki. Adèle bought her a statue of Saint Stanislas, possibly provoking Kiki to specify to Henry on another occasion that she wanted a mechanical ostrich. Thenceforth Henry sent Kiki's gifts himself: 'I've just sent Kiki a horrible Infant Jesus in wax, bought according to her directions,' he wrote to Adèle in 1891. 'I hope she'll be satisfied with it.'

On his own birthday, 24 November, Henry wrote to his mother: 'I'm writing to you from my 24th year, my dear Maman, first of all thanking you for all your shipments which have arrived safely. *La petite vérole* [smallpox] is the blemish on everything, for I'm trying to figure out if I should put all my eggs in one basket, not having seen Bourges for the last two times. He's moved into the hospital.'

There is no evidence that Henry, who had been repeatedly vaccinated for smallpox, was ever in any danger of catching *la petite vérole*. This mysterious

reference may be to syphilis, *la vérole*, with the word *petite* added in irony or to throw Adèle (or others who might see his letter) off track. It is possible that Henry was wondering whether to continue treatments for the disease if Bourges was not there to supervise. At the time, the prescribed, if largely ineffective, medication for syphilis was mercury, in itself dangerously poisonous, which had the side effect of turning the patient's teeth black. Henry suffered constantly from dental problems, and not even casual snapshots ever show his teeth.

Otherwise Henry seemed in good spirits, mentioning to his mother that his cousin Gabriel, who was studying medicine in Lille, had been to see him twice and that although he hadn't seen Alph recently, he intended to see him the next day. 'I'm in good shape, courageously working on three different studies at the same time. The skies are clear – a rare thing in this season, and that makes it easy for me to keep to my good intentions ... I lead the life of a recluse, going out in the evenings only just enough to get a little exercise. It's scarcely varied, but thoroughly satisfying.' He signed himself 'Harry', a nickname he used several times over the next year or two.

The references to reclusiveness and going out only for exercise in this letter seem intentionally misleading. Perhaps he was trying to reassure Adèle about his health or even about his nocturnal habits, but it seems unlikely that he was only going out 'for exercise' in the evenings. Always uneasy about being alone for very long, he is not known to have had reclusive periods. On the contrary, his tendency was to go where there were other people, using the rowdy crowds at the Montmartre cabarets to create an artificial atmosphere of gaiety and camaraderie which he reinforced with alcohol.

Henry spent Christmas 1888 at Le Bosc, visiting his Grandmother Gabrielle and attending a family reunion. He was apparently having such a good time with his two grandmothers and his cousins that he stayed on after his mother left, for he wrote to her on New Year's Day to say how much they all missed her, again signing himself with his new nickname, Harry. Then he went on to Pau, where he had a painting in a group show opening on 15 January.

His visit to Le Bosc seemed a very happy one. Two of his favourite cousins, Gabriel Tapié de Céleyran and Gabriel's little sister, Kiki, were also there. Surprisingly, Henry commented that they were planning to spend the afternoon climbing the Miramont with its high view of Albi. It seems obvious that in this family handicaps were ignored if at all possible.

It was perhaps during this visit that Henry renewed his friendship with his 'uncle', Georges Séré de Rivières. Georges was only fifteen years older

than Henry and didn't really seem like an uncle at all – in fact, he was a cousin of Adèle's generation. He was married and had a household outside Paris, and as a boy Henry had enjoyed going there with Adèle for Sunday dinner. As an adult, Henry renewed the habit of going to Uncle Georges' and was on excellent terms with his family. When Henry's financial situation became out of control, it was Georges who mediated with Adèle and Alph to increase his income to 1,000 francs a month.

Many years later, Georges' daughter Aline Séré de Rivières, who was some fifteen years younger than Henry, recalled that the other aunts and uncles were scandalized that Georges was his friend: 'They talked about Henri behind their hands, because he lived in Montmartre *n'est-ce pas* [you know] and these were people who were always most proper in word if not in deed.'

In Henry's adult life, Uncle Georges played the ambiguous role of drinking buddy and saviour. He had become a judge, and because he was known for easy sentences, Henry's friends called him *'le bon juge'*. He often accompanied Henry and his artist friends to the cabarets, holding his liquor badly, telling racy stories and contributing his endless good humour to the evening. One friend commented that Georges had a ridiculous laugh – a sort of high giggle. But Henry always looked up to the older man, and later it would be Uncle Georges whom an alcoholic Henry perceived as all-powerful and able to grant him anything he desired.

It was from conversation at Georges' table that Henry as a child had first formed a clear idea of the status of women in his own milieu. 'Hélène [Georges' sister] is very nice,' Henry had once written to his Grandmother Gabrielle, 'and M. de Bonne told her she'd do better to marry a <u>dog dressed as a man</u> than to stay an old maid.' Now Henry expressed a similar awareness of one of Georges' other sisters: 'Marie de Rivières is entering [the convent of] the Sacred Heart (not having found a husband).' In Henry's art, women are never portrayed as dependent on men for their status and support. In general, they are alone or with other women. When they are in images with men, the relationships indicated are almost always financial, in which the woman holds the power and the man is offering money for her attentions. When he was sober, Henry was perfectly aware that this was his own situation with women, that his handicap was too great a deterrent, that in general he would never be loved for his qualities and that he would have to pay for sexual favours. Perhaps it gave him some satisfaction to see that women also suffered from lack of love.

Late in 1888 or early in 1889, Henry set to work on a series of studies

that would culminate in his painting called *Au Bal du Moulin de la Galette* (At the Moulin de la Galette Dance Hall, Plate 14). It was inspired by Auguste Renoir's painting of the same title (Plate 13), which had been exhibited in Paris in 1888. Renoir lived less than a block away from Henry's studio in the rue Lepic, and Renoir's studios in the rue Laval, avenue de Clichy or Boulevard de Rochechouart were always close by. Jean Renoir, in his biography of his father, also remembered that in the late 1890s, Henry had said complimentary things to him about his father's painting. Henry, no doubt somewhat intimidated, treated the famous painter with deference and extreme politeness, but Henry's version of *Au Bal du Moulin de la Galette* could easily be interpreted as a challenge to the older artist's vision of the world.

It seems certain that he intended his own painting in part as a commentary on that by Renoir. Each canvas is a striking work, but they are at their most striking when placed side by side. Renoir's easy, sun-dappled exterior of young working-class couples courting and dancing in the afternoon garden of the well-known dance hall seems positively bucolic when contrasted with the livid tubercular faces of the isolated beings who stare past each other in Henry's grim, gas-lit interior of the same name. Henry's *Bal* portrayed an anecdotal encounter between a man and a woman, set in an easily identifiable setting painted on unprimed canvas. It was his last painted work with the clear outlining of the Cloisonist style – a technique he would use again only in his lithographs after 1891.

Although Henry's painting is also strongly reminiscent of Degas' painting *Femmes à la terrace d'un café, le soir* (Women on the Terrace of a Café in the Evening, 1877), it has so many visual parallels to the Renoir scene of laughing youths and rosy-cheeked beauties that it seems impossible that the contrast was not intentional. At every point Henry transforms Renoir's cheerful images into his own unsentimental interpretation of the same scene. Where Renoir shows us the Moulin de la Galette's outdoor garden on a summer afternoon, Henry shows us its dark, greenish, artificially illuminated interior, probably in winter. In Renoir's painting a smiling girl invites the spectator into the painting, even offering an empty chair. The principal woman in Henry's painting stares stonily at a man sitting behind her, who stares equally stonily past her, unnoticing. Both are visible to the spectator only in profile, and a strong diagonal barrier, the railing of the dance floor, cuts the spectator off from the woman. The foreground of Henry's painting is occupied by a tipsy-looking stack of saucers, showing us just how many drinks Henry must have had while sketching the scene.

In this painting, through his use of violent, disruptive diagonals and dark, sordid colours as well as through the postures of his models, Henry concentrates on the alienation of his subjects from each other, with an ironic aside on his own alcoholic isolation. Although he may not have been making an artistic judgment on Renoir's work, it seems that he was deliberately criticizing his colleague's sentimental point of view.

Henry's scene is not incidental. We know from the number of preparatory sketches, particularly of the woman, that the work was carefully planned and constructed, assembled from a series of oil studies of individual figures done in his studio and from pencil and charcoal sketches made at Le Moulin de la Galette. We know that Henry's model for the male figure was his friend and fellow artist, Joseph Albert, Dodo Albert's brother, who may have been the first owner of the painting. Although it has been said that the female model was named Jeanne Fontaine, there is no information on who she might have been. The preparatory drawings indicate that Henry's posing them in this scene doesn't necessarily mean that his models frequented Le Moulin de la Galette. Stylistically, the work is one of his 'dry' paintings, using rather liquid paint applied thinly in long brushstrokes, layering colours but often allowing the unprimed canvas to show through.

Henry's 1889 studies directly related to this large painting are often complete works themselves, and it is not absolutely certain whether they were done before the large work or afterwards as individual developments. They include *Femme à la fenêtre* (Woman at a Window), a painting on cardboard of the female figure in the right foreground, as well as *La Fille du sergent de ville* (The Policeman's Daughter) and *Fille à la fourrure* (Girl in a Fur-Trimmed Dress) which, although stylistically different and of a different model, use the same pose as the model for *Au Bal du Moulin de la Galette*. Several other undated female portraits are closely related in brushstroke and colouring to the larger painting. Although some of these works bear later dates and dedications, Henry's dating of works sometimes indicated the time when he signed the work and presented it as a gift to a friend, rather than the date it was actually finished. Henry's Moulin de la Galette painting was certainly completed by the late spring of 1889, because it was published as an illustration in *Le Courrier français* on 19 May 1889. When the painting was shown at the September 1889 Salon des Indépendants, Théo Van Gogh mentioned it in a letter to Vincent: 'There are some Lautrecs, which are very powerful in effect, among other things, a *Ball at the Moulin de la Galette*, which is very good.'

Although there is a photograph of Henry drinking in the garden of Le

Moulin de la Galette, accompanied by La Goulue and two other friends, it is said that he never went there after Le Moulin Rouge opened in October 1889.

Henry's fascination with the seedy Montmartre milieu had already led to the commissions he had so long desired from the popular illustrated magazines. In February or March 1889, he wrote to Adèle that he was sending photos of paintings Bruant had bought and hung in Le Mirliton to Jules Roques, publisher of *Le Courrier français*: 'What will happen as a result of all this, I have no idea ... They decided my other drawing didn't work once it had been reduced for publication. That's annoying.' All Henry's published illustrations in 1889 were in *Le Courrier français*.

Gradually Henry had grown away from his mother. He was too busy to write often, and she spent more and more of the year away from Paris. The tone of his letters to her remained affectionate, confidential and bantering but avoided true intimacy. He complained, for example, that his Grandmother Gabrielle allowed Adèle to worry by not forwarding a letter he had written: 'I don't know why Grandmother can't manage to send on my letters to you, she knows it doesn't take much to ruffle your henfeathers – and that you need to know what your duckling is doing.' In one sentence he managed to allude to Adèle's over-protective 'mother-hen' attitude and his own alienated 'ugly duckling' role in the family, exemplified by his duck-like walk. He sometimes suggested things they would do together if she were in Paris: 'we could take a carriage to the Champs Elysées in the evening ... you'd see more of me, since everybody else has bailed out of Paris,' but the reference to everyone else being gone implied that she wouldn't see much of him if his friends were around.

Typically he gave his mother an account of his health and the weather, but said little about exactly whom he spent his time with or what they did. He often described in some detail his most recent attack of indigestion although, as has been noted, he made only veiled references to his more serious health problems. In the early spring, he wrote that he had been sick after eating pâté, as had two of his friends: 'verdigris or dubious meat? *That is the question*. In any case it's over, let's not talk about it. I shot off like a rocket both top and bottom, with profusion and perfumes as varied as they were delicate.'

Henry often referred to his artistic concerns, combined with reports of his daily activities. In September 1889, he mentioned that he had an appointment to see the paintings of a family friend and that he was interested in the hospital where his roommate, Henri Bourges, now recovered from tuberculosis, was

completing his residency: 'Bourges is being unfaithful to me; as all the others are on holiday, he's obliged to sleep at the hospital. His hospital moreover is very cheerful, full of little gardens. Maybe I'll go over there to do some studies of the women in their white caps which make them look a little like milkmaids.' At the time, Bourges was doing a psychiatric residency at the Bicêtre insane asylum. Gauzi mentions going there with Henry and Grenier to visit him because Henry was fascinated with insanity and insisted on observing Bourges' patients. At the time, mental illness was thought to be a punishment for excessive attraction to vice of any kind. The visit to Bourges quickly turned disagreeable. Some child patients, attracted by Henry's dwarfism, followed him, screaming and pointing, embarrassing him greatly, an incident he did not report to his mother.

In 1889, enormous cultural activity was provoked in Paris by the combined celebrations of the French Centennial and the Exposition Universelle (World's Fair). This was a chance for France to throw the biggest national party since the fall of the Bastille. Focused on progress and the potential of the future, the Exposition featured such inventions as the telephone, telegraph key, electric battery and incandescent bulb. But opinions of the event were mixed. Was this glorious year a time to provoke public outcry by highlighting the least dignified aspects of French culture when it should be focused on the history of French art and letters?

At the beginning of the Exposition Universelle in 1889, the 12 May cover illustration of *Le Courrier français* was a caricature by Lunel showing Paris's two most recent displays of bad taste: the Eiffel Tower, which critics, scandalized by its huge cost, called the Tower of Babel, and La Goulue high-kicking and showing her private parts to a group of well-dressed tourists. This shameless nineteen-year-old had quickly come to represent the vulgarity and decadence of turn-of-the-century Paris. The caption 'Greetings to the Provinces and Abroad!' represented Paris's disdain for public opinion and, in its resolute search for 'modernity', the city's willingness to insult the rest of the world. Public opinion of La Goulue was divided, with some journalists considering the dance halls themselves 'a threat to bourgeois morality, tantamount to pornography' and others finding it not only appropriate but necessary to *épater les bourgeois*.

1889 was also a year of burgeoning reputation for Henry. He produced art frenetically, showing and publishing it everywhere. In May he exhibited, along with Willette and Chéret, in the Exposition Universelle des Arts Incohérents (World's Fair of the Incoherent Arts), as he had in 1886. The works he submitted were titled *Portraits d'une malheureuse famille atteinte de*

la petite grêlure (Portraits of an Unfortunate Family with Smallpox Scars). The catalogue again described Henry as the fictitious Hungarian painter 'Tolav-Segroeg', and elaborated: 'address Rue Yblas, under the third gas lamp on the left, pupil of Pubis de Cheval [a reference to Puvis de Chavannes], specialist in family portraits with a yellow pastel background'.

In a complete reversal of his participation in the Incohérents' exhibition, Henry also joined the fashionable Cercle Volney, where in June he exhibited a portrait. The yearly Exposition du Cercle Artistique et Littéraire Volney was a conservative art show which a younger Henry had often attended with his parents. Exhibitors were limited to members, generally well-to-do Sunday painters, but the Volney increased its prestige by showing a few paintings lent by well-known Salon painters. As a nineteen-year-old, Henry had written an ironic commentary on the ultra-fashionable dress and snobbishness of the people who visited the show. But as his friend Gauzi observed, for a young painter it was essential to show one's work as often as possible. Now Henry got two members to back his admission to the group and joined. He may well have made this decision to prove to his family that he could succeed by their artistic standards as well as his own. He exhibited at the Volney for the next three years, but the fourth year, 1893, his submission was refused, and he cancelled his membership.

Although Henry displayed his work any way he could, making no distinctions between showing in the private clubs and having his work hung in Le Mirliton or printed on sheet-music covers and in the popular press, his 1889 Cercle Volney showing had an unexpected repercussion. Paul Gauguin used Henry's decision to participate in the conventional bourgeois exhibition as an excuse to refuse to invite him to participate in the Café Volpini show, which was the first official manifestation of L'Ecole de Pont-Aven, now called the Groupe Impressioniste et Synthésiste. On 16 June, Théo Van Gogh explained as much in a letter to Vincent. Gauguin had also remarked that he didn't like Henry because he found him too self-centred. To be fair to Gauguin, Henry had been late to join the 'anti-Naturalists'. Until the beginning of 1888, his mainstream painting showed little experimentation and his most unconventional works at the time were the drawing-like, almost caricatural works he had done of ballet and cabaret images, for example the Auberge Ancelin frescos and the two *Chaise Louis XIII* paintings he had done for Bruant.

The Café Volpini was on the Champ de Mars, where the newly opened Eiffel Tower was attracting throngs of people. In the summer of 1889, the Ecole des Beaux Arts had an official exhibition on the Champ de Mars as part

of the Exposition Universelle. The Café Volpini exhibition was organized as a sort of 'Salon des Refusés' to refute the nearby Beaux Arts show. Calling themselves 'anti-Naturalists', the artists in the Café Volpini show accused the obligatory Naturalism of the Ecole des Beaux Arts of 'empty prowess and cheap tricks'. Although many of the young avant-garde artists, including Vincent Van Gogh, Emile Bernard and Louis Anquetin showed in the Café Volpini exhibition, in practical terms it seemed to have little impact – no paintings were sold and it received only one review from Félix Fénéon in the anti-establishment magazine *La Cravache* (The Riding-Whip). At the time, Henry possibly felt that being excluded from that exhibition was less important than acceptance at the Cercle Volney, but in later years Nabi artists Paul Sérusier and Maurice Denis both recalled its profound effect on their work.

In September, Henry exhibited for the first time in the fifth annual Salon des Indépendants, along with Louis Anquetin, Vincent Van Gogh, Georges Seurat and Paul Signac. Henry showed two or three works: *Au Bal du Moulin de la Galette*, *Monsieur Fourcade* and possibly a study of a woman. In spite of his wish to impress his parents with the Cercle Volney exhibition, Henry was quite aware that showing at the Salon des Indépendants was much more his own style and a proof of recognition from the French avant-garde. He invited his Aunt Odette and Uncle Odon to the opening and wrote to his mother in September: 'We've been caught up in the great enthusiasm of the opening, which was very lively in spite of the pouring rain.'

Camille Pissarro, who also attended the opening, noted in a letter: 'The Toulouse-Lautrecs are very interesting.' The art critic Félix Fénéon discussed the painting *Au Bal du Moulin de la Galette* at length in a review in *La Vogue*, September 1889. He appeared most interested in the variety of human types Henry had included in the painting, labelling Joseph Albert as 'Alphonse the lawyer' and referring to a character generally assumed to be the morals officer 'Père la Pudeur' as a 'municipal officer'. He summed up Henry's style as influenced by both Forain and Degas, without copying either.

Henry's ambivalence about whom he was trying to impress continued. Although his work was well known by other painters as experimental as himself, and Théo Van Gogh continued to exhibit and sell it, Henry himself seems to have sought the respect of more conventional (and now forgotten) artists. In two letters written in September 1889, Henry commented cynically, but perhaps nonetheless with pride, that the sculptor Charles du Passage, the

family friend and mentor from the days when Henry had shared Princeteau's atelier, had 'distilled his blessed saliva onto my young forehead. I have thus been saved by the laying on of hands of that fat colossus.'

After the Salon des Indépendants, Henry found it hard to get back to work. His health seemed increasingly fragile. At twenty-five, he was having renewed digestive problems, possibly, he thought, exacerbated by the unusually cold weather: 'My work is not yet what you'd call brilliant,' he wrote to Adèle. 'It's hard to get back to it. It's enough to make one lose the taste for relaxing, since the side effects are truly painful.' He also admonished his mother not to 'get upset', the last a comment on his own stomach problems. As the year went on, he was repeatedly ill. Around the New Year of 1890, he mentioned in a letter to his Grandmother Gabrielle that he had had the flu twice: 'I'm still dragging around with it. I can barely open my eyes, and for four days I've scarcely been able to work, for each time I get set up and start looking at my model, I begin to cry like a baby, although I must say there's no reason to.'

The exterior of the Moulin Rouge with Henry's poster, c. 1891.

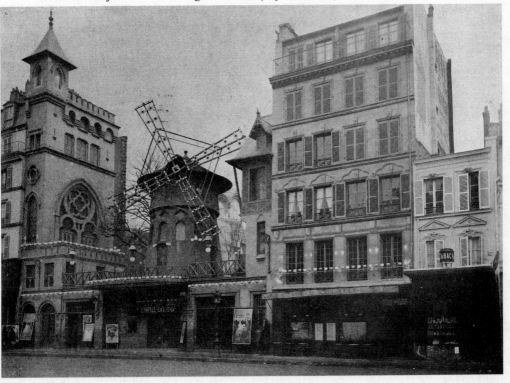

Once again the opening of a nightclub was a curious milestone in Henry's artistic existence. On 5 October 1889, Le Moulin Rouge opened for the first time at the foot of Montmartre, and in the entrance hall hung Henry's massive circus canvas, *Au Cirque Fernando, l'écuyère*, which had been purchased by the owners. Henry was at the opening, of course, accompanied by his cousin Gabriel Tapié de Céleyran, who came down from medical school at Lille just for the occasion.

Although there had previously been a dance hall called La Reine Blanche at the same site, until now 90, Boulevard de Clichy had been considered the far limit of Montmartre's nightclub district. Now that changed. Le Moulin Rouge became the centre of Montmartre by night, representing the excitement of 'decadent' Paris. It was as flashy, glittering and full of artifice as the revolving, scarlet vanes of its fake windmill, which, outlined with lights, served as a landmark in the night sky. Its director was Charles Zidler, a man with a genius for theatricals. A contemporary, Jacques Lassaigne, commented: 'he built a beautiful factory which provided those always-

The garden of the Moulin Rouge with the papier-mâché elephant, c. 1891.

appreciated commodities: amusement and pleasure.' Even its location proved to be advantageous to the mix of social classes which would characterize its customers, for it was midway between working-class and bourgeois neighbourhoods.

Owned first by Zidler and later by Joseph Oller, Le Moulin Rouge was the first major competition for L'Elysée-Montmartre, some ten blocks away, where La Goulue and her friends were the top dancers. In fact, the first thing Zidler did was to hire La Goulue and the others to star at Le Moulin Rouge.

He made no attempt to match the rustic reputation of Le Moulin de la Galette, instead trying to appeal to a more snobbish clientele, calling his nightclub 'Le Rendez-vous du High Life' and focusing his decor on the brassy excitement of the circus, making Le Moulin Rouge into a sort of private street fair. In fact some of its most assiduous patrons were princes, counts and dukes, including the Prince of Wales. Advertising it, somewhat inaccurately, as 'a most Parisian spectacle which husbands may attend accompanied by their wives', Zidler used everything to excess. The place was brilliantly lit with both gaslight and electric lights. There were also footlights on the stage. The orchestras in each dancing and performance area, if not excellent, were at least loud, leaning heavily on the brass.

Even the entrance hall became an art gallery, heavily draped in crimson velvet, displaying posters, paintings and photographs. Henry's very large canvas had the place of honour, hanging opposite the entrance.

In the garden, Zidler installed an enormous wood and papier-mâché elephant he had acquired from the recently closed 1889 Exposition Universelle. Its side opened up to hold an orchestra which adjoined a small elevated stage. A squadron of tame monkeys roamed among the spectators' seats in the garden. The corridors were set up like a fairground, with belly dancers, a shooting gallery and a fortune-teller. In the main ballroom, the public paid 5 *sous* a couple to take a turn around the dance floor, displaced occasionally by paid dancers who performed the scandalous *quadrille naturaliste*.

In 1900, a tourist guidebook described Le Moulin Rouge as looking

like a railway station miraculously transformed into a ballroom ... To the left, at little tables, sit the *petites dames* [little ladies] who are always thirsty, and who buy drinks for themselves while they are waiting for somebody to buy drinks for them. When that happens, their gratitude is so overpowering that they immediately offer you their hearts – if you are willing to pay the price.

On each side of the room is a raised platform, a broad open gallery from which

you can watch the dancing without taking part in it and enjoy a general view of all the women in full regalia, strolling about and parading before you in this veritable market-place of love . . .

A few English families . . . are scandalized by the sight of these women who dance by themselves, without male partners, and whose muscular elasticity, when they spread their legs wide apart in the *grand écart* [splits], betokens a corresponding elasticity of morals . . . Through the lace ruffles of drawers or the transparent gauze of silk stockings, you can often catch glimpses of pink or white skin, displayed as samples by these pretty vendors of love.

The Moulin Rouge's reputation as the largest 'free market' of love in Paris appeared to be well deserved. A later habitué, the English writer Arthur Symons, said the nightly turning of the 'flame-like' red wings of the windmill was very exciting to him. He described Le Moulin Rouge as tawdry and somehow infernal: to enter, for example, the clients had to choose between two doors, both yellow. One led to the bare-skinned women at the *bal* and the other to the strange and scandalous sideshows. The decor for the ballroom, he said, included some 'tattered wooden representations of the flames of hell (as I imagined), the red paint much worn from their artichoke-like shoots'.

The famous Pétomane was one of the featured performers at Le Moulin Rouge. This gentleman had the unusual ability to swallow large quantities of air, letting it work its way through his system and controlling its release through his sphincter with such skill that he could apparently imitate cannons exploding, trains passing and produce a variety of tunes. 'Modern' couples flocked to his nightly performances, although some bourgeois ladies primly refused to go in.

Here, at last, Henry was in his element. The bawdy goings-on, the flagrant artificiality and ill-disguised lasciviousness, the available spectator sports both on and off-stage, the heady odour of tobacco and rice-powder stimulated and amused him. 'He was the only painter who absolutely adored it,' said Symons somewhat exaggeratedly. But Henry quickly became a regular, occupying a front-row table with his friends nearly every night. According to Symons, during breaks the *chahut* dancers crowded around Henry, who would buy them drinks and then sketch them. Then he'd 'take a few turns in the hall'.

Henry's first painting of the world of Le Moulin Rouge was probably *Au Moulin Rouge, la danse*, which he signed and dated 1890 and showed in the March 1890 Salon des Indépendants with the title *Le Dressage des nouvelles* (Training the New Girls, Plate 15). He may well have begun this painting in

late 1889, for his fascination with Le Moulin Rouge began immediately. In this first painting, Henry shows a red-stockinged woman in street clothes, skirts raised, with Valentin le Désossé, dancing with such enthusiasm that her chignon has begun to fall down, and instead of standing perkily on top of her head is flopping at the back. Such a flaw in a woman's appearance would have quickly caught Henry's eye, for he is described as working from 'the detail that had most particularly struck him ... his work began from that point, he continued painting around it, and almost always finished with a perfectly unified image'. It is not known if this painting was commissioned for Le Moulin Rouge, but it was purchased by the owners and hung over the bar from 1890 on. Now images from Le Moulin Rouge appeared repeatedly in Henry's work. His representations of the famous nightclub – and his presence there nearly every night – became as much a trademark of the place as the red windmill blades. In the next six or seven years, he would do thirty paintings of Le Moulin Rouge and its habitués. In most of them he included La Goulue. In Henry's works, as in real life, she was always somehow affronting the public – either with her brazen stare or, more often, showing her drawers.

Henry's art de-mythified *fin de siècle* Paris. His cabaret works are bathed in brutal artificial light that reveals the unreality of the world that attracted him. The grey underpinnings of poverty, crime and exploitation often show through the images and give the lie to the superficial gaiety, high living and hypocrisy of the Belle Epoque.

Just as he found Le Moulin Rouge infernal, Symons insisted on perceiving Henry's interest in La Goulue and the other inhabitants of the nightclub as diabolical: 'In his pictures of this night-haunt and of other night-haunts of an equally evil character, he created stupendous effects, which I can only compare with those of Degas ... in both an equal nobility, an equal incomprehension of these enigmatical creatures; of the inexorable stains and configurations of sin.'

Calling Henry's paintings 'magnificent and abnormal' and his mockery 'heart-rending', Symons, who was not one of Henry's intimates but moved in the same circle, said he found their strength in the sense of satire, which he attributed to Henry's bitterness at being deformed: 'Lautrec – when he most hated himself – created deformed monstrosities.' With 'that nervous exasperation which rarely left him ... he sought for the physical signs of the vices of men and women'. Speaking of Henry's drawings of *chahut* dancers, Symons observed, 'their obscenity was to Lautrec, as to Degas, a clean thing when you touch it with clean hands'.

It must have been frustrating to Henry to realize that his nightly companions, as fascinated with the lusty Moulin Rouge as he was, chose to single out his interest as perverse, a side effect of his handicap, while considering their own to be completely normal. Le Moulin Rouge was one of the most fashionable spots in Paris. Not just the haunt of Montmartre thugs and artists, it attracted bourgeois and aristocrats and an international public of tourists eager to experience the worst of Paris. Henry's friends Louis Anquetin and Edouard Dujardin regularly shared his table.

Henry found Dujardin most interesting. The Baron Dujardin had been Anquetin's friend since secondary school and, like Henry, was passionately attracted to life in Montmartre. Thin, with a drooping lower lip and a great deal of frizzy red hair and beard, Dujardin tried to overcome his inauspicious appearance by being something of a dandy, affecting a monocle and an ever-present lace-trimmed handkerchief. He had a reputation as a risk-taker, betting assiduously on horse races and getting into romantic scrapes that at least once ended in a duel. He was highly intelligent and preoccupied by artistic and literary theory. When he was still only in his twenties, Dujardin, whose friends included the older poets Verlaine and Moréas, would be considered an influential figure in the Symbolist literary movement, and his magazines, *La Revue indépendante* and *La Revue Wagnerienne*, had substantial impact in the literary world. He was even said to have invented the writing style later known as stream-of-consciousness. Henry made numerous portraits and caricatures of Dujardin over the years. Through him Henry came to know writers and critics outside his immediate circle of artist friends.

Dujardin was perhaps the first of Henry's close friends who was considered to be a serious intellectual and member of the élite which defined and elucidated high culture for the outside world. Henry, although pointedly uninterested in intellectual pursuits such as art theory and literature (his favourite novels were trash erotica of the sort sold in train stations), appeared to be very pleased by the company of writers, editors and journalists who sought him out because of his art.

Around this time Henry also grew close to the family of Désiré Dihau, a bassoonist at the Paris Opéra. The three siblings were intimates of Degas, who had painted their portraits and was said to have been in love with Marie Dihau. It is possible that Henry's awareness of this friendship provoked his own interest in them, for in 1890 he painted a portrait of Marie with, hanging on the wall in the background of his painting, Degas' portrait of her in the same pose. Henry's portrait in turn influenced Van Gogh's 1890 portrait *Marguerite Gachet jouant du piano* (Marguerite Gachet Playing the Piano),

which again repeats the pose. Writing to Théo, Vincent commented: 'Lau-trec's portrait of a musician is really astonishing. I was deeply moved by it.'

Henry also painted portraits of Henri and Désiré Dihau. He greatly admired Edgar Degas' 1868 portrait of Désiré playing the bassoon, *L'Or-chestre de l'Opéra*. In 1893, imitating Degas' style in an alert, conscious way, almost at the level of parody, Henry intentionally echoed Degas' pose of Désiré in his lithographic songbook illustration for one of Désiré's com-positions, 'Pour Toi' (For You). It has been said that when he gave Marie Dihau the canvas of her portrait, he asked anxiously if it did not look ridiculous beside Degas' works.

Henry once gave an elegant dinner which ended before dessert. Insisting that his guests put on their coats and come with him, he led them outside and across the way to the Dihaus', where he knocked on the door and asked if they could all come in. Leading his guests to the Degas painting of Désiré, he turned to them and said, 'This is your dessert.' He apparently repeated this gesture, for in 1892, he wrote a note to Emile Verhaeren proposing to meet him one afternoon at the café La Nouvelle Athènes around the corner from the Dihaus', to 'go and see Degas' picture'.

Degas' use of unconventional subjects, perspectives and painting tech-niques had disordered the conventions of academic art in ways that Henry found both fascinating and challenging. Degas had chosen to represent some of his women in clearly unidealized ways, particularly in brothel settings, presenting sometimes distasteful images from unconventional and visually difficult perspectives, using his media in unusual ways, sometimes mixing monotype, oils, charcoal and pastels on the same canvas. The complexity of such works, the numerous ways they challenged the artistic status quo, must have been a liberating discovery for Henry.

Far from simple imitation, Henry's variations on Degas' themes and techniques had an impact of their own and, although openly referential, created a different impression from Degas' use of the same ideas. Degas' brothel works, for example, were generally small, in many cases painted for a particular purchaser. Henry would make his own works on the same subject large, intentionally choosing a format that was physically difficult for him to master, and eventually would display them publicly to a wide audi-ence, as if proclaiming his social transgressions. Where Degas worked and reworked his canvases in a variety of media, Henry left large portions of raw canvas bare, also working in mixed media at times, but thinly, so that many of the layers showed. In summary, Degas' work often feels private, highly

controlled and carefully reworked, while Henry's on the contrary is grandiose, open and rapid. He was not peeking around corners at forbidden subjects, he was revealing them, stripping off their disguises, putting his viewers off-balance with his skewed perspectives, and revealing his painting techniques at the same time. He continued to distort space as Degas had before him, but his distortions were often more radical, abandoning any concern with real perspective. A significant example is his 1891 poster *Moulin Rouge, La Goulue* (Plate 25), where he shows the globes of the Moulin Rouge's electric chandelier viewed from the balcony at the same time that he represents La Goulue as seen from the dance floor.

The effect of the lack of foreground in Henry's work is quite different from Degas' perspectives or even from the same phenomenon in Japanese wood-block prints. Henry's desire was to capture that evanescent moment in which his models revealed some normally invisible element of their personality. By using Japanese foreshortening techniques perfected by Degas,

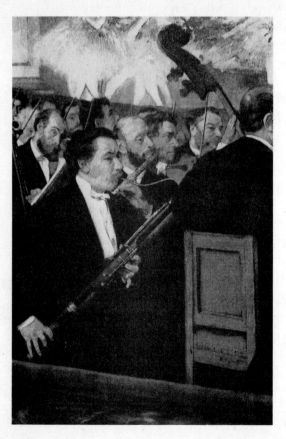

Edgar Degas, L'Orchestre de l'Opéra, *1868.*

Right: Pour toi, *1893.*

Henry put the spectator on the same footing as the subjects of the paintings. The emotional effect of finding oneself literally within the visual framework of the painting is that the viewer tends to engage with the subjects, who not infrequently stare boldly back from the canvas. His earlier portraits of the model Carmen Gaudin are a remarkable example of his success (see Plate 9).

'At the end of January, I'm going to carry the good word, or rather, the good art (?) to Belgium. Poor Belgians!' Henry announced in his 1890 New Year letter to his Grandmother Gabrielle. As he also had works in a group show in Pau, opening on 15 January, he had had to make a decision about which opening he preferred to attend. He went to Brussels for the 18 January opening of the seventh exhibition of Les XX, accompanying five works.

Although Henry had often painted prostitutes, his XX painting called *La Toilette* or *Rousse*, showing a woman seated on the floor washing herself, may be considered his first representation of a brothel scene (Plate 16). In this work, which seems drawn with a brush rather than painted, using oil

Henry painting Berthe la sourde in Père Forest's garden, c. 1889.

paint greatly thinned with turpentine on an unprimed wood panel, Henry went a step further in daring, both in subject matter and style, than his earlier work. Yet it bore in common with *Au Bal du Moulin de la Galette* its intentional references to works by other artists, to *Le Tub* (Woman Bathing in a Shallow Tub, 1886) by Degas, and to Raffaelli's painting technique. Two of the other paintings, posed in Père Forest's garden, are representative of the long series of women's portraits he had done there since 1887 while he painted and drank on sunny afternoons.

Van Gogh, who had also been asked to exhibit, did not attend the opening, but at its riotous banquet on 16 January 1890, a drunken Henry entered into an argument with the Belgian painter, Henry de Groux, himself a dwarf, whom he overheard insulting Van Gogh's work. Octave Maus described Henry de Groux as a sickly little man, always dressed in a greenish greatcoat, from which emerged his tiny head at one end and his feet at the other, making him look like a bell. De Groux apparently called Van Gogh an *'ignare'* (ignoramus) and an *'esbrouffeur'* (show-off), whereupon the two tiny men nearly came to blows and Henry's friends struggled to keep him from insisting on a duel. The fight finally ended when Signac threatened to kill de Groux if he hurt Henry, and Maus got de Groux to retract his criticisms of Van Gogh.

No doubt any contact with a dwarf reminded Henry of his own pain and humiliation. He apparently compared himself to a Parisian dwarf by commenting, 'I may be short, but I'm not a dwarf.' From a legal point of view, this was true, as Henry measured a little over four feet eleven inches tall. Any man over four feet ten inches tall was liable for military service unless excused for other handicaps.

The XX exhibition was wildly successful. Since the first show in 1882, attendance had doubled, and by 1890 the opening was so crowded that only members and personally invited *notabilités artistiques* were allowed to enter. The members of the group were very proud of the curiosity and scandal provoked by their shows and revelled in the condemnation of the bourgeois press. The kindest of these critics said Les XX only continued to exist because they were amusing and had absolutely no limits on what they considered to be art: what he called their absence of all artistic restraint. He predicted that they would be completely lost if they had to exhibit serious work by serious artists. Taking apart the show artist by artist, he criticized the 'mish-mash, skeletons, and masks, painted God knows how' by James Ensor, Cézanne's 'bad colour sketches' ('*mauvaises pochades*') and Renoir's 'sign painting'. Henry got off comparatively easily: according to the critic, his 'racy modernism is like Raffaelli in its unhealthiness, but not without talent'. Another paper mentioned him as one of the most popular artists in the show.

The critic Eugène Demolder called Van Gogh's sunflowers 'apoplectic', Renoir's entry 'smeared with vulgarity', and Cézanne's *Baigneuses* (Women Bathing) 'housepainting'. He admitted, however, that Henry had 'the gift of precise observation ... It's accurate, lively, marked out with brushstrokes in violent colours, scratched, cut with charcoal hatchmarks, with pastel, with pencil, using a skilful facility which sketches, silhouettes, catches personalities.'

Although Henry's work sold quite well, the price it brought is not always clear. In 1890, Henry attempted to sell two of the paintings he had shown that year in Les XX – *La Liseuse* (The Reader) and *La Toilette* (Washing) – to a gallery for 300 francs each, or twice what Théo Van Gogh had paid for the masterpiece *Poudre de riz* two and a half years before. To put these prices into focus, it is useful to know that until the 1860s most art was not sold through galleries, but bought at auction or directly from the artist at the Salon. In 1885, five years before, the average price of an oil painting in France was between 500 and 650 francs, but in the 1890s works by Manet, who had died in 1883, sold in the United States for 4,000–6,000 francs. Although some of the best-known artists, including the Impressionists of the earlier

generation – Manet, Monet, Degas and Renoir, as well as Cézanne, who was still unappreciated – had patrons who bought dozens of canvases, the traditional 'Maecenas' who supported an artist all his life was becoming increasingly rare. Henry, who already had a handful of faithful admirers, never would have one consistent patron.

Nonetheless, in the 1890s original art was beginning to be a status symbol. By 1893, even in a town as conservative as Bordeaux, 'every rich family was buying a gallery of pictures'. The role of the art critic and picture dealer became almost that of investment counsellor. From one hundred and four picture dealers and perhaps a hundred art critics in Paris in the 1860s, the number of art merchants became so great that in the 1890s the art critics formed a trade union to protect themselves from invasion by opportunists hoping to make money in the art market. Gallery owners, increasingly powerful, became more demanding. But the three who carried work by artists of Henry's generation were always at risk. Durand-Ruel insisted on having a monopoly on the work of the artists he sold and opened a branch gallery in New York in 1886, but at times was near bankruptcy. Le Barc de Boutteville, who also showed the Impressionists, made ends meet, it was said, because he 'cared little about what he sold'. The Goupil gallery, despite having branches in The Hague, New York, Berlin and London, changed hands three times, becoming Boussod et Valadon in 1884, and then Manzi, Joyant et Cie. in 1898.

Investment values for non-academic artists remained low. Even the now-famous Impressionists were still rejected in the provinces. Henry, although his annual allowance kept him from serious material want, was profoundly concerned with selling his work. He accepted any commission he received and asked the highest prices the market would bear. To him, selling his work was not so much income – although he was always short of money – as a form of recognition and further evidence to his family that he was a serious professional artist. His family responded with ambivalence, embarrassed by his style, by his subjects, by the tone of the magazines in which he published and by his unaristocratic commercialism.

Henry seemed to like showing with the rebels. After the opening of the Salon des Indépendants in March, Henry had written to his mother: 'I'm still feeling the effects of the second opening. What a day! but what a success. The Salon has received a slap from which it may recover, but which will give a lot of people something to think about.' Henry was also fighting for art with his wallet. That same March, Claude Monet contacted Henry through the art dealer Alphonse Portier to persuade him to contribute to the purchase

of Manet's *Olympia* for the Louvre. Henry sent 100 francs and a note that said: 'Dear Monsieur Monet, Here is enough to pay for a little bit of Olympia. I beg your pardon for having kept you waiting and for not doing better. Cordially yours.'

In May 1890, Henry showed again, though the record of the works he showed is lost. He joined Anquetin in the first exhibition of the Société Nationale des Beaux Arts, a group in opposition to the official training of the Ecole des Beaux Arts. Their show was called the Salon du Champ de Mars and was held in the same space where the year before the Ecole had held a show for the Exposition Universelle.

Like the infighting at Cormon's, the battle of the avant-garde against academic art was invigorating. However, once again, after the excitement, Henry felt let down. He complained that there wasn't much to do in Paris: 'Models are scarce and good models are very scarce.' His art life was uninteresting. His only news was second-hand: his cousin Louis, just back from a trip to Belgium, seemed down on his luck, Alph and Princeteau were eating glamorous dinners at Lucas's with a visiting Turkish nobleman, Nabarroy Bey. He wished it were summer so he could 'brave the dangers of the bay of Arcachon'. His last comment was that his servant was 'decidedly odious'.

It happened occasionally that Henry himself was odious to servants, especially when he had had too much to drink. Gauzi recounts two incidents around 1890 when Henry mistreated Léontine, the housekeeper of the apartment he shared with Henri Bourges at 19, rue Fontaine (then called Fontaine Saint-Georges). Both incidents reflected the gratuitous, dictatorial whimsicality he had often witnessed in his father. Once he sent her out late at night, unnecessarily, to buy biscuits to accompany his after-dinner port. On another occasion, when he and Suzanne Valadon were dining together at the apartment, Henry, who was bored, persuaded Suzanne to undress, so that when Léontine came in to serve the dessert, Suzanne was seated at the table with almost affected correctness, dressed only in her black stockings and shoes. Léontine said nothing at the time, but the next morning she complained to Bourges that Henry had treated her disrespectfully. When confronted by Bourges, Henry protested: 'Léontine was wrong to feel offended. I was not trying to shock her. Maria was the only one who was naked. She was too warm, so I suggested she get comfortable. I myself was fully clothed; I had only taken off my hat. There was nothing indecent in all that. Léontine knows perfectly well what a woman looks like.'

Some years later, visiting friends at their home in the country, Henry, drunk from too much wine at dinner, offended them by propositioning the maid, who was mortified.

This was all part of Henry's chosen role of *fêtard* – the sophisticated man-about-town, provoking scandal and outrage wherever he went. Arthur Symons wrote:

Every night one came on him somewhere in Paris, chiefly in Montmartre, in the streets, in the cafés, in the theatre, in the music halls, in the circuses. He walked, his huge head lowered, the upper part of his body, which was in perfect proportion, leaning heavily on his stick; he stopped – owing to the difficulty he had in walking – stared this way and that way; his black eyes shone furiously – eyes that amused themselves enormously; he began to speak in his deep, biting voice, and always in some unimaginable fashion – jests or jokes or bitter sarcasms, or single phrases in which each word told: simple and brutal, mocking, serious and sardonic ... His tragedy was that he imagined a few hours of sleep were enough for him – a ruinous expenditure of so prodigious a constitution; which led him also into that 'expense of spirit in a waste of shame' which is bound to have an evil effect on such temperaments as his.

Le Moulin Rouge remained a favoured haunt, and Symons mentioned meeting Henry there in June 1890, seated at the table that was always reserved for him, accompanied by a dancer called 'La Mélinite' (The Explosive). Jane Avril, as she called herself, was, according to William Rothenstein, a British artist then studying in Paris, 'the single attractive figure' at Le Moulin Rouge. He described her as 'a wild, Botticelli-like creature, perverse but intelligent, whose madness for dancing induced her to join this strange company'. Symons agreed, saying she had 'the beauty of a fallen angel. She was exotic and excitable.'

Jane Avril had a very different reputation from La Goulue, but like her had a legendary aura and was the subject of many men's fantasies, including, certainly, Henry's. Arsène Alexandre, an art critic, called her 'a very graceful, filiform person, with her delicate goat-face, her wondrous urge to dance, the truly original, instinctively artistic agility and elegance of all her movements and techniques'. Arthur Symons' description of her dancing at Le Jardin de Paris in 1893 gave more detail: 'She danced in a quadrille: young and girlish, the more provocative because she played as a prude, with an assumed modesty, *decolletée* nearly to her waist, in the Oriental fashion. She had long black [sic – she was really blonde] curls around her face, and had about her

a depraved virginity.' The next night he went to see her at Le Moulin Rouge, where she also performed:

She danced before the mirror, the orange-rosy lamps. The tall slim girl: the vague distinction of her grace; her candid blue eyes; her straight profile. She wore a tufted straw bonnet, a black jacket and a dark blue serge skirt – white bodice opening far down a boyish bosom. Always arm in arm with another jolly girl who also seized my arm for the invariable reason of giving them drinks. The reflections – herself with her unconscious air, as if no one were looking – studying herself before the mirror ... [she] had a perverse genius, besides which she was altogether adorable and excitable, morbid and sombre, biting and stinging; a creature of cruel moods, of cruel passions; she had the reputation of being a Lesbian; and, apart from this and from her fascination, never in my experience of such women have I known anyone who had such an absolute passion for her own beauty. She danced before the mirror under the gallery of the orchestra because she was *folle de son corps* ... She was so incredibly thin and supple in body that she could turn over backward – as Salomé when she danced before Herod and Herodias – until she brushed the floor with her shoulders.

One reason Lautrec painted so many portraits of her was because she remained *une grande amoureuse des ateliers*, and another because she obeyed all the painter's caprices, and another because she was all fine nerves, and as passionate as abnormal. Did she appreciate Lautrec's genius? I imagine that she did, because she loved the odour of painting.

It has been said that Henry asked Jane Avril to go to bed with him, even though she was the official mistress of someone else, and that she accepted, just once, 'as friends'. In any case he painted her many times over the next two or three years, in a series of portraits which show the conflicting sides of her personality indicated by Symons (see Plate 27).

On 6 July 1890, Henry was invited to lunch at Théo Van Gogh's apartment with Vincent, who had come in from Dr. Gachet's house on the outskirts of Paris at Auvers-sur-l'Oise, where he had been treated since his mental breakdown the year before. This was the last time the two artists would meet, for three weeks later Vincent shot himself. Henry learned the news too late to join the cortège of young Parisian artists who went to Auvers to be Vincent's pallbearers. 'You know what a friend he was to me and how anxious he was to prove it,' Henry wrote to Van Gogh's brother Théo on 31 July 1890. 'Unfortunately I can acknowledge all this only by shaking your hand cordially in front of a coffin, which I do.' In the early autumn, Théo Van Gogh, distraught over Vincent's death, also fell ill and had to be replaced

as manager of Boussod et Valadon. Within six months, suffering from hysterical paralysis, Théo went back to Holland, where he too died.

Lethargic, possibly depressed, Henry did not go south in August. Instead he tried, somewhat ineffectively, to get on with business. In a letter to an art dealer he said, 'The other day I forgot and left two paintings ... please confirm that you have them.' It was September before he actually managed to rouse himself to go for his annual visit to his mother.

He and Louis Pascal both stayed with Adèle, making excursions to Arcachon and Taussat, where Henry promenaded a tame cormorant. As Adèle put it, this 'was the big event' in Arcachon Bay. According to her, the 'salt life' was marvellous for him: 'under his layer of brown, he has a good healthy look.' She seemed unaware that Henry must have intentionally exploited the parallel between the cormorant's web-footed waddle and his own clumsy gait as a self-mocking sight-gag. According to Gauzi, at the end of the day, Henry in his yachtsman's hat would lead his cormorant on a string through the streets to the café and make it drink absinthe. 'It has developed a taste for the stuff,' Henry said. 'It takes after me.'

Back in Paris, Henry himself referred to the cormorant in a letter to his Grandmother Louise: 'having become used to the *farniente* of sailing in Arcachon where I brilliantly upheld family tradition by fishing with a cormorant ... now I am carrying on with more perseverance than results, dragging myself by the ear to my studio which is awfully small compared to Arcachon Bay.' He wrote to her that the cormorant 'came to a sad end, internally bitten by an eel that may have merely blocked its throat, causing it to die from lack of air, as the man from Marseilles put it'.

Everyone in the family was concerned, not about Henry, but about his father, who was being treated in Paris by Bourges for an injured shoulder which was keeping him from hunting. He went every day to the hospital l'Hôtel Dieu, near Notre-Dame, to receive static electricity treatments. Uncle Odon, in a letter to Grandmother Gabrielle, referred to Alph as having had a close call, which implied that the injury was quite serious. Odon added: 'It's odd that Henry is off paddling around in Arcachon just when his father needs him most, it's quite strange, all in all, and I've been saying so to his father, secretly, of course.' Odon seemed very hostile to Henry. The tone of this letter, as of many of Odon's letters, was captious and depressed, implying perhaps that he as well as Alphonse suffered from periods of severe depression. By the end of 1890, Henry was refusing to have any further contact with one of his uncles, most likely Odon, apparently with his father's approval. 'Papa and I had a very calm discussion about my lack of haste in

going to see my uncle, and he <u>approved completely</u>. All was very diplomatic, so I have won my case. Spread the word.'

Back in Paris for the autumn season, Henry received news from a very old friend. Théo Van Gogh had been replaced at Boussod et Valadon by Maurice Joyant, who had attended school with Henry in 1872. Going through the storerooms at Théo's gallery, Joyant had discovered not only paintings by Gauguin, Redon and Pissarro, but also works left on consignment by his childhood friend, the same Henri de Toulouse-Lautrec with whom he had competed for classroom prizes at the age of eight in Paris, to whom Henry had once given a photo dedicated 'to the other great man'. Henceforth, Joyant became an important figure in Henry's life, not only promoting his work through exhibitions and sales, but protecting him when he was ill and weakened by alcoholism, and interceding with his family when he was short of money. After Henry's death, whether out of real concern or merely economic self-interest, Joyant's role in preserving Henry's work and making his reputation became primary. As a contemporary, he was the first to attempt a *catalogue raisonné* of Henry's works and to write an account of his life.

As the autumn progressed, Henry seemed to be working more and more freely. A studio photo taken around this time shows the canvas *Femme en toilette de bal à l'entrée d'une loge de théâtre* (Woman in Evening Dress at the Door to a Theatre Box, Plate 17). The work is unusual for two reasons. The painting is clearly superimposed on an unfinished study of a ballerina, turned upside down, and is the only known example of Henry's painting one work over another. In addition, the subject of the new work was scandalous, because the woman was shown with her skirt raised up to mid-calf at a time when women's skirts touched the floor. The reflection of a man in the mirrored door of the box implies that her skirt had been pulled up in his company. The activity indicated by this is even more daring than Henry's earlier works showing male observers in dancers' dressing rooms, for it seems as if an assignation has taken place in a theatre box, surrounded by spectators, during a performance. This exhibitionistic fantasy is related to Henry's interest in masked balls. In the latter, encounters are possible because of the anonymity offered by costumes. In the former, the encounter in the box is possible because although the boxes are in a public theatre, it is possible to place oneself where one cannot be seen.

At the same time, Henry seems to have worked frequently outdoors. Although most of the open-air portraits he did in Père Forest's garden are not dated, the series painted around 1889–90 is so numerous that it is reasonable to think they continued for some time. Henry generally posed women

in this garden, but he also painted the Dihau brothers, Henri and Désiré, there, including his portrait of Désiré Dihau sitting oddly on a dining room chair, reading the newspaper, another parodic reference to Degas' portrait of Désiré playing the bassoon in the Paris Opéra.

As in Henry's earlier *plein-air* portraits in Père Forest's garden, each model seemed ironically out of place there. A good example is Henry's portrait of *Casque d'Or* (Plate 18). The bare canvas shows through on her cheeks, which, in contrast to her artificially gold hair, appear pasty white, as if under a thick layer of make-up. She appears almost to be blinking, owl-like, in the unaccustomed brilliance of daylight. According to Gauzi, Casque d'Or (Golden Helmet) was a famous *pierreuse*, or streetwalker, of the time, and was the cause of more than one street fight outside Le Moulin de la Galette. It must have amused Henry to contrast her sickly pallor and dyed hair with the soft colours of sunlit greenery. To heighten the paradox, he dressed her primly in a high-necked Chinese jacket, removing any nuance of coquetry from her unpretentious, slightly wistful demeanour.

Similarly, *Gabrielle la danseuse* (Gabrielle the Dancer) is far too dressed up to be in a garden, and looks not pastoral, but impatient and arrogant, very ill-at-ease. La Gabrielle, as she was often called, was a favourite model of Henry's, for she appeared in at least four portraits over a number of years, beginning with this one, where she is shown as a slim, still-young woman, and ending with her fat and aged, standing beside Cha-U-Kao in *Cha-U-Kao au Moulin Rouge* (1896). By 1890, he called these portraits, in which the natural background of the garden is never a real nature painting but only a contrasting pattern, *'impositions'* (punishment works), as if they were exercises he imposed on himself without pleasure, to compensate perhaps for the joyous works done in the nightclubs. Maybe it was an attempt to get at all sides of his models' existences, not just their lives in artificial light. Light was essential to Henry's image of things and a constant subject in his letters. In December 1890, writing to his mother, he commented that he continued to work, despite the lack of light.

It is at this period that we have almost the only concrete references to Henry's relations with women, aside from accounts by his friends: a letter to Henry from one of his mistresses, dated Thursday, 4 December 1890, and signed 'Suzanne'. It has generally been attributed to Suzanne Valadon, but the return address is Mademoiselle Mignon, 8, rue Colbert. Suzanne Valadon lived at 7, rue Tourlaque until 1896. Written in practically illiterate French, full of misspellings and grammatical errors, the text reads more or less as follows:

My dear Toulouse,

Excuse me for not being able to get to your rendezvous on Tuesday it was totally impossible for me for the very simple reason that I absolutely had to go immediately rue Colbert seeing as I had received a letter to go there as soon as I got the letter. I hope you ain't mad at me and if you don't want to come and see me at least you'll write me a note. I'm waiting for a little letter from you because I'd be real unhappy if you have a grudge against me. Here is my address: Melle Mignon, rue Colbert 8. Come and sleep over when you want only not before half past midnight. That's all. I give you a kiss on your (little bedroom slipper, etc.)

<div style="text-align: right">Suzanne</div>

We do know that just after New Year's Day 1891, Henry had dinner with Suzanne Valadon at L'Auberge du Clou at the foot of Montmartre, not far from where he lived in the rue Fontaine. A few months later, sometime in the spring of 1891, Adèle must have mentioned to Henry in a letter that she had heard that he had been seen with an elegant young woman. No doubt she was hoping that her son was at last courting a girl of his own social class, whom he might marry. His response was categoric: 'What you say about the chic young lady is of no interest to me – it's just another stupid mistake by the person who thought that idea up – the girl in question is nothing but a tart – she used to work in a bakery.'

Overall, Henry's taste in women appears to have fallen into two categories: the women he admired from afar, who frequently were singers or dancers whom he could observe in the evenings during his bar wanderings, and the prostitutes he frequented for sexual encounters. It is not clear, however, that he perceived any of these women as equals. They were of either greater or lesser status than he. Despite this tendency to categorize women as objects either of reverence or exploitation, he also sought them for tenderness and fellowship – aspects of love which were excluded from either heroine-worship or sex-for-hire. Typically, he attempted to get to know each of the women who interested him, prostitute or object of unrequited love, painting and drawing her sometimes dozens of times, and on rare occasions making of her a lifelong friend.

That season in Paris, the theatre became Henry's *furia* and would continue to be one throughout the 1890s. He went in black tie to the Comédie Française night after night, always with a friend, sometimes with his new acquaintance, Paul Leclercq, a poet and *viveur* (pleasure-seeker), often with Jean de Tinan or André Rivoire, both playwrights. He always sat in the first row, soaking

in the theatre's elegance, its smell, the people he saw there time after time, occasionally emitting, as Leclercq described it, 'a brief, joyous chuckle'.

Although the Comédie Française was his favourite, he varied his menu, supplementing classical theatre with scantily-dressed dancers at Les Folies Bergère, comedians at the Théâtre des Variétés and avant-garde productions at André Antoine's Théâtre Libre or Lugné-Poë's Théâtre de l'Oeuvre. He began doing a series of portraits of the major actors of the period, both serious and boulevard, most often showing them in the roles they played, works which were usually developed from sketches made during performances. His friend Leclercq observed his technique with interest:

Sometimes he would hold his hand to his brow like a visor for a few seconds, blink a few times, stare at a corner of the scene before him, pull a little sketchbook out of his pocket, make a quick note with one pencil line and shove the sketchbook back in his pocket.

This minuscule sketchbook, about as big as a matchbox, bound in beige cloth and held shut by a wide rubber band, was always with him. It was in some way the diary of his impressions ... his line-drawings told where he had been and what he had seen ... Each of his sketches about the theatre carries the weight of profound commentary or skilful revelation.

Contrary to the snapshot quality of the drawings Henry made of performers onstage, his formal portraits of them were often based on posed photographs, most characteristically on the publicity photographs theatre people had made for themselves and which were sometimes even sold as postcards. These works, which he continued nearly all his life, create a sort of history of Paris theatre in the 1890s, serving as a precious social document. As Arsène Alexandre described them, they were nonetheless 'a history written by a historian with a particular point of view, sardonic and absolutely devoid of illusions'.

Curiously, Henry's interest in the theatre had nothing to do with the plays themselves. 'At the theatre it doesn't matter if it's bad, I always like it,' he said to Alexandre. 'The plays mean nothing to me.' Gauzi recounts an anecdote where Edouard Dujardin invited his friends to a presentation of *La Fin d'Antonia*, a Symbolist play he had written. For the evening he had rented the Théâtre du Vaudeville and asked Lugné-Poë and the other actors to play the roles. The guests, even though they were supposed to be friends of the author, hated the play, and 'signs of impatience began to be manifest in the audience in the form of murmurs, whispers, stamping of feet, animal

imitations and loud remarks. In reaction, others started to applaud. Then the whistling began, and it was so noisy that the disconcerted actors had to stop speaking.' Dujardin came onstage to ask those who didn't wish to watch the play to leave. 'Dujardin is right,' Henry told Gauzi, 'we are his guests; out of politeness we should keep quiet and simply leave if the play bores us ... as for me, I'm staying ... you don't abandon a friend when he's down.' Gauzi agreed to stay, but he asked Henry if he understood the play. 'I don't understand a single word, but that's fine with me. I'm not listening. I'm never bored at the theatre; I watch the actors making faces, and posturing. I always love seeing them ham it up.'

He told Leclercq that plays were 'not his profession', that what he liked at the theatre were the 'side dishes', the architecture and decoration of the building itself, the curtain, the lighting, the sets, the ways the actors and actresses looked and behaved. He liked to go backstage, into the 'labyrinth', to see how the theatrical artifices were produced. He even got to know the stagehands. Like Renoir, he considered the audience to be as much a part of the spectacle as the show itself and did nearly as many works of people attending the theatre as he did of actors and actresses. This was also true, of course, in his Moulin Rouge works.

In January 1891, Henry was in the midst of a move. He and Bourges decided to leave their apartment at 19, rue Fontaine, possibly because of a fire on the floor below: 'I almost got roasted last night,' Henry wrote to his mother, '... one of the beams under my bedroom having caught fire. Luckily the firemen got it out in a quarter of an hour. The whole thing happened last night around 11 o'clock and by the time I got home to go to bed, the only thing I saw was a lot of smoke.' He added that the weather was freezing and that he didn't know whether he would be able to go to Belgium, presumably to see the annual XX exhibition, although he wasn't showing there that year. It was so cold that he waited until the friends who were posing for him got to his atelier in the morning before he even got out of bed. He said he had to stamp his feet continually while he worked, to keep them from going numb, and that the ice floes in the Seine had to be dynamited to restore river traffic. 'Bourges even saw two swans dragged by the ice floes fluttering weakly between two bridges and falling exhausted onto the ice.' He added that his friend Louis Fabre was in Paris 'fighting the frost with quite a few small glasses'.

He seemed somewhat disoriented around this time, mentioning in one letter that he couldn't find any stationery and was writing on a page from a school notebook, and in another that he was astonished to learn he had

mailed an empty envelope to his father and forgotten to include the letter.

He and Bourges finally solved their housing problem by moving together to 21, rue Fontaine, two doors away on the same street. 'That way the move won't be very perilous,' he observed to his mother, whose Christmas present of a *miroir de style* (large wall mirror) he was planning to hang in the new apartment. The disruption caused by the fire and the move didn't keep him from devoting full energy to a pâté sent by his Grandmother Louise ('it had a rough fifteen minutes,' he said) and to a capon from Albi sent by his mother at his special request. They were celebrating Bourges' M.D. thesis defence.

Shortly thereafter Bourges went to Beirut to report on the cholera epidemic there ('Each of us takes his pleasure where he can,' commented Henry sardonically) and then, after several false starts, took off on horseback to the Congo with two explorers for a five-month trip, which included the possibility of hunting gazelles. Bourges had invited Alph, who had recently moved to Paris to a studio in the Cité du Retiro, to come along, and Henry felt left out: 'What a pity I can't go with him.' Alph apparently chose not to go. Gaston Bonnefoy, son of a Bordelais doctor and family friend, whose portrait Henry was trying to finish for the Exposition at the Cercle Volney, due to open on 26 January, had just come back from Saigon. Henry must have felt like a homebody in comparison, since the biggest trips he took that spring were moving two doors down the street and taking Alph's horse and buggy to the Bois de Boulogne.

Around this time, in addition to a large number of paintings, Henry must have begun doing his first lithographic prints. Dodo Albert, his friend from Cormon's, was a printmaker and may well have influenced Henry's interest in this medium, in which Degas was already a master. It was just beginning to enter the consciousness of the younger artists that original, signed prints in limited editions could be sold to people who could not afford original paintings, and several of Henry's acquaintances, Maurice Denis, Pierre Bonnard and Edouard Vuillard, were already working on lithographs and other kinds of prints. Unfortunately, the public was slower to see the investment possibilities of fine prints, and in spite of the availability of publishers of fine prints, among whom the best at the time was Ambroise Vollard, the support of critics such as Mellerio and Roger Marx, and the existence of dealers interested in selling the works, including the publisher Vollard, Durand-Ruel, Kleinmann, Sagot and soon Henry's gallery, Boussod et Valadon, there was practically no commercial market for prints in France until the beginning of the twentieth century.

Although it has been said that Henry studied with Eugène Delâtre, who

taught printmaking to Mary Cassatt and possibly to two of the Duchamp brothers, Gaston Duchamp (known as Jacques Villon) and Raymond Duchamp-Villon, there is no reference to Delâtre among contemporary documents alluding to Henry, and it seems more likely that he learned his lithographic skills *sur le tas* (hands on), by watching and doing lithographs himself, following the advice of professional printers. Henry formed his first such alliance with a magnificent technician, Père Cotelle, who worked for the Imprimerie Ancourt which for years printed most of Henry's lithos. Henry developed an equally strong relationship with his second printer, Henri Stern, who also worked for Ancourt.

In retrospect, lithography seems an obvious choice of medium for Henry. His desire to be modern had already led him to photography, and he believed in reproducing his own work. He had always been interested in 'popular production' – theatre programmes, magazine covers, menus, painted fans – as much as in the production of individual drawings and paintings. He had been reproducing drawings in Parisian magazines since 1886. The fashion was to create art not only to hang in galleries but also in all aspects of life: home décor, book design, advertising. Since the advent of Japanese prints in Europe and the enormous admiration they aroused among the artistic avant-garde, prints of all kinds were becoming recognized art forms.

In addition, lithography matched Henry's skills. His greatest virtuosity was his drawing – his ability to capture the essence of his subject with one sure line. This skill was invaluable to a lithographic artist, for once the soft lithographic stone had been ground to a perfect, oil-free surface, it was very difficult to make corrections on it, and even the oil from a handprint could mar the final image. Henry may also have loved the sensuous coolness of the stone and the rapidity and variety of the effects produced with the oily inks and crayons used to mark its surface. He always had needed to repeat gestures, to trace images, to draw the same line over and over, to work compulsively with certain symbols and shapes. From his own physical repetitions to producing multiples of his work was only a small step.

His lithographic skills developed rapidly, and by the next autumn he began to have important commissions, including for posters. Henceforth, Henry would be at least as productive as a printmaker as he was as a painter. Over the next ten years he produced something like three hundred and twenty-five lithographs and thirty lithographic posters as well as nine dry-points and four monotypes, in editions ranging from sixteen for a small litho to three thousand for a large poster.

That spring of 1891, his work in all media was going well. His submissions

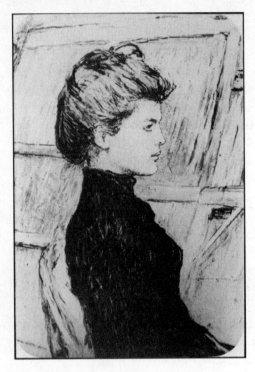

Juliette Vary, *1890.*

to the Cercle Volney included a portrait of Juliette Vary and portraits of the two Dihau brothers. He was pleased by a 'flattering' review, possibly the one by Jules Antoine published in *La Plume* on 13 February 1891. Although the comments on Henry's work are brief, the review is interesting for its description of how the Volney and other shows of the sort functioned:

Do you know what these club exhibitions are? Collections of works by socially prominent amateurs, spiced up by a few canvases with famous signatures. This is the reason for the old-fashioned feel of the place, and the presence of Parisiennes who obviously have no interest in art, as well as the embarrassing landscapes and portraits whose subjects are either deformed or discoloured. In addition, the famous painters who are members of these clubs send only unimportant pieces, and save their serious work for the salons.

He accused the works in the show of being above all boring and without ideas: 'You feel the influence of the system, the terrible system, which engenders monotony and impotence.' Compared to these criticisms, his evaluation of Henry seems like high praise: 'M. de Toulouse-Lautrec has something of the expressive drawing of Degas, but with more focus and point of view; in

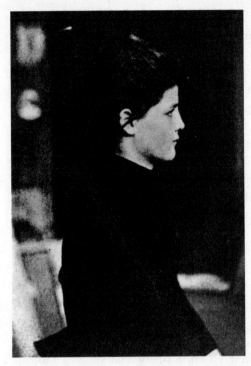

Juliette Vary photographed by
François Gauzi, c. 1890.

colour, he has intentionally reduced his palette to neutral tones; sometimes even, as in the case of his study of a young girl, colour seems to be present only to strengthen the drawing.'

Henry's entries, unlike the work of the well-known academic artists, were badly hung, and he felt lucky that his work had even been noticed, off at the sides of the exhibition as it was. He commented to his mother that the light wasn't as good as the year before, adding in his next letter: 'I feel as if I did not get off too badly, given the old men who have the right to be hung from the mouldings.'

That winter he had begun a series of *portraits en pied* (full-length portraits) of male friends, generally standing in his studio. Reminiscent of Whistler's standing portraits of men, these studies would continue in his work over the next ten years and, although they are substantially less famous than his portraits of women, they are among his finest works. Forain's full-length sketch of Alph which Henry kept in his studio was supposedly the inspiration for the series. Between January and March 1891, he completed three of them, one of Bourges, the portrait of Gaston Bonnefoy, and another of his cousin Louis Pascal accompanied by a separate study (see Plate 19).

In general, Henry's works representing his male friends are far more

subdued in palette, more detailed in style, than his works showing women. Influenced by Japanese art, he manifested a greater awareness of their silhouettes, which he stylized into pleasing, almost abstract shapes – a characteristic which would mark his mature work, particularly the lithographs he began doing this same year. Except for his 1886 drawing of Gauzi in *Un Jour de première communion à Paris*, at that time his portraits of men were generally studies of his friends exactly as they were. It was rare for him to represent men in roles or to change their social class. But like his women in Père Forest's garden, the men always look ill-at-ease. In his studio, where the 1891 series of men's portraits was painted, they are always garbed in coats, hats and gloves standing in the doorway, as if they had accidentally wandered in or were preparing imminently to depart.

These portraits are in a real sense a homage to Henry's friendships with men. Although he was able to meet his sensual needs in the brothels, Lautrec turned to men to meet his profounder emotional needs. These friendships were often intense and tended to be more enduring than his friendships with all but a very few women. He usually had one close male friend; for many years it was his roommate Bourges. After his cousin Gabriel Tapié de Céleyran moved back to Paris in 1891, 'Gab' became his constant companion. These friends were much like himself – if not actually relatives, often southerners of good family; frequently, but not always, artists. Although he has been described as being somewhat anti-intellectual, at times he was close to two of the most complex minds of his generation: Edouard Dujardin, titular head of the Symbolist movement, and Félix Fénéon, the anarchist and art critic. Rather than seeking out men with similar professional interests, Henry tended to choose as friends men who shared his obsessive fascination with alcohol or brothels, 'partners in crime' – rebellious sons of aristocratic families willing to go out slumming, but who held in common with him a love of elegance, gourmet cooking and witty conversation. An example was the well-to-do, heavy-drinking, man-about-town and champagne merchant Maurice Guibert, a former student at Cormon's who lived on his family's estate, the Villa Guibert, within the city limits. He and Henry travelled together on a number of occasions, taking along large supplies of good wine and indulging in the best each city had to offer, from museums to brothels. In a letter to his Grandmother Gabrielle written around 1890, Henry said an armchair she had had made for him was so admired by Guibert that he would like her to order one for him too and have it sent C.O.D. to Guibert in Passy.

Guibert was also an amateur artist and an enthusiastic photographer who belonged to the national photographic society and took photographs of

Henry in various poses and costumes, including at least two trick photographs which required a certain creative imagination and skill. Henry in turn involved Guibert in his art in a variety of ways, including having Guibert finish the background of his huge circus painting. Once Henry had a professional photographer, Paul Sescau, take a photo of Guibert with a model which Henry used as the pose for his 1891 painting *A la mie* (Down to the Crumbs). In addition Henry used Guibert's image in at least ten lithographs and a number of comic-erotic drawings as late as 1899.

In all his friendships, in all his relations with those around him, Henry was extremely sensitive to the balance of power. Getting others to do as he wished was not a new activity for him, and it takes no great insight to understand the need for a small, fragile man to prove he can dominate those around him. He had learned as a child how to impose his will by psychological means, and his friends, both male and female, found him irresistibly charming but unrelentingly tyrannical. He had become extremely good at getting others to do his bidding – and managed to do so in large part without resorting to demands on their pity for his physical state. He was skilled at making his crowd the in-group, so that people would want to belong to it, and in fact his own freedom was a liberating influence for others, allowing them to act out their own unacceptable impulses by yielding to his escapades. Although most of his friends willingly participated when he launched one

Trick photo of Henry by
Maurice Guibert, c. 1891.

of his pranks, anyone who resisted was treated to an entire spectrum of coercion, insults, entreaties – even bribes of food and drink. His friends were tolerant, considering him an 'unbearable but charming spoiled child'.

In the spring of 1891, Henry was in a period of intense productivity, provoked perhaps by the deadline for the seventh Salon des Indépendants, which opened on 20 March. The show included a lot of artists of Henry's generation, Anquetin, Seurat, Signac and, posthumously, a number of paintings by Vincent Van Gogh. Henry exhibited at least eight works: the three new portraits of male friends, plus the earlier portraits of the Dihau brothers and one of the photographer Paul Sescau. In addition to the six portraits of men alone, there were two anecdotal works: *En Meublé* (Furnished Rooms) and his posed study *A la mie*. For unknown reasons, only the last two paintings were listed in the catalogue.

Although *A la mie* (Plate 20) was posed and painted from a photograph, the work is extremely effective as a Social Realist anecdote. The title is a slang expression with a double meaning. Literally it means there is nothing left to eat, but by extension it refers to a person of little worth, possibly a fake or a fraud. As a critic said when the painting was shown in 1908, it represents 'a no doubt somewhat untrustworthy couple sitting at a table which holds a litre of wine, the remains of a loaf of bread and a little cheese. The cynical expression on the man's face is profoundly moving in its realism.' To Henry's friends, who actually knew the model, Maurice Guibert, the irony must have been both troubling and amusing, for Guibert as we see him in a photo is younger and more attractive than the man in Henry's painting. Although Guibert was of an entirely different social class from the pimp he was representing, Henry had captured something of Guibert's psyche in the work, painting him not as he was, but as he perhaps would look some years later.

Several reviews of that year's Salon des Indépendants mentioned Henry, always positively. Emile Verhaeren complimented Henry's *faire*, his painterly style, which 'stood out from everyone else'. Octave Mirbeau, in a long encomium of Van Gogh, also pointed out Henry's work: 'in spite of the blacks with which he unduly dirties his faces, M. de Toulouse-Lautrec shows a real force which is both witty and tragic in his study of expressions and his revelation of personalities.'

Henry next exhibited at the end of May in the Salon des Refusés at the Palais des Arts Libéraux. Anquetin had organized this 'show for the rejected' to criticize the new policy of the official Salon and the Salon des Beaux Arts

of reducing their acceptances by as much as two-fifths. Once again, however, negotiations with the Divisionists, who had allied themselves with the Salon des Indépendants, broke down, and Anquetin's new group showed without them. 'Thursday, brilliant opening with too many people, but some good friends,' Henry wrote to Adèle. This time he showed only two pictures, *Paul Sescau, photographe* (Paul Sescau, Photographer) and *Un Coin au Moulin de la Galette* (A Corner at the Moulin de la Galette), a painting which may have been either *Au Bal du Moulin de la Galette* or *Un Coin au Moulin de la Galette*.

G. Lessauly wrote, 'I would also like to call attention to the savage realism of the remarkable study by Toulouse-Lautrec, *Un Coin au Moulin de la Galette*,' which he judged superior to the 'inevitable dead wood which can be found [in this show] as everywhere'. Another critic said Henry was a 'rare' talent among 'the nobodies'. Al. Georges elaborated, 'The first thing [that strikes you] is the personal and curious drawing-style of M. Toulouse-Lautrec, a cruel, subtle observer, closely related to Forain, whose detailed portraits and Parisian scenes, nicely done with a witty, teasing, and fero-

Moi en bicycle

Maurice Guibert, c. 1891.

ciously accurate line, I have already had the pleasure of mentioning in the Independants and at the Volney. Go and see *Un Coin du Moulin de la Galette* and the portrait of M. Sescau, where the model seems, in the intimate quality of both his physiognomy and his posture, completely alive, as if caught by surprise.'

Two critics, Gustave Geffroy (who signed his review G.G.), commenting that Henry's pastels (sic) were 'amusingly fanciful', and Arsène Alexandre (signing A.A.), who said, 'The only works worth mentioning are the curious drawings by M. Toulouse-Lautrec and M. Fauché,' appeared to notice Henry for the first time. In later years, each critic would become Henry's friend and defender.

Adèle was ill, now back at Malromé, apparently with some kind of partial paralysis. Henry consulted Bourges, who wanted more details before attempting a long-distance diagnosis. Then he tried to reassure his mother: 'I know several painters who have had similar attacks, and who get along. Moreover, anyone who works outside gets them, so the future will hold some for me, too, no doubt.' Himself recovering from jaundice, he seemed less preoccupied by either of their states of health than by his money problems: 'It would be most kind if you could, around that memorable date of July 14, send me a few *sesterces* to distribute to various kinds of dealers ... M. Roques has been making me wait indefinitely to be paid, and since there's no written contract, I'm very afraid I'm in hot water. Always check people's honesty!!!'

His instincts were excellent. Adèle recovered completely, helped perhaps by the gift of a puppy from Henry, but his relations with Jules Roques fell apart entirely. As early as 1886, Roques, editor of *Le Courrier français*, had commissioned a number of drawings from Henry to be published in his magazine. Some had been published. Others were neither used nor returned. None had been paid for. A letter Henry wrote to his mother in June 1891 gave more details: 'I spend my free time in legal actions against the editor of *Le Courrier français*, who, as you remember, hadn't paid me for some drawings, and then had the audacity to sell them. I had him served with papers and have received the payments owed. Boy, is his face red.'

According to Gauzi, Henry discovered Roques' intent to sell his drawings because his name was listed in the Paris newspapers as one of the artists whose work was to be auctioned at the Hôtel Drouot on Monday, 1 June 1891. Henry sought an injunction to prevent the sale of the drawings until he himself had been paid for them, 'then he vanished, stayed out of sight and diverted himself by playing hide-and-seek with the distracted Roques, who pursued him all over Paris to secure a lifting of the ban. Two days later

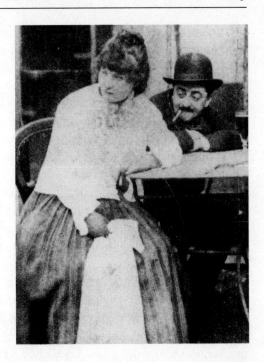

Maurice Guibert and a model posing for A la mie, *1891.*

Lautrec ... let himself be caught ... and the sale took place.' The drawings were finally sold on 20 June. Roques, whose newspaper had been the first to publish Henry's drawings and who considered himself in some ways Henry's patron, was convinced that it was he who had been wronged, and never forgave Henry, even going so far as to bring the matter up in Henry's obituary.

When Henry got back to Paris in the autumn of 1891, after a holiday in the south, he was immediately caught up in the typical concerns of his life: art and money. He was quite worried about his maid, who had contracted a mild case of typhoid fever: 'I hadn't expected this blow. The poor girl is in a sorry state ... I'm probably going to have her taken to a room in the hospital. That'll cost me about 4 francs a day, and she'll have everything she needs. Moreover, my apartment won't be disturbed by the neighbours, who are devoted, it is true, but whose presence doesn't exactly charm me.' Fortunately, his father 'opened his cash box without any trouble'. That autumn a gallery had sold a study for 300 francs, which he called 'a small increase in price'. He received 200 francs, or two-thirds of the selling price. 'Degas has been encouraging, telling me my work from this summer isn't too bad,' he wrote to Adèle. 'I certainly would like to believe him.' He nonetheless seemed discouraged and somewhat 'fussy', as he put it: 'Business, moreover, is in the

doldrums. Grenier [recovering from a broken leg received in a fall from a carriage], who came to Paris yesterday, is more terrified than ever, and Anquetin almost came down with rheumatism again. My haemorrhoids are better thanks to *populeum* unguent. My studio has been turned over to the cleaners and chimneysweeps and me, I'm not yet exactly sure what I'm going to do.'

As it happened, the autumn of 1891 was a very busy and productive time for him. On 5 October, his cousin Gabriel Tapié de Céleyran began his internship in Paris with a noted surgeon, Dr. Jules-Emile Péan, and Henry developed a new *furia*, for surgery. Hospital paintings, paintings of famous doctors, as well as of the ill, insane and infirm were no longer a novelty in French art as they had been in the 1860s, and it is not surprising that Henry, too, wished to try his hand at the mode. As Gabriel later commented, Henry was not a 'mono-painter ... he was interested in anything that squirms', in other words, in all the teeming, swarming, truly living aspects of the world. Now he began going with Gab every Saturday morning to the Hôpital Saint-Louis, where he was allowed into the operating rooms as an observer and did hundreds of sketches of various surgical procedures, particularly of Gab's teacher, Péan, at work. Afterwards he and Gab would go to the employees' dining room for lunch.

Péan was already a legend. As well known in France as Charcot, member of the Académie de Médecine and decorated with the Légion d'Honneur, Péan had been the first Frenchman to try his hand at major abdominal surgery. Best known for his gynaecological operations, Péan also did important operations of the tongue, the back of the throat, the trachea and the thyroid. He invented haemostats to close off blood vessels during surgery. When he was forced to retire from the municipal hospitals in 1892 at the age of sixty-two, he established his own hospital, the Hôpital International, in the rue de la Santé, and Gabriel continued his internship there for the next four years. Henry made his Saturday morning visits to the operating room for many months. Apparently he sometimes even invited other artists to join him, for William Rothenstein recalled in his memoirs that 'another time [Lautrec] was enthusiastic about operations performed before clinical students, and pressed me to join him at the hospital'. 'If I hadn't been a painter, I would have become a surgeon,' Henry is supposed to have said. Péan, in an odd reversal, at one time had wanted to be a painter.

Watching Péan operate was as much a ritual spectacle as going to the Comédie Française. Péan enjoyed being observed as he operated. Although part of his success as a surgeon is attributed to his scrupulous hygiene at a

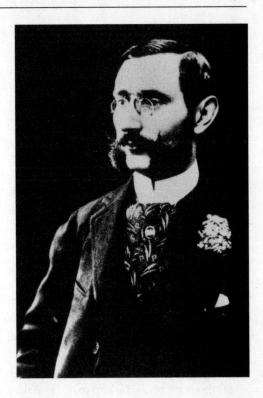

Gabriel Tapié de Céleyran, 1892.

time when aseptic conditions were unknown in the operating room, he generally operated in a dress suit, its cuffs turned up under clean cloths attached to his forearms and with a large napkin or towel tied around his neck. As a biographer later explained, 'his immaculate false shirt-fronts were interchangeable; if a little blood squirted on one, after the operation he changed it for another.'

His precise movements made him seem calm and forceful as his enormous hands skilfully wielded a scalpel, rapidly excising huge tumours, then carrying them 'prickly with haemostats still attached' into the waiting room to announce to an anxious husband, 'Look, my good man, at what your poor wife had growing inside her belly.' He collected his fee on the spot. It has been suggested that Henry's operating-room works were representative of his fascination with all that was forbidden, hidden, organic, possibly disgusting – illness, vice, death. In addition, Péan had some striking similarities with Henry's other preferred male model, Aristide Bruant. Both men were 'hearty', physically solid, blustering, theatrical personalities, supremely confident of their skills in their chosen domains. They may have been subconscious mentors for Henry, resembling the absent Alphonse but easier and

more neutral to observe. Another male figure, the singer and comedian Caudieux, whom Henry painted and made a poster of in 1893 (see illustration on p. 361), shows many of the same characteristics.

The perspective of Henry's famous oil painting of Péan operating on someone's jaw or throat is interesting, for it is from the point of view of an observer who is standing behind the first row of spectators, looking over the shoulder of someone whose head and ear are visible in the foreground of the painting (Plate 30). Although this work and a second painting, *Une Opération par le docteur Péan à l'Hôpital International*, were the result of at least forty-five drawings, Péan apparently never paid the slightest attention to Henry or expressed any interest in his work. As a friend said, if the drawings and paintings had appealed to him, he would have acquired them, but not even one was ever found among his family's possessions. In this, Péan resembled Degas and, of course, Alphonse.

Although they had never been particularly close before – Louis Pascal had always been Henry's closest cousin – Henry's younger cousin Gabriel was to become a sort of foil to him. The two now formed a nearly inseparable couple, going everywhere together. Although there was a family resemblance and Gabriel would soon have similar problems with alcohol, they made a striking pair because Gab was extremely tall and thin (see Plate 23). Repeating the same remark he had made to Adèle about his friend Anquetin, Henry told his friends that he liked to be seen with his cousin because Gabriel was so much taller than he. In his painting of the two of them in profile, side-by-side in the background of his famous oil *Au Moulin Rouge* (Plate 21), Henry is nearly three heads shorter than his cousin.

With Gab, as with everyone else, Henry refused to tolerate the slightest affectation or vanity, and Henry's friends felt that he baited Gab mercilessly. Five years younger than Henry, Gabriel was a gentle, patient man, still besieged by adolescent acne, whose nose seemed too large for his face. Near-sighted like Henry, he wore a pince-nez and long, modish sideburns. Henry profited from 'le Docteur's' sweet disposition to tease him about his pinkie rings and his attempts at elegant dress, accusing him of being a 'ladies' man'. He dominated and ridiculed him, calling him an idiot before their friends and forcing him to submit to all sorts of frivolous whims. Several of their friends mentioned an incident in which Henry had an absurd jacket made for Gabriel out of the bottle-green felt used to cover billiard-tables. On Henry's insistence, Gabriel actually wore it. Henry's tyranny was so strong that it makes one think there was some sort of emotional blackmail going on – perhaps Henry knew too many of his cousin's transgressions, himself

having led him into iniquity. Gabriel submitted patiently to such frivolities and may have taken comfort in the fact that he was neither the first nor the last of Henry's friends to suffer from his despotism.

Through the next seven or eight years, the two cousins saw each other nearly every day, dining together, going to art openings and the theatre, spending weekends with friends. Adèle, unable to control Henry, must have been relieved that at least he was not alone in a world she did not understand. Gabriel in his own way was trying to help them both. He reported to Adèle on Henry's activities, thus acting in some ways as her stand-in, and he perhaps allowed himself to be made a subject of ridicule to attract painful teasing away from Henry.

MONSIEUR HENRI

In mid-September 1891, or thereabouts, Henry designed and drew his
first clearly datable lithograph, the poster *Moulin Rouge, La Goulue*
(Plate 25). Aged not quite twenty-six, after nine years in Paris, Henry be-
came famous overnight. Despite an intentionally confusing signature (the
architect and painter Francis Jourdain commented that when he first
saw it, he thought the poster was by someone named 'Hautrec'), many
recognized his work, and members of his family, apparently including his
father, were outraged.

Forty-five years later, a cousin was still claiming that Alphonse never
spoke to Henry after the poster was put up. Although this is demonstrably
untrue, for Henry remained in constant and intermittently friendly contact
with his father throughout his life, it is easy to see why a family like his
would be scandalized. Posters were not fine art; they were advertising, work
for pay, commissioned in this case by the owners of a nightclub famous for
its vulgarity. In addition they were not hung in museums and galleries.
Printed on cheap paper, they were stuck up by the thousand on walls all over
Paris, to be viewed by anyone, rained on, pasted over and left to disintegrate
with time. Some, attached to sandwich boards, were even dragged in donkey-
carts up and down the Champs Elysées.

Henry's poster, it must be said, was provocative. He knew he had to grab
the attention of the man in the street. As Thadée Natanson later put it, a
poster had to be like a 'fist in the face'. Henry had understood clearly that
La Goulue was the most powerful symbol of Le Moulin Rouge at the time.
If people of all social classes flocked there night after night, it was in part
because of her reputation for lewdness and in the hopes of seeing her throw
her skirts over her head on a night when she had on especially transparent
bloomers, perhaps with a heart embroidered on the *derrière*. His poster
focuses unhesitatingly on the real centre of attraction of Le Moulin Rouge,

La Goulue's bottom, as she danced the *quadrille naturaliste*, 'when these women – without any inhibitions, because they're paid to do it – raise their leg, without any knickers if you please, up to eye level'. In Henry's preparatory drawing for the poster, his intent shows clearly: 'vigorous charcoal lines radiate from the region of La Goulue's sex, the pivot of her propellor-like pose and quintessence of the poster's subject.'

Despite its almost vulgarly simplistic statement, Henry's poster is quite complex and contains a number of allusive remarks which must have pleased Montmartre habitués. First of all, La Goulue is blocked from the viewer, who must strain to see her around two shapes, one of which is the odd silhouette of Valentin le Désossé, her habitual partner, caricaturally distorted but easily recognizable to anyone who had ever seen them dance. The other shape looks a little like part of a string of beads, more of which are visible in the distance on the right side of the poster. These are highly abstracted references to the yellow globes of the modern electric chandeliers which hung from the ceiling at Le Moulin Rouge to light the dance floor. The position of this shape in the poster is intentionally confusing, designed perhaps to make the viewer stop and ask himself what it is, for Henry had displaced the perspective of the audience in two ways at once, so that La Goulue is viewed at the left side of the poster from above, from the balcony, perhaps, where one would look past the chandelier to see her, and from floor-level on the right, where the spectator has to peek around the dancing Valentin to see the object of his desires. To confuse the issues of perspective further, Henry shows the floorboards receding under La Goulue's feet as if he were lying on the floor when he drew them. This disregard for conventional Renaissance laws of perspective is a bow to Japanism and the flattened perspective common in Japanese prints, but Henry is also thumbing his nose at his own years of academic training.

The other reference to the contemporary Montmartre scene is the background frieze of silhouetted 'porcine' faces of the bourgeois audience, clustering on the dance floor to watch. The black shapes are a homage to the extraordinary shadow-plays that Henri Rivière had been presenting at Le Chat Noir since the late 1880s and which were considered as much a part of Montmartre's nightclub offerings as Le Moulin Rouge. The extremely complicated backstage operations for these plays required ten or twelve people. The silhouette puppets and the stage decors were cut out of thin sheets of zinc based on designs by Rivière and his friends, including Caran d'Ache and Willette. They were then painted and illuminated with coloured lights which cast surprisingly detailed coloured shadows on the transparent

screen and changed the atmosphere of the play from scene to scene. Even the music was elaborate. The composer Vincent Auriol is said to have played the triangle for the performances.

In 1891, poster art was in its infancy. Until the 1860s in France, posters had contained only printed matter. The acknowledged master of the publicity poster in Henry's time was Jules Chéret, who had begun drawing his pictures directly onto the lithographic stone shortly after mechanical presses came into use. For the first time in history, images could be consistently reproduced cheaply and in large numbers. Chéret had dominated the field with his pretty, laughing girls and baroque detail since the 1870s, and it was he who had been given the honour of the commission for the first poster of Le Moulin Rouge when it opened in 1889. There is a curious photograph of Henry, standing with Charles Zidler, in which they pay homage to Chéret's Moulin Rouge poster. But Chéret's image; 'a red windmill, towards which a troupe of his pretty "Chérettes" rode on donkeys, was not specific enough to become a trademark for the nightclub'.

The guiding principles of poster art had been immediately clear to Henry. A poster had to be impossible to miss, instantly effective and unforgettable. Chéret, astonishingly, had incorporated none of these concepts into his poster for Le Moulin Rouge. Although Henry admired Chéret's work, only a year later Chéret would exclaim, 'Lautrec is a master!'

One of the strengths of Henry's image was that it could be understood at a glance, but it had enough intriguing features to tempt a passerby to stop and look at it longer, absorbing not only the advertising message but the artistic complexities and allusions of the design. Francis Jourdain, who subsequently became Henry's friend, documented how effective this was: 'I still remember the shock I had when I first saw the Moulin Rouge poster ... carried along the avenue de l'Opéra on a kind of small cart, and I was so enchanted that I walked alongside it on the pavement.'

Henry's simplification of line and colour and his abstraction of images into compelling, unmistakeable shapes, such as the L-shaped wedge of La Goulue's dancing legs in their ruffled bloomers, revolutionized poster art.

It has been claimed that Pierre Bonnard, an artist three years younger than Henry who was to become a close friend, had already created the break with Chéret's pretty posters in his 1891 lithographic poster *France-Champagne*, but the precise date that poster was printed is not known, and the original source for this observation, Roger Marx, does not give any documentation to support it. Thadée Natanson claimed that Henry saw the

Bonnard poster and asked to meet the artist who had made it, but he seems a little unreliable on this matter, as he calls Bonnard's work *Paris-Champagne* and says it was printed in 1890. He also believed it was Bonnard who took Henry for the first time to the Imprimerie Ancourt. In any case, *Moulin Rouge, La Goulue*'s printer put his name and address on the poster in large letters: 'Ch. Levy, 10 rue Martel, Paris', to Henry's irritation. In a letter to his mother he mentioned 'some printer's goofs which take the sheen off my own product'.

At the time he commented on the event almost as an afterthought: 'My poster was put up today on the walls of Paris, and I'm going to make another one,' was all he wrote to his mother in a letter otherwise devoted to Alph's bout of influenza and instructions to Adèle about shipping him fowl and truffles. 'On re-reading my letter,' Henry commented, 'I find it has a gastronomic character.' Thirteen lines were devoted to food and only two to the hanging of the poster which made him famous.

Henry, following in his father's footsteps, took pride in his gastronomic *finesse*, both in the preparation of good food and in the recognition of fine quality ingredients. He liked to cook for friends and did so often enough for Maurice Joyant to begin collecting the recipes he used. Several anecdotes refer to Henry's arriving in a friend's kitchen armed with all the ingredients for some complicated dish, like lobster *à l'Armoricaine*. However, as such preparations required the drinking of large quantities of alcohol in the kitchen, his impromptu dinners received a mixed welcome. One legendary recipe which persisted in Henry's family as having been invented by him was 'Steak à la Lautrec': 'You grill three of them, one stacked on top of another (on a fire made of grapevine wood, naturally) copiously covered with pepper and mustard – but you only serve the one in the middle, which is the only one which is cooked perfectly.'

Everyday life seemed to take a lot of Henry's energy in the autumn of 1891, despite his successes in the arts. He was forced to have extensive dental work done, and descriptions of treatments as well as discussions of money to pay the dentist dominated his letters to his mother. The dentist gave him cocaine injections which managed to 'completely suppress the pain', and Henry was grateful not to be confined at home even in the 'black' rainy weather. In December, along with thousands of others, he fell victim to the influenza epidemic which struck Paris: 'My influenza is over. Thanks to energetic medications (Bourges made me spray from both head and tail), my vision, appetite and gaiety came back after only 24 hours of sickness. That's not much, and if I'm careful, I will have got off lightly. Gabriel

has had it for quite a while – not seriously, it's true, but explosively.'

As winter approached he showed his typical dissatisfaction with his models: 'my excuse [for being late] is the tantrums my new models made me throw. Decidedly, this race is dangerous for the serenity of painters who unfortunately can't do without them.' The recalcitrant models may have been La Goulue, a woman Henry's friends knew as La Goulue's sister Jeanne Weber, and another Moulin Rouge regular, possibly La Môme Fromage, who posed around that time for the painting *La Goulue entrant au Moulin Rouge* (La Goulue Entering Le Moulin Rouge). It is known that La Goulue, who was happy enough to let Henry buy her drinks after her nightclub number, refused to pose for him in his studio and was so uncooperative that Henry appealed to Zidler to force her to by making posing for Henry part of her job. It is presumed that Zidler did so because Henry's poster had increased the fame of Le Moulin Rouge, and he calculated that any work Henry did of La Goulue would only draw more clients. The painting Henry produced, of La Goulue, arm-in-arm with the other women on each side, making a grand entrance into the bar with her dress cut open down to her navel, was not destined to please her, for he painted her not as she was then but as she would look a few years later, with a permanent sneer engraved on her face and sadly flaccid breasts. She looks so arrogant and so shameless that the painting may be considered the first of a new theme which would now come to dominate his art: of loose women plying their trade, not only in the brothel but also on the street and in the cabarets and dance halls.

The opening of the autumn exhibitions and his sale of *Etude de jeune fille* (Study of a Young Girl), which had been shown in the Volney that January, kept Henry's interest in marketing his work very high. This painting also earned him 200 francs, or two-thirds of the gallery price. In December, he showed a number of works in the first exhibition of the Peintres Impressionistes et Symbolistes at Le Barc de Boutteville's gallery. Works by Anquetin, Bernard, Bonnard, Denis, Van Gogh, Sérusier and Signac were shown at the same time.

All Henry's paintings exhibited at Le Barc were of women, and most of them were somehow scandalous. One, for example, showed a woman sitting in a bedroom with a mirror and washbasin, looking exhausted and smoking a cigarette. He also showed five paintings of a woman combing her hair, one of which, *Celle qui se peigne*, was shown at the Volney a month later. These works are closely related visually to a Degas 1883 pastel of a woman combing her hair, which was owned by Michel Manzi, who had also bought two

works from Henry. According to Gauzi, the model for *Celle qui se peigne* was once again Suzanne Valadon.

For the first time in months, Henry showed real enthusiasm when he wrote to his mother: 'We have just opened a boutique, a sort of perpetual exhibition in the rue Lepelletier. The papers were most kind to your off-spring. I'm sending you a clipping written in honey mixed with incense. My poster has been a success on the walls.' This was probably a laudatory article by Jacques Daurelle in *L'Echo de Paris*, 28 December 1891, on the work of Henry, Bernard, Denis, Bonnard and Anquetin. He said that he considered this to be a group of young artists who showed promise of a brilliant future.

As the Volney exhibition opened in January 1892, Henry commented on the increasingly positive tone of his reviews: 'my stuff, even though it was hung in the worst possible places, got favourable remarks in the press. In fact, ever since my poster came out, the papers have been extremely nice to me. *Le Paris*, a very republican paper (don't tell the family), went so far as to devote two whole columns to revealing my person without omitting a single detail.'

Henry went off again to Brussels for the opening of the XX show in 1892, accompanied on the train this time by Maurice Guibert and by a doctor friend of Bourges' named de Lostalot, on his way to 'open a few Belgian bellies. He's an old friend of mine, so that's nice,' Henry wrote to his mother. There is no way of knowing if the doctor's company was pure coincidence, or if Bourges, possibly in concert with Adèle, was worried enough about Henry's increased drinking to arrange for someone responsible to make the trip with Henry. Writing to Adèle from the Grand Hôtel, Henry said he was pleased both with the friendliness of the Belgians and the way his works were hung in the exhibition, 'satisfactory, given my immense talent (see the tale of the owl: "my little ones are darling", etc . . .)'.

Henry showed nine works in Les XX in 1892, seven paintings and, for the first time, his lithographic poster *La Goulue (Moulin Rouge)*, as he titled it, in two different states. One work which he ironically titled *Nocturne* may have been the scandalous *La Goulue entrant au Moulin Rouge*. Two of the works were sold, one before the show opened. After the show closed, *Moulin Rouge*, *La Goulue* and *La Goulue entrant au Moulin Rouge* were shown in Antwerp in the Salon de l'Association pour l'Art.

During Henry's six days in Belgium, he and Guibert met and were invited to dinner by the well-known Belgian lawyer Edmond Picard, who was also an art critic, poet and playwright. In his role as editor of the magazine *L'Art moderne*, Picard, part of the intellectual avant-garde in Brussels, was trying

to influence public taste in art. Henry no doubt profited from this visit to do the preliminary sketches for a portrait, and Picard later commented favourably on Henry's work in the exhibition. The evening was apparently very lively, and a great deal of excellent Bordeaux was consumed by all present.

It was possibly during this same trip to Brussels that Henry and fellow Parisian Paul Leclercq were at Le Taverne du Globe when a man asked Henry in a rude way where to find the men's room. Henry answered, 'Go downstairs. You'll find a door marked Gentlemen. *Go in anyway.*'

The art world, at least in part, had begun to identify Henry as one of the major artists of his generation. The XX reviewers commented on his work in terms that ranged from lukewarm to glowing. Eugène Demolder, a fan since 1890, wrote: 'There's vice even in the colour he uses ... strong, male, spicy colour.'

Other commentary was even more positive: Eugène Georges remarked, 'You can't miss the unhesitating brushstroke. Everything in [the painting] is vigorous ... while his posters have an inexplicably captivating, gentle quality; they attract your attention without loud colour.' He added prophetically, 'the one exhibited here [*Moulin Rouge, La Goulue*] is a masterpiece of the genre and will take its place in the finest collections.'

The French critic Roger Marx, who was on the editorial staff of two magazines, *L'Image* and *Le Voltaire*, had also begun to notice Henry's work. He was particularly interested in prints, and after Henry exhibited in the Salon des Indépendants in the spring of 1892, he asked for permission to photograph one of Henry's La Goulue works for publication in a review. Henry was pleased, but a little wary. 'I authorize you to take all the photos you want. But no interpretative drawings like the ones in the magazine of unfortunate reputation.' Henry's illustrations had been clumsily 'adapted' without credit in a popular magazine some time before.

Subsequently, Henry would grow to count on Roger Marx's support, and later that spring he even asked him to mention his work in a review: 'We are only going to put the poster up on the first. I hope you'll spread the word and take it into account when you write a line about me as you so kindly promised.'

The poster may have been *Le Pendu* (The Hanged Man), which Henry had prepared for Arthur Huc's journal *La Dépêche de Toulouse*. On 27 April 1892 it began serializing a novel called *Les Drames de Toulouse* (The Dramas of Toulouse), which it was publicizing as 'a great, unpublished local novel'. Henry's poster, designed to be attached to the corner of a larger poster

containing the advertising text, was in black and white. His use of large grey areas created by spattering black ink on white paper produced a mono-chromatic effect which was probably intended to highlight the historical character of the serial, based on a true event, the Calas affair, made famous in the eighteenth century by Voltaire. In it, a father was tortured to death for not confessing to his son's murder – in fact, a suicide. The notoriety of the case was based on the anti-Protestant bias of the trial, which condemned the father by arguing that he had murdered his son to prevent him from con-verting to Catholicism. Henry apparently thought his poster was successful and he was so pleased with it that in 1895 he decided to print a small second edition of the lithograph for collectors. Like a number of his previous works, the grim subject and sombre tones of this poster seem to symbolize Henry's

Poster: Le Pendu, *1892.*

own deepening discomfort. That he chose to print a second edition of this particular work, where a father is convicted of his son's suicide, may have been more for its symbolic reflection of his relations with Alphonse than for its artistic merit.

Although he exhibited his characteristic symptoms of depression over models and the weather and compulsive description of minor health problems, 1892 was a year of enormous activity, artistic and otherwise, for Henry. A printed announcement had been superimposed on Henry's Moulin Rouge poster, announcing that the *cabaret artistique* now had masked balls on Wednesday and Saturday nights. On 19 March 1892, Jules Roques organized a transvestite ball at Le Moulin Rouge. Henry attended, notwithstanding his battles with Roques. He apparently borrowed a fur boa and feather-draped hat, along with a checked cape, all of which he wore for the occasion without, naturally, shaving off his full beard. The ball apparently was not a success: 'For the rare men invited were judged to be ugly and sad-looking in their costumes, and the women didn't have much fun. Lautrec had invited a friend to go with him, Bob the clown, whom he had costumed as "Bella Fathma",' the belly dancer.

This wasn't the first time *Le Courrier français* had held its notorious masked balls at Le Moulin Rouge. Late in 1891, Henry and his friends had all dressed up for the 'Mystic Ball', which Henry attended dressed as an altarboy. The other artists went as gods, saints, monks and nuns. There was also a chariot full of naked models representing 'angels', with which they paraded through the streets and, according to one observer, causing the nuns in the convent on the Boulevard de Clichy to cross themselves as they went by. In early 1892, after a ball where the guests wore paper costumes, the writer Edmond de Goncourt, commenting on the fad in his journal, wrote: 'Now painters get their thrills from costumes.'

As spring drew into summer, Henry received a commission from Bruant for a poster advertising his appearance, beginning on 4 June 1892, at Les Ambassadeurs, a *café concert* on the Champs Elysées. Located near the Hôtel Crillon, it attracted a clientele of foreign diplomats who wanted to see Montmartre's famous singers and dancers but felt uneasy about going to the *butte*. More and more now, the best entertainers in Montmartre were moving to the Champs Elysées. As the singers and dancers they liked moved on, so, to some extent, did Henry and his friends, even though it was a long ride.

Henry hadn't done any paintings or illustrations for Bruant for several years and was probably pleased to do a poster portrait of his friend for the first time. The commission led to a series of drawings and oil studies of

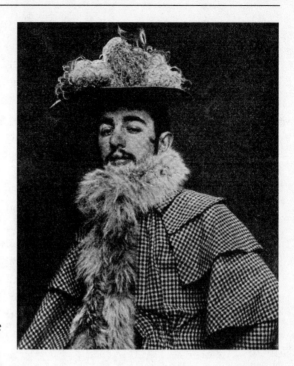

Henry dressed in a woman's hat and boa, 1892.

Bruant, resulting in at least six posters and lithographs over the next two years. As he had with La Goulue, Henry isolated the elements of Bruant's image that would be instantly recognizable and put them into this first Bruant poster, *Ambassadeurs, Aristide Bruant*. Its large areas of flat colour, *à la japonaise*, showed a tough-looking Bruant in his trademark wide-brimmed hat and red scarf, literally carrying a big stick, leaving the cabaret. In the background hovered the almost menacing silhouette of a man in a workman's cap.

The manager of the 'Ambass', Pierre Ducarre, who had committed himself to pay for the poster, felt it was far too brutal and coarse to appeal to the snobbish patrons of his café, but Bruant insisted, and the poster was finally used. One anecdote has it that Bruant said he would not perform unless the poster was displayed all over Paris and even on the stage. Ducarre submitted to Bruant's will but never paid Henry for either the drawings or his production costs. Two years later, in 1894, when Bruant was thinking of performing at the Eldorado, a *café concert* located at 4, Boulevard de Strasbourg, near the Châtelet, Henry did a poster which reversed his Ambassadeurs poster. Strategically, this was a brilliant move, as the Ambassadeurs poster was already well known to the public. The new poster, which was

identical to the first one with two exceptions – the name of the cabaret and the reversal of the image – functioned as a sort of sight-gag, a visual joke in which Henry seemed to say to the viewer, 'I almost fooled you, didn't I?' Unfortunately, like Ducarre, the directors of the Eldorado thought his poster ugly. Henry wrote to Bruant about it, saying, 'the directors of the Eldorado acted like swine and bargained with me on my price, which was below the printing rates at Chaix. So I worked personally for nothing. For their sake I'm sorry they took unfair advantage of our good relationship to deceive me. Let's hope that next time we'll be smarter.'

That February, *La Revue blanche* had published a glowing review of Henry's work exhibited at Boussod et Valadon. The first Paris issue of *La Revue blanche* had been published in the autumn of 1891 although Henry may not have known it at the time. This new magazine, which would become the champion of the avant-garde both in art and literature, had recently moved from Liège to Paris, where it was published by two brothers, Alexandre and Thadée Natanson, from an office near Pigalle in the rue des Martyrs, and Henry developed the habit of dropping by its offices to hang around with the artists and writers who worked for them.

There he made an acquaintance which led to his next poster commission. This person, who lived near him in Montmartre, was an ambiguous hanger-on, a Polish immigrant whose real name was Victor Joze Dobrski de Zastzebiec, and who wrote under the *nom de plume* of Victor Joze. Joze was both an intellectual and a hack writer, who made his living in part by writing a series of low-quality erotic novels which he called 'the Social Menagerie', giving the individual works titillating names like *La Cantharide* (Spanish Fly). He asked Pierre Bonnard, another *Revue blanche* regular, to illustrate and draw the cover for one of them, *Reine de joie, moeurs du demi-monde* (Queen of Joy, or, The World of Easy Virtue), which was to appear in serial form in the erotic magazine *Le Fin de siècle*, started by Edouard Dujardin, where Joze was also an editor. He commissioned Henry to make the poster advertising it. In April and May 1892, Henry prepared the poster for *Reine de joie*, using as models Georges Laserre and Luzarche d'Azay. Henry mentioned in a letter to his mother that it was to go up near the end of May, in time for the joint publication of the book and the serial. The poster image was also used for the title page of *Le Fin de siècle* on 4 June 1892, the day the serial began.

Henry had to leave on a trip to London before the poster was actually printed, which frustrated him. Shortly before he left, he wrote to Adèle: 'I'm

finally going to leave on Monday. I hadn't wanted to leave Paris before seeing my productions on the walls, but I've been robbed anyway because there's another delay, and since this time my departure can't be changed, I wasn't able to get the results I wanted.'

He was in London from 30 May to 10 June with another artist, Giuseppe Ricci. Camille Pissarro mentioned in a letter to his son Lucien that he was thinking of taking the same train to London as Lautrec, so it seems likely that the three artists were planning the trip together, although there is no evidence that they were participating in any sort of group show or salon in London at the time. Henry liked London very much, writing to his mother that he was '*breakfasting*' and visiting the National Gallery: 'I'm already in the grip of the spell arising from the *hustle and bustle* of London. Everybody

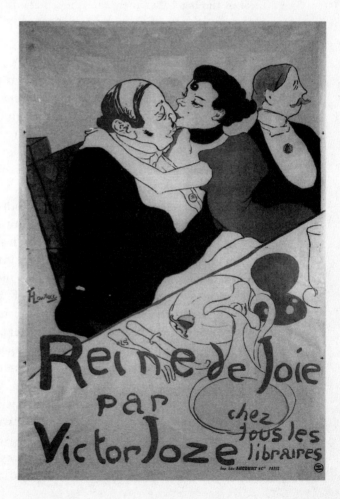

Poster: Reine de joie, *1893.*

wrapped up in his business and neither man nor beast letting out a superfluous cry or word. The hansom cabs here have an air that would put plenty of private carriages to shame.' Alph had written him a letter of introduction to the distinguished Sackville family, but as they were away, Henry didn't meet them. From his letters home, it sounds as if his trip was strictly tourism:

the things I've seen in the past week. Paintings, pictures, sculptures, tapestries, palaces, abbeys and even street scenes that are interesting because of the readiness with which people fight. I saw a sweeper, beet-red with indignation, knock an unfortunate old man down in the middle of the road ... because he had urinated into the corner of a doorway. I also had the tiresome experience of a Sunday in London. Everything is closed until six o'clock in the evening ... you can scarcely get a meal in the hotel. But there are compensations in the libraries where the artworks are available to artists, with an obligingness unknown in France.

By the time he got back, *Reine de joie* was in serious trouble. The novel concerned the relations between a lecherous old banker, a gross fool called Olizac, Baron de Rozenfeld, and a young *demi-mondaine*, Hélène Roland. Henry's poster shows her kissing him on the nose at a dinner party and symbolically implies the kind of relationship they had by paralleling the young woman's sensuous figure in the curves of a wine carafe on the table. The lip of the vessel in turn points to the Baron's coat of arms enamelled on a dinner plate.

A Parisian banker, the Baron Alphonse de Rothschild, thought the hero of the anti-Semitic book was intended as a caricature of himself and tried to have both the novel and the poster confiscated. In support of his attempt, a party of young stockbrokers went around Paris tearing Henry's poster off the walls and bribing the billstickers to give it to them instead of posting it. Rothschild created such scandal that the chief of the Parisian police investigated both Bonnard and Bidault, the publicity firm responsible for putting up the poster, and arrested two hapless billstickers. By the time Henry got back to Paris on 10 June, an anti-Semitic newspaper, *En Dehors* (Out!), had reported the story and had itself bought up the remaining prints of the poster. At the end of July, *Reine de joie* and *Ambassadeurs, Aristide Bruant* were both offered in the sale catalogue of Edmond Sagot, one of the first champions of the print as an art form, for 4 and 3 francs respectively.

Although Henry himself is not known to have been anti-Semitic, his decision to do a poster for a friend who wrote 'trash' is perfectly consistent with his tendency to accept any commission and to choose subjects in his

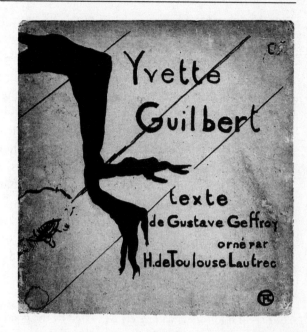

Henry's album-cover for
Yvette Guilbert

own work which verged on the scandalous. Although he has been credited with liking Nietzsche and Balzac and is known to have liked plays by Eugène Scribe and caricatures by Rodolphe Töpffer, Henry was not above reading racy novels written by people like Joze. In fact, like many French aristocrats, Henry was openly anti-intellectual. His literary tastes consisted largely of the wide-circulation daily and weekly newspapers, which focused on popular events and erotic fiction. Joze's magazine, *Le Fin de Siècle*, like the journals he illustrated, is a good example. It was devoted to erotic cartoons, gossip, political jokes, sexy anecdotes and discussions of fashionable events in Paris. In that sense Henry's illustrations for the popular press were quite sincere – he illustrated the things he read himself.

Henry later did two other works for Joze: a book poster for another of Joze's erotic *romans de gare* (novels that could be bought in train-station newsstands), an anti-German novel, *Babylone d'Allemagne* (Babylon in Germany), and the cover for *La Tribu d'Isidore, roman de moeurs juives* (The Tribe of Isidore, a Novel of Jewish Morals), yet another anti-Semitic product of the incorrigible Joze. Henry didn't seem to care. He was interested in images, not in morals. If anything, he was attracted to such works for their portrayals of decadence, vice and forbidden activity.

In Henry's work, images were often refined and repeated until their primary

value was as abstract shapes. One of his most characteristic abstractions was his repeated imagery of the black gloves worn 'up to her armpits' by the *café concert* performer Yvette Guilbert. She herself admitted that she had chosen the gloves as an identifying trademark, offsetting the innocence of a long pastel or white dress. Through Henry's posters, the gloves became so much her own image that even when portrayed alone, they represented her.

It may never be clear exactly when Henry first met Yvette Guilbert. She had begun her career as a *diseuse*, speaking rather than truly singing the suggestive, even bawdy verses of popular songs written by men such as Bruant, Xanrof, Jean Richepin and Maurice Donnay, beginning in 1887. She had appeared onstage at Le Divan Japonais and at Le Moulin Rouge in 1890, where Henry first saw her. She quickly gained a reputation as the best performer of her kind, and according to Gauzi, he and Henry went to see her at the 'Ambass' (Les Ambassadeurs) around 1892. Henry first mentioned her in a letter to his mother written during the winter of 1892–93:

Your natural kindness will surely be stirred by the good luck I've just had. M. Jules Courtaut, who was in Nice with us, spoke of my work to Yvette Guilbert, the *fin de siècle* singer, and yesterday in her dressing room she asked me to do a poster for her. It's the greatest success I could ever have dreamed of, for she has already been done by the most famous [artists] and this is going to be a really nice work. The family will not join in my excitement, but you are different.

Arthur Symons' description of Yvette Guilbert performing was very complete:

Tall, thin, a little angular, she walks to the front of the stage with a distracted air and the exquisite gaucherie of a young girl, her shoulders sagging, her arms hanging at her sides. She bends in two in an automatic curtsey in response to the thunderous applause, and her strange smile flutters across her lips and rises like a dancing flame to her eyes, brilliant blue and wide open with the expression of an astonished child. Her dark blonde hair rises in a supple mass above her wide, pure brow. She wears a yellow and pink-striped dress with a train but no other decoration. Her arms are covered with long black gloves. Suddenly the applause stops; silence reigns; she begins to sing ...

There is nothing conventional about her; even from afar she resembles no other French singer. Her voice, her face, her gestures, her mime, everything is different, everything is her very own. She's a being of contrasts, who suggests purity and perversity at the same time. She has the eyes of a child, of a pure, cloudless blue,

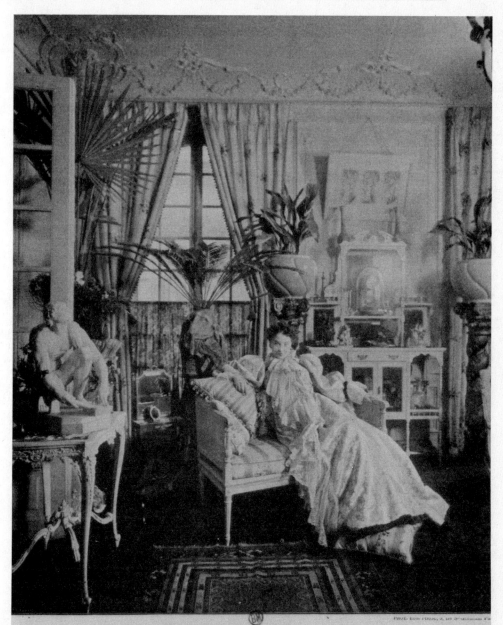

MADEMOISELLE YVETTE GUILBERT

Nicely minded she likes to be surrounded with artful works in order to take some rest when her songs are over. Sometimes she is tired, having sprinkled salt and peper to her authors. Fortunately she has an unexhausted stock. She made a compact with Devil, and, nevertheless, she can occasionally have many pure and soft repentance accents.

She really is a skilful artist.

Esprit délicat, elle aime à s'entourer d'œuvres d'art pour reposer de ses chansons. Elle est lasse, parfois, de fournir le sel et le poivre à ses auteurs. Par bonheur, sa provision est in puisable : elle a fait un pacte avec le diable, ce qui ne l'empêche pas, du reste, à l'occasion, d'avoir la note chaste, tendre et repenti

C'est véritablement une grande artiste.

Yvette Guilbert in her sitting room, c. 1895.

shining with malicious cleverness, closed in extreme lassitude, open in surprise which empties them of all expression.

Her ingenuousness is perfect, as perfect as that subtle, strange smile of understanding which ends her act.

Not pretty in any classical sense, the singer capitalized on her angular figure, her extreme flat-chestedness, and her long, graceful neck and arms to develop distinctive gestures which enchanted Henry: 'Her inborn purity and distinction, freeing her from any coquettish tendencies, allowed her to transfigure herself, to become a caricature, a "living, macabre poster".'

Their relations were not always simple, although, according to Gauzi, Henry pursued her endlessly. Yvette Guilbert only recalled meeting Henry in May or June 1893, while Gauzi dated the first time he and Henry went to see her at Les Ambassadeurs to May or June 1892. It is predictable that Henry would have sought any way he could to meet the star he admired onstage. Guilbert's account says it was one of her songwriters who brought Henry to her home:

He came to lunch at my house, brought by Maurice Donnay. My footman, after letting the two men in, rushed in to tell me, his face aghast, 'Mademoiselle, oh, Mademoiselle, M. Donnay is here with the strangest little thing!'

'What do you mean, the strangest little thing?'

'A little thing, you know, like a puppet.' I went to meet my visitors ... try to imagine a dark-haired head, enormous with a very red face and a black beard, oily, greasy skin, a nose big enough for two faces, and a mouth! A mouth like a slash across the face from cheek to cheek, with drooping purplish pink lips, thick and flattened like a hem around that frightful, obscene opening. I stood there, struck dumb. Finally I looked into Lautrec's eyes. They were beautiful – huge, wide, full of warmth. As I continued to look into his eyes Lautrec, aware of my gaze, snatched off his glasses. He knew his one redeeming feature and he offered it to me wholeheartedly ... Maurice Donnay said, 'I've brought Lautrec to have lunch with you, he'd like to sketch you ...' I am suddenly obsessed with how I'm going to get him seated at the table. To my stupefaction, he jumped onto his chair by hoisting himself up with his palms ... I'll never forget that lunch. The food was engulfed into his gaping mouth and every time he chewed you could see his wet, drooling lips working.

From this inauspicious beginning, the two artists would share a long history. Henry portrayed Guilbert for the first time in January 1893, in the background of his poster publicizing the reopening of the cabaret Le Divan

Japonais (Plate 24). Its new owner asked Henry to create a poster which would capitalize on its former reputation. Henry did this by putting Yvette Guilbert onstage. However, the truth was that Yvette Guilbert hadn't appeared at Le Divan Japonais since 1890 or 1891 and was not expected to perform there. Henry dealt with this discrepancy by creating a slightly misleading image: the woman onstage is cut off above the neck, so that her head is missing from the image. Only Yvette's trademark black gloves show in the poster. If Henry had been accused of misrepresentation, he could have answered that the singer was not supposed to be Guilbert, but another woman wearing black gloves.

Henry portrayed Guilbert repeatedly over the next few years, always as ugly and generally without her permission. Although she was said to have no appreciation of art in general, or of Henry's in particular, Guilbert was nonetheless aware of the power of his work and of the fact that he was influencing her reputation. She tended to take an affectionate, mocking tone when dealing with his sketches of her. The poster she commissioned in 1893 (Plate 42), however, was too unflattering and she refused to use it: 'for the love of heaven, don't make me so appallingly ugly! Just a little less so! So many people who saw it here have shrieked with horror at the sight of your coloured sketch . . . Not everyone will see the artistic merit of it . . . so please!' She finally used a poster designed by Steinlen. As late as the 1930s, Yvette Guilbert apparently told the actress Arletty, 'Lautrec, he's worthless!'

On another occasion when she was irritated at some of his drawings of her, she remarked, 'Really, Lautrec, you are a genius at deformity.' He replied cuttingly, 'Why, of course I am!' In her memoirs, Guilbert commented: 'I at once realized my clumsiness and felt myself blushing.' The two became quite fond of each other as the years passed, and Guilbert affectionately called Henry '*mon petit-monstre*'. Henry chose to mock her insults, as witnessed by an anecdote Guilbert tells:

One day he admired a large turquoise tile table of mine and I expressed the wish to have a tile from him to make a little tea table. He did not answer but later brought me a caricature of myself to sign. I wrote: '*Mais petit-monstre, vous avez fait une horreur!!* Yvette Guilbert.' [But little monster, you have made me horrible!!] Soon after this incident a tile made from that sketch with my criticism and my signature arrived.

Henry had taken the signed sketch to a potter, Emile Muller, who had a kiln at Ivry on the outskirts of Paris. It was copied onto a ceramic tile, from which

an edition of about ten tiles was reproduced. The design is similar to the rejected sketch for the 1893 poster and may be interpreted as a joke to tease Guilbert for her anger. His decision to place a comment so insulting to himself on a work which in reproduction was almost certain to be seen by people who were not in on the joke seems complex. In a way, this is another negative self-image, a joke on himself to ward off the unkind jokes of others.

Yvette Guilbert, unable to appreciate Henry's art, didn't realize that he was similar to her. Both of them worked with careful research into character which they then deformed into epic dimensions. It was only in her autobiography, *La Chanson de ma vie*, long after Henry's fame was widespread, that she showed any sense of what he was doing in his art. Then she quoted him as often having said to her: 'Ugliness, no matter where it is, always has a beautiful side; it's fascinating to uncover beauty where no one else can see it.'

Henry spent a great deal of time in 1892 on family matters. Just as he was leaving for England in May, he had learned that his aunt Cécile Pascal was about to go bankrupt and that her son, his cousin Louis, was deeply in debt. Over the next six months he wrote his mother at least twenty-two letters trying to help the Pascals arrange their affairs and went to see them at Respide at least once. He also helped his destitute Aunt Cécile move to Paris, and when the convent she had been lodged in proved to be unacceptable, persuaded his mother to pay for her to live in more comfortable surroundings. Adèle seems to have taken a moralizing attitude towards her cousins' predicament, having felt for years that they lived beyond their means. Henry begged her to be more charitable: 'you mustn't forget that we found at Respide what we had sought in vain elsewhere: a *home*.'

His sympathy for their plight may have been because he was feeling pinched for funds, as usual: 'I would like a clear answer as to how much I'll have available, being out of money, and I certainly have the right to know what to expect, since I've lived for two years on one year's income.' He mentioned that 20,000 francs would allow him to live 'a good part of next year'. Almost every letter requested money, if not for himself, for the Pascals. He even wanted his mother to lend him 500 francs in June, to be reimbursed on 1 July. On 17 August, Adèle apparently refused to increase his allowance, as he referred in a letter to her 'categoric answer'.

The entire family seems to have been under extreme stress: 'Did you know that Papa told me Uncle Charles has been decorated with the Order of Saint

Gregory the Great? And Albi is ecstatic ... Aunt Alix wrote to Papa too, probably to make the pill less bitter.' For Alphonse, whose anti-clericalism was notorious in the family, to be envious that his brother had received a medal from a religious order, there had to have been a backlog of envy for many years. The issue may have had to do with Charles having inherited the Albi townhouse, the Hôtel du Bosc, in which he lived, whereas Alph, having sold the Château du Bosc to Alix and Amédée, was without a functional estate: 'as for the way Papa talked to me about Le Bosc,' said Henry, who himself would have liked to have inherited the château, 'it was more or less hot air.' By 1894, Alph had moved into the tower of Charles' Hôtel du Bosc.

The complexities and tensions of the emotions in the family took a lot of energy but remained more or less unresolved. No doubt Henry was relieved to find refuge in the concrete demands of his art. That summer Roger Marx reproduced one of Henry's paintings in a magazine, and Henry asked him for six copies of the reproduction. He seemed more and more pleased with his printmaking experiments: 'My little jobs are a perfect success, and I've started down a path which I hope will take me far,' he wrote to Adèle. At the end of July, he had the honour of watching *le bon juge*, Georges Séré de Rivières, convict a group of men who had been producing counterfeits of his work: 'they got between two weeks and one month in prison.'

In August, Henry took a boat to Bordeaux for what by now was his annual break at Taussat-les-Bains, but this time he stayed with Louis Fabre at his Villa Bagatelle. Fabre and his wife were friends who lived near Henry in Paris, and with whom he would now stay repeatedly on holiday. On at least one of these occasions he painted portraits of Madame Fabre. Although he also stayed briefly at Malromé in 1892, he did not see Adèle there, for she was so uneasy about her relations with the Pascals that she was afraid even to go to Malromé for fear of having to see them. Henry ended up going to Malromé without her, accompanied by Fabre and an old friend, Paul Viaud de la Teste, who as time passed would come to play an important role in his life.

Back in Paris on 14 October, Henry wrote an excited letter to Roger Marx asking him to write a review of his first collector's edition of prints, which had been printed by the Imprimerie Ancourt for Boussod et Valadon and was finally for sale. Around the time of the Salon des Indépendants the preceding spring, Michel Manzi, already a collector of Henry's work and head of fine print editions at Boussod et Valadon, had taken the risk of commissioning Henry to design two large colour lithos of Le Moulin Rouge,

which were printed in the autumn in an edition of one hundred each after which the stones were ground down.

The two prints, *La Goulue et sa soeur* (La Goulue and her Sister), loosely related to *La Goulue entrant au Moulin Rouge*, and *L'Anglais au Moulin Rouge* (The Englishman at the Moulin Rouge) measured $18\frac{3}{4} \times 13\frac{1}{2}$ in. and $18\frac{1}{2} \times 14\frac{1}{2}$ in. respectively, unusually large dimensions for lithographs at the time. They sold for 20 francs apiece, compared to the bought-up poster stock from the scandalous *Reine de joie*, which had sold for 4 francs a poster.

The model for the Englishman was William Tom Warrener, a painter from an influential family, who had moved to Paris in the mid-1880s to study at the Académie Julian. He moved to Montmartre in the 1890s where he met Henry. After successfully showing in the Salon, he returned to England, exhibited at the Royal Academy and had moderate success. The scene shows him being flattered by two women who could possibly be La Goulue and La Môme Fromage. The working title of the piece was *Flirt*. These two lithos could be considered, along with *La Goulue entrant au Moulin Rouge*, as continuing Henry's favoured theme of the relations between men and women and, loosely implied, their economic undertones. In *L'Anglais au Moulin Rouge*, as in *Moulin Rouge, La Goulue*, although the figure of the man is imposing and in the foreground, his importance compared to the women is greatly diminished by the monochromatic treatment of the print, which makes him almost a silhouette while the brightly-coloured figures of the two women dominate.

There was an unusual aspect to Henry's printmaking which led to a series of striking works he might otherwise not have produced. The preparatory stages of his lithographs not only include sketches, studies and finished drawings, but in many cases a complete, highly detailed oil painting from which he took the shapes and outlines of the final lithograph. It is not known if this odd habit was his own idea or perhaps a suggestion from his dealer, Joyant, who perceived the oils as having greater commercial possibilities than the lithographs and didn't want Henry, now that he was obsessed with printmaking, to give up painting entirely.

Lautrec is the only artist known to have painted masterpieces as pre-paratory studies for graphic works. His oil paintings continued to be insight-ful studies which focused the viewer's attention on the interactions among the people in the work but his portrayal of the same scene in the final lithograph, no longer a psychological study of its subjects, was marked by increased abstraction and preoccupation with formal concerns, leaving the

viewer instead with a strong impression of shapes and colours. The striking dissimilarity between the lithos and the oil paintings led to Henry becoming known for work in apparently unrelated modes: for his sensitivity and psychological accuracy in oils, drawings and some lithographs and for his abstraction and daring formal invention in colour lithographs and posters.

Lithography became his permanent *furia*, and he built daily morning visits to Père Cotelle at Imprimerie Ancourt's printing works into his routine. Usually he had the prepared lithographic stones delivered to his studio, where he worked out his drawings on the stones and had them taken back to the printer. He then went to the shop to supervise the printing itself and to verify the coloured inks. Sometimes at the print shop he requested a stone on which he would draw right there, and he could be found in the shop, all alone during the lunch hour, working away on a stone which he was eager to have printed. He befriended the printers and endlessly discussed techniques and solutions with them, happily experimenting on his own stones. Like all things he loved, the printing press and Père Cotelle soon turned up in a lithograph themselves.

He quickly developed a personal approach to colour printing which revolutionized the impact of the publicity poster and marked a significant transition in his own work. From his rapidly, often loosely brushed painting style, which until then had been marked by the kinds of nuance which came out of the Impressionist and Divisionist traditions, with his first Bruant poster he had moved abruptly to powerful flat-surface colours – colours that made no attempt to shade or dimensionalize the figure. Instead they rendered it abstract – a mere shape on the page – but, like Yvette Guilbert's gloves, a shape so compelling that it took on an identity of its own.

In the autumn of 1892, Henry continued his connection with Le Barc de Boutteville, exhibiting in the gallery's permanent show of Impressionist and Symbolist painters. He also exhibited again in Antwerp, showing his poster *Reine de joie* in a series of states, including the final one. Now he considered his lithographs, even in preparatory states, to be fully as worthy of exhibition as his oils and didn't hesitate to exhibit as art a poster that had been the subject of scandal and removed from the walls.

In October he wrote to his mother with an anecdote he had heard about his Uncle Odon's and Aunt Odette's disdain for his painting: 'My Aunt Odette is supposed to have said "My nephew gave me a painting. I quickly stored it in the attic." So there's no reason for this interesting branch of the family to have a portrait done by me, when my outpourings are surely already destined for the latrine.' The painting, *Danseuse assise sur un divan rose*

(Dancer Sitting on a Pink Sofa), was later found to have written on the back: 'This canvas was given me by my nephew. [signed] Count Odon de Toulouse-Lautrec.'

His work was changing again, directly influenced by Art Nouveau. He agreed with its philosophy which recognized all the arts, not just painting, as valid forms of expression for an artist. Not only had he launched himself as a print and poster artist, but within a few months he would explore even farther, doing designs for a bookbinder and another for a Tiffany stained-glass window. The loose, 'noodle' formations so characteristic of Art Nouveau were beginning to appear in his work. In November 1892, his preparatory watercolour for the stained-glass window, *Au Nouveau Cirque, Papa Chrysanthème* (At the New Circus, Papa Chrysanthemum, Plate 22), outlined the two females in a Japanist serpentine manner which referred to the Japanese subject of the spectacle it represented. The fashionable Nouveau Cirque near the Place Vendôme was far from his usual hangouts, but close to the Champs Elysées. There, in November, the Japanese-influenced 'ballet' *Papa Chrysanthème* was attracting throngs of people, and Henry did a number of works featuring not only the glowing, electrically illuminated spectacle, but also members of the audience. In this watercolour sketch, he shows Jane Avril, elegantly costumed, sitting in the audience watching a female dancer doing one of her own characteristic dance movements, leaning so far back-wards that her hair brushed the floor. Jane Avril, who had first attracted Henry in her professional role as a dancer, was now appearing repeatedly in his work offstage, often as an observer herself. Frequently her face is invisible, although she is easily recognizable by her characteristic hairstyle or hats. Degas before him had used spectators seen from behind as the foreground for views into ballet scenes and had also explored the use in general of figures whose faces are eclipsed – seen from the back or with their faces fragmented by the frame, as Henry had done with Yvette Guilbert in the Divan Japonais poster.

The innovative uses of electric lighting for theatrical productions inter-ested Henry. *Papa Chrysanthème* had used lighting with great success to create the illusion of a lily pond in the circus ring, illuminating the dia-phanous gowns of the nymphs swirling in the 'water'.

At exactly the same time, the American performer and avowed lesbian Loïe Fuller began appearing at Les Folies Bergère, where she was paid 8,600 francs a month for an act that consisted, very precisely, of walking and turning on the stage, waving huge swathes of silk mounted on long poles which she held in each hand. Not truly a dancer, and decidedly overweight,

Loïe Fuller nonetheless was perfectly in tune with what was most modern in both technology and art. Below her, electric lights in changing colours, shining through a glass floor, gave a spectacular, luminous effect to the graceful arcs and loops made by the cloth, which echoed the fluid lines of the budding Art Nouveau movement. Her influence on the time was so great that at the Paris Exposition Universelle of 1900 she was allowed to perform in a specially constructed theatre designed by a sculptor and an architect to imitate the flowing movement of her robes, and some art historians use her act to date the real beginning of Art Nouveau in France.

Henry was not the only artist of the time to hasten to create art works based on her performance. Images of her appeared everywhere, by Chéret, Steinlen, Anquetin and others. In December 1892, Henry completed his own view of what he called her 'Samothracic' quality, referring to the armless, winged *Victory of Samothrace* in the Louvre. Although Loïe Fuller had refused Henry's offer to do a poster for her, he had been commissioned to do a print by the publisher André Marty, who hoped that in addition to the poster and illustration market, there was a collector's market for Henry's lithographs. He commissioned a number of important works from Henry over the next few years, and in this first commission, Henry went to a great deal of effort to achieve unexpected effects.

In an attempt to catch the iridescent play of light on Loïe Fuller's costume, Henry used five stones, the fourth inked with a rainbow of colours and the fifth hand-sprinkled for each print with silver or gold dust. As a result each print was different from the others. He put his edition of fifty small, abstracted *Loïe Fuller* lithographic portraits into individual paper mats, each stencilled with an Art Nouveau border. They have become among his most precious works.

Henry's high energy continued. Frenetically he extended himself in all sorts of directions at once, using his evenings with friends at the cabarets and bordellos as the images for his remarkable artistic productivity. In January 1893, he was working on a number of projects. He was painting a portrait of his friend and fellow printmaker, Henri-Gabriel Ibels, which was published in *La Plume* on 15 January, and his poster *Divan Japonais* was being printed. The poster, showing Jane Avril and Edouard Dujardin watching a headless 'Yvette Guilbert' perform, went up on 20 January. In addition, he was shipping works to Brussels for the annual XX show and working on his poster *Confetti* for the English paper company Bella Brothers, which was delivered in early February. Somehow he still had time to go to a banquet in

honour of Roger Marx, now one of the most influential art critics in Paris, given by Les Artistes du Décor.

However, Henry also had several setbacks around this time, and it is possible that his intense artistic activity was fuelled by anxiety. In January, he discovered that his submission to the 1893 Cercle Volney show, one of his portraits of women in Père Forest's garden, had been rejected. Outraged, he wrote to Roger Marx: 'I was not aware that as we pay part of the rent, they had or they gave themselves the right to throw artists out. So I sent in my resignation. If you could make all this known at some point, it would be my finest revenge.'

That Henry should react to the Volney rejection with rage seemed excessive given the low opinion held by serious artists, including himself, of the Volney exhibitions. Charles Angrand, a painter whom Henry had met as a *rapin* at Cormon's, reflected that opinion in a letter in February 1893: 'Also at the Goupil were some recent paintings by Toulouse-Lautrec: I don't mean the Cercle Volney and Mirliton ones. I don't mix in those fashionable circles where oil paintings are displayed between two servings of afternoon tea.'

It is not known exactly which painting the Volney rejected nor for what reason. Was it *de facto* censorship of a work considered to be immoral in subject matter or scandalously innovative in style? Since many of Henry's models in Père Forest's garden were streetwalkers who looked distinctly out of place in the pastoral setting, Henry may intentionally have offended the Volney judging committee's sensibilities. It took no psychic powers to predict that Henry and the conservative Cercle Volney would in time part ways, but it is surprising that Henry did not realize that he had initiated the break himself. The act seems like one more example of his tendency to create situations in which he was rejected, and Henry's rage is similar to his anger at being rejected by the Salon when he submitted an intentional parody of an academic painting.

This bitterness at rejection by an art establishment he didn't entirely respect is perhaps best explained by his ambivalence about his responsibility as a Toulouse-Lautrec. He had never had a painting accepted by the Salon, but so long as he showed at the Volney he could provide concrete proof of artistic recognition according to a measure his family recognized. By extension, rejection by the Volney was tantamount to rejection by the family and society he had come from, forcing him against his will to choose between his two worlds.

There may have been both positive and negative unconscious forces

behind his provoking such a choice. In a negative sense, Henry's rejected painting was symbolic of the personal rejections he had experienced from his own world since adolescence. When the painting was rejected, it served as renewed proof that in such circles his art was as embarrassing as his physical presence. By provoking the humiliation he feared, he could ease the anxiety of waiting for it to come. But inevitably it came, in part because he provoked it.

Henry may also unconsciously have provoked the art world his parents admired, out of an ambivalence about being a successful artist. Success, though desired, brought guilt at the separation it created between him and his family, particularly at the growing distance between him and his mother. If he had failed in his family's world, then he could hardly be blamed for moving on to the world of avant-garde art. That world, for its part, greeted his rejection with enthusiasm. Apparently the gallery-owner Le Barc de Boutteville even offered to hang the offending work in his gallery with the notation 'refused by the Cercle Volney'.

Henry seemed caught in an increasingly feverish, even dizzying existence, one which his friends observed with misgivings, convinced that he would do himself harm. Bourges, for example, believed that syphilis as an illness produces great fatigue and that those suffering from it need far more sleep than healthy people. But Henry was producing works without interruption, showing right and left, staying up late every night, meeting new people as well as his old friends. Sometimes the influences did not seem beneficial. He had become increasingly close to the printmaker Charles Maurin, whose aquatint portrait of Henry would appear in the first issue of *L'Estampe originale* (The Original Print), 31 March 1893. Henry shortly returned the honour by caricaturing his friend.

A tall, massive man with a large head and a blond beard, Maurin was an alcoholic like Henry. Often he could be found stretched dull-eyed on the couch in Henry's studio. Under Maurin's deceptively quiet, slow-moving, slow-talking exterior was the sharp verbal style and political intensity of a proponent of violent anarchy. A group of anarchists had received substantial publicity in Paris in the wake of a series of random bombings which had begun in 1891. Maurin and Henry's other anarchist friend, Félix Fénéon, may have tried to interest the impenetrably apolitical Henry in their views, but it is unlikely that they had much success. As with the anti-Semitic Victor Joze and others who had strong political convictions, Henry remained friendly and non-committal. He just didn't care.

Maurin also had quasi-religious convictions about art and tended to get

into ferocious arguments in which he defended his ideas absolutely. Again, Henry reacted without interest. He liked the fact that Maurin was almost as eccentric as he, and that he liked to have a few drinks, and to go to the zoo with him. Henry was delighted, for example, one day when he and Maurin were talking with the Nabi painters Edouard Vuillard and Félix Vallotton, to hear Maurin, in no particular context, launch into a detailed description of the love life of monkeys they had observed in the zoo, apparently greatly embarrassing the younger painters. Although Maurin did not get on well with most people, his cynical approach amused Henry. He was also pleased by Maurin's meticulous accounts of experiments he conducted on his own person and of his conclusions about the aetiology of hunger, taste and odours. As time passed, the two men had more and more drinks together, more and more often.

Now Henry was organizing his first one-man show, a retrospective of paintings, pastels and prints, scheduled to open at Boussod et Valadon on 30 January 1893. Henry had been thinking about and preparing for this show for nearly two years, ever since his friend Maurice Joyant had become head of the gallery, but late in the planning, for unclear reasons, Maurin was invited to share the exhibition space. The two artists' work had little in common, although Henry appreciated Maurin's technical skill and the men had been friends for a number of years. The show had mixed results for Henry's reputation.

Edgar Degas attended the opening with a friend, Henry Laurent, who was buying art for investment purposes. Degas, who surely knew the reverence Henry felt for him, was overheard by several sources telling his guest such things as 'Buy Maurins! Lautrec has a great deal of talent, but he merely paints period pieces; he will be the Gavarni of his time. As far as I'm concerned there are only two painters that count, Ingres and Maurin,' and 'Buy Maurin, there's a man who knows how to draw hands.' Henry no doubt was told of the latter comment, for years later, he was heard saying sardonically: 'Maurin ... now there's a man who knows how to do hands!' Later, leaving the opening, Degas gave Henry a backhanded compliment, saying, 'Vous êtes du bâtiment,' a remark that could be interpreted to mean 'You're one of the gang', but which also contained a sly reference to house-painting (peintre en bâtiment). Later that year, in a letter to the Belgian artist Octave Maus, Henry commented: 'as regards Degas, he's quite unapproachable'. After his opening, Henry did not mention Degas, but proudly wrote to André Marty that a cabinet minister was among the guests.

Public opinion of the thirty works Henry exhibited in the show was largely

positive. He noticed, writing to his mother in early February, that a friend of Alph's was able to look at his work 'without seeming terrified', although he added, 'my painting is still selling, and I'm still not being paid.' He was pleased when the exhibition was kept open a week longer than planned and undoubtedly devoured the reviews with the same hunger he always showed for recognition. Although *L'Eclair* (The Flash) said that Maurin for some years had been the better-known of the two painters, its review complimented Henry's use of colour, his dry humour and his pictorial flair. A lively but accusatory review by critic Thiébault Sisson in *Le Temps* addressed Henry directly, saying he was 'hard on our kind, and cynical ... you make [your models] look so awful! ... you find them ... anywhere that animal instincts hold sway, writhing and acting up ... The world [you paint] isn't comforting, or moral. You paint it with disconcerting mastery, exactly the way it is, even more repulsive than it is ... stripping its sores bare. Pretty daring stuff, my friend.'

One of the strongest reviews was by Gustave Geffroy. Writing in Georges Clemenceau's left-leaning journal *La Justice* on 15 February 1893, Geffroy referred to the 'irresistible power' of Henry's posters in the street and the unexpected spontaneity of the poses in his paintings:

Toulouse-Lautrec has been banished, called disgusting for the baseness and horror revealed by the scenes and subjects he holds dear. This baseness and horror cannot be denied, and are no more to be forbidden than the pity, melancholy or bitterness that others, seeing things in their own ways, might extract from the same shameful scenes. Lautrec lends himself easily to cruel mockery, as he makes us visit dance halls, bordellos and unnatural couplings. But he retains his integrity as an artist; his power of observation and his refusal to see his subjects as pitiful support the beauty of life. The defiant philosophy of vice he sometimes ostentatiously displays, given the strength of his drawing and the seriousness of his diagnosis, has the effect of a clinical demonstration, a lesson in morals.

Henry had personally asked Roger Marx to review the show, and he was not disappointed. In a thoughtful review in *Le Rapide*, published two weeks after the show opened, Roger Marx commented in detail on Henry's work, singling out his 'penetrating analysis and accuracy of expression, his cruel, implacable powers of observation'. He pointed out that his art was in the tradition of the Naturalist writers who wanted 'the exterior physiognomy, or mask, to be the image of a person's interior temperament, or self'. Although Roger Marx acknowledged that 'at the beginning of his career, his

brushwork and drawing were reminiscent of Forain and Degas', he defended Henry's individuality:

The work is singularly revealing of the behaviour patterns of our time, taking snapshots of humanity in mid-gesture, with a specific posture, point of view and self-image, both interior and exterior. It is not just the scenes from the Moulin-Rouge that we are thinking about, despite their exacerbated truth and fierce humour, but also the studies, the portraits, especially the one of the red-headed man with his unmistakable individualism [possibly *Vincent Van Gogh* (Plate 6) or *Louis Pascal* (Plate 19)], and the posters, the lithographs, the whole of this artistic production, doubly valuable for its psychological as well as its plastic interest.

Thadée Natanson, editor as well as publisher and financier of *La Revue blanche*, wrote an excited review for the February 1893 issue. This article may have been the beginning of the close friendship he and Henry developed over the next year. He lauded Henry's posters as surprising, disturbing and delightful. He was particularly enthusiastic about 'the delicious *Reine de joie*, bright, pretty, and exquisitely perverse ... [provoking] troubling memories, the exquisite emotion of art, that the disquieting intentions of M. Toulouse-Lautrec have made almost painful'.

Félix Fénéon, now arts editor of an anarchist journal called *Le Père peinard* (The Sly Old Slacker), loved the anarchistic and anti-social elements in Henry's work. He reviewed Henry's posters in enthusiastic street-slang:

Lautrec's a guy with a hell of a nerve and lots of guts; his drawing and his colours don't beat around the bush. Big, simple patches of white, black, and red – that's his scam. Nobody can match him at snagging the snoots of capitalist pigs chowing down with loose chicks who lick them on the snout to make them pay out. *La Goulue*, *Reine de joie*, *Le Divan Japonais* and two of a barkeep named Bruant, that's all Lautrec has turned out in the way of posters, but they're daring, determined and tough, and those idiots who want everything in spun sugar really get left with jam on their faces.

Henry's posters were on walls all over Paris, so pervasive that *La Vie parisienne* complained, 'Who will deliver us from the likeness of Aristide Bruant? ... You can't go anywhere without finding yourself face to face with him.' Bruant, of course, adored the publicity, and on 9 June Steinlen's title page drawings for Bruant's magazine *Le Mirliton* showed a man looking at Henry's poster of Bruant.

The critic and printer André Marty, who the year before had commissioned

Henry's Loïe Fuller lithograph and who was considered to be one of the major promoters of the print movement, wrote in the February 1893 issue of *La Vie artistique* that Henry had earned a 'medal of mastery' for the 'faithful rendering' and 'philosophical cruelty' of his *caf' conc'* paintings, saying that Henry was 'always inimitable, everything should be cited and seen' and that he deserved a 'place of honour in the golden book of the modern print'. On 31 March 1893, Marty accorded Henry exactly that place, using him as the artist for the cover of the first issue of *L'Estampe originale*, his magazine devoted exclusively to the art of the print, and focusing on provocative art by unconventional artists such as the Nabis, Odilon Redon, Paul Gauguin and the American James Whistler. Roger Marx had been invited to write the text. Marty insisted on high-quality reproductions for the magazine, which was left unbound as a portfolio, so that individual works could be framed separately; he had arranged for it to be printed by the foremost lithographic printer in Paris, Henry's print shop, Imprimerie Ancourt.

Lithograph: the cover for L'Estampe originale, *1893.*

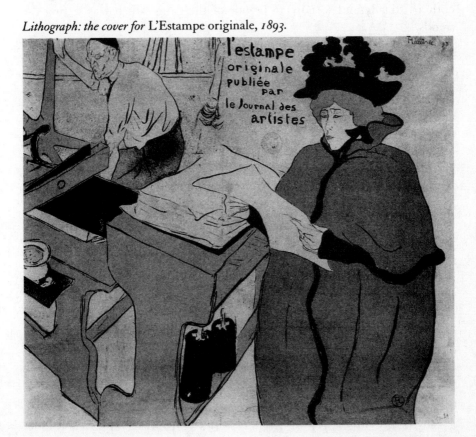

Henry, aware that this magazine represented the avant-garde of 'all the Young Artists', was proud to be chosen to do the cover and apparently consulted with Roger Marx on its design. It depicted Henry's printer at Imprimerie Ancourt, Père Cotelle, working at a press, while Jane Avril, dressed in street clothes, looked at a printed proof. The lithograph is a double homage to his models – to Henry's frequent collaboration with Père Cotelle, who died shortly after, and to Jane Avril's intellectual and artistic sensibilities which, although they set her apart from most of the dancers on the nightclub circuit, symbolized the *modern style* philosophy of giving equal status to the popular arts along with the classic modes of painting and sculpture.

Henry's commitment to developing the art of the print was the opposite of the snobbery with which many academic and even Impressionist artists of his time greeted the growing technology of art reproduction. It was a reflection of his resolute desire to be modern – to place himself in the front line, both artistically and socially, to be one of the gang which was setting the trends.

Marty's magazine published prints by many of the major young artists including Henry's friends: Louis Anquetin, Pierre Bonnard, Eugène Carrière, Henri-Gabriel Ibels, Charles Maurin, Félix Vallotton and Edouard Vuillard. Consistent with his interest in what the French called '*modern style*' and the English called Art Nouveau (thus allowing each country to attribute the scandalous phenomenon to the decadent influence of foreigners), Marty was engaged in a wide spectrum of artistic endeavour. Quality materials and beautiful workmanship in all things, both practical and decorative, were an integral part of the *modern style* movement, and Marty was also an interior decorator.

Printmaking was suddenly all the rage, and artists who had been primarily painters were eager to learn about it. Camille Pissarro, for example, now in his sixties, had bought a small press. He mentioned in March 1893 that he had met Henry, who in turn had introduced him to Marty, and he seemed pleased that Marty had asked him to do a print for the second issue of *L'Estampe originale*. Henry, of course, was already deeply involved. Although he had shown only one print in the Salon des Indépendants in the spring of 1893, while the show was on his poster of Jane Avril at Le Jardin de Paris, a posh nightclub near the Champs Elysées, appeared on walls all over Paris, and in June, his poster of Aristide Bruant in his cabaret also went up.

Jane Avril, unlike his other cabaret-singer subjects, was quite aware that

she was to some extent a product of Henry's publicity. In the spring of 1893, she had commissioned him to do a publicity poster for her, not for any particular performance, but a general one that might be sold to fans. The first edition of what was to become one of Henry's most famous posters, *Jane Avril*, was only twenty impressions, each signed by Henry, printed for the singer herself in early May 1893. However, later that month, when she opened at Le Jardin de Paris to large crowds, the club itself quickly ordered two more editions of Henry's poster. Henry wrote on Saturday, 3 June, to Roger Marx and André Marty, announcing that the poster was up on the walls of Paris in the hopes that they would talk about it in their reviews. As usual, he was paying careful attention to the production and promotion of his art.

This poster, one of his most successful, was full of references that an informed public would find amusing. Jane Avril's pose, kicking her leg high in the air, is identical to the one in a publicity photo, but the contrast between the immobility of her photographed pose and the energy conveyed in Henry's drawing is so strong as to suggest that the photo was made to copy the poster, rather than vice versa. In the poster, Jane Avril's high-kicking leg seems to take on a life of its own, forming a striking abstract shape that even now remains a symbol of her dancing.

In this poster, as in *Moulin Rouge, La Goulue*, Henry used stylistic devices culled from Japanese prints, particularly in the skewed perspective and the flat areas of colour which delineate the dancer's skirt and abstracted leg. He framed the poster with a reference to Art Nouveau in the fanciful, serpentine extension of the neck of a bass viol. This instrument and the musician playing it take up the foreground of the poster in mimicry of Degas' frequent use of the same perspective, and, of course, like the repeated lines of the diagonal stage, they copy Henry's first Jane Avril poster, *Divan Japonais* (Plate 24), where she is in the audience, not onstage. As in *Divan Japonais*, Henry included intentionally comic touches, sketching hairs onto the knuckles of the bass-player's hand and giving him a lunatic hairdo which from some angles looks like a monster or a mad dog.

To his surprise, in late June Henry received a request from his old enemy, Roques, asking permission to reproduce the Jane Avril poster in *Le Courrier français*. Henry had already given reproduction rights to another magazine, *L'Art français*, and wrote to Firmin Javel, its editor, to confirm that Javel had first rights, and to suggest that the two magazines publish the poster on the same day 'so as not to deflower the thing'. 'This letter gives you full rights,' Henry repeated, ever wary of another misdeed by Roques, 'so if the *Courrier*

pulls a fast one on you, we – you, Kleinmann and I – will be able to rap the
director on the knuckles.' Henry was apparently right to expect the worst,
for *Le Courrier français* managed to get its reproduction out on 2 July, three
weeks before *L'Art français*. It is not known if Henry and Javel tried to get
even with Roques. Probably not, since *Le Courrier français* published another
lithograph by Henry the next week. For Henry, even questionable repro-
duction had its advantages, since it resulted in increased visibility for his
work. At the end of the summer, *Le Fin de siècle* reviewed the Jane Avril
poster, complimenting his use of colour.

It was not long before Henry's posters became so well known that some
people went around Paris the nights they were hung, peeling them off the
walls while they were still wet, for their private collections. Increasingly, the

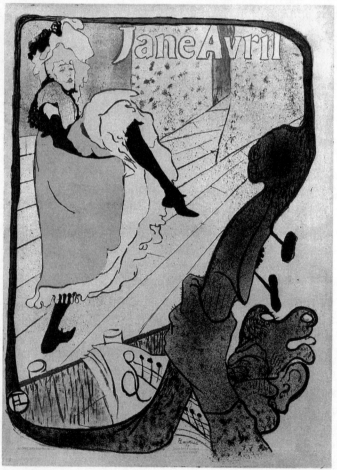

Poster: Jane Avril,
1893.

Publicity photograph of Jane Avril, dancing, c. 1893.

poster was his preferred art form. '*L'affiche y a qu' ça!*' (The poster that's all there is!), he is said to have declared to his cousin Gabriel. There are indications that Henry's reasons for preferring to make posters have strong roots in the poster's symbolic meaning for him. One of Henry's most consistent behaviour patterns since childhood had always been to *s'afficher*, to show off, a habit he copied from his father. This word, which means to attract public notice or notoriety, comes directly from the word *affiche*, or poster. By devoting himself to posters, Henry was continuing, in a most literal sense, to show off, to be as flamboyant as his father, to go public with his sometimes scandalous art and at the same time to rebel against his family's attempts to hide his ungainly physique or to muffle his unaristocratic behaviour to protect the family name. Not content to have this name posted on all the walls of Paris (albeit illegibly), he had also intentionally made his physical presence into a recognized persona (role or mask). When he went out now, he often wore unconventional, attention-getting clothing like the beige and black checked trousers that can be seen in a number of photographs (see illustrations on pp. 226 and 285). Contemporary accounts show that many people in Montmartre recognized 'Monsieur Toulouse' when they saw him

sketching in the bars and *bals*. This self-advertising was in part a conspicuous defence, an extension of his policy of joking about his handicap. But it also showed his modernity, his awareness of the growing power of publicity – even negative publicity. There was also a sexual element to Henry's need to display himself, like a peacock spreading its tail. Although his forms of display, including his art, were risky and made him vulnerable to both physical and verbal attack, he also used them to seduce, to conquer his prey, luring women he admired close to him as models or because he was famous.

Between January and June 1893, Henry showed in eight different exhibitions. Not only was he in the tenth (and last) exhibition of Les XX, but also in the ninth Paris Salon des Indépendants which opened on 17 March, in a show at the Musée Communal d'Ixelles, Belgium, which opened at the same time, and in the second Salon de l'Association pour l'Art in Antwerp, Belgium, where he showed with other artists from Les XX a short time later. He was also in an outdoor show in Bordeaux, as well as in Le Barc de Boutteville's and in Durand-Ruel's ongoing exhibitions. In almost every show, he exhibited paintings, drawings, lithographs and posters, making the point that for him all were of equal status and value.

That spring, Henry's friend Dodo Albert, who was secretary of the Société des Peintres-Graveurs Français, was able to invite him to contribute to its fifth exhibition, held at the Durand-Ruel gallery. This was a distinguished invitation, as his entry had to be approved by its members who included artists much better known than he, such as Redon, Chéret, Bracquemond, Helleu and Lunois. Henry showed eight lithographs with their drawings and intermediate states, to favourable reviews in *La Chronique des arts*. This decision to show the preparatory stages alongside the final work marked his interest in showing his process to the public. Whether or not he meant it to be educational, his revelation of the usually hidden preparatory stages of all his work was a way of training his audience. The viewer was attracted to the chance to peek behind the opacity of a finished work of art to see how it came into being, what ideas the artist had developed and rejected while making his final decisions. Just as Henry revealed the personalities behind his models' faces or the grey underpinnings of the bordello, he liked revealing the secrets behind his own art. Even his paintings, now almost always done with thin washes of *peinture à l'essence* (oil paint thinned with turpentine), left open for examination *all* the preliminary steps leading to the final result. Instead of being hidden, the oil sketching and *pentimenti* just under the surface of the finished work were still clearly visible, and the layers of colour,

and bare patches of unpainted cardboard or canvas showed the viewer the early stages of the work. This must have seemed shocking alongside the glossy, perfectly finished portraits of his former teacher, Léon Bonnat.

Frenetic as was his spring, preparing prints and shows, Henry still had time to notice the work of other artists and to try to support those he felt deserved it. Just before the opening of the Salon des Indépendants, he wrote to André Marty to invite him to the preview and to rave about Félix Vallotton's painting, *La Valse* (The Waltz). 'Vallotton has one painting that's splendid. The other [*Le Bain au soir d'été* – Bathing on a Summer Evening] will probably be taken down by the police. Well, you will see.' The latter painting was a large work representing at least twenty-three females in various stages of undress. It was shocking because their bodies were shown realistically, young, old, fat, thin, distorted by pregnancy or by childbirth, and it did provoke a scandal at the Salon des Indépendants, which must have pleased Henry, himself no stranger to official censure. Henry could be generous about others' talents. In a letter, he asked Roger Marx not to forget to review the painting *La Mariée piémontaise* (The Piedmont Bride) by Henry's fellow student from Bonnat's, Giuseppe Ricci, 'victim of the Salon's corridors'. Henry's use of influence was not indiscriminate, however. Very sensitive to good work, he also knew how to avoid artists he didn't think were worth his time: 'I was visited by M. de Mathan, who brought with him his son, a painter, whom he introduced to me. As usual, I did not assume any responsibility whatsoever,' he commented dryly to his mother in December 1893. Raoul de Mathan, a native of Albi, specialized in landscapes.

Henry's reviews from the Salon des Indépendants were glowing:

M. de Toulouse-Lautrec evolves here towards a serenity and decorative clarity which he had seemed to disdain as a matter of principle. Around the face of a woman which reflects the fatigue of excess and long, hard nights, he sketches imprecise images of branches and sunlit leaves, singing happiness along the path of this shopworn beauty, like celestial voices around a coffin. I don't believe the eminent artist has ever attained greater mastery.

The critic, who may have been describing the painting rejected by the Volney a few months earlier, had been struck, as many observers were, by Henry's wicked accuracy at psychological analysis, his uncanny ability to show the jadedness just under the surface of a woman's face and to create an ironic contrast between that moral and physical exhaustion and her self-image.

Whimsically, Henry had included as one of his submissions to the Salon des Indépendants a lithographed menu he had designed for the Indépendants' banquet to be held on 23 June 1893. He had chosen as his model for the menu Dodo Albert's fiancée, Renée Vert, who had posed for him as early as 1888. In this rather small litho, he showed her in her hat shop. One reviewer commented particularly on the one-colour print as an example of Henry's 'strikingly felt impressions', calling the model a 'svelte grisette'.

Like the laundress, the milliner was a subject of story, portraiture and fantasy for many nineteenth-century men. Such women, struggling for economic independence in the few legitimate professions available to them, were viewed with the same fascination as prostitutes. They were considered morally suspect if only because they worked instead of staying home to raise children and because they could be seen walking in the streets to make deliveries. It was common for them to be propositioned by the husbands of the women they worked for and it is not surprising that the critic of Henry's lithograph should equate a milliner with a grisette. This was the word used for a young working-class girl who shared her tiny salary with her student, artist or poet lover in exchange for the status of being the mistress of a bohemian or an intellectual. As in *La Bohème*, she often found herself abandoned once he could earn his own living.

Renée Vert may have had a parallel history, except that she ended up marrying her artist and having a family. A thin, dynamic red-head whom Henry had met in a ladies' hat shop in 1888 – possibly when he was choosing hats for Suzanne Valadon – Renée had fallen in love with Henry's old friend Dodo, whom she finally married in September 1893, asking Henry to give her away. Henry used her as a model for several years between 1888 and 1893. Although we do not know whether Henry was infatuated with her, as he was with many of his red-headed models, it seems this was not the first time that one of his friends courted and won a woman he had discovered.

Paul Leclercq commented that it sometimes seemed as if Henry, knowing that he himself would not succeed in conquering the women he desired, offered them up to his friends, perhaps with some vicarious pleasure. 'The feeling he experienced for his women friends was a curious mixture of jovial comradeship and restrained desire. And as he was fully conscious of his physical inferiority, and, like Cyrano, did not suffer from petty jealousy; when he appreciated a woman to whom he refused to show it, his greatest joy was for her also to be appreciated – but more fully – by a friend.'

*

1. *Etude de nu* (Study of a Nude), 1882.

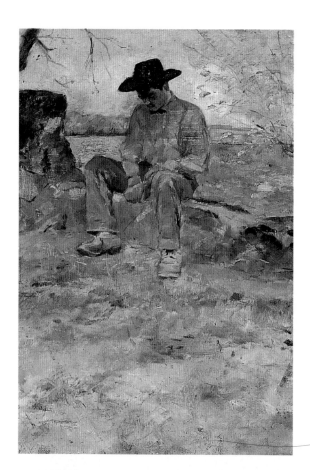

2. *Le Jeune Routy* (Young Routy at Céleyran), 1883.

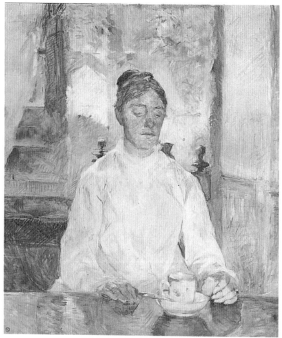

3. *Comtesse Alphonse de Toulouse-Lautrec*, 1883.

4. Poster: *Aristide Bruant dans son cabaret*, 1892.

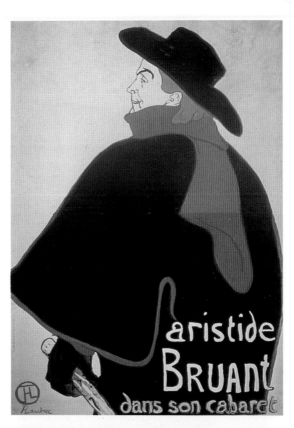

5. *La Goulue entrant au Moulin Rouge*, 1892.

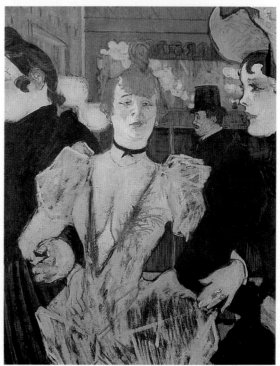

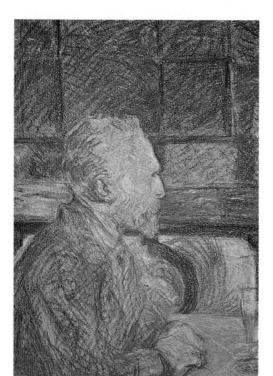

6. *Portrait of Vincent Van Gogh*, 1887.

7. *La Comtesse Alphonse de Toulouse-Lautrec dans le salon du Château de Malromé*, c. 1886.

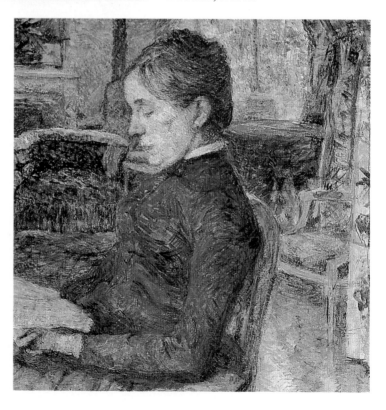

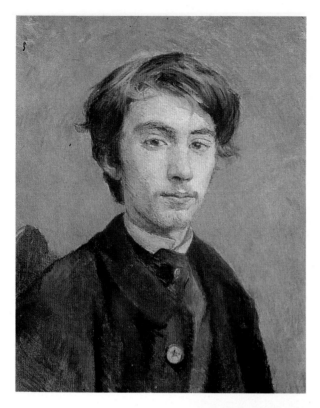

8. *Emile Bernard*, 1886.

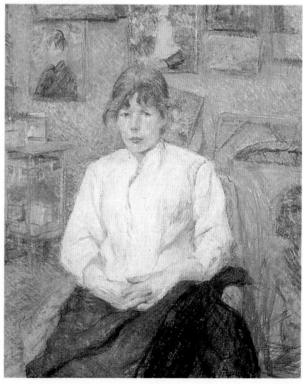

9. *Rousse au caraco blanc* (Red-Haired Woman in a White Blouse), c. 1886.

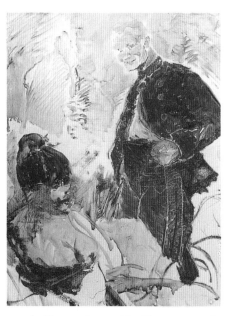

10. *Artilleur et femme* (Artilleryman and Woman), one of the series, 1887.

11. *Poudre de riz* (Rice Powder), 1887.

12. *Au Cirque Fernando, l'écuyère* (At the Cirque Fernando, the Bareback Rider), 1888.

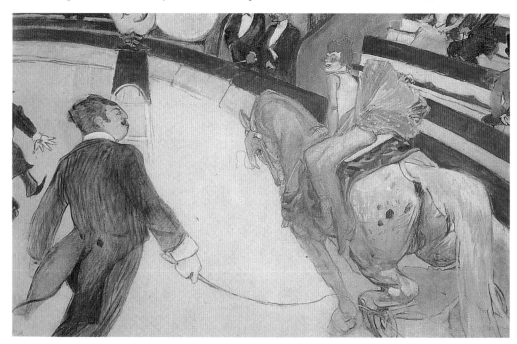

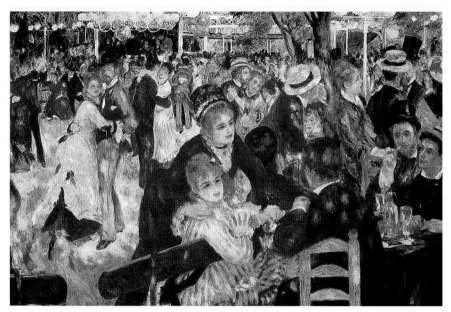

13. Auguste Renoir, *Un Bal au Moulin de la Galette*, 1876.

14. *Au Bal du Moulin de la Galette*, 1889.

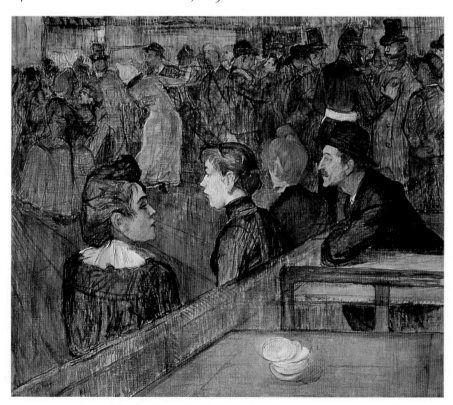

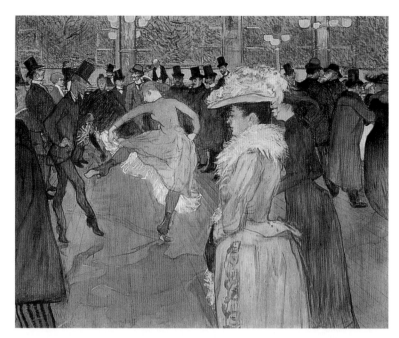

15. *Dressage des nouvelles, par Valentin le Désossé* (*La Danse au Moulin-Rouge*) (At the Moulin Rouge, Training the New Dancers), 1889.

16. *Rousse* (*La Toilette*) (Red-Haired Woman (Washing)), 1889.

17. *Femme en toilette de bal à l'entrée d'une loge de théâtre* (Woman in Evening Dress at the Door to a Theatre Box), 1889.

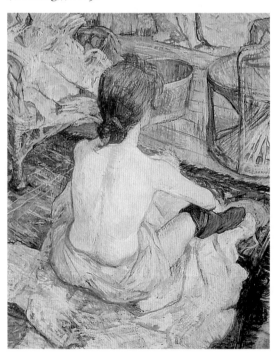

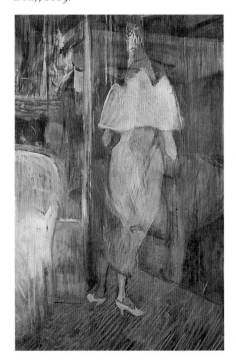

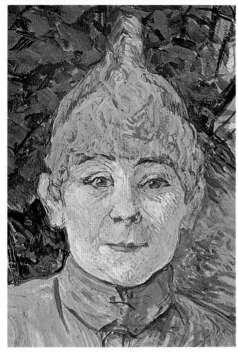

18. *Casque d'Or*, 1890.

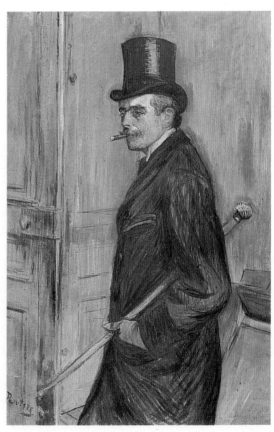

19. *Louis Pascal*, 1891.

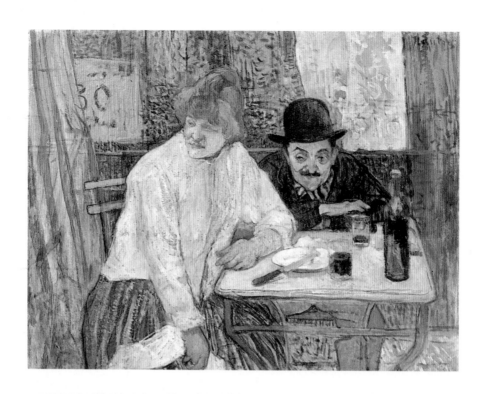

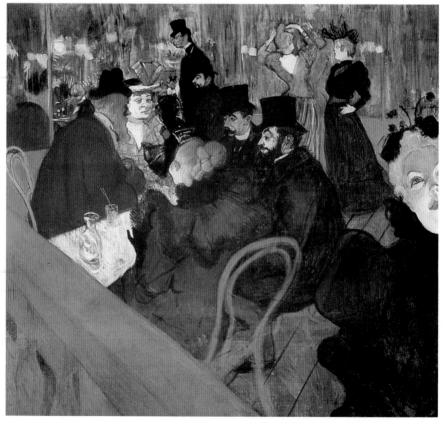

22. *Au Nouveau Cirque, Papa Chrysanthème,*
Tiffany stained-glass window designed by
Toulouse-Lautrec, 1895.

23. *Gabriel Tapié de Céleyran dans un couloir
de théâtre* (Gabriel Tapié de Céleyran at the
Comédie Française), 1894.

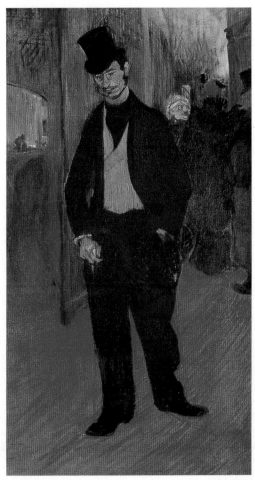

OPPOSITE ABOVE
20. *A la mie* (Down to the Crumbs), 1891.
LEFT
21. *Au Moulin Rouge,* 1894–5.

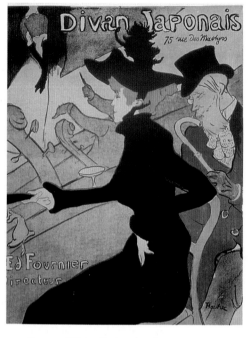

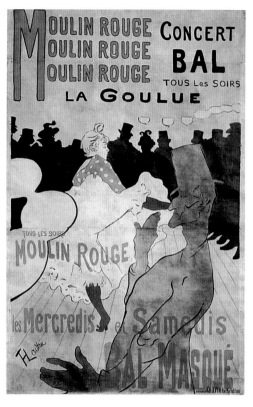

24. Poster: *Divan Japonais*, 1892.

25. Poster: *Moulin Rouge – La Goulue*, 1891.

26. *A Table chez M. et Mme Thadée Natanson* (At Dinner with Monsieur and Madame Natanson), c. 1897.

27. *Jane Avril sortant du Moulin Rouge* (Jane Avril Leaving the Moulin Rouge), 1893.

28. *Misia Natanson* (Misia Natanson at the Piano), 1897.

29. *Tristan Bernard au Vélodrome Buffalo*, 1896.

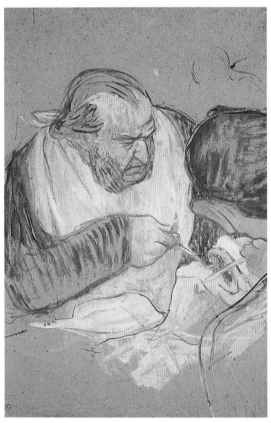

30. *Le docteur Péan opérant* (Dr Péan Operating), 1892.

31. *Monsieur,
Madame et le chien*
(Monsieur,
Madame and the
Dog), c. 1894.

32. Study for
*L'Inspection
médicale* (The
Medical
Inspection),
c. 1894.

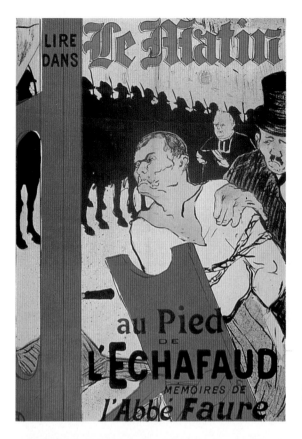

33. *Au Pied de l'echafaud* (At the Foot of the Scaffold). Poster for *Le Matin*, 1893.

34. Bookbinding for Goya's *Tauromaquia*, 1894.

35. *En Cabinet particulier – au Rat Mort* (At the Rat Mort, Lucy Jourdan, Private Room no. 7), 1899.

36. *Au Salon de la Rue des Moulins*, 1894.

37. *Au Salon de la Rue des Moulins (reprise)*, pastel, 1894.

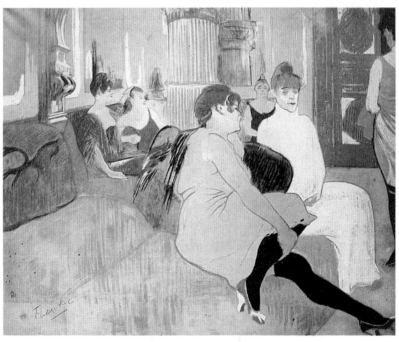

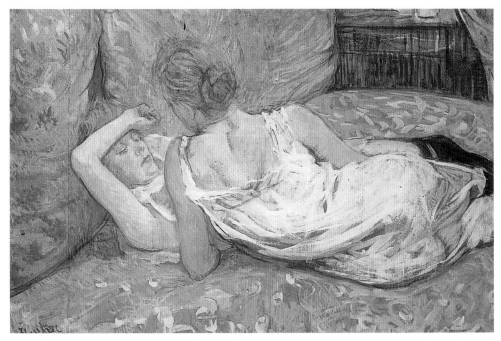

38. *Les Deux amies* (Abandon, The Two Friends), c. 1894–5.

39. *Le Baiser* (In Bed (The Kiss)), 1892–3.

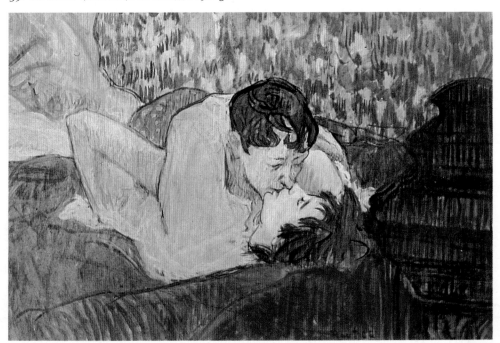

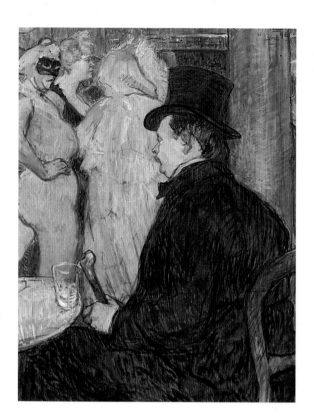

40. *Maxime Dethomas: au bal de l'Opéra* (Maxime Dethomas at the Opéra Ball), 1896.

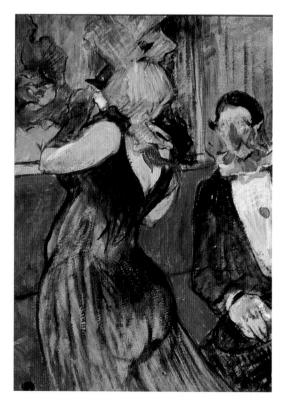

41. *Repos pendant le bal masqué* (Resting during the Masked Ball), 1898.

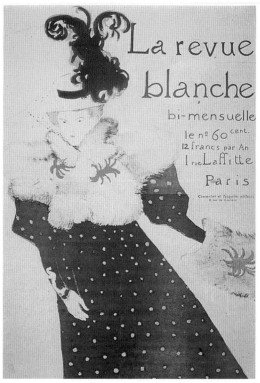

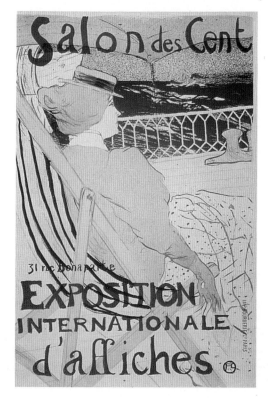

42. Drawing for a poster for Yvette Guilbert, 1894.

43. Poster: *La Revue blanche*, 1896.

44. Poster: *Le Salon des Cent: La Passagère du 54 – Promenade en yacht* (The Passenger in Cabin 54), 1895.

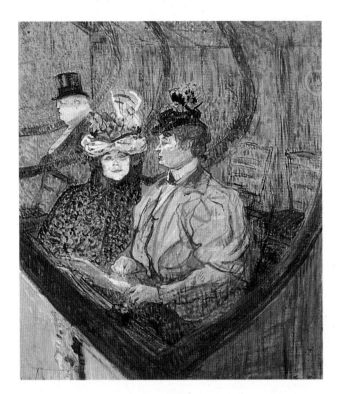

45. Study for *La Grande Loge* (The Large Theatre Box), oil painting on canvas, 1896.

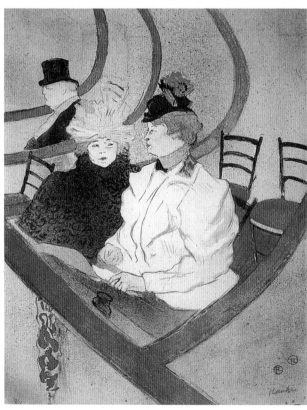

46. *La Grande Loge* (The Large Theatre Box), lithograph, 1896.

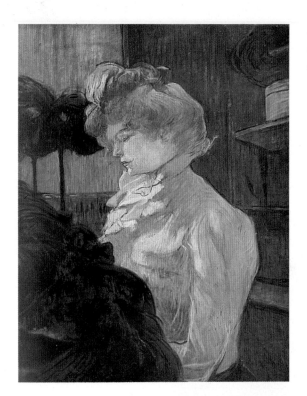

47. *La Modiste – Mlle Louise Blouet*, dite *d'Enguin* (The Milliner), 1901.

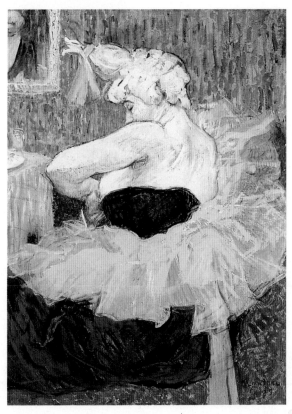

48. *La Clownesse Cha-U-Kao*, 1895.

49. Poster: *Napoleon*,
1896.

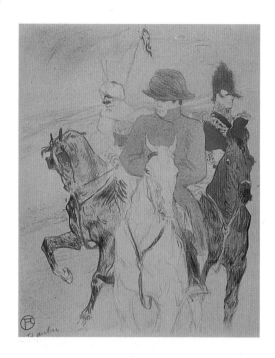

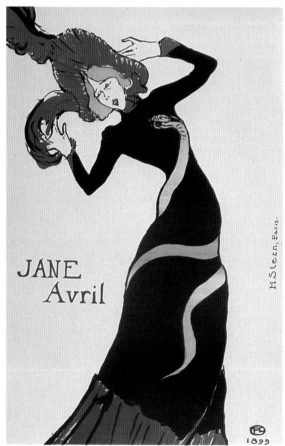

50. Poster: *Jane Avril*,
1899.

It was around 1893 that Henry began to spend most of his time with a group of friends who, although still not of a social class his family would approve of, were a much closer match to himself than his nightclub acquaintances. The journal *La Revue blanche*, which had reviewed his work since 1891, now began to commission him to do posters and illustrations, thus making him an official part of its clan. Although early on Henry had developed friendships with two of its writers, Paul Leclercq and the pulp novelist Victor Joze, as time passed his closest relations at *La Revue blanche* were with the magazine's editors, publishers and financiers, Polish-Jewish brothers Alexandre and Thadée Natanson, who had moved to Paris in 1880. They were part of that new class of people, neither aristocrats nor bourgeois nor working class, coming to be known as 'intellectuals'. A third brother, Louis-Alfred, who wrote plays as Alfred Athis, and whom everyone called 'Fred', was better known for his marriage to the distinguished actress Marthe Mellot than for his thin dramatic productions. He worked as the magazine's drama critic. The magazine's new offices in the rue Laffitte hosted a constant stream of artists and writers. Henry came often, taking over one of the green leather armchairs in the editorial office, disrupting the endless discussions of people like André Gide and Léon Blum with his personal brand of puns and witticisms. Léon Blum later remarked that he had no idea at the time that he would have a major political career and forty-three years later become a socialist Prime Minister. He said that he went into government work (as an auditor at the Conseil d'Etat) 'seeking through austere labour an antidote to menacing hyperaestheticism'.

La Revue blanche, whose name implied the mixing of all colours of the spectrum to produce white light, tried to explore all the newest tendencies in art and literature. Through 1903 it also published a number of individual novels, some important, others less so. Conceived by a group of French and Belgian artist-poets spearheaded by the otherwise undistinguished poet Leclercq, *La Revue blanche* had became a catalyst for the Parisian intellectual scene, for the 'rich collective state of mind' which was becoming known as the *fin de siècle*. It is now regarded as one of the strongest supporters of avant-garde art, literature and music at the end of the nineteenth century in France. Among its more famous contributors were Paul Verlaine, Stéphane Mallarmé, Alfred Jarry, Marcel Proust, Paul Claudel and Guillaume Apollinaire. It published illustrations not only by Henry, but by Pierre Bonnard, Edouard Vuillard, Félix Vallotton and many others. André Gide, writing in *Feuillets d'automne* (Autumn Leaflets – 1946), admitted that although he was intimidated by Thadée Natanson, 'he was, notwithstanding, sensitive to

everything, curious about everything, listening for every echo, indifferent to nothing. In love with art and literature equally, admirably well-informed by Fénéon [whom Thadée hired as an editor after Fénéon was fired from a government job for anarchist activity in 1894] and by his natural instincts, his mind and his heart open to all generous causes.' Paul Leclercq insisted that Thadée's infectious enthusiasm was a source of inventive energy for *La Revue blanche*, and that it was largely through his influence that, over the next ten years, the magazine had such an enormous impact on French arts and letters. Thadée in turn thought that Henry was a great artist, and had one of the finest minds of his generation. Thadée remarked that when Henry was sober, his observations on Balzac were second in perceptiveness only to those of Marcel Proust, and that Henry was 'more profoundly human'.

It must be admitted, however, that the society of distinguished intellectual acquaintances interested Henry only within limits. Although he regularly went out on Wednesdays to meet the *Revue blanche* writers, actors and painters at a café or at someone's house, he almost invariably brought along his cousin Gabriel, not only to provide a foil to his witticisms, but as moral support and a kindred spirit. He needed someone to lighten the atmosphere, if not Gabriel, then his 'uncle', Georges Séré de Rivières, or Maurice Guibert.

The men Henry felt closest to at *La Revue blanche* were much like himself, 'originals' who refused to fit themselves into French society's neat class compartments. They were highly creative, devoted serious attention to play and pleasure, and were appreciated at the magazine for their unconventionality. In fact, most of the writers and artists he liked are now forgotten, a string of second-rate writers such as Joze, Pierre Louÿs, whose fashionably scandalous erotic works focused on lesbianism, Marcel Prévost, a novelist and playwright, another playwright, Henri de Régnier, or actors like Lucien Guitry, whose face began to appear repeatedly in Henry's work around that time. As usual, they really interested Henry because they were *viveurs* and *boulevardiers*, men whose principal concern was the quality of the entertainment: the food, drink and female flesh, and being seen in the right places.

The conversation at such gatherings only interested Henry if it was witty. As ever, his subliminal concern was his art, and he occasionally took out his small sketchbook to scrawl a profile in it. Theory and politics bored him, and he sometimes spent large parts of the evening dozing on a chaise longue although he was always the last to leave.

In 1893, Thadée Natanson married a striking Polish heiress named Misia Godebska, who promptly became the queen of *La Revue blanche*, and it was

possibly Henry's infatuation with Misia that drew him at last into the nucleus of the group. At twenty-one, she was eight years younger than he, but the two were similarly self-indulgent and strong-willed. Not beautiful in the classic sense, Misia was elegant, wasp-waisted and dramatic, lying about her age and dressing almost exclusively in pale colours that highlighted her abundant red hair and ivory skin. She became the focus of the admiring artists, poets and intellectuals who worked for *La Revue blanche*, and she accepted Henry's homage, like that of her other admirers, as her natural due. His relations with her were reminiscent of those he had developed with Lili Grenier as an art student, or with Jane Avril and Yvette Guilbert – a sort of enthusiastic puppy love, worshipping her wit and beauty from a playful but ultimately distant position.

Misia ended up by reciprocating his affection, if not his desire. In time they developed a platonic complicity built of teasing and humour, but years later Misia could not resist recalling her first negative impressions of Henry, admitting that she had found him a sort of monster, with swollen lips, bulbous nose, oversized head and enormous hands. Her first reaction she said, was to want to look the other way.

That head [her husband Thadée later wrote], unstable, like everything heavy that is suspended, bobbed up and down ... Between the ebony black of his bushy beard and the unruly tufts of his india ink hair which he had vigorously flattened and lacquered with grease – there protruded the swollen, pendulous lower lip of an outsize mouth decorated by the comma-shapes of a moustache which always looked as if it were dripping. His hand, which could hold in its enormous fingers a full-size palette with all its brushes, could also handle the most delicate knick-knacks.

Describing Henry's walk as 'rolling', Natanson pointed out that 'He always took a carriage, and often tormented a comrade to get him to agree to tour the Salon with him, side-by-side in wheelchairs. Wiles and jokes to try to hide his horrible difficulty walking.'

Misia didn't seem to know whether it was his ugliness, his unpleasant public drunkenness, or the distressingly painful way he dragged himself along with his cane which made her most uncomfortable. 'He loved to drink only too well,' Thadée elaborated. 'To treat himself to a syrupy Comtes de Lur Saluce [Sauternes] or a dry, spare Cantanac or Léoville. But also, at the crack of dawn to empty a glass of rot-gut rum, which he poured as if he were already leaning his elbow on the greasy zinc counter, into a thick-bottomed glass brought home from a neighbourhood bar.' They compared Henry to

the poet Verlaine, whom the intellectual community was watching in the 1890s as he hopelessly drank himself to death.

Misia and Thadée became so fond of Henry's unconventional artistic imagination and cynical, irrepressible humour that they forgot their first negative reactions. Thadée observed that they 'who adored him, whom he tyrannized' no longer noticed his deformity, his children's clothes, or his funny voice and strong southern accent. 'We didn't even hear him sniff any more ... We saw only his eyes, glowing with wit and tenderness, and sometimes a flash of anger: their brilliance heightened by the lenses of his pince-nez.'

Thadée was himself a 'large, lumbering young man, sensitive, intellectual and filled with ambition ... slightly pretentious, somewhat conceited, distinctly overdressed'. Despite these mildly comic aspects, he, like Misia, was a charismatic iconoclast, and, like her, he had an extravagant disregard for practical detail which Henry would have understood, but which must have caused some tense moments in the magazine offices.

Thadée and Misia seemed to hold permanent open house, both in their large Paris apartment and in their country houses. They freely adopted the artists who worked for the magazine, particularly a group of painters a little younger than Henry, who were part of the Nabi group. Pierre Bonnard and Edouard Vuillard seemed to be constant visitors, and both did paintings of Misia in her living room. To some her salon, decorated in expensive Art Nouveau style by the Belgian furniture designer and architect Henry Van de Velde, epitomized the 'snobbishness' of *La Revue blanche*. It was true that the Natansons had lots of money, but that did not prevent them from warmly welcoming, for example, the radical and impoverished anarchist, Félix Fénéon, as an esteemed comrade.

The Natansons were like Henry in many ways: in their quirky élitism, extravagance, sense of playfulness and love of company. He was absorbed from the *Revue blanche* offices into their household as a frequent dinner guest, and on excursions to the country where Stéphane Mallarmé and Alfred Jarry were their neighbours. He began to spend nearly every weekend at their country homes, Le Relais at Villeneuve-sur-Yonne and La Grangette at Valvins, joining other guests such as the Symbolist artist Odilon Redon, playwrights Tristan Bernard and Romain Coolus or the novelist, journalist and art critic Octave Mirbeau.

Misia, whose affectations did not preclude a true musical talent, was a gifted pianist trained by Gabriel Fauré. She often played the piano for Mallarmé. This was a time when artists, composers and poets frequently

influenced each other, and in some cases, as with Debussy and Mallarmé, or Fauré and Verlaine, actively collaborated. Appropriately, Henry's first work showing Misia was the lithograph done in the autumn of 1893 for the cover of *Sagesse*, a song by Désiré Dihau.

In her memoirs, Misia talked about constantly entertaining the *Revue blanche* crowd in 1894: 'By now I invited only the ones I really liked: Toulouse-Lautrec came regularly from Saturday to Monday. He liked to bring his cousin Tapié de Céleyran with him and also Care de Riviere [sic – Georges Séré de Rivières], known as the "good judge" because he acquitted all the people who came before him.' Although the Natansons were shocked by Henry's 'irreverent, foul-mouthed, dictatorial' behaviour and with trepidation watched him bully his cousin Gabriel, to them, as to Bonnard and Vuillard, he was usually gentle and teasing, perhaps feeling that they were kindred spirits. 'I would sit in the grass,' Misia reported, 'leaning against a tree, engrossed in some entrancing book; he would squat beside me, and armed with a paintbrush, dextrously tickle the soles of my feet. This entertainment ... lasted for hours.'

Henry also liked Misia's half-brother, Cipa (Cyprien) Godebski, who like himself was crippled, having been born with one arm and leg shorter than the other. Henry did a portrait of Cipa and over the next five years at least

Henry performing with a dog, c. 1894.

six portraits of Misia. Seventy-five years later, a Parisian doctor who had purchased the Natansons'country house, La Grangette, uncovered a sketch by Henry scratched into the plaster over the living room mantel. He had drawn a caricature of his cousin Gabriel, 'looking rather like a nineteenth-century Don Quixote in top hat and frock coat'.

Life at the Natansons' in the long summer weekends was an oasis of freedom and friendship for Henry. He did exactly as he pleased, wandering around the property, sketching, drinking, boating, swimming in the river and inventing ridiculous pranks which made him laugh so hard he cried. He particularly liked having his picture taken, mugging for the camera. For the large informal dinners with a dozen or more guests, Henry would draw comic menus which Misia blithely threw away the next day.

There were conflicts, however. Henry found their neighbour, Stéphane Mallarmé, to be rigid and pompous. He was most amused that Mallarmé had painted his initials, S.M., on his boat, so that no one else would use it. Henry promptly nicknamed him 'Sa Majesté'. Misia later told how Henry managed permanently to offend the acknowledged leader of the hermetic Symbolist movement in poetry:

One day Lautrec came to see me in a bathing-suit he had found on Mallarmé's boat. Intended to be knee-length, it hung down to his ankles. He had placed a red and silver crown made of hoop-la rings on his head. Around his shoulders was draped a cloak consisting of an assortment of towels borrowed from the beach dressing-room. Mallarmé got to hear of this innocent prank, and took such a grave view of it that in his heart of hearts he bore a grudge against Lautrec ever after.

Henry's admiration for Misia also had limits. As both of them were dictatorial, they sometimes had huge spats and on one occasion he got even by painting a work with an edge of cruelty disguised as humour. *A Table chez M. et Mme Thadée Natanson* (At Dinner with Monsieur and Madame Natanson, Plate 26), painted around 1897, is a sharp contrast to his other portraits of Misia. She herself described it as showing her as a madam in a brothel, fat, ageing and vulgar. She said the incident was related to the quite beautiful portrait Henry did of her playing the piano (Plate 28):

Lautrec was working on a large picture of me which he wanted to call 'The Ruin of Athens'. He had conceived a passion for this work of Beethoven, which he obliged me to play over and over, insisting it inspired him ... I made myself insufferable by complaining that my eyes were not big enough [etc.] ... in short I so irritated him

Another popular Paris ritual was the formal banquet, considered one of the best ways to honour an occasion or a comrade. The lithographic menu Henry did that spring for the banquet in honour of the opening of the Salon des Indépendants shows the elaborateness of this turn-of-the-century fashion where men of the Parisian intellectual and artistic avant-garde met to indulge in food, wine and conversation. At the Indépendants' banquet, after being seated at 8 p.m., the guests were served two kinds of soup; hors d'oeuvres including radishes, sausage, shrimp and olives; a fish course; two kinds of vegetables; roast turkey with watercress; salads and ice cream, followed by assorted desserts. All this was accompanied by Madeira, claret, champagne, coffee and Cognac.

Such banquets were accompanied by endless speeches and toasts, ending only after everyone was thoroughly drunk. Women generally were not invited to the rowdier ones where the men hired a restaurant to prepare the meal. At the end of such long evenings, there were sometimes memorable incidents. Leaving a banquet which had been held in the upstairs room of a restaurant, Henry's acquaintance, the playwright Alfred Jarry, reportedly stopped at the table of a woman who was dining with friends downstairs. When she would not respond to his drunken approaches, he is said to have pulled a pistol from his pocket and shot at a mirror, which crashed to the floor in pieces. 'Alors, Madame,' he said, bowing deeply, 'j'ai brisé la glace, nous pouvons parler' (Now, Madame, I've broken the ice/mirror, we can talk).

It was at one of the Friday banquets at the Restaurant Drouant that Henry had met the critic with whom he would be closest over the next few years, the journalist Gustave Geffroy, who had first reviewed his work in 1891. These banquets, like Henry's monthly dinners with former students from Bonnat's, were regular rather than one-off occurrences, and in this case went on for many years. Over the years, other regulars of the august Restaurant Drouant group included Monet, Rodin, Raffaelli, Joyant, François Rupert Carabin, Georges Clemenceau and Edmond de Goncourt.

Over time, Henry and Geffroy collaborated on a number of projects and eventually became close friends, possibly because Geffroy, a socialist and cynical observer of Parisian mores, was attracted to Henry's relentless fascination with sexual trangression, combined with his insistent rejection of hypocrisy.

In his review of Henry's two-man show in February 1893, Geffroy had pointed out a new aspect to Henry's work. In his early drawings, such as *A*

and indecent exposure. The trial was scheduled for 30 June 1893. Naturally, Henry and his friends, who gave Béranger the nickname 'Père la Pudeur' (Daddy Decency, the nickname also attributed to the police vice squad officer), perceived the trial as an extension of the farce and flocked to the visitors' galleries that day. The students of the participating ateliers had signed a petition saying they were as guilty as any of the accused, and a police commissioner testified that nothing obscene had happened at the ball itself. La Goulue, possibly goaded by her friends, appeared as the only witness for the prosecution, testifying that she personally had been gravely offended by the nudity at the ball. As she had recently attracted attention in the press by kicking off the top hat of Edward, Prince of Wales during one of her dance routines at Le Moulin Rouge, it was assumed that her testimony would be taken lightly at best.

To the astonishment of those who had followed the courtroom antics, the defendants were found guilty and fined 100 francs each. The next day the art students took to the streets in protest, chanting Béranger's name. The scene suddenly became violent. The police, armed with truncheons, charged the crowd, which fought back. In the riot that followed, a bystander, sitting on a café terrace in the Place de la Sorbonne, was killed. The demonstrations went on for days, with protesters barricading the Latin Quarter and national guard troops being brought in to control the crowds. It was six days before order was restored. Since the 1870s France had been subject to repeated popular uprisings. Like anarchist acts of terrorism, marches and violent confrontations with the forces of order were increasingly considered effective forms of protest against the reigning government, particularly in Paris. However, like the Bal des Quatz' Arts, they seemed to take place consistently in the spring, when the weather was warm enough for it to be agreeable to be outdoors.

The irony of La Goulue's contribution to the convictions was not lost on Henry, who commemorated the event with a lithograph of her appearing in court wearing a revealing animal trainer costume which underscored the hypocrisy of her testimony. There is no record of what she may really have worn for that occasion.

It may well have been around this time as well that Henry gave a monkey he called a 'sénateur' (senator) to his friend Henri Rachou, claiming that it resembled Béranger. His antipathy to Béranger emerged again in 1896, when he drew a poster for the short-lived artists' magazine La Vache enragée (The Crazed Cow). On it he showed an enraged cow, symbol of the frustration of the starving artist, chasing a caricatural Senator Béranger.

boat, as if hunting duck, he costumed him in yellow oilskins.

When they were back in Paris, it was Henry's turn to entertain. He invited his new friends to his mother's for dinner, where he liked to do the cooking himself, or went out with them to lunch or to nightclubs in the evenings, where he introduced them to Aristide Bruant and other performers. They sometimes travelled together, once visiting Mont Saint-Michel.

Here at the centre of the privileged world of well-to-do bohemianism in Belle-Epoque Paris, in this odd mixture of elegance, beauty and snobbishness, of intentional marginality, Jewish intellectualism, internationalism and high living, Henry at last found a meeting of his two worlds, and he felt very much at home.

In the spring of 1893, in the midst of all his shows, Henry, along with two or three thousand others, found time to attend the second annual Bal des Quatz' Arts in Paris, organized at Le Moulin Rouge by Jules Roques. Henry had attended the first Bal the year before, dressed as a 'lithographic worker, in blue overalls and a soft hat with a pipe stuck through it'.

The high point of the official ball was the presentation of the artists' models, carried in by a long procession of art students, who offered them up to the stage nearly naked, sometimes in baskets. William Rothenstein, who was also there, described the costume of Sarah Brown, 'the most famous model in Paris ... carried by four students in a litter as Cleopatra, clad only in golden net'. However appealing the formalized presentation of the scantily clad models was, by the end of the evening, the ball had degenerated into drunken riotousness, with terrified models and other young women being stripped of their remaining garments, and in some cases sexually assaulted by gangs of students. It ended with hordes of revellers emptying into the streets, as the students of the different ateliers, themselves dressed in costumes and sometimes painted in the colours of the atelier banners, went from café to café threatening to destroy the premises if they were not given drinks. When the police were finally summoned, several people were arrested for riot and obscene behaviour.

Although the artistic community of Montmartre treated the events of the evening as an enormous joke, Senator René Béranger, who since 1891 had been leading a campaign to repress morally offensive conduct, now in his official role as president of the specially formed Ligue Morale (Moral League) 'against licence in the streets', filed a formal complaint, and the ball's organizer and several of the women present were accused of corruption of morals

*Thadée and Misia Natanson
with Henry at Saint-Malo, c.
1896.*

that once the picture was finished he took his revenge on me by making an incredible caricature of a dinner-party at my house in which I was represented as a procuress.

In the background of the painting is a pretty servant, dressed not in black, as a servant would be, but in pink, as a prostitute might be. This was Henry's subtle reference to another fight between the Natansons and himself, for it was at their house that a drunken Henry had so importuned a housemaid at dinner that the Natansons were obliged to ask him to stop.

Misia, like many of his friends, could not resist describing Henry's drinking habits:

For Lautrec the summer ended at the beginning of the shooting season. He would put on lemon-yellow oilskins with a sailor's hat of matching material, turned back from the face, and in this attire which he considered in some way connected with hunting and shooting, he would 'open' the shooting season by an exhaustive pub-crawl through the small town. No pub was left out, however sordid it might be, and every autumn the bars of Villeneuve saw the small frail figure faithfully reappear in its yellow oilskins to perform the opening ceremony.

Years later, when Henry posed his friend Joyant standing with a rifle in a

Saint-Lazare (At Saint Lazare Prison), Henry had sometimes used prostitutes as models, anonymously, and sometimes portrayed prostitutes in his work, but indirectly, by inference. Now he was doing works showing the interior of brothels, and prostitutes in the context of their work, bathing, undressing, often with a male figure in the background, observing.

Henry's participation in the life of conventional couples had generally been limited to the role of friend or voyeur. He often developed intense friendships with women like Lili Grenier or Misia Natanson who were already safely attached to other men, but, with the possible exception of his liaison with Suzanne Valadon, he himself had never formed a serious romantic couple with a woman. For his erotic needs, since his years as a *rapin*, he had behaved as many turn-of-the-century men did, married or otherwise, frequenting brothels. For him this was even a source of pride, a proof of virility. Rather than being discreet about such visits, he liked to go to brothels accompanied by male friends or relatives, using the *maisons* (houses), as was common, as extensions of the café, where one could sit around with friends, drink or play cards and, when the time was ripe, choose a female companion with whom to go upstairs. Despite the wide acceptance of such behaviour at the time, when his mother heard from his younger cousins of his bad influence, she invited a priest to try to talk to him. 'I'm digging my grave with my cock,' he is supposed to have responded to the priest's remonstrations.

An anecdote told by Thadée Natanson gives additional insight into Henry's attraction to prostitutes. One evening in a fashionable salon, Natanson sat near Henry who was paying court to a beautiful, aristocratic woman, obviously with little success. When at length Henry rose to leave, the woman suddenly insisted that Henry meet her for lunch the next day, saying that she had something she needed to tell him in private. After Henry had gone, she turned to Natanson apologetically and explained: 'He looked so sad, so mortally sad, that I was afraid to let him leave like that all alone. It seemed as if at any cost, I had to give him a reason to live until lunchtime tomorrow.' Henry's fear of the hypocrisy of his own social class was perfectly justified. He had no need for the pity of a woman he couldn't seduce.

It is not surprising that he was more comfortable in brothels, *cafés concerts* and cabarets than he was in fashionable gatherings. In the former, 'kindness' was eliminated. Nothing was given away there; there was no pretence that the women loved their clients. The interactions were straightforward; everything was for sale. No one was being nice to him because they felt sorry for him. He, like any client, paid for drinks, amusement, sex. He owed no emotional debts and could choose to accept or decline what he was offered.

This choice pleased him. It conformed to the scorn of conventional niceties, to the 'belligerent attitude' typical of artistic bohemia at the time, which he had unsentimentally adopted. One evening, for example, Henry was at an elegant party at the home of Alexandre Natanson, Thadée's brother, surrounded by bare-shouldered women draped in expensive jewels. When Alexandre asked him if he was having a good time, Henry responded, blowing out a cloud of cigar smoke, 'Am I having a good time? Marvellous, my friend. You'd think we were in a brothel.'

Perhaps Henry preferred the licentiousness and unconstrained behaviour of the cabarets and brothels to the artificiality of the salon because the breakdown in social conventions offered more potential for glimpsing or experiencing unleashed, uncontrolled passions. He had extended his activity in brothels beyond socializing and physical satisfaction to artistic voyeurism, doing numerous works depicting the life there – particularly the life of the prostitutes when they weren't actually with clients. He explained his preference in simple terms: prostitutes were less self-conscious with their clothes off than other models.

For him, aestheticism bordered on erotic pleasure, whether it was looking at beautiful images or producing drawings of them. He said he was 'spellbound by Renoir's mouths'. He invited women he found attractive to pose for him, thus forming a pretext for controlling, dominating and perhaps seducing them. He made symbolic love to women he was unable to seduce by drawing or painting them, capturing them on paper. Sometimes his brushstrokes almost caress their bodies. At other times his lines are cruel, accentuating any physical or psychological flaw, perhaps possessing his love objects by degrading them, making them as vulnerable as himself. He tended to prefer the *type de la Montmartroise*, the tough-looking, somewhat vulgar woman of his own neighbourhood, to the aristocratic models his family and social class provided. Like a famished man attacking a banquet, he worked in all media: paint, gouache, watercolour, ink, silverpoint, pencil, charcoal, coloured pencils, pastels, burin and lithography.

To achieve his artistic goals, however, he had to break the pure prostitute-client relationship and establish himself behind the scenes. He invaded the prostitutes' private quarters as he had the dressing rooms of cabaret singers. Throughout 1893, in the midst of all his other preoccupations, Henry's brothel paintings accumulated like a second existence, intimate, clinical, sometimes with clear elements of social criticism or irony. A few of them, such as the painting *Monsieur, Madame et le chien* (Monsieur, Madame and the Dog, Plate 31), are distinctly amusing. This painting shows a *petit bour-*

geois couple with a tiny dog sitting in the salon of a brothel, looking very out of place. According to contemporary accounts, the painting is intended to show the hypocrisy of bourgeois morality: the owners of the brothel who were making a visit, not for pleasure, but to check on their investment. This kind of commentary, pushing a true scene just far enough to make it comic, was an extension of Henry's verbal style into his art. Creating a subtle visual pun or humorous symbolism in a work became a kind of trademark for Henry, and from 1892 on, such sight-gags are often present in both lithographs and paintings.

Most of Henry's brothel paintings, however, are not funny. Often he used the same technique of unexpected juxtapositions to highlight the discrepancy between male fantasy and female realities. His painting *Femme à sa fenêtre* (Woman at Her Window), for example, intentionally contrasts the garish opulence of a brothel bedroom, unambiguously defined by its chamberpot, washbasin, pitcher and towels, with the simple figure of a young girl, sitting with her back to the spectator, looking blankly, passively, out of the only window, to the world beyond.

Brothel scenes were not a new fashion among artists. But with notable

Lassitude, *a drawing for* Elles, *1896*.

exceptions, until now these had been scenes of titillation and sensuality, glamorizing the world of prostitution. Degas had done some private works showing the unattractive side of brothel life and Henry kept a photo of Carpaccio's painting *Two Courtesans* in his studio. Like theirs, Henry's works were not at all erotic in the 'peephole' sense. Brutally demystifying the male client's perception of the brothel, Henry showed instead the humiliation of a woman forced to stand in line, naked from the waist down, waiting for her weekly medical examination for venereal disease (see Plate 32) or lying exhausted across a bed, symbolically pointing out that she was treated as an object, much like the bed itself.

His works show both the static, blank expressions the women often wore when they were not trying to attract a customer, and the closeness and tenderness of their relationships with each other. Living as they did in a sequestered world, often their only real friendships and love relations were within the family of the brothel. These works as a whole subsequently earned for him a reputation as a 'sociologist' of prostitution. They now constitute the most famous single subject matter of his paintings, nearly equalling the fame of his posters.

His artistic *furias* were most often for women; it was women that he drew obsessively, sketching the same profile dozens of times. Images of women dominated Henry's work almost from the time he began to take himself seriously as an artist, beginning with images of his mother. Now Henry's tendency to focus on 'fallen women' was partly a rebellion against Adèle's puritanical qualities.

At first his brothel paintings were kept behind locked doors, shown only to a few select friends. It was only as time passed that Henry, perhaps influenced by alcohol, abandoned self-censorship. As he had trained a cormorant to waddle behind him through the streets of Arcachon, and drink absinthe from his glass, making a spectacle of his handicaps in front of strangers, now he gradually stopped discriminating between those paintings which, as he explained to Gauzi, he had no intention of ever showing to anyone, and did only for his own amusement, and the paintings and prints that could be exhibited. Instead of keeping them secret, he began showing them to people he knew would disapprove.

Even though his friends recognized the importance and originality of the brothel paintings, they often found them distasteful. Rothenstein commented:

Lautrec's unpitying eyes noted only the sinister figures of *fille* [girl] and *souteneur*

[pimp], of degenerate and waster ... since he could not live in the social world to which he belonged, he would at least not deceive himself and others about the company in which he chose to spend his life ... Lautrec explored a society which even a physician hates to enter – an underworld whose existence is more frankly acknowledged in France than in England ... No artist has ever shown so brutally, so remorselessly as Lautrec the crude ugliness of the brothel. Nor can I imagine anyone else ready to face what Lautrec did in order to get material for his studies. He seemed proof against any shock to his feelings and he deemed others equally indifferent.

As his other interests had in the past, now the bordello became an obsession, a *furia*, for Henry. 'I shall set up my tent in a brothel,' he was quoted as saying around this time, possibly referring to his father's habit of occasionally setting up a tent instead of sleeping indoors.

In a gesture consistent with his outrageous showing-off, Henry sometimes persuaded the madam of a brothel to rent him a room, where he would stay for days at a time as if he were in a hotel. He is known to have frequented at least five such brothels in Paris and occasionally to have done the same thing in provincial cities. It is even said that in 1899, he wrote in advance to a bordello in Bordeaux, to reserve a room.

The women who worked in the brothels became quite friendly with 'Monsieur Henri', as they called him. 'They're the only places in Paris where you can still get a good shoeshine,' he remarked to a friend. Staying in brothels, drawing the women when they were 'off-duty', Henry found a home of his own choosing, oddly parallel to the manless houses of his child-hood. And he became, in a sense, one of the family to the women in the brothels, a friend and confidant, eating meals with them, getting to know their problems, participating in their gossip, observing them in their various occupations and pleasures. In one elegant brothel in the rue d'Amboise run by Blanche d'Egmont, Henry and two friends helped with the decoration, doing a series of sixteen medallion portraits of the prostitutes, one to decorate each panel of its eighteenth-century salon.

By involving himself personally with the prostitutes, Henry was taking an emotional risk. He had always felt a drive to do what was forbidden, to see behind the surfaces of illusion, to perceive what each of his models wished to keep secret, to slip into the closed worlds of theatres, circuses, cabarets and brothels. He found the temptation to invade these sanctuaries irresistible, but in doing so he left the neutral security of purely economic relations.

He was no longer simply paying for the favours he received in the brothels, and he found himself in the peculiar position of being subject to hypocrisy, pity or emotional blackmail again by the very act of pulling aside the veils these women used to protect themselves from the average client. Although he was undeniably exploiting the prostitutes for his art as they continued to exploit him for money and gifts, the situation was ambiguous. Was he, when he listened to their problems and took them out to dinner, merely pretending to be a friend? Henry had few other sources of physical intimacy and even fewer opportunities for romantic relationships. It was possible for him to know perfectly well that prostitutes were unacceptable choices as mates and still to feel real tenderness for them, to be quite aware that they were kind to him because he paid them and still to exercise his charm on the only love objects he had. They, in turn, unable to reject his advances as another woman might have, may have got to know him well enough to forget their revulsion at his appearance and appreciate the inner qualities his other friends loved in him: warmth, wit, humour, kindness, generosity.

9

H. T-LAUTREC

Hautrec

Art critic Arsène Alexandre, editor of *Le Rire* (The Laugh), a popular humorous magazine, felt Henry was one of the most important painters of his time but was painfully aware of the artist's alcoholism. He said that Henry was almost philosophical about it, and had a 'resolute, natural' air while drinking heavily, 'as if he didn't even notice it'. Alexandre perceived this as intentional self-destruction, of 'profound drama and poignant elegance ... Visibly, before the very eyes of his friends, he began to burn himself out, slowly at first, then with ever-increasing speed. Much as we deplored his fabrication of his own ruin, we lacked the courage to admonish him. There are men whose lives are shortened precisely because they live so intensely. They rarely survive to old age.'

Heavy drinking had become so much a part of Henry's persona that he was uncomfortable with anyone who would not drink with him, even where his art was concerned. In addition to befriending the alcoholic artist Maurin, Henry began to work with Henri Stern, a skilled printer who had the reputation of drinking as much as he did. In 1893, his favourite printer at Imprimerie Ancourt, Père Cotelle, had grown too old and ill to work. Henry seems to have been bitter at this loss, for in a typical gesture, he rejected what he had once loved, reportedly commenting to friends that Cotelle's skullcap was so greasy that he used it to oil the lithographic stones. For the rest of his career he worked with Stern, and dedicated an artist's proof of each edition to the printer. Henry and Stern got into the habit of working together every morning, printing lithographs, then going out to a café for lunch where they would drink liberal amounts of wine. Henry took a nap to sleep off the wine from lunch, then worked in his studio in the afternoon until *apéritif* time, when he started drinking seriously, not stopping until he fell asleep, often in public.

A casual acquaintance of Henry's, who wrote under the name of Sylvain

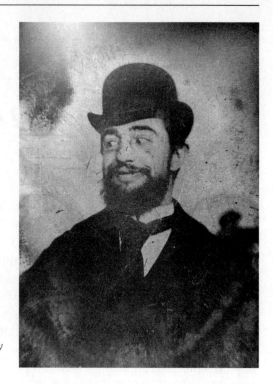

A photograph of Henry taken by a travelling photographer at a country fair, c. 1895.

Bonmariage, said that while Henry was still in his twenties, he sometimes went on binges that lasted three months. Others recounted the ways in which alcohol affected his judgment. Being drunk gave him licence to misbehave. When he had been drinking he was known, for example, to pick quarrels with strangers and at least once tried to get Gauzi to fight a bunch of *marlous* (pimps and, by extension, hooligans) who had 'insulted' him. On that occasion, he had been attracted to a certain restaurant precisely because it was known as a hangout for thugs, but then was incensed when someone made fun of him there. Gauzi managed to get him out before blows were exchanged.

Henry's behaviour, which many considered debauched, was perhaps best understood by Jane Avril. According to her memoirs, she was also *déclassée* and had suffered psychological damage caused by conditions over which she had no control. Although she was always told that her father had been an Italian prince, she grew up in poverty, beaten and forced into prostitution by an alcoholic *demi-mondaine* mother, whom her father had not married. While still very young, she fled, working at the Hippodrome at the Place de l'Alma

and as a cashier at the 1889 Paris Exposition. She was diagnosed about that time as having chorea, a nervous disease causing involuntary muscular movements, and she became a patient of Jean Martin Charcot, the noted neurologist whose research on mental patients at the Hôpital de la Salpêtrière in Paris had won him justified praise. She discovered dancing, so she explained, while a patient of Charcot's, when she went to a fancy-dress ball given by a local doctor, and she claimed that using dancing as a way to release all her turbulent feelings had cured her. Those who saw her dance were struck by the wildness of her movements. However, Jane Avril remained somewhat unstable. When Henry put her in the audience of his *Divan Japonais* poster in 1893, she had not danced professionally for nearly two years. At the time a critic had commented on the strange contrast between her exalted dancing and her 'lugubrious, dolorous face', using her as an example of the whole generation's loss of spontaneity and descent into mechanistic behaviour. Linked in part by their traumatic childhoods, Jane Avril and Henry remained quite close. She was an unambiguous supporter of him as an artist no matter how much he drank, and he in turn had paid homage to her interest in the arts by placing her in his 1893 lithograph cover for the first issue of *L'Estampe originale* (see illustration on p. 323). Of all Henry's cabaret performer models, she is the only one of whom he also did intimate works showing her offstage. The most striking of these is a series of oil or pastel portraits done between 1892 and 1899, showing her in street clothes, often with an indescribably sad and meditative expression (see Plate 27). Her sadness may have symbolized to Henry the constant threat of madness hovering behind her.

Despite his growing reputation as a rich, snobbish barfly, who practically lived in the brothels and regularly got revoltingly drunk, at twenty-nine years old, Henry was recognized by the general public and critics alike as a great artist. This was not just accident or whim of fate. Henry's art was his primary source of self-esteem. He had spent years of productive exploration, constantly drawing and painting wherever he happened to be, integrating his art into late nights and heavy drinking. He sketched in the cabarets, set up his easel in the brothels, and after a night on the town, was known to show up at the printer's at dawn, literally climbing up on the table to work directly on the huge stones.

Even Arthur Symons, who in some contexts considered Henry to be the embodiment of Parisian decadence, accorded a grudging respect to his willpower and hard work: 'Lautrec, as far as he could, got in this world all he wanted, for he had willed it intensely and persistently; it came – fame and

success. He had conceived a great end and he worked towards that end without deviating and without tiring. His power of creation to him seemed inexhaustible.'

Henry devoted serious attention to the business side of his art as well. Given the chaos of his usual existence, constantly overspending his allowance, living in studios whose dust and disorder had taken on mythical proportions, not to mention his fatiguing and scandalous social life, it is almost astonishing to note his meticulous focus on the conditions under which his art was to be reproduced or sold. As he grew older, his correspondence contained fewer and fewer personal letters, but literally hundreds to printers, publishers and dealers, in which he described sizes and colours for reproductions, details of framing, hanging in exhibitions and rights for publication, or inquired about works left at galleries, making sure that he was paid correctly when they were sold and getting them back if they were not.

However, since he saw no reason to separate hard work from hard living, creativity from drunken wildness, or physical limitations from rejection of social boundaries, Henry often gave others the impression that his major concern was not art at all. The young Belgian painter Henri Evenepoel, a student of Gustave Moreau, who went to knock on Henry's door in Paris in January 1893, was shocked by the famous artist's priorities:

Behind the door we could hear his voice and his feet shuffling as he came to open. I saw before me a tiny little man who came only up to my chest ... He muttered: 'Don't forget, we're here to drink,' and began preparing '*short drinks*' that we had to swallow in one gulp! He seemed more or less indifferent to what we might think of the paintings of Toulouse-Lautrec, but he would never forgive us if we made fun of his American drinks!

Henry's penchant for American cocktails was typical of his old habit of glorifying his weaknesses. The concept of drinking wine or spirits mixed with anything (except occasionally water) was foreign, even repellent, to the French. Henry, on the contrary, loved the idea of curious mixes of liquors and the way they sometimes intensified the effect of the alcohol. He was one of the first in France to be interested in mixed drinks and seemed to enjoy subjecting his friends to unlikely combinations, mixing according to variations in colour or specific gravity rather than taste. From Henry's point of view, if he was going to spend a lot of time drinking, he might as well make an art of it.

The writer Francis Carco, who referred to Henry as 'Monsieur Toulouse',

later interpreted his drinking as part of a pattern of wilful decadence. He also considered Henry's preference for coarse, lower-class models to be typical of *fin de siècle* burn-out, whose symptoms included anarchy, lassitude, disgust, a feeling of paradise lost. Not just with Henry, but all over Paris, anxiety about the end of the century took the form of brutal rejection of conventional standards. All was lost and everything had been tried; the only way to avoid boredom was to plunge oneself into vice.

In July 1893, Henry did colour illustrations for a scathingly ironic article by Gustave Geffroy, '*Le Plaisir à Paris: les restaurants et les cafés-concerts des Champs Elysées*', published in *Le Figaro illustré*. In this article, which on the surface was a report on Parisian nightlife, Geffroy accused bourgeois Parisians of becoming decadent voyeurs who had lost the initiative to amuse themselves and who, rather than actively engaging in life, could only find pleasure in watching spectacles provided by the lower classes.

The word Decadence had come to represent a whole movement in *fin de siècle* Europe. The term *Décadent* was not used to describe just a passive abandonment of bourgeois morality, but a group of writers and artists who flaunted such behaviour in order to question definitions of morality. In many cases they hoped that new creative forms might be produced by pushing the limits of experience, by subjecting themselves to what were considered abnormal influences: unconventional drugs, alcohol or sex, for example. Many of Henry's themes represented Decadent behaviour, particularly his decaying figures of alcoholic pimps, ageing prostitutes and dancers past their prime.

But Henry was not easily characterized as Decadent. In August 1893, he left Paris to go on a strenuous holiday with Henri Bourges, Louis Fabre, Paul Viaud de la Teste, and Maurice Guibert. They went on a five-day expedition, taking a 'magnificent turbulent trip' on a small open boat through a series of lakes connected by a river with rapids from Cazaux to Mimizan, south of Arcachon, sleeping at night in a tent. Although they were roughing it, the trip was fairly luxurious, for as Bourges later wrote, 'We bought chickens, lamb and fresh vegetables . . . a cask of wine.' The two sailors they hired to guide them also cooked for them. Nonetheless 'the last day was hard', Henry wrote to Adèle. 'The men had to lift the boat over veritable rapids, over rocks. We were on our own,' he exaggerated, '. . . camping and cooking for ourselves. The softies stayed in hotels,' he added, 'but paid for this relative comfort with bedbugs and other *babaous*.' The word, of his own invention, perverted the childish word for a bump or wound (*bobo*) to sound like the barking of a small dog ('*ouax rababaou*,' he often said). To him

it meant something irritating. 'I myself divided my pleasures ... it was remarkably hot, but we bore it by going swimming two or three times a day. I'm going to go back in two weeks with some cormorants,' he added optimistically. Bourges mentioned in his own account that on the fourth day, as the boat was portaged, they had been forced to walk nearly the whole way, climbing around waterfalls and rapids. Henry did not mention this *babaou*, which must have been exceedingly difficult for him.

Notwithstanding his physical limitations and his attachment to Paris, Henry was always ready to travel. Paul Leclercq, who accompanied him on some more civilized ventures, observed that no matter whether the trip were long or short, whenever Henry took the train, he 'dozed conscientiously from departure to arrival'. Over the next few years he continued his annual trips to Belgium, as well as going to Holland, Spain and England on several occasions, carrying his characteristic soft satchel. 'He was so short,' Leclercq explained, 'that he could not have carried a normal suitcase, whose bottom would have dragged on the ground, so he had found somewhere a khaki bag, certainly the only one of its kind, very long and narrow like a sausage.' Invariably he travelled with a friend, sometimes Guibert or Leclercq, sometimes Joyant, in 1894 with Joseph Albert and J. Robin-Langlois, going to country houses, beach homes and repeatedly on a steamer up and down the English Channel between Bordeaux and Le Havre. He talked at times about going to Japan where, according to Gauzi, he said he could find 'brothers his own size', but the plans never became concrete.

In September 1893, he recuperated from his white-water expedition by swimming and sailing at Louis Fabre's beach house, the Villa Bagatelle in Taussat-les-Bains, living, as he described it, 'half naked in an isolated little house by the sea'. He and his friends also took off for a few days to San Sebastián in Spain, to gamble and go to the bullfights, another recent *furia*. Unfortunately their pleasure trip was interrupted by a civil insurrection. Henry watched the action from his hotel balcony that night but wisely returned to France the next morning.

Henry's growing passion for sports led to his friendship with another *Revue blanche* regular. Tristan Bernard was a popular playwright and former amateur boxer who had exchanged his boring given name, Paul, for something more romantic. Two years younger than Henry, he was incorporated into *La Revue blanche* as a journalist and comic writer. In the 1890s he earned his living managing the Vélodrome Buffalo – a racetrack for bicycles – Paris's newest fad. He later managed a second one, the Vélodrome de la Seine in

Levallois-Perret, and edited a bicyclists' magazine, *Le Journal des Véloci-pédistes*.

The bicycle, which had been invented in the 1780s, grew popular with the general population when the pneumatic tyre was developed in 1889 by the Scotsman J.B. Dunlop. Suddenly, the streets and country roads were full of people riding bicycles. The automobile and the aeroplane soon joined the bicycle in the public imagination, making speed the hallmark of the turn of the century. Henry, whose childhood tricycle had been his last taste of physical freedom, became an impassioned spectator of bicycle races.

Bernard, as the director of the two tracks, established the programmes, organized the matches and races, and was well placed to take Henry into the inner sanctum of this world:

Lautrec often came to the races. He would meet me on Sunday, we would lunch together and go off to one of the stadiums. I would let him into the enclosure along with the officials, but he usually went off and sat on the lawn. I think the race results interested him little, but he was fascinated by the setting and the people. One day we met at a rugby match. There too he was less interested in the outcome than in those pile-ups of players which resembled a thousand-legged animal.

There was a general upsurge of interest in all sports in Europe at that time, leading in 1894 to the revival of the Olympic Games. Henry, the frustrated athlete, was compulsively familiar with the vocabulary and technical aspects of a variety of sports in which he could participate as a spectator: horse and bicycle racing, wrestling, navigation and yachting, bullfighting. He watched them all with the same intensity that he watched a line of dancers or a circus bareback rider, attracted by the beauty of movement, but also by the smells, sounds and excitement of the spectacle. Thadée Natanson described Henry at a boxing match: 'He had the habit of completely sucking in his thick lips as a boxer flexed his muscles, or when one was knocked groggy with a right hook.' He also mentioned that when he went to the bicycle races with Henry in Belgium, Henry liked going into the locker room, 'leaning over closely to watch the massages that revived the athletes', noting that Henry was at first very interested and excited, but as the afternoon and the drinks progressed, he grew exhausted, 'circled briefly on the lawn in the middle of the track, like a dog looking for a place to lie down, and finally curled up on the ground and fell asleep'.

Tristan Bernard also proved to be an astute observer of Henry, many years later:

It is only now that I discover that Lautrec seemed supernatural to me because he was natural in the extreme. He was truly a free being. But there was no dogma to his freedom. He had no disdain for banality; he simply refused all authority ... Lautrec played in life with the sovereign freedom of a little boy playing in a park. He was a tyrannical playmate, organizing us like an eight-year-old inventing and directing the games of everyone on the lawn.

Over the next year or so, Henry often went with Bernard to watch bicycle riders and sketch them in motion. He met all the most famous racers and their coaches: Arthur Zimmerman, known as the 'American Flyer', Jimmy Michael, the Welsh cyclist, their coach, 'Choppy' Warburton, and the French representative of the Simpson bicycle-chain manufacturer, Louis Bouglé, known as 'Spoke', with whom he travelled to England in 1896. He did drawings, paintings and prints of all of them, including a large oil of Tristan Bernard in his bowler and knickerbockers, standing in the stadium, which Bernard proudly hung in his living room (Plate 29). He also did a striking, though unfinished, oil sketch on cardboard of Spoke. Spoke subsequently commissioned Henry's 1896 poster *La Chaîne Simpson* (The Simpson Bicycle Chain), which can be considered one of his most innovative works, for several readings of it are possible.

This poster shows the Vélodrome Buffalo during a bicycle race, the far ends of its track cut off by the frame of the poster on both left and right. In the grassy oval in the middle can be seen the band playing as the racers ride round and round. Standing in the centre of the green are the manufacturer of the Simpson bicycle chain and Spoke himself. Circling the track are, far in the background, what appears at first sight to be the *peloton*, the 'pack' of racers, and in the foreground, a lone rider overtaking what looks like two identical riders on a tandem bicycle. The lone racer's bicycle sports a carefully drawn Simpson lever chain.

The scene can also be interpreted as containing only three riders. One, far in the background, is shown as if in a Muybridge stop-action photo, in a series of overlapping images, as he moves through time and space. In the foreground, a second rider is overtaking another single rider, whom Henry portrays literally doubling in space as he moves. It seems possible that Henry's enthusiasm for the photographic studies of Muybridge and Marey influenced him to try to communicate the dynamic sensation of speed by showing a rider in multiple positions as he moved, prefiguring the Italian Futurist movement which developed some fifteen years later. In the right foreground image, Henry subverts the concept into a sight-gag by making the rider

ambiguously resemble twins riding a tandem bicycle that has somehow
wandered into the wrong race.

However, a third reading of the poster may be the most likely one for the
time. Five-man bicycles, although uncommon, may conceivably have raced
at the Buffalo Velodrome. Thus the background may show two five-man
bicycles, and the right foreground the last two riders on another five-man
bicycle. Then the point of the poster becomes apparent: a single rider with a
Simpson lever chain can easily win a race against five-man bicycles!

This kind of visual triple-play is characteristic of Henry's lithographic and
poster work. From the beginning with *Moulin Rouge, La Goulue*, his posters
had always worked at three levels: the immediate, perfectly comprehensible
image (in this case, bicycle riders in a race); the abstracted, theoretical and
often ambiguous level (in this case, the portrayal of the visual dynamics of
movement) and the comic reference (here, to the possibility of an out-of-place
tandem or one-man bicycle). They combine his instinctive visual skill with
highly intelligent analysis of the image and a whimsical sense of humour.

Poster: La Chaîne Simpson, *1896.*

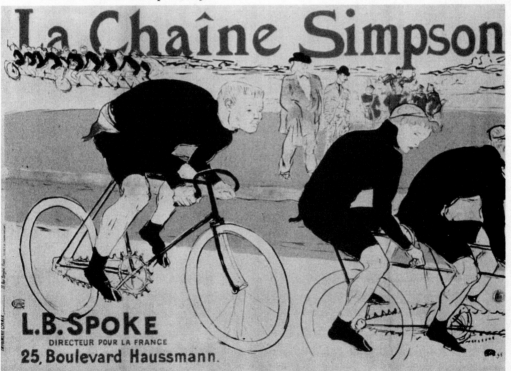

Bernard himself commissioned Henry to do illustrations for an erotic magazine he published as an offshoot of *La Revue blanche*: *Le Salon du Chasseur de Chevelures* (The Salon of the Tress-Hunter). Henry subsequently illustrated the programme for Bernard's very successful play, *Les Pieds nickelés* (an expression meaning approximately: to have a golden touch) in 1895, and drew the cover for his comedy, *Le Fardeau de la liberté* (The Burden of Liberty) in 1897. In 1898, Henry also did as one of his first drypoints a portrait of Bernard, scratching in the hairs of his voluminous beard with a dramatic, sweeping motion.

Another *Revue blanche* writer, and one of its editors, was the playwright known as Romain Coolus (the pseudonym of René Weil), who for a time in 1893 and 1894 was Henry's constant sidekick. Like Tristan Bernard, Coolus represented the lighthearted, sociable side of *La Revue blanche*. His playful doggerel, which to an American is reminiscent of Ogden Nash, alternated in the magazine's pages with the hermetic Symbolism of Mallarmé, José-María de Heredia and Verlaine.

Like Gabriel Tapié de Céleyran, Coolus became a sort of foil for Henry, who reportedly teased him almost as mercilessly as he teased his cousin Gabriel, calling him 'Coco' or even 'Cocotte' (meaning 'flirt'), and representing him caricaturally in several lithographs, although he showed him with great sensitivity in a portrait '*à la manière du Greco*' (in the manner of El Greco), as he put it. Coolus, an eccentric who liked to drink and go to brothels as much as Henry did, tolerated this with good grace. Both he and Gabriel may have felt that it would be ungenerous for an able-bodied man to confront a beloved and much-pitied friend who struggled so courageously to surmount his handicaps. As Thadée Natanson remarked: 'There is an overwhelming pleasure in bowing down to someone who has been denied the recognition he deserves ... it is a fine gift to submit to the will of someone who has so little power.' Guilty at their own well-being, they bore Henry's bullying as a sort of penance.

Coolus said he enjoyed Henry's company, commenting that 'paradoxically, when you consider his strange physique, Toulouse-Lautrec was very seductive'. Contemporaries, who described Coolus as hoarse-voiced, with a cracked laugh, nearly as short as Henry and just as explosive, recounted that Henry once persuaded Coolus to join him as a lodger for several days in a Paris brothel, each working hard – Henry at his drawings and Coolus on his writing, but Coolus himself left no account of this experience. He did however describe in detail the admiration he felt for Henry's power and originality:

He combined charming ingeniousness with an extraordinary sharpness of sensations and impressions and took childlike pleasure in using striking verbal expressions to describe them to his friends. I can still hear him in his teasing, childish voice … making fun of the 'gargoyle side' of certain individuals, or putting down both pedants and light-weights by announcing 'Keep out of that, not your business.' There is no arguing with the philosophical point of view he summarized in a typical comment: 'The ones who say they don't give a damn, do give a damn, because if they really didn't give a damn they wouldn't bother to say they don't give a damn.'

Coolus described coming to appreciate Henry's particular brand of wit while spending weekends with him visiting the Natansons: 'through his drooping moustache, damp with vermouth or absinth, came humorous comments, startling theories, spontaneous remarks, good-humored sarcasms, all mingled with the aphorisms of a great writer; this incomparable draughts-man, printmaker and painter had wonderful literary gifts.'

The two men often went to the theatre together: to the Comédie Française, to see Molière, to the Théâtre de la Renaissance to see the great Sarah Bernhardt, or to the experimental theatres: the Théâtre Libre, and the Théâtre de l'Oeuvre. Henry's attention to the sensual and visual aspects of the experience at the expense of the performance itself was driven home to Coolus as it had been to others before him,

when in the winter of 1895 he forced me to accompany him twenty times to the Théâtre des Variétés to see the revival of Hervé's *Chilpéric*. The lovely Marcelle Lender had a major role in it and she was dressed, or one might say, undressed in such a way that each muscle of her back was available for inspection with lorgnettes. As I was getting a little tired, around the sixth time, of hearing the chorus sing, 'It's ten o'clock, time for Chilpéric to get up …' I asked Lautrec why he insisted on repeatedly force-feeding me these unimpressive lyrics. 'I only come so I can see Lender's back,' he answered. 'Look at it carefully. It's rare that you see anything so magnificent. Lender's back is a feast.'

Henry's fascination with Marcelle Lender began when he portrayed her in his lithographs for the left-wing magazine *L'Escarmouche* (The Skirmish) in 1893 and lasted for some two years in which he produced fifteen lithographs of her and a large painting, *Marcelle Lender dansant le boléro dans 'Chilpéric'*.

Like La Goulue, Jane Avril and Yvette Guilbert, Marcelle Lender had a violent, unleashed stage presence, attracting his attention and admiration with her sexual energy. However, despite Henry's repeated attempts to get to know her, she never felt any positive interest in him. In her memoirs, she

mentioned that he once came to the Café Viel, where she habitually ate dinner after her shows, and was introduced to her by his companions Jules Renard, the playwright, and Alfred Edwards, who some years later would become Misia Natanson's second husband. Lender was shocked that Henry sat down without being asked and stared at her fixedly while nibbling ham and sour pickles from her plate. When he offered to give her the painting he had made of her dancing the *boléro*, she refused it, later commenting to a friend: 'What a horrible man! ... He likes me very much ... but as for the portrait, you can have it.' He later gave the painting to Paul Leclercq.

Henry suffered a traumatic setback late in the autumn of 1893, provoked by his roommate Bourges' decision to marry. The two men had shared lodgings since 1887. Bourges, who seems to have been a paragon of responsibility and kindness, had for years now taken care of Henry almost like a child, watching over his medical problems and his lifestyle, trying to influence his behaviour as well as treat him for his maladies. In practical terms, Bourges had taken on the role Adèle had formerly played in her son's life, and Henry had grown dependent on Bourges at every level, including for the everyday help he needed with the physical difficulties of running a household. As the years had passed, and Henry's alcoholism led to unpredictable behaviour, Bourges had become an important buffer against the outside world.

As late as June 1892, Bourges and Henry had been talking of getting a larger apartment together. The nature of Henry's friendships, as single-minded as his artistic obsessions with certain models, meant that Bourges had been his 'best friend' for the past six years. Now Bourges had decided to leave their lengthy comradeship to get married, and by extension to have a family – two things Henry had nearly lost hope of having in his own life. There was also a material problem: Henry wouldn't be able to maintain the apartment at 21, rue Fontaine all by himself. Henry repeatedly complained of the disruption in letters to Adèle and to his Grandmother Gabrielle as he began dispiritedly to look for another place to live.

This event seemed to provoke Henry into an obsession with living places which went on for years. Returning in some sense to the vagabond quality of his childhood and paralleling Alphonse's constantly changing lodgings, he moved a number of times, and renovated several flats. Henry seemed restless and nestless, moving from his own digs to a friend's for a night or two, spending almost every weekend in the country with the Natansons, Bourges and his wife or Joyant, on one occasion moving in for weeks with a neighbour, J. Robin-Langlois, while remodelling his own apartment. His

passing stays in brothels, literally *maisons de passe*, seem closely related to this compulsion. Not unaware of the comic aspects of his nomadism, he stayed briefly once in a Paris pension called Henry's Hotel.

A letter he wrote that same autumn mentioned his distress over another displacement. The increasingly successful exhibitions of the Société des Artistes Indépendants, which had been held at the Pavillon de la Ville de Paris since they began in 1884, were being forced to move. The building was to be destroyed, and the last exhibition was held that autumn. To Henry, the Indépendants, a show that was open to any artist who paid the monthly fee of 1 franc 25 centimes to belong to the society, was another home he was losing. It had been a haven of freedom in the face of the Salon-dominated art world which, as he put it, supported 'only a fraction of art, destined to sink under the imbecility of its jury, which is imbecilic just as all juries are'.

Henry now often stayed out all night, sleeping wherever he happened to be when he passed out from drinking. One anecdote tells of his hiring a cab to go home, but refusing to get out when it arrived, insisting that the driver and his horse wait in front of his gate until he felt like waking up.

In early October 1893, Henry was spending most of his spare time with his cousin Gabriel or with Maurice Guibert. Henry sent a trick photo Guibert had taken of him (see illustration on p. 285) to Adèle who was still in Malromé, and Guibert himself improbably sent her (on Henry's recommendation) a 'banana plant that was going to be thrown onto the rubbish heap'.

Henry sounded bored, commenting to Adèle that putting his wine in bottles had been interesting, 'but less interesting than drinking it'; however, he was not as inactive as he sounded. Henry always worked on several fronts at once. Making prints and posters continued to be his primary activity. By November, he was writing enthusiastically to Adèle, saying he was printing with 'might and main', that his experiments in lithography were going exactly as he wished, and that he had invented a new printing process which he thought might bring him quite a bit of money. Although he felt a little overwhelmed at having to handle patenting this invention himself, and so far as is known, never actually did so, in a second letter he described how he was directly involved with the printing process: 'I slaved like a black, keeping watch over three machines and doing my work flat on my back under the printing press. I've finally finished and believe I have success at hand.'

The process he invented, although not described, may have been a method for producing the unusual spatter effect or *crachis* (spit or drizzle) which

characterizes his backgrounds and closely resembles the effect of resin-ground aquatint in etching. Suppositions as to what this technique was have ranged from running his thumb-nail over an ink-laden toothbrush, spattering the stone, to 'Shooting paint from a pistol … at a lithographic stone', but the most likely description of it was formulated by the noted twentieth-century British artist and printmaker, S.W. Hayter, who described the 'Lautrec bite' as a light wash of soap solution over the whole stone to get an 'almost imperceptible' background.

This delicate bite is used very effectively in the background of a poster he made that year for the singer and comedian Caudieux, who was appearing at Le Petit Casino. It contrasts with the dramatic, flat black pattern of the actor's body to give a sense of infinite perspective. The pinwheel image of Caudieux himself is so large that both legs, one arm and part of his other hand are amputated by the edge of the paper, almost as if Henry were intentionally handicapping him just before thrusting him, spinning, out of the poster. This impression of a sort of revenge through art is heightened by the skeletal, mask-like face of the prompter looking up at Caudieux from his floor-level box at the edge of the stage, as Henry may have looked up at the massive Caudieux while drawing in the wings. From 1893 on, Henry showed an increasing tendency to cut off his models' legs at the edge of the canvas, making them as physically limited as he was.

Now involved with a variety of ephemeral journalistic and printmaking activities, Henry was participating enthusiastically in the production of *L'Escarmouche*, in which, although it only lasted for ten weekly issues, he managed to publish twelve of his lithos. Each image was printed with the commentary: '*J'ai vu ça*' (I saw this), quoting Goya, who had used the phrase as a preface to his etchings, *Los Desastres de la Guerra* (The Disasters of War), for which Henry would later design a binding. Henry's comment was ironic: his lithos were of contemporary Paris life. In addition, he was contributing to the magazine *Le Rire*. Throughout the autumn and winter, he worked on prints for other collaborations: eleven on *café concert* performers for an album with Henri-Gabriel Ibels and Georges Montorgueuil, numerous songbook and sheet-music illustrations for the composer Désiré Dihau, and another collaboration on an article with Gustave Geffroy, for which Henry did seven illustrations, published in colour. Such collaborations between creators were bearing fruit all over Paris. The composer Claude Debussy, for example, was writing *Prélude à l'après-midi d'un faune* based on poetry by Mallarmé and developing the idea that music, like Symbolist poetry, should explore varied tonal effects and freedom of form and structure. On 29 December 1893, his

G Minor Quartet was performed in Paris, where it was recognized as a striking innovation in composition.

Early in December, Henry resolved the apartment problem caused by Henri Bourges' marriage. As Bourges and his wife had decided to keep the apartment at 21, rue Fontaine, Henry rented an apartment on the ground floor of 5–7, rue Tourlaque, in a building which connected around the corner to the building where he already had his studio, at 27, rue Caulaincourt. He wrote his mother a lengthy explanation of his choice: 'This will let me get organized. Either I'll rent the ground floor of the building my studio is in for the same price [800 francs a year] and set up completely [in adjoining spaces] or find another studio with an apartment attached. I doubt if I can get the same amount of space elsewhere for the same price. The advantage

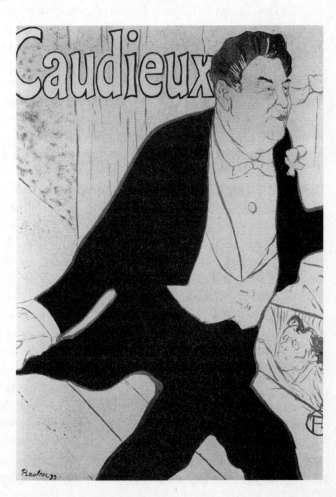

Poster: Caudieux, *1893.*

is that I know the other tenants, the concierge, the owner, etc.' He counted on her support: 'If you could give me six small tablecloths, it would be very helpful, since I'm going to be obliged to set up a household ... some perfectly ordinary table knives would also be a great help,' and as usual, he took pains to rationalize his expenses to her: 'I'm keeping the maid I have now, and find that it is all to my advantage, since for around forty francs a month, my mending is done and I can have lunch at home.'

'All these mundane matters bore me to death,' he continued in another letter, 'and my back really has to be to the wall before I do something about them.' 'I shall have the ineffable pleasure,' he wrote in the same tone to his Grandmother Gabrielle at Christmas, 'of keeping my own household accounts and knowing the exact (?) price of butter. It's charming.' Nevertheless, he had the new lodgings extensively remodelled, camping with Robin-Langlois and his wife in the rue Fontaine while the work was being done, and finally moved into the new apartment in mid-January 1894. In the end he lived there only intermittently over the next year and a half. In July 1895, he moved again into number 30, the same building as Robin-Langlois. Little is known of 'Robin', as Henry called him, except that he was a southerner and an engineer, and that he would be kind and supportive as Henry grew more and more difficult to live with.

In the midst of camping with friends, remodelling and moving, Henry continued producing art with impressive discipline. On 11 December, he and Geffroy had signed a new contract with André Marty to publish a print 'album' on Yvette Guilbert. The definition of 'album' as a collection of photos or autographs had been extended by the Parisian popular press to mean a published book in homage to a certain fashionable person or subject, consisting mainly of illustrations, with a secondary text. These sold rather well, and Henry did a number of them over the next five years including another of Yvette Guilbert in 1898.

He was still 'enormously busy', he wrote to his mother at the end of December to explain why he wasn't going to Albi for Christmas; however, he sent her an urgent request: 'Have 6 red flannel shirts made for me, with wide collars and large buttons. All the buttonholes should be horizontal.' This extremely precise and eccentric sartorial detail fits in with substantial circumstantial evidence that an excessive preoccupation with his appearance had become one of Henry's *furias*. Gauzi and other friends observed that around this time, Henry became compulsive about hygiene, acquiring an elaborate set of bath brushes and manicure tools and taking long daily baths, no easy matter in a flat without running water. A maid is reported to have

given notice because she couldn't tolerate his *manies*: his requirements for clean clothes and perfectly ironed silk shirts several times a day.

At Christmas 1893, Henry was working on a poster for the serial *Au Pied de l'échafaud* (At the Foot of the Scaffold) which was going to be published in *Le Matin*. This poster is one of his most grisly works, designed to illustrate the memoirs of the Abbé Faure, chaplain at La Roquette prison, who had been present at more than thirty-eight executions. Ernest Maindron described the poster thus: 'It shows the victim's last moment: he is about to pay for his crimes. He is frozen with terror; the blood has congealed in his veins. The head, about to fall, is wonderfully observed and horribly realistic.'

The timing of the poster may have been coincidental, but its subject fitted in well with Henry's mood of grim humour and violent activity. Henry had often shown an interest in La Roquette prison, where the condemned were guillotined at the end of the nineteenth century, and there are several reports of him trying to persuade friends to go with him one morning at dawn to witness an execution – a practice, celebrated by Emile Zola in his 1880 novel *Nana*, which apparently was not uncommon among a certain group of elegant night-owls, who liked to take their mistresses to view a decapitation at the end of a long night's revelry. Whether Henry actually got up the courage to go is not clear, but he referred to La Roquette often, as for example when he called getting puppies' ears docked '*une vraie petite roquette*' (a true little Roquette).

A fascination with death pervaded his work during this period, appearing both in his subject matter and, abstractly, in his compositions, which often represented eerily lit or cadaverous faces. Of the series of eleven *café concert* prints he was doing with Henri-Gabriel Ibels which were published on 13 December 1893, six bear such features. This preoccupation with death stands out particularly when his prints are regarded collectively over the period 1887 to 1894. Beginning with the Mirliton illustration *Dernier salut, salut au corbillard* (a pun on the double meaning of *salut*: Last Salvation, Salute to the Hearse) in 1887, Henry's posters and illustrations on macabre themes included *La Dernière goutte* (The Last Drop: a drawing of a drunk sprinkling holy water on a coffin), 1887; *Le Pendu* (The Hanged Man), 1892; *Au Pied de l'échafaud* (At the Foot of the Scaffold, Plate 33), 1893; *Ultime ballade* (Last Ballad, with an implied pun on the word *balade* or stroll, showing a hearse on the way to the cemetery), 1893; and *Los Desastres de la guerra* (The Disasters of War), 1893. Works on related themes, like his lithograph *Lugné-Poë dans 'L'Image'* (the actor-director in *The Image*, a ghost story), 1894, were dominated by menacing shadows. Even apparently neutral subjects appear-

ing in his art now – bicycles and bicycle racing, a series of works done in law courts and the 1892 series of operating rooms – were related to morbid themes, in that their subjects were manifestations of risk, conflict and threatened health. His schematic, disturbing cover-design in 1893 for the art-book reproduction of Goya's *Tauromaquia* portrayed two skulls: the bull's and the bullfighter's, lying on a matador's cape, red as a pool of blood (Plate 34).

The weather was frightful that winter. Henry wrote to Adèle complaining that he was an 'ice cube', that it was snowing and that he was drinking to fight the cold. By mid-January, he wrote to her that it was ten degrees below zero and he was staying in bed 'like a marmot' to keep warm. On 15 January, he nonetheless had to confront the reality of abandoning to Bourges and his new wife the apartment he had lived in for so many years and establishing himself in the 'fairly vast' new place at 7, rue Tourlaque. 'Having nearly finished moving out,' he wrote to Adèle, 'I now have to face moving in.' He warned her that she would need to give him 500 or 600 francs for 'maid's furniture, kitchen utensils, dishes, armoire, etc.... My poor head is full of numbers, even though I've made a lot of progress on that front.' Despite his constant pleas, it does seem as if he were trying harder to manage his money, for within a week or so he wrote to his friend, André Marty, asking to be paid for work done more than a year earlier. He excused the insistent tone of his letter by saying, 'I'm cleaned out, and I have to put all my accounts in order,' adding, 'the sooner the better'.

He stepped up his artistic production, as if he could conjure away death and find immortality through art. As the New Year came in 1894, Henry was personally supervising the printing of *Aux Ambassadeurs, gens chics* (At the Ambassadors, Fashionable People) for Roger Marx, even down to ordering the paper. He also had two posters due before 15 January, was painting a portrait of his cousin Gabriel, with whom he had dinner once or twice a week, and was preparing works for the first Libre Esthétique (Free Aesthetic) exhibition in Brussels in February. On 26 November 1893, Octave Maus had disbanded Les XX in Belgium to eliminate the 'dead wood', then immediately reconstituted it as the Libre Esthétique. Henry was included in the new group and sent only posters and lithographs: his own way of showing that he too was breaking with past definitions of art.

In February, barely through with his move, Henry went on a trip with Anquetin to Holland to visit museums before their show opened in Brussels. From Amsterdam, Henry wrote to Adèle:

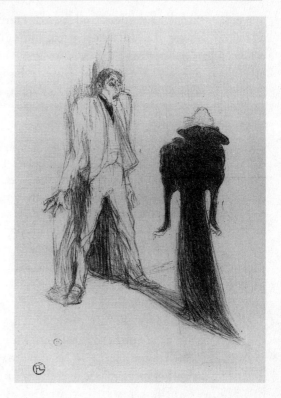

Lithograph: Lugné-Poë dans
'L'Image', *1894.*

We have been, for the last three days, among the Dutch, who barely understand
you. Luckily, we can get by with the little English I know, plus <u>pantomime</u>. We are
in Amsterdam, which is an extraordinary town, <u>the Venice of the North</u> since it is
built on pilings. We've been travelling, Baedeker in hand, amongst the marvels
of the Dutch masters, themselves nothing special compared to the <u>unbelievable</u>
landscape. The amount of beer we've drunk is incalculable, and even less calculable
is the kindness of Anquetin whom I burden with my small and slow person, keeping
him from going full speed, and who pretends that it doesn't bother him.

He later referred to this visit as 'a beautiful week-long lesson with Professors
Rembrandt, Hals, etc.'. According to friends, Henry was absolutely dic-
tatorial in a museum. They were only allowed to stop at works that interested
Henry and only permitted to go on when he was ready.

They ended their trip in Brussels, where they were joined by Joseph Albert
for the private opening of the Libre Esthétique exhibition. The new group
was attracting a lot of attention. Even King Léopold of Belgium came to see
the show, which devoted three of its rooms entirely to decorative arts and
crafts to make the point that the distinction between high art and the

'secondary' arts was artificial and stupid. Henry was noticed in the reviews as being 'among the virtuosos of the lithographic crayon', whose 'cruel' works were 'astonishing in their grandeur, force and incisive irony'. Many of Henry's Parisian friends had gone to Brussels for the show, including Francis Jourdain, who later recounted running across Henry in the Royal Museum

in ecstasy before Cranach's portrait of the Man in Red. After stopping a long time to discuss this masterpiece with our friend, we left him to visit the other galleries. When, an hour later, we passed back by the Cranach again, little Lautrec was still there, his chin leaning on the railing where his companion the painter Joseph Albert was resting his elbows. Lautrec was attentive, absorbed, serious, happily nourishing himself on this work, without however, managing to get his fill of it.

Joyant, who was also in Brussels for the show, later quoted Henry as commenting, 'It's magnificent, it's as beautiful as the side-panel of a delivery-cart.'

Continuing his annual tradition of showing in Les XX, Henry showed in the Libre Esthétique until 1897 and found this contact with the other artists of the avant-garde stimulating to his imagination. It was in the 1894 show that he probably got his first look at the way James Ensor, the Belgian painter, had begun reworking his earlier canvases by painting macabre, mask-like faces into them, adding an inexplicable element of horror to an otherwise conventionally posed work. Suddenly, similar elements appeared in Henry's work, notably in the portrait of Gabriel he had begun before the show opened (Plate 23). In its completed state, dated 1894, the portrait of Gab in the corridor of the Comédie Française includes a grotesque mask, a disproportionate head daubed in white onto an otherwise shadowed area of the canvas, which appears to be painted in as an afterthought, much as Ensor's were. By the time Henry painted his portrait of Gabriel, *Repos pendant le bal masqué* (Resting During the Masked Ball, c. 1899), he showed Gabriel with his own face made up as a caricatural mask (Plate 41). Other grotesque figures, sometimes masked, appear in Henry's portrait of Maxime Dethomas at the Opéra Ball (Plate 40) in 1896 and in *Ballet de Chilpéric* (1896).

The spring of 1894 was full of social and artistic gatherings for Henry – the Bal des Quatz' Arts, which he attended with Gauzi and another friend, Edouard Marty, who went as Hercules in a costume Henry admired enough to make a drawing of, and the annual banquet of the magazine *La Plume*

(published by the Galeries de la Plume), where he sketched a woman's profile on the back of the programme. On 26 April 1894, he drew the menu for a dinner given by the managing editor of *Le Temps*, Adrien Hébrard. This was more a social than an artistic coup, as the latter was 'famous for his conversation and the way he made dinner parties sparkle', but Henry's public reputation had already been further cemented by his colour lithograph *Aux Ambassadeurs, chanteuse de café-concert* (At the Ambassadors, *Café Concert* Singer) which was used in Marty's sixth portfolio of *L'Estampe originale*, printed in an edition of one hundred and sold to collectors. It may have been a copy of this print that he sent to Claude Monet in April 1894, for on 24 April, the older painter wrote him a note thanking him for a 'poster'.

Henry was promoting and showing his work very creatively, even exhibiting the lithographic stones from his *café concert* series in the third Salon des Cent at the Galeries de la Plume in May, pointing out to the public that for him the process of printmaking was as much an art as the product. He showed constantly: in June, when the fourth Salon des Cent was held in the Casino at Boulogne-sur-Mer and again in October, in the fifth exhibition, also held in the Galeries de la Plume. (About fifty Salons des Cent featuring artists' prints were organized by La Plume between 1894 and 1900.) In April and May, at the Salon des Indépendants on the Champ de Mars, he showed the portrait of a pimp, *Alfred la Guigne* (Bad-luck Alfred). It had already been bought, according to the programme, by Oscar Métenier, who had written a play with the same title. Also in May, he showed recent lithographs at the Durand-Ruel gallery in Paris, and joined Anquetin, Bonnard, Sérusier, Vallotton, Vuillard and others in an exhibition of contemporary art arranged by the editor of *La Dépêche de Toulouse*, Arthur Huc, in the newspaper's offices in Toulouse. Huc's effort to introduce the Paris avant-garde to the provinces met with little notice. The conservative population of Toulouse was almost entirely ignorant of and resistant to modern art. Predictably, the few reviews the show received focused their attention on the only 'local' artist, Henry. Anticipating this, Huc had asked Henry to contribute a print for the catalogue of the exhibition, and Henry had not hesitated to thumb his nose at bourgeois values. The print, called *Danse excentrique* (Strange Dance), at first glance is a discreet rear view of a *cancan* dancer holding her abundant white petticoats high up in front of her face. However, Henry left no ambiguity about what she was exhibiting since close in front of her, almost hidden by the ruffles, is the profile of a man in a top hat, viewing the spectacle beneath her lifted undergarments.

Paradoxically, since theatrical principles and styles were not of the slightest

interest to Henry, who openly admitted that he did not even listen to the plays he went to see several times a week, he had begun to be closely engaged with experimental theatre. What he liked there as elsewhere was the sensual pleasure of the spectacle, the play of lights and figures onstage, the sets, costumes and movement, the discreet rustlings in the boxes, the feel of the plush seats.

Over the years that he had been going to experimental plays, Henry had developed friendship and admiration for André Antoine, founder and actor-director at the Théâtre Libre near the Place Pigalle. The fame of the Théâtre Libre had begun in 1887 as a *succès de scandale*, because Antoine was the first French director to turn out the house lights and insist that the audience, instead of watching each other, watch the actors on the stage illuminated by electric spotlights. He was also the first to bring literary Naturalism to the theatre, having his actors eat real food onstage, or hanging a bleeding side of beef on the set of a butcher's shop, and the first French director to produce plays by the dark Scandinavian playwrights Strindberg and Ibsen, captivating a public already well trained by twenty years of gloomy Naturalist novels. However, the only people who could attend his plays were the two hundred patrons who bought season tickets. Naturally they included the élite of the intellectual avant-garde: Henry, the Natansons and their friends. This theatre, and the Théâtre de l'Oeuvre which was opened in 1893 by Antoine's friend and former actor, Lugné-Poë, were to the classical dramatic arts what the new art movements were to the official Salon, and Henry became involved with the two actor-directors, doing programmes, posters and set decors for them over a period of years. Like him, these artists were concerned with stretching the known limits of their art form.

Henry designed his first theatre programme for the Théâtre Libre's double production of *Une Faillite* (A Failure) and *Le Poète et le financier* in November 1893, also doing a companion litho of Antoine and the actor Firmin Gémier. Although Antoine liked the production of *Une Faillite*, calling it 'the most pathetic tragedy ever produced', the play lived up to its name.

Henry's last programme for the Théâtre Libre, which closed down in 1896, was for *Le Missionnaire* which opened on 24 April 1894. For it, he did the preparatory painting and lithograph known as *La Loge au mascaron doré* (The Box with the Gilded Mask), which became one of his best-known lithographs. In this work, Henry took as his subject not the play or even the stage, but the audience, paradoxically focusing on precisely what Antoine did not want to be visible in his theatre. The litho shows two spectators, in fact two friends, the young British artist Charles Conder and a red-headed

woman with opera-glasses who strongly resembles Jane Avril, sitting in a theatre box. Henry had often shown performers with spectators observing them, as in the *Moulin Rouge, La Goulue* poster, but his explicit representation of the spectator rather than the spectacle had begun that autumn with the litho *Une Spectatrice* (A Spectator) for the *caf' conc'* album he had done with Ibels. Now the spectator became a recurring theme in his work. The choice of subject could be considered reactionary on Henry's part, expressing his preference, which Renoir also shared, for the old-style performances with the house lights on, or more simply, it could be a way of showing his own role as voyeur or another example of his desire to reveal what was hidden, to show people who did not know they were being observed, to watch them watching something else.

Henry also did programmes for Lugné-Poë's Théâtre de l'Oeuvre, which featured actors playing 'in a frenzied style with their backs to the audience'. Aurélien Lugné had added the 'Poë' to his own name, perhaps in homage to the American poet Edgar Allan Poe, who was something of a cult figure in France, known through the magnificent translations of his work by some of the best poets of the century, including Baudelaire, Verlaine and Mallarmé. Lugné-Poë's theatre had earned its reputation in part by virtue of the contrast it offered to that of his friendly rival, Antoine, who was experimenting with Realism and Naturalism. The Théâtre de l'Oeuvre joined with the Symbolist poets and Nabi painters to produce theatre which was abstract and fanciful in nature, seeking deeper, symbolic meaning in plays which were often ritual or even childlike, concentrating on provoking catharsis in the audience without relying on a concrete, realistic dramatic situation. The Théâtre de l'Oeuvre is best remembered today for mounting the first production of the tradition-shattering *Ubu Roi* by Alfred Jarry on 10 December 1896. Henry, always eager to participate in the latest scandal, helped paint the sets, along with Bonnard, Vuillard, Sérusier and Jarry himself.

Now that Art Nouveau had an official existence and its accompanying theory of 'art everywhere' – that is to say, that even everyday objects were worthy of beautiful design or decoration – dominated Paris fashion, Henry extended his interest in covers for theatre programmes and sheet-music into a brief but intense involvement with designing the images for bookbindings. He had begun collaborating on a design for a book cover even before the first French exhibition of bookbinding as an art form, in late spring 1893, at the Salon du Champ de Mars, when it attracted both positive and negative critical attention as a 'revolutionary' art form and inspired the appellation *reliure artiste* (artistic bookbinding). Aesthetic choices in bookbinding had

historically been the decision of the owner of the book, who bought it unbound and uncut. Collections of books typically were bound in matching Morocco leather with gold lettering and Italian endpapers. Students and others without much money never got around to having their books bound at all, but read them in unbound paperback, cutting the pages as they went. Thus an artist who chose to design a modern exterior for a book was considered to be making another inroad into the definition of art, moving into a formerly artisanal domain with historic conventions.

The first record of Henry's interest in bookbinding as art dates from early 1893, when Henry made contact with a Nancy bookbinder named René Wiener. Wiener was a friend and possibly a cousin of Henry's own friend and loyal supporter, Roger Marx, also a native of Nancy. On 14 January 1893, Henry had written Roger Marx a note asking him for the address of the bookbinder he had mentioned. 'It's urgent,' Henry had added, although no evidence remains as to what created the urgency for him. They began a collaboration which continued intermittently through the next year or more. By the end, Henry had done designs for two book covers: *L'Art Impressioniste* by Georges Lecomte (1893) and an edition of Goya's *Tauromaquia* (1894). A close look at this collaboration shows the care with which he worked.

Wiener kept many of the letters and sketches documenting these projects. The first letter from Henry is dated 11 March 1893, saying that he has received the 100 francs for the *carton* (design) Wiener was commissioning for the binding of *L'Art Impressioniste*. Wiener seems not to have realized either that this was a bargain price or that Henry was a famous artist. A letter from Roger Marx reassured him that 'a Lautrec at this time is worth 3[oo] to 400 francs, I suppose depending on size', and 'I am not as uneasy as you seem to be about the Toulouse-Lautrec *carton*, which you were lucky to obtain at the time when his exhibition [with Charles Maurin] has him in the limelight and he is swamped with commissions. The masses are well distributed, its appearance is unusual.' In a later letter he remarked, 'saw Lautrec ... he's really one of the finest artists of today'. In another letter he observed, 'He's one of the biggest stars of Impressionist art, and he's done a lot of things with Japanese influence.'

Henry himself had not yet seen any of Wiener's work. He saw it for the first time when the Salon du Champ de Mars opened in late May 1893: 'I was very interested to see your bookbindings exhibited at the Champ de Mars.' He seemed excited by the collaboration and signed his letter almost effusively: 'please be assured of my great involvement.'

Henry wrote to Wiener again while on holiday in Taussat-les-Bains late

that summer, describing the design for the cover of *L'Art Impressioniste*, showing a cormorant and a crab. The subjects, as usual, refer to the things that interested him at the time he did the drawing, in this case, the fauna of the seashore. A naturalist looking at the drawing was impressed by the accuracy of the scientific detail, even in a greatly simplified drawing, and noted that it showed a male common cormorant in mating plumage and that the position of the bird's foot and beak were characteristic of cormorants, indicating that Henry had carefully observed his model. The cormorant was no doubt one of Henry's own hunting birds, for he referred to his cormorants in a letter that summer, and the study clearly shows the ring placed around the bird's neck to prevent its swallowing its prey. Similar precision in Henry's rendering of both the body and position of the crab show it to be unmistakably the edible crab common on the Atlantic seacoast, which the French call a *tourteau*. The finished binding was exhibited at the Cercle pour l'Art in Brussels in 1894 and was purchased by the Musée des Arts Décoratifs in Brussels.

Curiously, the second cover Henry did with Wiener, *La Taureaumachie*, for an album of Goya's etchings, was also Henry's second cover for a collection of works by Goya. It must be unusual for an artist to draw the cover for a book of another artist's work and more so that Henry should have done so twice, both times for the same artist. The first cover, a lithograph printed on vellum, was also made in 1893 for the 1892 edition of Goya's prints *Los Desastres de la Guerra*.

Both book covers are macabre, reflecting Goya's themes, but also the themes of death and foreboding which had been appearing repeatedly in Henry's work in recent years. *Los Desastres de la Guerra* is dominated by a looming vulture, with the menacing shadows of Napoleon and a French officer in the background.

For the enormous *Taureaumachie* cover, the front of which measures nearly three by four feet, Henry used the whole book surface, including the spine and the back as part of his overall design (Plate 34). Henry's approach to the subject possibly had been provoked by his brief trip to San Sebastián to see the bullfights in the summer of 1893. Although no other works exist from this trip, an anecdote survives describing a portrait by Henry of the bullfighter known as El Agujetas who apparently was not appreciative of the honour, saying: 'If my mother saw me like that she'd have a nervous breakdown.'

Henry took great care with the binding preparations, giving Wiener specific instructions about the colours to use on his images: 'Make the outlines

greenish, the bones white and the red fairly glossy,' and requested the same green-yellow leather Wiener had used in an earlier binding.

From references in more than one letter, it looks as if Henry, with his usual concern for accuracy, actually arranged to borrow two skulls (one human and the other of a bull) from the natural history museum in the Jardin des Plantes. He depicted them in his preparatory *carton*, an oil study on cardboard.

Wiener exhibited the binding in Nancy from 22 June to 31 July 1894, but Henry didn't go to see it. It was also reproduced and reviewed in *La Revue encyclopédique*, 1 October 1894, and a list of the books Wiener exhibited in the 1895 Salon du Champ de Mars included *La Taureaumachie*, but he stopped binding books altogether shortly after. In 1894, Henry asked Wiener to make a leather belt to match a buckle he had bought from the sculptor Jules Desbois.

Henry's interest in new forms, even though, as he put it, he was '*tout à la lithographie*', placed him at the cutting edge of innovative art. The official Salons had never showed much interest in artist-printmakers and the Parisian critics hated them. When the Durand-Ruel gallery gave Henry a print show from 5 to 12 May 1894, Camille Pissarro noted in his journal that a critic had berated the 'gangsterism of Lautrec'. Nonetheless, the show attracted so much attention that *Le Fin de siècle* announced that people were waiting in line to get in.

The time Henry was devoting to drinking and the brothels was beginning to have a serious impact on his artistic reputation. In April, he had managed to endanger his forthcoming show with Durand-Ruel by missing an appointment. His frantic telegram bears witness to the disorder in his life: 'I was dumbfounded to find your card. But I had waited in vain for a model and was sleeping so deeply that I didn't hear you ... Pardon my sleep and believe me to be yours truly.' Later that year he offended Durand-Ruel again, this time by asking the dealer to meet him at 24, rue des Moulins for a business appointment. When the coachman pulled up at the address, it turned out to be a brothel, already known in 1889 for 'having an assortment of the most remarkable women and the most varied styles for the jaded client'. Durand-Ruel went in, but the coachman insisted on waiting down the street, in front of a more respectable building.

This brothel in the rue des Moulins had become a favourite hangout of Henry's, serving as backdrop, it is said, to his ongoing series of brothel paintings. The most famous of all his brothel works, *Au Salon (de la rue des*

Moulins) (Plate 36), was presumably done there. It is an imposing work (44 × 52 in.) showing a madam surrounded by her girls, all of whom have the characteristically vacant faces and passive body language he used to demystify their eroticism. Henry also did a pastel copy in nearly the exact dimensions of the original with different colours, although his reason for doing so is unclear (Plate 37). His dealer friend Joyant later wrote that the pastel copy was a colour study 'to treat the subject like an Utamaro woodcut'. Critics have suggested that the copy was a study for a lithograph, but there is no apparent reason for its size if that was Henry's intent.

Henry's unsentimental images of women, whether sensitive or brutal, were somehow tied to his own deformity. His contemporaries repeatedly noted that Henry revealed ugliness where others saw beauty. A critic

A room in the Rue des
Moulins brothel, c. 1896.

commented: 'he saw the sharp, fierce side of things ... exploring [the surface] to find the cracks in it.' Rothenstein observed in talking about Henry's art that along 'with his misanthropy and his personal excesses, he had the spirit of an epicure – he saw the artistic refinement of many revolting elements of human life', while Leclercq merely commented that Henry sometimes seemed 'haunted' by particular models, becoming so familiar with their faces that he could draw them directly on the lithographic stone from memory.

Confirmed documentation of Henry's relations with women is sparse. Most of those who knew and could have told (Maurice Guibert, Maurice Joyant, Gabriel Tapié de Céleyran, Henri Bourges, etc.) did not discuss Henry's love life in any detail. But a model's presence in Henry's work consistently reflects whom he was seeing at a particular time and how inter-ested he was in the individual. Thus the frequency of brothel paintings from 1892 onwards lends credibility to accounts by friends such as Thadée Natanson of Henry's relations with prostitutes. This is further supported by a curious photograph he had taken in 1894 of his *Au Salon* painting in his studio. Although the artist himself is fully dressed, the other person in the photograph is a nude woman holding a long spear. She seems to be the model for the central figure in the work, although that figure is clothed. Leaning against the bottom of the easel are three other paintings representing aspects of prostitution. Henry, in carefully composing such a photo, seems to be making a formal response to those who would have liked him to be more conventional, whether they were art critics or his family.

Henry's sexual images often contain an element of perversity or degrad-ation of women, as in the photograph, in which only the woman is naked, treated as an object, while he remains fully clothed. At almost all periods of his adult life, his work contains numerous obscene caricatures in which he and others are depicted in compromising situations. The latter form circumstantial evidence that he and his friends shared partners or were present during each others' sexual encounters, although the drawings may also have been from purely imaginary sources. Given his traditional stance as a voyeur, he may have been more an observer than a participant in many of the scenes that intrigued him. It is said that when he met a man who had read Krafft-Ebing's *Psychopathia Sexualis*, he immediately wanted him to describe it in detail. Nonetheless, there are at least two accounts of people discovering him undressed in the company of two women at a time.

As an art student, Henry had also begun to frequent lesbian bars, especially two, located close to his studio in the rue Caulaincourt, called Le Rat Mort

(The Dead Rat) and La Souris (The Mouse). There he observed, as Bonmariage said, 'with a sort of troubled fascination', the rituals, rules and relations of women who preferred the society of women. Le Rat Mort in the Place de Clichy, one of the oldest cafés in Montmartre, was so famous that its Second Empire decor – huge mirrors and elaborate gas lamps – appears in paintings and drawings by Forain, Manet and Degas. As early as 1887, Henry and fellow *rapins* from Cormon's had gone there for lunch, in a little room on the mezzanine where William Rothenstein remembered first meeting Henry:

The Rat Mort by night had a somewhat doubtful reputation, but during the day was frequented by painters and poets. As a matter of fact it was a notorious centre of lesbianism, a matter of which, being very young, and a novice to Paris, I knew nothing. But this gave the Rat Mort an additional attraction to [Charles] Conder and Lautrec. It was there that I first met Toulouse-Lautrec, Anquetin and Edouard Dujardin ... The luncheon at the Rat Mort cost two francs, which was rather a large sum for me.

Henry and a model in his studio, 1895.

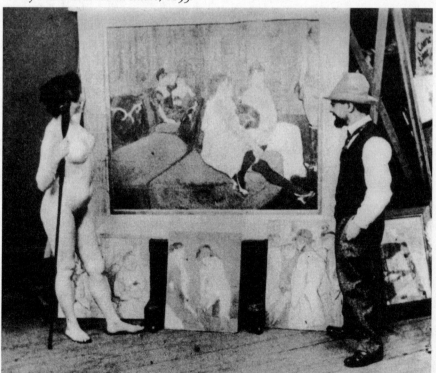

There was an atmosphere of ill-disguised eroticism surrounding this place which had long been frequented by the most provocative members of the literary and artistic avant-garde. It was in Le Rat Mort, for example, that on a dare, one day in 1872, the poet Arthur Rimbaud cut the wrist of his homosexual lover, Paul Verlaine. When they left the café, Rimbaud stabbed him three more times in the thigh. The more easily intimidated went to La Nouvelle Athènes, in the rue Pigalle.

In the late 1880s and 1890s, Le Rat Mort was haven to a number of disparate groups, homosexuals of both sexes, Italian artists' models who gathered there when the Monday *marché aux modèles* in the Place Pigalle was closed, and writers from *Le Courrier français*, who sometimes had poetry readings there on Fridays. It is possibly through them that Henry originally discovered the place, since they wrote about it as well as about their other favourite hangouts, L'Elysée-Montmartre and L'Abbaye de Thélème. So-named because a huge dead rat had been found in the basement beer-pump on opening day, Le Rat Mort had walls decked with illustrations of the life of a rat, and the menus had similar drawings by one of the better-known illustrators of the time, Henry Somm.

Late in 1892 or early in 1893, Henry had done a series of oil paintings representing the caresses of lesbians in their bedroom (see Plates 38 and 39). Le Barc de Boutteville, who had a permanent 'Impressionist and Symbolist' exhibition to which he added new works, immediately caused scandal when he showed these paintings. He had hung in his gallery window Henry's *Dans le Lit* (In Bed), a canvas of a lesbian couple in bed together kissing. A horrified neighbour protested and the police were called. Le Barc removed it. Scandal notwithstanding, there was a tradition in France of pornographic works representing lesbian relations, painted for a male audience which found them titillating. It is significant that although Henry's brothel paintings remained largely unsold at his death, his friends bought the works showing lesbians for their private collections. Charles Maurin paid 400 francs for *Dans le Lit, le Baiser* (In Bed, the Kiss) in 1893; Gustave Pellet, who published some of Henry's brothel lithos, owned two of the lesbian works and the critic Roger Marx owned another.

These are almost the only works Henry ever painted which show any tenderness between human beings. His ability to show love between women when his representations of heterosexual couples are uniformly cynical may have sprung from the fact that love between women was not a specific rejection of him, but of all men. For him to paint tenderness between a man and a woman forced upon him the painful recognition that he was not the

Lithograph: Eros vanné, *1894.*

man in the couple, and probably never would be. But Henry may also have felt rejected by lesbian love. One of his most self-revelatory lithographs was done in 1894 as a sheet-music cover for 'Eros vanné' (Worn-out Love), a song Yvette Guilbert performed, about the decadence of lesbianism. It shows a lesbian couple standing at a bar, and, in the foreground, a naked boy Eros on crutches, his foot and head bandaged, not only a phallic joke, but a figure reminiscent of Henry himself, bandaged and on crutches at about the same age.

Sylvain Bonmariage, in his accounts of Henry's habits, was particularly impressed by this apparent obsession with lesbians, describing Henry as a kind of adolescent gone wild, spending all his time with a 'bizarre harem' of well-known lesbians who had awakened a sort of sexual curiosity in him. According to Bonmariage, they included 'Lucy Jourdan [see Plate 35], one-eyed Armande (nicknamed "Gambetta") and Palmyre, whose bar [La Souris] would later be famous'. Bonmariage elaborated: 'One evening Lucy Jourdan asked Lautrec for a favour – I don't know what – sending him a note by messenger. Lautrec obliged her immediately, including the following

response: "Remember, dear friend, that in certain cases a service rendered can be likened to a proposition." '

Thadée Natanson, who had observed Henry in many different situations, at one point attempted to analyse the artist's relations to women, but even he did not understand how hopeless Henry perceived his situation to be. Natanson described Henry's way of relating to women as unhealthy, somehow lacking in whatever would make a woman take his courtship seriously, saying that above all it was Henry's behaviour that blinded the women to his real depth and 'tragic power'. As Henry's friend, he could easily perceive the richness and subtlety of the artist's personality. What he could not see was that Henry could not simply change his luck with women by changing his behaviour. No matter how great Henry's value was – as an artist, as a friend, as a loving and generous individual – his courtships were always a lost cause, defeated, if not by his physical appearance, then by his conviction that no woman, with the possible exception of his mother, could recognize his true worth. Henry felt that there was no reconciling his inner superiority to his deformity: '*Je ne serai jamais plus qu'un pur-sang attelé à un tombereau*' (I will always be a thoroughbred hitched up to a rubbish cart), he said.

Natanson tells a revealing story of Henry's behaviour with women: 'Let me sit behind you,' he overheard Henry begging a beautiful woman one night when he had been drinking. 'Do not look at me, just listen to what I say to you.' The contrast between superficial appearance and interior complexity was the dominant theme of his experience.

According to friends, Henry craved the presence of women – if he could not be thought a suitor, then he sought just to be tolerated, not ignored, allowed to 'stay in the atmosphere created by feminine odours and nerve-endings'. And the intensity of his unsatisfied desire led him to masochistic behaviour, putting up with almost any treatment so long as he was not totally rejected.

According to Natanson, despite Henry's sometimes cruel pencil and equally scathing remarks, he tended to form servile and unequal relationships with women, whether there was sex involved or not. Such self-depreciating, not to say self-destructive, tendencies gave his amorous relations a suicidal quality. Women seemed to hold a deadly fascination for him, and he defined them as necessarily unattainable: 'The body of a woman, the body of a beautiful woman is not made for love,' he once said to Paul Leclercq. 'It is too exquisite.'

However, Yvette Guilbert's friendly insult: '*Mais petit-monstre, vous avez*

fait une horreur,' perfectly characterized the way Henry increasingly rep-
resented the *monstres sacrés* of the stage. Although he accepted his position
of scapegoat/pet, a drunken dwarf who amused and horrified the women
he idolized, his characterizations of them were sometimes monstrous, in
shocking contrast to the tenderness he showed in works like his brothel
paintings or his offstage portraits of Jane Avril. To the objects of his desire,
when he talked about love, it seemed always to be with the utmost cynicism:
'Ah, love! Love!' he once said to Yvette Guilbert, 'You can sing about it in
any key you want, Yvette, but hold your nose, my dear, hold your nose! Now
if you sang about desire, we would understand each other, and about the
variety of its explosions, we'd have fun ... but love! My poor Yvette ... love?
There – is – no – such – thing,' he said, pausing between each word.

He repeated to her his family's old edict: 'The heart? The heart has
nothing to do with it. How can an intelligent girl like you mix up "love"
with matters of ...?' As far as he was concerned, he said, lovers were just
animals in heat and a beautiful woman should know that the man she loved
had nothing but depravity on his mind, 'in his eye, on his lips, in his hands
... a bellyful of vice'.

With his male friends, Henry developed a sexual mystique, part of which
was the reputation he had, and probably promoted, for being a sexual super-
man with a larger-than-life sexual endowment – as Natanson put it, 'a penis
with legs'. This presumably explained Henry's preferential treatment in
brothels, although prostitutes say that a man with a physical disability often
has problems with sexual potency. In addition, to a certain extent, Henry's
sexual reputation may have grown out of the widespread cultural belief that
dwarfs are sexually rapacious and have extraordinary powers in that domain.
And although friends who observed Henry naked were convinced that he
suffered from *macrosomogénitalisme*, physicians specializing in endo-
crinology, noting that macrogenitalism is a pre-adolescent condition and
never appears in the adult male, have speculated that the source of Henry's
reputation is very possibly the simple contrast between normal, if large, sex
organs and his abnormally short legs.

Despite his sexual posturing, Henry was ambivalent about his relations
with prostitutes. Although he paid them for their attentions, he seemed
unclear about whether they were mere objects for his pleasure or sources of
tenderness and affection. He repeated more than once how touched he was
the day Mireille, one of his favourites, brought him a bouquet of violets when
she came to the studio to pose. Henry's behaviour with prostitutes in private
cannot be known; in the public salons of the brothels he treated them with a

mixture of buffoonery and affection. Natanson described how Henry, sitting with him in the living room of a brothel, 'would wrap the pendulous breasts of a willing, chubby thing around his neck like the softest muffler'. From Natanson's tone it is clear that, so far as he was concerned, such behaviour was too 'tender' for a business relation.

Was this 'tenderness' or insult? Although he knew many prostitutes well and, having used them as models, eaten with them and observed them at off-hours, came to treat them as friends, there were differences of class and economic standing that Henry could not ignore. Further observations by Natanson of Henry in such situations – for Henry repeated these behaviour patterns for the rest of his life – show that women seemed to lack any reality for him, whether they were admired from afar or available for hire. To Henry they were objects of pure fantasy, creating a disconcerting incongruity between his sympathetic renderings of prostitutes in his art and his dealings with them in person.

It was not uncommon for him to refer in conversation to women as abstract parts: disparate limbs, organs and items of clothing which attracted him individually and collectively. Each part symbolized the desired ideal sexual entity, but the individual woman had no such reality for him. On one occasion, for example, Natanson described the way Henry introduced a woman in his company: 'Let me introduce Paulette to you, cute, isn't she? We're in love ... Hey, stand still! What breasts! Calm down, I'm not going to touch them ... and look at this shoulder. Hold still, already! ... We're in love ... Stop giggling ... We're in love ... Hasn't she got the ass of a little princess? You're forced to love her ... you have to, you know?'

At other times, as he and Natanson were talking, he would wax eloquent on the general category of feminine charms. He loved red-heads, he said, and didn't mind women who were past their prime, especially if they were very thin. He loved their armpit odour, he said, because sniffing it reminded him of their past splendour. He called that kind of smelling of women 'technique du gousset' (the armpit method), and their armpits, 'tobacco shops'.

He would talk about women's mouths, the colour of their faces, their hands, the smell of their hair, their thighs and those soft, hidden nooks of the body – for example, the inside of knees and elbows, where the skin is 'made of living silk which never gets worn'. 'You had to have seen Lautrec playing, for as long as an hour, with a woman's hand,' Natanson said. 'If she tried to withdraw it, he would hold it delicately in his palm, caressing it, rubbing it against his furry cheeks, his very large nose, his eyelids, his ears, sniffing its dampness without ever even touching his lips to it. Then starting

all over again.' Henry was very conscious that for him the experience of women was deeply sensual and involved all his senses.

Henry was also fascinated by female accoutrements: clothes and hats, corsets and underclothes, jewels, veils, muffs, perfumes. Natanson once observed him looking almost ecstatic as, with his eyes shut, he sniffed the stockings a model had just taken off in his studio. He particularly liked seeing women when they didn't expect to be seen – he liked, he said, to see the kinds of dresses women wore precisely when no one was going to see them – as he put it, 'neither to be fashionable, nor to take off'. He would go to dressmakers and milliner's shops, observing the subtle dependencies and power struggles between the purveyors of fashion and their clients. Later, when he got back to his studio, he drew them from memory. In this way, too, he was a child of his family. Henry had heard his mother discuss fashion, had accompanied her shopping since his earliest visits to Paris and, like his father Alphonse, had always loved costumes.

Given to cross-dressing since childhood, having been photographed repeatedly in the garments of his women friends, Henry's relationship to femaleness is complex and ambiguous. In part, it was the comfort of the company of women: part disguise, part showing off, part seduction. Was he fetishistic, unclear about his sexual identity, imitating Alph or merely playing around? In any case, he was thoroughly ambivalent.

One of Henry's favourite Montmartre cafés, the Café des Incohérents, was located at 16bis, rue Fontaine, across the street from the apartment he had shared for so many years with Bourges. In 1893, it changed its name to Le Cabaret des Décadents. Its floor shows were so scandalous and had such political overtones that the government censor's office closed it for a time in 1894.

The café's most provocatively 'Decadent' incarnation came in 1896, when it reopened as Le Concert Duclerc, better known as the *concert du pendu*; it had been taken over by Marguerite Duclerc, a retired 'Spanish' singer from Les Ambassadeurs and Le Cabaret de la Feuille de Vigne. Its star was Joseph Durand whose act was described by a contemporary client: 'The orchestra struck up a waltz, the velveteen curtains opened and we could see a man about thirty years old, thin, his face and head shaved clean, dressed in a pea jacket and white trousers, with a red woollen belt, hanging from a cord ten feet long, his eyes closed, his mouth twisted into a bitter grimace, his hands clenched at his thighs, the veins of his head and hands bulging.' After several

weeks the police closed down the *concert du pendu*, as they had Le Cabaret des Décadents.

Some of the performers at Le Cabaret des Décadents, Jane Avril, May Milton and May Belfort, were also Henry's models. Henry's painting *Au Moulin Rouge* (c. 1894–5, Plate 21) shows Jane Avril seen from the rear, and the strikingly pale English dancer May Milton as the ghoulish blue-shadowed figure in the foreground. She was painted by Henry in the same costume, but less brutally, as a figure study. She is probably one of the lesbian figures he shows in the sheet-music cover, *Eros vanné*. She was reputed to be involved in an openly lesbian affair with the Irish singer May Belfort (whose real name was May Egan), who also sang at the Cabaret des Décadents in 1895. That year, Henry was commissioned to make identically sized posters in contrasting colours for the two women: blue and yellow for May Milton, red and black for May Belfort. These posters, printed in small editions for the singers themselves, were greatly admired. Pablo Picasso, for example, kept the May Milton poster on his studio wall, as evidenced by its presence in his own painting, *Interior with Bathing Figure* (1901).

May Belfort, whom Henry represented in at least ten works, had gained a reputation for corrupt innocence by appearing onstage dressed as a baby holding a black kitten in her arms, and 'miaowing or bleating' her popular song, 'Daddy Wouldn't Buy Me a Bow-Wow', whose lines had a double meaning which was not lost on the French-speaking audience: 'I've got a pussycat, I'm very fond of that.' Henry, enthusiastic, later wrote letters to friends trying to find a mate for the cat, and even got a cat himself. When, predictably, it produced a litter, he tried to give one of its kittens to Adèle.

Bonmariage recounted later that the architect Octave Raquin, who claimed to have had an affair of several months' duration with May Belfort while she was posing for Henry, perceived her as intelligent, a fine performer and sensitive to Henry's artistic goals. Henry apparently had some curious philosophical discussions with Raquin about the failure of his love affair with the singer. 'The final stage of our passions,' said Henry, presumably trying to console Raquin, 'is an immense desire for calm. But who among us would want to start out like that? Also, the way to feel better about a break-up is to think about other people's break-ups, as to accept your own death, is to think about the deaths of your friends.' Raquin, commenting to Bonmariage that he found Henry 'precociously disillusioned', quoted Henry again: 'Don't judge mankind too severely,' Henry apparently said. 'People make love and do evil out of habit; it's not for personal gain.'

The popularity of British performers like May Milton and May Belfort

may have been related to the developing reputation, on the Continent, of the British Isles as an incubator for decadent ways. The British, of course, thought just the opposite, seeing Britain as strait-laced and Paris as a haven for all forms of licence. Oscar Wilde's frequent trips to Paris with his lover Lord Alfred Douglas, as well as the glamorous, libidinous presence at Le Moulin Rouge of the Prince of Wales himself, provided fuel for both prejudices, and the public trial of Wilde for sodomy in April 1895 did much to confirm the British reputation for degeneracy. Notwithstanding a male fascination with lesbianism, French society was far from accepting open homosexuality in men, and when the anarchist Paul Adam, whose May 1895 article in *La Revue blanche* defending Wilde was illustrated by Henry, called Wilde's trial malicious, he was considered to be taking a radically left-wing position.

Henry seemed fascinated by Wilde, apparently announcing that he intended to go to England to witness Wilde's trial, although there is no evidence that he ever did so. He may have asked Wilde to sit for a portrait in 1895, but it has been said that Wilde refused, and Henry's works showing Oscar Wilde were probably done from photographs or from memory.

There is only anecdotal evidence that Henry ever met the British playwright. An 1898 drawing by Ricardo Opisso shows Henry sitting at a café table with Yvette Guilbert and Oscar Wilde, and Leclercq described realizing, one evening while drinking with Henry at the Irish and American Bar at 23, rue Royale, that one of the other clients, wearing a long grey overcoat and a felt hat pulled low over his brow, was Oscar Wilde. In 1898, Wilde, in permanent exile from Britain was living incognito in Paris using the name Sebastian Melmoth.

To the French, Wilde was a perfect example of the British mixture of frivolity, eccentricity, wit and irony which had also been a model of behaviour in Henry's own family. Like Alphonse, like Henry himself, Wilde unhesitatingly transgressed taboos, and like Henry was considered to be the degenerate offspring of an otherwise respectable family. However, Maurice Joyant later violently denied that Henry could have had anything in common with the '*hypocrisie puritaine et protestante*' (the Puritan, Protestant hypocrisy) of Wilde and slightly younger British writers and artists like Arthur Symons, Charles Conder or Aubrey Beardsley, saying Henry was too noble, too clear-headed and virile to be attracted to their 'impotence'.

So far as is known, Henry never had any homosexual relations. But his sexual interests and needs were ambiguous. His unfulfilled passions for women, the intense, exclusive friendships he developed with one male 'best

friend' after another, his bragging about his life in the brothels, or the many times his art focused on anal material such as the hindquarters of horses, women's buttocks and men either viewed from the rear (see illustration on p. 403), or holding phallic objects at groin-level (see Plates 19 and 40), perhaps all bear witness to repressed homosexual longings or confused sexual orientation.

It seems fair to say that Henry was Wilde's parallel in scandalousness, if not in sexual preference, and both felt they were outcasts in their own societies. The difference is that the Irishman was brutally punished for his failure to conform. Henry, who admittedly did not extend deviance into avowed homosexuality, was already marginalized by his disabilities. Given the reputation dwarfs already had for sexual transgression, his deformity may even have been perceived as God's own punishment. Both men used their flamboyantly Decadent behaviour to mask their feelings, consciously self-destructing at the pinnacle of their artistic success to fulfil the prophecy inherent in their reputations as degenerates.

At a more superficial level, Henry also reflected the British dandyism personified by Wilde, causing his friend Francis Jourdain to comment that Henry was *'très élégant, très anglais'* in his dress. Trained by his mother since childhood to be Anglophile, Henry had maintained their affectation of occasionally speaking English together, and often ended letters to her with a few words in the language. Nonetheless, Gauzi as witness supported Henry's contention that his English was very weak. Trying to explain to Americans that they'd arrived too late to see a shadow-play at Le Chat Noir, Henry was only able to stammer: 'Is to end ... The show is finish.'

In the late 1880s and early 1890s, he had befriended a number of younger English artists in Paris. These friends, Charles Conder, William Rothenstein, A.S. Hartrick and a number of other aspiring young Britons, had gathered there to study, living sparingly, taking life drawing at Julian's or Cormon's and usually renting wretched quarters on the *butte*. Henry's relations to this group were marked by a sort of reciprocal fascination. Just as he saw in them the seeds of English Decadence, they were fascinated by him because of his open acceptance of all the things that were taboo in England. To them he seemed the embodiment of 'Parisian' vice and sensuality. He was the artist *par excellence* of the world they were exploring, living it as well as painting it. 'No one who was acquainted with Toulouse-Lautrec could ever forget him,' wrote Symons, '... nor have I ever seen a man so extraordinary and so sinister.' Although Rothenstein did not put it in the same terms, he liked to accompany Henry in Montmartre, observing Parisian Decadence first-hand.

One of Henry's favourites was Conder, who shared lodgings with Will Rothenstein. In 1890, Conder had moved to Paris from Australia, where he had lived for five years, and studied art in the European capital until 1894. A pale, aristocratic-looking youth with thinning blond hair, Conder had a distinguished, slightly effeminate profile which Henry drew in several works. Like Henry, Conder drank too much and had a tumultuous love life which enchanted his friends. They observed, amused, as his Montmartre girlfriend, Germaine, abandoned him for Edouard Dujardin, then returned to him, provoking a challenge to a duel by Dujardin. Each man chose seconds, and they all met in the woods at dawn dressed in black gloves and black clothing. Luckily the seconds were able to arrive at a compromise, and no shots were fired. In fact, duels were so typical of Decadence and of the general exhibitionism of the period that in the 1890s in Paris, they were announced in the daily newspapers as *affaires d'honneur* (affairs of honour), a custom that was only outlawed after World War I.

In addition to frequenting the English in Paris, Henry continued the brief trips to England he had begun in 1892. At the end of May 1894, he went to London for three weeks, probably to deliver the thirteen works he would exhibit in October in a group show at the Royal Aquarium. As frontispiece for the catalogue, the show's organizers, paper manufacturers J. and E. Bella, used their own poster, *Confetti*, commissioned from Henry to advertise the flecks of paper they sold to replace plaster confetti which, considered too dangerous, had finally been outlawed in Paris in 1892. Henry apparently had a marvellous time, travelling with Joyant and going on a buying spree to redecorate his Paris apartment and studio. They met up again with Conder, who had recently moved back to London and was struggling to find his place in the art scene. Henry and Conder, both in formal garb, went out each night to dinner or the theatre, sometimes in the company of Art Nouveau artist Aubrey Beardsley or the English Impressionist Walter Sickert. In the autumn of 1894, Henry returned to London to see his works at the Royal Aquarium and in 1896 he showed there again. He made his last visit to open a one-man exhibition at the London branch of Manzi et Joyant in 1898.

In London in June 1894, Joyant arranged for Henry to meet the American expatriate painter James Whistler, once a friend but now an avowed enemy of Oscar Wilde. As Joyant told it, despite their expectations, they had no conversation about the arts at all. Instead, Whistler went to some trouble to impress them with his culinary knowledge, inviting them to a carefully planned French dinner at the Café Royal, which finally even he was forced to admit was 'quite execrable and a perfect disaster'. Eager to 'beat Whistler

on his own ground', the competitive Frenchmen invited him to lunch at the Criterion, where the 'purely English' meal was perfect. Perhaps the high point of the trip for Henry, however, was visiting a London dog-pound, where he bought an abandoned fox-terrier, promptly named it Judy and planned to ship it home to his mother. It reappeared in Paris in his company two weeks later, named Tommy. It finally ended up at Malromé later that summer.

Suddenly stereotypically British faces repeatedly appeared in Henry's work, not only William Tom Warrener, whom he had portrayed in *L'Anglais au Moulin Rouge* in 1892, but also Tom, a cockney coachman who worked for the Baron de Rothschild, Conder and Wilde, whom Henry used in at least four works. Henry also painted, drew and made prints of a series of transient British and Irish music hall stars such as Ida Heath, whose aquiline nose he portrayed both onstage and at the bar, dedicating one of the lithographs to Chéret. This attention in his art to British friends and performers is noteworthy, as Henry is not known to have used other non-French models with any consistency.

Just a few days after Henry got back from London, the French President Sadi Carnot was assassinated, on 24 June 1894, in Lyon by a young Italian anarchist named Santo Jeronimo Caserio. This murder was intended to avenge the execution of the anarchist Emile Henry for throwing a bomb into the Café Terminus in Paris, an act itself designed to avenge Carnot's refusal to pardon the executed anarchist Auguste Vaillant, who had bombed the Chambre des Députés in December 1892. Carnot's death was part of a chain of violence which had begun with government repression of strikers in 1891 and gave Henry's only known political lithograph, *Carnot malade*, unexpected impact for its prophetic resonance.

Henry's response to the assassination and to the election of Jean-Paul-Pierre Casimir-Périer three days later was typical. He was irritated at having his work on the Yvette Guilbert album interrupted by what he described to Théo Van Rysselberghe as 'tawdry banners, military services, official colour portrait prints. In short all the jetsam of a "boorocracy" in delirium.' Was this tone of disdain a bow to Van Rysselberghe's anarchist sympathies or homage to his own family's royalist hatred of democracy? In a letter to Adèle on the day of the election, Henry said: 'all this is very stupid'.

At a time when anarchist bombings kept Paris's nerves raw, and when many of his friends at *La Revue blanche* were committed and, in some cases, violent anarchists, Henry remained largely apolitical. By complete accident

it seems, he was closely involved with a group of 'intellectual anarchists' many of whom had been his friends for years. Charles Maurin, Paul Adam, Tristan Bernard, Gustave Kahn, Théo Van Rysselberghe, Arsène Alexandre, Octave Mirbeau, Emile Verhaeren, Emile Zola and others supported the principle of anarchist protests against the government, if not the bombings themselves. Félix Fénéon, who had reviewed Henry's posters, and whom Henry would portray in at least three works, had been in the Mazas prison since the end of April, accused of bombing the Restaurant Fayot on 4 April. Misia and other friends visited him regularly there, taking him fresh fruit and sweets, but a number of artists and writers fled France to avoid the massive round-up of suspected anarchist sympathizers. In August 1894, the Trial of the Thirty included at least one man, a coffee-roaster, who had been imprisoned for months in a case of mistaken identity.

Although three of the defendants were convicted of theft, all were acquitted of conspiracy charges, and Thadée Natanson picked up Fénéon at the prison on the evening of his release to take him to dinner with Misia and his defence lawyer Demange who, later that year and again in 1898, would defend Captain Alfred Dreyfus in his trial for treason.

There is no evidence that Henry devoted any attention to the matter at all. His concerns were more pragmatic. 'Everything here is ugly and stinks,' he wrote to Van Rysselberghe, repeating his complaints a few days later to Adèle: 'It's hot, and everything stinks.' Just as his preoccupation with personal cleanliness had led a maid to give notice, his complaints about the smells around him led to conflicts with his neighbours on more than one occasion over the next few years. For the time being, he left town at every possible opportunity, going at the end of June to Rouen, in July to Belgium and finally to Malromé and Arcachon for August, with an excursion to Spain in September, stopping only briefly in Paris between trips to take care of business like signing off the proofs of the slowly advancing Yvette Guilbert album.

Henry's July trip to Belgium, as he wrote to his mother, was 'to get complete furnishing information'. He was engaged in seriously redecorating his lodgings in the rue Tourlaque. The February trip to Brussels had fixated Henry on Art Nouveau décor. According to Joyant, who was also there, they were invited to lunch at the home of the Belgian artist and pre-eminent Art Nouveau architect and designer Henry Van de Velde, who had decorated Misia Natanson's salon in Paris. Van de Velde's house was done in such pure *modern style* that it almost made them uneasy. After they left, Henry remarked that the only rooms he really liked were the bathrooms and the

nursery, painted entirely in glossy white. Nonetheless, he had come home from that trip with an Art Nouveau rug, ochre-yellow plates and turquoise pots decorated with peacocks. Even on holiday in August, he was writing to Van Rysselberghe about decorating details, thanking him for purchasing copper hooks for him and inquiring about cloth printed with peacock feathers.

In the autumn of 1894, he hired workmen for the redecorating, using his Belgian purchases in combination with items he had bought in June from Liberty of London and 'furniture from Maple's ... stiff, cold, without decoration', but which, according to Gauzi, stood out by 'the beauty of its material, the fineness of the grain, the faultless workmanship'. Gauzi, who was not entirely impressed with the results, said Henry put a Liberty cotton print 'in harmonious, sickly colours' on his divan, and rigged some kind of draped awning over it. 'The monumental washstand was the piece he was most proud of, because of its spotless white marble and its washbasin, which was hinged so that it could be emptied by tilting it.' Gauzi seemed relieved to notice that Henry still slept directly on a mattress on the floor and that he had kept his bearskin quilt.

By the time he finished, Henry had a *style nouille* (noodle-style) lindenwood mantel set with stained-glass motifs, a custom-made table which had a crank so that it could be adjusted to any height, depending on the size of the diner, as well as low couches and stacks of cushions covered with a yellow Liberty floral print. The walls had been repainted in blue and yellow and were absolutely bare of his own work.

Consistent with his passionate interest in the sensual and decorative aspects of theatre and opera, Henry was creating the *mise-en-scène* for his own *spectacle*. Now his weekly parties were so striking that a writer for *La Revue blanche* included the description of one in a potboiler novel serialized in the magazine in 1897. The author of *La Câlineuse* (an untranslatable title implying a woman who uses caresses to get what she wants), signing his work with the pseudonym Hugues Rebelle, called Henry 'Mauffret-Ponthieu' in the serialized version of the novel. Henry apparently found the name too close to Toulouse-Lautrec, so the author was asked to change it before the serial came out as a book in 1899.

The description in the novel of Henry's studio supported his remark to Joyant that he'd like to decorate his place like 'Menelik's tent, – with lion skins, ostrich plumes, naked women – either black or white in gold and rouge, with giraffes and elephants'.

Changing Henry's name to 'Jacques de Tavannes', the author of *La Câli-neuse* said:

When we were shown in, we felt as if we were entering some strange Pagoda from the depths of Asia. Hanging or leaning against the walls were massed all sorts of things which in the bad light we could scarcely see or guess the use of. It was like both a temple and a country bazaar, full of shadows and glinting lights, lit with rays of purple, shafts of turquoise, the shine of some weapon, the glimmer of silk, full of cracked old pottery and huge dolls with ruddy cheeks who were barely dis-tinguishable from the living beings, men and women, who formed the painter's court. Seated all alone in the middle of a low, wide sofa under an antique hanging lamp at whose opening glowed a fiery star, Jacques lifted his short legs, rubbed his hands together, turned from side to side in perpetual motion. His head, which looked enormous on his tiny body, had close-clipped hair and was engulfed by a stiff black beard which seemed to have grown on him expressly to hide the teasing, faunlike soul revealed by the expression on his face. He was betrayed by his glowing eyes, large flat satyr-ears and sarcastic mouth. He sat there, like a Buddha among his guests, themselves lolling on either side of the divan in silent adoration, solemnly digesting their dinners, eyes fixed on their pipes or gazing at the cigarette smoke rising to the ceiling.

'If you're coming to tell me a secret,' he said in the short, yet somehow lazy accent of a Parisian worker, spitting out his words, but indolently dragging out the last syllable, 'please do so, my dear, for I am alone. Pay no attention to these ladies and gentlemen. They are dead. I gave them too much to eat this evening.'

Later in the same scene, the author described a couple of the sycophantic guests:

Perdriel and Vermacher, who perceived men as something like gold or copper mines, to be exploited for their profit, held Jacques de Tavannes in almost religious esteem. Perhaps it was for his name, or his art, or simply because he could earn so much money by just putting a few lines on a piece of paper, when their own profits cost them so much intrigue. Maybe the gratuitous jokes he played on people impressed and confounded them, since he was not interested in money. In any case, how could they not love a man whose house always offered good food and female flesh – vulgar perhaps, but skilled, and easily satisfactory to the wavering whims of an ageing understudy?

At length Henry cancelled the Friday parties and secretly invited his real friends over on Tuesdays. Finally, he had no more parties at all, but let people

know he could be found every afternoon in a certain bar. For several years from 1894 onwards, it was the Irish and American Bar next door to the Restaurant Weber, at 23, rue Royale, not far from the Hôtel Pérey, which he portrayed in his 1895 poster, *The Chap Book*. There, it is said, Henry presided over the clients in the bar as he had over his house guests, insisting to Ralph, the Chinese-American Indian bartender, that people he didn't like not be admitted. These apparently included Jean Lorrain, the well-known newspaper columnist, who thoroughly reciprocated his sentiments, and Colette's husband Willy (Henry Gauthier-Villars), who called himself a writer, but hired others, including his wife and Henry's friend Félix Fénéon, to write books which Willy then signed with his pen name. In time, the Restaurant Weber bought out the Irish and American Bar, but Henry continued to patronize it. He also liked Le Cosmopolitain, a *bar anglais* in the rue Scribe, behind the Opéra.

The high point of the late summer for Henry was the publication of the Yvette Guilbert album by André Marty. He, Marty and Geffroy all received a glowing review from Arsène Alexandre on 18 August 1894, for their parts in the enterprise, but Guilbert did not much like Lautrec's work, and her friends frankly hated it, even encouraging her to sue him for defamation of character. In the end she agreed to sign the edition of one hundred prints, persuaded perhaps by the liberal politician Georges Clemenceau's commentary, published in his magazine *La Justice*, on Geffroy's accompanying text:

There's no mistaking it: on the pretext of doing an album of Yvette Guilbert, he has just given a speech, and to tell the whole truth, a socialist speech! Geffroy, up on the stage on the café-concert looks into the eyes of the pale muse and concludes philosophically: 'The joke is over my friends!' The idea of turning the macabre singer with her icy, violent irony over to this tranquil Breton, whose eyes are full of dreaminess and will-power, is a sign of deep insight, especially when the philosopher's pen is accompanied by the biting pencil of Lautrec.

Perhaps the most negative review of the album was written by Jean Lorrain. After having helped Guilbert get her start, he had turned against her in 1893, and she no longer saw him. His scathing comments in *L'Echo de Paris* on 15 October were typical of his attacks, for he was a well-known *mauvaise langue* (back-biter):

No one has the right to push the cult of ugliness so far. I know perfectly well that

Mlle Guilbert is not a pretty woman, but to have agreed to the publication of these portraits seems to me not merely a craven but an abject act on her part. Mlle Guilbert has been blinded by her love of publicity; where is her feminine modesty and self-respect? It goes without saying that Monsieur de Toulouse-Lautrec sees everything as ugly, but that you, Yvette, accepted these drawings ... printed in goose-shit green and with those shadows that spatter your nose and chin with shit! ... I came home saddened, a trifle nauseated; I felt the vague and uneasy indignation that one feels on meeting a very pretty woman on the arm of a hideous lover.

Proud of his *bon mot*, Lorrain repeated it several times, referring to Henry's work as 'birdy shits', continuously scandalized that Guilbert would allow herself to 'be drawn by that little jerk who printed you in goose-shit'. The images were in fact printed in olive green.

Nonetheless, she wrote to Henry: '*Cher ami*, Thank you for your lovely drawings for the book by Geffroy. I am delighted! You have all my gratitude, believe me. Are you in Paris? If so, come by my new house, 79 avenue de Villiers [see illustration on p. 309] for lunch next week. Kind regards and thanks again. Yvette.'

Despite their repeated collaborations, Henry's illustrations and Geffroy's text for this album, as for their other work, seemed to bear no formal relationship. Henry's illustrations were a series of drawings of Guilbert in all his favourite poses (see Plate 42), while Geffroy's text was once again a social commentary, this time on the *café concert*, where he used Guilbert's performances as just one example of the cynicism and ironic social criticism he found typical of performances there. Georges Clemenceau, reviewing Geffroy's article in his liberal magazine *La Justice*, admiringly called Geffroy a 'woolly old socialist' and commented that he and Henry made a strange team. Once again Henry remained resolutely unengaged in dogma. That this stance was intentional is supported by the fact that when he did illustrations for other works, the poster *Le Pendu* for example, he showed no difficulty in creating an image which was appropriate to the text.

It seems that for the first time, Henry had now begun collecting art, buying a painting by Van Rysselberghe for Adèle in Malromé in June and requesting prints of work by Eugène Carrière and Auguste Renoir in payment for a litho he'd done for André Marty. He was pleased to learn from Marty in July that fourteen copies of the Yvette Guilbert album had been sold in advance but disappointed that the prints by other artists he'd requested were no longer available. He was forced to accept extra prints of his own work instead.

The Yvette Guilbert album which sold for 50 francs a copy was unusual from a collector's point of view because, except for a few artist's proofs, the lithographic illustrations were not printed in a separate edition without the text. Most of Henry's prints had a double commercial value. He would design the print for a publisher who then reproduced it, by any method he pleased, with the addition of text – whether it was a poster, sheet-music or a journal article. An original design cost 100 francs. However, Henry would retain copyright in his drawings *avant la lettre* (before text) and thus kept the right to reproduce and sell his work without any text. Publishers who purchased his drawings could use them as often as they wanted so long as they added text, which they changed as they liked. They could not, however, sell the design to someone else for reproduction purposes.

Henry, who hoped that his illustrations would be of additional value as separate lithographs, had developed the habit of pulling an edition of each lithograph, even menus, posters and other incidental pieces, before the lettering was added or after it had been removed. These editions usually numbered one hundred prints and were for sale separately. Although he almost invariably ordered such collector's editions, he was inconsistent about numbering and signing them. He generally offered them for sale through an art dealer, usually the printer, who charged between 20 and 50 francs for the collector's prints, of which probably half went to Henry. In fact, they sold badly. Henry was ahead of his time. It would be nearly a century before a true investment market for artists' prints and multiples existed.

Given the slow sales of collector's editions, Henry's concern with marketing them is perplexing. The rather small income from selling prints, like the dubious recognition of being in a second-rate, even amateur, show like the Volney, seems entirely unimportant for an artist whose income and artistic reputation were already assured. However, the time and energy Henry spent on such apparently inconsequential endeavours make sense in the context of his conflicts with his father, who in tandem with Adèle controlled Henry's purse strings.

Living in what can only be described as a weakened but persistently feudal mode, Alph, who had never worked for his living, had taken the position that Henry was both too well-born to stoop to earning his own living, especially through art, and too irresponsible to be given control over his share of the family fortune. Instead he treated Henry as a child, criticized him for his unaristocratic behaviour and insisted that Adèle keep him on a tight financial leash. Henry had not forgotten that Alph had already partly disinherited him and symbolically robbed him of his title by selling the Château

du Bosc to his Aunt Alix. Henry's insistence on earning a living insofar as he could from his own labour was more a response to this disentitlement than it was a successful solution to his financial problems.

The battle was incessant. Henry continued to resist control, and Alph continued to undermine Henry's financial security. In the summer of 1894, for example, Henry discovered that Alph had sold almost two thousand five hundred acres of Ricardelle, the primary source of Henry's annual income. Henry did, however, receive income from Ricardelle's remaining acreage at least as late as 1899. A younger artist, Jacques Villon, knew Henry well enough in 1901 to report that Henry's annual allowance was 43,000 francs. Henry's 1898 financial records indicate that he received around 15,000 francs a year from Ricardelle alone.

Although Henry's income may not have been diminished by Alph's sale of part of Ricardelle, Henry was clearly trying to gain at least some control over his own existence by selling his art. It was perhaps not coincidental that he fought his parents' domination in the way that would offend them most. Not only did he take his work seriously, but as he was increasingly seen socializing with working-class people like his printer Stern, not to mention prostitutes and cabaret performers, it must have seemed to his family that he had become intentionally *déclassé*.

One of the most dramatic instances of Henry's self-destructive alienation from his family was his decision, the same summer his father sold the land at Ricardelle, to store a number of brothel paintings in the Albi townhouse, the Hôtel du Bosc, which now belonged to Uncle Charles. Henry, who was visiting Albi that summer, had a number of paintings in the south, probably including the ones shown in May at the *Dépêche de Toulouse* exhibition, where as a local son he had been singled out in the reviews for criticism of his vulgar subject matter. Inexplicably, rather than shipping them home to Paris after the show, he left them in Albi. Then he went back to Paris, giving no indication that he was aware of the tense situation between his father and his uncle.

For reasons which can only be surmised, Alphonse had decided shortly before to move into the tower of the Hôtel du Bosc, where he lived in arguably pathological isolation, surrounded by owls, falcons and a cormorant, periodically even lowering a basket to the ground with a note in it, requesting that Charles supply him with food or other things he desired. When he finally moved out, his family found the tiny tower room thick with dust and full of curious objects: old clock faces, a crystal chandelier, a helmet from the Napoleonic army and more than a hundred old books on herbal

medicine, cooking, ocean fishes and the classification of animal species. When the weather was too hot, he would move down to the courtyard where he slept in a tent and bathed in a tub. This offended his conservative brother, who stopped the servants from working in the courtyard during Alph's bath-time, so they would not be offended by his public nakedness. Their relations became so strained that Alph insisted that his letters to his brother be carried to the post office and posted, to be delivered by the postman, but he continued to live thus, at least at times, for around four years, largely estranged from his brother, yet totally dependent on him.

When Uncle Charles realized that Henry's paintings, already the cause of humiliating commentary in the press, had been left in his care, he seethed with rage and finally invited witnesses to watch him burn them in the courtyard to 'protect the honour of the family name'. Franz Toussaint, a son of one of the witnesses, later wrote an account of the event: 'One Sunday morning, Monsieur de la Portalière, a close friend of our family whose daughter [Marguerite] married Odon Tapié de Céleyran [the son of Henry's Uncle Amédée and Aunt Alix], stopped my father as he was taking a walk on the city walls. "I've just come from your house," he said. "Charles de Toulouse-Lautrec asked me to get you, Lagonde and Lapanouse to come to his house around four o'clock. He wants us to watch him burn some of his nephew's paintings so we can testify that they were destroyed."' M. Toussaint agreed to go, hoping he could perhaps save the paintings. When the time came, he went to the Hôtel du Bosc and tried to talk Charles out of destroying them by suggesting that he sell the offending works and give the money to one of the many charities he supported. "You can stop right there," Charles answered puritanically. "That money would dirty my hands. I wouldn't contribute it to good causes for anything in the world." Sick at heart, Franz Toussaint's father 'witnessed the *auto da fé* in the courtyard. Eight large canvases by Henri de Lautrec, of his dancers, bareback riders and prostitutes, were thrown onto a pile of grapevine trimmings which was then lit by two domestics. "This rubbish will no longer dishonour my house," announced Charles after the treasures were completely consumed by the flames.' Alphonse, in his tower, presumably was not invited to witness the act, and Toussaint thought he may not have known of it.

After he heard of the incident, Henry apparently declared that he would have only 'funeral relations' with his Uncle Charles and referred to him thereafter as 'the family honour', saying to Paul Leclercq that he found the most amusing part of the incident the fact that the only witnesses Uncle Charles had been able to find for his act of moral indignation were a butcher

and a furniture upholsterer. Later in Paris, Henry also mentioned the matter to Gauzi as a joke, as if he did not consider it very important. But the destruction of Henry's work by his once beloved uncle, the man who had taught him to draw, violently exemplifed the conflict with his family which dominated every aspect of his life. What sense can be made of Henry's risky behaviour in entrusting brothel paintings to a sanctimonious uncle who would feel justified in destroying them?

Although the exact circumstances surrounding these events can never be known, there seems to be no practical explanation for Henry's storing paintings with Uncle Charles. It had been many years since Charles had been his mentor, and Henry was well aware that his uncle was deeply religious and spent much of his energy on good works. The paintings had to be shipped from Toulouse to Albi; they could easily have been shipped to Paris instead. Henry's part in the destruction of his work only makes sense if we look at what may have been unconscious but irresistible pressures.

It has been suggested that much abnormal and even self-destructive behaviour in both children and adults is somehow provoked by the individual's altruistic need to protect a vulnerable parent even if the parent mistreats the child. In some cases, this amounts to the child's taking on the role of scapegoat, by acting badly in order to distract attention from a parent's misbehaviour.

As an explanation for Henry's setting up a situation which led to the destruction of his work, this theory makes a kind of perverse sense. Alph's behaviour in the months preceding the event, living in a self-imposed state of siege in the tower of Charles' inherited home, insisting that his brother feed and care for him as if he were a prisoner, pushed the limits of eccentricity to serious mental disorder. It would seem that Alph somehow felt Charles' property should by rights be his and decided to occupy it in order to make this clear. But for Henry, the embarrassment and pain of seeing his father ridiculed by the family and the whole city of Albi may have provoked an unconscious attempt to divert attention from Alph by creating an even greater scandal. Whatever his motives, that was certainly the result, for although Alph's living in the tower and camping in the courtyard were regarded as innocuous eccentricity by later generations of Toulouse-Lautrecs and Albigeois, it was the burning of Henry's paintings that attracted international attention and, as in the case of Henry's syphilis, caused subsequent generations of second cousins to deny that such a thing could ever have happened.

*

Uncle Charles' 'censorship' of Henry's work was not an isolated example of that kind of behaviour. Social and political repression were significant in France even during the Third Republic, as witnessed by the repeated closings of Le Cabaret des Décadents. The assassination of Carnot had ended a string of anarchist bombings and reprisals, but people remained very uneasy, eager for the government to control unruly factions. The arrest and summary conviction of a Jewish army captain, Alfred Dreyfus, for treason in the autumn of 1894 unleashed a wave of anti-Semitism which led to a distinct polarization of the political left and right which would be exacerbated two years later when it was revealed that Dreyfus had been falsely accused, specifically because he was Jewish and considered untrustworthy by defini- tion. The scandal of the Dreyfus affair went on through the next several years as the real traitor was acquitted and Emile Zola wrote his famous open letter in the press, *J'accuse!*, which brought the political crisis to a head and led to the election of a left-wing government. Even so, the innocent Captain Dreyfus was only 'pardoned' for an act he had not committed. He was not officially cleared until 1906.

Although the injustice wrought on Captain Dreyfus was the pretext for the social and political upheaval that followed in France, the true causes were the same injustices that had led to his false conviction. Just beneath the glossy surface of turn-of-the-century France festered widespread corruption, favouritism and prejudice in many of its most respected institutions: the Church, the army, the government, the nobility, the newspapers and the courts. The fear of attacks on Jews grew so intense that a *caf' conc'* singer, Henri Dreyfus, best known for writing and singing *chansons rosses* (street songs), changed his stage name to Fursy. Marcel Proust, trying to find accept- ance in the elegant living rooms of Paris at the same time, was painfully aware that being half-Jewish made him a permanent outsider.

Henry was in an odd situation. He had been raised by a family where anti-Semitism was an expected mode of thinking. Common in royalist, Catholic, aristocratic families, it manifested itself in a variety of ways from his mother's remarks about his bargaining for carpets with 'all the old Jews in Paris' to his father's rabid anti-Dreyfus position in 1898. But Henry also knew something about how it felt to be an outsider. Now that his leisure time was largely spent with the *Revue blanche* crowd which, as Edmond de Goncourt noted in his journal in 1896, was 'a real nest of young yids' led by the unambiguously Jewish Natansons, Tristan Bernard and Coolus, Henry's advocacy of his family's position became muted, to say the least.

He seemed content to live with this paradox. He did not hesitate to plop

himself down in one of the green leather armchairs at the *Revue blanche's* offices to listen to the conversation of anarchists Verhaeren and Fénéon, but Thadée Natanson was well aware that Henry's father was an arch-conservative as well as an anti-Semite, and that Henry did not wish to have to choose sides in the Dreyfus affair as it obsessed the French for the next few years. Subjected to the conflicting opinions of his family and his friends, he tried to stay on neutral ground, which created some interesting inconsistencies in his work. He had of course done the poster *Reine de joie* for the anti-Semite Victor Joze which had offended the Baron de Rothschild in 1892, but most of his work remained highly personal and intimate with no overtly political agenda: portraits and brothel paintings, along with

Poster: Babylone d'Allemagne, *1894.*

commissioned illustrations, mostly for menus, sheet-music, theatre programmes and the like.

However, one work done in 1894 caused a furor. Late in 1893, Joze had commissioned a second poster, this time for an anti-German work. French xenophobia was not in any way limited to Jews, and the humiliation of losing the Franco-Prussian war in 1870, including France's ongoing payment of reparations, meant that hatred for Kaiser Wilhelm remained high. Joze, of course, made his living from writing potboilers which capitalized on any popular sentiment, especially political anxiety and sexual curiosity. He was at his worst when he combined the two, as he did in the two novels for which Henry did posters. This time his novel was called *Babylone d'Allemagne* (Babylon in Germany), a story about the immoral sexual behaviour of the inhabitants of Berlin. Henry's poster focused the spectator's attention on the hindquarters of four horses, the largest of which was also being closely observed by a caricature of the Kaiser standing in a guardbox. The implications of this, along with the book's title, provoked a protest from the German ambassador to France and nearly caused an international incident. Henry, anticipating that his poster was likely to create as great a scandal as his *Reine de joie*, had paid to have it printed privately, so it could not be seized. Over the ambassador's objections, Henry refused to stop distribution of the poster, and as he had paid for it, the publisher was not able to stop distribution himself. After the *Babylone d'Allemagne* outcry, according to art dealer Edmond Sagot, the value of Henry's work quadrupled.

As the Dreyfus affair progressed, Henry's political neutrality became absolute. In November 1897, in the midst of the continuing uproar, he wrote to the pro-Dreyfus newspaper *L'Aurore*, where Georges Clemenceau was the political editor, saying that he refused to do drawings '*d'actualité*' (of current events), that it was not his style. That same year, Henry was commissioned to do two political works representing two opposing points of view. He completed both commissions: one for Clemenceau illustrating his pro-Jewish work, *Au Pied du Sinai*, and the other for the incorrigible Joze to illustrate another incendiary pulp novel, *La Tribu d'Isidore* (The Tribe of Isidore). It seems clear that Henry had made a decision about such matters: he refused to allow politics or his feelings, whatever they may have been, to interfere with lucrative commissions. Later, in 1899, he not only did not contribute to an album to which a number of other artists had donated work: *Hommage des Artistes à Picquart* (The Artists Honour Picquart), but he refused to sign the petition in which tens of thousands of artists and intellectuals, including many of his best friends, gave public support to this Colonel who

was imprisoned for pointing out the miscarriage of justice in the Dreyfus trial.

In fact, during the Dreyfus affair, Henry's life went on much as it had before all the political uproar. In October 1894, he returned to London for four days for the opening of the print show at the Royal Aquarium. In November, he went with Bourges and his wife to see the sculptures Anquetin was carving for his village church in Etrépagny, wrote letters to his mother about family matters and sent photos of the two of them taken at Malromé in the summer of 1894 by Maurice Guibert. In Paris, Henry's major involvement continued to be with the *Revue blanche* crowd. *La Revue blanche* had just published Jules Renard's heartbreaking novel of an abused child, *Poil de carotte* (Carrot-top), and Henry asked Tristan Bernard to introduce them. Renard was fascinated by Henry, noting in his journal, when they first met on 26 November 1894:

A tiny blacksmith with a pince-nez. A little bag divided in two that he puts his poor legs in. Thick lips and hands like the ones he draws, bony, widely spread fingers and semicircular thumbs. He often refers to short men as if to say 'I'm not as short as all that!' He likes Zimmerman [the bicycle racer] and Péan. Above all Péan, who digs into bellies as if he were looking for change in his pocket.

His bedroom is in a 'house'. Is in well with all those ladies, who have exquisite sensitivity, never felt by honest women, and who are admirable models.

He makes you feel bad at first because he is so little, then so full of life, so kind, punctuating his sentences with little grunts which puff out his lips like the wind puffing out the padded edges of a door.

He is as big as his name.

He returns to the subject of Péan, greatly amused by all the gore, the aluminium table worth ten thousand francs, raised and lowered by piston – by the patient being operated on who slides on the table and has to be pulled back, by Péan's strength: he can move anything: the aides, the patient, the table in one go; he can pull a molar with his fingers; and while butchering talk graciously to his audience ...

Constantly the same grunting, the same desire to tell you about things that are 'so stupid they're great'. And bubbles of spit fly into his whiskers.

The progress of their friendship is interesting to follow. On 9 December, Renard and Bernard dropped by to see Henry at his studio, where Renard was shocked at what they found:

Yesterday at Lautrec's with Tristan Bernard. From a street where it was pouring rain into a suffocatingly hot studio. Little Lautrec opened the door dressed in a

shirt, with his trousers falling down, and wearing a flour-worker's hat. The first thing I saw, on a sofa at the back of the room, was two naked women, one showing her stomach, the other her behind ... Bernard went to shake their hands, saying 'Hello, *Mesdemoiselles*!' I was too embarrassed to look at the two models and wondered where to put my hat, coat and dripping umbrella. 'Don't let us keep you from working,' said Bernard. 'We've finished,' said Lautrec. 'Put your clothes back on *Mesdames*.' He went to find a ten-franc piece which he put on the table. They got dressed, partly hidden behind some canvases, and every now and then I ventured a glance in their direction, without managing to get a proper look; I can still feel their defiant stares as I blinked at them. At last they left. I had seen pasty buttocks, drooping breasts, red hair, yellow body hair.

Lautrec showed us his 'brothel' pieces, his early work; from the beginning it was daring and ugly. He struck me as above all curious about art. I'm not sure that what he does is good, but I know that he likes the unusual, that he's an artist. This little man who calls his cane 'my little staff', who undoubtedly suffers because of his size, deserves by his sensitivity to be a man of talent.

Henry was very busy and feeling exhausted: 'nothing but marches, counter-marches, appointments, etc.,' as he said to Adèle. He seemed to be very active in promoting a whole series of projects, both his own and others'. As ever, his own obligations didn't keep him from tirelessly writing notes and making appointments to introduce artists to dealers and to each other, the French art world to the British and the Belgians.

For himself, he was working simultaneously on the sets for a play called *Le Chariot de terre cuite* (The Little Clay Cart), a new colour lithograph of Yvette Guilbert for publication in *Le Rire*, getting entries ready for the second Libre Esthétique exhibition in Brussels, continuing work on redecorating his apartment and preparing his own new magazine *NIB*, which was published for the first time on 1 January 1895.

NIB (a title meaning 'nothing special' or 'nowhere') was a four-page supplement to *La Revue blanche*. Its first issue was completely illustrated by Henry, with text by Tristan Bernard. The second issue was written by Renard and drawn by Vallotton, and the third was written by Coolus and drawn by Bonnard. Henry had suggested the unfortunately prophetic title. The magazine proved too expensive and folded on April Fool's Day, 1895, after only three issues.

In his issue, Henry drew everything, including the advertising for Chocolat Potin, a brand of powdered cocoa, showing his favourite new models, a clown act called Footit et Chocolat who were performing at the Nouveau Cirque. The advertisement, possibly the first example of the comic stooge

act, shows George Footit, a British clown, kicking his fall guy, the black clown known as Chocolat, and insulting him, saying, 'You dirty darkie … you aren't Chocolat … There's only one Chocolat … That's Chocolat POTIN.'

Having befriended Footit and Chocolat, Henry introduced them to the Irish and American Bar where he later showed Chocolat dancing, with the bartender Ralph and Tom, the Rothschilds' coachman, looking on. Apparently Chocolat introduced ragtime music to the habitués and generally enlivened the mood at the bar, which was frequented by an odd assortment of individuals: Claude Debussy, whose *Pelléas et Mélisande* was to open the same year, and who was virtually unknown outside *La Revue blanche*, May Belfort after her shows at the Cabaret des Décadents, but also jockeys and other racetrack characters ('people in checks' as Debussy called them). George Footit and Henry loved to bet on almost anything. One night they provoked a foot-race up the Champs Elysées to the Arc de Triomphe, between two competitive but out of shape and somewhat inebriated literary types. On another occasion Footit bet Henry that he could get into his bedroom on the third floor of the building without using the staircase. Henry and his friends watched amazed while Footit free-climbed up the front of the building, scrambling from crevice to ledge, and finally made it in through the window.

Footit also inspired an article in the 26 January issue of *Le Rire* written by Coolus and illustrated by Henry, called *'Théorie de Footit sur le rapt'* (Footit's kidnapping theory) highlighted by a sexually ambiguous drawing at the end of the article showing Footit dressed in a dancer's tutu, reminiscent of Alphonse's legendary costume from Henry's childhood. All that is visible of Footit, who is taking a low bow, is his buttocks and the back of his legs, surrounded by the billowing tutu.

From a biographical perspective, the most significant image Henry produced at this time was the new signature he created for himself in *NIB*: a small drawing of an elephant with his monogram inside its body. It appeared in a marginal *remarque*, which in this case was a separately printed lithographic stamp. Such stamps, showing Japanese influence, were often used by artists at the time. From now on, he often made small lithographic *remarques* which appeared in the margins of larger lithographs but could also be printed separately, sometimes as calling cards. As time passed they included a variety of subjects, but Henry's most interesting use of them was as a series of true 'remarks' – self-images, varying from his own monogram printed into animal bodies: an elephant, a mouse, a series of little dogs, and

his own caricature, seen from the rear, naked and squatting in front of a drawing board.

Much can be made of the images he chose, from an elephant, the largest of the land mammals with its phallic trunk, long an advertising symbol of Le Moulin Rouge, to the mouse, capable according to legend of scaring the elephant and symbol of two of his favourite lesbian bars: Le Rat Mort and La Souris. At the time he had begun to keep dogs and even a cat as pets in Paris and over the next four or five years would own a series of small dogs, usually fox-terriers, each briefly. As for his caricatures of himself, they are in the long tradition of his many self-caricatures, which frequently include obscene or scatological references and invariably show him as smaller and uglier than he was.

The image of the elephant, no doubt originally inspired by the huge papier-mâché elephant in the garden of Le Moulin Rouge, came from his work with the play *Le Chariot de terre cuite*, for he repeated the elephant image in a number of works thereafter, always emphasizing its long, supple trunk.

Henry's remarque *with his initials drawn inside an elephant, c. 1895.*

This was possibly Henry's most intense involvement with the Théâtre de l'Oeuvre, since he was commissioned both to draw the programme and to do some of the sets for one act of the play as well. *Le Chariot de terre cuite*, a Hindu drama more than a thousand years old, had been adapted by Victor Barrucand, a *Revue blanche* journalist and anarchist sympathizer. Although the traditional plot was the age-old theme of the 'courtesan in love', dear to Romantic playwrights Victor Hugo and Dumas *fils*, Barrucand's intent was to use the play as allegorical propaganda for social change. He already had become known for trying to revive the Revolutionary demand of *le pain gratuit* (free bread for the people) and lived with an anarchist actress, Hedwige Morre.

A group of young artists worked as walk-ons in the play, which had numerous crowd scenes, and Francis Jourdain, then twenty-two years old, later recalled dyeing his skin with yellow ochre from a big vat backstage to acquire the necessary skin tone. Lugné (as Jourdain and Henry called him), the director, tried to save money on costumes by draping all the characters in sheets. In the tradition of creating scandal at the openings of controversial

Lithograph: Footit en ballerine, *1894.*

plays, the first-night performance on 22 January 1895 had been planned as an offstage event as well, and all the young turks of the avant-garde came with their girlfriends, dressed outrageously, the men in velvet jackets and the women with 'pre-Raphaelite' hairdos. This élite audience, which didn't like the play, laughed at the serious scenes and complained loudly throughout.

Although *Le Chariot de terre cuite* received mixed reviews, Henry was very enthusiastic about his own part in it, and images from the play reappeared in his work for nearly a year: elephants, rajas, exotic processions, Indian palaces. His programme included a drawing of his anarchist friend Félix Fénéon garbed as a Hindu priest. Although Fénéon's name was not on the programme, he appeared in front of the curtain, dressed in the requisite 'white linen wrapping', to recite the prologue, which contained an anarchist message: social injustice will be defeated by nobility of soul.

Jean Lorrain predictably hated the play and wrote in a review: 'The programme says sets by Henri de Toulouse-Lautrec? I'd rather not stay.' Lorrain, courageous in his way for he was one of the few avowed homosexuals on the Paris cultural scene, unafraid to appear in make-up and

ostentatious jewels in public, was known for his viperous attacks on those he disliked, but he also had loyal partisans like Edmond de Goncourt. Liane de Pougy, whom Henry may have portrayed in a *remarque* and two ice-skating lithos between 1895 and 1896, was a famous *demi-mondaine* who later wrote in her memoirs the following description of Jean Lorrain: 'Poor Jean ... basically sensitive and tender, flaunter of vices, valet to fame, intoxicated with the theatre and literature, heart of a child. Poor dear charming Jean, seeking after anything that might be described as a sensation of happiness.' Lorrain died of alcohol and drug addiction in 1906.

The weather was typically awful that winter; freezing rain coated the roads with ice that left the horses slipping and falling, 'strewing the plain' as Henry said, and no doubt affecting his own mobility since he did not go to the Libre Esthétique show in Belgium in February although he sent seven works, all prints or posters. Auguste Renoir's son Jean remembered meeting Henry that winter, for Henry had befriended the Renoirs' house servant, a young woman named Gabrielle. She knew him well by sight, as he had visited Auguste Renoir several times in his studio and often stopped to have a drink with the *bougnat* (slang for a small coal dealer who sold fuel from a small street-front bar) on the corner by the pump where she pumped water for the household.

Jean Renoir believed, as many did at the time, that Henry's handicaps had been caused by a fall from a horse, and as a child he was very curious about this adult who was only a little larger than himself:

Gabrielle knew him well. While I was still little, she used to carry me on her arm when she went out to do errands in the shop near our house in Montmartre. Toulouse-Lautrec was often to be seen sitting enthroned in the window of a café on the corner of rue Tholozé and the rue Lepic. I was too young to remember anything; but in later years I was able to form some idea of what he was like through Gabrielle's stories about him. He called to us and made us sit down with him between two female friends of the moment – two Montmartre women in Algerian dress with exotic names. They did the belly dance at the Moulin Rouge. When she gave me a description of him, I often asked Gabrielle: 'Do you think he was self-conscious about his deformity?' 'Not at all,' she replied. 'He joked all the time. He was always asking after the boss [Auguste Renoir], and his eyes shone with real tenderness. He was very fond of the boss.'

The day Gabrielle met him, Henry's friends Kouloudja and Alida, pseudo-Oriental tarts from the Boulevard de Clichy, were huddled in a

corner, trying to get warm with a few mugs of hot wine. They had no desire to go back to their rooms in the rue Constance, where the water had turned to ice in the pitchers. Henry, according to Jean Renoir, came out of the bar and called to Gabrielle to come in with her jug of water:

He offered her some hot wine and started to talk about his father, even more of a bohemian than himself. The old gentleman had come all the way to Paris from his crumbling castle four hundred miles away, riding on his mare and without a penny to his name. He slept on straw at night alongside his mare and drank her milk, when she had any. When Gabrielle told me this tale, she explained: 'People had a great deal of time in those days.'

According to Gabrielle, she was most impressed by Henry's politeness:

He took off his hat to the *bougnat*'s wife. He was very clean, and he wore a white starched shirt, sometimes without a cravat. When he did put on a cravat, it was always a black one. He was cheerful and agreeable. People made fun of him and called him 'short-arse'. He didn't give a damn. Then people got used to it. You get used to everything. As the boss would say, 'You don't see yourself.'

Around this time, Auguste Renoir, speaking to the art dealer Vollard, who was having some success selling Henry's work and in April sold one of Henry's brothel paintings, observed: 'They are frequently pornographic, but always desperately sad.'

However much his works may have showed sadness, Henry was resolute about amusing himself. Now there was going to be a huge party, and he was helping to organize it. His friend Vuillard had been working for months painting *Jardins publics* (Public Gardens), six enormous panels to decorate Alexandre Natanson's spacious apartment in the Bois de Boulogne. Vuillard, noting in his journal that Henry had been to his studio and a few days later had invited him back to lunch at his own apartment, commented that Henry, whom he sometimes called Lautrec and sometimes called Toulouse, was '*très anglais*' (very English) and that he found him 'good, but an aristocrat at heart'. Now that Vuillard's paintings were ready, Alexandre asked Henry to draw the invitation for the unveiling. Accepting the commission, he also volunteered to be the bartender for the party, using his practised skills at mixing 'American and other drinks'. The invitation was signed with a mouse standing on its hind legs, and Henry's new elephant monogram.

The party, on a Monday night, 16 February 1895, must have been the

event of the decade. At least three separate accounts of it exist. More than three hundred people attended and Henry stood behind what he called 'Alexander's Bar' perfectly costumed in a short white jacket, with a vest made of an American flag. He had become so involved with dressing the part of a barman, that in a dramatic gesture, in order to look more working-class, he shaved off his beard, revealing a 'chubby baby-face with outsize full-blooded lips under a somewhat heavy nose'. According to Thadée Natanson, he also shaved his head. This led to a severe scolding from Leclercq and Bourges, who felt that Henry had demeaned himself by appearing clean-shaven, the trademark of an employee, and by seeming all evening to be so deeply engaged in playing his role as a domestic servant.

For hours Henry mixed and poured deceptively strong cocktails. Several guests, including the habitual teetotaller Bonnard, had to be put to bed. 'You mustn't forget the lemon peel,' Henry said to Gauzi with a wry smile, as he served him a cocktail. 'Nor the sugar. They don't do a thing, but they're indispensable!' At dawn, when the party was over, Henry proudly announced that he had served two thousand drinks. He had remained stone sober while taking childish delight in getting everyone else thoroughly drunk.

Exactly one month later, he did the menu for another party, this time to celebrate Tristan Bernard's new hit play, *Les Pieds nickelés*, which had opened the night before. On the menu he showed his two photographer friends, Maurice Guibert and Paul Sescau, who was playing his banjo. The menu included bouillabaisse and '*foie gras de L'oie Fuller*' (liver of Loïe/Goosie Fuller), an irascible reference to the unfortunate corpulence and possibly the foolishness of the dancer who had rejected his work in 1892. At another dinner, this time at Sescau's, Henry is said to have put goldfish into all the water carafes, to make sure the guests did honour to the wine.

Henry's artistic production was slowing. He seemed to be devoting his attention almost entirely to prints and attracting a fair amount of criticism in the process. That year, for example, the curator of the Print Room at the Bibliothèque Nationale in Paris, Henri Bouchot, published a book called *La Lithographie* which gave his evaluation of the young artists of the *Estampe originale* group. Although he agreed with Henry's supporter, Roger Marx, that it would be a mistake to limit human creativity to predetermined formulae, he attacked the young artists on moral grounds, saying they were 'victims of adolescent mirages and drawn to unaccustomed sensations', discreet terms for accusing them of being hormone-driven teenagers and sexual perverts. Warming to his task, he went on: 'These are either extremely subtle

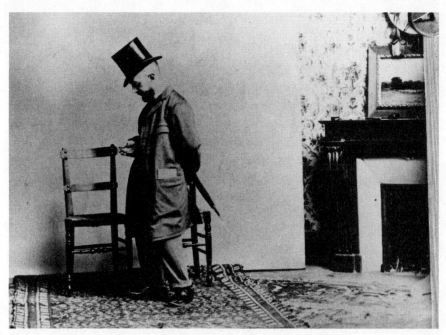

Henry with his head shaved after Alexandre Natanson's party, 1895.

cases of pathological malady or peculiar drives to bond with the lower class.'
Picking out Henry's 'rudimentary polychromatic sensations' as examples, he
said, 'most of these fanatics are for cruel, violent, colour-blind combinations.'
He described Signac's colour theory as *'pointilliste, viruliste, insenséiste'*
(pointillist, comma-ist, insane-ist), and concluded by referring to work by
Henry, Signac and others as *'ces tortures visuelles'* (those visual tortures). He
said that only one thing about them touched him: the complete sincerity of
the young artists and the selflessness of their publisher, André Marty: 'We
may choose not to follow them, but their conscience and their courage have
to be praised. It is not fortune they are after.' As late as 1899, Henry was still
furious at Bouchot. One cannot help wondering if he would be pleased or
outraged to know that the world's finest collection of his prints is now in the
same Print Room.

In his own world, Henry was receiving both praise and commissions.
Renard, writing in his journal on 19 February 1895, commented: 'The more
you see Toulouse-Lautrec the bigger he gets, till finally he appears of more
than average stature.' On 6 March he quoted friend and artist Jean Veber as
saying: 'Lautrec draws admirably.' On 15 March, *La Revue blanche* published

a story by Renard signed with a vignette by Henry, depicting a fox (in French, *renard*). At the time, Henry was working on a huge poster for *La Revue blanche*, which many people feel is his strongest individual work (Plate 43). In it, using a combination of economical line and implied movement, large flat areas of colour and carefully observed detail, he showed Misia Natanson, wearing a fur jacket and muff, and a polka-dotted coat, ice-skating at the Palais de Glace, an ice rink opened at the Rond-Point des Champs Elysées by Jules Roques in 1894.

The strength of this work comes in large part from the fact that, as in many of Henry's posters, the figure is cut off by the lower edge just below the knees. The only concrete reference to ice-skating is the faint curved outline of a skating rink in the upper half of the poster. However, it is instantly clear from the slight angle of the model's body and the position of her muffed arm, that she is gliding serenely on ice-skates. The entire poster is like a little joke, as if Henry were amusing himself by proving that he could show an ice-skater without ever showing her skates.

One of the most striking images in the poster is her fantastically plumed hat. Although Misia's face is tiny and prim, almost pinched, and hidden behind a veil, her head is dominated by the elaborate black cloud of ostrich feathers, as if she had some protective genie hovering over her, prepared to attack any aggressor. Henry may have preferred male companions who would allow him to dominate them, but his images of women are often imposing, even massive. In many cases, beginning with very early works, he focused affectionate attention on women's hats, sometimes showing the same hat in a number of different works. That this was conscious is borne out by the anecdote told by Suzanne Valadon, who said that when Henry offered to buy her a hat, he insisted upon choosing the most outlandish hat in the shop, and then painted her portrait wearing it. Valadon, like so many of the women he admired – Misia, Lili Grenier, Yvette Guilbert, Jane Avril, La Goulue, or Marcelle Lender – was a *monstre sacré*, strong-willed and full of sexual energy. For Henry, the huge, whimsical, elegant but monstrous hats he painted somehow represented the kinds of women he loved. However, as time passed, the hats took on a looming, nightmarish quality.

Around the same time, he made drawings of Marcelle Lender's elaborate hat with two huge poppies on it, part of her costume in *Chilpéric*, which that spring he attended nightly, it is said, always sitting in the same seat in the first row, on the left, taking with him not only Coolus, but at times Geffroy and Guibert. Although only one of his lithographs actually shows her famous back, in his large oil painting of *Chilpéric* done the next year, one of the

courtiers is looking pointedly at her back, which is turned away from the audience as she dances.

That spring Henry also learned that La Goulue, the subject of so many of his major works, was dancing in a street-fair sideshow on the outskirts of Paris. He went to see her and stopped by her dressing room to say hello at the end of the performance. A few days later, he received a curious request. In a letter written on 6 April 1895, La Goulue asked him to decorate the portable tent where she performed: 'My booth will be at the Trône, where I am on the left as you go in. I've got a very good pitch, and I shall be glad if you can find time to paint something for me; just tell me where to buy the canvases, and I'll let you have them the same day.' For some years, La Goulue had nearly disappeared from the Paris scene, having stopped dancing at Le Moulin Rouge and grown fat. Now she was attempting a comeback, trying to set up as a belly-dancer at a Paris street fair, La Foire du Trône, also called La Foire aux Pains d'Epices (The Gingerbread Fair) held late every spring near the Place de la Nation. A publicity flyer printed that April and distributed at the fairgrounds described her act as follows: 'Booth No. 10: *Great Attention!* [sic – in English] the public will be admitted for a trifling and

La Goulue's tent, c. 1894.

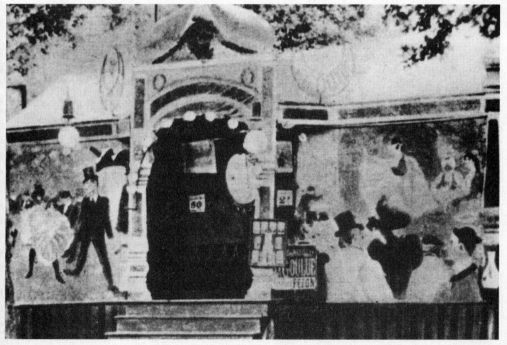

derisory sum to view the celebrated dancer "La Goulue", the idol of Montmartre. She will certainly score more of a success than "Nini les-pattes-en-l'air" who is currently showing off her legs in Berlin.'

Henry, who had already tried his hand at the stage sets for *Le Chariot de terre cuite*, and who liked the idea of creating what might be called commercial art, promptly set about painting two huge canvas panels that could be hung outside the tent and rolled up for storage. His work, rapidly sketched in colour onto cheap, heavy-grained canvas, was obviously not a paid commission, but a gesture to help out an old friend, down on her luck. To the left of the entrance, he showed La Goulue in her former glory, dancing with Valentin le Désossé at Le Moulin Rouge. Watching her are 'Père la Pudeur', Jane Avril, Maurice Guibert and, standing near the bandstand, Maxime Dethomas, a painter friend of Henry's who specialized in theatre sets.

On the right, the other panel showed her in her *almée* incarnation, with two 'Oriental' musicians, one of whom may have been one of Henry's other belly-dancer friends from Montmartre. Watching the new act, with their backs to the spectator, Henry painted himself and a number of his friends: Sescau the photographer playing the piano, a man who may have been *le bon juge* Georges Séré de Rivières, ruddy-faced and wearing glasses, flanked by Maurice Guibert, Henry's cousin Gabriel, Oscar Wilde, Jane Avril standing next to Henry, and on his other side, the pale, ascetic profile of Félix Fénéon. Fénéon, who admitted that he had not posed for the painting, seemed pleased to be included, although he was a little amused that some viewers identified him mistakenly as Valentin le Désossé: 'It does seem that we two had something in common, though the comparison was not a flattering one for either of us,' he later wrote.

La Goulue later tried her hand as a lion-tamer and, when she got old and poor, sold peanuts outside Le Moulin Rouge. At some point Henry's canvas panels were sold to a collector, Dr. Viau, and sold again to a dealer, who, thinking they would bring a better price, cut them into eight separate pieces.

In 1929, the same year that La Goulue died penniless, the canvases were bought by the Louvre and eventually reassembled.

As the spring season came, Henry was in three group exhibitions at once: at the Durand-Ruel gallery in the rue Laffitte, at the Salon des Indépendants in the Palais des Arts Libéraux, and at the Société Nationale des Beaux Arts. At the first two, he showed only prints and posters. The third show was more unusual, for it was an exhibition organized by Siegfried Bing of a series of stained-glass windows, each made by the New York glass-worker Louis

Comfort Tiffany, working from designs by young Paris artists, including Henry, Ibels, Bonnard, Vuillard, Vallotton, Ker Xavier Roussel, Albert Besnard, Paul Ranson, Maurice Denis and others. Bing was very taken with Art Nouveau, and in December would incorporate a number of the windows into his newly redecorated gallery, which he called the Salon de l'Art Nouveau, where Henry also exhibited other works. Henry's stained-glass window was enthusiastically singled out by a reviewer, Jacques-Emile Blanche, who said: 'The most astonishing of all these pieces is perhaps that of M. de Lautrec, who has composed the loveliest, and the most modern, of decorative motifs out of a circus scene and a harlot's hat' (see Plate 22). Like Henry's brief venture into bookbinding and his ceramic plaque of Yvette Guilbert, it was a one-off experiment, but the final product shows how skilfully he planned his drawing, fully aware of the constraints of the form.

He went off in May to Granville and Mont Saint-Michel in Normandy with the Natansons, dining one evening with his new Parisian friend, Maxime Dethomas, at the latter's summer place in Dinard. Dethomas came from a good family and would have an honourable career doing sets for the Opéra, but, like Henry, he was fond of all *spectacle*, especially in its unsanctioned forms: street scenes, sideshows, shady nightclubs. He was a physically imposing man, both tall and corpulent. Henry, who had nick-named him 'Gros Narbre' (approximately: Big Tree) because of his size, enjoyed his company, in part perhaps because he always enjoyed the contrast he formed with a much larger friend. As Dethomas was on his way to Turin, Henry wrote a letter introducing him to Giuseppe Ricci (whom Henry called Joseph), the Italian artist with whom Henry had gone to London in the spring of 1892. In it, he described Dethomas as a 'charming lad and a painter who does not talk about his own painting, which is greatly to be admired'. He asked Ricci to introduce Dethomas in turn to 'some friends like Botticelli, Uccello *et tutti quanti*'. Dethomas would be a good friend to Henry, who included him in two works of a lascivious nature, leering at the buttocks of a masked woman in *Maxime Dethomas: au bal de l'Opéra* (Plate 40), and pinching the nipple of a lightly-clad woman in the lithograph *Le Débauché* (The Rake). It has been said of Dethomas both that he was an eager par-ticipant in seductions and brothel visits, and that he was in fact a little strait-laced and that Henry's use of him in these images was a kind of teasing. Increasingly, however, when Henry showed friends in compromising pos-itions, it was because he had observed them thus.

Suddenly, there was a market for reproductions of Henry's work. He

himself arranged to have a new lithographic printing made of his macabre poster *Le Pendu*, which he had done in 1892, transferring the work to another stone for a collector's edition of thirty prints dated 1895. He was also getting requests to reproduce his work from magazines other than those which had originally commissioned them and for photo-reproductions of his original lithos and drawings, to be sold individually. Naturally, Henry, who had always gone to great lengths to limit the ways in which his work might be reproduced, was eager to control this market for reasons of both quality and economics. Over the next few years he gave permission for several reproductions of this sort, 'on the condition that he be shown the proofs before the print run'.

The drawings he had done 'with a quill pen' for Paul Adam's 15 May 1895 article defending Oscar Wilde had attracted substantial attention in Paris, as had Wilde's trial and conviction. Late that spring, Henry was astonished to discover that, without consulting him, the new editorial direc- tor of *La Revue blanche*, Lucien Muhlfeld, had sent the photographic plate of his Oscar Wilde portrait to the magazine *Le Fin de siècle* to illustrate an article by Edouard Dujardin. Henry seemed to enjoy social engagements with Dujardin, writing notes hoping 'that there will be ladies there' and requesting that Dujardin, whose dandyism was notorious, 'wear a white tuxedo and made-up face'. But despite their long friendship, Henry refused to allow the drawing to be reproduced for Dujardin's article, and later scolded Muhlfeld for thoughtlessly turning over the plate 'to a half-baked schoolboy magazine'.

Henry himself was doing original illustrations for other people: *La Revue franco-américaine*, which folded after three issues, and for two stories by Coolus in *Le Figaro illustré*, a cover for Bernard's play *Les Pieds nickelés*, and other works planned for publication in the autumn. One of his illustrations for Coolus' parodic short story *La Belle et la bête* ('a fable for our time'), published in *Le Figaro illustré* in September 1895, played an unexpected role in establishing his credibility as an artist. Henry had used watercolours to do a colour study directly on this lithograph, *Le Bésigue* (Bezique), planning a colour print which was never made. In the 1970s, the Art Institute of Chicago in the United States purchased his hand-coloured litho as a companion-piece to an original watercolour variation of the same scene that it already owned. It was only when his work on the litho was compared to the museum's watercolour that it became apparent, even to a casual observer, that the 'original' watercolour was a counterfeit, obviously painted by someone who had no clear idea of Henry's intent, so lucidly delineated in the few strokes

of colour applied to the lithograph. Henry, who did not hesitate to prosecute those trying to create false 'Lautrecs', would have been pleased to know that the purity of his own work was still protecting him.

It was a busy summer, in part because he had decided to move again, abandoning his newly remodelled apartment at 7, rue Tourlaque to move back to the rue Fontaine, into the same building and on the same landing as his friend, Robin-Langlois. There, although Henry's studio remained at 27, rue Caulaincourt where it had been for many years, he rented what appeared to be a spacious apartment: 'left-hand mezzanine ... comprising a hall, kitchen, W.C., dining room, two rooms without fireplaces, bedroom and living room'. It cost 400 francs a month. Naturally, he had it redecorated, asking Théo Van Rysselberghe in Brussels to draw a plan for the installation of his fireplace tiles and complaining bitterly to his mother about the 'state of exasperation' he was in from the move: 'Everything is approximately done, but I know nothing so atrocious as these moves in the heat, dust and other disagreeable things. Everything is ugly and uncomfortable; they say that the hotel becomes our ideal at moments like this.'

Finally, in August, he left Paris on an excursion with Guibert which proved to be very elaborate. They went from Paris to Le Havre by train, then by boat from Le Havre overnight to Bordeaux, whence they made a loop past Malromé to visit Adèle for two days, leaving Bordeaux again by boat to go back to Le Havre to pick up Bourges and his wife, who were planning to join them on a longer cruise. 'That will make three ocean trips one on top of the other. I'll be lucky if I don't smell like codfish,' Henry remarked to Adèle.

As the story is told, he, Guibert and their friends set off in early August in high spirits with a case of wine and champagne, on a cargo liner called the *Chili*, to cruise down the coast from Le Havre to Lisbon. Henry and Guibert were planning to come back overland via Madrid, stopping at Malromé some ten days later to see Adèle again and spending part of September at Louis Fabre's summer house in Taussat-les-Bains. As Adèle put it dryly, 'he's rewarding himself amply for not having been in England this year.'

Aboard the ship, they saw a lovely young woman travelling with her daughter and their poodle, on their way, it was said, to join her husband, a colonial civil servant in Dakar. Henry was enchanted by her beauty, and a photograph, a drawing and a marvellous lithographic poster, called *La Passagère du 54, Promenade en yacht* (The Passenger in Cabin 54, Sailing; Plate 44), survive to document his infatuation. According to Joyant, Henry was so

taken with her that Guibert had a hard time getting him to leave the ship at Lisbon. He wanted to follow her to Dakar.

It is not known whether he ever actually spoke to his perhaps unwitting model. The title of the work implies that he did not know her name, and his lithograph shows her from a viewpoint which suggests she may not even have realized she was being observed, leaning back in her deck chair, protected from the sun under the white canvas awning of the steamer deck, as she gazes out over the rail at another boat passing. Her book, unread, dangles from her hand. Joyant later called Henry's litho 'an exquisite thing, in its tone, in its elegance, in its mood of indolence, in the way it conveys the delight of being alive, with eyes idly wandering, on a fine day'.

The quietness, delicacy and tenderness with which the subject is portrayed can only be compared to Henry's poster of Misia skating, done the same year. Both works seem to reflect his comment to Octave Raquin that he had 'an immense desire for calm'. The Salon des Cent used the litho as the poster for their October exhibition at 35, rue Bonaparte in Paris, and Henry showed it in the Libre Esthétique show in Brussels the following spring. The litho also appears in a pastel by Vuillard, *Femme entrant dans le salon* (Woman Entering the Living Room), thought to have been done at Thadée and Misia Natanson's around 1896.

On 18 August, Henry and Guibert arrived at Malromé, as Adèle wrote to her mother-in-law the next day, 'directly from Madrid, delighted and enchanted by their lovely trip ... a little blackened by the Spanish sun ... They saw so many beautiful things that they are fully capable of doing it again next year.' While in Spain they apparently visited museums to see the work of El Greco, Goya and Velazquez, possibly provoking Henry's comment to a younger cousin: 'There is only one painter ... and that's Velazquez!'

From Taussat-les-Bains, where Henry stayed for two weeks in September, he was already busy dealing with business, organizing articles, printings and reviews. Dodo and Joseph Albert's brother, Henri, best known for translating Nietzsche into French, had become the Paris director of the German review *Pan*, whose art editor, the critic Julius Meier-Graefe, had bought four of Henry's drawings from the art dealer Vollard in Paris on 6 July. Now *Pan* was publishing a colour lithograph of Marcelle Lender, and Henry suggested that Henri Albert collaborate with Arsène Alexandre on the accompanying article. Writing to Alexandre, Henry warned him that he would be asked to write 'a few words about my sickly self. Since you were the first to say good

things about me, I'd like it to be you who proclaims my high deeds to the far side of the Rhine.'

It is generally conceded that this was Henry's most elaborate and technically difficult lithograph. Showing Marcelle Lender's head and shoulders and the ridiculous poppies on her hat (but as usual, not her back), it was printed in eight separate colours. Shortly after, Meier-Graefe, who presumably commissioned the print, was dismissed from the magazine which, although it had paid Henry nothing, had paid the cost of printing this extremely complex and expensive work.

At the end of September, Henry returned to Paris by boat, as he said, 'on a sea like a lake, which didn't keep Fabre, who was travelling with us, from being violently ill; that's what imagination will do for you!!' Although he was showing in a number of group exhibitions and preparing a second poster for *La Plume*, which was publishing it for an American literary magazine *The Chap Book*, he didn't seem to be doing any other work. As his work nearly always reflected the places he went and the people he saw, the subject of this poster, *The Irish and American Bar, rue Royale*, is a strong indication of where he was spending his time. By November, he was off on the water again, this time going by rowboat down the rapids of the Gorges du Tarn, not far from Albi. He went with a fairly large crew: his cousins Gabriel, Raoul and Odon Tapié de Céleyran, and three other friends, apparently inspired by the memory of his exciting white-water trip in 1893.

Although the trip down the Gorges du Tarn was 'magnificent from every point of view', once back, Henry faced Paris with grim resolve, announcing to his mother that it was black and muddy outside, and he had to force himself to work. In the same letter he asked her to have a barrel of wine sent to him to put in bottles, as he calculated that he drank about a barrel and a half a year in daily consumption. He still hadn't finished the Irish and American Bar poster, and remarked in a second letter that he was eating all his meals there: 'that is to say, I'm on a diet of roast beef'. Writing to her, he seemed hostile to other members of his family, suggesting where his Aunt Emilie (Uncle Charles' wife) might <u>buy</u> posters to give to her nephews, instead of offering to give her his own, and admitting he was trying to avoid his Aunt Odette and Uncle Odon. He sounded depressed, saying to his mother, 'I lead a monotonous life.' Now his notes to friends, instead of suggesting outings, asked them to come to his studio.

He was having constant problems with his work. In November he had spent great effort on his entry for a contest sponsored by Boussod et Valadon.

Since Joyant had suggested that he enter the contest for a poster to announce a biography of Napoleon written in English by W. William Sloan and published in New York, Henry had high expectations of winning. However, the judges, who included an expert on Napoleon and three academic French artists – Jean Léon Gérôme, Jean Baptiste Edouard Detaille and Georges Vibert, chose the design by Lucien Métivet, a friend of Henry's from Cormon's, now substantially less well-known than he. Henry came third. When Henry offered his original sketch to the Napoleonic historian, Frédéric Masson, it was refused, apparently on the grounds that it was not realistic enough and looked unfinished. Years later, Henry's cousin Gabriel quoted Henry expressing his point of view on such judgments: 'These people annoy me. They want me to finish things, but I see them that way and paint them that way. You see, it's easy to finish things; I can easily paint you a Bastien-Lepage … Nothing is simpler than to complete pictures in a superficial sense. Never does one lie so cleverly as then.' Depressed but unbowed, Henry had the litho printed himself in an edition of one hundred, without lettering (Plate 49).

Henry continued to get good reviews from sensitive reviewers such as Ernest Maindron and Frantz Jourdain (the father of his friend Francis), who called him 'a fantastic satirist because he doesn't distort nature, he just waits until it reveals its grotesque side'. But Le Tocsin (The Warning Bell), a poster he did in December 1895 for La Dépêche de Toulouse, was sombre and nocturnal, reflecting what seemed to be his own mood.

He had asked Jules Renard to let him do the illustrations for the new edition of Renard's Histoires naturelles, apparently hoping the book would earn money, and dragged Paul Leclercq, whose house was on the Champs Elysées, over to the Jardin d'Acclimatation in the Bois de Boulogne to keep him company while he sketched animals. Their first stop every morning was to see the giant anteater, who came to recognize Henry and would lumber over to the rail to say hello. Henry's own monogram now appeared inside a remarque of an anteater. According to Leclercq, Henry also befriended a tapir and would discuss the health and activities of his protégé with the zookeepers as if the tapir were an old friend. This animal may have inspired Henry to invent the most memorable of many nicknames he had created over the years for his cousin Gabriel Tapié de Céleyran, 'Tapir le Scélérat' (Tapir the Scoundrel). Leclercq was impressed with the way Henry worked, sketching the same animal so many times that he could finally catch its essence from memory, in just a few lines.

Although Henry produced twenty-three quite beautiful vignette studies

of animals, he and Renard quarrelled over questions of style, and as Henry refused to change them, the project was never completed. The book was finally published in 1899 with the twenty-three original drawings transferred by a printer to lithographic stones. It had no commercial success. The formerly positive tone of Renard's observations in his journal became nasty. On 26 December, he noted that the reason Henry liked going to bars was 'no doubt because he could perch on the high stools and be almost as tall as us'. On 3 February 1896, he wrote: 'Madame T[ristan] Bernard says "Lautrec is so little that it gives me vertigo to look down at him."'

Henry was not only growing more difficult to get along with, he was also becoming increasingly disorganized. He finally turned all his affairs over to Joyant, who had been having some success in selling his work. Joyant continued to handle Henry's art career and reputation for nearly thirty years after the artist's death. It was at the 'home of a friend', in reality the recently remodelled Boussod et Valadon gallery at 9, rue Forest, now called Manzi, Joyant et Cie., that Henry finally had a one-man show. It opened on 12 January 1896, and consisted of two parts.

Most accounts of this show say that the gallery exhibited Henry's more conventional lithographs and posters in an open section of the gallery, while showing his 'scandalous' brothel paintings in two separate, locked rooms upstairs, draped with red, yellow and green curtains, to which he admitted only certain friends. But Gustave Geffroy's review, written the day after the opening, spoke positively of the strength of this 'terrible documentation' of prostitution, without implying that access to the paintings would be denied to anyone.

It seems most likely that the draped rooms were merely a dramatic setting, for the rue Forest show went on until at least 22 April, the day Henry's newest publisher, an erotic book dealer named Gustave Pellet, brought out Henry's most famous brothel series, the edition of lithographs of prostitutes called *Elles* (Them). This ambiguous title both recalls the common phrase *ces dames* (these ladies), and at the same time is the pronoun indicating all females. The series was placed on exhibition at the Galeries de la Plume's twentieth Salon des Cent on 22 April 1896, where the lithographs could be viewed by anyone who wished. Thus it makes little sense to think that Henry would have refused to exhibit some of his brothel works in a one-man show while openly showing others, equally scandalous, in a large group show.

The welcome Henry's work received in the two shows was quite different. The *Elles* series attracted almost no attention, and despite the subtlety and delicacy of the lithographs, which must have taken many months to prepare

and which were printed on special paper watermarked with both Henry's and Pellet's names, they proved very hard to sell. Maurice Barrès, who saw them, apparently said: 'Lautrec ought to be subsidized by parents to inspire young people with a horror of illicit relations.' One set of ten lithos was bought by the Norwegian artist Edvard Munch, who had first shown in Paris in 1893, and whose woodcut *The Scream* had been reproduced in *La Revue blanche* in December 1895.

Henry's retrospective exhibition, which he, Joyant and Joyant's new partner, Michel Manzi, who had originally been the master printer for the Boussod et Valadon printing works at the same location, had been planning for two or three years, was a great success. It attracted crowds of visitors and Henry's work in some cases sold for prices far higher than those paid for the works of Cézanne, Van Gogh or Gauguin at the same time. Count Isaac de Camondo for example, a well-known art collector, paid something like 1,000 francs for a painting of Cha-U-Kao, now grown blowsy and fat, seven years after her gymnastic triumphs at Le Moulin Rouge. The painting he bought, which Henry nicknamed 'Clown with tits', shows the performer hooking up her corset, wearing an absurd white wig topped with a yellow bow (Plate 48). Joyant claimed that Camondo hung it in his bathroom. It was given to the Louvre with the rest of the Camondo donation in 1914.

Cha-U-Kao had not attracted Henry's artistic attention when she was younger, but he was fascinated by the bloated, white-wigged, white-faced woman she had become, the soft rolls of her flesh pouring over the edges of her *décolleté* clown costume, her drooping lids and double chins a contrast to her sprightly yellow tulle clown ruff. She became a leitmotif for his work over the next year or so, appearing in at least eight works.

Her ageing image may have epitomized for the painter the implacable ravages of time, since in the mid-1890s Henry also repeatedly acted out a scene which is recounted by a variety of different witnesses: he would announce mysteriously to a friend that he was going to introduce him to someone, then lead him down alleys and narrow streets and up a dark staircase to the top floor of a building in the rue de Douai, where he would knock on a dingy door. It was invariably opened by a woman the visitors describe as stooped, old, wrinkled and nearly bald, to whom Henry would present chocolates or a bouquet of flowers and introduce to his friends as 'Victorine Meurent, the model for Manet's *Olympia*'. Meurent, who had posed for Manet from 1862 to 1874, from her late teens throughout her twenties, was fifty-one years old in 1895. Henry was twenty years younger. He had contributed 100 francs to help purchase *Olympia* for the Louvre in

1889 and seemed obsessed with the change thirty years had made in the model. Was he commenting on the fleeting nature of female beauty, or, since she, like Henry, was a painter and apparently an alcoholic, did he see her as a symbol of what he himself would someday be? He may also have seen age as the great equalizer, making others as limited as he was already.

At about this time, he commented to Gauzi, as they looked at work by André Gill, who had died in 1885 of tertiary syphilis after being confined to the insane asylum at Charenton: 'That's how we'll all end up.' Among his friends, Jane Avril, the Van Gogh brothers, Charles Conder and Arthur Symons were all at times hospitalized for mental illness. Beginning with the Cha-U-Kao portrait, mirrors begin to appear repeatedly in Henry's work, reflecting a variety of images. Sometimes they show a man, watching the woman in the work; sometimes they reflect her own image, but older or younger than she seems in the primary image; sometimes the mirrors themselves are in elaborate frames, showing nymphs and satyrs. They always seem to contain ironic comment about desirability and illusion. In 1896, it was not unlikely that Henry had read Oscar Wilde's *The Picture of Dorian Gray*, published as a book in 1891, and translated into French shortly after.

While his one-man show was going on, Henry was invited with Joyant to Camondo's to meet the ex-king of Serbia, Milan IV, who had bought a different Cha-U-Kao portrait and another circus work. Henri arrived drunk, refused to take off his coat, hat or scarf, and seemed bent on insulting the exiled ruler. Joyant reported that as they left the gathering, Henry said, 'Basically it's just a family of swineherds! All those guys are just people who the day before yesterday didn't wear trousers and ran around in fustanellas.' Later, Henry couldn't resist joking to his Grandmother Gabrielle about his new patron: 'I'll be able to put Painter to the Court of Sofia on my cards.' Conversely, he actively pursued Léon Deschamps, editor of *La Plume*, and the sculptor Auguste Rodin, writing to both of them on 20 April that he would like to give them a preview of the *Elles* lithographs at Joyant's rue Forest gallery. The lithographs, individually framed, were being exhibited two days later at the Galeries de la Plume. He probably assumed they would see his retrospective at the same time, but it is not known if Rodin actually attended.

The show did, however, warrant a visit from Edmond de Goncourt who, already convinced that the artists of *La Revue blanche* were responsible for the decline of modern culture, went there under pressure from Geffroy. Henry, perhaps unaware of Goncourt's point of view, had been quite interested for several years in getting the attention of the novelist who was also a

waspish but powerful art and cultural critic. His friend Geffroy was part of Goncourt's literary 'attic', and Henry was well aware of Goncourt's prestige. Goncourt's novel *La Fille Elisa*, about a prostitute who ends up in prison after murdering her husband, had been a best-seller in 1877 but was considered so scandalous that the play by the same name was censored in France and had to be produced by André Antoine in Belgium. Henry had decided he wanted to illustrate the new edition of the novel, planned in 1893, and even did a series of sketches on the endpapers and chapter headings of his copy of the book, possibly hoping to show them to the author. He first referred to this in a letter to Roger Marx in May 1893, saying, 'Perhaps it's time to act,' but how far he was from gaining such a commission now became clear.

Goncourt, clearly irritated by the pressure from Geffroy to view Henry's work, finally went in April to Henry's one-man show. Although Goncourt was seventy-four and would die just a few months later, age and illness did not take the bite out of his commentary. He wrote acerbically in his *Journal*: 'Exhibition *chez* Jouault [sic] of lithographs by Toulouse-Lautrec, a ridiculous homunculus whose caricatural deformity is reflected in each of his drawings.' If he had ever considered asking Henry to illustrate *La Fille Elisa*, he had changed his mind.

Undaunted, Henry went on with other work. He was asked by Lugné-Poë to do the programme for a presentation of two one-act plays which opened on 10 February in Paris. One, by his friend Coolus, *Raphael*, is now forgotten. The other was the first staging of Oscar Wilde's *Salomé*, which had been banned in England in 1892. Ernest Dowson and Aubrey Beardsley went to Paris to see it and also went to see Henry's show. Wilde, in prison in England, found the production of the play comforting: 'It is precious to me that in this time of disgrace and shame I can still be considered as an artist. I wish I could feel more pleasure, but it seems that I am dead to all feelings save those of anguish and despair.' The front cover Henry designed for the programme, which was also used as an advertisement for the production, shows Wilde looking blond, aged and bloated, with the fogs of London in the background. The rear cover showed Coolus.

After his initiation into the artistic possibilities of the courtroom, drawing La Goulue testifying at the Bal des Quatz' Arts trial in 1893, Henry now went to watch criminal trials at the Palais de Justice, sketching the scenes being played out on the witness stand. To him it was a new form of theatre, and he did four lithographs of the Lebaudy and Arton trials. Although it might be imagined that he would choose murder or other dramatic crimes for his visits, what attracted him were *escroqueries* (swindles). He referred to

Arton, who had bribed officials with a million and a half gold francs to cover up the Panama Canal swindle, as 'a sort of artist, a man who had placed all his faculties of invention at the service of his crimes'. Arton (whose real name was Aaron) was apparently delighted with Henry's lithographs of his trial and hung one in his bathroom to bolster his courage every morning.

Henry may have identified with Max Lebaudy, the victim in the second trial. Lebaudy, child heir to a huge sugar fortune, had been cheated out of his money by a variety of people. The fact that he died under mysterious circumstances while unwillingly doing his military service caused an anti-military reaction at the time more intense and more generalized than even the Dreyfus scandal.

Between January and May 1896, Henry made seven posters and then stopped abruptly, doing no more until 1898–1900, when he did the last two of his career. Five of the 1896 posters were commissioned by friends: for Jane Avril in London, where she was on tour with three other dancers (*La Troupe de Mlle Eglantine*), for André Marty's new decorating store, L'Artisan Moderne, for Paul Sescau's photography business, for Willette's short-lived art magazine *La Vache enragée*, for Spoke's Simpson bicycle chain, for the cover of *L'Aube* (Dawn), said to be a left-leaning review, and a lithograph poster from a zinc plate, sent to the United States for printing by the Ault-Wiborg company, 'makers of fine printing and lithographic inks – Cincinnati – New York – Chicago'.

These commissioned posters were very different from the delicate, tranquil representations of women he had done the year before. They tended to be exuberant, brilliantly coloured and full of fanciful images and sight-gags, forming an odd contrast with the quiet, subdued, even depressed tone of the *Elles* series. This was even more interesting because the posters, although not about explicitly sexual subjects, contain many sexual allusions, while the women in *Elles*, although prostitutes, are desexualized, shown in postures that emphasize the everyday and unglamorous nature of their occupation: sleeping, getting up in the morning, bathing, dressing, combing their hair, lying exhausted across a bed after the last client has gone. The *Elles* series may have been a kind of sad parody of the latest rage in erotic theatricals: 'peepshows' with titles like *Le Coucher d'Yvette* (Yvette Goes to Bed) where the audience watched a woman, onstage in a set supposed to be her bedroom, undress, bathe, comb her hair and get into bed, all without saying a word.

The posters are full of little sexual and adolescent scatological jokes, like the *remarque* on the *Vache enragée* poster which represents a urinal, whose shape echoes the monogram of the poster's printer, Chaix. Henry shows a

vachalcade, the cavalcade of starving, angry artists for whom the magazine was spokesman, attacking Senator Béranger, whose morals squad was trying to censor them. It resembled a number of works Henry had done in 1895 and 1896 showing processions of various sorts. They may have seemed important to him because naturally, every time he moved, he had to hire movers with carts and wagons, and in a carriage follow them as they carried his many belongings tortuously through the narrow curving streets of the *butte*. A young cousin of Henry's, Robert de Montcabrier, who came to Paris to study art in 1897, reported Henry's comment that such moves looked like funeral processions.

In Henry's *Sescau photographe* poster, the photographer, who was reputed to use his studio primarily for sexual liaisons, is completely hidden under the black cloth of his camera, but the cloth itself dangles between his legs in a long phallus-shape, and the elegant woman of his focus seems to be trying to flee. Sescau, who also played the banjo, appeared often in Henry's work from now on, and the two men spent much time together. Henry told Natanson that he thought Sescau was going to die young, and wondered if he should give him money to 'soften his end', a remark reminiscent of his desire to be a benefactor to the ageing Forain, as Alph had been when Henry was a boy.

The poster for L'Artisan Moderne, a designer's collective with ten shops selling limited editions of jewellery and beautiful home-decorating objects which André Marty had organized that year, shows an elegantly dressed 'repairman' making a 'house call' like a physician, to the mistress of the house in her bed, while her maid reacts with shock. The model for the repairman was Henri Nocq, a Belgian jeweller and medallist, who felt Henry's portraits of him were 'spiteful in the extreme' and whose opinion Henry gaily discounted, since Nocq, as he said, had a *'nom à renversement'* (reversible name). Nocq's name reversed sounded like a French obscenity, popularly used to denote stupidity. In a letter to Nocq, Henry expressed his opinion on the conflict between art and crafts. Speaking of the English designer William Morris, he pointed out that despite some unfortunate Pre-Raphaelite tendencies and imitations of earlier styles, Morris had 'produced books that are readable and objects that can be used. We could summarize [with] the following *desideratum*: fewer artists and more *good workers*. In a word: more craft ... As for the public, it would be entitled to criticize (although one might choose to pay no attention) if it were paying. However, since it is not paying ...' Nocq, a craftsman himself, surely agreed.

The 1896 posters are funny and bawdy. Henry, cheerfully drunk in those

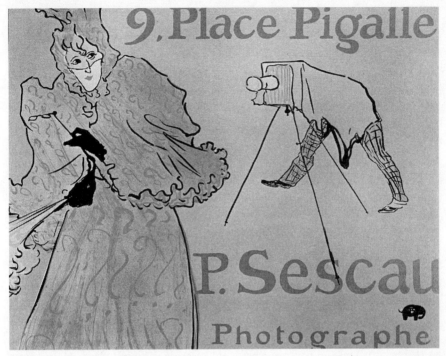

Poster: Sescau photographe, *1896.*

days, was letting his playful imagination and desire to have fun add an inimitable, fanciful quality to each day. His friends, although worried, could not help but be charmed by his antics. Paul Leclercq told the story, for example, of Henry's beard: 'One day ... he spotted, in a modest neighbourhood general store, a false beard made of short black rabbit fur mounted on a brass wire.' Henry, who was fully bearded at the time, stopped in front of the display and announced: '"My beard!" He went into the shop, came out with a little package, and lifting one finger, murmured: "My supplies!" After a short silence he added, with the gravity of a prudent bourgeois buying an extra bag of flour the day before a military siege: "Ah! You never know what might happen."' This story, although comic, also shows that Henry had not forgotten that he had been criticized for shaving his beard to look like a bartender.

HTL

Henry seemed listless. Although in 1896 he continued to send works to a few group shows, he did not exhibit in Paris at all. He exhibited at the Brussels Libre Esthétique in March for a third time, and at the Royal Aquarium in London for a second time, probably in June. His last show in 1896 was a poster retrospective of all twenty of the posters he had done to date. The Exposition d'Affiches Artistiques, held in Reims in November, used his litho *Le Débauché* as the poster advertising the show.

By June 1896, Henry was hardly working at all, even missing a commission to do an illustration for *La Plume* in May. He spent much of his time travelling, and when he was in Paris, which 'after . . . days of rain [was] fairly roasting', he headquartered himself at the Irish and American Bar. There, 'in a sour atmosphere of pale ale, gin and smoke', in the eccentric but familiar crowd of jockeys, circus performers and bohemians who were the bar regulars, Henry, almost always accompanied by his cousin Gabriel, sat on a high stool, throwing dice for glasses of port. His mother and Bourges had made him promise not to drink anything stronger than wine. He carried with him, as part of his principle of making drinking an art, a whole nutmeg and a tiny grater to season the port. Although he tolerated the other habitués, who included members of the Paris avant-garde such as Stéphane Mallarmé, Claude Debussy, Caran d'Ache and the novelist Jean de Tinan, Henry continued his attempts to persuade Achille, the bar's owner, to give bad service to people he didn't know or like, to discourage them from ever coming back.

It was probably in the '*bar d'Achille*', as he sometimes called it, that Henry uttered one of his most often-repeated *bons mots*. Next to him two women were arguing about a 'rather pitiful-looking' dog whose legs shook from hip displasia. The owner of the dog, agreeing that he wasn't '*beau*', nonetheless insisted that he was a purebred. Her friend, incredulous, laughed at her. 'Are

you kidding, that dog has a pedigree? ... Have you taken a look at his ugly fur and his twisted feet? He makes you feel sorry for him.' 'You obviously don't know anything about it,' said the dog's owner, turning to Henry: 'Tell her, Monsieur, that my dog can perfectly well be ugly and still be pedigreed.' Henry, getting down from his high barstool and standing up to his full four feet eleven inches, saluted her with a charcoal-stained hand, murmuring, 'You're telling me!'

Leclercq, describing Henry later, observed that he systematically hid the pain his physical state caused him behind exactly this veneer of well-bred, even good-natured, irony; that it was the outstanding characteristic of all his human relations, far more apparent to his friends than any other aspect of his personality. However, it was possible to insult him. One evening when Henry, Leclercq and a bunch of other *Revue blanche* regulars, including Debussy, Jean de Tinan, Pierre Louÿs and Félix Fénéon, were in a restaurant on the Champs Elysées, as Leclercq told it: 'falsetto-voiced Ernest Lajeunesse, a journalist who was as filthy as he was erudite, came towards us scratching himself. When he saw Lautrec, he grabbed him under each elbow and tried to lift him up ... What blows from the furious short cane were rained on the skinny thighs of Lajeunesse, who cleared out, howling and hopping like a monkey!'

Henry didn't mind being a mascot, but he chose his own teams. He went to London for a long weekend in June 1896 with Spoke, to accompany a team of French bicycle-racers, spending 'three days outdoors', as he wrote to his mother, announcing that the poster he had made for Simpson's lever chain when he got back was 'perhaps destined to be a resounding success'. Henry sounded particularly well after this trip, because, according to Joyant, Henry found British drinking habits depressing and when he was in England refused to drink himself. However, as he couldn't go long without drinking, he always returned to France in just a few days.

That summer, he spent almost every weekend at Thadée and Misia's summer place at Villeneuve, where he was working on two projects with Cipa Godebski, Misia's handicapped half-brother, a composer and writer. The first was a bust-level portrait by Henry in which the composer is shown in the garden, smoking his pipe, looking over his shoulder at the artist. This is an unusual pose for Henry but may have been a homage to Cézanne's self-portraits, exhibited at Vollard's gallery in Paris for the first time the year before.

Their second joint project was to do a book of aphorisms called *Le Célibataire* (The Bachelor), which they somehow could never get down to

writing. The countryside, the river, the wine – all distracted them, and finally the project consisted of only one sentence: 'Bachelorhood is really only regrettable in the country.'

Now Henry was almost always in the country. His work had dragged to a near-halt, and his friends tried to spur him to paint or do a litho by requesting portraits and other works, aware that he was only really happy when he was working and that when he was working he drank less. As usual, he went south for the last part of the summer to Taussat-les Bains, near Arcachon, where he and Guibert had rented a châlet near the summer homes of his friends Fabre and Paul Viaud de la Teste, a distant relative. They were elaborately set up: Henry took his maid with him from Paris, and Guibert, joined by his brother Paul, brought their cook. Adèle was asked to send a half-barrel of wine to their rental agent, to be put in bottles for their use. Henry's behaviour seems to have attracted a lot of attention in Taussat during that summer visit. Not only was he prone to wearing a blue jersey and red woollen trousers, rolled up to his knees, but he often went out with one or more fishing cormorants on a string.

He decided their villa was not private enough and set about painting a canvas screen reminiscent of those he had done for La Goulue's tent, which he stretched between poles around the house. The images on the now lost canvas were apparently so obscene that the landlady was provoked into writing a complaint to the authorities:

The tenant in my house, at 207 Châlet de la Plage, has placed between himself and the passage which serves the tenants of several of the villas in front, a screen of rough canvas, daubed with designs which I won't bring myself to mention ... It is not permissible for every tenant to erect anything he pleases in the locality ... particularly when these screens are adorned with such unsuitable pictures that decent and respectable parents must shelter their children from them.

He also got a fair amount of amusement that summer observing Maurice Guibert's difficult relations with one of his female cousins, whom Henry referred to as his '*boulet*' (ball and chain), and from whom Guibert spent most of the summer hiding. In November, Henry wrote to his mother that Guibert had 'won out over his finally-tamed cousin'. Adèle considered Guibert a perfectly appropriate house guest and welcomed him at Malromé on several occasions. Thadée Natanson, who described Guibert as Henry's 'very black scapegoat', classified him among the friends like Henry's cousin Gabriel, Coolus and now Dethomas, whom Henry loved to take along on

scandalous escapades and who went along in part to make sure that Henry got home safely. Repeatedly, from 1896 onwards, Guibert's moon-like face appeared in Henry's erotic works and in the increasing numbers of obscene cartoon-like drawings which were apparently scribbled references to their forbidden activities. After Guibert's death, his brother Paul left Maurice's photographs to the Bibliothèque Nationale. The collection included a photographic copy of a pornographic Japanese 'pillow book', with a note from Paul Guibert saying that it had once belonged to Henry. Paul himself had a mistress he had met in a brothel. Her name was Pauline, but everyone called her Mademoiselle Popo, and she modelled for Henry's *Elles* series and other works exhibited in 1896.

That summer Henry mentioned nothing about the scandal of the canvas screens but wrote cheerfully to his mother that he and Guibert had just spent two days deep-sea fishing on a friend's steam-driven commercial fishing boat. He was impressed at the quantity of fish that were thrown back, particularly given the fact that when he and his friends tried fishing from close to shore, even with cormorants, they had no luck at all. Despite his

Henry with his Grandmother Gabrielle and his Uncle Amédée, clowning at the Château du Bosc, summer 1896.

affectionate tone, each letter he wrote to Adèle asked for considerable sums of money: 500 francs in June, 2,000 in early September and another 500 on 19 September – 3,000 francs in four months, presumably in addition to his normal allowance.

In September, Henry and Guibert made ritual visits, first to Adèle at Malromé, where she was having her first successful grape harvest, and then to Le Bosc where Henry painted a portrait of his cousin Raoul's wife Elisabeth in the garden while his relatives played croquet around them. Going back north, he took a 'yacht' to Le Havre, arriving back in Paris in early October.

Paris in the dreary autumn was far less playful. Henry was rumoured to be drinking 'tumblers of Cognac', and his few paintings were in cruel reds and blacks, centring on the grotesque encounters of masked balls and brothels. He ate dinner in the evenings with Gabriel and sometimes with Alph, who was also in Paris. Although Henry was planning a couple of projects – submissions for the Brussels Libre Esthétique show in the spring of 1897 and a set of lithographs of stage performers for a British publisher, W.H.B. Sands – they were slow to come to fruition, and he worked very little.

His major pleasure of the autumn seems to have been a trip to visit the châteaux of the Loire over the All Saints' Day weekend in early November. Joyant, Gabriel and Guibert headed out, riding a bicycle and a tandem along the Loire from Blois to Amboise, intending to go on to Chambord while Henry followed with the luggage in a carriage, but it rained so hard that they all bundled into the carriage for the last part of the journey. The rain did not stop them from taking guided tours of the interiors of the three châteaux, complete with the history of Marie de' Medici escaping from Blois through a window. The day after Christmas Henry drew a comic menu showing the four of them carrying off a nearly naked Marie de' Medici by candlelight: Guibert in his nightshirt, Gab in the guise of a snake, a crocodile which Joyant identified as himself, and Henry, shown from the back, drawing the scene. He later had his self-caricature printed separately as a *remarque* and used it on a calling card. Although he helped paint the sets for the opening of Alfred Jarry's *Ubu Roi* on 10 December 1896, he did few paintings, and almost his only lithographs that autumn were a Christmas card for May Belfort and three menus. He commented wryly to his mother, who was ill, that he himself was 'a little knocked out ... but by too good a dinner', and added that he found the evenings 'very empty'. In another letter he said: 'I fight every day against sleep in order to go to the printing shop,

Lithograph: Menu: Le Crocodile, *1896.*

against laziness in order to work with a reliable model whom I was finally lucky enough to hire. It's tough to get back to work, and what I'm doing up to now doesn't interest me much. But it's a necessary stage.'

He was not always at home, however. Renard commented, having seen him on 31 January 1897: 'Lautrec is very amusing. He's always using the word "technique", but without really knowing what it means. He'll announce, "Here is a vase which is the technique of the bowl form," or say of someone, "He is the technique of a jealous man." ' Renard, who had never really worked out his disagreement with Henry about the *Histoires naturelles* illustrations, apparently didn't realize that Henry had appropriated the word into his own language and given it a special meaning. A few days later, Renard commented on Henry again: 'Lautrec [said he] was waiting for the death of old Victoria. As soon as it was announced, he would shoot off to London to see the spectacle of the century.'

Henry was beginning to seem a little paranoid, writing anxiously to Octave Maus to ask if he had been excluded from the Libre Esthétique, even though he had been corresponding with Belgian publisher Edmond Deman on the subject for at least two months. His two letters to Deman also show a quick change of tone from neutral to hostile, beginning with a friendly request for printing paper and the posting of a print and ending with a formal denial of

reproduction rights and a request for a signed receipt for the letter. Henry did contribute to the Libre Esthétique, although it was for the last time. He attended the opening in Brussels, having lunch in Van de Velde's newest Art Nouveau architectural wonder, the 'Bloemenwerf', in the suburb of Uccle. At the Libre Esthétique, and later that spring in the thirteenth Salon des Indépendants and the Société des Peintres-Graveurs Français shows in Paris, he chose to exhibit the *Elles* lithographs and some other related lithographs and drawings but showed no paintings at all.

By now his paintings were primarily studies for his lithographs. In late 1896 and early 1897, he did perhaps his most strikingly contrasting works of that nature. Henry, who had been complaining that he didn't have any ideas, on Joyant's recommendation began reworking old themes and, as preparation for a litho showing two lesbians in a theatre box, he did a marvellous oil study, *La Grande Loge* (The Large Theatre Box, Plate 45). It shows an improbable trio of models: the actress Emilienne d'Alençon gazing tenderly at her companion, Madame Brazier, known as 'One-eyed Armande', manager of the lesbian café Le Hanneton, and, in the next box, the distinguished profile of the Rothschilds' coachman, Tom. The painting is a dappled study in closely related colour tones whose outstanding characteristic is the psychological acuity with which Henry rendered the three faces. The lithograph, printed by Pellet in an edition of only twelve in January 1897, was exactly the same in outline, yet entirely different in character (Plate 46). The models no longer have the slightest importance in the work: it is a study of abstract repetitions, the four curves of the velvet handrails of the boxes, the three white ovals of the faces, the repeated black rungs of the three chairs. Henry's concerns in his paintings remained consistent – he sought psychological insight into his characters – but in his lithographs his goals were different. Over the years since he had focused on the abstracted shapes of Jane Avril's leg or Yvette Guilbert's black gloves, lithography for him had become a study of spatial relations, a form of abstract art. Around this time, Thadée Natanson said that Henry rescued a spoiled proof which consisted only of three red dots, two large and one smaller, declaring that it was magnificent, and made Thadée provide it with an equally magnificent frame. Although Natanson saw this as a symptom of Henry's decline into alcoholic fancy, it seems nonetheless to be a manifestation of Henry's real concern with abstraction as an art form. Natanson was most unhappy with the Salon des Indépendants that April, feeling that almost all the artists were in decline and that the most interesting artist there was the 'astonishing' Henri 'Douanier' Rousseau. Henry, who had probably been aware of Rousseau's primitivist

paintings since they were first shown at the Salon des Indépendants in 1886, would surely have concurred.

Thadée and Misia still saw Henry almost every weekend and had joined the ranks of his friends who felt he was intentionally killing himself with alcohol. They, like the whole intellectual community in Paris, had been horrified the year before by the death in an attic of the poet Verlaine from alcoholism, poverty and neglect. Now they tried hard to keep Henry from drinking, serving no wine at meals and encouraging him to work instead, but several times a day he would slip out of the little door at the end of the garden in Villeneuve and go to the café down the street to have a drink. He was showing signs of delirium tremens and of having hallucinations. One day a gunshot was heard in the house. When his alarmed friends ran to see what was the matter, they found Henry sitting cross-legged on his bed, a smoking pistol in his hand. He had been attacked by spiders, he explained.

In May 1897, Henry was working hard on a commission he had signed in April. Georges Clemenceau had asked him to illustrate his book, *Au Pied du Sinai* (At the Foot of Mount Sinai), intended, in that time of anti-Semitism and political strife, to explain to the French what Jews were like. Henry wrote to his mother twice about the project, once stating carefully that Clemenceau's book was *against* the Jews, the second time saying it was *about* the Jews. Clemenceau's intent seems to have been to promote a positive, or at least factual, image of Jewishness, but it has recently been argued that French anti-Semitism ran so deep that even when he was trying to be fair, Clemenceau couldn't help being anti-Semitic.

In the meantime, Henry had decided to move once again. He needed to leave his low-ceilinged mezzanine apartment at 30, rue Fontaine, which he called 'a flat for a fried flounder', and was even threatening to sue the owner of that building, he said, because he disliked the display counters of the fruit-seller across the street, who, to Henry's apparent discomfort, also sold oozing wheels of Brie cheese. To the friends observing his strange behaviour and paranoia, he seemed more and more disturbed.

At some point the preceding autumn, he had found his dream house at 5, avenue Frochot, only a few blocks from his current apartment in the rue Fontaine. Located next door to Marie Dihau in a famous, tree-lined private street full of studios with skylights and huge north-facing windows, and inhabited by artists, musicians and writers (Victor Hugo had briefly lived at Henry's address in 1870), it was substantially more charming than anywhere he'd ever lived in Paris. As he wrote to his mother, he hoped to live there in peace for the rest of his days. It was on the top two floors of the building,

with a country-sized kitchen and nine windows that looked out on gardens. On 11 May 1897, he signed the first year's lease, but he had begun using the mailing address of the apartment as early as January. Convinced that he would be moving soon, he had even asked his mother to have two barrels of wine delivered to the new address in November 1896. However, as he mentioned in a letter to his mother that he had 'been tricked again by the concierge of the new place', the delay was possibly due to the concierge's demands for key money. The move, which finally began in 'terrible heat' in the late spring of 1897, turned out to require two stages. First he had to move his household from 30, rue Fontaine; then, in January 1898, he was able to rent a large artist's studio at 15, avenue Frochot, at the end of the same private street, so he closed down his studio at 27, rue Caulaincourt, which he had used since 1885. As Joseph Albert was taking over the old studio, Henry had to carry out the second move rapidly, this time taking more than ten years of work to the new studio.

A newspaper article published in *L'Eclair* on 18 June 1914 tells an almost incredible tale about this move. At around the time Henry gave up the apartment at 7, rue Tourlaque, which was connected to the building which housed his studio, presumably when he moved to 30, rue Fontaine, he abandoned to the concierge 'to do with as he liked' as many as eighty-seven of his canvases. The new occupant of Henry's apartment, a Dr. Billard, who was interviewed for the article, said that the concierge had stacked them in a corner of the otherwise empty apartment and told him he could take any he liked. Unenthusiastically, he took about thirty, and the concierge exchanged the others, one at a time, for drinks in the neighbourhood bars. As the doctor never got around to hanging the canvases he had taken, he gave his maid permission to use the frames for kindling and later said she used some of the canvases themselves to wash floors. Finally she asked if she could take the rest to her house in the country to stuff cracks in the walls. Even the one work the doctor had liked enough to save was eventually traded to a patient for a painting by someone else: 'a little thing I still have,' he said. 'I keep it to remind me that I did not deserve the good luck that fell into my hands, then, when I was both blind and deaf.'

Joseph Albert would never have permitted such a thing had he known about it. Over the next few years, it was Joseph more than either Dodo or Henri, his brothers, who stayed close to Henry and tried to protect him as his health deteriorated.

On 15 May 1897, Henry held open house at his new apartment, to which guests were invited in the following fashion: 'Henri de Toulouse-Lautrec

Lithograph: Invitation à boire une tasse de lait, *1897.*

will be most f[l]attered if you will accept a glass of milk on Saturday, 15 May, at about half past three in the afternoon.' Although there was milk served for the ladies from a *modern style* table, decorated with wild flowers and decked with every kind of cheese as well as brown bread, cherries and strawberries, at the other end of the room there was a full bar and a bartender to make serious cocktails. The whole affair received a write-up in *La Vie parisienne* on 22 May.

The invitation itself contained a number of funny allusions, including one to Henry's frequent statement: 'I'll drink milk when cows begin to graze on grapes!' A 'milk bar' had recently opened in Paris, and the cartoonists in the humorous journals had been making fun of it. The cow in Henry's invitation, being herded by a caricatural Henry wearing spurs, a plaid shirt and polka-dotted trousers, is the *vache enragée* (crazed cow) of the poster for Willette's magazine for starving artists, but now she looks good-natured and friendly. At her feet, his beak next to her *pis* (udder), is a *pie* (magpie), forming an

infantile rebus or visual pun: *pis* + *pie* = *pi-pi* (pee-pee).

Henry was off for the summer almost before the party was over, a wise decision, since naturally he was having the place extensively remodelled. He sailed first to England for two days with Joyant, who was setting up a London branch of the Goupil gallery. Henry himself was promised a show there for the following year. The two days were spent seeing old friends from Paris, Charles Conder and Will Rothenstein. Soon after he went to the coast, to Le Havre and to Joyant's summer place at Le Crotoy, where they fished for mullet with great success at high noon in the broiling heat. As usual he was worried about paying his bills and requesting significant supplements from Adèle. Before the month was out he was off again, this time on a canal trip through Holland to Walcheren on a barge with Maxime Dethomas. The cruise had perhaps been suggested by Bourges, who was still Henry's doctor and whose study of treatments for syphilis, *L'Hygiène du syphilitique*, was published that year. Henry was manifesting so many symptoms of mental disorder that it is possible Bourges suspected tertiary syphilis of having taken hold.

Although Henry was delighted with the paintings by Frans Hals he saw on the trip, it was largely ruined for him when the island's children took him and the much taller Dethomas for a circus act and followed them through the streets, pointing and cheering.

At the end of the summer, he spent some time in Trouville in Normandy and planned to go from there to Arcachon and on to visit Adèle at Malromé. It was probably at Adèle's that he found the opportunity to do a portrait of his favourite godchild Kiki, now a young woman. The painting only shows her head and shoulders, but she manifests the distinctly receding chin which is a common symptom of certain forms of dwarfism. He had announced that he might bring along Leclercq, whose portrait he was also planning, but in the end that portrait was painted in the new studio in the avenue Frochot. Leclercq's description of posing for Henry shows how much the artist's ability to concentrate had degenerated:

For at least a month, I came regularly, three or four times a week, to the avenue Frochot. But I clearly remember that I did not pose for more than two or three hours in all. As soon as I arrived, he always asked me to take up the pose in a large wicker armchair and, wearing the soft little felt hat he always wore in his studio, he set himself up in front of his easel.

Then he looked hard at me through his pince-nez, screwed up his eyes, took his brush and, once he had clearly seen what he wanted to see, he set down on his canvas

a few light touches of highly diluted paint. While he was painting he remained silent, and his wet lower lip seemed to indicate that he was savouring something of exquisite flavour. Then he would start singing the 'song of the smithy' [an old French song with very licentious lyrics], put down his brush and declare with great finality: 'That's enough work for now! Weather's too nice!' and we would go out to take a stroll around the neighbourhood.

The stroll usually led them to the nearest bar, just outside the avenue Frochot at the corner of the rue de Victor Massé.

No matter that he actually worked very little on the painting, the results were striking. It is one of Henry's best portraits, done in beautiful blues and fine dry brushstrokes, showing the poet looking quizzically at his friend while he paints. Later that year, Henry drew the cover litho for Leclercq's book of poetry, *L'Etoile rouge* (The Red Star).

Several people, notably Gauzi, said that Henry never used the avenue Frochot studio, but it is clear that he did. Not only did he do a series of nudes, usually crouching or seen in a view that emphasized their buttocks, but also, in January 1898, he began a series of nine drypoints, the only ones he ever made. The first, dated 25 January, is inscribed *'Bonjour Monsieur Robin* [...] *mon premier zinc'* (my first zinc plate). The others were all sketches of friends and acquaintances. Still, Henry was not working much, making almost nothing but lithographs, and he was almost constantly drunk. His work was sometimes quite odd. A New Year card he drew for his cousin Gabriel bore the following text: 'New Year's Day, it's time, the child, tender and sincere ... (well-known song)'. It showed Gabriel doffing a curious round hat and bowing to a curtseying woman whose open bodice revealed her bare breasts. In the lower left-hand corner, Henry sketched himself naked as a new-born, sitting on a low stool formed by the three letters of his monogram: HTL.

Some of his friends describing him at this time spoke of his nervousness and fearfulness: 'His disposition had become more bitter, more tyrannical. A contradiction or an attempt to lecture him sometimes caused him to become very irritated.' According to Leclercq, Henry had become so para-noid that he saw spies and police informants everywhere. In cafés, when someone sat down at the next table, he often got up and moved, hissing indignantly at them the word *raclette*. In his mind this word, which normally refers to a cheese dish eaten by scraping melted cheese with a piece of bread, had taken on the implications of *rafle*, a police round-up. 'Lautrec was haunted by *"raclettes"*, believing that he saw them wherever he went,' said

Leclercq. 'And above all you had to be careful not to try to convince him otherwise.'

That January, he had taken under his wing a young cousin, Robert de Montcabrier, then about seventeen years old. He let him come to the studio and work by his side. Montcabrier defended Henry fiercely against attacks on his reputation, declaring that he was never vulgar, always polite and aristocratic, and that even if he salted his vocabulary with Parisian street slang, he never did so in the presence of ladies. Montcabrier felt that the principle of Henry's art, like the principle of Henry's freedom, was expressed in the reason Henry gave for refusing to criticize the works of his friends: 'Everybody has the right to paint the way they want to, and it's nobody else's business.' Henry sent Montcabrier another piece of advice by letter: 'I'm not saying this to discourage you, but finish your studies first before you take up this lousy profession of painter, which costs more than it brings in. I know what I'm talking about.' Henry was not painting: 'I'm in a rare state of lethargy,' he wrote to Adèle early that spring. 'I'm relishing my Avenue Frochot quiet so much that the least effort is impossible for me. My painting itself is suffering, in spite of the works I must get done, and in a hurry. Also no ideas and therefore no letters.' There is no sign that he was aware of the furor raised by the acquittal on 11 January 1898 of the true culprit in the Dreyfus affair, an aristocratic Hungarian, Major Marie-Charles Ferdinand-Walsin Esterhazy, and by Zola's furious reaction *J'accuse!*, published two days later, or of Zola's exile to England later that spring, to avoid a prison sentence.

Adèle, probably motivated by her sense of Henry's decline, decided to move back to Paris. In 1898, she rented a flat just down the street from the avenue Frochot at 9, rue de Douai, in a modern, bourgeois building on a respectable street. For 2,000 francs per quarter, Adèle rented the *étage noble*, or first floor, of the building, and despite the elevator of course insisted on taking the stairs. Her spacious apartment had high ceilings and large windows looking out on both the street and the courtyard. It had hot and cold running water, individual gas heaters and electric lights, but still also used fireplaces for heating. As it was all on one floor, she needed only two servants, a cook/housekeeper and a personal maid. The concierge of the building helped with heavy tasks.

Leclercq, who described Adèle as an 'elderly lady with beautiful hands who went to Mass every day', spoke of the sunny interior where he was sometimes invited to lunch, with its waxed floors and brilliant white tulle

curtains, over which hovered a delicate odour of lavender and furniture polish.

As Adèle hoped, her new apartment became Henry's headquarters and, taking up his old habits, he began having dinner with her there almost every night. In addition, by going down the back stairs from her kitchen and cutting through her courtyard, he could enter the back of the building at 10, rue Fontaine, across the street from his old apartment with Bourges. In 1898, 10, rue Fontaine housed the livery stable of Edmond Calmès, a hackney-carriage driver, who had recently become one of Henry's favourite drinking partners. He liked to take sugar over for Calmès' pony, Philibert, and he put both Philibert and Calmès' dog into lithographs. According to Leclercq, Calmès and Philibert took Henry for a ride nearly every day.

Adèle bravely tried to tolerate his eccentricities and to control his drinking. Remembering the problems caused when she had refused to accept one of his guests at Malromé, she now always encouraged him to bring his friends to her home, even allowing him to invite Calmès and his mother one evening. Henry responded perversely by insisting on introducing her to people he knew would scandalize her. Was he testing the limits of her promise, or did such scenes occur simply because his judgment was impaired by drink?

In any case, a cousin, Aline Séré de Rivières, later said that

he profited from the situation by bringing home girls from the streets to whom my aunt gave a polite welcome, one day even [introducing her to] a strange looking man dressed in a suit with large yellow and brown checks, and a matching cap. He wore rings on every finger and a very loud necktie. My aunt received him exactly as she would any guest. It must have been extraordinary to see the Countess of Toulouse-Lautrec seated across the table from the manager of the principal bordello in Paris. I have no idea what they can have found to talk about, but he kept his cap on throughout lunch.

Having Adèle back in Paris seemed to help Henry pull himself together. Suddenly, he was working again, producing two major lithographic albums, one of Yvette Guilbert, and one for W.H.B. Sands, the British publisher, to whom he wrote dozens of letters and even shipped completed lithographic stones. He was preparing about fifteen lithographs of theatrical and cabaret performers, many of whom were old favourites of his. An aquaintance, Arthur Byl, was preparing brief written monographs to accompany each

Lithograph: Mlle Aline Séré de Rivières avec son chien *(invitation to Henry's London exhibition), 1898.*

print. Henry seemed very excited about the commission, particularly since he was paid 100 francs per drawing, and Sands sent payment punctually.

Although Henry was still meticulous and conscientious about his work, his ability to keep other engagements appeared to be slipping. Various notes from the spring of 1898 break social appointments and, on more than one occasion, apologize for not showing up as promised. A letter by an acquaintance, Charles Angrand, writing to Paul Signac, called Henry a 'refined eccentric' and said he claimed 'that what he wanted was the joy of producing these delicate little successes without going to too much trouble. Isn't he going to put on a pantomime shortly at a major circus?' Angrand added nastily, 'Coming from him that wouldn't surprise me in the least.'

Henry was preparing his long-planned one-man show for Goupil in London, due to open on 1 May 1898, and on 18 and 19 April, he held a reception in Paris, to show friends and 'the ambassadors and other big cheeses who will inevitably flock to it' the works he was sending across the Channel. The invitation showed his young cousin, Aline Séré de Rivières, Georges' daughter, who had just left a convent school and was living in Paris for the first time, playing with her dog. Another litho for a menu, done some months later, showed the same or a very similar little girl, naked except for her long

Lithograph: La Fillette nue, *menu, 1898. This reproduction has been retouched to clarify the detail.*

Menu

socks, standing by the armchair of a bald man who was looking at her with great interest.

As Henry's studio was up a flight of stairs, he borrowed an empty studio downstairs at 14, avenue Frochot and with the help of the concierge and his cousin Montcabrier carried all the works for the London show down to the empty studio, where they were placed on the floor, leaning against the wall, face out. Montcabrier confirmed that Gauzi, who had visited the upstairs studio, was right. In his own studio, Henry's finished work was now always turned with its face to the wall.

The London retrospective, announced as 'Portraits and other works by Henri de Toulouse-Lautrec', had seventy-eight pieces in it. Henry went to London for the preview on 30 April. The show opened officially, by invitation, on 2 May 1898. In addition, James McNeill Whistler borrowed four paintings and a lithograph from the show for a group show he was organizing in London, the International Society of Sculptors, Painters and Engravers Art Congress. An anecdote about the opening of Henry's London retrospective is perhaps apocryphal. No firm documentation of it exists, but it would not be entirely out of character. As the story was told, Henry, who had too much wine for lunch, fell soundly asleep on a sofa at the gallery on

the day of the private opening. As promised, his distant relative, the Prince of Wales, arrived to visit the show. When Joyant rushed to wake Henry up, the Prince intervened, saying he should not be disturbed. Henry woke sometime later, after the Prince had left, and when told of the incident remarked, 'A nice chap!' The show received almost entirely hostile reviews, warning that decent women should not go to see it. Nothing was sold.

Now, many of his works had the image of a dog in them. Often it was Calmès' little mongrel, sometimes it was Robin-Langlois' collie or Madame Palmyre's bulldog, Bouboule, who often sat on the bar at her café La Souris. The little dogs were everywhere in his lithos, climbing into bed with women, poking their noses into a marriage proposal, talking to Calmès' pony, Philibert.

On 9 September, Stéphane Mallarmé, one of the Natansons' best friends, died. Henry went with them to the burial, and back to their house at Villeneuve-sur-Yonne, along with

Renoir, Vuillard, Vallotton, Bonnard, Claude Terrasse, Vollard, Mirbeau, Coolus, Bourges, Maurice Maeterlinck and Georges Leblanc. At dinner that evening, their nerves strained to the breaking point by the ordeals of the day, the entire company was overwhelmed with hysterical giggles. Misia, the first to recover herself, was both furious and full of shame. Renoir, who adored Mallarmé and was nearer to him in age than the others, gently reassured her: 'Don't be upset, Misia, it's not every day that you bury Mallarmé.'

Two months later, another writer was dead, twenty-five-year-old Jean de Tinan, for whose Symbolist novel *Ninon de l'Enclos amoureuse* (Ninon in Love) Henry had just drawn a cover illustration. He wrote a note of condolence to Tinan's parents, saying, 'I was very fond of your son.'

Suddenly, in the face of mortality, Henry was obsessed with controlling the whereabouts of his work. He wrote to all the dealers who had been selling prints and insisted that they pay for any that had been sold and immediately send back to him any unsold prints. The tone of his letters was such that printers like Kleinmann, who had sold Henry's work for years, or Gustave Pellet, whom only two years before Henry had called 'the intrepid publisher' for his courage in printing works that would never sell, must surely have been offended. Henry didn't care. He was convinced that he was being followed, that the police were about to arrest him.

It seemed to everyone that Henry was going crazy. He was struggling des-

perately for control, if not over his own feelings and behaviour, then over the world around him. It was in this tense, delusionary atmosphere that Henry discovered, on the evening of 3 January 1899, that he could not have dinner with his mother because she had left Paris without warning. It is true that Adèle had gone with her brother Amédée to Le Bosc and that she had told no one in Paris except her servants that she was leaving, but letters from the time show that she had been considering leaving for several weeks. It is probably true, as Henry clearly believed, that Amédée had come to Paris to persuade her that she had to get away from Henry for her own good.

Since Henry's oddly tranquil announcement early in 1898 that he could no longer work, his behaviour had grown more and more erratic. Now he was obsessed with being caught in a police raid. He had started sleeping with his cane where he could reach it from his bed, in case he was attacked in his sleep and had to defend himself. He had taken to swatting at invisible flies. Similar stories had been coming back to Adèle from others. Humiliated by his behaviour, she found herself making excuses for Henry, acting as his intermediary with the outside world. As Henry grew more and more careless about his accounts, his landlady, for example, began dunning his mother for the unpaid rent.

Although Adèle had difficulty accepting it, no one else doubted that Henry was an alcoholic. In early January, he was visibly shaking with delirium tremens and subject to hallucinations which may also have been the result of tertiary syphilis. A prescription Bourges had given Henry in December was apparently for psychological disturbances, but not for any specific illness. He prescribed linden tea, well known as a soporific, sulfonal in case of insomnia, and one coffee-spoon daily of *Valerianate d'ammoniaque* for a month. Valerian, a plant extract, was used in the nineteenth century as a treatment for hysteria. Its twentieth-century counterpart is Valium.

In his paranoid, hallucinatory vulnerability, Henry perceived Adèle's departure as an absolute and final rejection. His Maman, who had cared for him through his childhood illnesses, had now left without telling him. Perhaps her act called to mind his despair when he was nineteen months old, and Adèle, saying she was leaving for two days, did not come back for two months. In any case, the irrationality and intensity of his reaction were reminiscent of a two-year-old's fury at discovering that his mother is not always going to be there when he wants her. The frustrated child eventually subsides into tears and sleep. Henry raged until he saw that he was powerless, then sought comfort in drink.

Although Adèle had hesitated a long time before deciding to leave, when she finally made the decision it was obviously for reasons of self-preservation. She seems to have been unable to quell her anger and frustration with her son's increasing craziness. He had, temporarily, entirely ceased to be her ally and the head of her dinner table, and had become the monster others had always believed lurked underneath. Other relatives writing letters to her at the time supported her decision and suggested that going to Albi was essential to her well-being, that she was tyrannized by her son and needed to be surrounded by those 'down there who love you tenderly'. Still, in the light of Henry's growing physical and mental disintegration, to outsiders it seemed irresponsible for Adèle simply to leave Paris. She hoped, no doubt, that the situation would somehow magically take care of itself.

Paradoxically, once Adèle had managed to leave Paris, she frantically contacted everybody there who might give her news of her son. Henry correctly suspected her of 'spying' on him. Not only did Adèle's housekeeper, Berthe Sarrazin, write nearly every day, but letters from Henry's cousin Gabriel show that he, too, considered himself to be reporting to Adèle on Henry's condition. Joseph Albert also wrote to her and said in a postscript, 'Henri shouldn't know that I've written to you.'

The reports were not reassuring. Berthe wrote that Henry was racing from house to house, finally ending up at Calmès' livery stable. Calmès was the only man Henry knew who drank more than he did. Henry was to spend many afternoons with him in the weeks to come, growing more forgetful and unkempt, drinking until his rage turned to gaiety, then to stupor. After each bout, Calmès would harness up a hansom cab and drive Henry back up the street to his studio, depositing him unconscious outside the gatehouse. On the night Adèle left Paris, Henry arrived at midnight so drunk that the concierge had to manoeuvre him up the street and put him to bed.

The next day, 4 January, he couldn't remember what had happened the night before. He had lost the keys to his mother's apartment. He made Berthe get him an extra set and flew into a new rage about his mother's leaving. 'He told me he didn't understand what kind of trick they were pulling on him,' Berthe wrote, 'why Madame hadn't warned him, [he insisted] that when there was something happening in the family he was always the first person to be informed.'

Suddenly growing more cheerful, he ordered Berthe to cook dinner for four people at his mother's house. Then he went out. Berthe set the table in

vain. Henry never came back. The turkey she had roasted went uneaten.

Then he disappeared, buying all sorts of things, including dolls. 'He had another litre of turpentine delivered,' Berthe wrote. 'I took it back. All he does is buy a lot of things, old pastry-moulds, spoons for 20 francs at the paint-shop; but I'm going to take them all back and tell them not to deliver anything else ... Overnight he spent a thousand francs.'

Henry's extravagance was not just with money. On 6 January, Berthe wrote to Adèle: 'Tonight we are having people to dinner, six places. I don't think it will be like last night. I'm doing a fish, a rabbit and the cold turkey and a pineapple ice. Monsieur wanted lobster à l'Américaine, bouillabaisse, goose-livers in sauce, but I made him understand that it was too complicated and that I was all by myself.'

Seven men came to dinner at his mother's house to eat the 'bad luck turkey', as Berthe called it, smoking and singing. Henry himself slept on a chaise-longue by the fire, rousing himself at midnight to make a huge fuss and insisting upon being put in his mother's bed to sleep. Then he wanted Berthe to find him four flannel shirts, all of which he put on. Finally, when all the other guests had left, Joseph Albert persuaded Henry to go back to his own studio to sleep.

His mood changes were pronounced, shifting from the fear that he was being cheated or robbed to prodigal generosity. A shopkeeper reported that Henry was telling 'everybody' to charge purchases to his account although he hadn't paid his bill in two years. 'This morning,' said Berthe, 'he told me he was going to settle an income of 3,000 francs on me. I couldn't help laughing. I saw in a minute that he was going to take offence.' A day later he wanted to gaol the girls at the telegraph office because he could not remember that they had already given him 1,000 francs that had come in a money order.

No madness could be more palpable to Berthe's frugal French sensibility than wasting food or money. As Henry's extravagance grew, so did her anxiety. She tried hard to protect him. A poignant element of her attempt was her neutrality in expressing her own feelings to Adèle. She merely reported what happened: 'Yesterday I went over [to Henry's apartment] eight times.' When Henry's behaviour was so upsetting that she could not contain herself, she wrote what she really thought to another servant, Adeline Cromont, who promptly showed the letters to Adèle anyway.

On 7 January, Henry paid 172 francs for painted plaster figures which he had delivered. When his masseur (whose treatments were more comforting

than curative) came for payment of a 70-franc bill, Henry tipped him 100 francs. Later, Berthe saw the masseur in the street and told him that he shouldn't have accepted the tip, that 'Monsieur' was out of his mind. 'He told me he was a poor fellow, that he had six children, that the money would do him a lot of good, in short, he didn't want to give it back.' She felt helpless: 'I'm not always there and can't see everything,' she explained to Adèle.

Many of Henry's friends also came to his aid. Adèle considered some of them to be better for him than others. Gabriel, Sescau and Joseph Albert tried actively to control his drinking. Joyant, the Natansons and Bourges were trying to remain neutral in Henry's struggles with Adèle. Calmès, Stern and Maurin got drunk with him. In a misguided attempt to fend off the bad influences, Adèle had asked Berthe to order some of them, notably 'La Gabrielle', the now ageing prostitute he had so often painted, to stay away. But like his low-class drinking buddy Calmès, Gabrielle would soon be back. 'That dirty bag told him that I had sent her a telegram telling her not to come again on orders from Madame, and so Monsieur is even more angry with Madame ... It's terrible to have him in the clutches of that slut. She has taken everything in the studio that could be carried off.' Berthe worried that he was being exploited: 'The shopkeepers take advantage by selling him lots of dirty old stuff,' she said.

'There's nothing new,' Berthe reported matter-of-factly on 8 January: 'He is still buying antiques, varnishing his pictures with glycerine and rubbing them down with a sock.' Only later, in a letter to her friend Adeline, did she show her anxiety: 'I'm very much afraid he's going to spoil them all.' Apparently Adèle was also worried, for Maurice Joyant responded to a question on her part by writing: 'There is no need to worry about the Vaseline he put on his canvases; one of these days I'll go and see how his pictures are doing.' Glycerine, so far as can be determined, did not hurt them either. It is used as a lubricant and as an ingredient in varnishes, papermaking and artists' colours. Normally transparent unless of low quality, glycerine is about as solvent as water or weak alcohol. Henry's curious treatment of his paintings may have been related to his hatred of varnished paintings and his practice of leaving the surface of his own works matte.

'This morning,' Berthe wrote the same day, 'his face was red and swollen like the other day ... I'm sure he's still drinking; if it could only be kept away from him for a week or so, he would be cured,' she added optimistically. 'He's calmer and doesn't touch the stove at all. He isn't disinfecting things any more either. The thing he's still doing that's unreasonable is buying old

stuff. He's spending a lot of money.' Joseph Albert, possibly hoping to control his behaviour, had spent the whole day with him.

When on 9 January Berthe tried to stop Henry from pouring rum into the marmalade at breakfast, he put her in her place 'in no uncertain terms'. He was eating only raw eggs mixed with rum, and coffee, and talking to her incessantly, which she encouraged, since when he was talking, he forgot to drink. Unfortunately, Calmès came every day to take Henry out, and they ended up spending the rest of the day in the bars. 'They both drink, one as much as the other.' Someone had given Henry a fox-terrier puppy, which had to be fed with a bottle. Naturally Berthe ended up taking care of it.

She urged Adèle to come back. Henry had invited Paul Sescau and Charles Maurin to lunch at Adèle's, although only Sescau actually appeared. 'It's easy to see that when Madame isn't here he takes advantage,' she wrote to Adeline. 'Tell Madame that things are going a lot better, that she can come back. I think Monsieur would be VERY pleased.'

A couple of days later, Berthe wrote to Adeline again: 'What's going to be done to help Monsieur Henri? He can't stay this way forever, but no one is taking care of him. I never see Monsieur Gabriel or anybody. It's strangers, mostly Calmès, who take care of him.' Her frustration showed. To Adèle, she tried to soften the bad news. Henry, she said, didn't remember 'anything at all ... Every time he sees me he shows me his hand and tells me it's all right, it's well again; this morning he asked me if Madame knew he had burned his hand,' she felt obliged to say, adding in a more reassuring tone, 'He doesn't touch the fire any more. He doesn't even light newspapers any more. He didn't buy anything today or yesterday.' She thought he was out of money. When she went to the studio, Calmès and his dog were asleep on the couch. Henry begged her for rum. 'I gave him the rest of the bottle that was in the cupboard.'

On 11 January she wrote: 'Monsieur is still very angry with Madame. He told me ... that Madame had left him right in the middle of work, that he had done everything to keep Madame but that she had wanted to go travelling, that her leaving had upset him and made him sick.' Having figured out that it was his Uncle Amédée who had taken Adèle to Albi, Henry reacted almost as if his uncle were the 'other man' who had stolen his mother from him. His anger at his mother and his uncle became an obsessive theme of his conversation. He was convinced, for example, that Amédée was trying to turn his mother against him and that his mother had shown favouritism to Amédée in the question of the Château du Bosc inheritance. He repeatedly threatened to go to Albi to settle the whole thing. Henry, of course, had a

real grievance against Amédée, although it probably was not directly his fault that Alph had decided to sell Le Bosc to his sister Alix, Amédée's wife. Now Henry focused all his pent-up anger on his uncle.

As his hostility increased, he experienced paranoid delusions. He was afraid to go to sleep at night. At one in the morning, he crossed the street from the avenue Frochot to Père François' bar to ask the owners to send their errand-boy back with him to search the studio 'to see whether anybody was hiding there. He told them he was on bad terms with his family, that his family wanted to have him locked up and that he was afraid they'd take him away while he was asleep.' Berthe duly repeated this prophetic remark to Adèle, who must have been finding it increasingly embarrassing to have the family's dirty linen washed in public.

By odd coincidence, Henry's obsession with cleanliness had now manifested itself at the level of his linen. In addition to wearing layers of underwear, put on one over the other, he wanted fresh linen several times a day. The day before, Berthe had written: 'Monsieur keeps on making a mess of his linen. He takes all of it out of the chest, throws it all on the floor. This morning I gave him 8 pocket handkerchiefs. At 10 o'clock when I returned, he didn't have one of them left. He puts vaseline on his pictures and wipes it off with his handkerchiefs.'

Many people outside Henry's immediate family knew how his behaviour had degenerated. Since the time he had shot off a gun in Thadée and Misia Natanson's country house, his friends had been aware that he was having hallucinations. But they had learned long before that it was hopeless to try to control Henry in any way, particularly in his drinking. On the contrary, he was so persuasive that he could succeed in getting even teetotallers to join him. He hated to drink alone and he was proud that he drank only 'good stuff' in the bars, though when he thought nobody was watching he plied himself with Père François' cheap rum.

Although he appeared to be disintegrating both physically and emotionally, at least for the time being he continued to see many friends. On 12 January, he signed and dated a drawing of his father's profile, which he gave to Spoke. He continued to go to Le Hanneton, one of the lesbian bars he liked, and did a lithograph there that January, called *Conversation*, showing two lesbians talking. But his decline was showing strongly in his art, and the drawing on the litho is so shaky that it is almost unrecognizable. He also saw, at least occasionally, his young cousin Robert de Montcabrier, his friend Robin-Langlois and the photographer Paul Sescau, to whom he raved that he was going to make his family account to him for what they'd done. Sescau

confided to Berthe that he found Henry worse every day and that he didn't know what was going to happen to him. 'Monsieur was in a sorry state all day yesterday,' Berthe wrote to her friend Adeline on 13 January. 'He was furious with Madame over not having heard from her. He told me he'd never set foot in her apartment again ... He thinks Madame will never come back again, he is very worried.'

Henry's persecution complex was spreading. Angry with Uncle Amédée, Henry now rejected Amédée's son Gabriel, too, convinced that Gab had betrayed him. Two letters Adèle received from Gab that January show his hurt and grief when Henry's paranoia began to affect him directly.

Berthe had already written to Adèle that she never saw 'Monsieur Gabriel' any more. Then, twice in five days, Gab himself wrote to Adèle. Friday, 13 January, seemed especially unlucky to him: 'I had been eliminated from the dinner. Henri doesn't want me around much any more. I have lost my novelty for him, and scarcely correspond to his ideal of the moment,' Gab wrote, referring to Henry's new attachment to the alcoholic hackney cab driver, Calmès. 'Let's be patient and see what time will do; that's the best course.'

By Tuesday, however, relations between Gabriel and his cousin were much worse. He wrote:

My dear Aunt,

What was bound to happen one day or another has just happened. Berthe came early this morning to tell me that Henri has ordered her to throw me out if I should try to see him, because I am nothing but a spy ... Sooner or later, somebody was bound to tell him that I have been watching over him. I have no idea who denounced me, and I won't try to find out ... Only yesterday evening I dined with Henri at Leclercq's, and he confided in me and told Leclercq how fine I was, that he would make something of me, etc. At last it's over. I have done everything I could for Henri, even letting him destroy the friendship between us, to act in his best interest ...

In any case, I must not see him again, for a scene between us would be too painful to bear, and since it would probably take place in public, it could only have unfortunate consequences ... The future doesn't look too rosy to me, for in addition to his malady, your son's disposition, as you know, is impossible.

Unknown to Gabriel, Henry also had written an astonishing letter. Dated 16 January, the day of the dinner at Leclercq's, it reads: 'My cousin Gabriel having cared for me day and night during the nervous breakdown provoked

by my mother's unexpected departure, I request that my family bestow on him a sumptuous gift in commemoration of this.'

Over the weekend, Henry also sent a number of telegrams, including a garbled one to Bernard Jalabert, his overseer at Ricardelle in Coursan: 'Send the number three registered letter urgent 15 I say fifteen avenue Frochot, Letter follows, reimbursable end of month.' Berthe's daily report to Albi clarified what was going on: 'Monsieur asked me if I had any money. I said Madame hadn't left me any. Monsieur told M. Sescau that he was going to call them to account, that he would get 3,000 francs tomorrow.' The next day she wrote: 'He got a telegram from Coursan. Monsieur told me he was going on a trip. He's going to go to Coursan with two detectives and get his due. He said . . . that he's being robbed.' She added, 'If I listened to him, I'd be spending at least 500 francs a day.'

Henry's concierge complained to Berthe that Henry kept waking him up to go in and out of the locked gate all night long. Henry confided to her during a lucid moment that he wasn't sleeping at all any more and that he thought he was much worse. He didn't know what was going to happen to him.

He drank to give himself courage, and sometimes it gave him too much courage. The same weekend, around 15 January, Henry wrote to his uncle, Georges Séré de Rivières, inviting him to lunch. At luncheon, he formally asked to marry Georges' twenty-year-old daughter, Aline, whom Henry had drawn in a lithograph several months before. After lunch he bragged to Berthe that he was going to have a judge for a father-in-law and that then his family would be obliged to account for their deeds.

Aline was probably polite and kind to her handicapped, alcoholic cousin, but she certainly was not considering him as a suitor. Suddenly, he seemed to have lost his usual insight and good judgment. In chaos, perhaps panicked by the breakdown of his friendships and family relations, he committed a painful and embarrassing act of self-revelation. He abandoned his habitual defensive aloofness and ironic disdain to ask inappropriately for something that he had never been willing to admit he wanted: a wife, a family, a life like everybody else.

Georges was unreceptive, politely vague and neutral. Aline herself was never given the opportunity to respond to Henry's proposal. It was only much later that she even learned of the incident. Many years later, having never married herself, she told a reporter: 'My father told me that he [Lautrec] had asked to marry me when I got out of the convent; this proposal was never transmitted to me; moreover, at that age you have rather stupid

dreams, and I would not at all have understood the great honour he bestowed on me.'

Adèle had been gone only two weeks, yet Henry's condition had grown truly frightening. Berthe wrote that he was fidgety and restless, preoccupied, angry; his face was very red. She said that he was continually flying into rages, threatening to have people thrown into jail. He was convinced that other people had keys to his house, that they would sneak in and wait in hiding for him, to take him by surprise. He forced his way into his mother's apartment, demanding that all the locks be changed not only there, but also in his own studio. He made Berthe send for the locksmith, but she talked the man into only 'pretending' to change the locks. She reassured Adèle that nothing had been stolen from either house: 'They have robbed him all the same, but by taking things from him, personally. He no longer has his watch, or his fine silk scarf. His tie pin has disappeared.' He was sleeping in his clothes and had grown careless of personal cleanliness. She was also beginning to be seriously worried about his physical health. Now he was jaundiced and had a boil on his neck, which he swathed in poultice-soaked cloth, wound around like a scarf. His lips were covered with 'yellow crust'.

She wrote detailed accounts of Henry's days to Adèle:

It's true that Monsieur has no one ... we never see any of his friends any more. Only Calmès and Gabrielle are there, and they never leave. Monsieur is giving away everything in his atelier, all the knick-knacks, to Calmès and Gabrielle. He even gave away his bed-cushion. I don't know where this new craziness will lead ... when I talk to him about Madame, when I say she's going to come back, he says he doesn't want her to come back any more; other times he says we have to be indulgent, that Madame is ill. He changes his mind twenty times in two minutes. I don't pay any attention to what he says, but at bottom he's very angry that Madame isn't here. He isn't working any more at all. He doesn't even rub things with glycerine any more.

That January 1899, only one of his famous posters was printed. It was the last poster Henry made for Jane Avril, from a design he had painstakingly prepared the autumn before. One of his few activities now was to supervise the printing of this work, which had been transferred to a small stone, probably by his printer, Stern. For years the two men had worked together every Sunday, having lunch afterwards. Now they usually just started with lunch and didn't work. Berthe found them on Thursday, 19 January at suppertime, still sitting at their table at Père François' bar, along with La

Gabrielle, 'drunk as I don't dare tell you what'. Despite all this, Henry was obviously excited and proud as the first print of the Jane Avril poster was pulled. Enthusiastically, he dedicated it 'to Stern, in the emotion of a first beginning'.

Although the poster (Plate 50) is as pure of line as his earlier work, certain elements of it seem inconsistent with a cheerful publicity poster for a cabaret performer. As in much of his work, the black silhouette of the woman is cut off at the ankles. Her body rises from the bottom edge of the paper to arch diagonally to the left in a serpentine curve. Her hat is monstrous and seems to form a menacing head dominating the upper left quarter of the poster. It and her hem are flame orange, contrasting with her hair, which is a crude yellow. She holds her hands to the sides of her head in alarm, and her facial expression is difficult to interpret. The eyes gaze distantly to one side while the mouth is open, in shock perhaps, or passion. Coiling around her body, its head protruding between her breasts, is a huge, rainbow-tinged snake. The sense of madness or fear in this face is utterly unlike the expressions Henry typically portrayed in his models. Jane Avril's expression and gesture resemble those in Edvard Munch's 1893 work *The Scream*, which Henry had almost certainly seen reproduced in *La Revue blanche* in 1895, if he had not seen it exhibited in Paris. Munch had shown twice in Paris in 1896, and the same year, Jane Avril had played the role of Anitra in Ibsen's *Peer Gynt* for which Munch designed the poster. Henry's poster, however, was judged too ambiguous or frightening to attract the public, and was never used.

A few sketches by Henry also remain from this period, but they are very different from the planned, finished poster done only a few months earlier. These hasty drawings all have in common a cartoon-like quality. They seem anecdotal, like illustrations in a humorous story. A drawing published in Thadée Natanson's study *Un Certain Henri de Toulouse-Lautrec*, with the title *The 1899 Crisis*, depicts, in tremulous line, a puffy cartoon face, and beside it what looks like a pregnant satyr with beard, breasts, a protruding belly, feminine hips and posture, and a tiny penis.

Other sketches took up childhood themes, using again parrots, trains and tunnels, animals in costumes, pipes inserted in various bodily orifices, personification of objects. In one, a caricature of Maurice Guibert rises like a sun from the horizon, to observe a smiling fox-terrier. The dog, wearing spurs and a pince-nez, has a pipe stuck in its anus. It is confronting a suspicious-looking cat, curled in a ball.

Since 1896, Henry had been portraying his friend in obscene sketches which looked as if they had been done in brothels. Henry also put himself

into these sketches, sometimes as an actor, more often as an observer, stuck into the lower left-hand corner of the picture like a signature. Occasionally he drew a dog in his observer's spot. Since Henry owned at least two fox-terriers during his lifetime, and often replaced himself with a dog in his sketches, the fox-terrier found in this drawing wearing Henry's characteristic pince-nez and the spurs he had worn in the *Invitation to a Glass of Milk* may well be a symbol for Henry himself. Implicit also in this drawing of the fox-terrier and the cat are two obscene puns: *une pipe*, a French slang expression for fellatio, and *une chatte*, an expression referring to female genitalia. He had been greatly amused by May Belfort's allusive performance with a live cat on stage. It is not at all farfetched to see this drawing as a sketch of Henry himself, armed with spurs, a seductive smile and openly erotic intentions, encountering a wary *chatte* while his friend and fellow brothel-goer looks on. The rising sun has a fierce, condemnatory expression.

His disturbed drawings were matched by equally disturbing behaviour. As the end of January approached, there was almost a monotony to the outrages Berthe described. An errand-boy delivering breakfast to Henry's studio was greeted by the sight of Monsieur in bed with La Gabrielle and another woman. Monsieur was drunk all the time; he couldn't stand up; he had 'beaten up the little concierge'; he broke into his mother's apartment and insisted on cooking a whole ham in a bouillon of red wine, white wine, rum and vinegar. He made a present of the inedible ham to Calmès, along with a lot of his mother's wine.

At first, he insisted on sleeping at the rue de Douai, in Adèle's bed, and kept the fire going in the fireplace all night long, but by 22 January, his paranoia had grown so strong that he refused to set foot in his mother's apartment at all and even moved out of his own studio. He did not go far, however, for Berthe discovered that he was sleeping near his mother's, in the apartment of his friend Robin-Langlois and his wife, who lived around the corner at 30, rue Fontaine. 'I must warn Madame that Monsieur Robin is completely hostile to her. He says that it's the family's fault if Monsieur is like that, that he's been abandoned, that nobody is taking care of him, that he's greatly to be pitied, that he feels sorry for him.'

Berthe confided to Adeline: 'All of Monsieur's friends blame Madame for having gone away, for having left her son in this condition in the hands of strangers. Just between us, I think they're right. Madame's place should be here.'

Far from Paris, Adèle had no more idea what she should do about her son than she had had before. Her behaviour had become as indecisive as Alph's

habitually was. She asked advice of everybody, even her son's friends.

In her indecision in mid-January, Adèle had also sought an ally in the mother of Henry's childhood friend, Etienne Devismes. Madame Devismes not only gave her advice on what to do about Henry but tried to persuade her to contact Alphonse, who so far knew nothing about the situation with his son.

Adèle was feeling similar pressure from her family. They too thought Alphonse needed to be told. After her many years of martyred silence, enduring her husband's refusal to act as a father to Henry, not to mention his blatant rejection of her as a woman, she let her rage rise to the surface. She decided that no one was to tell Alphonse about Henry. Although she did not enumerate them, it is easy to imagine her reasons: Alphonse was unreliable in a crisis and absent when confronted with responsibilities. Worse, he was unpredictable and sometimes turned up in the middle of a difficult situation, insisting that his opinions determine any decisions. Adèle had decided long ago that the easiest way to deal with Alphonse was to make all important decisions without consulting him. Less rationally, she may also have felt that Alphonse did not deserve to know about his son. Had he only been present in the household, perhaps Henry would not now be uncontrollable. She both desperately needed and angrily scorned the comfort, moral support and decisiveness that a husband's presence might have provided. She wrote to Madame Devismes again, asking whether a good Catholic might have permission to divorce. The answer was discouraging: 'One cannot under any circumstances, from the Christian point of view, ask for a divorce. You can only have it imposed upon you.' In the meantime, Henry telegraphed his father himself, to ask him why Amédée had first gone to Paris. It is not known if Alph replied, but he did not come.

By now, Henry was so alcohol-soaked that the first sip in the morning would make him drunk again, and his friends observed his decline with increasing alarm. His speech, said Thadée Natanson, already difficult to understand, had become incomprehensible, 'staccato, interrupted by grunts. He laughed a lot. He loved to laugh; hiccuping with laughter, he laughed till he cried.' He observed that while Henry was working, he hadn't had the need to drink, that he never worked drunk. But by extension, when Henry was drunk, he couldn't work, and because he couldn't work, he drank. Natanson admitted that now he felt ashamed to be with the confused, shaking, incoherent Henry: 'He was afraid, and this fearful Lautrec made me afraid.' Now Henry believed he was being tracked by the police. He hid at Calmès' livery stable.

Henry had described to Thadée 'a beast which had no head, which slithered, although it had feet, which hovered over him menacingly, pushing him into his bed. Fox-terriers surrounded him, howling.' Around the same time, Théo Van Rysselberghe, Henry's champion from the days of the XX exhibitions, visiting Paris from Brussels, ran into Henry in the street and described him to fellow painter Paul Signac as 'wearing red trousers, carrying a blue umbrella, clutching a pottery dog under his arm'. He was fighting off an imagined attack by the cardboard elephant used as an advertising billboard outside Le Moulin Rouge. Maurice Joyant tried to get Henry to leave Paris with him, to go to Le Crotoy, and Berthe packed a bag, but Henry, confused and paranoid, disappeared and did not come home.

His symptoms were beginning to read like a casebook study of organic psychosis. Advanced stages of certain diseases, including neuro-syphilis and alcoholism, can be marked by psychotic behaviour caused by damage to the brain. He manifested many of the symptoms particularly common in advanced cases of alcoholism: personality changes, physically violent behaviour, increasing paranoia, obsessive-compulsive behaviour patterns, careless personal hygiene, alienation from family and friends, irresponsibility about money, frequent moving about even within the same neighbourhood and reliance on other alcoholics for understanding. Terminal stages of both diseases include isolation of the personality in a fantasy world, aural and visual hallucinations, physical disintegration, heart palpitations, breathing problems, sweating, shaking, convulsions and general paresis.

As Henry's condition continued its precipitous spiral, the pressure on Adèle increased. Her sister-in-law Emilie wrote to say that the family had decided that Adèle had vacillated long enough. A group decision had been reached: she had to return to Paris. She should be handling this herself. Writing letters, far from improving things, tended to make them more complicated. She should not, however, try to stay at the rue de Douai but return to the old family stronghold, the Hôtel Pérey.

Still Adèle hesitated, and more misdeeds piled up. On 2 February, the overseer at Ricardelle, Bernard Jalabert, forwarded to her a furious letter he had received from Henry's landlady in the avenue Frochot. She began by threatening to send Henry's rent bills, unpaid since October, to a collection agency. Then she continued: 'I must warn you that he has already set fires in his house, pouring petrol on rags he's put into our toilets and then lighting the liquid, which flames up! The frightened neighbours went to get the

concierge who put out the beginnings of a fire. He had to be put to bed. He doesn't realize what he's doing!!!'

Henry's behaviour around fire was becoming more and more irresponsible and resembled the pyromania of disturbed adolescent boys: first he had burned himself by putting his hand down on the stove, then he had built a roaring fire in Adèle's bedroom, before going to sleep in her bed; now he was trying to burn the bathrooms. According to Gauzi, this was an extension of Henry's obsession with hygiene, which had begun with fantastic bathing rituals and now involved many layers of clean linen. One night, Gauzi said, Henry had washed down Adèle's apartment with kerosene 'out of fear of germs'. Now, possibly on more than one occasion, Henry had burned newspaper and kerosene-soaked rags in the toilet bowls of the building his studio was in, complaining that the toilets 'almost asphyxiated him' with their smell and threatening to write to the Department of Public Health.

Henry had turned vicious. On 3 February, Berthe wrote to Adèle that Henry was 'like a madman. I had never seen him so violent. He wanted to hit the little concierge.' A few nights before, in a hotel room with two whores, Henry had nearly been arrested for not being able to pay the bill. He had announced to the police that he was the Comte de Toulouse. Finally a café-owner lent him the 3 francs 50 centimes that were due. He went to bars and talked out loud about how his family was trying to do him out of his inheritance and how he was going to have them all put in jail. He was also telling people that he didn't have a mother any more, or any family. For the Toulouse-Lautrecs, the worst possible threat was scandal. Adèle was perhaps more distressed over the public staining of the family image by her misfit son and the implicit criticism of her capacities as a mother, after all her years of self-denial, than she was over Henry's painfully obvious cries for help. In any case, the scandal was more effective in prodding her to action.

After weeks of chaos, Henry did one last, incomprehensible lithograph. Its uncertain, fragile lines depicted a collie with its tongue hanging out, looking at a parrot on a perch. The parrot, wearing Henry's pince-nez and an absurd little hat, had a pipe in its mouth. Henry's childhood emblem of evil had finally come to represent himself. In the background, a frail stick-figure appeared to be trying to stop an oncoming train. Farther down the track, in front of the train, was a prancing poodle. The drawing was dated 8 February 1899, almost certainly the day that Adèle returned to Paris.

As her sister-in-law had suggested, she stayed at the Hôtel Pérey, with the family all giving advice in letters, but she still did not know how best to

approach her son. A long letter two days later from Amédée, safely ensconced in Albi, as was Alph, expressed worry that she might wait too long before deciding to deal with the situation. He mentioned that sooner or later Henry was bound to find out she was there.

She probably went back to the rue de Douai the same day, because in a letter Henry himself wrote that day to Calmès, he invited the hackney carriage driver and his mother for dinner at Adèle's apartment. Adèle's attempts at a normal interaction with Henry failed very quickly. On 13 February, she hired a male nurse to stay with him around the clock. The next day, Berthe wrote that there was trouble again: 'This man is stupid as a goose. I don't think he'll be able to keep on looking after Monsieur. He lets him drink, he doesn't at all know how to handle him.' Then Berthe enumerated Henry's most recent escapades. He had taken his 'guard' to a lesbian bar. After they had both drunk copiously (perhaps without taking along any money to pay the bill), Henry sent two of the bar's employees with baskets to collect wine from Adèle's wine-cellar to take back to the bar.

Lithograph: Chien et perroquet, 8 février 1899. *The lithograph, including the date, was drawn directly onto the stone, producing mirror-writing in the print.*

When Berthe refused to let them in, an errand-boy came back with a letter from Henry instructing Berthe to give them the wine. The drunken guard even made a pass at Berthe when he brought Henry back to the rue de Douai for lunch. 'I didn't dare tell Madame by word of mouth that he wasn't decent to me and that's why I don't want to spend the night here any more.' The next day, Adèle hired a new guard for her son.

This solution remained unsatisfactory, and less than two weeks later she began talking to doctors and having them examine Henry.

The most likely scenario for what happened next is that Adèle, exhausted by the increasing difficulty of dealing with Henry, his guards, his drunken sprees and his public embarrassments, called on her traditional allies, Bourges and Gabriel, both medical doctors, to help her persuade Henry to enter treatment. As both of them had been avoiding contact with Henry in recent weeks, it is not clear whether or not they came to her aid. Nor is there any evidence that Uncle Georges gave her support at this juncture. In any case, within a week, Adèle, going against the family's advice, had committed her son to a private insane asylum. Subsequent accounts claimed that he collapsed in the street, or that he was paralysed by an attack of delirium tremens in the brothel in the rue des Moulins, or that he was carried, screaming, from his studio, but apparently Henry, terrified in his lucid moments by his hallucinations and his failing health, agreed to be taken to the clinic. Evidence that this was done with some planning is provided by a note he wrote to his young protégé, Robert de Montcabrier, cancelling a lunch and sketching session they had planned together for that Sunday, 5 March, with what Montcabrier called a 'white lie' – saying that the model couldn't come and that he had to work on a portrait in town – so Montcabrier wouldn't know he was being taken to an asylum.

Dr. René Semelaigne's clinic at 16, avenue de Madrid in Neuilly, almost across the street from the Bois de Boulogne, in no way resembled the popular conception of an insane asylum. Built in the eighteenth century, La Folie Saint-James had originally been the 'folly' or country estate of a royal courtier. The irony of the unintentional pun on *folie* (madness) was not lost on Henry. As he grew accustomed to his new abode, his sense of the comic returned. He dubbed his new home 'Madrid-les-Bains' and 'Saint-James Beach', as if he were on holiday at a Spanish spa.

Adèle had tried hard to find the best possible place for her son, getting a list of suggestions from doctors she knew, and her choice was certainly impressive. Dr. Semelaigne took in twenty-five men and thirty women, each

of whom paid between 500 and 600 francs a month for full-time residential treatment.

The clinic was a small palace which guests entered through a mirrored vestibule, passing into vast, elaborately decorated salons. A huge park surrounded it. Walking down the wide tree-lined paths, one came unexpectedly upon a clearing where two stone fauns, sculpted by Augustin Pajou, hid in the shadows. Farther on, a pastoral group of statues by François Lemoine played in the sunshine. There were labyrinths cut in the hedges and Marie Antoinette-style playhouses for milkmaids. Hidden in the ivy were fake ruins, built to look like vestiges of temples. 'Bring a camera,' Henry wrote to his friend Joyant. 'The garden is astonishing, with Louis XV statues. It used to be a rendezvous for courtly lovers.'

Neither the fifteen acres of grounds, nor an interior which had modern plumbing and every possible comfort, changed the fact that Henry was not free to leave. His own quarters were at the end of a narrow corridor, itself lit only by the daylight that came in through fortress-like slits in the walls. Behind a low, locked door were two tiled cells with barred windows. One of these was Henry's bedroom. The other was occupied by a round-the-clock male nurse.

After four or five days 'on pure water', he was greatly improved and back to work doing drawings. But one of the side effects of this improvement was to make him feel the full impact of his incarceration. He realized that a rich patient in a posh private sanatorium was possibly in even more danger than a patient locked up in Paris's notorious Saint-Anne charity hospital. In such a 'resort', the doctors might find it advantageous to keep a well-paying client indefinitely. It was not long before Henry reacted to his hospitalization with anger and despair. He began referring to himself as 'the prisoner'. To save himself from permanent incarceration, Henry would accomplish the single most powerful act of self-validation in his short life.

His first visitors on record were Thadée and Misia, who went to the Château Saint-James on Thursday, 9 March. Thadée was stunned by the change in Henry. When they first arrived, they were shown out into the garden, where they saw the patient some distance away. Spotting them, he tried clumsily to run to greet them. 'Was it always so hard for him?' Thadée asked himself, observing the crippled artist's stumbling gait. Henry had grown very thin. His clothes hung on him. Misia, who claimed that she went to see him 'every day', later described her impressions: 'I was thunderstruck by the change in him. His cheeks had fallen in; his complexion was grey – he looked like a doomed man.' Though his conversation was the same – he

laughed and smiled, delighted to see them – Thadée had to admit that things weren't yet normal. Henry was still prey to sudden attacks of rage. Nonetheless, his horror of being institutionalized made a deep impression on his visitors. They were aware of his emotional pain and his disorientation: 'When his mind started wandering, we felt like crying. In the hospital we knew it couldn't be alcohol that was keeping him from understanding.'

Most striking, perhaps, was the fact that he seemed almost indifferent to the work he was doing. He showed them his drawings, making rapid, timid remarks. He offered one to Misia. Both more fragile and more constrained than his typical work, it was a delicate pencil rendering, heightened with a few spots of colour, of a circus bareback rider in a tutu and pink ballet shoes, standing awkwardly in the wings, waiting for her turn to go into the ring, her horse nowhere to be seen. Henry may well have felt that he, also, had been dismounted and was waiting in the wings.

He dedicated it: 'To the dove of the Ark'. It is easy to imagine that as Misia strolled around the garden in her long, pale skirts and ostrich-feather hat, Henry wished to see her as some wonderful bird, coming to announce the end of his personal calamity.

In the meantime, Adèle was staying away. She had told her brother and other members of the family what she had done, and her relatives and in-laws now solidly backed her decision. Their letters were supportive, expressing sympathy and keeping her up-to-date on two of her major worries: preventing her mother from finding out and seeing how Alphonse was going to react.

She was no doubt reassured when Alix, her sister-in-law and trusted ally, sent a message that Alphonse was calm and adapting to the idea that Henry was content and in good hands. Adèle's brother, Amédée, filled her in on the details the next day: 'You can relax about Alphonse, at least for the time being. It's true he was a little unreasonable at times, but always rather calmly … He rationalizes out loud to prove to himself that his son's situation in Neuilly is the best thing, given his condition.' In fact, as became clear in subsequent letters from Alix, Alph was not so much angry that his son had been put in an asylum as he was furious that nobody had consulted him about the matter. The relatives had clearly taken sides with Adèle, if only because Alph's personality made dealing with him so difficult.

It is possible that the first real news Alph had of what had happened was a brief note from Henry himself: 'Papa,' he wrote, 'you have a chance to do a noble deed. I am locked up, and anything that is, dies.' He was referring, of course, to Alph's own dedication in the book Henry had received from

him so many years before when he was imprisoned, also in Neuilly, at M. Verrier's, for useless treatments on his legs. Alph went to Georges de Tanus, a cousin, saying: 'You must know the truth. No one will be honest with me. Has Henry been locked up by force or not?' Tanus reassured him that Henry had agreed to be hospitalized, but Alph was deeply concerned and threatened to go to Paris to see for himself. But Alphonse's characteristic incapacity to act once again took over, leading him to hesitate, delay, and finally indefinitely postpone the trip to see his son. Nevertheless, it was Alph, far more than Adèle, who would make Henry feel accepted and loved as he came out of this crisis.

Gradually, Henry's friends were also finding out what had happened, and Joyant, ever discreet, wrote to Adèle before he actually went to the clinic to

Drawing: Au Cirque, cheval pointant, *1899.*

see how her son was doing. In her answer, she said that Henry was better, reading and drawing a little. In fact, Henry was frantic with boredom. He wrote to Joyant: 'Come to see me, *Bis repetita placent* [Things twice repeated are pleasing – i.e. more than once would be welcome] ... Come quick and send Albert as a messenger.' He also sent a shopping list: 'Send me ground [lithographic] stones and a box of watercolours with sepia, brushes, litho crayons and good quality India ink and paper.'

By now, although he had only spent about two weeks in the clinic, Henry was of the opinion that he was cured, and all he wanted was to get out. He was eager to get on with his work and to have as many visitors as possible. He had, of course, been missed in Paris, for he had suddenly stopped appearing where his friends expected to meet him and where people were used to seeing him drinking in the evenings. He had also left some work unfinished, without warning. His printer Stern came carrying two small stones so he could finish the last two illustrations for Jules Renard's *Histoires naturelles*, finally to be published later that year. The publisher, Pierrefort, who had come to visit the same day, was most impressed by Henry's skill as he picked up a crayon 'on the spot, to draw the two animals needed for the book directly on the stone, without any models, as unhesitatingly as a medium receiving spirit-writing'.

It must have been quite a chore for Stern to haul the heavy stones all the way to Neuilly for Henry to draw on, particularly since it was unnecessary. It was common practice at the time to transfer drawings done on paper to stones for printing, apparently with little loss of quality or definition, and Stern almost certainly had previously done so for Henry. Perhaps it had been decided that Henry should be humoured in anything which would help him to work.

After sending the requested art supplies, Joyant had gone with 'anguished sadness' to visit the artist in his little cell. He discovered 'a lucid, calm Lautrec', who hailed him as a liberator, ecstatic to have contact with the outside world.

In less than three weeks, Henry seemed almost entirely normal again. He explained to his friend that he was working on a plan to procure his release. He would present a cheerful, uncomplaining façade to the doctors and guards and prove his sanity by producing works of art. He showed Joyant portraits of some of the patients around him and a drawing of his guard. The art dealer later observed that the first drawings still showed Henry's instability: 'The line was agitated, sharp, like claw marks; the effects of alcohol were pronounced; it had guided his hand – a hand which, in spite of

all obstacles, insisted on wielding a pencil.' Henry also had begun a really significant body of work: a series of circus drawings, the first of which had already been given to Misia. He showed Joyant a pencil drawing of a seated female clown, whose trained pig was standing on its hind legs.

That afternoon, Henry gave his friend the grand tour of the park, including the compost heap for the vegetable garden. Once they were out of earshot of the doctors and guards, Henry turned to his friend, suddenly serious. He explained that he was terrified to think that his family and the doctors might, by arguing that it was in his best interest, manage to keep him locked up there permanently. He looked up at him with a pleading expression and said, 'Help.' Joyant vowed to do his best.

To whom else could he turn? His father had not responded to his letter; his mother showed no signs of regretting that she had committed him. He decided also to ask Georges Séré de Rivières, the judge, to help him go to court if necessary to prevent himself being permanently committed. Henry had somehow managed to get a *procureur de la République* (public prosecutor) to visit him in the clinic and then to send a note to Georges saying Henry wanted to see him. But Georges, who had been forced to deal with Henry's unpredictable behaviour when Henry asked to marry his daughter, was wary. Rather than go at once, he instead sent Henry's request on to Adèle, saying he wouldn't visit until she and the doctors felt it was advisable. 'In the meantime,' he wrote, 'send him my love, and explain the delay ... any way you want to.' The kind of help Henry wanted was not going to come from anyone in his family.

It came, in fact, from an unexpected quarter. From an unknown source, the daily papers got hold of the news that Henry was in an asylum and built it into a huge scandal. Facts were irrelevant. Stirring up public opinion has always been a good way of selling newspapers. 'The day before yesterday,' wrote *L'Echo de Paris* on 18 March (two weeks after Henry's arrival at Saint-James), 'the artist, H. de Toulouse-Lautrec, had an attack in an establishment near the Opéra, which caused him to be immediately transported to an insane asylum.'

Henry's 'attack' was newsworthy in Paris as much because of his reputation as a public figure as because of his fame as an artist. It was of interest to the people who recognized him on sight as he hobbled through Montmartre and to those who had noticed he was missing from his habitual table at the Irish and American Bar to know that there was a new scandal and that he was involved. The next day, a brief but favourable note in *Le Journal* defended Henry's status as an artist and stopped just short of calling for

action to get him out of the hospital: 'All those who liked the artist and admired the beauty of his efforts are waiting impatiently for him to be cured.'

The straightforward tone of that notice disappeared almost immediately. The day after the first articles appeared, one of *Le Journal*'s editors, Alexandre Hepp, published a pompous and calumnious editorial on the subject: 'Toulouse-Lautrec's friends will say that they are not surprised, that his life had to end this way, that Toulouse-Lautrec was destined for the asylum. He has just been locked up, and now his pictures, his drawings and his posters officially bear the signature of the madness which has so long been anonymous.'

He claimed Henry's work revealed that he had always been insane:

The man himself, deformed, lame, grotesque, was that rare phenomenon, a symbol of his own work; more than one of his extraordinary figures is endowed with his own features and his own manner, as if they were an obsession ... The artist's body seems to have affected his personality directly, cruelly, physically, as if he had no soul to liberate him. But it was above all in his attitude towards life that the true mentality of this candidate for the madhouse revealed itself. The conversation of Toulouse-Lautrec seemed to spring from an all-embracing desire to destroy. In the opinion of his talent, nobody else had any talent; for this heart, nobody else had any heart. The world contained only idiots, knaves and rogues ... I do not deny that these opinions were sometimes justified. But what a strange conception, what a consistently gloomy outlook, what a determination to suspect, disparage, and degrade everything, or rather what a persecution mania!

He ended his editorial by saying that although Henry was not the only Parisian to affect a style of ironic conversation made of 'sarcasm and hate' and that it was in fact a fashionable mode of Parisian discourse, it didn't mean Hepp approved of it. However, he failed to note that what he perceived as a sign of insanity in Henry was merely '*le grand chic*' elsewhere.

Naturally, the Albi newspapers picked up the story of their native son, creating new tensions in the Hôtel du Bosc, where Grandmother Louise still knew nothing of Henry's illness. His Aunt Alix wrote to Adèle to reassure her:

Even though the town is flooded with newspapers, each with its word to say about our poor Henry, we managed ... to waylay the *Gazette de France* ... which would have told your poor mother everything we've kept from her until now. She's irritated that the paper didn't come today, but it never will. The mail will be checked

tomorrow as it was this morning, and possibly we'll be able to postpone her finding out.

The papers continued to capitalize on the story. Apparently, Henry's strong personality and abrasive behaviour had offended a number of people who had not dared to say so while he could defend himself but who struck hard the moment he was vulnerable. One of the most irresponsible attacks came from Edmond Lepelletier on 28 March in *L'Echo de Paris*. It was all the more surprising because Lepelletier had for years been the champion of the poet Paul Verlaine, known throughout Europe for the scandal attached to his attempted murder of his homosexual lover Arthur Rimbaud, and who had died of alcoholism in 1896, three years before Henry's alcoholic crisis.

Lepelletier's article, '*Le Secret du bonheur*' (The Key to Happiness), said Henry was lucky to be locked up at last, for it spared him the humiliation of recognizing that he was an embarrassing failure, the poverty-stricken, deformed, last living son of a now decayed noble family:

The fruit of such genealogical trees is generally shrivelled and eaten away by a worm at its heart ... The last descendant of a worn-out lineage ... the painter of Montmartre looked like a caricature of his forefathers ... puny, stunted, deformed ... His virgin palette and his unused brush, like a shield that was seldom dented and a sword that remained too often idle in its scabbard, proved only too well that all he had inherited from his ancient blood was a fondness for pleasure and a distaste for that proletarian virtue, hard work.

Lepelletier explained, for the benefit of the uninformed public, that Henry had never been willing to work seriously at his art and had produced almost no works of value, preferring to drag his famous name through the dirt of the bars and the brothels, when he wasn't displaying it publicly, signed on his posters, on the walls of Paris. Ironically, given the fact that his arguments were couched in terms of class struggle, it was this last insult to the family that most offended Lepelletier. How could Henry not have had the modesty to take a pseudonym instead of attaching his bad reputation and his bad art to such an aristocratic family tree?

Either through weakness or hubris he continued to flaunt the glorious name of his ancestors. He did not have the modesty to adopt a plebeian pseudonym ... Unfortunately Toulouse-Lautrec did not conduct himself like one of the great men of his line ... Through a quirk of character that seemed like a moral chastisement, a visitation of divine wrath upon the seventh generation, this poor fellow, so

deformed, so awkward, so ungainly, was an ardent lover of women. He sought love at random ... He was a hunchbacked Don Juan, pursuing his ideal amidst the most tawdry realities ... The sordid debauchery, the travelling-salesman adventures that Toulouse-Lautrec delighted in, and into which he led his companions, certainly contributed, together with the chagrin caused by the realization of his physical misfortunes and his moral decadence, to his confinement in a cell.

Such attacks were so outrageous that even people who had never met Henry began to come to his defence. In his column *Le Journal d'un Parisien*, the writer Jules Clarétie, director of the Comédie Française and member of the Academie Française, wrote that he had read the attacks on Henry and been greatly moved to learn that he was in an asylum:

I know him only from his work. It is original and striking. There is, in his strange vision, in the opaque colours and flattened lines of his posters, something indefinably bizarre and disquieting which attracted me, chilling me like the poetry of a Baudelaire ... They were pictures of frightening girls, caked with make-up ... They say the man was strange. He is described like a character out of Hoffmann, very short, with huge lips.

For many of Henry's friends, particularly those who had been a little out of touch with him, the articles in the newspapers were their first inkling of what had happened. Charles Conder wrote to Will Rothenstein, who had moved back to London: 'It is very sad about poor Lautrec – shutting the man up when he is no more mad than you or I. We all hope to get him out.' Conder himself would be permanently institutionalized only a few years later.

Rothenstein felt the distance that separated him from his friend: 'I had not realized how excessive Lautrec had become; his habits with women I knew too well, but though he would drink much more than was good for him, I was unaware to what a state he had brought himself. His work was done, but few saw the importance that was to be given to his prints and paintings.'

Joyant began rounding up Henry's friends to see for themselves that the artist was sane and to spread the word that he would soon be out. On 29 March, the day after the insulting Lepelletier article appeared, Joyant went out to the asylum with Arsène Alexandre, who had first written reviews of Henry's art six years before. With his usual 'mocking alertness' Henry cried as soon as he saw Alexandre: 'You've come to interview me!'

Finally, Henry had a credible champion. Alexandre wrote a long, partisan defence of his friend's talent, character and sanity. Titled '*Une Guérison*' (A Cure), it appeared on the first page of *Le Figaro* on Thursday, 30 March.

He began by pointing out that the papers had been crucifying Henry, sometimes glorifying, more often vilifying him, but that none of the stories had been 'simply accurate'. Defending Henry, he stated that although it was true that Henry had been forcibly hospitalized to treat his alcoholism, his health was now better, he could still do art and he was not in the least mad. He pointed out that instead of being cared for and protected because of his illness and physical fragility, Henry's intelligence and talent had been ridiculed; if he was suffering, it was because he had been mistreated and exploited by unsympathetic bystanders who tempted him to even greater misuse of alcohol. Alexandre seemed not to know that Adèle was responsible for Henry's hospitalization, for he declared that if Henry were now alive and safe, it was thanks to those few friends who had taken it on themselves to remove him from his usual haunts and put him in a sanatorium where he couldn't drink.

Describing his visit to Henry in the clinic, he said:

Once, for a moment, we found ourselves alone with Henri in the doctor's salon; on a small table were some crystal goblets and a bottle filled with a beautiful liquid the colour of gold. 'That's Quinquina, you can't have any,' Henri said with such a droll air that we all burst into laughter. There was in it something of the child who has been deprived of his dessert, something of the man awakening from a bad dream, and something of the invalid who feels his health is returning by leaps and bounds.

However, Henry's health was better precisely because he had been removed from temptation, and his ability to return to the seductions of his habitual life in Paris was seriously in question. 'There is something tragic ... in the thought of what the great city sometimes does to her rarest talents, to her most precious minds ... At a distance of three kilometres from us he is cured – but what if he should come nearer?'

On Easter Sunday, 2 April, almost exactly a month after Henry was committed, Joyant and Alexandre went back to the clinic to show him the article. In gratitude, Henry gave Alexandre one of his precious circus drawings, a clown with a trained poodle, and signed it 'Madrid, Easter, 1899 ... Souvenir of my captivity'. Thereafter, Henry considered Alexandre his foremost ally against the public.

*

It is ironic that the hearing Henry had vainly tried to elicit from his family, his father and *'le bon juge'* finally came through scandal. Seeing the Toulouse-Lautrec name made a subject of public derision forced Adèle to act. The bad publicity was no doubt equally unwelcome to a discreet rest home designed to attract rich clients. It was in everybody's best interest to get Henry out of the clinic as soon as possible. It is no accident that on 31 March 1899, the day after Alexandre's defence appeared in *Le Figaro*, a medical consultation was held at the clinic. The report of Doctors Dupré and Séglos said that Henry no longer showed his previous symptoms of emotional strain, excitement or mental depression. The specific delusions he had manifested on arrival had disappeared: 'The patient is perfectly aware of his present situation and of the place he is living in, of the circumstances that brought him here and of the improvement in his condition.' They said that the improvement could only be attributed to the fact that he was deprived of alcohol and suggested that he stay on at the clinic for 'a period of several weeks' to consolidate his position, saying that they would allow him to continue 'to go out on trial excursions as a preparation for his ultimate release'.

Henry had permission to go out every day now. With his guard, Pierre Lazagne, he went each afternoon across the Bois de Boulogne, burgeoning in the full springtime, to the Jardin d'Acclimatation, the children's zoo, as he had years before when his parents took him on outings from M. Verrier's.

He didn't drink on these excursions. Legend has it, however, that he couldn't resist a typical prank. At least once, it appears, he encouraged his weak-willed male nurse to stop on the way home for a drink, or several, while Henry himself drank fruit juice. Proudly, the patient returned to the asylum for dinner, cold sober, leading his tipsy guard.

In the meantime, his family was relieved to have the support and vindication of the Alexandre article. A flurry of letters to Adèle confirmed that it had received widespread attention. One of her sisters-in-law wrote from Albi that she had shown the article to Alph: 'He was satisfied with it, as were we all. The article is just, thoughtful – consoling after some of the other misrepresentations, which it refutes moreover, point by point.' A friend to whom she sent a copy of the article wrote that it was 'almost perfect, and did me good'.

Henry, now that he had some privileges, lost no time in trying to exploit them. When his mother finally came to see him, arriving with art supplies, he was quick to manoeuvre for more freedom. He knew that his Grandmother Louise had fallen seriously ill again and that Adèle had been urgently sum-

moned to Albi. She was feeling very guilty, first about putting her son in the hospital and now about leaving him again, particularly because he had told everyone that her first trip to Albi had precipitated his illness. Using her ambivalence as a lever, Henry started negotiating to be able to go out without his guard, and not just to the Jardin d'Acclimatation, but to Paris to take care of pressing professional matters. Of course, he assured her, he did not want to go alone, but with a trustworthy friend, approved by Adèle, who would make sure he didn't drink. Adèle gave in, under the proviso that the doctors only let him go out with people she personally had designated in writing.

The publicity in the newspapers had brought him lots of other visitors. In fact, he seemed to be holding a salon in his tiny room. He wrote in high spirits to Berthe to bring him supplies from Paris: 'Bring me a pound of good ground coffee. Also bring me a bottle of rum. Bring me everything in a locked suitcase and ask to speak to me personally.' The request for alcohol is surprising, given his awareness that his rapid improvement had come from not drinking. In any case, the ploy didn't work. Berthe sent his letter on to Adèle with a note saying that she had taken only coffee, chocolate drops and clean handkerchiefs.

The clinic staff was getting nervous about all the visitors. Henry's cousin Louis Pascal was visiting him on a day when his friends Pierre Bonnard and Edouard Vuillard also showed up, only to be sent away by the director. No doubt they had come unannounced and looking dubiously bohemian, particularly in contrast to the elegant and handsomely aristocratic Pascal.

Adèle's friend Madame Devismes, no doubt looking more respectable, had gone to see him on 13 April. To her, Henry seemed more infantile than mad. He told her that he was pretending he was Jean-Henri Latude, a political prisoner famous for his repeated attempts to escape. He said he was preparing the brief for his court case presumably to gain release from the Neuilly clinic although he may also have been planning to sue his Uncle Amédée over the inheritance. 'The only completely incoherent thing he said to me,' she wrote to Adèle, 'and it was still in the general tone of his wit, was: "You know, my mother left on the pretext that her mother is sick but really to get away from me. But she found my father, camping out in the middle of the fields, in a camel's hair tent. That's just what she deserved! You can be sure she won't stay there long, and that she'll come back here as fast as she can." ' Madame Devismes probably did not know that Alphonse, in his way more out of touch with reality than Henry, really did sometimes camp

out in a tent and she may not have suspected what Henry clearly felt: that Adèle, after her years of devotion and martyrdom, wanted to be free of her burdensome son. Adèle may have been self-aware enough to think that not only he but she would be better off if he were dead.

In a postscript, Madame Devismes returned to the subject of divorce, which came up frequently in her correspondence with Adèle. Adèle, who had confided her bitterness about Alphonse, apparently considered Madame Devismes to be an authority on Church law concerning this extremely touchy subject. Madame Devismes was categorical: 'Divorce is in no case legitimate; it can be neither advised, nor approved, nor accepted. That's the official and theological response.'

Uncle Georges, *le bon juge*, had also finally been to see Henry at Neuilly. It was probably on the occasion of this visit that Henry gave Georges a painted fan, showing a little girl walking a small dog. He inscribed it, 'To my cousin, Aline Séré de Rivières, and to her daddy. Lautrec, [18]99'. He had not abandoned his fascination with Georges' young daughter, but he would never again attempt to have more than a simple familial relation with her. Georges wrote to Adèle that Henry was drooling a lot 'because of the medication'.

Daily, Henry tried a new way to get out, and daily there were new barriers to his freedom. On 16 April, his friend Dr. Robert Wurtz came to Neuilly to take Henry out canoeing on the Seine. A quick note from a clinic administrator explained to Adèle that even though the bad weather had unfortunately kept Henry in a great deal, he personally was opposed to this project, since there would be 'the chance, or at least the temptation, to drink. And it seems to me not useful to expose Monsieur Henri to either one.' This reaction was surprising, as Dr. Wurtz was a professor at the medical school and should have been well aware of the danger of letting Henry drink.

Stuck in his room most of the time, Henry took comfort where he could. He sent Berthe long shopping lists, and she came from Paris every few days, bringing him chocolate, a small pot of orange marmalade, lavender water, coffee, biscuits, powdered cinnamon, lemon syrup, clean handkerchiefs and socks. She sent his telegrams to Adèle and duly forwarded to her any letters she herself received from him. 'He finds the time passes slowly,' she wrote.

Even so, he was not abandoned. Joyant and Désiré Dihau had been to see him, and Léon, one of Adèle's Paris house servants, took Pamela the fox-terrier to the clinic one afternoon. 'He thought she was very pretty. She recognized him right away and couldn't make enough fuss over him.' Uncle

Georges came again and took Henry with him to visit some property he had inherited.

When Henry's Grandmother Louise was somewhat recovered from her severe illness, Adèle wrote that she was on her way back to Paris to care for her other invalid. Uncle Georges was supposed to bring her to Neuilly as soon as she got there, and Henry declared in a letter that he was looking forward to her visit.

However, he was not ready to trust her. In the same letter he asked her to give his studio keys to Robin-Langlois, 'who will keep them, since only he really knows all the nooks and crannies of my studio'. During the worst of Lautrec's alcoholic hallucinations, when, prophetically, he had been convinced his family was going to come and have him taken away to an asylum, he had spent most of his nights at Robin-Langlois', for safety. The engineer had been his friend for some time. During the crisis that led to Henry's hospitalization, Robin-Langlois and his wife had unconditionally taken Henry in and cared for him. If Henry wanted Robin-Langlois, who was openly hostile to Adèle, to have the key to the studio, it was probably to keep Adèle out of his things.

Although Adèle went to see Henry as soon as she got back, her visit must have provoked bitter recriminations from him, for Dr. Semelaigne wrote her a letter in which he forwarded a note from her son: 'When you had left, I asked him if he was happy he had seen you. "I gave her a moral shampooing," he said.'

Despite the permission to go out, Henry wasn't free yet. He was counting on his project. If he could convince the doctors that he was producing art that could only be done by a man in complete control of his faculties, they would have to release him. Every day he worked on his circus drawings. As Uncle Georges had mentioned to Adèle, Henry's plan was for Joyant to publish the entire series as soon as he got out. And whether intentionally or unconsciously, the drawings Henry was doing gave an impression of solid industry, rational lucidity and control.

First of all, there were a great many of them. Over fifty remain. This kind of productivity, not counting the incidental drawings he had made of his fellow inmates and other works done for pending projects, which Stern carried back and forth to Paris, is a sign of extraordinary diligence for an eleven-week stay in a mental hospital. It seems as if Henry spent almost no time resting, though given his condition when he went in, he might have been expected to be too ill to work for some time.

The circus drawings have a unified style which not only is radically

dissimilar to the works Henry was producing immediately prior to entering the asylum but which does not really resemble any of his other work, either before or after. They are among the most conventional works he did, generally classic in both perspective and line. Gone are the fluid outlines and loose washes which characterize much of his painting. Gone, too, are the bold areas of colour which identify his posters.

He was, of course, working in the media he had at hand – on paper, in pencil and coloured pencil, pastels and charcoal, with occasional watercolour washes. And Henry knew well what audience he was trying to impress. These drawings are sober, detailed and almost delicate in tone. He used his tools with utmost discretion, carefully avoiding his typical flamboyant style and eccentric subject matter. In this series of studies of circus performers, the individual works are constructed so that every part balances and stabilizes every other part in a kind of structured order totally uncharacteristic of Henry's other adult work. Perhaps, after all, he was not organizing his drawings so much to please the doctors as to satisfy his personal need for calm, for a new equilibrium after his shattering experiences of the preceding months. However, compared to the rest of his work, the drawings are so tight and controlled as to seem strikingly rigid.

It has been suggested that Henry chose to use the circus in these drawings as a metaphor for life in the insane asylum, transposing 'the "Madrid Circus", with its subdued lunatics and fanatical doctors, into the lively and cruel parody of the human comedy presented in the circus ring'.

There has also been speculation that Henry did not draw these personages from memory at all, but that he went to see the Cirque Molier, located in the rue Benouville, not far from the clinic, on his expeditions from Neuilly. The fact that in almost all the drawings, no spectators, or at most one or two shadowy figures, are present at the ringside, has been used as evidence to support the theory that he watched rehearsals in the afternoon, when no performances were going on. However, by coincidence, the Cirque Molier was travelling during the winter of 1899 and gave no performances in Paris. In addition, the drawings are too specific and too obviously drawn from memory of specific events to be considered drawings from the Cirque Molier. They refer, as Alexandre would point out in his preface to the publication of twenty-two of the drawings in 1905, to easily recognizable circus acts: a tightrope walker who put on a show in the treetops in Le Jardin de Paris in 1897; the ballet *Papa Chrysanthème*, presented by Donval at the Nouveau Cirque in 1892; Caviar, the trained bear at the Nouveau Cirque in 1888, etc. Henry drew not just any clown, but George Footit, his friend from

the Nouveau Cirque, whose bull-necked stockiness, contrasting with his chiselled facial features, is easily recognizable in three of the drawings. Henry had always drawn and painted circus performers; the difference was that now he was forced to work from memory. Ironically, drawing from memory had recently become part of the examination for admission to the Ecole des Beaux Arts.

One of the most disturbing symptoms of Henry's deterioration in February had been memory loss (although the doctors and Adèle were not above using his amnesia to their advantage, promising him things to calm him, in the hope that he would forget the promise). The circus drawings are startlingly accurate portrayals not only of physical realities – the perfect musculature of a horse or the body of an acrobat, for example – but also of specific persons and acts from circuses Henry had been to many times before. This was concrete proof to Henry's doctors that his long-term memory, at least, was intact. Even if Henry had gone to circus rehearsals from the Château Saint-James, he could not have watched the same acts he portrayed in his drawings. Perhaps a better explanation for the empty grandstands can be found in his own feelings of isolation and depression.

As the finished drawings accumulated, Henry's confidence grew. He was going out regularly to Paris now, on business, to lunch with friends and family, even to his mother's. He began to take control of his life again. He persuaded his mother to ask the doctors to look at his drawings and to review his case. She, the doctors, and Henry were all eager for the whole ordeal to be over. Six weeks had passed since the last conference. On 17 May, the doctors met again. This time, Henry passed.

They reported that his delirium had not returned and that, except for slight trembling and continuing memory loss, he seemed substantially cured. 'Still, on account of his amnesia, the instability of his character, and the weakness of his will, it will be vitally necessary to provide M. H. de Toulouse-Lautrec, in his life outside, with the material and moral safeguards of constant surveillance, to prevent any possibility of a return to his pernicious habits which would cause a relapse even more serious than his original disorder.'

At last, Henry was free to go. 'I bought my freedom with my drawings,' he announced proudly, and it was probably true. But his last comment on life in the asylum was typically ironic. He had had it with doctors. 'Those people,' he said to Joyant, 'think that sickness and sick people were created just for their benefit!'

*

In the first half of the 1890s, Henry had worked closely with Arthur Huc, editor-in-chief of *La Dépêche de Toulouse*, even going to Toulouse to supervise the printing of his poster, *Le Pendu*. When word of Henry's hospitalization got out, Huc had joined the mass of journalists writing about the artist. However, unlike Lepelletier's slanders or Alexandre's defence, Huc's editorial, published in *La Dépêche de Toulouse* on 23 March 1899, had not taken sides. Under the pen name 'Homodei', he wrote an intelligent, balanced evaluation of Henry's life and work. Although his observations must have been painful for Henry's family, they were in large part accurate.

He began by speculating that Henry, like so many artists and writers of his time, was suffering from tertiary syphilis and by wondering how long he would have to be hospitalized. Although his article consistently referred to Henry in the past tense, unconsciously reflecting the prevailing opinion that it was rare for a patient to be released from an insane asylum, his respect for the artist's work was obvious.

 Huc's uncompromising description of the handicapped artist's appearance, behaviour and nocturnal lifestyle was based on close observation of a man he liked and knew well. However, he made no attempt to disguise any of the realities he observed. Henry was 'admirably' ugly; his legs were so dwarfed that he could stand up inside a closed cab. His arms were so short that he used paintbrushes as 'long as canes'. His nearsighted eyes looked tiny behind his pince-nez. His lips were swollen and drooping, and he had a curious speech defect, whinnying, as Huc described it, rather than speaking. However, he went on:

in this malformed body lived an impulsive, agile mind, remarkably receptive to all aspects of art. Of all the painters I have known, he was certainly one of the most intellectual: well-read without pretending to be literary, subtle as amber and tough [*rosse*] as only a Parisian can be. I can't find a different word to describe his talent, and he himself would certainly not have wanted another. He was brutally cynical ... and he wished to be, in both his life and his painting. He has been criticized for his excesses. It's true that he was nocturnal, loved to frequent low dives and was hardly an enemy of potent spirits. But who is to say that for him this was not a form of agreeable suicide, an ingenious way of quickly shaking off that dusty cloak of flesh which must have been such a burden to him? 'I can paint until I'm forty,' he said to me one day. 'After that, I intend to dry up.' In fact, he did everything he could to *finish himself off*.

He had developed a fascination with English mixed drinks, and his greatest delight was to create, before the astonished eyes of a friend, some learned, complicated cocktail containing half a dozen liqueurs, which produced in the end, one

small, simple glassful. He loved staying out all night, and, a curious detail, this gnome, who seemed designed to frighten off love ... was not too often rejected ... No doubt, it is exactly such overindulgences which drove poor Lautrec to the asylum. But this excessive behaviour was inextricably mixed with his talent. Both came from the same source: they were a reaction to the bizarre accidents of Nature, which sometimes lodges the mind of an imbecile in the body of a Greek god and a delicate spirit in a deformed shell.

Huc went on to say that he thought Henry's originality as an artist came largely from his use of ugliness and exaggeration of physical quirks to reveal the psychological truths of his models, to bring forth, albeit with cruelty, the irony of the antagonism between interior and exterior beauty. He pointed out that the acuity of Henry's vision came from his ability to penetrate people's masks, to get to the 'warts and blemishes' of their characters, and from his refusal to compromise or make pretty pictures. All his portraits, even those of friends, observed Huc, were marked by his insistent portrayal of sometimes brutal truths.

He concluded by wishing, as both friend and admirer, that Henry would be back to painting soon, remarking prophetically: 'His works are already numerous. Even if he were to disappear forever right now, what he leaves behind him is enough to assure him one of the most important places in the artistic movement of recent years, for Lautrec has been the most living painter of our decadent era.' Huc, alone of Henry's contemporaries, foresaw the permanence of his impact as an artist.

On 17 May, Henry sent copies of his medical certificates to Alphonse, begging him to make sure that he was in fact released. Alph responded by telling Henry to come to Albi as soon as he got out, and when Henry left the Château Saint-James the same day, he immediately travelled south to Albi. Although Joseph Albert had offered to go with Henry, in the end he was accompanied by his cousin Louis Pascal.

The reactions of various members of his family to his impending arrival were understandably ambivalent. On one hand, they were eager to help Henry and to protect him from falling back into the old habits which would surely kill him; on the other, they had no experience with a person openly declared to be mentally ill. Was Henry permanently mad? Would he behave in embarrassing or possibly dangerous ways? They had no idea if he was able to act responsibly or not, if he would need a full-time guardian, how they were supposed to treat him.

Henry's Aunt Alix was particularly worried that Alph and Henry would form an alliance against Adèle, who had decided to stay at Malromé rather than increase the potential for conflict in Albi. Grandmother Gabrielle was anxious about what kind of condition Henry would be in and how to deal with him if Henry were 'strange'. She also worried about how Alph was going to react to Henry's arrival.

When he eventually arrived on the evening of 20 May 1899, he seemed to be the Henry they had always known. According to Grandmother Gabrielle, he really did seem better 'except for the swelling of his horrible lips'. She mentioned that she had had a fight with Alphonse, who, at a loss as to how to welcome his son, had offered Henry white wine. Neither of them really knew what to do with their conflicting feelings about Henry's drinking. Although everyone knew that he must not drink, the rules of politeness required that drink be offered to him, and they both felt very uncomfortable about humiliating Henry in front of others by flatly denying him the right to drink. The only acceptable solution was for Henry to behave rationally, to limit his drinking himself. They finally drew a compromise in the battle between politeness and reason. Alphonse agreed henceforth to slip water into Henry's wine. In the meantime, Henry was full of resolution. Perhaps unaware that it had already been watered, he added water to his wine himself.

The second day, Emilie wrote to Adèle that everyone found Henry to be fine, that one wouldn't suspect he'd been so ill. Henry himself told someone he'd just come south to catch up on family news and that he would go back to Paris soon, 'where he had an album to finish'. His family reacted with relief. Shouldering the burden of Henry's illness made them nervous. His behaviour was unpredictable, but it was convenient to assume that Henry could look after himself. They waited for him to take charge of his own life. On the third day, when Louis Pascal left without taking Henry with him, Grandmother Gabrielle was distressed. She felt that given the enormous publicity surrounding his hospitalization, his presence in Albi amounted to a prolongation of the family's humiliation. He had to leave, she wrote to her daughter Alix: 'I can't see any other solution.' She was reassured that Henry had brought no luggage. She took it as an indication that he didn't intend to stay long.

Henry was not well – he had diarrhoea and stomach flu – but his visit was going better than expected. He was eating and sleeping, and the swelling in his lips was subsiding. His Grandmother Louise, who had been ill and from whom the situation had intentionally been hidden, saw him and suspected

nothing. He was talking openly to the rest of the family about the clinic and was being very amusing. Eager to counteract the bad publicity which had surrounded Henry's incarceration, they all went for a walk around Albi together, so other people could see that Henry was not a raving madman and that he was not estranged from his family.

However, Henry's anger at Adèle remained unresolved, and his repeated statements that his mother had abandoned him and then had him locked up, however true they may have been, perturbed his family. Shortly after being released from the hospital, he had written a note to André Antoine which began: 'Lautrec out of prison,' and now that he was at home he insisted on talking about 'the days he had spent in prison'.

In a repetition of earlier conflicts over the best way to treat Henry's various maladies, Alphonse had stepped in to support his son and by doing so implicitly criticized Adèle. A good day's journey away, Adèle made no attempt to come to Albi. Aunt Emilie had given Henry a letter from his mother when he arrived. Acting as her daily informant, Emilie reported that both Henry and Alph were being 'very reasonable', but she added, 'What are the two of them going to do now? Everybody is wondering.' Alph seemed happy to have Henry in Albi and was 'lavishing attention on him'. His first idea had been that Grandmother Gabrielle should take Henry to live with her at Le Bosc, but she refused outright. Henry's Aunt Alix, also living at Le Bosc, agreed with Grandmother Gabrielle. She reported to Adèle that Henry had been having disagreements with his cousin Odon and that she couldn't imagine why Alph thought it would be appropriate for Henry to move to Le Bosc. She said that Alph found Henry to be 'absolutely the way he always was and that he practically believed that Henry's illness had been totally exaggerated'. Now Alph was thinking of renting a place for Henry near Albi, but Henry was insisting that he had to get back to Paris and his work. Alph was planning to go with him.

It was not to be. Four days later, on 29 May, Henry left Albi alone for Paris on the night train, with 900 francs in his pocket. Who was going to take care of him? Where should he live? According to his Aunt Emilie, Henry bluntly announced that he wouldn't live with Alph, and that moreover he refused to stay at Adèle's apartment in the rue de Douai. 'He argues that when people don't have the same temperament, it's better not to live together,' Emilie wrote to Adèle.

Adèle must have reached the same conclusion, for she had asked Louis Pascal to make Henry move all his belongings out of her Paris apartment. She could not resist trying to impose her will, even though she was not

present or being consulted. She was also very unhappy about an arrangement Alph had made for Henry's care. Alph, who was doing his best to simplify Henry's life, had hired a long-time friend of Henry's to meet up with Henry in Paris. Paul Viaud de la Teste, a distant relative from Bordeaux who apparently could not tolerate alcohol, was to accompany Henry wherever he went, in part to help him avoid drinking. Henry promptly nicknamed Viaud his 'cornac', his elephant-keeper, but did not resist. He rather liked Viaud, with whom he had often spent time when he was near Bordeaux. Alphonse had also written to Jalabert to say that Henry was 'completely well' and to prepare him to send money to Henry's account. He then wrote to Georges Séré de Rivières in Paris, asking him to give Henry 500 francs and to send another 500 francs to Adèle with which to pay bills. Alph explained to Georges that Henry didn't trust Adèle and that he was counting on Georges to persuade Henry to trust Jalabert and to calm Henry's anger at 'the authors of his sequestration'.

In Paris at the beginning of June, Viaud began to accompany Henry everywhere, a phenomenon which his friend Francis Jourdain found disconcerting. He didn't consider Viaud to be a friend of Henry's at all, but merely a hired guard, and said no one was fooled by the depressing charade they put on:

Lautrec didn't seem embarrassed by this forced intimacy. He introduced his new buddy to old friends: 'My friend, "Messieu" [*Monsieur* pronounced with a working-class accent] Viaud' ... when I ran into them in the rue Notre-Dame de Lorette, Lautrec had only recently been allowed out with supervision. Nothing showed, in either his appearance or his disposition of the ordeal he had just undergone. He talked about it without embarrassment or bitterness. He seemed to have no bad feelings about his stay with the 'nuts'.

He had bought a rowing machine which he had set up in his studio so he could exercise his upper body.

Joyant and Henry's friends, possibly along with his Uncle Georges, tried to get him to consider a new project, doing well-paying portraits of society ladies. However, he made no attempt to flatter his aristocratic clients either in his paintings or when they were sitting in his studio. The ladies themselves, originally attracted by Henry's fame, could not tolerate the brutal honesty with which he insisted on painting them and telling them anecdotes in which he compared them to his preferred models, the prostitutes.

Gauzi, although he does not say exactly when it happened, tells one story

of wounded vanity. According to him, Henry had met the model's husband through Bourges, and one of their first contacts was the portrait commission:

He went to work, but things quickly degenerated. Mme L., pretty, quite coquettish, had adorned her beauty before going over to the painter's studio, spending a long preliminary session at her dressing table. Her lips, face and eyes, painted in red, white and blue, had been embellished by skilful make-up. On the canvas, to the great despair of the lady, her complexion took on a deathly pale tone, and her features no longer seemed to her to have the charm and delicacy of the reflection in the mirror. She thought she looked ugly and insisted that Lautrec change the portrait. He didn't like being told how to paint and was raging inside. When I asked, 'How is your portrait going? Are you happy with it?'

'No, nobody's happy! Mme L. is driving me crazy. She doesn't think she looks beautiful enough, and I made her as pretty as I could. Her husband isn't saying anything, he stands guard during the poses and paces around me like a bear.'

Once home, the painting hung first in the study, then moved into the corner of the hall, behind the large leaves of a palm tree which kept anyone from approaching it. When Lautrecs later became valuable, the portrait could at last be admired in the window of the Bernheim Gallery.

Another project Henry's friends used to try to distract him from his old habits and haunts was sketching fashion models in the couturiers' salons, but he did not produce works from the experience. People tried to pretend everything was as before: the Dihaus had him to dinner with Degas; his closest friends went, when invited, to a small, uncomfortable party in Henry's studio. But denied his former lifestyle, Henry must have found Paris oppressive.

In June 1899, Henry agreed to go to Joyant's summer place at Le Crotoy on the Normandy coast for a few weeks to 'convalesce'. He was very bitter still over his treatment by Adèle and at the hands of the press. He responded to a request for an interview by referring the journalist to Arsène Alexandre, who had so ably defended him when he was in the asylum: 'Alexandre ... is very well documented on my case, better than I am myself ... during the sad ordeal from which I am emerging [he] was the best and most loyal of friends and put things back into order.'

A month later, in early July, he and Viaud, whom Joyant had nicknamed Henry's 'dry nurse', moved on to Le Havre, some miles southwest of Le Crotoy. Although their original intention was to take a steamer from there to Bordeaux, they ended up staying in Le Havre for nearly another month, from 22 June to mid-July. By coincidence, Oscar Wilde arrived in Le Havre

on 23 June and stayed there until 1 July, when he returned to Paris. On 3 July, Wilde wrote to his publisher asking for copies of his forthcoming *An Ideal Husband* to be sent to a variety of friends. Henry's name was on the list, possibly indicating that they had met one last time in Le Havre that summer, before Wilde died in Paris on 30 November 1900.

In Le Havre, Henry was losing control of his drinking again. He assiduously frequented the bars for sailors and fishermen that lined the waterfront. He knew them well already, for he had stopped there on the way to London in previous years and done lithographs of some of the performers. These waterfront bars seemed to hold the same fascination for him as the decadent clientele of Le Moulin Rouge or the perverse denizens of La Souris. In Le Havre, the sailors were often English, as were the barmaids who sang and danced in the taproom and might sometimes be persuaded to leave with a customer. A new *furia* struck Henry – a passion for Miss Dolly, the blonde English girl who served drinks at the Star, in the rue du Général Faidherbe, where the year before he had done a couple of lithographs of performers leading the audience of sailors and dockers in English songs. Once again Henry both seduced and possessed his conquest, not physically but through his art. He wrote to Joyant asking him to send paints and brushes.

First a study in red chalk, then a few days later an oil painting of Miss Dolly on a wood panel were sent to Paris. The oil was a lighthearted portrait of a young woman, laughing. Both the sanguine chalk study and the oil portrait show that Henry had not in any way lost his faculties as an artist. The oil in particular is notable for the delicacy and suppleness of the brushwork, the skilled use of contrasting rosy pinks with blues and greens, and the woman's charming smile. In comparison to the works done shortly before Henry was hospitalized, this portrait shows not only his mastery as a portraitist but also a sense almost of optimism and gaiety. Whether or not he was drinking again, Henry seemed focused, productive and cheerful.

'Let it dry and have it framed,' Henry wrote to Joyant. Henry's neutral comment about framing is one of his few recorded references to the subject. From the context it seems that he did not consider the frame to be an important consideration in the presentation of his art and was happy to leave the aesthetic decisions of framing to Joyant.

He concluded his letter by adding, 'Thanks for the good news on the financial front. I hope my guardian is pleased with his ward.' Joyant, whom Henry now called his 'guardian', was acting as intermediary between Henry

and his family on financial matters. Joyant's news probably concerned an agreement that he had reached with Henry's parents.

Since at least 1883, when Henry had set up his first studio, money had been a constant source of conflict and power struggles between himself, Adèle and Alph. Each side in the argument was in some ways justified. Henry's parents correctly accused him of irresponsibility: temperamentally spendthrift and refusing to keep accounts, Henry was always out of cash. Almost every letter or meeting included a request for funds. However, it could not be denied that Henry worked hard to earn money at his art, accepting commissions indiscriminately, proud to prove that he was a professional artist, measuring his success by his ability to sell his work. Because he was so meticulous in his professional dealings, his inability to live on his allowance seems like 'bad boy' behaviour, to get his parents' attention.

And yet Henry was quite aware that his parents used money both to try to get him to conform to their expectations and to influence him to take sides in their quarrels with each other. In the end, ever conscious of his handicap and fragile health, and no matter how troublesome he became, they supported him as a Toulouse-Lautrec deserved to be supported, providing him with a comfortable income, whether he sold his art or not.

Since his mental breakdown, extreme unpredictability about money had become symbolic of his degeneration. One of his paranoid symptoms was a fear that somehow his parents would get their hands on the money he earned himself from commissions and selling paintings. While he was in the asylum, he and Joyant had discussed the problem and come up with a solution. His uncle, Georges Séré de Rivières, whom all parties trusted, was to handle all Henry's money. Henry was to have two separate bank accounts. The first would be for his allowance from his family, sent monthly by Jalabert. The second account would be accessible only to him and Uncle Georges and would contain all the money he himself earned from his art. It was agreed that he would only dig into this account for exceptional reasons and that neither his parents nor Jalabert would be allowed to know how much money was in it, as Henry was afraid they would curtail his allowance if they knew how much money he made. By now he earned a considerable amount. His prints had never sold particularly well, but the commissions for posters, illustrations and song covers were paid in advance, no matter how the work itself was received. And occasionally his paintings did very well indeed. On 29 April, while he was still in the asylum, one of his paintings, *Jeune femme assise* (Young Woman, Seated), had sold at auction for 1,400 francs. Others were stored in dealers' basements, 'maturing', as Henry said.

With Joyant as his gallery dealer, handling the business side of his art, both he and his family felt more secure. However, the arrangement never worked very well. Just under the surface, Henry's parents remained ready to use money to control him if necessary.

At the end of July 1899, Henry and Viaud took a boat to Taussat-les-Bains via Bordeaux. In Taussat, they stayed once again at the Villa Bagatelle, the summer home of Henry's friend Fabre, where they passed their days swimming, fishing and sailing. Despite the superficial appearance of a holiday, it became clear that the trip was very stressful. Henry was not well in any sense of the word, and his grasp on the world was shaky at best. Apparently he was doing no art. Three letters which remain from the stay in Taussat reveal Henry's state of mind: just beneath a veneer of descriptions of fishing lay distrust and paranoia about his relations to the art world, and grief and humiliation at the cruel way he was treated by those who thought he was mad.

One letter he wrote from Taussat was to Frantz Jourdain, the well-known architect and critic. In it Henry announced that he refused on principle to send lithographs to the 1900 Exposition Universelle, that he had already refused to be on the committee to decide where works would be hung in the show, and if there was to be a jury, he absolutely refused to submit works. However dogmatic he sounded, he hedged a little: 'Send me the rules anyway ... I would like to be helpful to you, but after books on lithography like M. Bouchot's ... I have to remain extremely reserved, especially where the old boy clan has a say.' Henry obviously had not forgotten Bouchot's 1895 review of the new lithographers, which had been insultingly critical of his work. Another letter, to Adèle, said one of his cormorants had been shot and that people seemed embarrassed when he was present.

At the end of the summer, Henry, still accompanied by Viaud, visited Adèle for several weeks at Malromé, finally returning to Paris in October after the grape harvest. In Paris from the autumn of 1899 to the summer of 1900, Henry, although gradually drinking more uncontrollably, seemed to lead his former existence, making paintings and prints and maintaining contact with friends whom he met at the former Irish and American Bar, now called the Café Weber. In some ways he seemed more willing to live conventionally than he had before. He returned to his childhood interest in horses and the race track, having himself driven regularly to Chantilly, the Bois and Longchamps to watch the horses. The works he did now main-tained the fine-lined, almost drawing-like quality typical of his painting, and

he did a series of lithographs of horse subjects which were published by Pierrefort.

However, even as he did the skilled, delicate but perfectly comprehensible racecourse lithographs, Henry also created a striking series of works in a markedly different style from his earlier art. Working primarily on wood panels, as in the portrait of Miss Dolly done at the beginning of the summer, Henry abandoned his thin, powdery turpentine washes and brilliant colours for a dark palette of muddy lines and sharp contrasts, plastering both wood and canvas with thick impasto. The first of these, *En Cabinet particulier – au Rat Mort* (At the Rat Mort, Private Room No. 7; Plate 35), is said to show the famous lesbian, Lucy Jourdan, with a male companion, strangely lit by the garish gaslight, leaning against the violent red velvet upholstery of an alcove in the scandal-plagued restaurant. Looking for all the world like a burst pomegranate, she has a puffy, voluptuous, somehow irrational aura redolent of too much champagne. The image of an overripe fruit is reinforced

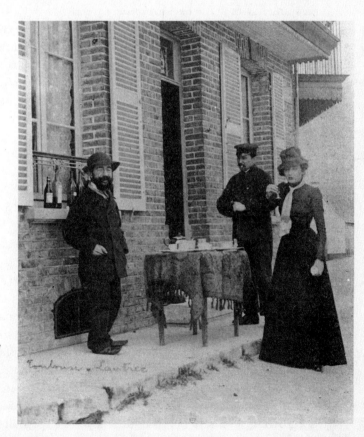

Henry with Joyant and Louise Blouet at Le Crotoy, on the Normandy coast, c. 1900.

by her similarity in shape and colour to a rounded pear in a basket of fruit in the foreground. Although the painting is reminiscent of his portrait of Gabriel in the corridor at the Comédie Française in its almost caricatural rendering of Lucy Jourdan's face, she has an expression of underlying savagery which would reappear in several of his women's faces over the next year.

As the new century began in 1900, Henry was lethargic and seemed not to be interested in anything. He was working only intermittently, and his art now was consistently sombre and depressed. He made a poster for the play *La Gitane* (The Gypsy) at the Théâtre Antoine, which opened on 22 January. The commission possibly came from Thadée Natanson's brother Alfred, whose wife, Marthe Mellot, was playing the gypsy of the title, but this time, instead of the pretty, singing woman he had portrayed on a cover for *L'Image* in 1897, Henry drew a menacing, wraith-like statue, mocking a stealthy, escaping figure in the background.

Meeting friends after the dress rehearsal, Henry raved about the play: '*La Gitane* is a huge success, an unheard-of success!' 'How can you say that?' someone answered. 'It's a complete failure, people were even booing.' Henry, who had spent the entire rehearsal in the theatre bar, drinking with one of Antoine's stagehands, hadn't seen the play at all. He was always supportive of work by friends whether he liked it or not. 'Maybe they were, but they were just spiteful people!'

He had refused to be on the committee to hang works for the poster show at the Exposition Universelle and, when he went to see it in April, he was not strong enough to visit the huge World's Fair on foot – a result of the accumulated fatigue of his disability, ill health and poor living habits. If contemporary accounts are correct, he asked the *Gros Narbre*, Dethomas, to push him around the Exposition Centennale et Décennale de la Lithographie in a wheelchair. He was thirty-five years old.

He worked slowly on a few portraits. Although very frail, he maintained his sense of humour. He had developed a playful, teasing friendship with Joyant's newest girlfriend, a model and hatmaker named Louise Blouet d'Enguin, who was described by Leclercq as looking like 'an alert squirrel'. Henry immediately nicknamed her 'Le Margouin' (a slang word for model), which he then lengthened to 'Croxi-Margouin' (or *croques-y Margouin* – good-enough-to-eat Margouin). He used her delicate features and thick reddish-blonde hair in a series of works. The most striking of these, however, is a glowing yet sombre portrait dominated by the looming black silhouettes

La Goulue shortly before her death in 1929.

of ladies' hats, looking like huge birds or hovering bats, and the model's sad, introspective face (Plate 47). He was out of money again, and neither Joyant nor Jalabert would listen to him. 'Sell anything at any price,' he wrote to Joyant. 'That's straightforward. Answer me with something besides very carefully worded concealments. My situation here is untenable.'

His health failed quickly once he allowed himself to drink again. Shrivelled and unsteady, that spring he encountered his old friend, La Goulue, herself a parody of what she had once been. Blowsy, obese and hopelessly dissolute, only ten years after her triumphs at Le Moulin Rouge, she was slumped on a chair in the sideshow tent where she kept a moth-eaten menagerie of lions. She hardly remembered 'Toudouze'.

Viaud was caught in a trap between gentlemanly discretion and the arguments that would result from any attempt to exercise serious control over Henry's drinking. To Henry's detriment, Viaud chose dignity over dominance. He did his best to supervise, to keep the damage to a minimum, but gradually Henry returned to all the habits which had marked the bleak winter of 1899. Paris was the culprit, his friends decided. It had too many temptations.

In May, as they watched him growing weaker and more ill, Joyant and his other friends again persuaded him to leave for the country. He chose the itinerary of the previous summer, going first to Le Crotoy, still accompanied by Viaud. There he began working on a portrait based on a photo of Joyant

holding a rifle, hunting duck, standing in a small boat. Comically, Henry changed the costume, clothing his friend in yellow oilskins, as he had costumed himself in oilskins to visit all the bars of Villeneuve, 'to open the hunt'. He was having a hard time, and he repeatedly painted out one day what he had done the day before. Henry insisted that Joyant, despite the photo, pose in person for his portrait 'not less than seventy-five' times. The drawings, the sketchy preparatory painting and the finished oil all have a hasty, incomplete character and the same areas of looming shadow that had always been premonitory signs in Henry's work.

All indications are that he was drinking heavily now. The other photos taken that day in the Baie de Somme show Henry bloated and inebriated, in a variety of poses, including being carried to the boat piggyback and, in three separate photographs, squatting on the beach, defecating. The existence of one such photograph might have been a prank by one of his friends, literally 'catching him with his trousers down', but three views of the pose, including one in which he is smiling, tend to indicate that he was a willing model and possibly even requested the childish photograph. This extension of his exhibitionism, like his caricature of himself naked and seated on a chamberpot or his scatological rear-view portraits urinating or labelled 'Boy does that fart stink', is another example of Henry's literally turning his 'production' into art, making a visual image of his frequent comment: *'L'art, c'est de la merde'* (Art, it's shit).

After leaving Le Crotoy, in Honfleur he ran into his actor friend Lucien Guitry, who suggested that he do the programme for the revival of Zola's *L'Assommoir*, which was due to open in November 1900 at the Théâtre de la Renaissance in Paris. Working sketchily on zinc, Henry drew a depressing waterfront saloon, using a couple named Cléry, hotel-keepers from Le Crotoy, and Joyant's sailor, Languerre, as models for Coupeau and his wife, along with their baby and another client, drinking rot-gut in the distillery bar.

The image seemed to reflect his perception of Normandy that wet spring. On 30 June, he wrote to Joyant from Le Havre complaining how things had changed since the year before: 'Old Chump,' he began in English and then switched to French, 'The Stars and other bars are being closely watched by the police. Nothing's happening. There aren't any more barmaids, so I'm embarking for Taussat, Worms Company, this evening. Yours, H.L. and Co. most limited!' This last reference, according to Joyant, was to Henry's renewed financial straits. In spite of their promises, Henry's parents again were pressing Joyant to use money as a way of controlling Henry. In another

Henry defecating on a beach, c. 1900.

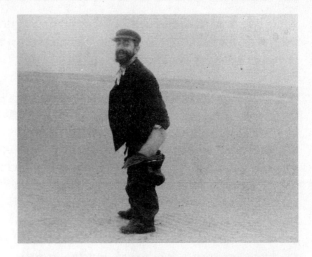

note to Joyant, Henry pleaded in English, 'Send the "dough".'

Again he spent the summer at Fabre's at Taussat-les-Bains. He caught a pair of praying mantises in the dunes and sent them to his friend, the sculptor François Rupert Carabin (whom for unknown reasons he called 'Viande Crue' – Raw Meat), in Paris, writing, 'Look after them carefully. We'll organize fights between them.' He was painting a portrait of Viaud, barefoot with his trouser legs rolled up. Briefly he seemed to have found the lighter, pastel quality of his typical work, but it was not to last. Moving to his mother's at Malromé in the early autumn, he decided to paint a scene to decorate the mantel over her dining room fireplace. The painting, *Admiral Viaud*, is a huge, odd portrait of his 'keeper' dressed in eighteenth-century garb with a

white wig, posed looking out at a frigate in a stormy sea. He didn't finish it
and left it hanging in its place for the winter, with bare canvas and paint
drips showing.

Two atypically conventional notes he wrote that summer and autumn,
one to theatre director André Antoine and the other to Joyant's gallery-
partner Michel Manzi, congratulated each of them for receiving the medal
of the Légion d'Honneur. These notes were unlike Henry's usual cor-
respondence which, unless he was writing to his mother or grandmothers,
for many years had referred to almost nothing but business or social engage-
ments. In addition, iconoclast that he was, it was odd that he did not ridicule
the ultra-conservative Légion d'Honneur, a civilian medal that Napoleon
Bonaparte had invented, as he openly admitted, to keep potential rebels loyal
to the government. According to one account, Joyant had been lobbying
to obtain the medal for Henry, but the artist spoiled his meeting with a
sympathetic cabinet minister by saying: 'Have you considered, Monsieur le
Ministre, how odd the red ribbon will look when I go to paint a brothel?'

As the winter of 1900 approached, Henry decided not to go back to Paris.
Instead he and Viaud moved to Bordeaux, a bustling but very bourgeois port
city where he had never lived. They took quarters at 66, rue de Caudéran,
and Henry rented a studio in the nearby rue du Porte Digeaux. Although it
was not as cold as Paris, Bordeaux in the winter was gloomy and wet. Almost
defiantly, Henry seemed to regain his lost energy and intensity. As he wrote
to his Grandmother Gabrielle: 'I'm beginning to share your opinion about
the fogs of the region, but I'm so busy I hardly have time to reflect on it. I
work all day long. I have four paintings in the Exposition de Bordeaux and
I'm getting some recognition. I hope that will give you a little pleasure.'
Naturally he was out of money. 'Send the entire amount in the B account,'
he wrote to Joyant.

He was working feverishly, and he threw himself into the offerings of
Bordeaux: its artists and museums in the daytime, at night, its theatres, bars
and prostitutes. As always Henry liked to go backstage, to be in on the unseen
as well as the spectacle. He did a huge drunken sketch of the heroine of
Jacques Offenbach's operetta parody of the *Iliad*, *La Belle Hélène*, which
was playing in the Grand Théâtre. In its looseness and rapidity, its crazy
theatricality, it is strikingly modern. He was now working in conflicting
styles, one dark and elaborated, the other thin and rapid with bright colours
used straight from the tube.

He also went several times to *Messaline*, an opera by Isidore de Lara, and
he had become very caught up in several works on the production when it

Henry at Le Crotoy with Viaud (left) and Languerre, the sailor, c. 1900.

closed. Six paintings on canvas from the *Messaline* series survive, heavy with impasto, dominated by blue-blacks and violent reds, the faces of the models lit from below with ghoulish footlights. Now the skilled line drawing which had dominated his work for years was replaced by loose areas of colour, giving the paintings an intense, expressionistic impact. 'I'm doing great paintings,' he noted in the margin of a letter Viaud wrote to Joyant. 'Don't make fun of me. I'm not asking for cash.' In the letter wishing his Grand-mother Gabrielle a happy New Year, he commented, 'and from someone like me, who is back from the dead, that counts double'.

As ever, Henry was short of money. Bad wine sales and a flood which had nearly destroyed the grape harvest had caused his family to threaten to cut his allowance from Jalabert, although Joyant felt that Henry was also mismanaging the money he had. As Viaud explained in a letter to Joyant on 9 January 1901, 'Last month, it is true, he overdid the ladies a bit, which means that he's a little short of cash.'

Although Henry justifiably felt his family had broken their promises to him, his reaction to the threatened allowance cut created strife. As Joyant observed, everyone was being intractable and there was little chance that

they would ever understand one another, but to make things worse, Henry had developed 'an obsession, which was, purely in the spirit of contradiction, to get his hands on enough money to do exactly as he pleased and to misuse it just to prove that he had the right to do so'. Even his relations with the go-between, Joyant, became very irritable. On 25 January, he sent a telegram to Joyant, who was publishing the album of circus drawings Henry had done while in the asylum: 'Do what I ask you. Album payment. I've had enough. Lautrec.'

As spring began to arrive in Bordeaux, Henry had a stroke. Although he survived, he could not walk for a time and, as part of his rehabilitation, he was told to refrain from drinking and carousing with women. He said to Joyant on 31 March that his calves hurt, but that mild electric pulses were being applied to them. He made light of his situation and mentioned his health only as an aside in a letter whose principal purpose was to ask Joyant to find out about a sale by Mancini, announced in the *New York Herald*, which would include some of his work: 'Will you be kind enough to look about the prices and write me about?' he asked in English. He added that he had received 'papal benediction' and included a caricature of the Bishop of Bordeaux, commenting that he looked like Camille Groult, a well-known art collector. Now that Henry wasn't drinking at all, Joyant noticed that he was surly and quite depressed. On 2 April, Henry wrote to him, 'I'm living on *nux vomica*; also both Bacchus and Venus are barred. I'm painting and even sculpting. If I get bored, I write poetry.'

He did not stop working. In mid-April he wrote to Joyant in English that he was 'very satisfied'. He thought Joyant too would be pleased with the *Messaline* series. His friends Guibert and Dethomas, hearing about his latest troubles, had gone to Bordeaux to visit him. Henry sketched a caricature of Guibert chasing a woman on the Bordeaux waterfront. He told Joyant that when he took Dethomas to the station to catch the train back to Paris, he had given him as a going-away present two chameleons 'who rolled their eyes terribly. We drank café au lait together at the station, and he's off like Saint-John the Baptist, the Forerunner, to announce my arrival.'

As soon as he could travel, Henry did go back to Paris, arriving accompanied by cases of paintings: not only the *Messaline* series, but portraits of Madame Marthe, her son with Henry's dog Pamela, Paul Viaud de la Teste, the violinist Dancla, Louis Fabre 'in his railway officer's uniform', as well as preparatory drawings for his paintings, sketches of violinist's hands, of daily life in Bordeaux, of children's heads, and a drawing which had been reproduced as an advertising flyer for the Bal des Etudiants de Bordeaux, an

event which must have reminded him of the wild student artists' balls of the old days in Paris.

He and Viaud set up quarters in the avenue Frochot (probably at Henry's studio at number 15) sometime near the end of April. Did he arrive before the sale held at the Salle Drouot on 25 April? Four of his paintings were sold, for most satisfying sums: *La Toilette* for 4,000 francs, *La Pierreuse* for 2,100, *Aux Ambassadeurs, gens chics* for 1,860 and *En Meublé* for 3,000. But the time had passed when Henry would be thrilled by financial success: 'Our hearts were saddened to see him after those nine months away,' Joyant later said. '... Thin and weak, he was barely eating at all, but he was still as lucid as ever, and at moments, full of verve.'

As weak as he was, Henry continued to work. He did a few portraits in Paris in the late spring of 1901. One was of his architect friend Octave Raquin, whom Henry had nicknamed 'Le Copeau' (Shaver) because his curly blond hair resembled wood shavings. Another was of Michel Manzi, who in turn sketched Henry as he worked – a Henry who was terribly thin, shrunken, prematurely old. Another was of André Rivoire, playwright and editor of *La Revue de Paris*. He had written several articles about Henry in

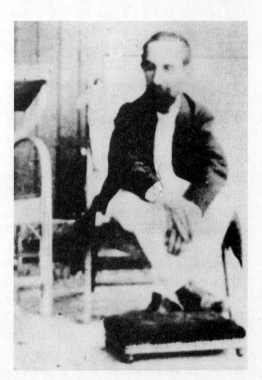

Henry in 1901.

art magazines, and Henry was eager to repay the favour, but at the end of less than an hour's work, Henry's hands were shaking so badly that he had to stop. Rivoire, worried about Henry's health, sent a message to his close friend Paul Leclercq to warn him of Henry's state. Leclercq in turn warned Gabriel, but even a physician couldn't help Henry by then.

In June 1901, Henry began one last painting, *Un Examen à la faculté de médecine* (An Examination at the Faculty of Medicine). Traditionally, this has been described as a portrayal of Gabriel's thesis defence, but the candidate being examined bears little resemblance to Gab. The only recognizable members of the jury are the professors Wurtz and Fournier. This makes it particularly unlikely that the work was intended to represent Gabriel's exams, since Fournier was not on the examining committee when he had defended his thesis (on vaginal herniation) two years earlier, on 15 March 1899. In any case Henry, who was in the asylum at that time, could not have attended. The thesis, dedicated to Péan who had died in 1898, was signed by Wurtz, Tillaux (director), Landouzy and Legueu. However, in the late spring of 1901, Henry had begun an oil sketch of his friend and frequent Bordelais host, Robert Wurtz, and the scene may simply have been intended as a homage to him. It has been pointed out that the three men in the painting had in common their studies of syphilis and alcoholism, thus symbolically making this painting a kind of testimonial to Henry's decline.

The canvas itself is very different from almost any painting Henry had ever done. Like an avant-garde interpretation of the classical academic tradition, retrograde in subject matter but with an unusual viewpoint and poses, it is painted in thick impasto with loose brushwork on canvas, in sombre greens and blacks, with occasional touches of white and red. It completely lacks his habitual hatchmark shading or clear, fluidly drawn line. Yet even in its changing relation to his previous work, its thick brushstrokes and violent dark colours could be interpreted as a foreshadowing of the Expressionist movement to follow him.

According to Joyant, Henry now stopped working. Instead, Joyant said, fully aware that his health was failing for good, Henry systematically went through his studio, 'finishing some paintings, stamping with his red monogram everything he wished to keep', putting everything in order. Such an orderly ending sounds good, but Joyant had a reason for wanting people to believe that Henry himself had been the last person to go through his work and that he himself had stamped his colophon on each work left there. After Henry's death, Joyant would take over administration of his artistic estate, decreeing which works were originals and which were not, arranging to

donate a complete collection of his prints to the Palais du Luxembourg and another to the print room at the Bibliothèque Nationale, apparently trying to get Henry's work accepted as a whole by the Louvre and, when that did not work out, having a museum built for it in Albi. Joyant was a good businessman. As a gallery owner, he knew how to increase the value of his personal holdings.

On 15 June 1901, Henry left Paris for good, to spend the summer in Taussat-les-Bains one last time. He was accompanied to the Gare d'Orsay by a number of friends, including Gab and Joyant. Before getting on the train, he said to Renée Vert, 'We can kiss, for you won't see me again.' As an after-thought he added, looking comically at his friends' sad expressions, 'When I am dead, I'll have a nose like Cyrano!' In 1898, Edmond Rostand's play *Cyrano de Bergerac*, on the life of the seventeenth-century poet, had been a big hit in Paris, and Henry had done portrait lithographs of both the author of the play and the actor who played the title role, Coquelin Cadet. Henry had no doubt thought about the similarities between himself and Rostand's Cyrano. Each man's ugly exterior belied his interior beauty, a beauty that could not be perceived by those interested in superficial appearances but which each man's genius expressed in words or art. Each man was famous for his repartee and scathing wit, for unmasking the hypocrisy and sentimentality of an unsympathetic world but also for making fun of himself. Each man insisted on total liberty and lived according to his whims, wearing many masks to protect his vulnerability from the scorn of others, making his life itself into a work of art. Each would die before he was thirty-seven years old.

The summer in Taussat, in spite of the sunshine and bracing sea air, could not restore Henry's strength. Horribly weak and thin, he arrived, by train this time, instead of via his habitual boat voyage, so exhausted he couldn't even eat. His friends at Taussat were worried, and they communicated their concern to Adèle, who wrote to her son asking him to come to Malromé where she could take care of him. But Henry was determined to reassure her. Too weak to write himself, he asked Viaud to respond: 'Madame,' Viaud wrote, 'The General was very stupid to alarm you on Henry's account. It is true that the trip tired him a bit, but thank the Lord, that has all passed now, & a piece of good news is that he's beginning to eat again & that's why I'm not pushing anything on the subject of our arrival at Malromé, for since the sea is helping him regain his appetite, it's better I think to wait a few days before moving him.'

Henry added a brief note, '*Dear Mother*, We'll arrive shortly. Viaud will advise. Love and friendship. Henri.'

They did not travel in a few days, however, and Henry did not improve. In mid-August he suffered a second stroke from which he would not recover. At last he was moved to Malromé, at his request, to die at his mother's home. He arrived on 20 August, during the hottest part of the year, and was placed, paralysed, intermittently comatose, in an upstairs bedroom. But death did not come quickly. His mother, her ambivalence resolved by outside events, was at his bedside night and day. The heat was unbearable, and flies buzzed around his immobile body, landing on him and biting him. He could do nothing to keep them away. He drifted in and out of sleep, appeared to hear nothing, and called out to his mother for reassurance. 'You Maman, no one but you.' Gabriel and Louis and Joseph Pascal came. 'Dying's damned hard!' Henry announced. Alphonse, who had been notified, finally arrived. 'Good, Papa,' Henry said, when Alph entered the darkened room. 'I knew you wouldn't miss the kill.' The priest came to give him the last sacraments. After he left, Alphonse, forced to be inactive, helpless to do anything for his son, was completely at a loose end. Maladroitly, he made eccentric suggestions, like cutting off Henry's beard, which he said was the custom in Arab countries. He sat uselessly in the bedroom, irritated by the buzzing flies. Finally, he took the elastics he used as shoelaces and tried to shoot the flies down, to drive them away from his son. Gab was standing by the bed. Henry looked up at Gab and said, 'The old fool.' These were the last words he spoke.

Heat thunder could be heard in the distance, but the storm did not come. The air was motionless, and Henry's laboured breathing went on and on. The women in the bedroom, Adèle and a nun who had come to be with her, said their rosaries. Finally, on 9 September 1901, at a quarter past two in the morning, he died.

Shortly afterwards the rain began, falling in torrents as it had the night he was born, just two and a half months short of thirty-seven years before.

The death certificate was witnessed by Gabriel and Joseph Pascal. Curiously, it was Alphonse who left the clearest account of the grief they were all feeling. Writing to René Princeteau on the afternoon of the day Henry died, he said:

Reality has been for all of us very harsh, in every sort of disappointment ... My son Henri – 'the little one', as you called him, died this morning at a quarter past two. I had arrived four or five hours earlier, and I witnessed the unforgettable and horrible sight of the best person you could wish to meet, mourned in advance by everyone

who, like you, was able to realize what a treasure of rectitude and friendship he was when you got to know him. I saw him, but he could not see me, as his wide eyes could no longer see anything after three or four days of quiet, gentle delirium. He made practically no recriminations against anything or anyone, despite the suffering he must have endured because of his appearance, which made people turn around for a second look, more in pity than in scorn.

His sufferings are over. Let us hope that there is another life where we shall meet again, without hindrance to eternal friendship.

I almost telegraphed to tell you that I was passing through Libourne yesterday on the express train, at around half past four. But it's better that you did not see your jovial comrade disfigured by grievous anguish, perhaps more for those of us who have lost him than for him whose sufferings are now over.

Even at Henry's death, however, Alphonse had to insist that all attention be focused on himself. On the day of the funeral, instead of walking behind the hearse in the funeral procession, Alphonse complained that his corns were so painful that he could not walk that far and insisted upon climbing up on the box of the hearse beside the coachman. Visibly irritated at the man's driving, he took away the reins and whipped the horse to increase the pace, leaving the other mourners running behind through the muddy lanes to keep up.

The power struggle between Alphonse and Adèle over Henry did not end with their son's death. Adèle wanted Henry buried in the churchyard at the convent of Verdelais, which she loved so well, but he was interred in the cemetery of Saint-André-du-Bois, which was nearer. Although no record remains of the reasons for this decision, it is easy to imagine that Alphonse, ridiculing his wife's attachment to the nuns at Verdelais, insisted that the convent was too far for a funeral procession. However, some years later, on the pretext that the cemetery at Saint-André was to be deconsecrated (an event that did not take place), Adèle had Henry's remains moved to Verdelais.

Alph, who died in 1912, denied to the end that his son's work was anything more than 'rough sketches', and officially signed his '*droits paternels*' (parental rights) in Henry's art over to Maurice Joyant, saying, 'I have no plans to change my opinion, and, now that he is dead, praise to the skies something that during his life I could regard only as audacious, daring studio studies.' Adèle, who lived until 1930, devoted the rest of her life to working with Joyant to preserve her son's work and enhance his reputation, even funding a museum to be established in his name, the Musée Toulouse-Lautrec in Albi.

BIBLIOGRAPHY

PRIMARY

Abélès, Luce. *Toulouse-Lautrec: la baraque de La Goulue*. Paris: Cahiers Musée d'Art et d'Essai, Palais de Tokyo, 1984.

—— and Charpin, Catherine. *Arts incohérents, académie du dérisoire*. Paris: Editions de la Réunion des Musées Nationaux, 1992.

Adhémar, Jean. 'Toulouse-Lautrec et son photographe habituel.' *Aesculape* 12 (December 1951) pp. 229–34.

——. *Toulouse-Lautrec: Elles*. Monte Carlo, 1952.

——. *Toulouse-Lautrec: lithographies, pointes-sèches*. Paris/London, 1965.

——, Gerard Bauër, Pierre MacOrlan, Paul Colin, J.-G. Domergue, M. G. Dortu, Edouard Julien, Henri Perruchot, Maurice Rheims, Claude Roger-Marx. *Toulouse-Lautrec: collection génies er réalités*. Paris, 1962.

Adriani, Götz. *Toulouse-Lautrec: the complete graphic works*. London, 1986.

——. *Toulouse-Lautrec*. London, 1987.

Alexandre, Arsène. 'Chronique d'aujourd'hui: Henri de Toulouse-Lautrec.' *Paris* (8 January 1892b) n.p.

——. 'Celle qui dance.' *L'Art français* (29 July 1893) n.p.

——. 'Une guérison.' *Le Figaro* (30 March 1899) n.p.

——. 'Toulouse-Lautrec.' *Le Figaro illustré* 145 (April 1902) pp. 1–24.

——. 'Note sur les vingt-deux dessins aux crayons de couleur *Au Cirque*' (preface to Toulouse-Lautrec, *Au Cirque*). Paris, 1905.

——. 'Exposition rétrospective de l'oeuvre de H. de Toulouse-Lautrec.' *Les Arts* 152 (August 1914) pp. 1–14.

——. 'Toulouse-Lautrec et les femmes.' *La Renaissance* 6 (June 1931) pp. 173–9.

Arnold, Matthias. 'Das Theatre des Lebens.' *Weltkunst* 52 (February 1982) pp. 302–6.

——. *Henri de Toulouse-Lautrec*. Cologne, 1987. French edition, 1989.

Arts Council of Great Britain. *Toulouse-Lautrec 1864–1901: his lithographic work*

from the Collection of Ludwig Charell. London/New York, 1950.

Astre, Achille. *H. de Toulouse-Lautrec*. Paris, 1926.

Attems, Comtesse (Mary Tapié de Céleyran). *Notre Oncle Lautrec*. Third edition. Geneva, 1963. Revised edition 1975.

Aubert, Louis, 'Harunobu et Toulouse-Lautrec (Toulouse-Lautrec et l'influence japonaise du XVIIIe siècle)'. *La Revue de Paris* (19 February 1910) pp. 825–42.

Baragnon, Numa. 'Toulouse-Lautrec chez Péan.' *Chronique médicale* (15 February 1902) pp. 98–101.

Barrucand, Dr. D. and M. Barrucand. 'La psychologénèse de l'oeuvre de Toulouse-Lautrec: la place du complexe d'Oedipe.' *La Revue Médicale de Toulouse* 6 (1970) pp. 603–11.

Baxter, C. 'Mistaken Identities: three portraits by Toulouse-Lautrec.' *Print Collector's Newsletter* 10.3 (1979–80) pp. 41–4.

Bazin, Germain. 'Lautrec Raconté par Vuillard.' *L'Amour de l'Art* Paris (April 1931) pp. 124–5.

Beaute, Georges, ed. *Il y a cent ans: Henri de Toulouse-Lautrec*. Geneva, 1964. Revised edition: *A Toulouse-Lautrec Album*. Salt Lake City, 1982.

——. *Toulouse-Lautrec vu par les photographes suivi de témoignages inédits*. Lausanne, 1988.

Bernard, Emile. 'Des relations d'Emile Bernard avec Toulouse-Lautrec.' *Arts-Documents* Geneva (March 1952) pp. 13–14.

Bernard, Tristan, and H. de Toulouse-Lautrec. 'Le Salon du Tatare et le Salon des Champs-Elysées.' *La Revue blanche* 6.32 (June 1894) pp. 577–84.

——. *Catalogue de Tableaux: aquarelles et dessins par Henri de Toulouse-Lautrec*. Sale catalogue. Hôtel Drouot, Paris, 30 April 1913.

——. 'Toulouse-Lautrec sportsman.' *L'Amour de l'Art* 4 (April 1931) p. 135.

Bibliothèque Nationale and Queensland [Australia] Art Gallery. *Les Lautrec de Lautrec*. Brisbane, 1991.

Blanche, Jacques-Emile. 'Sur Henri de Toulouse-Lautrec.' *L'Art vivant* (June 1931) pp. 260–3.

Bonmariage, Sylvain (pseudonym of de Cercy d'Erville). 'Henri de Toulouse-Lautrec pile et face.' *Maintenant* 6 (July 1947) pp. 28–48.

Bouchot-Saupique, Jacqueline. '62 dessins de Toulouse-Lautrec entrant au Musée du Louvre.' *Les Arts plastiques* 7 (1947) pp. 15–21.

——. 'A Group of Toulouse-Lautrec Drawings in the Cabinet des Dessins.' *Master Drawings* 3.2 (1965) pp. 166–8, Plates 29a–34b.

Bouret, Jean. *Toulouse-Lautrec*. Paris, 1963. London, 1964.

Brabant, Charles and Martine Cadieu. *Henri la tendresse*. 16mm documentary film, TF1, Paris, 1975–6.

Brécourt-Villars, Claudine. *Yvette Guilbert, l'irrespectueuse*. Paris, 1988.

Cate, P. D. and P. E. Boyer. *The Circle of Toulouse-Lautrec: an exhibition of the work of the artist and of his close associates*. Exhibition catalogue. Jane Vorhees Zimmerli Art Museum, Rutgers University. New Brunswick (N.J.), 1985.

Charles-Bellet, L. *Toulouse-Lautrec, ses amis et ses maîtres*. Musée d'Albi, France, 1951.

Charpentier, Thérèse. 'Deux aquarelles inédites de Henri de Toulouse-Lautrec.' *La Revue des Arts* 10.2 (1960a) pp. 87–92.

——. 'Un aspect peu connu de l'activité de Lautrec: sa collaboration à la reliure d'art.' *Gazette des Beaux-Arts* 6.56 (September 1960b) pp. 165–78.

——. 'Quelques Lettres et un dessin inédits de Toulouse-Lautrec, conservés au Musée Lorrain.' *Annales de l'Est* 3 (1962) pp. 215–26.

Clemenceau, Georges. 'Au Café-concert.' *La Justice* (15 September 1894) n.p.

——. *Au Pied du Sinaï*. Illustrated by Toulouse-Lautrec. Paris, 1898.

Cogniat, R. *Lautrec*. Paris, 1966.

Coolus, Romain. 'Souvenirs sur Toulouse-Lautrec.' *L'Amour de l'Art* 4 (April 1931) pp. 137–40.

Cooper, Douglas. *Toulouse-Lautrec*. London/Paris, 1955. Republished 1988.

Coquiot, Gustave. *H. de Toulouse-Lautrec*. Paris, 1913.

——. *Lautrec, ou quinze ans de moeurs parisiennes, 1885–1900*. Paris, 1921.

Cousturier, Edmond. 'Oeuvres de Henri de Toulouse-Lautrec et de Charles Maurin.' *Entretiens politique et littéraire* 37 (23 February 1893) pp. 187–8.

Daulte, François. 'Plus vrai que nature.' *L'Oeil* 70 (October 1960) pp. 48–55.

——. *Toulouse-Lautrec: chefs d'oeuvre du Musée d'Albi*. Exhibition catalogue. Musée Marmottan. Paris, 1976.

Delaroche-Vernet Henraux, Marie. *Toulouse-Lautrec dessinateur*. Paris, 1949.

Delteil, Loys. *Le Peintre-graveur illustré. X–XI: Henri de Toulouse-Lautrec*. Paris, 1920.

Desloge, Nora, Phillip Dennis Cate and Julia Frey. *Toulouse-Lautrec: the Baldwin M. Baldwin Collection*. Exhibition catalogue. San Diego Museum of Art, San Diego, 1988.

Devoisins, Jean. 'Toulouse-Lautrec d'Albi.' *La Revue française* 250 (February 1972) pp. 5–16.

——. 'Les Séries de Lautrec.' *Galérie Jardin des Arts* 164 (December 1976) pp. 44–8.

——, ed. Catalogue of the Musée Toulouse-Lautrec, Albi. Albi, n.d. (*c.*1985).

Devoisins, Pierre. *Henri de Toulouse-Lautrec: essai d'étude clinique. Ses maladies, sa mort*. Albi, 1958.

Donos, Charles. 'De Toulouse-Lautrec.' *Hommes d'aujourd-hui* 9.460 (1896) pp. 1–3.

Dortu, M.-G. 'Toulouse-Lautrec paints a portrait.' *Art News* (February 1964) pp. 24–6.

——. *Toulouse-Lautrec et son oeuvre.* Six vols. New York, 1971.

——, ed. *Jeune Routy à Céleyran* (facsimile). Paris, 1975.

——, ed. *Tout Toulouse-Lautrec.* Paris, 1981.

——, Madeleine Grillaert and Jean Adhémar. *Toulouse-Lautrec en Belgique.* Paris, 1955.

——, Jean-Alain Méric and Germain Bazin, eds. *'Artilleur et femme'* (facsimile). Paris, 1972.

Druick, Douglas. 'Toulouse-Lautrec: notes on an exhibition.' *Print Collector's Newsletter* 18.2 (May–June 1986) pp. 41–7.

Dupouy, Pierre. 'Toulouse-Lautrec et la presse bordelaise.' *Revue historique de Bordeaux* 22 (1973) pp. 121–34.

——. 'L'Affiche du *Bal des étudiants* de Toulouse-Lautrec.' *Nouvelles de l'estampe* 24 (1975) p. 14.

Duret, Théodore. *Lautrec.* Paris, 1920.

Ernst. 'Oeuvres exposées de Toulouse-Lautrec.' *Le Siècle* (1 June 1891) n.p. Dossiers of the Musée d'Orsay, Paris.

Esswein, H. *Henri de Toulouse-Lautrec.* Munich, 1912.

Eugny, Anne (d'). 'Toulouse-Lautrec et ses modèles.' *L'Amour de l'Art* 7 (1946) pp. 189–95.

Exposition Henri de Toulouse-Lautrec. Introduction by A. Alexandre. Exhibition catalogue. Galeries Durand-Ruel. Paris, 1902.

Exposition rétrospective de l'oeuvre de H. de Toulouse-Lautrec. Introduction by A. Alexandre. Exhibition catalogue. Galerie Manzi-Joyant. Paris, 1914.

Feinblatt, Ebria and Bruce Davis, *Toulouse-Lautrec and His Contemporaries: posters of the Belle Epoque from the Wagner Collection.* New York, 1985.

Fermigier, André. *Toulouse-Lautrec.* Paris/London, 1969.

Florisoone, Michel. 'Toulouse-Lautrec, découvreur de l'humain.' *Le Concours médical* 1 (7 February 1956) pp. 89–99.

Focillon, Henri. 'Lautrec.' *Gazette des Beaux-Arts* 6 (June 1931) pp. 366–82.

——. *Dessins de Toulouse-Lautrec: pages de Henri Focillon.* Catalogue d'Edouard Julien. Lausanne: Mermoz, 1959.

Fondation Pierre Gianadda. *H-T Lautrec.* Exhibition catalogue. Martigny, Switzerland, 1987.

Frankfurter, Alfred M. 'Toulouse-Lautrec: the artist.' *Art News Annual* 20 (1951) pp. 87–126.

Frèches, Claire and José Frèches. *Toulouse-Lautrec, les lumières de la nuit.* Paris, 1991.

Gauzi, François. *Lautrec et son temps*. Paris, 1954a.

——. 'Les modèles de Lautrec.' *Beaux-Arts* (17 December 1954b) p. 14.

——. *Lautrec mon ami*. Paris, 1992.

Geffroy, Gustave. 'Exposition Toulouse-Lautrec, boulevard Montmartre.' *La Justice* (15 February 1893) n.p.

——. 'L'Art d'aujourd'hui: H. de Toulouse-Lautrec.' *Le Journal* (14 January 1896) n.p.

——. *Yvette Guilbert, orné par H. de Toulouse-Lautrec*. Paris, 1894. Facsimile with English translation: introduction by Peter Wick. Cambridge (Mass.), 1968.

——. 'Henri de Toulouse-Lautrec (1864–1901).' *Gazette des Beaux-Arts* 4.12 (August 1914) pp. 89–104.

Georges-Michel, Michel. *De Renoir à Picasso: les peintres que j'ai connus*. Paris, 1954.

——. 'Lautrec et ses modèles.' *Gazette des Beaux-Arts* 6.79 (April 1972) pp. 241–50.

Griffiths, Antony. 'The Prints of Toulouse-Lautrec' in Wolfgang Wittrock, *Toulouse-Lautrec: the complete prints*, vol. I. London, 1985, pp. 35–48.

Hanson, L. and E. Hanson. *The Tragic Life of Toulouse-Lautrec*. New York, 1956.

Haraszti-Takács, Marianne. 'Etudes sur Toulouse-Lautrec.' *Bulletin du Musée Hongrois des Beaux-Arts* 26 (1965) pp. 51–80.

Hayter, S. W. 'The Lautrec Bite.' *Art News* (November 1955) pp. 26–9.

Heilmann, C. *Henri de Toulouse-Lautrec*. Exhibition catalogue. Bayerische Staatsgemäldesammlungen. Munich, 1985.

Heller, Reinhold. 'Rediscovering Henri de Toulouse-Lautrec's *At the Moulin Rouge*.' *Art Institute of Chicago Museum Studies* 12.2, pp. 115–36.

Hepp, Alexandre. 'La vraie force.' *Le Journal* (26 March 1899).

Hiatt, Charles. 'Toulouse-Lautrec and His Posters.' *The Poster* 2.11 (May 1899) pp. 181–8.

'Homodei' [Arthur Huc]. 'Toulouse-Lautrec.' *La Dépêche de Toulouse* (23 March 1899), n.p.

——. 'Une Ame d'artiste.' *La Dépêche de Toulouse* (21 September 1922) n.p.

Huisman, Philippe. 'L'Attitude révolutionnaire de Toulouse-Lautrec.' *Connaissance des Arts* (April 1964a) pp. 58–64.

——. 'Lautrec et le Croxi-Margouin.' *L'Oeil* 113 (May 1964b) pp. 10–19, 69.

——. *Toulouse-Lautrec*. Milan, 1971. London, 1973.

—— and M. G. Dortu. *Lautrec par Lautrec*. Paris, 1964.

Huyghe, René. 'Aspects de Toulouse-Lautrec.' *L'Amour de l'Art* 4 (April 1931) pp. 143–57.

Jedlicka, Gotthard. *Henri de Toulouse-Lautrec*. Berlin, 1929. Tr. J. Erskine. New York, 1962.

Johnson, Lincoln F. 'Time and Motion in Toulouse-Lautrec.' *College Art Journal* 16 (1956–7) pp. 13–22.

Jourdain, Francis and Jean Adhémar. *T.-Lautrec*. Paris, 1952. Republished 1987.

Jourdain, Frantz. 'L'Affiche moderne et Henri de Toulouse-Lautrec.' *La Plume* (15 November 1893) pp. 488–93.

Joyant, Maurice. *Henri de Toulouse-Lautrec, 1864–1901*. Two vols. I. *Peinture*, Paris, 1926. II. *Dessins, estampes, affiches*, Paris, 1927a.

——. 'Toulouse-Lautrec.' *L'Art et les artistes* (February 1927b) pp. 145–72.

Jubert, Yves. 'Henri de Toulouse-Lautrec.' *La Petite Gironde* (8 September 1941) p. 8.

Julien, Edouard. *Les Affiches de Toulouse-Lautrec*. Monte Carlo, 1950.

——. *Pour connaître Toulouse-Lautrec*. Albi, 1953.

——. *Toulouse-Lautrec: au cirque*. Paris, 1956.

Keller, H. *Toulouse-Lautrec: painter of Paris*. Tr. E. Bizzari. New York, 1969.

LaMure, Pierre. *Moulin Rouge: a novel based on the life of Henri de Toulouse-Lautrec*. New York, 1950.

Lapparent, Paul de. *Toulouse-Lautrec*. Paris, 1927. London, 1928.

Lassaigne, Jacques. 'Lautrec et les autres.' *L'Amour de l'Art* 12 (April 1931) pp. 159–64.

——. *Toulouse-Lautrec*. Tr. M. Chamot. Paris, 1946.

——. *Lautrec*. Geneva, 1953.

——. *Toulouse-Lautrec et le Paris des cabarets*. Paris, 1976.

'Lautrec au Salon de 1894.' *L'Oeil* 189 (December 1969) pp. 24–9.

Lazareff, Pierre. 'Yvette Guilbert nous parle de Toulouse-Lautrec.' *L'Art vivant* (April 1931) pp. 129–30.

Leclercq, Paul. *Autour de Toulouse-Lautrec*. Paris, 1921. Republished Geneva, 1954.

——. 'Toulouse-Lautrec et la scène.' *Comoedia* (4 September 1943) n.p.

Leclerq [sic], Paul [Paul Leclercq]. *Henri de Toulouse-Lautrec*. Zurich, 1958.

Lepelletier, Edmond. 'Le Secret du bonheur.' *L'Echo de Paris* (28 March 1899) n.p.

——. 'Actualités: H. de Toulouse-Lautrec.' *L'Echo de Paris* (15 September 1901) n.p.

'Les Fous' cited in La Librairie Niçoise. Autograph catalogue. n.d., p. 63.

Libowitz-Henry, Claudine. 'L'Exposition Toulouse-Lautrec à Londres en mai 1898 et la presse anglaise.' *Gazette des Beaux-Arts* 6. 14 (November 1957) pp. 297–303.

Lucie-Smith, Edward. *Toulouse-Lautrec*. Oxford, 1977. Republished 1983.

'M.' 'Nécrologie: Toulouse-Lautrec-Monfa.' *La Revue universelle* 49 (7 December 1901) pp. 1174–5.

Mack, Gerstle. *Toulouse-Lautrec*. New York, 1938. Republished 1953.

MacOrlan, Pierre. *Lautrec: peintre de la lumière froide*. Paris, 1934.

Magné, Jacques-René and Jean-Robert Dizel. *Les Comtes de Toulouse et leurs descend-
ants: les Toulouse-Lautrec*. Paris, 1992.

Maroteaux, Pierre and Maurice Lamy. 'The Malady of Toulouse-Lautrec.' *The
Journal of the American Medical Association* 191.9 (1 March 1965) pp. 715–17.

Marx, Roger. 'L'Art nouveau. Sur l'exposition des ouvrages récentes de M. de
Toulouse-Lautrec et de M. Charles Maurin.' *Le Rapide* (13 February 1893).

Melot, Michel. 'Questions au Japonisme' in Y. Chisaburo (ed.) *Japonisme in Art: an
international symposium*. Tokyo, 1980, pp. 239–60. Tr. Block 13, 1987–8, pp. 51–
60.

——. *Les femmes de Toulouse-Lautrec*. Paris, 1985.

Muller, Joseph-Emile. *Toulouse-Lautrec*. Paris, 1975.

Murray, Gale. 'Problems in the Chronology and Evolution of Style and Subject
Matter in the Art of Henri de Toulouse-Lautrec, 1878–1891.' Ph.D. diss. Col-
umbia University, 1978a.

——. 'Review of M.-G. Dortu, *Toulouse-Lautrec et son oeuvre*.' *Art Bulletin* 60
(March 1978b) pp. 179–82.

——. 'Henri de Toulouse-Lautrec: a checklist of revised dates.' *Gazette des Beaux-
Arts* 6.95 (February 1980a) pp. 77–90.

——. 'The Theme of the Naturalist Quadrille in the Art of Toulouse-Lautrec: its
origins, meaning, evolution and relationship to later Realism.' *Arts Magazine* 55.4
(December 1980b) pp. 68–75.

——. *Toulouse-Lautrec: the formative years, 1878–1891*. Oxford, 1991.

Musculus, Pastor P. R. 'L'Ascendance royale de Toulouse-Lautrec.' *Gazette des
Beaux-Arts* 74 (1969) pp. 179–80.

Natanson, Thadée. 'Oeuvres de M. de Toulouse-Lautrec.' *La Revue blanche* 4.16
(February 1893) p. 146.

——. 'Toulouse-Lautrec: the man.' *Art News Annual* 20 (1951a) pp. 75–86.

——. *Un certain Henri de Toulouse-Lautrec*. Geneva, 1951b.

Neret, Gilles. 'Toulouse-Lautrec et la caméra-crayon.' *L'Oeil* 248 (March 1976) pp.
2–9.

——. *Toulouse-Lautrec*. Paris, 1991.

Nicolson, Benedict. 'Notes on Henri de Toulouse-Lautrec.' *The Burlington Magazine*
93.582 (September 1951) pp. 299–301.

Novotny, Fritz. 'Drawings of Yvette Guilbert by Toulouse-Lautrec.' *The Burlington
Magazine* 91 (June 1949) pp. 159–63.

——. *Toulouse-Lautrec*. London, 1969.

Oursel, Hervé. 'Un Tableau de Toulouse-Lautrec.' *La Revue du Louvre* 25.4 (1975)
pp. 275–7.

Paret, Pierre. *Lautrec Women*. Tr. Diana Imber. Paris/Lausanne, 1970.

Perruchot, Henri. *Toulouse-Lautrec*. Paris, 1958. London, 1960.

——. 'Toulouse-Lautrec et la passagère du 54.' *L'Oeil* 145 (December 1966) pp. 48–51.

'Petites Expositions: oeuvres intéressantes de Toulouse Lautrec chez MM Bernheim jeune.' *The New York Herald* (Paris edition) (13 October 1908) n.p. Dossiers of the Musée d'Orsay, Paris.

Pigasse, Jules. 'Toulouse-Lautrec: conférence donnée à l'exposition d'oeuvres de H. de Toulouse-Lautrec et de Gairaud dans les Salons du *Télégramme*, à Toulouse, le vendredi 13 December 1907.' Albi, 1908.

Pilon, Edouard. 'Exposition Toulouse-Lautrec.' *La Plume* 124 (15 June 1894) p. 264.

Polášek, J. *Toulouse-Lautrec Drawings*. New York, 1976.

Reff, Theodore. 'Degas, Lautrec and Japanese Art' in Y. Chisaburo (ed.) *Japonisme in Art: an international symposium*. Tokyo, 1980, pp. 189–213.

Renaud, Jean-Louis. 'Toulouse-Lautrec.' *Le Télégramme de Toulouse* 15 (September 1901) n.p.

'Revue du Salon des Arts Libéraux.' *Estafette* (May 1891) n.p.

Rich, D. C. 'Where Shall We Put Lautrec?' *The Arts* 17 (February 1931) n.p.

——. *Toulouse-Lautrec au Moulin Rouge*. London, 1949.

Rivoire, André. 'Henri de Toulouse-Lautrec.' *La Revue de l'Art ancien et moderne* 10.57 (10 December 1901) pp. 391–401; 11.61 (10 April 1902) pp. 247–62.

——. 'Au jour le jour, Henri de Toulouse-Lautrec.' *Le Temps* (19 September 1901) n.p.

Rodat, Charles de. *Toulouse-Lautrec: album de famille*. Fribourg, 1985.

Roger-Marx, Claude. 'Toulouse-Lautrec, graveur.' *L'Amour de l'Art* 12 (April 1931) pp. 165–71.

——. *Yvette Guilbert vue par Toulouse-Lautrec*. Paris, 1950.

——. *Toulouse-Lautrec*. Paris, 1957.

Roques, Jules. 'Nécrologie: H. de Toulouse-Lautrec.' *Le Courrier français* (15 September 1901) n.p.

Rouquier, René. 'Cinquantenaire du Musée Toulouse-Lautrec.' *La Revue du Tarn*. Albi (1972) pp. 251–77.

Sadoul, Robert and Aline Séré de Rivières. 'Mon cousin Henri.' Radio interview, Radio Nice, 1964, published in *Spécial Toulouse-Lautrec*, Musée du Petit Palais, Paris (8 October 1964) n.p.

Sagne, Jean. 'Toulouse-Lautrec photographe.' *Prestige de la photographie* 10 (October 1980) pp. 48–67.

——. 'Invitation à boire une tasse de lait.' *Gazette des Beaux-Arts* 6.110 (January–February 1988a) pp. 128–30.

——. *Toulouse-Lautrec*. Paris, 1988b.

Schaub-Koch, Emile. *Psychanalyse d'un peintre moderne: Henri de Toulouse-Lautrec.* Paris, 1935.

Schimmel, Herbert, ed. *The Letters of Henri de Toulouse-Lautrec.* Oxford, 1991. French edition, *Toulouse-Lautrec: correspondance.* Paris: Gallimard, 1992.

—— and Phillip Dennis Cate, eds. *The Henri de Toulouse-Lautrec/W. H. B. Sands Correspondence.* New York, 1983.

—— and Lucien Goldschmidt, eds. *Unpublished Correspondence of Henri de Toulouse-Lautrec.* London, 1969. Revised French edition, *Toulouse-Lautrec: Lettres, 1871–1901.* Paris, 1972.

Schmidt, Vagn. 'The Malady of Toulouse-Lautrec: case report and diagnosis.' *Papers Dedicated to Torben Geill.* Copenhagen, 1966.

——. *Vie, maladie et mort de Toulouse-Lautrec.* Paris, 1968.

Schniewind, Carl. *The Art Institute Presents Toulouse-Lautrec.* Chicago, 1949.

——. *A Sketch-book by Toulouse-Lautrec owned by the Art Institute of Chicago* (facsimile). New York, 1952.

Seitz, William C. *The Circus of Toulouse-Lautrec.* New York, 1976.

Shone, Richard. *Toulouse-Lautrec.* London, 1977.

Simon, Alfred. *Toulouse-Lautrec.* Paris, 1990.

Stuckey, C. F. *Toulouse-Lautrec: paintings.* Exhibition catalogue. Art Institute of Chicago, 1979.

Sugana, G. M. *Tout l'oeuvre peint de Toulouse-Lautrec.* Paris, 1968.

Sutton, Denys. 'Some Aspects of Toulouse-Lautrec' in *Connoisseur Year Book 1956,* pp. 71–7.

Symons, Arthur. *From Toulouse-Lautrec to Rodin.* London, 1929.

Tapié de Céleyran, Gabriel. 'Toulouse-Lautrec et ses relations médicales.' *La Chronique médicale* 12.1 (December 1922) pp. 355–8.

——. Preface to Henri de Toulouse-Lautrec and Etienne Devismes, *Cocotte.* Paris, 1953.

Thomson, Richard. *Toulouse-Lautrec.* London, 1977.

——. 'The Drinkers of Daumier, Raffaëlli and Toulouse-Lautrec: preliminary observations on a motif.' *Oxford Art Journal* 2 (April 1979) pp. 29–33.

——. 'Toulouse-Lautrec: drawings from 7 to 18 years' in Sheila Paine (ed.) *Six Children Draw.* London, 1981, pp. 38–48.

——. 'Toulouse-Lautrec and Sculpture.' *Gazette des Beaux-Arts* 6.103 (February 1984) pp. 25–8.

——. 'The Imagery of Toulouse-Lautrec's Prints' in Wolfgang Wittrock, *Toulouse-Lautrec: the complete prints,* vol. I. London, 1985.

——. 'Toulouse-Lautrec: poster designer' in Georgia Fogg and Louise Berg (eds.) *Art at Auction.* London, 1986.

——. 'Toulouse-Lautrec in Germany and Switzerland.' *The Burlington Magazine* 129.1014 (September 1987) pp. 619–21.

——. 'Lautrec contre *Lautrec.' Combas et Toulouse-Lautrec.* Exhibition catalogue. Musée Toulouse-Lautrec, Albi/Centre Cultural de l'Albigeois, July–September 1990, pp. 7–17.

——, Claire Frèches-Thory, Anne Roquebert and Danièle Devynck. *Toulouse-Lautrec.* New Haven/London: Yale University Press, 1991.

Toulouse-Lautrec, Henri (de). *Submersion: suite de 49 dessins humoristiques et inedités à la plume.* Preface by Curnonsky [Maurice Sailland]. Paris: Knoedler, 1938.

——. *The Circus: thirty-nine crayon drawings in color.* New York: Paris Book Center, 1952a.

——. *Elles.* Preface by Jean Vallery Radot. Text and notes by Jean Adhémar. Monte Carlo: André Sauret (Edition du Livre), 1952b.

——. and Maurice Joyant. *L'Art de la Cuisine*, Lausanne, 1966. Republication of *La Cuisine de Monsieur Momo, célibataire,* Paris, 1930.

Toulouse-Lautrec, Raymond (de). 'Henri de Toulouse-Lautrec aurait 100 ans.' *Revue des Deux Mondes* (15 June 1964) pp. 525–34.

Toulouse-Lautrec, Paintings, Drawings, Posters. Exhibition catalogue. M. Knoedler and Co. New York, 1937.

Toulouse-Lautrec et son milieu familial. Exhibition catalogue. Musée, Rennes, 1963.

Toussaint, Frantz. *Sentiments Distingués.* Paris, 1945.

——. 'Le Templier.' *Candide* (10 February 1943) pp. 235ff.

'Un Cahier Inédit de Toulouse-Lautrec.' *L'Amour de l'Art* Paris (April 1931).

Valbel, Horace. *Les Chansonniers et les Cabarets Artistiques.* Paris: E. Dentu, n.d.

Vallery-Radot, Pierre. 'La Médecine et les médecins dans les oeuvres de Toulouse-Lautrec.' *La Presse médicale* 48 (14 July 1951) pp. 1021–2.

Van Gogh, Vincent. *The Complete Letters of Vincent Van Gogh.* Three vols. Second edition. Boston, 1978.

Vignaud, B. (du) and A. du Vignaud. *Drawings and watercolours by Toulouse-Lautrec.* Exhibition catalogue. Gallery of the French Embassy. New York, 1985.

Vignaud de Villefort, Jacqueline (du). *Autour de Toulouse-Lautrec, sa famille, ses amis.* Albi, 1978.

'Vingt photographies d'estampes japonaises érotiques, lot ayant appartenu à Henri de Toulouse-Lautrec.' [Paul Guibert] Gift edition, Cabinet des Estampes, Bibliothèque Nationale, Paris.

Visani, M. C. *Toulouse-Lautrec.* Tr. D. Fort. Paris, 1970.

Vuillard, Edouard. 'Lautrec raconté par Vuillard.' *L'Amour de l'Art* 4 (April 1931) pp. 141–2.

Warnod, André. *Les Peintres de Montmartre: Gavarni, Toulouse-Lautrec, Utrillo.* Paris, 1928.

Wittrock, Wolfgang. *Toulouse-Lautrec: the complete prints.* Two vols. London, 1985.

——— and R. Castleman, eds. *Henri de Toulouse-Lautrec: images of the 1890s.* Exhibition catalogue. Museum of Modern Art, New York, 1985.

GENERAL

Abelès, Luce. *Les Incohérents.* Paris: Dossier of the Musée d'Orsay, 1992.

Adler, Laure. *La Vie quotidienne dans les maisons closes, 1830–1930.* Paris, 1990.

Alexandre, Arsène. *L'Art du rire et de la caricature.* Paris, 1892a.

———. 'La vie de Paris: l'art de la Loïe Fuller.' *Le Figaro* (17 October 1901).

———. *Jean-François Raffaëlli.* Paris, 1909.

———. 'Degas, nouveaux aperçus.' *L'Art et les artistes.* 29.154 (February 1935) pp. 145–73.

Anquetin, Louis. *De l'Art.* Ed. Camille Versini. Paris, 1970.

Antoine, Jules. 'Exposition du Cercle Volney.' *La Plume* 44 (15 February 1891) pp. 77–8.

Arwas, V. *Belle Epoque: posters and graphics.* London, 1978.

Auriant, A. 'Souvenirs sur Emile Bernard.' *Maintenant* 7 (1947) pp. 124–67.

A[urier], G.-Albert. 'Choses d'art.' *Mercure de France* 4.26 (February 1892) pp. 186–7.

Avril, Jane. 'Mes Mémoires.' *Paris-Midi* (7–26 August 1933) p. 2c.

Baedeker, K. *Le Midi de la France.* Paris, 1892.

Benjamin, Walter. 'Paris: capital of the nineteenth century' in Peter Demetz (ed.) *Reflections.* New York: Harcourt Brace Jovanovich, 1978.

Bernard, Emile. 'Souvenirs sur Van Gogh.' *L'Amour de l'Art* 5 (December 1924) pp. 393–400.

———. 'Louis Anquetin, artiste peintre.' *Mercure de France* 239 (1 November 1932) pp. 590–607.

———. 'Louis Anquetin.' *Gazette des Beaux-Arts* 6.11 (February 1934) pp. 108–21.

Bernard, Tristan. 'Du Symbole dans la Chanson de Café-concert.' *La Revue blanche* 1 (October 1891) pp. 48–53.

———. 'Le Salon du Chasseur de Chevelures.' *La Revue blanche* 6 (June 1894) pp. 557–84.

Bernheimer, Charles. *Figures of Ill-Repute: representing prostitution in nineteenth-century France.* Cambridge (Mass.), 1989.

Bernier, Georges. *Paris Cafés: their role in the birth of modern art.* Exhibition catalogue. Wildenstein Galleries. New York, 1985.

———. *La Revue blanche: ses amis, ses artistes.* Paris: Hazan, 1991.

Besombes, Albert, Gilbert Boyer, Martine Boyer, Jacques Estadieu, Christian Fournier, François Moral and Jean Roques. *D'Eau et de feu: le saut de Sabo et les hommes.* Albi, 1979.

Billy, André. *La Vie des Frères Goncourt.* Three vols. Monaco, 1956.

Birkett, J. *The Sons of the Fathers: decadence in France, 1870–1914.* London, 1986.

Blanche, Jacques-Emile. 'Les Objets d'art: 1. au Salon du Champ-de-Mars.' *La Revue blanche* 8 (15 May 1895) pp. 463–7.

Bloch, L. and Sagari. *Paris qui danse.* Paris, n.d. [c. 1890].

Block, J. *Les XX and Belgian Avant Gardism, 1868–1894.* Ann Arbor (Michigan), 1984.

Bodin, Thierry. *Les Autographes.* Bulletin d'Automne, Nice, 1979.

Boime, A. *The Academy and French Painting in the Nineteenth Century.* New York, 1971.

Bonnetain, Emile. *Mon Petit homme.* Brussels, 1885.

Bouchot, Henri. *La Lithographie.* Paris, 1895.

Bruant, Aristide. *Dans la Rue.* Paris, 1889.

——. *L'Argot au XXe siècle: dictionnaire français-argot.* Second edition with supplement. Paris, 1905.

Caradec, François and Alain Weill. *Le Café-concert.* Paris, 1980.

Carco, Francis. *L'Ami des peintres.* Geneva, 1944.

——. *La Belle Epoque au temps de Bruant.* Paris, 1946.

——. *Nostalgie de Paris.* Geneva, 1945.

Carel, André. *Les Brasseries à femmes à Paris.* Paris, 1984.

Cate, Phillip Dennis, ed. *The Graphic Arts and French Society, 1871–1914.* New Brunswick (N.J.), 1988.

Chadourne, André. *Les Cafés-concerts.* Paris, 1889.

Champion, Jeanne. *Suzanne Valadon, ou la recherche de la vérité.* Paris: Livre de Poche, 1984.

Chartrain-Hebbelinck, M.-J., ed. 'Les Lettres de van Rysselberghe à Octave Maus.' *Bulletin des Musées Royaux des Beaux-Arts de Bruxelles* 1:2 (1966) pp. 55–112, 119–30.

'Choses et autres.' *La Vie parisienne* (5 October 1878) p. 581.

Christophe, Jules. 'L'Exposition des Artistes indépendants.' *Journal des artistes* (29 September 1889) pp. 304–6.

——. 'Lugné-Poë.' *La Plume* 112 (15 December 1893) pp. 530–1.

Clarétie, Jules. 'Les Fous' (c. 31 March 1899). *Journal d'un Parisien.* Paris [c. 1899].

Clark, T. J. *The Painting of Modern Life: Paris in the art of Manet and his followers.* London, 1985.

The Color Revolution: colour lithography in France, 1890–1900. Exhibition catalogue,

Rutgers University Art Gallery, New Brunswick, September–October 1978.

Coolus, Romain. 'Notes Dramatiques: petites réclames.' *La Revue blanche* 8 (1 February 1895) pp. 139–40.

Cooper, Douglas. *Paul Gauguin: 45 Lettres à Vincent, Théo et Jo Van Gogh.* Amsterdam: Staatsuitgeverij, 1983.

Copelman, L. S. and Liliane Copelman-Fromant. 'Les Portraits psychiatriques dans le miroir des beaux-arts.' *Psychiatry and Art* 3 (1971) pp. 25–32.

Coquiot, Gustave. *Les Cafés-concerts.* Paris, 1896.

Crespelle, J.-P. *Les Maîtres de la belle époque.* Paris, 1966.

Darragon, Eric. 'Pégase à Fernando: à propos de Cirque et du réalisme de Seurat en 1891.' *La Revue de l'art* 86 (1989) pp. 44–57.

Darzens, Rodolphe. *Nuits à Paris.* Paris, 1889.

Daulte, F. 'Plus vrai que nature.' *L'Oeil* 70 (October 1960) pp. 48–55.

Davis, Richard Harding. *About Paris.* New York: Harper, 1895.

Dayot, Armand. 'La Vie artistique: les artistes indépendants.' *Le Figaro illustré* 37 (April 1893) pp. xiv–xv.

Delvau, Alfred. *Dictionnaire de la langue verte.* New edition. Paris, 1883.

Demolder, Eugène. 'Les XX à Bruxelles.' *L'Artiste* 4 (March 1892) pp. 225–9.

Destremau, Frédérique. *Anquetin: la passion d'être peintre.* Paris: Brame et Lorenceau, 1991.

Didier, Robert. *Péan.* Paris: Maloine, 1948.

Donations Claude Roger-Marx. Exhibition catalogue. Cabinet des Dessins, Musée du Louvre, Paris, November 1980–April 1981.

Drimmer, Frederick. *Very Special People.* New York, 1973.

Dujardin, Edouard. 'Aux XX et aux Indépendants: le cloisonnisme.' *La Revue indépendante* 6.17 (March 1888) pp. 487–92.

Duranty, Edmond. *La Nouvelle peinture à propos du groupe des artistes qui expose dans les galeries de Durand-Ruel.* Paris, 1876.

Duthuit, Georges. 'Mort et transfigurations de la Goulue.' *L'Amour de l'Art.* Paris (Année 10, 1929) pp. 146–8.

Ellmann, Richard. *Oscar Wilde.* New York, 1988.

Emile Bernard, 1868–1941: the theme of bordellos and prostitutes in turn-of-the-century French art. Exhibition catalogue. Jane Voorhees Zimmerli Art Museum, Rutgers University. New Brunswick (N.J.), April–May 1988.

Enault, Louis. *Paris – Salon 1886.* Paris, 1886.

Fénéon, Félix. *Oeuvres plus que complètes.* Ed. J. U. Halperin. Two vols. Geneva, 1970, in which the following are cited:

——. 'Calendrier de Décembre 1887: cirques, théâtres politique.' *Revue indépendante* (January 1888). In II, pp. 720–1.

——. '5e. Exposition de la Société des Artistes Indépendants.' *La Vogue* (September 1889). In I, pp. 168–9.

——. 'Au Pavillon de la Ville de Paris. Société des Artistes Indépendants.' *Le Chat Noir* (2 April 1892). In I, 21–3.

——. 'Peintures, Henri de Toulouse-Lautrec et Charles Maurin.' *L'En dehors* (12 February 1893). In I, p. 217.

——. 'Balade chez les Artistes indépendants.' *Le Père peinard* (16 April 1893a). In I, pp. 222–8.

——. 'Les Peintres-Graveurs: 5e. Exposition – Galeries Durand-Ruel (7–28 April 1893b).' *Le Chat Noir* (22 April 1893). In I, pp. 220–1.

——. 'Chez les Barbouilleurs: les affiches en couleurs.' *Le Père peinard* (30 April 1893c). In I, pp. 229–3.

——. 'Périodiques.' *La Revue libertaire* (1 February 1894). In II, p. 938.

Fiedler, Leslie. *Freaks: myths and images of the secret self.* New York: Simon and Schuster, 1979.

Flaubert, Gustave. *Dictionary of Accepted Ideas.* Tr., introduction and notes by Jacques Barzun. New York: New Directions, 1954.

Fossier, Françoise, Françoise Heilbrun and Philippe Néagu. *Henri Rivière graveur et photographe.* Paris: Les Dossiers du Musée d'Orsay No. 3, 1988.

From Manet to Toulouse-Lautrec: French lithographs, 1860–1900. London: British Museum, 1978.

Frèches-Thory, Claire and Antoine Terrasse. *Les Nabis.* Paris/London, 1990.

Fuller, Loïe. *Quinze ans de ma vie.* Paris, 1908.

Gauthier-Villars, Henri. 'Le Salon des Indépendants.' *La Revue indépendante* (19 April 1891) pp. 106–13.

Geffroy, Gustave. 'Chronique d'art: Indépendants.' *La Revue d'aujourd'hui* 1–14 (1890) pp. 267–70.

——. 'Les Indépendants.' *La Justice* (29 March 1892) n.p.

——. *Claude Monet.* Paris, 1922.

Georges-Michel, Michel. *De Renoir à Picasso: les peintres que j'ai connus.* Paris, 1954.

Gold, Arthur and Robert Fizdale. *Misia: the life of Misia Sert.* New York/Paris, 1981.

Goldwater, Robert. *Symbolism.* New York, 1979.

Goncourt, Edmond (de). *La Fille Elisa.* Paris, 1879.

—— and Jules de Goncourt. *Journal: Mémoires de la vie littéraire.* Ed. R. Ricatte. Twenty-two vols. Monaco, 1956.

Gronberg, Theresa Ann. 'Femmes de brasserie.' *Art History* 7.3 (September 1984) pp. 329–44.

Grunfeld, Frederic V. *Rodin: a biography.* New York, 1987.

Guide des Plaisirs à Paris (edition photographique). Paris, 1900.

Guilbert, Yvette. *La Chanson de ma vie: mes mémoires.* Paris, 1927.

—— and Harold Simpson. *Yvette Guilbert: struggles and victories.* London: Mills and Boon Ltd., 1910.

Guinon, Albert. 'Bals masqués.' *Paris illustré* 10 (10 March 1888) pp. 149–51.

Halévy, Ludovic. *La Belle Hélène: épitre à mon vieil ami Paul Duport.* Paris, 1865.

Halperin, Joan U. *Félix Fénéon: aesthete and anarchist in fin-de-siècle Paris.* New Haven/London, 1988.

Hansen, E. C. *Disaffection and Decadence: a crisis in French intellectual thought.* Ann Arbor (Michigan), 1983.

Hanska, Eve. *La Romance de La Goulue.* Paris, 1989.

Harrison, T. R., Raymond D. Adams, Ivan L. Bennett, William H. Resnik, George W. Thorn, M. M. Wintrobe, eds. *Principles of Internal Medicine*, revised edition. New York, 1966.

Hartrick, A. S. *A Painter's Pilgrimage through Fifty Years.* Cambridge, 1939.

Hemmings, F. W. J. *Emile Zola.* Second edition. Oxford, 1966.

Henderson, John A. *The First Avant-Garde (1887–1894): sources of the modern French theatre.* London, 1971.

Herbert, E. W. *The Artist and Social Reform: France and Belgium, 1885–1898.* New Haven (Conn.), 1961.

Herbert, Michel. *La Chanson de Montmartre.* Paris, 1967.

Herbert, Robert L. *Impressionism: art, leisure and Parisian society.* London/New Haven, 1988.

—— and E. Herbert. 'Artists and Anarchism.' *The Burlington Magazine* 102 (1960) pp. 472–82, 517–22.

Holt, Elizabeth Gilmore. *A Documentary History of Art, III. From the classicists to the Impressionists: art and architecture in the 19th century.* New York, 1966.

'Homodei' [Arthur Huc]. 'Nos expositions: les oeuvres.' *La Dépêche de Toulouse* (21 May 1894) n.p.

Impressionist and Post-Impressionist Masterpieces: the Courtauld Collection. Washington (D.C.): International Museums Foundation, 1987.

Ives, Colta. *The Great Wave: the influence of Japanese woodcuts on French prints.* New York: Metropolitan Museum of Art, 1974.

——. *French Prints in the Era of Impressionism and Symbolism.* New York, 1988.

Jamison, Kay R. *Touched with Fire: manic-depressive illness and the artistic temperament.* New York, 1993.

Japonisme. Paris: Musée Nationale de l'Art Moderne, 1988.

Jasper, Gertrude R. *Adventure in the Theatre: Lugné-Poë and the Théâtre de l'Oeuvre*. Brunswick (N.J.), 1947.

Johnson, Lincoln F., Jr. 'The Light and Shape of Loïe Fuller.' *Baltimore Museum of Art News* 20.1 (1956) pp. 9–16.

Jourdain, Francis. *Né en '76* . Paris, 1951.

Joze, Victor (pseud. of Joze Dobrski de Jastzebiec). *Mon Album: les petites démascarades*. Paris, 1889.

——. *Reine de joie, moeurs du demi-monde*. Paris, 1892.

——. *Paris-Gomorrhe*. Paris, 1894.

——. *Les Rozenfeld: histoire d'une famille juive sous la 3e république*. Three vols. Paris, 1897.

Juilland, Philippe. *Montmartre*. Tr. A. Carter. New York, 1977.

—— and Diana Vreeland. *La Belle Epoque*. New York, 1982.

Kermode, Frank. 'Loie Fuller and the Dance before Diaghilev.' *Theatre Arts Magazine* (September 1962) pp. 6–23.

Kleeblatt, Norman L., ed. *The Dreyfus Affair: art, truth and justice*. Exhibition catalogue [New York Jewish Museum]. Berkeley, Los Angeles and London, 1987.

Knapp, Bettina and Myra Chipman. *That Was Yvette: the biography of Yvette Guilbert, the great diseuse*. New York: Holt, Rinehart and Winston, 1964.

L'Affichomanie. Collectionneurs d'affiches: affiches de collection, 1880–1900. Paris: Musée de l'Affiche, 1980.

Lambotte, P. *Evenepoel*. Brussels, 1908.

Lebensztejn, Jean-Claude. *Chahut*. Paris, 1989.

Le Livre des Expositions Universelles. Paris: Edition des Arts Décoratifs, 1983.

Lemaître, Jules. *Impressions de Théâtre*, vol. 9. Paris, 1896.

'Les Indépendants.' *L'Art français* 155 (12 April 1890) p. 4.

Les Maîtres de l'Affiche, 1896–1900: reproduction intégrale de la collection originale. Ed. Alain Weill and Jack Rennert. Preface by Roger Marx. Paris, 1977. London, 1978.

'Les Théâtres de Paris, 1890.' *Le Figaro illustré* 11.39 (1890).

'Les Théâtres de Paris, 1893–4.' *Le Figaro illustré* 11.42 (September 1893) n.p.

Levin, Miriam R. *Republican Art and Ideology in Late Nineteenth Century France*. Ann Arbor (Michigan), 1986.

Lipton, Eunice. 'The Laundress in Late 19th-Century French Culture: imagery, ideology and Edgar Degas.' *Art History* 3.3 (September 1980) pp. 295–313.

——. *Alias Olympia*. New York: Charles Scribner's Sons, 1993.

Loïe Fuller: magician of light. Exhibition catalogue. Virginia Museum. Richmond, March–April 1979.

Lorrain, Jean. *Poussières de Paris*. Paris, 1899. Republished Paris, 1902.

——. *Femmes de 1900*. Paris, 1932.

Lot, Fernand, *Alfred Jarry*. Paris, 1934.

Lugné-Poë, Aurélien. *La Parade*. Four vols. Paris, 1931–46.

Maindron, Ernest. 'L'Affiche illustrée.' *La Plume* 110 (15 November 1893) pp. 474–80.

——. 'La Publicité sculpturale.' *La Plume* 115 (1 February 1894) pp. 41–2.

——. *Les Affiches illustrées, 1886–1895*. Two vols. Paris, 1896.

Mannheim, Städtische Kunsthalle. *Emile Bernard, 1868–1941*. May–August 1990.

Marx, Roger. 'Les Indépendants.' *Le Voltaire* (28 March 1893).

Maus, Madeleine-Octave. *Trente Années de lutte pour l'art, 1884–1914*. Brussels, 1926.

'M.C.' 'Quatrième Exposition des Peintres impressionnistes et symbolistes.' *L'Art littéraire* 5 (April 1894) p. 19.

Melikian, Souren. 'Nabis and a Serious Spoof.' *International Herald Tribune* (23–4 June 1990) p. 7.

Mellerio, André. *Le Mouvement idéaliste en peinture*. Paris, 1896.

——. *La Lithographie originale en couleurs*. Paris, 1899.

Meredith, Stephen C.; Michael A. Simon, M.D.; Gerald S. Lavos, M.D.; Marsha A. Jackson, B.A. 'Pycnodysostosis: a clinical, pathological and ultramicroscopic study of a case.' *Journal of Bone and Joint Surgery*, Vol. 60-A, No. 8 (December 1978) pp. 1122–30.

Merlin, Olivier. *Tristan Bernard ou le temps de vivre*. Paris: Calmann-Lévy, 1989.

Métenier, Oscar. 'Aristide Bruant.' *La Plume* 43 (1 February 1891a) pp. 39–42.

——. *La Lutte pour l'amour: etudes d'argot*. Paris, 1891b.

Michlet, Emile. 'L'Eté à Paris.' *Paris illustré* 27 (7 July 1888) pp. 425–7.

Milès, Roger. 'Beaux-Arts, Cinquième Exposition de la Société des Artistes Indépendantes.' *L'Evénement* (4 September 1889) n.p.

Mirbeau, Octave. 'Vincent Van Gogh.' *L'Echo de Paris* (31 March 1891) n.p.

Montorgueuil, Georges. *Paris dansant*. Paris, 1898.

Mouloudji, M. *Aristide Bruant*. Paris, 1972.

Natanson, Thadée. 'Art Nouveau.' *La Revue blanche*. 10.64 (February 1894) pp. 116–17.

——. *Peints à leur tour*. Paris, 1948.

Nimal, H. (de). 'Antipriapée.' *La Plume* 103 (1 August 1893) p. 342.

Nochlin, Linda. 'A House is not a Home' in Richard Kendall and Griselda Pollock (eds.) *Dealing with Degas: representations of women and the politics of vision*. London: Pandora, 1992.

Oberthur, Mariel. *Cafés and Cabarets of Montmartre*. Salt Lake City, 1984.

Paradise, Jo Anne. *Gustave Geffroy and the Criticism of Painting*. New York, 1985.

Patrick, Emmanuel. 'Les Bals de Paris.' *Le Courrier français* (11 January 1885) p. 3.

——. 'Les Bals de Paris: Le Jardin de Paris.' *Le Courrier français* (28 February 1886a) p. 6.

——. 'La Boule-Noire.' *Le Courrier français* (12 September 1886b) p. 7.

Pennell, E. R. *Nights*. New York, 1916.

Pissarro, Camille. Unpublished journals. Institut de France, Paris.

——. *Lettres à son fils Lucien*. Ed. John Rewald. Paris, 1950.

——. *Correspondance de Camille Pissarro*. Ed. Janine Bailly-Herzberg. Four vols. II 1886–90, Paris, 1986. III 1891–4, Paris, 1988. IV 1895–8, Paris, 1990.

Pougy, Liane (de) [M. C. Ghika]. *Mes Cahiers bleus*. Paris, 1977. English edition, *My Blue Notebooks*. Tr. Diana Athill. London, 1977.

R[ambosson], Y[vanhoé]. '3ème Exposition des Peintres Impressionistes et Symbolistes.' *La Plume* 88 (15 December 1892) pp. 531–2.

Rearick, Charles. *Pleasures of the Belle Epoque: entertainment and festivity in turn-of-the-century France*. New Haven/London, 1985.

Rebell, Hugues [Georges Grassal]. *La Câlineuse*. Paris, 1899.

Renard, Jules. *Journal, 1887–1910*. Ed. L. Guichard and G. Sigaux. Paris, 1960. New edition, two vols., Paris, 1984.

Renoir, Jean. *Renoir, My Father*. Tr. Randolph and Dorothy Weaver. Boston, Toronto, 1958, 1962.

Rewald, John. *Post-Impressionism: from Van Gogh to Gauguin*. New York, 1956. Paris, 1961.

——. *The History of Impressionism*. Fourth revised edition. New York, 1973.

——. 'Théo Van Gogh, Goupil and the Impressionists.' *Gazette des Beaux-Arts* 76.6 (January 1973) pp. 1–4; (February 1973) pp. 63–108. Reprinted in *Studies in Post-Impressionism*. London, 1986.

Richardson, J. *The Bohemians: la vie de bohème in Paris, 1830–1914*. New York, 1971.

Roberts-Jones, Philippe. *La Presse satirique illustrée entre 1860 et 1890*. Paris, 1956.

——. 'Les "Incohérents" et leurs expositions.' *Gazette des Beaux-Arts* 6.1007 (October 1958) pp. 231–6.

——. *De Daumier à Lautrec: essai sur l'histoire de la caricature française entre 1860 et 1890*. Paris, 1960.

Roques, Jules. 'L'Elysée-Montmartre.' *Le Courrier français* (20 June 1886) p. 6.

——. 'A l'Elysée-Montmartre.' *Le Courrier français* (13 November 1887) p. 4.

——. 'A l'Elysée-Montmartre.' *Le Courrier français* (13 January 1889) p. 4.

Rosen, C. and H. Zerner. *Romanticism and Realism: the mythology of nineteenth-century art*. New York, 1984.

Rothenstein, William. *Men and Memories*. Two vols. London, 1931–2.

Rubin, William. 'Shadows, Pantomimes and the Art of the Fin-de-siècle.' *Magazine of Art* 46.3 (March 1953) pp. 114–33.

——. *Shadow and Substance: the shadow theater of Montmartre and contemporary art.* Exhibition catalogue. Contemporary Arts Museum. Houston, Texas, 1956.

Saunier, Charles. 'Chez Boussod et Valadon, bd. Montmartre.' *La Revue indépendante* 36 (February 1893a) pp. 285–6.

——. 'Critique d'Art, Salon des Indépendants.' *La Plume* 96 (15 April 1893b) pp. 171–3.

——. 'Les Maîtres de l'Affiche.' *La Plume* 160 (15 December 1895) pp. 572–5.

Schneider, Louis. 'A Montmartre: les cabarets artistiques.' *La Revue illustrée* 256 (1 August 1896) pp. 116–21.

Schwob, Marcel. 'Lettre parisienne.' *Le Phare de la Loire* (2 May 1892) in J. Alden Green (ed.) *M. Schwob: chroniques.* Geneva, 1981, pp. 123–4.

Segal, Harold B. *Turn-of-the-Century Cabarets.* New York, 1987.

Seigel, J. *Bohemian Paris: culture, politics and boundaries of bourgeois life, 1830–1930.* New York, 1986.

Sert, Misia. *Misia par Misia.* Paris, 1952.

Shattuck, R. *The Banquet Years: the origins of the avant-garde in France, 1885 to World War I.* Revised edition. New York, 1968.

Signac, Paul. *D'Eugène Delacroix au Néo-Impressionnisme.* Paris, 1899. Republished 1964.

Silverman, Debora Leah. *Art Nouveau in Fin-de-Siècle France: politics, psychology and style.* Berkeley (California), 1989.

Sisson, Thiébault. 'Petits Salons.' *Le Temps* (4 February 1893) n.p.

Smith, F. Berkeley. *How Paris Amuses Itself.* New York/London, 1903.

Staley, A., et al. *From Realism to Symbolism: Whistler and his world.* Exhibition catalogue. Wildenstein Galleries. New York, 1971.

Stars et monstres sacrés. Exhibition catalogue. Musée d'Orsay. Paris, December 1986–March 1987.

Stein, Donna and Donald Karshan. *L'Estampe originale: a catalogue raisonné.* New York: Museum of Graphic Art, 1970.

Stone, Irving. *Depths of Glory.* New York, 1985.

Storm, John. *The Valadon Drama: the life of Suzanne Valadon.* New York, 1959.

Symons, Arthur. *Colour Studies in Paris.* London, 1918.

——. 'The History of the Moulin Rouge.' *English Review* 34 (1922) pp. 5–12.

——. *Confessions of a Study in Pathology.* Privately printed (542 copies), London, 1930.

——. *Poetry and Prose.* Ed. R. Holdsworth. Manchester, 1974.

Thomson, Belinda. *Vuillard.* Oxford, 1988.

Thomson, Richard. 'Les Quat' Pattes: the image of the dog in late nineteenth century

French art.' *Art History* 5.3 (September 1982) pp. 323–37.

——. *Seurat.* Oxford, 1985.

——. *Degas: the nudes.* London, 1988.

——. Takashimaya, Tokyo. *The Impressionists and Post-Impressionists, from the Courtauld Collection.* Exhibition catalogue. University of London. January–May 1984.

Thurman, Judith. *Isaac Dinesen.* New York, 1982.

Van Rysselberghe, Théo. 'Lettres à Octave Maus.' *Bulletin des Musées Royaux des Beaux Arts de Belgique* 15 (1966) p. 67.

Vaucaire, Marius. *Effets de théâtre: la scène et la salle, le ballet, cafés chantants, à la foire.* Paris, 1886.

——. 'Les Cafés-concerts.' *Paris illustré* 50 (August 1886) pp. 130–8.

Verhaeren, Emile. 'L'Exposition des XX à Bruxelles.' *La Revue indépendante* 6 (March 1888) pp. 454–62.

Verhagen, Marcus. 'Seurat's *Le Cirque* comme baromètre de la gaité publique.' Unpublished paper, 1990. (Available from the author: 14, Cité d'Alésia, 75014, Paris, France.)

Virmaître, Charles. *Paris-galant.* Paris, 1890.

——. *Trottoirs et lupanars.* Paris, 1893.

Vuillard, Edouard. 'Souvenirs du peintre.' Unpublished journals, 1890–1905. Institut de France, Paris.

Warnod, A. *Bals, cafés et cabarets.* Fifth edition. Paris, 1913.

——. *Le Vieux Montmartre.* Paris, 1913.

——. *Les Bals de Paris.* Paris, 1922.

Warnod, Jeanine. *Suzanne Valadon.* Tr. Shirley Jennings. New York, 1981.

Weber, Eugen. *France: fin-de-siècle.* Cambridge (Mass.), 1986.

——. *Peasants into Frenchmen: the modernization of rural France, 1870–1914.* Stanford, 1976.

Welsh-Ovcharov, Bogomila. *Vincent Van Gogh in Perspective.* Englewood (N.J.), 1974.

——. *Vincent Van Gogh: his Paris period, 1886–1888.* The Hague, 1976.

——. *Vincent Van Gogh and the Birth of Cloisonism.* Exhibition Catalogue. Art Gallery of Ontario. Toronto, 1981.

——. *Vincent Van Gogh à Paris.* Exhibition Catalogue. Musée d'Orsay. Paris, 1988.

Wittkonen, Rudolf and Margot. *Born Under Saturn. The Character and Conduct of Artists: a documented history from antiquity to the French Revolution.* London: Weidenfeld and Nicolson, 1963.

Zeldin, Theodore. *France, 1848–1945.* Two volumes. Oxford, 1973, 1980.

Zevaès, Alexandre. *Aristide Bruant.* Paris, 1943.

Zola, Emile. *Oeuvres complètes.* Ed. H. Mitterand. Paris, 1967.

KEY TO THE NOTES

NOTE ON TRANSLATIONS

In general, quotations marked 'Letter' are from *The Letters of Henri de Toulouse-Lautrec*, ed. Herbert Schimmel, Oxford, 1991.

Letters translated by the author are marked (tr. Frey) and are from Toulouse-Lautrec, *Correspondance*, ed. Herbert Schimmel, Paris, 1992.

WORKS BY TOULOUSE-LAUTREC

The identification numbers are from Wittrock 1985 (P – Poster; no prefix for lithograph) or from Dortu 1971 as follows: A (Aquarelle) Watercolour, C (Céramique) Ceramic; D (Dessin) Drawing; P (Peinture) Painting. Dortu Ic. refers to the Iconography of works and documents by others on the subject of Toulouse-Lautrec, to be found in the first volume of Dortu 1971.

PRINCIPAL SOURCES CITED	*cited as*
Autograph Letter Signed	ALS
Autograph Note	AN

In three main sources:

Unpublished letters in the Carlton Lake Collection of the Harry Ransom Humanities Research Center of the University of Texas, Austin, Texas	ALS (Carlton Lake)
Unpublished letters in the collection of Nicole Tapié de Céleyran, Château du Bosc, near Naucelles (Aveyron), France	ALS (Le Bosc)
Unpublished letters in the collection formerly owned by Herbert D. Schimmel, New York	ALS (Schimmel)

All are used with the permission of the owners. Other sources are individually noted.

PRINCIPAL INDIVIDUALS CITED	
Henri de Toulouse-Lautrec	HTL
Adèle de Toulouse-Lautrec	AdTL
Alphonse de Toulouse-Lautrec	ApTL
Gabrielle de Toulouse-Lautrec	GTL
Louise Tapié de Céleyran	LTC
Alix Tapié de Céleyran	ATC

NOTES AND SOURCES

CHAPTER ONE: THE CRISIS

(pp. 1–9)

1: dinner with his mother: Letter IV 1 (tr. Frey).

1: number 15, number 5: Henry's studio was at number 15 and his apartment at number 5. See Letter 441. But in 1899, he appears to have lived in his studio, whether or not he was still renting the apartment. There are receipts for 1899 confirming the studio rent but none for the apartment (see ALS Schimmel collection documents).

1: burn: Letters IV 4, 5.

1–2: Vuillard portrait: *Standing Portrait of Toulouse-Lautrec* (1898), Musée Toulouse-Lautrec, Albi, France (hereafter referred to as the Musée d'Albi).

2: wearing layers: Letter IV 4.

2: imagined protection: Christopher Hewitt, in a personal communication, attributes such behaviour to paranoia induced by alcoholic delirium.

2: knock-kneed legs: Pierre Devoisins, p. 55.

2: his button-hook: Natanson 1951b, p. 17.

3: quick to reflect: Coquiot 1921, p. 28.

3–4: her special 'burden': ALS (Carlton Lake) AdTL to ATC, 20 May 1878.

4: 'at the extreme limit . . .': Vignaud de Villefort, p. 12.

5: watched and drank every evening: Joyant 1926, I, p. 149.

6: emotional and social support: ALS (Carlton Lake) AdTL to LTC, 21 March 1882.

6: 'I long . . . old bachelors': Letter 488.

6: *J'ai deux vies*: Attems 1975, p. 266–7.

6: *'pauv' sainte femme de mère'*: Natanson 1951b, p. 13.

6: His correspondence . . . carriages: See for example Letters 14, 486.

6: over-decorated salons: Leclercq 1958, p. 85 and Letter IV 21.

6–7: The studio: For contemporary descriptions of Henry's studio see Natanson 1951b, p. 130; Alexandre 1902, pp. 15–19; Robert de Montcabrier cited in Beaute 1964, p. 179; Gauzi 1954a, p. 94.

6–7: A friend . . . eiderdown: Gauzi 1954a, pp. 66ff.

7: dripping moustache: Natanson 1951b, p. 131.

7: dress up in costumes: See photographs in Sagne 1980 and Beaute 1988 showing Henry and others. A French art dealer, improbably, has tentatively identified one room, from the decor, as the painter Gérôme's studio.

7: hollow cane: A hollow cane which is said to have been used by Henry was donated by the French writer and gastronome Curnonsky (pseudonym of Maurice Sailland) to the Musée

d'Albi, where it is on permanent display. This cane is of normal size, measuring nearly three feet long. Henry himself was only just under five feet tall and could not have used a cane which came to his breastbone.

7: Père François' bar: Letter IV 14.

8: 'rare state ... no ideas': Letter 493.

8: 'A thousand ... hour': Letter 519 (April 1898) (tr. Frey).

8: as usual ... dinner: See for example Letter 488.

8: buttocks: Letter 46.

8: She told ... her trip: ALS (Schimmel) ATC to AdTL [c. 7 January 1899].

8–9: 'I told him ... a word': Letter IV 1.

CHAPTER TWO: HENRI MARIE-RAYMOND MONTFA, VICOMTE DE TOULOUSE-
LAUTREC
(pp. 10–43)

10: built into the ramparts: The original address of the Hôtel du Bosc – 14, rue de l'Ecole Mage – is now 14, rue Toulouse-Lautrec.

10: sheets of rain ... bedrooms: Such a storm was personally observed by the author at the Hôtel du Bosc, on 15 August 1983.

10: though not a very big one: ALS (Carlton Lake) ATL to LTC, 22 February 1865.

11: Papal dispensation: Until a general codification in 1917, a wide variety of marital practices existed in different Catholic dioceses. Information on the offical Catholic position on first-cousin marriage and other forbidden degrees of relationship was kindly provided by the Very Reverend J. Anthony McDaid, Judicial Vicar of the Catholic Archdiocese of Denver, Colorado, 26 January 1990.

11: His father ... Montfa: Montfa is the spelling of Lautrec's name used on his birth certificate, reproduced in Dortu 1971 I, p. 17. It was not unusual at the time for a silent 'T' in a name to be dropped in a variant spelling. Henry himself used the spelling 'Monfa' as a pseudonym. On his death announcement, the family omitted the T. It was customary for newborns to be taken in person for birth registry, to prove they were not stillborn.

11: Henry himself ... Count of Toulouse-Lautrec: See family tree, p. xv.

11: resolute non-conformist ... impossible for him: Rodat, p. 39.

12: a reputation: Mack, p. 14 and Perruchot 1958, p. 29.

12: 'not mix ... copulation': Pierre-Joseph de Toulouse-Lautrec to the Duchesse de la Trémoille *c.* 1810, quoted in Perruchot 1958, p. 28.

12: 'impetuosity of impulse': ApTL to René Princeteau, 18 September 1901, cited in Perruchot 1958, p. 29.

12: 'fruit ...'/'moral class': Rodat, p. 39.

12: 'My mother couldn't resist ...': Perruchot 1958, p. 55.

13: 'piety ... prayer': Zeldin I, p. 291.

14: martyred silence: See ALS (Carlton Lake) AdTL to LTC, [Château] du Bosc, Pentecost [1866]: *'Du reste, je garde complètement le silence ...'*

14: 'Believe me ...': Perruchot 1958, p. 24.

14: Adèle had chosen ... home in Albi: ALS (Carlton Lake) GTL to 'Chère Tante' [Joséphine], Le Bosc, Monday evening, c. 10 May 1865. Joséphine d'Imbert du Bosc was the aunt of Henry's two grandmothers. Traditionally, Joséphine lived at the Hôtel du Bosc in Albi. Gabrielle de Toulouse-Lautrec, Henry's paternal grandmother, lived at the Château du Bosc near the village

of Naucelles, in the Aveyron near Rodez. Her sister Louise lived at Céleyran, near Narbonne on the Mediterranean coast. The third sister of his grandmothers, Blanche de Gualy de Saint-Rome, lived elsewhere, but visited the other sisters regularly.

14: three and a half months: ALS (Carlton Lake) GTL to LTC, Le Bosc, 31 March 1865.

14: Alphonse left Albi: See ALS (Carlton Lake) GTL to LTC, Albi, 25 December [1864].

14: 'an enormous foot': Ibid.

14: 'should you ... a little': Perruchot 1958, p. 42.

14–15: 'Alphonse ... solution': Beaute 1988, p. 86.

15: beans ... digestion: Ibid.

15: 'My dear fellow ...': Perruchot 1958, p. 37.

15: Family legend: Raymond de Toulouse-Lautrec 1964, p. 531.

16: Another story: Toussaint 1943, p. 236.

16: a third story: Perruchot 1958, p. 28.

16: One incident ... 'in Orléans': ALS (Carlton Lake) ATL to LTC, Paris, 29 April 1881.

16: exotic costumes: Coquiot 1921, p. 9.

16: 'This is my Circassian helmet ...': Letter c. 1879. Reproduced in Beaute 1988, p. 96.

16. The family ... 'get some fresh air': Raymond de Toulouse-Lautrec 1964, pp. 526, 529.

17–18: 'graceful ... digesting nails': ALS (Carlton Lake) GTL to LTC, 16 February [1865].

18: may have been side effects: For descriptions of sinus deformations and other respiratory ailments as corollary to a variety of forms of dwarfism, see Meredith et al.

18: 'Alphonse ... turkey': AdTL (April 1865), quoted in Attems 1975, p. 216.

18: Occasionally ... wish to buy: ALS (Carlton Lake) GTL to LTC, 23 May [1865].

18: In a letter ... was very wrong: See ALS (Carlton Lake) AdTL to LTC, 23 May [1865] and Zeldin I, p. 302.

18–19: Alphonse suddenly asked ... hired a cook: ALS (Carlton Lake) ATC to LTC, 30 October [1865].

19: 'a dagger-thrust ... at Loury': ALS (Schimmel) Jeanne Solages du Bosc to GTL, 23 June 1866.

19: 'My father-in-law ... for the best': ALS (Carlton Lake) AdTL to LTC, Pentecost [April 1866].

20: sorry for herself: ALS (Carlton Lake) AdTL to GTL, 18 August 1866.

20: very rugged: See photo in Attems 1975.

20: 'receiving ladies': Attems 1975, p. 217.

20: 'He's perpetually ... language': AdTL, quoted in Attems 1975, p. 217.

20: 'Alphonse ... his father': Attems 1975, p. 223.

21: soaked from the rain: ALS (Carlton Lake) AdTL to LTC, Le Bosc, Wednesday, [c. 10 May 1865].

21: steamed dry: This detail comes from the author's personal experience of hunting on horseback in the Loire region of France.

21: That September ... every night: ALS (Carlton Lake) AdTL to GTL, c. September 1866.

21: 'living on them'/'the land of dryness': Attems 1975, p. 217.

21: 'that doesn't mean ...': ALS (Carlton Lake) AdTL to LTC, 9 September [1866].

21–2: 'A little while ago ...': ALS (Carlton Lake) AdTL to LTC, 28 December [1866].

22: 'horribly ploughed up ...': ALS (Le Bosc) AdTL to GTL, 27 September [1866].

22: 'like galantines': Attems 1975, pp. 244–5.

22: 'Dear Mama ...': Attems 1975, p. 241.

22: 'It takes ... many things': Quoted in Attems 1975, p. 231.

22–3: 'After all ...': ALS (Le Bosc) AdTL to GTL, 30 November [1866].

23: Doctors have noticed: Observations on the sensitivity of parents to handicapped infants by Owen P. (Pat) O'Meara, M.D., Chief of Pediatrics, Denver General Hospital, September 1986.

23: 'I spent ...': AdTL to GTL, [January 1867], quoted in Attems 1975, p. 219.

23: wanted a daughter: ALS (Carlton Lake) AdTL to LTC, 26 December [18]66.

23–4: 'he's not ... legibly': Ibid.

24: 'about horses': ALS (Carlton Lake) AdTL to LTC, 25 June 1865.

24–5: the Toulouse-Lautrecs: The history of the Toulouse-Lautrec ancestors comes from Raymond de Toulouse-Lautrec, pp. 525–34, unless otherwise stated. It is interesting to note that the most violent parts of the story of Raymond VI are still obfuscated in family histories, even in writing. The most recent such volume (Magné and Dizel, *Les Comtes de Toulouse et leurs descendants, les Toulouse-Lautrec*, Paris: Editions Christian, 1992) disperses the account of the hanging of Baudouin in three chapters and six footnotes, which required nearly a half hour to reassemble.

25: 'who ... writ': Pcrruchot 1958, p. 28.

25: 'Ah, Monseigneur ...': Ibid.

26: When Adèle's grandfather had died: Rodat, p. 37. Coquiot 1921, p. 6, asserts that the entire estate amounted to 1500 hectares at the end of the eighteenth century, and Magné et Dizel 1992, p. 379n., list the estate of Louise's father-in-law, Esprit-Toussaint Tapié de Céleyran (d. 1866) as consisting of 'Céleyran, planted with 1500 hectares of vineyards, and his residence, called the "Villa de César", ... the lands of Le Pech, Quarante, Ricardelle, ... Sainte Lucie ... private homes at 7 Place des Jacobins and 1 Place Guynemer in Narbonne, as well as in Béziers ... [and] Perdiguier in Maraussan.'

26: 'of [their] world': Odon de Toulouse-Lautrec to GTL, *c.* 1883, quoted in Beaute 1988, p. 107.

26: Louise was nervous: ALS (Carlton Lake) LTC to GTL, 1 August 1867.

26: 'But you don't ...': Gauzi 1954a, p. 11.

26–7: In later years ... a cow: Beaute 1988, p. 87.

27: 'He's a great sketcher ...': ALS (Schimmel) GTL to ATC, 20 November [1867].

27: Alphonse ... suggested: Ibid.

27: 'It makes ... health': ALS (Carlton Lake) AdTL to LTC, 24 November [1867].

27: 'although ... brother': Attems 1975, p. 218.

27: 'a little rowdy ...': ALS (Carlton Lake) GTL to ATC, 26 November 1867.

27: 'He is very good ...': ALS (Carlton Lake) GTL to ATC, 20 November [1867].

27: 'He refuses ...': ALS (Carlton Lake) AdTL to LTC, 24 November [1867].

28: 'Decidedly ...': ALS (Carlton Lake) GTL to ATC, 26 November [1867].

28: 'hot and cold ...': Attems 1975, p. 48.

29: 'Tapajou': Attems 1975, p. 219.

29: Gabrielle was convinced: ALS (Carlton Lake) GTL to LTC, 1 August [1865].

29: 'a temper-tantrum ...': ALS (Carlton Lake) GTL to LTC, 1 February 1865.

30: 'yelled for Germain ...': ALS (Carlton Lake) AdTL to GTL, 18 August [1866].

30: Illness was seen ... (disease): Summarized from Zeldin I, p. 304.

30: when Adèle arrived: ALS (Le Bosc) AdTL to LTC, Loury, 26 August [1868].

31: Adèle prayed for a miracle: Ibid.

31: 'The unsaid things ...': ALS (Carlton Lake) ApTL to GTL, Loury, 27 August 1868.

31: 'without complaining ...': ALS (Schimmel) AdTL to GTL-, Loury, 30 August 1868.

31: 'My poor Henry ...': Ibid.

31: Louise encouraged ... baby comments: ALS (Carlton Lake) LTC to GTL, Loury aux Bois, 6 September 1868.

32: 'the beautiful ... babies': ALS (Carlton Lake) AdTL to GTL, Loury, 20 October [1868].

32: She had dressed ... a black one: Ibid.

32: he was fascinated ... to restaurants: ALS (Carlton Lake) AdTL to LTC, Loury, 21 October [1868].

33: strongly suspected: Letter V 4.

33: In the family, it was said: Raymond de Toulouse-Lautrec 1964, p. 533.

33: 'We are digging ... *Ave*': ALS (Carlton Lake) AdTL to LTC, Loury, 16 December [1868].

33: 'He's convinced ...': ALS (Carlton Lake) AdTL to LTC, Loury, 6 November 1868.

33: 'swear like a Templar': Attems 1975, p. 52.

33: drawings of parrots: See Henry's sketchbooks, owned by the Harry Ransom Humanities Research Center at the University of Texas in Austin and the Musée d'Albi.

33: housekeep for him: ALS (Carlton Lake) AdTL to LTC, 16 December [1868].

33: assertion by the French philosopher: Alain, 'Les Sentiments familiaux', *Cahiers de la Quinzaine*, 18th series, no. 8 (1927), quoted in Zeldin II, p. 329.

33: 'The poor little thing ...': ALS (Carlton Lake) AdTL to LTC, Loury, 13 January 1869.

34: 'the life of a galley-slave ...': ALS (Carlton Lake) AdTL to LTC, Loury, Sunday, 16 January [1870].

34: 'The prospect ...': ALS (Carlton Lake) AdTL to LTC, 15 May 1867.

34: hired a cook: ALS (Schimmel) Jeanne Solages du Bosc to GTL, 20 April [1867].

35: 'I have to be careful ...': ALS (Carlton Lake) AdTL to LTC, Loury, 1 February 1870.

35: she had asked her mother: ALS (Carlton Lake) AdTL to LTC, 25 June [1865].

35: 'I thought ... impossible': ALS (Carlton Lake) AdTL to LTC, Paris, [around March 1875].

35: as a young bride: ALS (Carlton Lake) AdTL to LTC, 25 June [1865].

36: forced to appease: ALS (Carlton Lake) GTL to LTC, Céleyran, 30 May 1868.

36: 'La Gravasse': Attems 1975, pp. 55ff.

36: 'kind-hearted ...': ALS (Carlton Lake) LTC to GTL, Céleyran, 30 May 1869.

36: puppet theatre: Beaute 1988, p. 22.

36: 'You mustn't count ...': ALS (Carlton Lake) AdTL to LTC, Le Bosc, Tuesday, [summer 1869].

36: 'Madeleine ... infallible': Ibid.

37: 'Climbing back ...': Ibid.

37: Henry's great-grandmother: See Attems 1975, pp. 29, 39.

37: exceedingly polite: Raymond de Toulouse-Lautrec 1964, p. 529.

37: 'made so few ...': ALS (Carlton Lake) AdTL to LTC, Tuesday, [summer 1869].

38: 'to me it feels ...': ALS (Carlton Lake) AdTL to GTL, Paris, Monday 4 October [1869].

39: 'The woods ...': Attems 1975, p. 26.

39: revaccinated against smallpox: ALS (Carlton Lake) AdTL to LTC, Loury, Sunday, 16 February [1870].

39: 'The word concupiscence ...': ALS (Le Bosc) AdTL to LTC, Loury, 6 April 1870.

39: 'He's delighted ...': ALS (Le Bosc) AdTL to unknown correspondent, Loury, Tuesday [probably June 1870].

40: 'the advantage ...': ALS (Le Bosc) GTL to LTC, 3 August 1870.

41: 'You can imagine ...': ALS (Le Bosc) AdTL to ATC, Le Bosc, Tuesday, 6 December [1870].

41: 'The truth is ...': ALS (Le Bosc) AdTL to LTC, Le Bosc, Sunday, 18 December [1870].

41: 'we hardly have ...': ALS (Le Bosc) AdTL to LTC, Le Bosc, Thursday, 29 December 1870.

41: 'How the poor soldiers ...': Ibid.

42: That summer: ALS (Carlton Lake) AdTL to LTC, Céleyran, 30 June [1871].

42: Louise had gone ... thirty baths each: ALS (Carlton Lake) AdTL to GTL, Lamalou-[Cabanes-de-]La Nouvelle, 10 August [1871].

43: He cried: Ibid.

CHAPTER THREE: HENRY
(pp.44–86)

44: tragic accident: ALS (Schimmel) AdTL to LTC [December 1871] and Marc Tapié de Céleyran, conversation, 15 August 1983. See also Perruchot 1958, p. 33.

45: a relative wrote: ALS (Carlton Lake) AdTL to GTL, Paris, 16 June 1872.

45: 'You should see ... their results': ALS (Carlton Lake) GTL to ATC, 11 April [1867], and ALS (Schimmel) GTL to ATC, Le Bosc, 5 April [around 1870].

46: 'When my sons ... the fork': Huisman and Dortu 1964, p. 19.

46: during thunderstorms: Leclercq 1958, p. 31.

46: to travel without warning to Lyon: Robert de Montcabrier, cited in Beaute 1964, p. 124.

46: raise two lion cubs: Marc Tapié de Céleyran, conversation, 15 August 1983.

46: his father made over: ALS (Carlton Lake) AdTL to LTC, Tuesday [summer 1869].

46: 'Where Papa is ...': Perruchot 1958, p. 41.

46: 'The Count ...': Huisman and Dortu 1964, pp. 14, 17.

47: 'he is still ... gloomy': GTL [spring 1872], quoted in Huisman and Dortu 1964, p. 19.

47: colds, flus, toothaches and rashes: See for example ALS (Carlton Lake) AdTL to LTC, Albi, 11 April 1872.

48: 'If my own pleasure ...': ALS (Carlton Lake) AdTL to LTC, Paris – Hôtel Pérey, 12 May 1872.

48: 'velocipede horse': ALS (Carlton Lake) AdTL to LTC, Albi, 5 May 1872.

48: moved to the Hôtel Pérey: ALS (Carlton Lake) AdTL to LTC, Paris – Hôtel Pérey, 12 May 1872.

48: accompanied by a sort of great-aunt: ALS (Carlton Lake) AdTL to GTL, Paris, Pentecost [19 May 1872].

48: The first few weeks: Ibid.

49: 'make him less stiff': Ibid.

49: 'he runs ...': ALS (Carlton Lake) AdTL to LTC, Pentecost [19 May 1872], and ALS (Le Bosc) AdTL to GTL, 2 June [1872].

49: To her surprise ... in the salon: ALS (Carlton Lake) AdTL to LTC, Pentecost [19 May 1872].

49: the Lycée Condorcet: As it was called both in 1872 and today. See ALS (Carlton Lake) AdTL to LTC, Paris, 28 May 1872. Although Lautrec's school records bear the school name Lycée Fontanès, in fact the name of the school had been officially changed in the Second Empire to Lycée Bonaparte and, after the fall of Napoleon III in 1871, from Lycée Bonaparte to Lycée Condorcet: *'depuis hier, il va 2h le matin et 2h le soir suivre les cours élémentaires du Lycée Bonaparte (on a changé le nom en Lycée Condorcet) ...'*

49: 'Decidedly ...': ALS (Carlton Lake) AdTL to LTC, Paris, 28 May 1872.

49: 'It's much more expensive ...': ALS (Le Bosc) AdTL to GTL, Paris, 2 June [1872].

50: 'We saw a horse ...': Ibid.

50: In Paris ... medical treatment: Ibid.

51: 'Now that's bad luck ...': ALS (Carlton Lake) GTL to ATC, [28 June 1872].

51: 'running wild'/'he's a real devil'/'after too much liberty': ALS (Carlton Lake) AdTL to LTC, Céleyran, Friday [August 1872].

51: a letter ... two years later: January 1874, see Letter 9.

51–2: 'Henry is happy ...': ALS (Carlton Lake) Adèle to GTL, Paris, Friday [November 1872].

52: 'Thus you found ...': Quoted in Bernier 1991, p. 56.

52: 'most intellectual': Merlin, p.38.

52: 'Monsieur l'Abbé ...': Perruchot 1958, p. 26.

52: 'except that he has ...': ALS (Schimmel) AdTL to GTL-, Paris, Tuesday, 17 December [1872].

52: Adèle spent her time: ALS (Carlton Lake) AdTL to GTL, Paris, Friday [November 1872].

52: 'Please tell Alix ...': ALS (Carlton Lake) AdTL to LTC, Paris, 30 November 1872.

53: repurchase ... at a loss: ALS (Schimmel) AdTL to GTL, Paris, Tuesday, 17 December [1872].

53: tried to renegotiate: See p. 395.

53: 'Papa wants me ...': Letter 5 (tr. Frey).

53: 'I'm not bored ...': ALS (Carlton Lake) HTL to LTC, Paris, 30 December 1872.

53: 'unfortunately ...': Letter 4 (tr. Frey).

54: 'They itch ... January first': ALS (Carlton Lake) AdTL to LTC, Paris, 30 December 1872.

54: 'all smudged with ink': ALS (Carlton Lake) AdTL to LTC, Paris, Friday, 10 January [1873].

54: 'I'd gladly ask ...': Letter 7 (tr. Frey).

54: Odon's wedding: Alph, who made no secret of his feelings about marriage, apparently gave Odon a fencing sword as a wedding present, saying 'You know what to do with it ...' See Beaute unpublished manuscript of *Toulouse-Lautrec vu par les photographes suivi de témoignages inédits*, p. 40. This passage was edited out when the book was published in 1988.

54: 'My dear Maman ...': Dated 19 June 1873, reproduced in Beaute 1988, p. 93, and as Letter 7a (tr. Frey).

55: 'As I am writing ...': Letter 8 (tr. Frey).

55: 'At Agen ...': ALS (Carlton Lake) HTL to LTC, Bordeaux, 29 November 1873.

55: 'My lodgings ...': ALS (Carlton Lake) AdTL to LTC, Bordeaux, 29 November 1873.

55: highly critical: See ALS (Carlton Lake) AdTL to GTL, Paris, Friday [November 1872]: *'dans cette maison ou l'on aime tant ses aises,'* and ALS (Carlton Lake) AdTL to LTC Paris, 30 November 1872: *'L'après–midi je vais souvent voir Cécile qui est très occupée à se meubler.'*

56: Adèle admitted ... bankruptcy: See for example Letters 236, 237.

56: 'Henry was welcomed ...': ALS (Carlton Lake) AdTL to GTL, Paris, 3 December 1873.

56: 'Odette': To distinguish her from Uncle Charles' wife, whose name was also Emilie.

56: 'hear the music': Robert Martrinchard, quoted by Perruchot 1958, English edn, p. 38.

56: 'I never paint ...': Ibid.

56: always exquisitely dressed: See illustration in Huisman and Dortu 1964, p. 28, which identifies the date of Henry's drawing of Princeteau as the spring of 1882. This drawing should more accurately be dated around 1878 [Dortu Ic. 21].

56: 'His great pleasure ...': ALS (Carlton Lake) AdTL to GTL, Paris, 4 December [1873]. See also ALS (Carlton Lake) AdTL to LTC, 21 December 1873.

56–7: 'he is stimulated ...': ALS (Schimmel) Odon de Toulouse-Lautrec to GTL, Paris, 9 February 1874.

57: 'eight elephants ...': Letter 9.

57: 'there are so many dolls ...': Letter 9 (tr. Frey).

57: 'more and more ...': ALS (Schimmel) Odon de Toulouse-Lautrec to GTL, 9 February 1874.

57: Miss Braine ... at school: ALS (Carlton Lake) AdTL to GTL, Holy Thursday, 2 April [1874].

57: 'It would be perfect ...': ALS (Carlton Lake) AdTL to LTC, 15 March 1874. See also ALS (Carlton Lake) AdTL to LTC, Paris, 15 February and 2 March 1874.

57: 'I have a French teacher ...': Letter 10 (tr. Frey).

57: He ended the year ... arithmetic: Perruchot 1958, p. 39. See also prize books, Musée d'Albi.

58: 'He is hardly growing ...': ALS (Le Bosc) AdTL to LTC, Paris, Tuesday, 30 June [1874].

58: 'go wherever ...': ALS (Carlton Lake) ApTL to GTL, Paris, Monday [*c*. March 1874].

58: 'Those contraptions ...': ALS (Carlton Lake) AdTL to LTC, Paris, Monday, 27 April [1874].

58: 'As I accurately foresaw ...': ALS (Le Bosc) AdTL to LTC, Paris, 2 March 1874.

58: 'Pray for your godson ...': ALS (Carlton Lake) AdTL to LTC, Monday, 27 April [1874].

58: 'Although ... a heavy cross': ALS (Carlton Lake) AdTL to GTL, Paris, Holy Thursday, 2 April [1874].

59: 'I would have had ...': ALS (Carlton Lake) HTL to LTC, Arcachon, 24 August 1874.

59: 'thanks to a stupid ...': ALS (Carlton Lake) AdTL to LTC, Paris, Sunday, 22 November [1874].

59: 'It's cured now ...': ALS (Carlton Lake) AdTL to LTC, Paris, 1 December [1874].

59: 'My big boy ...': ALS (Carlton Lake) AdTL to GTL, Paris, Saturday, 28 November [1874].

60: 'He finds ...': ALS (Carlton Lake) AdTL to LTC, Paris, 15 December [1874].

60: 'My dear Aunt ...': Letter 11. According to Schimmel 1991, Letter 11 may be dated 30 September 1874. In the author's opinion it is more likely to have been written around 9 January 1875, for his aunt's Saint's Day (Sainte Alix).

60: 'made some little boys...': ALS (Carlton Lake) AdTL to GTL, Paris, 2 January 1875 includes a note to Madeleine Tapié de Céleyran from Henry.

60: 'I have to admit ...': ALS (Carlton Lake) AdTL to LTC, Paris, 8 January 1875.

60: severe pains: Beaute 1988, p. 92. The diagnosis of hairline fractures was suggested in a personal communication from orthopaedic surgeon Stephen E. Conrad, M.D. San Francisco, CA.

61: 'Interrupting his studies ...': ALS (Carlton Lake) GTL to ATC, 17 January 1875.

61–2: 'The doctor ...': ALS (Carlton Lake) AdTL to LTC, Paris, 23 January 1875.

62: 'content with his fate': ALS (Carlton Lake) AdTL to LTC, Paris, 4 February 1875.

62: 'I cannot afford ...': Ibid.

62: 'jump with joy': Ibid.

63: 'I want it ...': ALS (Carlton Lake) AdTL to LTC, Paris, 16 February [1875].

63: 'by heart': ALS (Carlton Lake) AdTL to LTC, Paris, 11 April 1875.

63: 'The proof ...': ALS (Carlton Lake) AdTL to LTC, Paris, Easter Day, [18]75.

63: 'If I knew ...': ALS (Carlton Lake) AdTL to LTC, Paris, 9 June 1875.

64: 'I strongly recommended ...': ALS (Carlton Lake) AdTL to LTC, Paris, 23 May 1875.

64: 'I will submit ...': ALS (Carlton Lake) AdTL to LTC, Paris, 11 July 1875.

64: 'I'll never decide ... markets': ALS (Carlton Lake) AdTL to LTC, Paris, Thursday, 12 August [18]75.

64: 'I am very impatient ...': ALS (Carlton Lake) AdTL to LTC, Paris, Friday, 10 September 1875.

64: [Godmother's]: Henry's maternal grandmother, Louise Tapié de Céleyran, was also his godmother.

64: 'My dear Mama ...': Letter 13.

65: 'If I had wings ...': Huisman and Dortu 1964, p. 20, reproduced with errors as Letter 15.

65: 'If I could leave ...': Letter 14 (tr. Frey).

65: 'My position ...': ALS (Carlton Lake) AdTL to LTC, Paris, 5 November [18]75.

65: 'Henry has accepted ...': ALS (Carlton Lake) AdTL to LTC, Paris, 22 November [18]75.

65: 'The treatment ...': ALS (Carlton Lake) Odon de Toulouse-Lautrec to GTL, Le Bosc, 2 February [18]76.

65: 'Remember ...': Quoted in Mack, p. 24 (tr. Mack).

66: 'I am not very eloquent ...': Letter 17 (tr. Frey).

66: 'In the past ...': ALS (Carlton Lake) ApTL to GTL, Grignon, [between 23 January and 2 February 1876].

66: 'At the Jardin ...': Ibid.

66: 'disappointments of the hunt': ALS (Carlton Lake) GTL to ATC, Le Bosc, Thursday, 18 November [1875].

66: Toby ... five feet high: Ibid.

67: 'The dear child ...': ALS (Carlton Lake) AdTL to LTC, Paris, 24 March [18]76.

67: learned his catechism: Letter 16, n. 1.

67: arranged a guardianship: ALS (Carlton Lake) AdTL to LTC, Paris, Holy Friday [18]76.

67: a quack: ALS (Carlton Lake) AdTL to LTC, Paris, 22 April [1876].

67: 'as satisfied ...': ALS (Carlton Lake) AdTL to LTC, Paris, Good Friday [18]76.

67: 'liberty and good air': Ibid.

67–8: 'Naturally the bullet ...': Beaute 1988, p. 43.

68: 'The latter ...': ALS (Carlton Lake) AdTL to ATC, Paris, 14 May 1876.

68: 'This morning ...': Letter 20 (tr. Frey).

68: 'lost some of her *guincharderie*': Ibid.

68–9: *'wild with joy'* ... Castelpers: ALS (Schimmel) AdTL to LTC, Le Bosc, 7 October [1877].

69: doing well in his subjects: See Letter 21, where Henry writes a class exercise on *Le Cid* in the form of a letter presumably written by a contemporary of Corneille.

69: 'Not likely': Letter 97 [misdated 1884 but probably either 1885 or 1886, as Henry was not in Paris in August 1884]: *'Il peut se fouiller.'*

69: 'as good as ...': ALS (Le Bosc) AdTL to GTL, Paris, 8 December 1876.

70: 'very big and very strong': ALS (Carlton Lake) AdTL to LTC, Paris, 26 December [18]76.

70: 'I'm sending ...': Ibid.

70: 'already sharpening his teeth': ALS (Carlton Lake) HTL to LTC, a note attached to ALS (Carlton Lake) AdTL to LTC, Paris, 26 December [18]76.

70: 'My worry ...': ALS (Carlton Lake) AdTL to GTL, Paris, Sunday, 28 January 1877.

71: endocrine disorders: For information on this subject, I am indebted to Owen P. (Pat) O'Meara, M.D., Chief of Pediatrics at Denver General Hospital, and Jared L. Klein, M.D. Pediatric Endocrinologist and Oncologist, Assistant Professor at The Ohio State University College of Medicine, Columbus Hospital, Columbus, Ohio.

71: 'I'm still very worried ...': ALS (Carlton Lake) AdTL to ATC, Paris, 9 February [18]77.

72–3: 'I have more ...': Letter 23 (tr. Frey).

73: 'I am very frustrated ...': Ibid.

73: He was sorry when Louis: Schimmel 1991, Letter 22.

74: 'Henry is better ...': ALS (Carlton Lake) AdTL to LTC, Paris, 14 February 1877. It is not known what medications Henry was taking at the time.

74: 'I've decided ...': ALS (Carlton Lake) AdTL to LTC, Paris, 1 March 1877.

74: 'The doctor says ...': ALS (Carlton Lake) AdTL to LTC, Paris, 3 March [18]77.

74: 'The other treatments ...': ALS (Carlton Lake) AdTL to LTC, Sunday, 11 March [18]77.

74: 'I'm calmer now ...': Ibid.

74–5: 'I assure you ...': Ibid.

75: 'but it's not worth it ...': ALS (Carlton Lake) AdTL to LTC, Paris, 14 April [18]77.

75: 'To complicate ...': Ibid.

75: sketched ... a chaise-longue: See childhood drawing (D1490) [*c.* 1879–81]. Illustrated in Desloge et al., p. 23.

75: 'very time-consuming ...': ALS (Carlton Lake) AdTL to ATC, Holy Tuesday [1877].

75: 'His walk ...': Ibid.

76: 'The good thing ...': ALS (Carlton Lake) AdTL to LTC, Paris, 2 April 1877.

76: his new studio: Now located at 233, rue du Faubourg Saint-Honoré, not far from the Hôtel Pérey.

76: a painting ... portrait sketches: ALS (Carlton Lake) Odon de Toulouse-Lautrec to GTL, Paris, 7 April 1877. The Princeteau portraits of 1877 may have included *Portrait équestre du*

comte de T.L., his Salon entry for 1878. See Letter 25, n. 2, and Lautrec's comment: 'Uncle Odon is posing on a horse for M. Princeteau.' Misdated 17 April 1878, but not possible then, as Lautrec was at Céleyran in April 1878. By deduction, this letter was written in April 1877.

76: Alphonse ... openly admitted: Letter V 4.

76: 'I have to confess ...': Letter 25 (tr. Frey).

76: 'My canary de Béon': So named because she was the gift of Madame de Béon, in whose house in Arcachon Henry had taken a bad fall in 1872 and scraped his nose.

76: puppet theatre: Letter 26 and ALS (Carlton Lake) AdTL to LTC, Paris, 14 February 1877.

76–7: 'portrait'/'play the piano': Letter 26.

77: 'Henry is very proud ...': ALS (Carlton Lake) AdTL to LTC, Paris, 9 February [18]77.

77: 'Poor Henry ...': ALS (Carlton Lake) Odon de Toulouse-Lautrec to GTL, Paris, 2 May 1877.

77: near-sightedness: Around September 1879, he said that reading 'a little' gave him a headache. See Letter 29.

78: 'We didn't forget ...': Letter reproduced in Beaute 1988, p. 99.

78: 'good to agree ...': Baedeker, p. 51.

78: 'they take you ...': ALS (Carlton Lake) AdTL to GTL, Maison Gradet en face de l'Hôtel de l'Europe [Barèges, July 1877].

78: 'We are housed ...': Ibid.

79: 'almost over our heads' ... broken into it: ALS (Carlton Lake) AdTL to LTC, Barèges, 10 July [18]77.

79: 'would make a man' ... was worth it: Ibid.

79: 'Henry has made ... cracking': ALS (Carlton Lake) Marie de Toulouse-Lautrec to GTL, Foudelin, 7 September 1877.

79: Charles trained Henry: Murray 1991, p. 13.

80: *La Calèche*: See drawings: Dortu 1971, IV, D564, D595.

80: two drawings ... Grandjean: See Murray 1991, p. 10, and illustration p. 11.

80: 'It will make ... strange': ALS (Carlton Lake) GTL to ATC, Le Bosc, 24 November [1877].

80–1: Alph's photo ... first portraits: See Murray 1991, p. 16.

81: 'living happy in Grignon': ALS (Carlton Lake) AdTL to ATC, Le Bosc, 15 November [1877].

82: 'Henri is painting ...': ALS (Carlton Lake) GTL to ATC, Le Bosc, 15 November 1877.

82: 'I've never seen ...': ALS (Carlton Lake) GTL to ATC, Le Bosc, 13 November 1877.

82: 'His happy disposition ...': ALS (Carlton Lake) GTL to LTC, Le Bosc, 10 November [18]77.

82: 'Henry is looking ...': ALS (Carlton Lake) GTL to ATC, Le Bosc, 24 November [1877].

82: 'without being in pain ...': ALS (Carlton Lake) AdTL to ATC, Le Bosc, 15 November [1877].

83: 'marvellous watercolours ...': ALS (Le Bosc) AdTL to LTC, Amélie[-les-Bains], 21 February [18]78.

83: 'Madame ...': ALS (Schimmel) Dr. Genieys [to AdTL, Amélie-Les-Bains], 9 March [18]78.

83: 'reasoned observations ...': ALS (Carlton Lake) ApTL to GTL, Paris, Tuesday [probably 25 March 1878].

84: 'Since he came back ...': Ibid.

85: Henry was overjoyed: ALS (Carlton Lake) AdTL to ATC, Céleyran, 6 April [1878].

85: collecting miniature carts: See ALS (Carlton Lake) HTL to Raoul Tapié de Céleyran [between 3 and 14 May 1878].

85: 'He asks his cousins ...': ALS (Carlton Lake) GTL to ATC, Albi, Monday, 3 [but more probably 6] May 1878.

85: 'all the furniture ...': Ibid.

85: 'Dear Raoul ...': ALS (Carlton Lake) HTL to Raoul Tapié de Céleyran [c. 7 May 1878].

CHAPTER FOUR: LE PETIT
(pp. 87–115)

87: 13 May 1878: The date can be established from letters written contemporaneously to the event. Alphonse, in a letter written many years later, gave the date as 30 May, but must have remembered inaccurately. See Huisman and Dortu 1964, p. 22.

87: his left femur: See Letter 34 (tr. Frey): 'I fell off a low chair onto the floor and broke my left thigh.'

87: 'a sort of irony of destiny': Beaute 1988, p. 97.

87: 'Henry is doing …': ALS (Carlton Lake) AdTL to ATC, Albi, 15 May [1878].

88: 'sleeping well …': ALS (Carlton Lake) GTL to ATC, [Albi, *c.* 16 May 1878].

88: Alphonse was distraught: ALS (Carlton Lake) AdTL to ATC, Albi, 15 May [1878].

88: 'Tonight … cushions': ALS (Carlton Lake) GTL to ATC, [Albi, *c.* 16 May 1878].

88: 'Henri continues …': ALS (Carlton Lake) GTL to ATC, Saturday, 18 May 1878.

88: 'They stop one …': Ibid.

89: 'three agonizing hours …': ALS (Carlton Lake) AdTL to ATC, Albi, 20 May [1878].

89: 'You can imagine …': Ibid.

90: 'Dear Raoul …': ALS (Carlton Lake) HTL to Raoul Tapié de Céleyran, Albi, 22 May 1878. Dictated to his mother, but signed in his own hand. It is incorrectly quoted in Attems 1975, p. 236 and Letter 27.

90–1: 'Ennery has broken … Esq.': Ibid. 'Ennery' is 'Henry' in a Cockney accent.

91: 'Madame Mother Superior …': Letter 28 (tr. Frey).

91–2: 'Augé told me …': Letter 32 (tr. Frey). Probably late May 1878.

92: 'marvellous'/'as good as …': ALS (Carlton Lake) GTL to ATC, Albi, 25 May 1878.

92: 'in no hurry …': ALS (Carlton Lake) Joséphine du Bosc to LTC, Albi, 19 June [1878].

93: 'cormorant …': ALS (Carlton Lake) GTL to ATC, Albi, Thursday, 27 June, 1878.

93: 'I think …': Ibid.

93: 'like a blackbird': Ibid.

93: 'living crutches': Ibid.

93: 'My dear Tapié …': ALS (Carlton Lake) HTL to [Raoul] Tapié de Céleyran [*c.* 30 June 1878].

93: 'you wouldn't be able …': ALS (Carlton Lake) AdTL to LTC, Albi, 3 July [18]78.

94: 'exactly like a china doll!': ALS (Carlton Lake) AdTL to LTC, Albi, 12 July [18]78.

94: 'I thank you …': Letter 31 (tr. Frey).

95: his grandmother's comfortable *berline*: Attems 1975, p. 81.

95: 'His first word …': ALS (Carlton Lake) GTL to ATC, Albi, Monday, 10 a.m. [5 August 1878].

95: '[Alphonse] came in …': Ibid.

95–6: 'Decidedly …': Ibid.

97: filled a whole notebook: Dortu D189–235. See also Murray 1978a, p. 394.

97: his sketches … his first truly original oil paintings: Dortu P12–14, P19, P27, A80, P75, A154, A184. See also Murray 1978a, pp. 394–5.

97: dutifully signing them: See painting by Lautrec signed 'H.T.L., after Goubie' (Dortu P1).

97: independence and maturity: See watercolour painting: *Réunion de cavaliers de chasse à courre*, 1878, Musée d'Albi. catalogue no. A4, misdated 1873–5.

97: 'without fighting': ALS (Carlton Lake) AdTL to LTC, Le Bosc, 15 August [18]78.

97: 'for four': ALS (Carlton Lake) GTL to LTC, Le Bosc, 18 August [18]78.

97: 'the personage …': Letter 33.

98: *'Il n'est pas joli'*: Attems 1975, p. 75.

98: 'Look at …': Letter 46.

98: a ring ... baby teeth: ALS (Carlton Lake) AdTL to LTC, Le Bosc, 15 August 1878.

98: 'He carries her ...': ALS (Schimmel) GTL to Alix de Toulouse-Lautrec, Le Bosc, Friday, 11 October [1878].

98: 'Keep his secret ...': Ibid.

99: 'The whole time ...': Letter and drawing reproduced in Beaute 1988, p. 96. Schimmel 1991 misdates this letter spring-summer 1879 (Letter 41A (tr. Frey)). I have dated it from ALS (Carlton Lake) AdTL to LTC, 1 December [18]78.

99: 'better than he expected ...': ALS (Carlton Lake) AdTL to LTC, 1 December [18]78.

99: 'all the worries ...': ALS (Carlton Lake) AdTL to GTL, Céleyran, 27 December [18]78.

100: 'afraid of the Pyrenees': ALS (Carlton Lake) AdTL to LTC, 1 December [18]78.

100: 'unhealthy ...': ALS (Carlton Lake) AdTL to GTL, Nice, 28 April [18]79.

100: 'My dear Deloux ...': Letter 36 (tr. slightly corrected by Frey).

100: 'Cold weather ...': ALS (Carlton Lake) AdTL to LTC, 11 February [18]79.

101: stamp collection: See Letters 38, 40.

101: 'The dancing ...': ALS (Carlton Lake) AdTL to LTC, 11 February [18]79.

101: 'He's excellent ...': Letter 38 (tr. Frey).

101: 'The English women ...': ALS (Carlton Lake) AdTL to LTC, Nice, 27 January 1879.

101: 'for he understands ...': ALS (Carlton Lake) AdTL to LTC, 11 February [18]79.

101: 'Alph is bored ...': ALS (Carlton Lake) AdTL to LTC, 27 January 1879.

101: 'The sad faces ...': ALS (Carlton Lake) AdTL to LTC, 11 February [18]79.

101–2: 'Everybody has been ... studying his Greek': ALS (Carlton Lake) AdTL to LTC, Nice, 18 February [18]79.

102: 'We, too, participated ...': ALS (Carlton Lake) AdTL to LTC, Nice, Saturday, 1 March [18]79.

102: 'It was transformed ...': Ibid.

102: He walked ... a mile away: ALS (Carlton Lake) AdTL to LTC, Nice, 18 February [18]79.

102: 'but he's still heavy ...': ALS (Carlton Lake) AdTL to LTC, Nice, Saturday, 1 March [18]79.

103: 'He had a lot ...': ALS (Schimmel) AdTL to LTC, Nice, 28 March [1879].

103: 'Henry got along ...': ALS (Carlton Lake) AdTL to GTL, Nice, 27 March 1879.

103: 'He's regained ...': ALS (Carlton Lake) AdTL to GTL, Nice, 28 April [18]79.

103: 'Henri's so much better ...': ALS (Carlton Lake) GTL to LTC, Albi, Saturday, 21 June 1879.

103: 'You can imagine ...': ALS (Carlton Lake) AdTL to GTL, Barèges, Sunday, 20 July [18]79.

103: 'My dear little ...': Letter 45 (tr. slightly corrected by Frey), misdated as September 1879, but actually mid-July. See also Adèle's letters from July 1879.

104: 'I was wrong ...': ALS (Carlton Lake) AdTL to GTL, Barèges, 13 July [18]79.

104: 'in ecstasy ...': Ibid.

104: 'While his mother went ...': ApTL, 1901, quoted in Huisman and Dortu 1964, p. 22.

104: 'sprain': ALS (Carlton Lake) GTL to ATC, Barèges, 10 August 1879.

104: The famous apparatus ... other leg: ALS (Carlton Lake) Zoë de Gualy de Saint Rome to GTL, Albi, 23 July [1879].

104: 'Physically ...': ALS (Carlton Lake) AdTL to GTL, Sunday, 27 July [18]79.

105: 'when one has ...': Ibid.

105: 'The Doctor says ...': Ibid.

105: 'most good-natured': Ibid.

105: 'little hunchback Fragonard': ALS (Carlton Lake) GTL to ATC, Barèges, 31 [July, misdated by Gabrielle as 31 August] 1879.

106: 'They were four miles ...': Ibid.

106: 'Henry's doing ...': Ibid.

106: 'I hope ...': Letter 43. Misdated August-September 1879, but actually between 21 July and 1 August.

106–7: 'You realize ...': ALS (Le Bosc) GTL to LTC, Barèges, 4 August 1879, possibly A129, *Cheval de trait au repos.*

107: 'Henri, whom I love ...': ALS (Carlton Lake) Blanche de Gualy de Saint Rome to GTL-, Creissels, 9 August [18]79.

107: 'He's strong and dextrous': ALS (Le Bosc) AdTL to LTC, Barèges, 23 August [18]79.

107: 'I am indeed alone ...': Letter 29 (tr. Frey). Schimmel 1991 dates this letter Albi, June 1878. I date it Septem-ber 1879 because Jeanne d'Armagnac was at Barèges with her family at that time. See ALS (Le Bosc) AdTL to LTC, Barèges, 3 September 1879. Also, it seems likely in terms of Henry's sexual maturity that at age fifteen he would be more aware of a woman than a year earlier.

107: he showed *la bête*: See Romain Coolus, 'La belle et la bête', illus. Henri de Toulouse-Lautrec, *Le Figaro illustré* (September 1895).

107: one glass of mineral water/model ship: ALS (Le Bosc) AdTL to LTC, 23 August [18]79. At that time, the baths and mineral water cost about 5–6 francs a day – the equivalent of £10-£12 in the 1990s.

108: 'in despair': Ibid.

108: 'so many people ...': ALS (Carlton Lake) AdTL to LTC, Barèges, 19 August [18]79.

108: 'It's all well ...': Ibid.

108: 'Henri's care ...': ALS (Carlton Lake) GTL to ATC, Barèges, 27 August 1879.

108: 'On Monday ...': Letter 44 and Joyant 1926, I, p. 42, tr. Mack, pp. 28–29. Mislabelled Nice. Mack remarks that Joyant in his notes had labelled the letter 'Nice?'. It seems apparent from surrounding documents that Henry had no surgery of any sort in Nice in 1879, but that this letter corresponds closely to his experience after 3 September 1879 after the second leg break in Barèges. In addition, the first mention of Devismes in any of the family correspondence is at this time in Barèges. Schimmel 1991 dates one letter from Lautrec to Devismes as Nice, January 1879 (Letter 37), but it must have been written in February 1880 or later.

108: 'my fat clumsy paws'/'If you were ...'/'I pass the time ...': Ibid.

108–9: 'silicate bandage'/'I'm able to wait ...': ALS (Carlton Lake) GTL to ATC, Barèges, 23 August [18]79.

109: 'The apparatus ...': ALS (Schimmel) GTL to Amédée Tapié de Céleyran, Barèges, 2 September [18]79. Schimmel 1991 refers to this letter (Letter 43, n. 2) as being written by Henry's other grandmother, Louise Tapié de Céleyran. This is an error, as I have seen the original letter, which is in Gabrielle de Toulouse-Lautrec's handwriting. Louise was not at Barèges at the time.

109: 'We surely will ...': ALS (Le Bosc) AdTL to LTC, Barèges, 3 September [18]79.

109: 'so cheering ...': Ibid.

109: 'He's in great need ...': Ibid.

109: 'His ankle ...': Probably GTL, quoted in Attems 1975, p. 250.

109: 'for bathing ...': Grandmother Gabrielle's description of the need to keep the leg dry, and Henry's description of 'laying the fracture bare' and a surgical procedure, make it seem as if an incision may have been made at some point in his broken leg. There is, however, no concrete documentation to support this.

109: 'We haven't been ...': ALS (Carlton Lake) AdTL to LTC, Barèges, 9 September [18]79.

110: 'like a child'/'We have crutches ...': Ibid.

111: 'You can understand ...': Letter 47 (tr. Frey) does not give the complete date of the letter

(Friday, 5 December 1879), and Schimmel 1991, p. 36, mistranslates the name of the French card game *chemin de fer* as 'play trains'.

111: 'We were astonished ...': ALS (Carlton Lake) Odon de Toulouse-Lautrec to GTL, Cannes, 10 February 1880.

111: 'I say ...': Letter 49 (tr. Frey).

112: 'You tell me ...': Letter 37 (tr. Frey) misdated January 1879.

112: 'charissime Etienne'/'Even though ...': Joyant 1926, I, pp. 43–4.

112–3: 'Dear Madam ...': Letter 53.

113: ailing cousin Madeleine: See ALS (Carlton Lake) AdTL to LTC, Nice, 23 January 1881: 'Madeleine must be finding the snow hard to deal with.'

113: '19 January ...': Letter 56, tr. Mack, pp. 39–40.

114: 'Wednesday ...': Ibid. (tr slightly corrected by Frey).

114: 'Madame ...': Ibid.

114–15: 'He's most proud ...': ALS (Carlton Lake) AdTL to LTC, Nice, 23 January 1881. Schimmel 1991 identifies the Suermonds (sic) as a German father and daughter whom Henry and his mother befriended at the Pension Internationale in Nice in 1880 and saw again in 1881 (see Letter 48, n. 3).

115: No matter ... his canvases: See ALS (Carlton Lake) AdTL to LTC, Nice, 23 January 1881 and ALS (Carlton Lake) AdTL to GTL, Nice, Easter 1881.

CHAPTER FIVE: LOST

(pp.116–64)

116: 'to see what ...': ALS (Carlton Lake) AdTL to GTL, Nice, Easter 1881.

116: Princeteau found: Huisman and Dortu 1964, p. 27.

116: 'Princeteau ...': ALS (Carlton Lake) AdTL to LTC, Paris, 29 April 1881.

116: 'Henri is full ...': ALS (Carlton Lake) Odon de Toulouse-Lautrec to GTL, Paris, 8 May 1881.

117: the Ecole des Beaux Arts: As Henry's parents were deciding about where Henry was to study in Paris and wondering whether or not he should take the Beaux Arts exams, his Grandmother Gabrielle wrote to him that there was a rumour that the Ecole des Beaux Arts was going to be 'suppressed'. She recommended to him an article by Gounod on the Rome Academy. Uncle Charles also sent Henry clippings from *Le Figaro* on the Beaux Arts matter. See ALS (Carlton Lake) GTL to HTL [Le Bosc, 4 January 1882].

117: 'All Alphonse's ...': ALS (Schimmel) AdTL to LTC, 4 May 1881, and (ALS (Schimmel) AdTL to GTL, 8 May 1881.

117: 'There ...': ALS (Schimmel) AdTL to GTL, 8 May 1881.

117: 'René': Letters 57, 59.

117: the best of Parises': Letter 64 (tr. Frey).

117: 'The first study ...': See Dortu A172 and P100, *Cuirassier*, signed 'Lautrec 1881, copied from Princeteau'. ALS (Schimmel) AdTL to GTL, Paris, Sunday, 8 May [18]81.

118: 'Only a certain ...': Arsène Alexandre, April 1902, tr. Mack, p. 45.

118: 'At age fourteen ...': Quoted in Coquiot 1921, tr. Mack (corrected by Frey), p. 47.

118: 'age fourteen in 1879': Henry was in fact nearly seventeen, and the year was 1881.

118: 'The copy': Murray 1991 identifies this copy as the *Cuirassier* (Dortu P100) but wrongly supposes it to be from 1878 or 1879.

118: 'I had got ...': HTL quoted in Gauzi 1954a, p. 14.

118: 'all the artists ... a little': ALS (Schimmel) AdTL to LTC, Paris, 4 May 1881.

118–19: 'So, here ...': ALS (Carlton Lake) AdTL to LTC, Paris, 19 May 1881.

119: 'I wanted ...': Letter 59. See Huisman and Dortu 1964, p. 28.

119: 'offspring': The French word is *poulain*, which means both 'foal' and 'novice' or 'promising trainee'.

119: downright unpatriotic: ALS (Schimmel) AdTL to LTC, Paris, 14 July 1881.

120: 'They aren't ...': Ibid.

120: 'Dear friend ...': Letter 61, tr. Mack (corrected by Frey), pp. 30–1.

120–1: 'Are you at ...': Letter 62, tr. Mack, pp. 31–2.

121: 'My dear friend ...': Letter 64, tr. Mack (corrected by Frey), pp. 32–3.

122: 'I suggest ... helmets': See drawings Dortu D2020 and D2021. Although the third drawing has disappeared, it is interesting to note that years later, in 1894, Henry illustrated Goya's *Los Desastres de la Guerra* with a drawing of two skulls.

122: 'I thought ... with age': Letter 65, tr. Mack, p. 33.

122: 'our success': ALS (Schimmel) AdTL to LTC, 20 November 1881.

122: 'Tell them ...': Ibid. Henry's comments about the draft do not appear to be based in fact. In 1881 the draft was by lottery, and students, priests and married men were allowed exemptions. One could also purchase one's way out of military service for about 2000 francs (around £4000). See Weber 1976, pp. 292–5.

122–3: 'the jury ...': Letter 67, tr. Mack, p. 34. See Dortu D2015, Henry's drawing of the examination.

123: 'my letter ...': Letter 66 (tr. Frey). Schimmel places this letter chronologically ahead of Henry's 22 November letter to Devismes, but that is unlikely, as Adèle was at the exam in Bordeaux with her son on 17–18 November. Most likely the letter was written after 22 November 1881.

123: 'It's freezing ...': Letter 68 (tr. Frey).

123: '*grande cité* ...': Joyant 1927a, II, p. 54.

123: took pride in announcing: See Letter 73.

124: John Lewis Brown: See Letter 72, misdated spring 1882. As Adèle was in Paris in spring 1882 and 1883, at the earliest, this letter must date from spring 1884. The Pascal reference may be to events leading to that family's bankruptcy in May 1892.

124: 'painters of sporting ...': Murray 1978a, p. 27.

124: non-payment of debts: Charles-Bellet, p. 38.

124: watercolour portrait: Gauzi 1954a, p. 145. Reproduced in Joyant 1927b, II, p. 75.

125: while working at Bonnat's: Letter 71.

125: Bonnat had painted ... deathbed: Both portraits now hang in the Musée Victor Hugo in Paris.

125: 'the favourite of millionaires': Mack, p. 50.

125: 'Republican statesmen ...': Fermigier, p. 31.

125: Bonnat's personality: Natanson 1948, p. 171.

125: 'If you want ...': Quoted in Hanson and Hanson, pp. 43–4.

126: 'humbugs and revolutionaries': Perruchot 1958, p. 63.

126: 'He's Madame ...': ALS (Carlton Lake) AdTL to LTC, 35, rue Boissy d'Anglas [the postal address of the Hôtel Pérey], Paris, 21 March 1882.

126: the first meeting: On Tuesday, 28 March 1882. See Letter 71A, n. 2.

126: 'the portrait of Germaine': See Dortu P183.

126: 'On Monday ...': ALS (Carlton Lake) AdTL to LTC, Paris, 31 March 1882.

127: 'sucking her thumb ...': Letter 71a.

127: 'It seems ...': ALS (Carlton Lake) Emilie (Odette) de Toulouse-Lautrec to her mother, La Comtesse Lemorel de la Haichois, [Paris], Monday, [17 April 1882].

127: notably unhealthy places: A hundred years later, conditions had hardly changed. The author received her art training in a Paris atelier in the 1970s where the only improvements were electric lights and an oil rather than a charcoal stove.

127: A new arrival ... 1882: See Letter 73. The name Watson appears in the collective parody of the *Bois sacré* of Puvis de Chavannes, painted by Lautrec and atelier friends *c*. 1884. It is misread by Cate and Boyer 1985, pp. 10–11, as 'Watron'.

127: 'He is very proud ...': Quoted in Vignaud, p. 11.

127–8: 'all in all ...': ALS (Carlton Lake) AdTL to GTL, Paris, Thursday, 20 April 1882.

128: off-limits to anyone but Bonnat's students: See ALS (Carlton Lake) AdTL to LTC, Paris, 31 December 1882.

129: the races at Chantilly or at Auteuil: ALS (Carlton Lake) AdTL to LTC, 31 March 1882.

129: canvases of horses: Henri Rachou, quoted in Coquiot 1921 and in Mack (tr. Mack), pp. 61–2.

129: 'Princeteau ...': ALS (Carlton Lake) AdTL to LTC, 31 March 1882.

130: 'There is so much ...': Joyant 1926, I, p. 58. Alfred Philippe Roll and Jean-Paul Laurens were painters of military and historical subjects who exhibited regularly at the Salon each year.

130: the Impasse Hélène: It was at number 15 of what is now called rue Hélène, in the 17th *arrondissement*. See Destremau, p. 91. Schimmel 1991, p. 58, wrongly gives the address as number 71.

131: pay a toll: Oberthur, p. 9.

131–2: Descriptions of Montmartre are culled from a number of sources, principally: Shattuck; Philippe Juilland 1977; the publications of the Musée de Montmartre in Paris; Zeldin I, 1973.

132: *sous*: A *sou* was a five-centime piece, worth the equivalent of about ten pence today.

132: 'a neighbourhood ...': Letter 89 (tr. Frey).

132: 'Henri is ...': Attems 1975, p. 34.

133: the studio comic: Perruchot 1958, p. 69.

133: An art student at Bonnat's: See Murray 1991, p. 33.

133: 'Henry is working ...': Huisman and Dortu 1964, p. 32.

133: 'his painting ...': [1882], quoted in Perruchot 1958, p. 67.

133–4: 'I am certainly ...': I am quoting this letter to his Uncle Charles as given in Perruchot 1958, p. 67. Schimmel 1991, Letter 137, gives the first sentence of this quote as part of a letter by Henry to his Grandmother Gabrielle, tentatively dated 28 December 1886, but does not give the last sentence of the quote at all. I am inclined to believe the earlier date, as it is more consistent with the tone of Henry's letters in 1882 than in 1886.

134: Henry's looseness: Natanson 1951b, p. 155.

134: 'His haughtiness prevents ...': Letter 74 (tr. Frey).

134: a little cartoon: See drawing in Huisman and Dortu 1964, p. 36: 'Bonnat! Monfa!'

134: 'Bonnat exhibited ...': Joyant 1926, I, p. 142.

134: Albert Grenier: Destremau, p. 40, observes that Grenier has traditionally been called René, an incorrect first name, by art historians. Anquetin did a pastel portrait of Grenier in 1889 which is clearly and legibly titled *Gracieux profil de M'sieur Albert Grenier*. Henry painted Grenier for the first time in 1885.

134–5: 'His most striking ...': Huisman and Dortu 1964, p. 44.

135: 'All teeth ...': Natanson 1951b, p. 21.

135: Salon des Indépendants in 1883: Natanson 1948, p. 164.

135: Anquetin's imitations of Impressionist landscapes: See Letter 102.

135: oil painting and drawings: See Louis Anquetin, *Portrait of Henri de Toulouse-Lautrec*, 1885–6, Private Collection, Paris [in Welsh-Ovcharov 1988, p. 187] and drawings, Dortu Ic. 144, 147, 148, 150, 154.

135: His work ... Rubens: See Matthias Arnold, 'Toulouse-Lautrec and the Art of His Century' in Wittrock and Castleman, p. 52.

136: 'an abundant ...': Destremau, p. 40.

136: Grenier's work: He apparently did the unfinished painting *Place de l'Eglise à Villiers-sur-Morin* on the back of a Lautrec canvas known as *Madame L. Grenier* (Dortu P253), belonging to the Art Institute of Chicago.

136: Lili Grenier: See Destremau, p. 42. Lili Grenier's real name was Amélie Sans. She and Albert Grenier finally married in 1904.

136: 'Henry naturally ...': ALS (Carlton Lake) AdTL to LTC, Paris, Sunday, 15 May 1882.

136–7: 'Henry is more ...': ALS (Schimmel) AdTL to GTL, Paris, 4 June 1882.

137: 'Dr. Privat ...': ALS (Carlton Lake) AdTL to LTC, Lamalou-le-bas, 13 July 1882.

137: a drunken *clochard*: See Dortu P146. This possibly is the portrait traditionally called *Matthieu* and said to have been done at Le Bosc. It is signed and dated 1882.

137: 'shrimp woman': See Dortu P174, *La Vieille aux écrevisses*, Dortu P182 and Dortu D2639. All works signed and dated 1882.

137: 'A fine type ...': ALS (Carlton Lake) GTL to ATC, Le Bosc, Sunday, 13 August 1882.

137: Uncle Amédée: See Dortu P165.

137: Miquelou: See Dortu P153.

137: 'Henry studies ...': ALS (Carlton Lake) GTL to LTC, Le Bosc, 22 August 1882.

138: Alphonse ... sold Le Bosc: Marc Tapié de Céleyran, personal communication, 15 August 1983, and ALS (Carlton Lake) AdTL to LTC, Le Bosc, Sunday, 25 June [1865]: '... Alphonse s'est chargé d'écrire à Amédée pour la maison ... Il ne veut vendre qu'à des conditions exagérées ... Il ne mord donc pas à la proposition d'Amédée ...'

138: 'Papa finally ...': Letter 72, misdated 1882. Actually 1884 at earliest.

138: inside front cover of one of his numerous childhood sketchbooks: See Musée d'Albi no. D2, album of drawings dated 1873–1881–1895.

140: so much in disfavour: Letter 75.

140: 'My dear Papa ...': Letter 76 (tr. Frey).

140: *Cain Fleeing with his Family*: Fernand Cormon, 1880, now in the Musée d'Orsay (which catalogues it as *Cain*), Paris.

141: 'Henry is having ...': ALS (Carlton Lake) AdTL to LTC, Château de Respide, near Langon (Gironde) 26 October 1882.

142: He painted ... (Daddy Kneebone): See Dortu Ic. 136, photo of Cormon's atelier.

142: a student holding an open umbrella: Perruchot 1958, p.72.

142: 'Here we both ...': Letter 80.

142: 'Odon with his hands ...': See Dortu D2634.

142: *The Bat*: Possibly Dortu D2639.

142: *Uncle Charles ...*: See Dortu D2659.

142: one of Henry's fellow students: E. Bernard 1952, p. 14, quoted in Murray 1991, p. 40.

143: 'Princeteau ...': Gauzi 1954a, pp. 12–13.

143: 'become a hypochondriac ...': Letter 119. Beverley Conrad, M.A., Ph.D. candidate in Clinical Psychology at the Wright Institute, Berkeley, California, who is writing her dissertation on Lautrec, suggested this interpretation of separation guilt.

143: switching ateliers: See Letter 81.

143: 'I am getting ...': Letter 82 (tr. Frey).

143: 'The Watercolourists ...': Joyant 1926, I, pp. 60–1.

143–4: Training at Cormon's: See Murray 1991, p. 36 for a complete elaboration of this training.

144: 'Nothing can ...': F. Cormon, 'A Word to Young English Painters', *Magazine of Art* 16 (1893), p. 11, quoted in Murray 1991, p. 42.

144: 'He often ...': Quoted in Huisman and Dortu 1964, p. 44.

145: 'His gaiety ...': ALS (Carlton Lake) AdTL to LTC, Paris, Friday, 26 [February 1883].

145: 'Oh, how ...': Quoted in Hartrick, p. 92.

145: *étouffer un perroquet*: Oberthur, p. 89, n. 9 and Coolus 1931, p. 137.

145: Absinthe ... 1915: Oberthur, p. 20.

145: 'Do you know ...': Symons 1918, p. 372.

146: 'like a peacock's tail ...': Quoted in Joyant 1926, I, p. 71.

146: 'I would like ...': Huisman and Dortu 1964, pp. 45, 48. See also Letter 137, which is dated '[Paris 28 December 1886]'. There is nothing in the letter to indicate the date, but a note states 'partial dating from Privat records'. Logically, the content would place the letter earlier in Henry's career.

146: *marché aux modèles* in the Place Pigalle: Oberthur, p. 43.

146: '*La jeune pourriture*': Letter 86.

147: One of his friends later bragged: Perruchot 1958, pp. 77–8.

148: The original large room ... Carolus-Duran: Oberthur, p. 63.

150: 'You kept your mind ...': Claude Monet to Thiébault Sisson in 'Claude Monet, an interview', *Le Temps* (27 November 1900), quoted in Bernier 1985, p. 40.

151: 'Did I lose ...': Letter 81 (tr. somewhat corrected by Frey).

151: 'The era ...': Quoted in Joyant 1926, I, pp. 60–1.

151: *Un petit accident*: Exhibition entry no. 369. See Letter 82, n. 1. It was probably one of two paintings now called *Charrette embourbée* (Dortu P140 and P230).

151: 'I sent loyal ...': Letter 82 (tr. Frey).

151: 'I had thought ...': ALS (Carlton Lake) AdTL to LTC, Paris, 18 March 1883.

152: the most significant aspect of this fear: See Letters 89, 91 and Mack, p. 56.

152: 'moved [his] pillow': Letter 84 (tr. Frey).

152: 'The hard part ...': Ibid.

152: 'My work ...': Letter 83 (tr. slightly corrected by Frey). See Dortu P223 and charcoal drawings dated November 83 (Dortu D1625, D2746). 'D'Ennery' (a pun on Henry's own name) is Gustave Dennery, a friend from Cormon's.

152: 'thirty-eight votes ...': Letter 84.

152: 'Long live Manet ...': Letter 85.

152: 'Better and better ...': ALS (Carlton Lake) HTL to Amédée Tapié de Céleyran, Saturday, 24 March [1883]. See also Letter 24 (tr. Frey), misdated 1878.

153: 'as a journalist ...': Joyant 1926, I, p. 68.

153: Boldini / Sargent: See reproductions in Juilland and Vreeland 1982, pp. 31, 41.

153: 'spattering his canvas ...': Quoted in Juilland and Vreeland, 1982, p. 31.

153: 'Do you wish ...': Joyant 1926, I, p. 65, tr. Murray 1978a, p. 435.

154: 'What a mob ... Carolus-Duran': Ibid.

154: '"virilify" their brushes ...': Ibid.

155: 'You know ...': Attems 1975, pp. 263–4.

156: 'I'm not sorry ...': ALS (Carlton Lake) AdTL to LTC, Respide, Thursday, 19 July [1883].

156: he wrote to a comrade: Letter 86. Eugène Boch was a Belgian who worked at Cormon's

with Henry. At the time, Boch lived at the same Paris address as Rachou: 22, rue Ganneron. Later, Vincent Van Gogh would do a portrait of Boch.

156: 'ready to shelter': Ibid.

157: 'beginnings as a *châtelaine*': ALS (Carlton Lake) AdTL to LTC, Respide, Sunday [September/October 1893].

157: 'He's barely ever ...': ALS (Carlton Lake) AdTL to LTC, [Paris], Thursday, 11 October 1883.

157–8: 'Henry is enchanted ...': ALS (Carlton Lake) AdTL to LTC, Paris, Saturday, 20 October [1883]. The address of this studio unfortunately is never mentioned.

158: 'Right this minute ...': ALS (Carlton Lake) AdTL to LTC, Paris, Sunday, 25 November [1883].

158: blue-faced baboon: See drawing of Cardinal Lecot, Archbishop of Bordeaux, Huisman and Dortu 1964, p. 223.

158: 'I've just ...': Letter 101 (tr. Frey).

158: 'marvellous Chinese drapery': ALS (Carlton Lake) AdTL to LTC, Paris, 31 December 1883.

158: annual rent of 1,100 francs: Ibid. This sum was the equivalent of around £3000 a year in the 1990s. In 1989, studios in the same neighbourhood were let for four times that amount.

159: 'Poor little Madeleine ...': ALS (Carlton Lake) AdTL to LTC, Paris, Saturday, 16 February [18]84.

159: 'Please send ...': Letter 99 (tr. Frey).

160: 'which is really ...': ALS (Carlton Lake) AdTL to LTC, Paris, 30 May [18]84.

160: 'very busy ...': ALS (Carlton Lake) AdTL to LTC, Paris, Wednesday, 23 April [1884].

161: painted a number of cows: See Dortu P209, P235.

161: *traités en pochade*: See Gauzi 1954a, p. 12.

161: *artiste en faux bois*: Letter 106, 1883 (misdated 1884).

161: *Le Dressage des nouvelles danseuses*: Sometimes also called *La Danse au Moulin Rouge*.

161: 1893 poster of Jane Avril: See Dortu P361, Wittrock P4 and Cate and Boyer 1985, p. 74, figs. 52 [catalogue no. 12], 53, 54.

161: a team of painters from Cormon's atelier: Perruchot 1958, p. 83.

161: five minutes past nine: According to art historian Dennis Cate, this may refer to a possible date for the production of the painting: May 9. Cate and Patricia Eckert Boyer do a fairly complete analysis of this work in Cate and Boyer 1985, pp. 10–11.

162: 'and with bronzed rattlesnakes': Perruchot 1958, p. 77.

162: several thousand dollars: One franc in the late nineteenth century was equivalent to approximately £3.50 sterling or five US dollars in 1990s' purchasing power.

162: 'the upper reaches of art': Gauzi 1954a, p. 10.

162–3: 'For the time being ...': ALS (Carlton Lake) AdTL to GTL, Paris, Thursday, 19 June [1884].

163: 'As for Henry ...': ALS (Carlton Lake) AdTL to LTC, Paris, 20 July 1884.

163: 'Unfortunately ...': Ibid.

163: 'breathing the air ...': ALS (Carlton Lake) AdTL to GTL, Malromé par Saint-Macaire Gironde, Wednesday, 30 July [18]84.

163: 'Henry came ...': Ibid. See illustration in Murray 1991, p. 55.

163–4: 'The time ...': ALS (Carlton Lake) AdTL to LTC, Malromé [31 July 1884].

164: 'We've settled ...': ALS (Carlton Lake) AdTL to LTC, Malromé, 22 August [18]84. See Dortu P190.

164: 'Lately my artist ...': ALS (Carlton Lake) AdTL to LTC, Respide, 21 September [18]84.

CHAPTER SIX: TRECLAU
(pp. 165–222)

165: Cormon was very friendly: Letter 100: '... he was very nice.'

165: 'rather congratulated me ...': Letter 101 (tr. Frey). See also Letter 102. This painting may have been one of the Céleyran landscapes or portraits from the preceding summer.

166: '*la flânerie* ...': Gauzi 1954a, p. 138.

166: twenty artists, including Degas: See Perruchot 1958, pp. 85ff.

166: Lili Grenier: Information is taken largely from Destremau, p. 42.

166: '*Lili la Rosse*': See Gauzi 1954a, p. 137.

166: no firm evidence: Some obscene drawings Henry did between 1886 and 1888 have survived and have been said to depict him and Lili engaging in various sexual acts. It is not clear whether they represent realities, fantasies or merely sexual jokes which he shared with the Grenier couple. The drawings apparently were part of the couple's art collection. See Adriani 1986, p. 92 and pl. 32, 33.

167: 'Why is it ...': Quoted in Bonmariage, p. 30.

167: very flirtatious: See Gauzi 1954a, p. 137.

168: 'Our gang ...': Letter 101 (tr. Frey).

168: 'to become an oyster-monger': Letter 77 (tr. Frey). Misdated 1882, really 9 October 1884. Can be redated from ALS (Carlton Lake) AdTL to LTC, Albi, [September 1884].

168: 'I'm going ...': Ibid.

169: upset him disproportionately: Ibid.

170: 'They're capable ...': Letter 103.

170: 'Have you been ...': Letter 77 (tr. Frey).

170: 'I thought ...': Letter 102 (tr. Frey). The painting of oxen mentioned is probably Dortu P154. The 'Laffittes' are probably paintings done in an Impressionist style, like those exhibited at the Durand-Ruel gallery, located at 16, rue Laffitte.

170: 'I haven't ...': Letter 102 (tr. Frey).

170: 'There's been ...': Letter 92 (tr. Frey), misdated spring 1884, really November 1884.

171: *Le Figaro*: In fact his first drawings would only be published there in 1893.

171: Carmen Gaudin: Gauzi 1954a, pp. 129ff.

171: Adolphe and Joseph Albert: Information is summarized from Hansen, pp. 54–5.

171: exhibited in the official Salon: See Welsh-Ovcharov 1988, catalogue no. 121.

172: Students continued ... at home: Gauzi 1954a, p. 103.

172: 'to copy the model ...': Gauzi 1954a, quoted in Hansen, p. 63.

172: 'degrees of merit'/'a jury ...': ALS (Carlton Lake) AdTL to LTC, Paris, Easter 1885. Benjamin Constant was a distant cousin of the identically-named author of *Adolphe*.

172: 'Here horrible ...': Letter 103 (tr. Frey).

172: an excuse for staying out late: The best-known work by his friend Louis Anquetin, *L'Avenue de Clichy* (1887), focuses on the effect created by the gaslights from a butchers' shop in the evening darkness.

173: 'Not much to say ...': Letter 104 (tr. Frey).

173: 'I'm just about ...': Letter 107.

173: Henry's drawings ... were never used: See *Bataille de fleurs: Mail-coach à Nice* in India ink on Gillot paper, Dortu D2844. See also Letter 107, n. 3.

174: 'So, you think ...': Letter 79 (tr. Frey), misdated November 1882. The earliest this letter could be is November 1884, as Adèle was in Paris both the preceding autumns. In addition, Henry's cousin Madeleine, referred to in Schimmel's note, died in February 1884, not in autumn 1882.

174: 'My life ...': Ibid.

174: 'The studio ...': Letter 93, (tr. Frey), misdated June-July 1884. Actually *c.* 21 December 1884; see also ALS (Carlton Lake) AdTL to LTC, Hôtel Métropolitain, 8, rue Cambon, 21 December [18]84.

174: 'I'm told ...': Letter 106, misdated December 1884, actually December 1883. This letter can be dated by Henry's reference to a move to a permanent studio. He moved to his first permanent studio in the rue Lepic a month later, in January 1884.

174–5: 'He's much more ...': Attems 1975, p. 258.

175: 'is moving shortly ...': Grenier actually remained at 19 bis, rue Fontaine until 1886. See Thomson et al. 1991, p. 524.

175: 'He brought ...': ALS (Carlton Lake) AdTL to LTC, Hôtel Métropolitain, 21 December [18]84.

175: not quite two-thirds: In 1898, Henry received an annual income of approximately £50,000 from the Ricardelle vineyards. See ALS (Schimmel) Bernard Jalabert to HTL, Ricardelle [*c.* December 1898].

175: 'Every evening ...': ALS (Carlton Lake) AdTL to LTC, Paris, 15 January [18]85.

175: 'It's been snowing ...': Ibid.

175: neuralgia and boils: ALS (Carlton Lake) AdTL to LTC, 20 March [1885].

175: 'Henry had spent ...': Ibid.

175–6: 'suddenly fell ...': ALS (Carlton Lake) AdTL to LTC, Paris, Easter 1885.

176: 'in the greenery ...': Quoted in ALS (Le Bosc) AdTL to GTL, Céleyran, 23 April [18]85.

176: The committee ...': Letter 91 (tr Frey), misdated spring 1884. Actually around Easter 1885, as confirmed by AdTL's letters of the same period.

176: 'alongside some *Auvergnats* ...': Ibid.

176: 'rather tired': Ibid.

176: 'I don't believe it ...': Letter 94 (translation somewhat corrected by Frey). Misdated June-July 1884, but from the context and Adèle's letters it must be spring 1885.

177: 'A remarkable ...': See Huisman and Dortu 1964, p. 36.

177: Bordes: See Letter 101 n. 1: 'Ernest Bordes, born in Pau, fellow student of Lautrec at Bonnat's and Cormon's.'

177: 'The weather ...': Letter 111 (tr. Frey).

177: 'I must be ...': Letter 112 (tr. Frey).

177: One can only assume: My thanks to Beverley Conrad, M.A., a member of the San Francisco Psychotherapy Research Group, for suggesting Henry's unconscious motivation in this case.

178: 'which hardly ...': Letter 113 (tr. Frey), misdated July 1885, but from its context must be mid-May to early summer.

178: a brief holiday: Ibid.

178: When he got back ... Cormon's: Letter 108, misdated January 1885. From the context, it has to be July 1885. In addition, Adèle was in Paris in January 1885, so Henry would not have written her a letter.

178: 'his departure ...': ALS (Carlton Lake) AdTL to LTC, Paris, 26 July [1885].

178: spent a whole season in the company of an explorer: See Natanson 1951b, p. 49.

178: When Adèle left ... his son: ALS (Carlton Lake) GTL to LTC, Le Bosc, 15 June 1885 and Attems 1975, pp. 260–1.

178: 'And as for wanting ...': Letter 128 (tr. Frey), misdated July 1886, actually July 1885; cf. previous note.

179: 'I'm dutifully ...': Ibid.

179: 'Sunday ...': Letter 97 (tr. Frey), misdated August 1884 but actually August 1885. Lautrec was not in Paris in August 1884.

179–80: 'Now it's my turn ...': Letter 97 (tr. Frey).

180: 'Have you broken ...': Letter 98 (tr. Frey), misdated August 1884 but most likely August 1885.

180: 'It's quite cool ...': Letter 117.

180: Desiré Dihau, a distant cousin: Adriani 1986, p. 59.

181: Gauzi ... sparse black beard: See photo in Huisman and Dortu 1964, p. 48, and Dortu P276.

181: 'run the gamut of art': Hansen, p. 59.

181: Shocked ... nocturnal revels: Perruchot 1958, p. 107.

182: 'hunting crows'/'I'm here ...': Letter 118 (tr. Frey).

182: to hunt seals: Letter 118.

182: 'Try to get Kiki ...': Letter 119 (tr. Frey).

182: 'which for ... lens': Letter 123 (tr. Frey).

182: 'we circle ...': Letter 123.

182: astonishing processions: Perruchot 1958, p. 95.

183: Hanging on the cabaret walls: Murray 1991, p. 95.

184: Zola ... *Paris*: In *Oeuvres Complètes*, 1967, I, pp. 275–84.

184: 'would make a paralytic ...': De Bercy, p. 53, quoted in Mack, p. 96.

184: 'the woes ...': De Bercy, quoted in Mack.

185: 'THE MIRLITON ...': Huisman and Dortu 1964, p. 55.

186: ill-tempered and inhospitable: Perruchot 1958, p. 97.

186: 'Bruant ran ...': Pennell, p. 27.

186: 'From ten o'clock ...': Bruant quoted in Mack, p. 97.

186: Song lyrics quoted in Huisman and Dortu 1964, p. 55.

187: price of the *galopin*: Oberthur, p. 82.

187: Bruant published their work: Oberthur, p. 84.

187: 'very irregularly ...': Huisman and Dortu 1964, p. 51.

187: 'Silence ... I don't know': Perruchot 1958, p. 100.

188: 'We got in line ...': Quoted in Huisman and Dortu 1964, p. 56.

188–9: 'At the time ...': Gauzi 1954a, p. 88.

190: 'a strange girl ...': Symons 1922, p. 7.

190: 'the face ...': Warnod 1913, p. 34.

190–1: 'La Goulue ...': Quoted in Huisman and Dortu 1964, p. 92.

192: 'Toudouze': Edouard Toudouze, painter of portraits and '*compositions décoratives*'. See Goncourt 1956, IV, p. 1242.

192: a waiter from Le Chat Noir had been murdered: Murray 1991, p. 106, n. 62.

192: 'the ladies ...': Gauzi 1954a, p. 69.

192: 'tipping his hat ...': Joyant 1926, I, p. 83.

192: 'Don't say anything ...': Ibid.

192: 'dressed decently ...': Quoted in Gauzi 1954a, p. 69.

194: 'with her right foot ...': Bonnetain, *Mon Petit homme*, p. 37, tr. Huisman and Dortu 1964, p. 63.

195: Now, slowly ... avoiding sentimentality in the treatment: Murray 1978a, p. 68.

195–6: This work ... haystacks: See also: Monet's series of paintings titled *La Cathédrale de Rheims* (1892–4).

196: 'I have begun ...': Quoted in Huisman and Dortu 1964, p. 240.

197: 'I hope you ...': Letter 118 (tr. Frey).

197: not good enough to submit: Letter 95, misdated 1884, but impossible, as Henry was not in Paris in August 1884. Date of letter must be 15 August 1885.

197: 'Ah, Dayot ...': Letter 109 (tr. Frey). Schimmel 1991 has dated this January 1885, but from the context it seems more likely to be October 1885.

197: Armand Dayot: A journalist and art critic who wrote lengthy reports on the Salons. He reviewed Henry's work in 1893.

198: Federico Zandomeneghi: See Champion, p. 84.

198: Gauzi later said: See Gauzi 1954a, pp. 130–2.

198: top floor of the four-storey building: *Troisième étage* in French. See Archives de Paris, D1P4, Cadastre 1886.

198: 'Here Lautrec ...': Alexandre 1902, and quoted in Mack, pp. 71–2.

199: 'If Papa ...': Letter 130, misdated September or early October 1886, but this letter had to be before 6 May 1886. It was probably written on 24 April, as Henry's first quarter's rent was overdue.

199: 'I took pains ...': Letter 124 (tr. Frey), misdated spring 1886, but from the context it must be July.

199: referred to his father as 'Alphonse': Gauzi 1954a, p. 117.

200: Montmartre expressions: See Letter 75 (tr. Frey). Writing to his Grandmother Louise, he complained about the rain, saying '*ça ne déjute pas*' (literally: it won't stop juicing), then added, 'a choice expression which shows on my part an in-depth study of slang'. He did not add that in slang the verb also referred to male ejaculation.

201: 'once you understood ...': Quoted in Curnonsky preface to Henri de Toulouse-Lautrec 1938.

201: A high-class prostitute ... name: Joyant 1926, I, p. 212.

201: 'pachyderm in partibus': Attems 1975, p. 70.

201: 'Venetian tek-nik': Natanson 1951b, pp. 43–4, 52–3. Another example: when a mother promised her crying son that he could sleep in her bed if he would stop, Henry called the way the little boy clung to his mother's skirts for the rest of the evening 'wariness tek-nik'.

201: '*roup*'/a collection of ridiculous works of art: Joyant 1926, I, pp. 211–13.

201–2: 'giving jam ...'/'mustn't tell it ...'/'*ouax rababaou*'/'Once a friend ...': Ibid.

202: a bad son: See Letter 127, misdated spring 1886. This letter should logically be placed in October 1886, in the context of Letters 132 and 137. This is further confirmed by the opening of the fishing season mentioned in the letter, which is in October, not in the spring when fish are spawning.

202: 'tonsil tribulations': Letter 124 (tr. Frey), misdated spring 1886, but from the context is more likely to have been written in July 1886.

202: probably contracted syphilis: Natanson 1951b, p. 123. My belief that Henry had syphilis is based not only on the reports of his contemporaries, who stated that he was being treated for it, but also on numerous veiled allusions, in Henry's letters to his mother, to disgrace, venereal disease and medical treatments for an unnamed disease. Opinions on this subject are divided, and the family in particular denies that he could have had syphilis. The evidence is not conclusive and syphilis is not noted on his death certificate as a cause of death. However, given the secrecy surrounding any mention of the disease in the nineteenth century, and the disgrace and shame attached to venereal disease even today, it is not surprising that such evidence might have been intentionally hidden. I remain convinced that Henry had syphilis. This conviction colours many of my interpretations of his behaviour.

202: Bruant's song: The song went in part: '*C'est Rosa, j'sais pas d'où qu'a vient, All' a l'poil rouge, éun' têt' de chien.*' (That's Rosa – she comes from God knows where, With her hang-dog look and her red body hair.)

203: *'martyr du sigma'*: Bonmariage, p. 38.

203: *'ses femmes ...'*: Bonmariage, p. 39.

203: Henri Bourges: See Destremau, p. 52 for photo.

203: 'Everybody has it ...': Flaubert, p.78. See also Harrison et al., pp. 1628–41 and Zeldin I, pp. 304–6.

203: 'More than anyone ... impurity': *L'Hygiène du syphilitique* (Paris, 1897). Quoted in Perruchot 1958, p. 129.

204: Théodore Van Gogh ... Boussod et Valadon: See Welsh-Ovcharov 1988, p. 10.

204: 'And his dreams ...': Quoted in Welsh-Ovcharov 1988, p. 37.

204: 'weedy' and 'pinched': Hartrick, p. 41.

204: 'did not condescend ... back': Quoted in Welsh-Ovcharov 1988, p. 38.

204–5: 'I fancy ... in the future': A.S. Hartrick quoted in Welsh-Ovcharov 1974, p. 30.

205: 'If, when ...': François Gauzi, quoted in Welsh-Ovcharov 1974, p. 33.

205: A number of their drawings: See Dortu D2578, 2579, 2641, 2642. Works they clearly both did on the same day include: *Buste d'après un plâtre d'Antonio Del Pollaiuolo* (Van Gogh's is in the Rijksmuseum Vincent Van Gogh in Amsterdam; Henry's is in Albi, wrongly dated 1883–5), and drawings of statue of a woman. Henry's version is called *Torse d'après un moulage en plâtre* (in Albi, misdated 1883–6) and Van Gogh's, in the Rijksmuseum, is called *Etude de statuette en plâtre*.

205: portrait of Vincent Van Gogh: Schimmel has suggested this work may not be by Lautrec, but I find no evidence of any sort to dispute Joyant's claim.

206: possibly traded ... *Vue de Paris*: See Welsh-Ovcharov 1988, p. 74. (Rijksmuseum Vincent Van Gogh, Amsterdam, catalogues the painting as VVG F341a.)

206: of no importance to him: Letter 125.

206: hatred for varnished painting: See Gauzi 1954a, pp. 25–6.

206: a brush dipped in black ink on a piece of cardboard: See Dortu P77.

207: 'Lautrec was ...': Hartrick, pp. 91–2.

207: a gradual evolution: For a discussion of this, see Murray 1991, p. 90.

207: 'a most handsome boy'/'irreproachably well-bred': Letter 129 (tr. Frey), dated July 1886 by Schimmel. From Henry's description of the artist, this could not be, as Schimmel suggests, the atelier of René de Saint-Marceaux (1845–1915), who was twenty years Henry's senior.

207: working on sculpture/Carrier-Belleuse: Letter 120.

207: sent a 'small bronze': See Letter 116, misdated 1885, but more likely 1886, since Henry manifested his first interest in sculpture at that time.

207: *Gin Cocktail*: See Dortu D2965.

208: redid it several times: Letter 130, misdated September–October 1886, but actually *c.* April 24.

208: It is said ... generally supposed: See Natanson 1951b, p. 160.

208: He had maintained contact: Gauzi 1954a, p. 154.

208: Many of Henry's early drawings ... never wrote captions for them: Murray 1991, p. 98.

208: watercolour sketch of Alphonse: See watercolour painting, *Alphonse de Toulouse-Lautrec* by Forain, reproduced in Joyant 1927, II, p. 75.

208: made Henry very proud: Gauzi 1954a, p. 50.

209: In at least one work: *Au Cirque, dans les coulisses* (Dortu P321), 1887–8.

209: 'permanently adopted': Letter 140.

210: 'all individual misfortune ...': Quoted in Thurman, p. 253, which has further discussion of this widespread European attitude.

210: 'Henri IV': *Portrait de M. Lemerle*, 1890. See Catalogue, Musée d'Albi, p. 35, not listed in Dortu.

210 'H. Quatre': Around 1894. Henri Quatre was a nineteenth-century written variant of Henri IV.

210: Count of Toulouse: Letter IV 32.

210: a journalist accused him: Lepelletier 1899.

211: *'Me voilà ...'*: Letter 130 (tr. Frey), misdated September-October 1886, but probably 24 April 1886.

211: *'sale métier'*: Letter 124 (tr. Frey).

211: 'at the risk of ...': Letter 130 (tr. Frey).

211: Roger Claudon: Gauzi 1954a, p. 107 is the only source for Claudon's given name.

211: work in the country: Letter 130 (tr. Frey).

211: 'out in the sun'/'I'm somewhat cooked': Letter 129 (tr. Frey).

211: got sunburned and refused to continue: ALS (Carlton Lake) AdTL to GTL, Malromé, Wednesday, 4 [August 1886].

211: too cold for a model to pose nude: Letter 127.

211: A family anecdote: Attems 1975, p. 88.

211: 'absolutely terrifying': ALS (Carlton Lake) AdTL to ATC, 8 September 1886.

211: convinced Louis Pascal to visit and did his portrait: The *Seated Portrait of Louis Pascal* [Dortu P291] can be dated from ALS (Carlton Lake) AdTL to ATC, 8 September 1886.

211: 'My clean laundry ...'/'sky so black': ALS (Carlton Lake) AdTL to ATC, 8 September 1886.

211: 'far too fast': ALS (Carlton Lake) AdTL to LTC, Malromé, 17 October [18]86.

212: 'Naturally ...': ALS (Carlton Lake) AdTL to ATC, 8 September 1886.

212: finishing the huge model clipper: GTL, quoted in Attems 1975, pp. 265–6.

212: 'urgently': ALS (Carlton Lake) AdTL to LTC, Malromé, 17 October [18]86.

212: learning to growl: Letter 132.

212: 'for the winter': Ibid.

212: promptly made two paintings: See Dortu P323, 324.

212: 'I can't send ...': Letter 127, misdated spring 1886. Context places it in October 1886.

212: sent her its portrait instead: See Letter 132, n.1: 'Probably the dog depicted in the painting *Little dog* [Dortu P323] inscribed on the back by Grenier as given to Lautrec for his mother'.

212: 'didn't know how to draw': Abélès and Charpin 1992, p. 14.

213: 'the decaying ... nose of pessimism': Abélès and Charpin 1992, p. 8 quotes all three journals.

213: Entries in the Incohérents: Abélès and Charpin 1992, p. 94, entries 215, 224: Although Abélès has pointed out that there is no confirmation that Henry was the person who exhibited under the name Tolav-Segroeg, he referred to the Incohérents more than once and Letter 132 implies that he had submitted an entry to the show. It would certainly be in character for him to submit the kind of work attributed to Tolav-Segroeg in the catalogue.

213: 'an entry at the Eden': Letter 132 (tr. Frey).

213: the very title ... Cormon's studio: Bouret, p. 91.

213: 'oil painting on emery paper': Quoted in Cate and Boyer 1985, p. 15.

213: 'Tolav-Segroeg ...': Quoted in Cate and Boyer 1985, p. 15. See also Letter 132, n. 3.

214: 'in revolution ...': GTL quoted in Attems 1975, pp. 265–6.

214: despondent and penniless: Letter 126, misdated spring 1886, but probably November 1886.

214: In the spring of 1886: Destremau, p. 103, argues convincingly that it was April 1886. Other sources indicate that it was 1887.

214: Bernard ... pointy goatee: See Emile Bernard, Dortu Ic. 93, 94. See also Welsh-Ovcharov 1988. pp. 193ff, 318.

214–15: the unveiling ... Le Mirliton: See Thomson et al. 1991, p. 525.

215: hung with tambourines: Murray 1991, p. 144, n. 71.

215: It was in the café ... that spring: Hartrick quoted in Welsh-Ovcharov 1974, p. 30.

215: 'Cloisonist': The expression was coined by Dujardin in 1888.

215: pastiches of styles developed by others: See Louis Anquetin, *La Danse au Moulin Rouge*, c. 1893, reproduced in Cate and Boyer 1985, p. 74.

215: 'Personally ...': Letter 138 (tr. Frey).

215: 'very friendly'/'He has a little ...': Letter 126 (tr. Frey). Misdated spring 1886. Can be dated by Gervex-Freycinet duel to November 1886.

216: 'freezing hard ...': Leclercq 1921, p. 78.

216: 'with everybody ...': Letter 126 (tr. Frey).

216: even Alph didn't like it: Letter 138 (tr. Frey).

217: The *Chat Noir Guide*: In the cabaret's new location at 12, rue de Laval (later the rue Victor Massé). See Cate and Boyer 1985, p. 14.

217: exhibitions and costume balls given by the Incohérents: Cate and Boyer 1985, pp. 19–20.

217: admitted his work was suffering: Letter 129.

217: *Artilleur et femme* series: See Dortu 1972.

218: disdain ... Ecole des Beaux Arts: Gauzi 1954a, pp. 44–5.

218: 'Mars and Venus ... his trousers': Ibid. See also Letter 197, misdated 1891.

218: Venus of Montmartre: See *Fat Maria* (Dortu P229). Usually dated 1884–5, and redated 1886 by Murray 1991, p. 93, this painting is stylistically very close to the Lili Grenier portraits, usually dated 1888.

218: *Deux Pierreuses*: See Dortu D2897 and Welsh-Ovcharov 1981, catalogue no. 112 (not in Dortu).

218: *A La Bastille, Jeanne Wenz*: (Dortu P307), misdated 1888 but likely to be 1886–7.

219: *brasseries à femmes*: See Murray 1991, p. 139.

219: several more illustrations for Bruant: In 1887–8 *Le Mirliton* published *A Saint-Lazare*, *Jeune femme tenant une bouteille de vin*, *A Grenelle*, *Buveuse d'absinthe*.

219: 'For him ...': Gauzi 1954a, pp. 153, 158.

219: 'My model ...': Letter 138 (tr. Frey), misdated Paris, winter 1887. The true date is 17 September 1886, dated from ALS (Le Bosc) AdTL to GTL, 19 September 1886. See also Letter 197.

219: 'How do you expect ...': Gauzi 1954a, pp. 146–50.

220: 'To tell the truth ...': Gauzi 1954a, p. 158.

220: 'She's got brown hair ...': Quoted in Gauzi 1954a, p. 159.

220: 'I left Henry ...': ALS (Carlton Lake) AdTL to GTL, 25 [March 1887].

221: nothing to enter: ALS (Le Bosc) AdTL to GTL, Paris, 30 March [1887].

221: submitted another work to the Salon: Thomson et al. 1991, p. 525.

221: joke had backfired: See Gauzi 1954a, p. 46.

221: altered the title: Gauzi 1954a, p. 40.

222: 'We gave him ...': Letter 141, misdated 1885. Date of 1887 confirmed by Gauzi 1954a, p. 40.

CHAPTER SEVEN: TOLAV-SEGROEG

(pp. 223–93)

223: Although circumstantial evidence indicates that Henry used the name, no works with the signature Tolav-Segroeg have been found.

223: showed two works: Thomson et al. 1991, p. 526.

223: 'should not be encouraged ...': Jules de Lahondès, 24 June 1887, quoted in Attems 1975, pp. 264–5.

223: 'when you back up ...': Ibid.

224: 'I'm pleased ...': ALS (Carlton Lake) GTL to AdTL, Le Bosc, 2 May 1887.

224: 'bloodthirsty'/'after that scathing article': Quoted in Attems 1975, pp. 265–6.

224: 'If there only ...': Ibid.

224: 'bombarded with praise': ALS (Carlton Lake) AdTL to GTL, Paris, 8 May 1887.

224: given du Passage a work: Henry made three sketches of Charles du Passage (Dortu D3013–15).

224: 'It's almost too good ...': ALS (Carlton Lake) AdTL to GTL, Paris, 8 May 1887.

224: 'All I deserve ...': Letter 140, c. 15 May 1887.

225: 'a slight case ...': Letters 141, 142.

225: 'for the circus': Letter 142.

225: 'a large studio ladder ...' Gauzi 1954a, p. 115.

225: 'pretty stables': Smith, p. 247.

226: when the circus reopened: Letters 141, 142. If Letter 142 is dated correctly, this may be a concrete clue for dating the unfinished large circus painting which shows in a photograph of Henry in his studio, taken about 1890 (illustrated on p. 226).

226: *Toulouse-Lautrec et son modèle*: This 1895 painting, in the Musée Bourdin in Honfleur, shows Henry painting Cha-U-Kao. Hanging on the studio wall at right in the painting is the 'lost *écuyère*'. The details of how A. Voisard-Margerie came to do this painting are unknown.

226: 'in a trice': Gauzi 1954a, p. 120.

226–7: 'one day ...': Ibid.

227: against the studio wall: Gauzi 1954a, pp. 119–20.

227: 'anything that came ...': Perruchot 1958, p. 132.

227: Degas showed far more respect: Storm, pp. 56, 87–9.

228: likely Henry also was present: Storm, p. 56.

228: 'You who pose ...': Warnod 1981, p. 37.

228: 'who posed ...': Gauzi 1954a, p. 132.

228: the model ... riding instructor: Bouret, p. 126.

228: never saw or mentioned Suzanne Valadon again: Gauzi 1954a, p. 136.

228: '*cette pauvre Suzanne*': Letter 461 (tr. Frey).

229: collecting Japanese prints: Perruchot 1958, p. 124.

229: 'on account ... bill': ALS HTL to Alphonse Portier, 11 July 1887, location unknown. Sold at Hôtel Drouot on 6 October 1974. See Welsh-Ovcharov 1988, p. 331. See also Letter 145.

229: '*Le petit bas-du-cul* ...': Théo Van Rysselberghe, letter to Octave Maus, Paris [c. 7 July 1887], published in *Bulletin* (Musées Royaux des Beaux Arts de Belgique) 15 (1966), p. 67.

230: 'For anything new ...': Quoted in Dortu 1955, p. 7.

230: 'Belgian intransigent'/'alas undeserved praise': Letter 146 (tr. Frey).

230: Dodo Albert ... portrait of Henry: See Welsh-Ovcharov 1981, ptg. 121, n. 5. Adolphe (Dodo) Albert's portrait of Henry was done in 1887; Arsène Alexandre used it to illustrate an article in *Le Figaro illustré* (April 1902), p. 2.

230: Forain remained ... art world: Rothenstein I, p. 39.

231: 'For the last ...': Letter 146 (tr. Frey).

231: spent his work time ... Aline Gibert: Letter 143.

231: 'Henri is doing ...': Odon de Toulouse-Lautrec to GTL, 1 October 1887, quoted in Rodat, p. 85 and Beaute 1988, p. 110, who gives the date as 1 September 1887.

231: sent a painting ... the Hague: Welsh-Ovcharov 1988, p. 338.

231: Théo sold one: Rewald 1986, p. 104.

231: 'WORK HARD ...': Letter 134, misdated late 1886, but more likely March 1887. Capital letters are in original.

231: 'discretion'/'panic ...': ALS (Carlton Lake) AdTL to LTC, Paris, 11 December 1887.

232: Vincent Van Gogh/exhibition: Cate and Boyer 1985, p. 66. See also Welsh-Ovcharov 1988, pp. 39, 185–90, 311.

232: 'Impressionists of the Petits Boulevards': See Welsh-Ovcharov 1988, p. 12.

232: high bay windows: Destremau, p. 108.

232: 'He would arrive ...': Suzanne Valadon, quoted in Welsh-Ovcharov 1974, p. 35.

232: 'Nemo': Destremau, p. 113.

232: 'prostitute types': Emile Bernard 1924, p. 393, quoted in Murray 1991, p. 129.

233: for his personal collection: Théo finished paying Henry the 150 francs (around £300) purchase price on 12 January 1888. See Welsh-Ovcharov 1988, p. 322.

233: 'I do not think ...': Vincent Van Gogh, Letter 520 quoted in Welsh-Ovcharov 1988, p. 322.

233: emotionally dissociated from their surroundings: See Stuckey, pp. 22 and ff. for a discussion of this issue.

233: alienation and hostility: Beverley Conrad, M.A. suggested this idea in a telephone conversation, April 1993.

234: 'Landscape is nothing ...': Quoted in Cooper 1955, p. 78.

234: successive moments of a gesture: Lassaigne 1953, p. 19.

235: the Nabis: Melikian, p. 7.

235: 'But why are ...': Natanson 1951b, p. 157.

236: 'seizes one ...': Symons 1929, p. 358.

237: ten copies of the catalogue: Letter 162.

237: probably taken from his large circus canvas: Murray (1991, pp. 133–4) has formed the same supposition.

238: his initials/also be read as XX: See illustration in Murray 1991, p. 132, fig. 79.

238: three of the studies ... of Carmen Gaudin: Murray (1991, p. 133) thinks they are Dortu P343, P342 and P317.

238: 'portrait of a man': See *Monsieur François Gauzi* (Dortu P276) and Murray 1991, p. 131.

238: *Etude de face*: Possibly Dortu D3088 or (in Murray's opinion) P394.

238: *Etude de face* and *Etude de profil*: For a discussion of these two works, see Murray 1991, pp. 133–4.

238: an *écuyère*: Possibly Dortu P315. More likely the missing *écuyère* from his studio photo of around 1890.

238: a fan painted in watercolours: Probably Dortu A197.

238: *Au Cirque Fernando, l'écuyère*: Welsh-Ovcharov 1981, p. 38, remarks that this is Henry's 'most strikingly Japanist and Cloisonist painting of the 1880s'.

238: *Rousse (plein air)*: Thomson et al. 1991, p. 526.

238: Henry's success: Letter 177. By August 1890, Henry was charging 300 francs per painting.

239: a true artist: Lucien Solvay, quoted in Dortu 1955, p. 8.

239: 'the most interesting ...': P.-M. Clin quoted in Dortu 1955, p. 8.

239: 'precise ...'/'sometimes very hard lines ...': Ibid.

239: 'Certain feminine ...': Verhaeren, pp. 456–7. See also Murray 1991, p. 128.

239: 'It is in the south ...': Quoted in Holt III, p. 472.

239: the dating of Henry's striking *Gueule de bois* series: Although Joyant dates the Suzanne Valadon portraits to 1885, stylistically and in terms of subject matter they are more appropriately placed in 1887–9, when she modelled for Henry regularly.

239: The painting: Dortu P340.

239: a preparatory pastel: Dortu P339.

239: clearly not speaking of *Poudre de riz*: From the context, it also seems unlikely that Vincent was referring to the back view of a woman at a café table known as *A Grenelle, l'attente* (Dortu P328) dated the same year.

240: a companion piece: For a discussion of this see Welsh-Ovcharov 1981, p. 122.

240: Bruant, who purchased it: See Joyant 1926, I, p. 98.

240: works ranging ... paintings: Dortu P668 and P710.

241: 'Lautrec is seen ..': Gauzi 1954a, p. 53.

242: 'I expect ...': Huc 1899.

243: appropriate subjects for oil paintings: This concept is developed in Murray 1978a, p. 3.

244: drew on napkins: See illustrations in Beaute 1988, p. 114.

244: 'the victims ...': Lapparent, quoted in Cogniat, pp. 3–4.

244: On 10 March 1888 ... repeatedly in his work: Murray 1991 dates the related paintings *Bal masqué*, *Bal masqué* and *Bal de l'Elysée Montmartre* (Dortu, P301, P291 and P284) to 1888 because they are studies for the *Paris illustré* drawing.

245: a long-lasting fascination: Dortu D2969, 2970 and 3083. Several other stylistically similar works probably should also be dated to 1888: *Au Bal Masqué de l'Elysée Montmartre* (P285), *Souper* (P287), *Au Bar* (P288), *Bal Masqué à l'Elysée Montmartre* (P283). A tracing from a (possibly lost) larger work related to this last painting (Dortu D2960) is from the same year, though dated 1886 by Dortu 1971.

245: 'and others': Identified by Renée Vert's son, Dr. Louis Chouquet, quoted in Perruchot 1958, p. 207 n.

245: one of the few times Henry ever used this technique: See Cate in Wittrock and Castleman 1985, p. 77.

246: already famous ... laundresses: Lipton 1980, pp. 295–313.

246: horse-drawn trolleys: Jourdain 1951, pp. 17–18.

246: 'Posing for Lautrec ...': Gauzi 1954a, pp. 151ff.

247: 'transform one ...': Gauzi 1954a, pp. 153.

247: 'Don't thank me ...': Gauzi 1954a, pp. 152.

247: 'I have no news ...': Letter 144 (tr. Frey), misdated 1887, but really 1888, as it can be dated by Bourges' confinement to a tuberculosis asylum.

247: 'impure kiss': Letter 160 (tr. Frey).

247: 'I'm better ...': Letter 164 (tr. Frey).

248: '*Je vais changer* ...': Bonmariage, p. 44.

248: couldn't long resist: Ibid.

248: for his kindness: Letter 148, misdated 1898. He also mentioned that he was planning to build a case for the portrait Henri Rachou had done of him in 1883, to ship it to Adèle. Characteristically, he included a 114-franc bill for her to pay.

248: 'To tell the truth ...': Gauzi 1954a, p. 138.

248: got Lili to sit for two portraits: See Dortu P302, P303 [1888].

248: portraits of Albert Grenier: There is an oil painting of Albert Grenier [not in Dortu 1971] in the Metropolitan Museum of Art, New York. Henry also drew a portrait of Miss Dieterle, but it remains unidentified in the body of his work (see Bonmariage, p. 44).

248: the famous Auberge Ancelin frescos: Dortu 1971, II, P239–242, usually dated 1885. Murray 1991 has argued unconvincingly for 1886.

248: 'H. de Toulouse-Lautrec ...': Dortu P309.

248: works on ballet dancers: Huisman and Dortu 1964, p. 35. *Standing dancer in pink tights*, one of three 1890 studies of the same dancer, not in Dortu 1971. See also Adriani 1987, p. 114.

249: an *apache*'s red bandana: See Dortu P241.

249: caricature of . . . Gabriel: Gold, p. 56.

249: a series of ballet paintings: Including Dortu P262, P263, usually dated 1886.

249: watching the dancers from offstage: For an interesting discussion of this work, see Stuckey, p. 96.

250: a week or two at Arcachon: See ALS (Carlton Lake) AdTL to GTL, Malromé, 27 August [1888].

250: There . . . yacht basin that day: See Joyant 1926, I, p. 88, quoting ApTL and ALS (Carlton Lake) AdTL to GTL, Malromé, 27 August [1888]: *'Nous sommes seules depuis trois jours car Henry est allé passer une ou deux semaines à Arcachon. Il m'écrit qu'il est à l'Hôtel de France, et ravi naturellement de la saumure et du bateau. Il était très gracieusement invité à des promenades sur mer par M. de Damremont qui est outillé luxueusement et est en quelque sorte le roi maritime d'Arcachon.'*

250: 'very good'/'in the morning . . .'/'even though Henry . . .': ALS (Carlton Lake) AdTL to LTC, Malromé, 10 October [1888]. The only dates given by Dortu to works representing oxen are P154 (1882), P209 (1883) and P235 (around 1884). All three works could conceivably be from the same period, and all three appear consistent enough in style to be temporally related. Although Adèle's letter carries no year, and might possibly be 1884 or 1885, 1888 seems likeliest from the context.

250: Adèle bought . . . mechanical ostrich: See ALS (Carlton Lake) AdTL to LTC, Wednesday, 4 January [probably 1888], and Letter 182.

250: 'I've just sent . . .': Letter 210.

250: 'I'm writing you . . .': Letter 165.

251: patient's teeth black: Pierre Devoisins 1958, p. 83, and Ellman, p. 92.

251: 'I'm in good shape . . .': Letter 165 (tr. Frey).

251: he wrote to her on New Year's Day: Letter 157, misdated by Henry himself as 1 January 1888, but must be 1889, as he was in Paris at Christmas 1887–8.

251: a group show: At the Société des Amis des Arts, Musée de la Ville. See Thomson et al. 1991, p. 527.

251: his 'uncle': Georges Séré de Rivières was Adèle's second cousin, and not precisely Henry's uncle, but in the family he was called 'Oncle'.

252: Georges who mediated: Sadoul and Séré de Rivières 1964, n.p.

252: 'They talked . . .': Ibid.

252: a sort of high giggle: Natanson 1951b, p. 170.

252: 'Hélène . . .': Letter 23 (tr. Frey). See also drawings in Beaute 1988, p. 83, of a dog dressed as a man, and the caricature of Henry as a dog.

252: 'Marie de Rivières . . .': Letter 157.

253: how many drinks Henry must have had: See Stuckey, p. 145.

254: Joseph Albert: Ibid.

254: the first owner of the painting: Gauzi 1954a, p. 86, says Adolphe (Dodo) Albert was the model. No owner is listed in the 1889 Salon des Indépendants catalogue, where Henry first showed the painting, and in January 1890, when he showed it at Les XX in Brussels, the owner is listed as the collector Montaudon (see Welsh-Ovcharov 1981, painting no. 121.)

254: The preparatory drawings indicate: See Welsh-Ovcharov 1981 painting no. 121, n. 6, and Stuckey, pp. 144–5.

254: *Femme à la fenêtre*: Dortu P351, signed and dated 1889 by Henry. For other works, see Murray 1978a, pp. 323–4.

254: Henry's dating of works: Examples of this include a Tristan Bernard portrait etching done

in 1898 and inscribed 1899 (Israel Museum) and a number of early works inscribed to Stern around 1898.

254: 'There are some Lautrecs ...': Van Gogh III, p. 551, letter T16. Quoted in Murray 1978a, p. 322.

254: a photograph of Henry: See photograph in Beaute 1988, p. 52, *Lautrec au Moulin de la Galette avec La Goulue*.

255: 'What will happen ...': Letter 153 (tr. Frey), misdated 1887, but probably 1889. See Murray 1991, p. 139.

255: All Henry's published illustrations: *Le Moulin de la Galette* (drawing for painting *Au Bal du Moulin de la Galette*) (April 19); *Gueule de bois* (Suzanne Valadon) (April 21); *A la Bastille, Jeanne Wenz* (May 12); *Boulevard Extérieur* (reversal of painting of Carmen Gaudin in doorway) (June 2).

255: Gradually Henry had grown: The number of Adèle's letters which have been preserved falls off enormously about 1888, around the time Henry is fully independent and beginning to become famous. Similarly, there are fewer letters from him to her.

255: 'I don't know why ...': Letter 153 (tr. Frey). It seems likely that Henry did not exhibit in the XX Exhibition in Brussels in 1889.

255: 'verdigris ...': Letter 153 (tr. Frey).

256: 'Bourges is being ...': Letter 170 (tr. Frey).

256: report to his mother: Gauzi 1954a, p. 59.

256: a caricature by Lunel: See illustration in Murray 1980b, pp. 71ff.

256: 'a threat to bourgeois morality ...': Murray 1980b, p. 71.

256: *épater les bourgeois*: Vaucaire quoted in Murray 1980b, p. 69.

256: Exposition Universelle des Arts Incohérents: See Roberts-Jones 1958, pp. 235–6, and Cate 1988, p. 66.

257: 'Tolav-Segroeg'/'address rue Yblas ...': Quoted in Perruchot 1958, p. 130.

257: he exhibited a portrait: Entry no. 113: *Portrait*.

257: as often as possible: Gauzi 1954a, p. 41.

257: Théo Van Gogh explained: Van Gogh III, p. 544, letter T10.

257: too self-centred: Cooper 1955, pp. 103–4.

257: late to join the 'anti-Naturalists': For a discussion of Henry's anti-Naturalism, see Welsh-Ovcharov 1981, p. 38.

258: 'empty prowess and cheap tricks': Welsh-Ovcharov 1981, p. 46.

258: *La Cravache*: 'Autre Groupe impressioniste', 6 July 1889. Even the Beaux Arts exhibition attracted only a limited crowd. Art remained the interest of an exclusively middle to upper class, highly-educated public. Three-quarters of the people at the Exposition Universelle did not go to the art show. See Zeldin II, p. 445.

258: its profound effect on their work: Welsh-Ovcharov 1981, p. 41.

258: *Monsieur Fourcade*: Dortu P331.

258: In September, Henry exhibited: The fifth Salon des Indépendants opened on 3 September 1889. Henry's works were nos. 257, 258 and 259. See Thomson et al. 1991, p. 527.

258: 'We've been caught ...': Letter 170 (tr. Frey).

258: 'The Toulouse-Lautrecs ...': Pissarro 1986, p. 136 (Paris, 9 September 1889).

258: without copying either: Welsh-Ovcharov 1981, catalogue no. 121.

259: 'distilled his blessed saliva ...': Letter 170 (tr. Frey).

259: 'My work ... get upset': Letter 121 (tr. Frey). Although in the 1991 edition of Henry's correspondence Schimmel redates this letter to 1885, I find no evidence to support the redating. It fits perfectly in the context of other 1889 letters.

259: 'I'm still dragging ...': Letter 173 (tr. Frey).

260: for the occasion: Bouret, p. 100.

260: there had previously been a dancehall: Lassaigne 1976, p. 17.

260–1: 'he built a beautiful ...': Ibid.

261: Even its location proved to be advantageous: See Richard Thompson in Wittrock 1985, p. 15, who develops this observation.

261: 'a most Parisian spectacle ...': Lassaigne 1976, p. 17.

261–2: 'like a railway station ...': *Guide des Plaisirs à Paris*, quoted in Mack, pp. 128–30.

262: 'tattered wooden representations ...': Symons 1922, p. 5.

262: 'He was the only ...': Symons 1922, p. 7.

262: 'take a few turns ...': Ibid.

263: 'the detail that ...': Hartrick, p. 157.

263: 'In his pictures ...'/'magnificent and abnormal'/'heartrending': Symons 1922, p. 10.

263: 'Lautrec ... men and women': Symons 1922, pp. 6–7.

263: 'their obscenity ...': Symons 1922, p. 12.

264: shared his table: See Rothenstein I, pp. 62ff.

264: Henry found Dujardin most interesting: Huisman and Dortu 1964, p. 55.

264: a portrait of Marie: *Mlle Dihau au piano* (Dortu P358).

264: Degas' portrait of her: Painted 1869–72. Adriani 1987, p. 104.

265: 'Lautrec's portrait ...': Quoted in Cooper, p. 86.

265: 'Pour Toi': See also preliminary sketch, Dortu A20.

265: ridiculous beside Degas' works: Cooper, p. 86.

265: 'go and see Degas' picture': Letter 255.

266: lack of foreground: Lassaigne 1953, p. 19.

267: example of his success: See Gauzi 1954a, pp. 144–9.

267: 'At the end of January ...': Letter 173.

267: a group show in Pau: Musée de la Ville, Société des Amis des Arts de Pau, 15 January to 15 March 1890. See Thomson et al. 1991, p. 562.

267: five works: They included 'Le Bal au Moulin de la Galette' (*Au Moulin de la Galette*, Dortu P335); 'La Rousse' or *Femme rousse assise par terre, de dos, nue* (*La Toilette*, Dortu P610); 'Liseuse' or *Femme assise en rose* (*La Liseuse*, Dortu P349); 'Etude' (*Femme à l'ombrelle dite 'Berthe la Sourde', assise dans le jardin de M. Forest*, Dortu P360); and 'Etude' (not identifiable). See Murray 1991, p. 266. Henry apparently did not show in the 1889 XX, but it is not known why.

268: riotous banquet: Natanson 1951b, pp. 165–6. See also Maus, *La Lanterne magique* (1915) quoted in Dortu 1955, p. 10.

269: 'I may be short ...': Gauzi 1954a, p. 56.

269: The kindest of these critics: Edgar Baes in *La Revue Belge* (15 February 1890), quoted in Dortu 1955, p. 9.

269: 'mish-mash ... not without talent': All quoted in Dortu 1955, pp. 9–11

269: 'apoplectic ... catches personalities': Dortu 1955, p. 116, quoting Eugène Demolder in *La Société nouvelle* (*c.* January 1890).

269: 300 francs each: Letter 177.

269–70: To put these prices ... 'a gallery of pictures': All statistics from Zeldin II, pp. 459–61.

270: the Goupil Gallery: Welsh-Ovcharov 1988, p. 344.

270: 'cared little ...': Zeldin II, p. 466.

270: 'I'm still feeling ...': Letter 175.

271: 'Dear Monsieur Monet ...': Thomson et al. 1991, p. 528, quoting Geffroy 1922, p. 151.

271: first exhibition of the Société Nationale des Beaux Arts: See Cate and Boyer 1985, p. 66 and Welsh-Ovcharov 1981, Lautrec Chronology (n.p.).

271: 'Models are scarce ...': Letter 175.

271: 'brave the dangers ...'/'decidedly odious': Ibid.

271: after-dinner port: Gauzi 1954a, p. 122.

271: On another occasion ... 'what a woman looks like': Gauzi 1954a, p. 124.

272: propositioning the maid: Gauzi 1954a, p. 126.

272: 'Every night ...': Symons 1929, p. 356.

272: 'the single attractive figure'/'a wild ...': Rothenstein I, pp. 62ff.

272: 'the beauty of ...': Symons 1929, p. 356.

272: 'a very graceful ...': Alexandre 1902, p. 12.

272–3: 'She danced in a ...': Symons 1922, p. 7.

273: 'She danced before ...': Symons 1922, p. 8.

273: 'as friends': I have not been able to locate the source of this Jane Avril anecdote, although it is repeated by several Lautrec biographers.

273: 'You know what ...': Letter 176.

274: 'The other day ...': Letter 177 (tr. Frey).

274: 'was the big event': ALS (Carlton Lake) AdTL to GTL, Malromé, 1 September [1890 – date confirmed by ALS (Carlton Lake) Odon de Toulouse-Lautrec to GTL, 4 September 1890]: 'fait la joie'.

274: 'salt life'/'under his layer ...': ALS (Carlton Lake) AdTL to GTL, Malromé, 1 September [1890].

274: 'It has developed ...': Gauzi 1954a, p. 50.

274: 'having gotten used ...': Letter 150, misdated Arcachon, summer 1887, but really Paris, early September 1890. Account of cormorant confirmed by ALS (Carlton Lake) AdTL to GTL, Malromé, 1 September [1890].

274: 'came to a sad end ...': Letter 150.

274: keeping him from hunting: ALS (Carlton Lake) AdTL to GTL, Malromé, 1 September [1890].

274: 'It's odd ...': ALS (Carlton Lake) Odon de Toulouse-Lautrec to GTL, Le Haichois, 4 September [18]90.

274–5: 'Papa and I ...': Letter 181 (tr. Frey).

275: 'to the other great man': See Joyant 1926, I, p. 118.

275: *Femme en toilette* ...: Redated Murray 1991, p. 251, to 1889.

276: portrait of Désiré Dihau: Dortu P379.

276: *Casque d'Or*: Dortu P407.

276: According to Gauzi: Gauzi 1954a, p. 84.

276: *Gabrielle la danseuse*: Dortu P359.

276: far too dressed up: Adriani 1987, p. 107.

277: 'My dear Toulouse ...': The original of this letter is in the Musée d'Albi.

277: We do know that: Storm, p. 93.

277: 'What you say ...': Letter 189 (tr. Frey). Although Schimmel 1991 translates this letter in a way that implies that the woman could have been an aristocrat, there is nothing in the original French to support that translation.

278: 'a brief, joyous chuckle': Leclercq 1943, n.p.

278: 'Sometimes he would ...': Ibid.

278: 'a history written ...': Alexandre 1902, p. 17.

278: 'At the theatre ...': Alexandre 1902, p. 18.

278: a presentation of *La Fin d'Antonia*: Probably in June 1893.

278–9: 'signs of impatience ...'/'Dujardin is right ...'/'I don't understand ...': All direct quotes are from Gauzi 1954a, p. 102.

279: 'not his profession'/'side dishes'/'labyrinth': Leclercq 1943, n. p.

279: 'I almost got roasted ...': Letter 184 (tr. Frey).

279: 'Bourges ... glasses': Letters 183, 185.

279: mentioning in one letter: Letter 184 (tr. Frey).

280: 'That way the move ...': Letter 189 (tr. Frey).

280: a *miroir de style*: Ibid.

280: 'it had a rough ...': Letter 182 (tr. Frey).

280: 'Each of us ...': Letter 182 (tr. Frey).

280: 'What a pity ...': Letter 186.

280: Dodo Albert ... already a master: Adhémar 1965, p. viii.

281: Over the next ten years ... monotypes: Wittrock 1985, I, p. 35.

282: Juliette Vary: Although this model has frequently been called Hélène Vary or Hélène V., her real name was Juliette Vary. The model (later known by her married name, Juliette Vignier) pointed out the error and identified herself as the model for another painting, *Portrait of Mme P.* (a profile portrait of a woman in a matching silk dress and hat, seated with a closed parasol). See Catalogue, Musée d'Albi, p. 102.

282: 'flattering': Letter 188.

282: 'You feel ...'/'M. de Toulouse-Lautrec ...': Dortu 1971, I, p. 37.

283: Henry's entries ... as it was: Letter 185 (correct date is 27 January 1891).

283: 'I feel as if ...': Letter 187 (tr. Frey).

283: inspiration for the series: Gauzi 1954a, p. 146.

283: portrait of Gaston Bonnefoy: Dortu P410.

283: another of his cousin ... a separate study: See Dortu P467, P466 and Letter 186.

284: his constant companion: The relationship between Henry and his cousin was often depicted by Henry himself in his cabaret paintings. It is referred to in almost every account of his life. See ALS (Schimmel) LTC to AdTL, 22 November 1898.

284: within the city limits: Rue de la Tour, see Adhémar 1951, p. 230. However, in Letter 192, Henry gives Guibert's address as 28, rue Desbordes Valmore in Passy. See also Letter 194, n. 2, which gives Maurice Guibert's life dates (1856–1913) and says his mistress was named Mariette Berthaud.

284: Guibert in Passy: ALS (Carlton Lake) HTL to GTL, Paris, [*c*. February 1890].

284: the national photographic society: Société Française de Photographie. See Adhémar 1951, p. 229.

285: photographs of Henry: Guibert's brother Paul donated Maurice's large collection of amateur photographs to the Bibliothèque Nationale when he died.

286: 'unbearable ...': Natanson 1951b, p. 32.

286: a period of intense productivity: Letter 189.

286: two anecdotal works ... *A la mie*: Dortu P383, P365 and P386.

286: only the last two ... catalogue: Dortu 1955, p. 9.

286: 'a no doubt ...': 'Petites Expositions: Oeuvres intéressantes de Toulouse-Lautrec chez MM. Bernheim jeune', *The New York Herald*, Paris (13 October 1908): n.p.

286: 'stood out ...': Emile Verhaeren, *L'Art moderne* (5 April 1991), quoted in Dortu 1955, p. 9.

286: 'in spite of ...': Mirbeau 1891, n.p.

287: as much as two-fifths: Destremau, p. 118.

287: 'Thursday ...': Letter 190 (tr. Frey).

287: *Au Coin du Moulin de la Galette*: Dated 1892 by its owners, the National Gallery, Washington D.C.

287: 'I also would like...': G. Lessauly, *Bataille* (31 May 1891). (This and the following clippings are all in the Toulouse-Lautrec dossiers of the Musée d'Orsay in Paris. They have not been listed in the bibliography.)

287: 'rare'/'the nobodies': Unsigned, *Soleil* (31 May 1891).

287–8: 'The first thing...': Al. Georges, *L'Echo de Paris* (31 May 1891).

288: 'amusingly fanciful': *Le Matin* (31 May 1891).

288: 'The only works...': Arsène Alexandre, *Paris* (1 June 1891).

288: 'I know several...': Letter 191 (tr. Frey).

288: 'It would be most kind...': Ibid.

288: 'I spend...': ALS (originally from Privat collection, current owner unknown) HTL to AdTL [late summer or early autumn 1891]. Sold by B. Altman & Co., N.Y., December 1983 (price $1850). A similar letter is partially quoted as Letter 192. They may be the same, despite inconsistencies, as Schimmel did not own the letter he quoted.

288–9: 'then he vanished...': Gauzi 1954a, p. 50.

289: 'I hadn't expected...': Letter 204 (tr. Frey).

289: 'opened his cash box...': Letter 205.

289: 'a small increase...': Letter 205 (tr. Frey).

289: 'Degas has been...': Ibid.

289: 'fussy': Letter 204 (in English in the original).

289–90: 'Business, moreover...': Letter 205 (tr. Frey).

290: 'mono-painter... he was interested...': Tapié de Céleyran 1922, p. 355.

290: 'another time...': Rothenstein I, p. 64.

290: 'If I hadn't...': Tapié de Céleyran 1922, p. 355.

290: Péan/wanted to be a painter: See Baragnon, p. 100, and Thomson et al. 1991, p. 158.

291: 'his immaculate...': Didier, p. 40.

291: 'prickly with haemostats...'/'Look...'/'on the spot: Ibid.

292: jaw or throat: Dortu P384, incorrectly titled *A trachaeotomy operation*. The title when it was exhibited in Brussels in 1902 was *Le Docteur Péan opérant*.

292: foreground of the painting: For a discussion of the work, see Adriani 1987, p. 125.

292: *Une Opération par le Docteur Péan à l'Hôpital International*: Dortu P385.

292: at least forty-three drawings: Dortu D3155–3198.

292: among his family's possessions: Didier, p. 41.

292: similar problems with alcohol: Letter 413, n.2, and conversation with Marc Tapié de Céleyran, 14 August 1983.

292: baited Gab mercilessly: Leclercq 1958, p. 44.

292: Gabriel actually wore it: Leclercq 1943, n.p.

CHAPTER EIGHT: MONSIEUR HENRI
(pp. 294–346)

294: a cousin was still claiming: Sadoul and Séré de Rivières 1964, n.p.

294: disintegrate with time: Natanson 1951b, p. 182.

294: 'fist in the face': '*Coup de poing*', Natanson 1951b, p. 182.

295: 'when these women...': Virmaître 1893, p. 142, quoted by Richard Thomson in Wittrock 1985, I, p. 19.

295: 'vigorous charcoal . . .': Richard Thomson in Wittrock 1985, I, p. 20.

296: cheaply and in large numbers: Adriani 1986, p. 308.

296: 'a red windmill . . .': Richard Thomson in Wittrock 1985, I, p. 16.

296: 'Lautrec is a master!': Adhémar 1965, p. 9.

296: 'I still remember . . .': Quoted in Huisman and Dortu 1964, p. 91.

296: Thadée Natanson claimed: Natanson 1951b, pp. 168–70.

297: 'some printer's . . .': Letter 212 (tr. Frey).

297: 'My poster . . .': Letter 211 (tr Frey).

297: 'On re-reading . . .': Ibid.

297: the recipes he used: In 1930, Maurice Joyant published a collection of Lautrec's recipes: *La Cuisine de Monsieur Mono* (Paris: Editions Pellet). It was republished in 1966 as *L'Art de la Cuisine* by Toulouse-Lautrec and Joyant (Lausanne: Edita).

297: 'You grill . . .': Unattributed quote found in Attems 1975, p. 72.

297: 'completely suppress . . .': Letter 196 (tr. Frey), misdated early July 1891, but from the context, this letter was written in the autumn of 1991.

297: 'black' rainy weather: Letter 206 (tr. Frey).

297–8: 'My influenza . . .': Letter 212 (tr. Frey).

298: 'my excuse . . .': Letter 198, misdated July 1891, but from context follows Letter 196 (tr. Frey).

298: *Etude de jeune fille*: Dortu P325.

298: smoking a cigarette: See Thomson et al. 1991, *Femme cigarette* (Dortu P362).

298: He also showed five paintings: See Adriani 1987, p. 121, and Murray 1978, p. 419; the latter believes three of these were probably Dortu P509, P539 and P540.

299: Suzanne Valadon: Gauzi 1954a, p. 132.

299: 'We just opened . . .': Letter 212 (tr. Frey).

299: a brilliant future: Destremau, p. 119.

299: 'my stuff . . .': Letter 215 (tr. Frey). The article, by Arsène Alexandre, was in *Le Paris* (8 January 1892).

299: the XX show in 1892: See Henry's letter to his mother about the Brussels exhibition published in Huisman and Dortu 1964, p. 160 (n.d.) and Letter 216. For a description of the opening, see also Pissarro 1950, letter of 17 February 1892.

299: accompanied/by Maurice Guibert: Letter 216 (tr. Frey). This letter is photographically reproduced in Dortu 1955, plate 12. The Schimmel 1991 translation of the letter results from a misreading of the word *ventres* [bellies] as *centres* [centres].

299: 'open a few . . .': Letter 216 (tr. Frey).

299: 'satisfactory . . .': Ibid.

299: Henry showed nine works: See Letter 214 for list of works submitted, and Dortu 1955, pp. 11–12 for commentary.

299: Salon de l'Association pour l'Art: See Thomson et al. 1991, p. 545 and Letter 219, n. 2.

299: six days in Belgium: 3–8 February 1892. See Schimmel 1992, p. 159, Huisman and Dortu 1964, p. 160, and Dortu 1955, pl. 12.

300: Picard later commented: In *L'Art moderne* (13 March 1892), 'Clôture de Salon des XX'. (See Letter 217, nn. 2, 3. Schimmel dates Lautrec's visit to Picard as 1890 but gives no evidence for that dating.)

300: 'Go downstairs . . . Go in anyway': See Jean Adhémar, personal notes: 'Anecdote que raconte en 1975 Edouard Van Dievoiet'. Probably after Henry's death, Mr. Van Dievoiet heard the architect and art professor Henry Van de Velde, who had known Henry, talk about the importance of his art and was so impressed that he bought a complete series of Henry's posters. See Dortu 1955, p. 12.

300: 'There's vice ...': Eugène Demolder, *La Société nouvelle*, p. 347, quoted in Dortu 1955, p. 12.

300: 'You can't miss ...': Eugène Georges, *La Libre Critique* (13 March 1892), quoted in Dortu 1955, p. 12.

300: Roger Marx: Co-editor of *L'Image* and artistic director of *Le Voltaire*. See Letter 218, n. 2.

300: 'I authorize ...': Letter 218 (tr. Frey).

300: clumsily 'adapted': The pastiche referred to, an 1885 illustration in a popular magazine, contained not only images copied from Henry's work, but a caricature of the artist himself. Unfortunately the author has seen this work only in a photocopy given to her by Jean Adhémar, without attribution.

300: 'We are only ...': Letter 223 (tr. Frey).

300: *Le Pendu*: Dortu D340. The poster was printed in Toulouse by R. Thomas & Cie. from stones prepared by Henry, which implies that he did the work there, although it is not certain that he did so.

301: the Calas affair: Jean Calas died on the rack in 1762. Voltaire made the Calas case famous in his *Traité de la tolérance* (1763) as it became evident that Calas had been condemned for his Protestant beliefs and not for committing any crime.

301: small second edition: Wittrock P15.

302: more for its symbolic reflection: Beverley Conrad, M.A., suggested this motive.

302: 'For the rare men ...': Adhémar 1951, p. 231.

302: as an altar-boy: See Adhémar 1951, p. 229.

302: There was also a chariot: Georges Montorgueil quoted in Adhémar 1951, p. 230.

302: 'Now painters ...': Edmond de Goncourt quoted in Adhémar 1951, p. 230.

303: *Ambassadeurs, Aristide Bruant*: Wittrock P4.

303: One anecdote claims: Gauzi 1954a, p. 108 and Adhémar 1965, p. xiii.

304: 'the directors ...': Letter 393.

304: *La Revue blanche* had published: Perruchot 1958, p. 213.

304: Victor Joze Dobrski de Zastzebiec: Bibliothèque Nationale and Queensland Art Gallery 1991, p. 204.

304: Georges Laserre and Luzarche d'Azay: Adriani 1987, p. 136.

304–5: 'I'm finally ...': ALS (Carlton Lake) HTL to AdTL, Paris, Thursday [26 May 1892]. Partially reproduced as Letter 224.

305: Giuseppe Ricci: Letter 225, n. 2.

305: Pissarro mentioned: Pissarro 1990 (letter from Paris, 17 May 1892).

305–6: 'I'm already ...': Letter 225.

306: 'the things ...': Letter 226.

306: 4 and 3 francs respectively: See Adriani 1986, p. 136, Desloge et al., p. 204 , Wittrock and Castleman 1985, p. 82, and Adhémar 1965, pp. xiii-xiv.

307: liking Nietzsche and Balzac: Natanson, 1951b, p. 18.

307: Eugène Scribe and Rodolphe Töpffer: Letter 200, n. 2.

308: 'up to her armpits': Gauzi 1954a, p. 112.

308: 'Your natural ...': ALS (Collection P. Monart 60610 La Croix Saint-Ouen) HTL, to AdTL, autumn or winter of 1892–3. Quoted with minor changes in Letter 260. Given to the author in copy by Jean Adhémar.

308–10: 'Tall, thin ...': Symons 1918, n.p. (tr. Frey from the French, as the English original was unavailable).

310: 'Her inborn ...': Roger-Marx 1950, n.p.

310: 'He came ...': Yvette Guilbert quoted in Brécourt-Villars, p. 155.

311: 'for the love ...': Huisman and Dortu 1964, p. 109. The design is D519.

311: 'Lautrec, he's worthless!': Guilbert 1927, p. 269.

311: 'Really, Lautrec ...': Guilbert 1927, p. 272.

311: 'I at once ...': Ibid.

311: 'One day ...': Guilbert 1927, p. 273.

312: the rejected sketch: See Dortu C1.

312: into epic dimensions: Roger-Marx 1950, n.p.

312: her autobiography: *La Chanson de ma vie, mes mémoires*, Paris, 1927.

312: 'Ugliness ...': Guilbert 1927, p.270.

312: deeply in debt: ALS (Carlton Lake) HTL to Adèle Tapié de Céleyran, Thursday [26 May 1892].

312: at least twenty-two letters: See Letters 224, 228, 232, 233, 237, 238, 240–4, 250–3, 257, 259–61.

312: 'you mustn't ...': Letter 228 (tr. Frey).

312: 'I would like ...'/'a good part ...': Letter 227 (tr. Frey).

312: 'categoric answer': Letter 240 (tr. Frey).

312–13: 'Did you know ...': Letter 233 (tr. Frey).

313: 'as for the way ...': Ibid.

313: 'My little jobs ...': Letter 236 (tr. Frey).

313: 'they got between ...': Letter 237 (tr. Frey).

313: a boat to Bordeaux: See Letter 422 (tr. Frey), where Henry mentions that he has been working all summer 'which is ridiculous' and is planning to 'forget professionalism a little' on a sea voyage.

313: an excited letter: Letter 246.

314: *La Goulue et sa soeur*: Wittrock 1.

314: *L'Anglais au Moulin Rouge*: Wittrock 2.

315: turned up in a lithograph themselves: See the cover for *L'Estampe originale* (Wittrock 3), 1893 (illustrated on p. 323).

315: 'My Aunt Odette ...': Letter 248.

315: *Danseuse assise sur un divan rose*: Dortu P248.

316: 'This canvas ...': Letter 248, n. 2.

316: *Au Nouveau Cirque, Papa Chrysanthème*: See preparatory sketches Dortu P406 and P404.

316: fragmented by the frame: See Adriani 1987, p. 130.

316: 8,600 francs a month: Jean Devoisins *c*. 1985, p. 120.

317: the real beginning of Art Nouveau in France: See *Le Livre des Expositions Universelles*, Editions des arts décoratifs (Paris, 1983) p. 109.

317: different from the others: *Miss Loïe Fuller* (Wittrock 17). See Griffiths in Wittrock 1985, I, pp. 41, 44.

317: a portrait of his friend: *La Plume* 90 [15 January 1893] p. 30, illustrating an article by Charles Saunier: 'Henri-Gabriel Ibels'.

317: went up on 20 January: Letter 264.

317: shipping works to Brussels: Letter 265.

317: *Confetti*: Adhémar 1965, p. xv, correctly points out the similarities between Henry's 1893 poster *Confetti* and Bonnard's 1891 poster *France-Champagne*.

317–18: banquet in honour of Roger Marx: Letter 262, n. 2.

318: 'I was not aware ...': Letter 264, 19 January 1893 (tr. Frey).

318: 'Also at the Goupil ...': Charles Angrand quoted in Thomson et al. 1991, p. 531.

318: unconscious forces: I am grateful to child psychiatrist Gary May, M.D., of Denver, Colorado, for suggesting this insight to me.

319: ambivalence about being a successful artist: Beverley Conrad, M.A., suggested this further interpretation of Henry's motives.

319: 'refused by the Cercle Volney': Perruchot 1958, p. 168.

319: caricaturing his friend: See Lautrec drawing of Maurin (and himself) (Dortu D4005), *c.* 1893, and Maurin aquatint of Lautrec (Dortu Ic. 98), 1893.

319: Maurin also had: Natanson 1948, p. 168: 'Un cynique: Charles Maurin'.

320: hunger, taste and odours: Natanson 1948, p. 169.

320: at Boussod et Valadon on 30 January 1893: Letter 264. Later that year, Michel Manzi and Maurice Joyant would purchase the gallery, renaming it Manzi, Joyant & Cie.

320: thinking about and preparing for this show: Letters 264, 269.

320: to share the exhibition space: Letter 264.

320: Gavarni: pseudonym of Sulpice Guillaume Chevalier, French artist known for his illustrations of humorous and sarcastic social commentary, esp. 1838–53.

320: 'Buy Maurin! ...': Quoted in Perruchot 1958, p. 167.

320: 'Buy Maurin ...': Conversation with Jean Adhémar, 1983. M. Laurent's son, later the Director of the Hôtel Crillon in Paris, told Adhémar that his father recalled overhearing Degas say to someone at the Lautrec-Maurin exhibition, *'Prenez Maurin. C'est un artiste qui sait dessiner les mains.'*

320: 'Maurin ...': Natanson 1948, p. 167.

320: 'as regards ...': Letter 325.

320: a cabinet minister was among the guests: Letter 276. The Minister's name is not recorded, but it may be that same person whom Henry later insulted when he visited Henry's studio as part of Joyant's lobbying to have Henry nominated for the medal of the Légion d'Honneur. Thomson et al. 1991, p. 531 says it was the Minister of Fine Arts, but gives no documentation for that statement.

321: 'without seeming ...': Letter 278.

321: longer than planned: Letter 277.

321: his pictorial flair: Quoted in Adhémar 1965, p. xv.

321: 'hard on our kind ...': Sisson 1893, n.p.

321: 'Toulouse-Lautrec has been ...': Geffroy 1893, quoted in Dortu 1971, I, pp. 38–9.

321: personally asked Roger Marx: Letter 269.

321–2: 'penetrating analysis ...'/'the exterior ...'/'at the beginning ...': Marx 1893.

322: 'the delicious ...': *La Revue blanche* 16 (February 1893), p. 146. Translation from Wittrock and Castleman 1985, p. 83, with corrections by Frey.

322: 'Lautrec's a guy ...': Fénéon 1893c (tr. Frey) quoted in Joyant 1926, I, p. 105.

322: 'Who will deliver us ...': Adriani 1986, p. 33.

322: at Henry's poster of Bruant: See Adriani 1986, p. 42.

323: the first issue of *L'Estampe Originale*: Letters 279, 280.

324: 'all the Young Artists': Letter 270.

324: consulted with Roger Marx on its design: Letter 280.

324: died shortly after: Griffiths in Wittrock 1985, I, p. 46.

324: *'modern style'*: The phrase (in English) used by the French to designate the movement known in English as Art Nouveau and in German as Jugendstil.

324: bought a small press: Stone 1985, p. 606.

324: the second issue of *L'Estampe originale*: Pissarro 1988, pp. 45, 318.

324: Le Jardin de Paris: A fashionable *café concert* recently opened on the Champs Elysées by the man who now owned Le Moulin Rouge, Joseph Oller.

325: 'so as not ...'/'This letter ...': Letter 304 (tr. Frey) and *Le Courrier français* no. 27, p. 7.

326: before *L'Art français*: Letter 304, n.3.

326: the next week: *Le Courrier français* no. 28 (9 July 1893), p. 10, 'Pauvre Pierreuse' (Wittrock 13).

326: his use of colour: *Le Fin de siècle* (September 1893): *'la douce Jane Avril que les couleurs attirantes Lautrec-Toulousaines mirent si fort en vedette'*.

327: *'L'affiche y a qu'ça!'*: Baragnon, p. 98.

327: 'Monsieur Toulouse': Carco 1946, p. 166.

328: Helleu and Lunois: See Adhémar 1965, p. xvii.

328: *La Chronique des arts*: Adriani 1986, p. 44.

329: must have seemed shocking: This idea was proposed by painter Adek Zylberberg in conversation, Paris, 13 June 1992.

329: wrote to André Marty: Letter 285, and Schimmel in Fondation Pierre Gianadda 1987, n.p.

329: 'victim of the Salon's corridors': Letters 286, 294.

329: 'I was visited ...': Letter 329 (tr. Frey).

329: 'M. de Toulouse-Lautrec ...': Unsigned review in *L'Art français* (25 March 1893).

330: the Indépendants' banquet: The banquet was not held at the time of the exhibition opening.

330: 'strikingly felt impressions'/'svelte grisette': 'Exposition des Indépendants', *Journal des Arts* (March 1893).

330: to give her away: Perruchot 1958, p. 176.

330: used her as a model: See for example Dortu D2969, D2979 and D3083 (1888).

330: 'The feeling ...': Leclercq 1958, p. 24.

331: drama critic: Information comes from Bernier 1991, pp. 18, 79.

331: puns and witticisms: Bernier 1991, p. 183, quoting Thadée Natanson.

331: 'seeking through ...': Bernier 1991, p. 85: *'afin de trouver dans des travaux austères un antidote à l'hyper-esthétisme menaçant'*.

331: otherwise undistinguished poet: Leclercq is remembered principally for his memoir of Henry (Leclercq 1921; Leclercq 1958 is a revised version of the same memoir).

331: 'rich collective ...': Bernier 1991, p. 79.

331: *La Revue blanche*: All general information is from Bernier 1991, pp. 10ff.

331–2: 'he was ...': André Gide quoted in Bernier 1991, p. 80.

332: on French arts and letters: Bernier 1991, p. 80.

332: 'more profoundly human': Natanson 1951b, p. 16.

332: Marcel Prévost: His works include *Chonchette*, *Melle Jauffre* and *Les Vièrges fortes*.

333: negative impressions of Henry: Gold and Fizdale, p. 56.

333: 'That head ...'/'rolling'/'He always took ...': Natanson 1951b, p. 8.

333: 'He loved to drink ...': Ibid.

334: forgot their first negative reactions: Natanson 1951b, p. 9.

334: 'who adored him ...' / 'We didn't ...': Natanson 1948, pp. 151–2.

334: 'large, lumbering ...': Gold and Fizdale, p. 29.

334: a charismatic iconoclast: Perruchot 1958, p. 182: 'A born iconoclast. The magnetic center of one of the most gifted circles of artists Paris had ever known.'

334: an esteemed comrade: Bernier 1991, p. 18.

335: Fauré and Verlaine: Fauré's *Cycles* (1891) were based in part on Verlaine's *La Bonne Chanson*.

335: 'By now I invited ...': Sert, p. 40.

335: 'irreverent ...': Gold and Fizdale, pp. 56–7.

335: 'I would sit ...': Sert, p. 51.

336: 'looking rather like ...': Gold and Fizdale, p. 56.

336: 'One day Lautrec ...': Sert, p. 41.

336: *A Table chez M. et Mme Thadée Natanson*: Dortu P567.

336: 'Lautrec was working ...': Sert, p. 51.

337: ask him to stop: Natanson 1951b, p. 23.

337: 'For Lautrec ...': Sert, p. 51.

338: Bruant and other performers: Sert, p. 41.

338: In the spring of 1893: There is some debate about whether the following events happened at the Bal des Quatz' Arts in February 1893, or February 1894.

338: 'lithographic worker ...': Thomson et al. 1991, p. 529, quoting Coquiot 1921, p. 38.

338: 'the most famous ...': Rothenstein I, p. 268.

338: if they were not given drinks: The annual Bal des Quatz' Arts, in spite of repeated attempts to ban it, continued to exist until at least the 1970s.

339: order was restored: Gauzi 1954a, pp. 71–7.

339: hypocrisy of her testimony: *La Goulue devant le tribunal* (Wittrock 329). This lithograph, printed in an edition of twenty-five by Henri Stern, has been dated 1899 on convincing stylistic grounds. That year is the only period in Henry's life where he did works referring to things that happened years before.

339: the starving artist: From the expression '*manger de la vache enragée*', meaning to have nothing to eat.

340: lithographic menu: See example at Bibliothèque Nationale in Paris, Estampes DE 361 Réserve.

340: '*Alors, Madame ...*': Lot 1934, p. 77. See also Shattuck, p. 26.

340: other regulars included: Perruchot 1958, p. 166.

341: 'I'm digging my grave ...': Perruchot 1958, p. 243.

341: 'He looked so sad ...': Quoted in Simon, p. 236.

342: artistic bohemia at the time: Shattuck, p. 20.

342: 'Am I having ...': Bonmariage, p. 40. Henry is paraphrasing a famous quote from Gustave Flaubert's *L'Education sentimentale*.

342: uncontrolled passions: Roger-Marx 1950, n.p.

342: than other models: Leclercq 1958, p. 48, and Rothenstein I, p. 129. The latter made an observation which may have been part of Henry's basis for preferring prostitutes as models: 'Perhaps the figures of our models when they emerged from the clothes then worn, the high-shouldered bodices, with their wasp-cut waists, the rigid corsets and long, bell-shaped skirts, seemed yet more nobly, more radiantly classical by contrast. And contrariwise, after seeing young girls looking like goddesses on the model stand, how disillusioning to see them when they resume their poor, trumpery finery; they seem shrunken to half their size.'

342: 'spellbound by Renoir's mouths': Alexandre 1902, p. 6: '*Les bouches de Renoir me fascinent.*'

343: to the world beyond: Adriani 1987, p. 150.

344: Henry kept a photo: Alexandre 1902, p. 15.

344: family of the brothel: For more on this subject see Nochlin 1992.

344: his own amusement: Gauzi 1954a, p. 139.

344: 'Lautrec's unpitying eyes ...': Rothenstein I, p. 247.

345: 'I shall set up ...': Perruchot 1958, pp. 168–9.

345: to reserve a room: Bouret, p. 135 gives a list of Lautrec's brothels as: 1) 2, rue de Steinkerque; 2) 106, rue de la Chapelle; 3) rue Joubert; 4) rue d'Amboise; 5) rue Laferrière (see p. 198); 6) the famous brothel at 24, rue des Moulins, which opened in 1894. See also Beaute 1988, pp. 111–17 on provincial brothels.

345: 'Monsieur Henri': Leclercq 1958, p. 70.

345: 'They're the only ...': Perruchot 1958, p. 181.

345: eighteenth-century salon: Bouret, p. 140.

CHAPTER NINE: H. T-LAUTREC
(pp. 347–423)

347: 'resolute, natural'/'as if ...': Alexandre 1902, p. 6.

347: 'profound drama ...': Alexandre 1902, p. 9.

347: 'visibly ...': Arsène Alexandre quoted in Huisman and Dortu 1964, p. 196.

347: drinking as much as he did: Letter IV 18.

347: the lithographic stones: The story about Père Cotelle's skullcap has been repeated many times but always with the irrational explanation that the excellent quality of Cotelle's work was due to the fact that he used his skullcap to grease the lithographic stones. Anyone who has ever made a lithograph will realize that this would be impractical, as the heavy cloth and seams in a skullcap would produce irregularities in the water-resistant layer on the stone.

347: worked with Stern: Except for a brief period in 1898 when he had a few small editions pulled by E. Malfeyt, a paper dealer whose offices were at 8 rue Fontaine. See Adriani 1986 p. 344.

348: lasted three months: Bonmariage, p. 41.

348: blows were exchanged: Gauzi 1954a, pp. 62–6.

349: had cured her: Avril 1933, n.p.

349: nearly two years: Kermode, pp. 6–23.

349: a critic had commented: 'Coupures de Press 3 et 3b', unnamed critic, clipping marked p. 841, Bibliothèque Nationale, Paris.

349: an unambiguous supporter: In the spring of 1894, for example, she asked Henry to let her use a litho he had done of her (Wittrock 18 – for the *café concert* album published December 1893) as a cover for the sheet music to one of her own songs.

349: directly on the huge stones: Natanson 1951b, p. 94.

349–50: 'Lautrec, as far ...': Symons 1929, p. 356.

350: getting them back if they were not: See Letter 267.

350: in January 1893: See Dortu 1955, p. 14. This meeting may have taken place as late as 1895. See also Letter 399, n. 2 which says that Henri Evenepoel (1872–99) arrived in Paris in 1892, but only met Henry once.

350: 'Behind the door ...': Dortu 1955, p. 14, quoting Lambotte 1908, p. 31.

351: a feeling of paradise lost: Carco 1946, pp. 166, 199.

351: a scathingly ironic article: For an interesting discussion of this article, see Marcus Verhagen, Ph.D. candidate in art history at the University of California, Berkeley: 'Seurat's *le Cirque* as *baromètre de la gaité publique*', unpublished paper, 1990. Available from the author; address: 6 Villa Alésia, 75014, Paris, France.

351: a strenuous holiday: See Schimmel 1991, Appendix II, pp.379–80 for Henri Bourges' notes on this trip.

351: 'magnificent turbulent trip': Letter 305 (tr. Frey).

351: 'We bought chickens ...': Quoted in Schimmel 1991, p. 379.

351–2: 'the last day ... other *babaous*'/'I myself ...': Letter 305 (tr. Frey).

352: 'dozed conscientiously ...': Leclercq 1958, p. 106.

352: soft satchel: See photo of Henry with his satchel in Beaute 1964, p. 125.

352: 'He was so short ...': Leclercq 1958, p. 107.

352: 'brothers his own size': Gauzi 1954a, p. 55.

352: 'half naked ...': Letter 306.

352: his hotel balcony: Letter 311, n. 3.

352: something more romantic: Merlin, p. 30.

353: 'Lautrec often came ...': Tristan Bernard 1931, p. 135.

353: navigation and yachting: Alexandre 1902, p. 9.

353: 'He had the habit ...': Natanson 1951b, p. 91.

353: 'leaning over ...': Natanson 1951b, p. 92.

353: 'circled briefly ...': Natanson 1951b, p. 90.

354: 'It is only ...': Tristan Bernard 1931, p. 135.

354: to England in 1896: Letter 462.

354: oil sketch on cardboard: See *Portrait de Louis Bouglé (dit 'Spoke')*, Musée d'Orsay, Paris.

355: Five-man bicycles: I am grateful to Douglas Matthews for suggesting this interpretation of the poster.

356: playful doggerel: Coolus 1931, p. 139. This sonnet, in memory of Henry, gives a feel for his style:

TOULOUSE-LAUTREC

Blague et gouaille, la butte et toute sa vadrouille!
Oui, mais comme il voyait vif, strict, cinglant – avec
L'âpre don (que souvent tant de tendresse mouille)
D'emprisonner la vie au fermoir d'un trait sec.
Il adorait les bars où, pittoresque, grouille
Un peuple de rastas et de lads pêle-mec;
Et là, tapi derrière un drink, mais l'oeil qui fouille,
Il remplissait sa carnassière – en vrai Lautrec.
Pour saisir l'animal humain tel qu'il s'avoue,
Soit qu'impudique il danse ou qu'impudique il joue,
Il s'embuscait, fils d'une race de chasseurs,
Partout, au Moulin-Rouge où Jane Avril s'exalte,
Au théâtre, au caf-conce, aux fortifs, sur l'asphalte,
Féroce et doux pour tout ce gibier de noceurs.

Joking and teasing the *butte* and all its denizens!
True, but a lively view: strict and sabre-fine
With a harsh talent (often steeped in great tenderness)
For catching life in the swipe of one sharp line.
He loved the bars, teeming, picturesque, with dock hands and stable boys.
And there, slouched behind a drink, with his hunter's eye,
He filled his game-bag like a true Lautrec.
Capturing the human animal revealed,
As it comes out of hiding to dance or play.
Everywhere he'd lie in wait, that son of a race of hunters:
At the Moulin-Rouge where Jane Avril went wild,
At the theatre, the cabaret, in the bars, on the street,
Fierce and gentle, to catch his late-night prey.

356: representing him caricaturally: See Dortu P686, and Coolus 1931, p. 139.

356: 'There is an overwhelming ...': Natanson 1948, p. 156.

356: a sort of penance: Beverley Conrad, M.A., elaborated to me this concept of survivor guilt and forbearance.

356: 'paradoxically ...': Coolus 1931, p. 137.

356: just as explosive: Gold and Fizdale, p. 57.

356: no account of this experience: See, among many sources, Gold and Fizdale, p. 57.

357: 'He combined ...': Coolus 1931, p. 137.

357: 'through his drooping ...': Coolus 1931, p. 139.

357: 'When in the winter ...': Coolus 1931, p. 139.

357: Lender's back is a feast See *Lender de dos, dansant le boléro dans 'Chilpéric'* (Wittrock 105), 1895.

357: (Anne-Marie Bastien): Adriani 1986, p. 69.

357: her memoirs: Marcelle Lender, *Souvenirs*, summarized in Simon, pp. 271–2.

357: 'What a horrible man ...': Quoted in Simon, p. 272.

358: larger apartment together: See Letter 228: '*Nous allons déménager à côté, rue Mansart probablement.*'

358: while remodelling his own apartment: Letter 416 and Thomson et al. 1991, p. 536.

359: called Henry's Hotel: Letter IV 32.

359: 'only a fraction of art ...': Letter 316.

359: a trick photo: It should be noted that the caricature on the canvas shows Henry the artist in profile, not Henry the model, who is full-face.

359: 'banana plant ...': Letter 313.

359: 'but less interesting ...': Letter 314.

359: 'might and main': Letter 323.

359: 'I slaved ...': Letter 323A (tr. Frey).

360: 'Shooting paint ...': Letter 323, n. 1.

360: 'Lautrec bite'/'almost imperceptible': Hayter, p. 26.

360: ten weekly issues: 12 November 1893 to 14 January 1894.

361–2: 'This will let me ...': Letter 318 (tr. Frey), redated to December 1893 from Henry's reference to the Alliance Franco-Russe, which was finalized at that time. This allows the dating of Henry's works *Au Moulin Rouge, l'Union Franco-Russe* (Wittrock 40) and *Redoute au Moulin Rouge* (Wittrock 42, published in *L'Escarmouche* no. 1, 7 January 1894) to December 1893-January 1894. He based the latter work on the show of the same name at Le Moulin Rouge, which presumably was offered at the same time as *Redoute France-Russe*, a show performed at the Folies Bergère that Christmas season. See Adriani 1986, p. 75.

362: 'If you could ...'/'I'm keeping ...': Letter 318.

362: 'All these mundane ...': Letter 330.

362: 'I shall have ...': Letter 332.

362: the same building as Robin-Langlois: See Letter 416 and Thomson et al. 1991, p. 536.

362: 'enormously busy'/'Have 6 red ...': Letter 323A.

362: A maid is reported: Brabant and Cadieu.

363: working on a poster: Letter 318.

363: 'It shows the victim's ...': Maindron 1896, II, p. 112, quoted in Joyant 1927a, II, p. 114.

363: '*une vraie petite roquette*': Letter 194 (tr. Frey).

363: menacing shadows: Wittrock 49 and Wittrock P8.

363: 'like a marmot': Letter 335.

363: 'fairly vast'/'Having nearly ...'/'maid's furniture ...': Letter 338 (tr. Frey).

364: 'I just got cleaned ...': Letter 340 (tr. Frey).

364: Henry was personally ... in February: Letter 329.

365: 'We have been ...': Letter 343 (tr. Frey).

365: 'a beautiful ...': Letter 345 (tr. Frey).

366: 'among the virtuosos . . .': *L'Art moderne*, 11 March 1894.

366: 'cruel'/'astonishing . . .': E. Verlant writing in *Jeune Belgique*, n.d., p. 192, quoted in Dortu 1955, p. 16.

366: 'in ecstasy . . .': Quoted in Dortu 1955, p. 16.

366: 'It's magnificent . . .': Ibid.

366: a caricatural mask: See Dortu P521.

366: to make a drawing of: Dortu A211.

367: back of the programme: Dortu D3669.

367: the menu for a dinner: Wittrock 59. Adrien Hébrard also appears in a portrait study, Dortu D3506. See Adriani 1986, p. 115.

367: 'famous for . . .': Adhémar 1965, p. xxii.

367: It may have been . . . for a 'poster': Personal note from Jean Adhémar, who stated that the *dossier de découpures de presse* in the Cabinet des Estampes in the Bibliothèque Nationale in Paris had a copy of the letter from Monet. However, it was misplaced or missing in 1986.

367: He showed constantly: Thomson et al. 1991, pp. 533, 545.

367: About fifty Salons des Cent: See Cate and Boyer 1985, p. 26.

367: *Alfred la Guigne*: Dortu P516.

367: offices in Toulouse: Letter 367.

367: the few reviews: Bouret, p. 158.

367: *Danse excentrique*: Wittrock 60.

368: Henry, the Natansons and their friends: Shattuck, p. 7.

368: 'the most pathetic . . .': Ibid.

368: *La Loge au mascaron doré*: Wittrock 16.

369: 'in a frenzied style . . .': Adhémar 1965, p. xx.

369: helped paint the sets: Shattuck, p. 206.

369: an official existence: Although the movement had existed since the late 1880s, the expression was coined by Belgian architect Henry Van de Velde in 1894.

370: René Wiener: Letter 262 and Charpentier 1962, p. 221.

370: The first letter: Letter 287 (tr. Frey).

370: the binding of *L'Art Impressioniste*: See drawing reproduced in Charpentier 1960b, p. 168.

370: 'a Lautrec at this time . . .'/'I am not so uneasy . . .': Roger Marx to René Wiener, n.d. [early 1893], quoted in Charpentier 1960b, p. 166.

370: 'saw Lautrec . . .': Ibid.

370: 'I was very interested . . .': Letter 296.

371: a cormorant and a crab: Thomson et al. 1991, p. 395 (Dortu P513).

371: the fauna of the seashore: Not in Dortu 1971. In the collection of the Musée Lorrain, Nancy.

371: a letter that summer: Letter 305.

371: The finished binding: Letter 308, n. 4.

371: *Los Desastres de la Guerra*: Wittrock 29. See Adriani 1986, pp. 68–9.

371: 'If my mother . . .': Charpentier 1962, p. 216.

371–2: 'Make the outlines . . .': Letter 353 (tr. Frey).

372: actually arranged to borrow two skulls: Letters 352, 353.

372: Henry asked Wiener: Letter 347 [26 March 1894].

372: '*tout à la lithographie*': Letter 346.

372: a print show from 5 to 12 May 1894: Apparently reversing a decision no longer to exhibit prints, mentioned by Henry in a February letter. See Letter 346.

372: 'gangsterism of Lautrec': Camille Mauclair, critic for the otherwise liberal journal *Le Mercure de France*. See Pissarro 1990, letter of 29 May 1894.

372: waiting in line to get in: Quoted in Adhémar 1965, p. xxii.

372: 'I was dumbfounded...': Letter 350 (tr. Frey).

372: 24, rue des Moulins: Later number 6. Cf. Bouret, p. 140 and Thomson et al. 1991, pp. 426–7.

372: 'having an assortment...': Virmaître 1890, p. 77. Quoted in Thomson et al. 1991, p. 426.

372: *Au Salon [de la rue des Moulins]*: Dortu P559 and P560.

373: 'to treat the subject...': Joyant 1926, I, p. 154.

373: a study for a lithograph: Thomson et al. 1991, p. 427. The illustration, published in Joyant 1926, I, facing p. 152, without identification of medium, does in fact appear to be a lithograph, although no copies of it are known today.

374: 'he saw the sharp ..': 'Coupures de Press 3 et 3b', unnamed critic, clipping marked p. 838, Bibliothèque Nationale, Paris.

374: 'with his misanthropy...': Rothenstein I, p. 67.

374: Confirmed documentation ... is sparse: Major informants are Thadée Natanson, Sylvain Bonmariage, Paul Leclercq, François Gauzi and Emile Chabbert, according to an interview published in Beaute 1988, pp. 111–17.

374: Henry's sexual images: See for example Dortu P495.

375: 'with a sort of troubled fascination': Bonmariage, p. 44.

375: room on the mezzanine: Destremau, p. 99.

375: 'The Rat Mort...': Rothenstein I, pp. 59–60.

376: It was in Le Rat Mort ... thigh: François Porché in *Verlaine tel qu'il fut*, quoted in Oberthur pp. 44–5.

376: a huge dead rat: See Gustave Coquiot, 'Biography of Vincent Van Gogh', unpublished MS, Rijksmuseum Vincent Van Gogh, Amsterdam, [*c.* 1920], n.p.

376: the menus: See Wittrock 244 (1898).

376: *Dans le Lit, le Baiser*: Plate 38, Dortu P436. As two other paintings, Dortu P438 and P439, bear the title *Dans le Lit*, it is not known precisely which painting was in the gallery window.

376: Le Barc removed it: Thomson et al. 1991, p. 428.

376: his friends bought the works showing lesbians: See Thomson et al. 1991, p. 428 for a most interesting discussion of this phenomenon.

377: *Eros vanné*: Wittrock 56.

377: 'bizarre harem'/'Lucy Jourdan...': Bonmariage, p. 44. The name is sometimes written Lucy Jourdain. In 1899, Henry did a work showing a private room supposed to be in Le Rat Mort. According to Schaub-Koch, p. 209, the woman portrayed is Lucy Jourdain, and the painting was commissioned by 'her lover Baron de W.' Schaub-Koch gives no supporting evidence for this claim.

377–8: 'One evening...': Bonmariage, p. 44.

378: 'tragic power': Natanson 1951b, p. 111.

378: *'Je ne serai ...'*: Ibid.

378: 'Let me sit...': Natanson 1951b, pp. 122–3.

378: 'stay in the atmosphere...': Natanson 1951b, p. 62.

378: 'The body of a woman...': Leclercq 1958, p. 222.

379: 'Ah, love!...': Yvette Guilbert, quoted in Brécourt-Villars, p. 130.

379: 'The heart.../'in his eye...': Ibid.

379: 'a penis with legs': Natanson 1948, p. 151.

379: problems with sexual potency: See prostitutes interviewed in Brabant and Cadieu.

379: a legend, part of Western culture: Fiedler, p. 16.

379: macrogenitalism: For information on this subject, I am indebted to Owen P. (Pat) O'Meara, M.D. Chief of Pediatrics at Denver General Hospital, and Jared L. Klein, M.D. Pediatric

Endocrinologist and Oncologist, Assistant Professor at the Ohio State University College of Medicine, Columbus, Ohio.

380: 'would wrap ...': Natanson 1951b, p. 19.

380: 'Let me introduce ...': Natanson 1951b, p. 73.

380: *'technique du gousset'*/'tobacco shops': Natanson 1951b, pp. 52–3, 117.

380: 'made of living silk ...': Natanson 1951b, pp. 117–18.

380–1: 'You had to ...': Natanson 1951b, p. 108.

381: Natanson once observed him: Natanson 1951b, p. 100.

381: 'neither to be fashionable ...': Natanson 1951b, p. 58.

381: Was he fetishistic ... playing around?: Beverley Conrad, M.A., elaborated these possibilities to me.

381: the Café des Incohérents: In that guise it had put on 'incoherent' shadow-plays and Jules Lévy, 'Grand-maître de l'Ordre des Incohérents', organized Incohérent exhibitions there.

381: 'The orchestra ...': Michel Herbert 1967, p. 58, quoting Tanel (no further reference cited).

382: Some of the performers ... as models: Adhémar 1965, p. xxiii.

382: *Au Moulin Rouge*: Dortu P42. Despite recent attempts to deny that this figure was May Milton, or to return to a dating of the painting as 1892, I remain convinced by the arguments of Heller. They are particularly convincing if one inspects the painting in person.

382: as a figure study: See drawing of May Milton (Dortu P572).

382: May Belfort/May Egan: Adriani 1986, pp. 171, 188.

382: *Interior with Bathing Figure*: Also known as *The Blue Room*. The painting is in the Phillips Memorial Gallery, Washington D.C.

382: a mate for the cat: Letter 443.

382: kittens to Adèle: Letter 441.

382: 'The final ...'/'precociously disillusioned'/'Don't judge ...': Bonmariage, p. 42.

382: works showing Oscar Wilde: See Bodin 1979. One of Henry's most supportive critics, Félix Fénéon, considered these works to be very secondary and not worthy of the artist. In 1915, writing to Alexandre Natanson, Fénéon refused, as an agent of Bernheim-Jeune Gallery, to pay 600 francs for the watercolour study Henry had done for his 1896 litho of Wilde, complaining that the work was faded and in poor condition, and adding 'in spite of the prestige of the signature, its interest, you must agree – is more documentary than artistic'. Fénéon's letter itself was offered for sale for 300 francs in 1979.

383: Yvette Guilbert and Oscar Wilde: Reproduced in Bernier 1991, p. 229.

383: Leclercq described realizing: Leclercq 1958, p. 56.

383: attracted to their 'impotence': Joyant 1926, I, p. 176.

384: phallic objects at groin-level: See for example *Footit en danseuse* (Dortu D3776) 1894–95, illustration p. 403. A rapid survey of Henry's work produced at least thirty examples.

384: 'Is to end ...': Gauzi 1954a, p. 99.

384: 'No one who ...': Symons 1929, p. 356.

385: Conder: Rothenstein I, p. 55.

385: which Henry drew in several works: See *La Loge au mascaron doré* (Wittrock 16) and *Souper à Londres* (Wittrock 169) 1896, as well as paintings *Aux Ambassadeurs, gens chics* (Dortu P477), *Au Moulin rouge les deux valseuses* (Dortu P428) and plate 27, *Jane Avril sortant du Moulin Rouge* (Dortu P414).

385: enchanted his friends: Rothenstein I, p. 114.

385: duels were so typical: Shattuck, pp. 10–11.

385: group show at the Royal Aquarium: The show probably opened on 23 October 1894. See Letter 386, n. 2.

385: frontispiece for the catalogue: Letter 395, n. 6.

385: went out each night: Joyant 1926, I, p. 175.

385: Manzi et Joyant: By 1898, Maurice Joyant who had been hired to run the branch of Boussod et Valadon at 9, rue Forest, joined up with Boussod's top printer, Michel Manzi, and they became full partners in Boussod, changing its name to Boussod, Manzi et Joyant, then later to Manzi et Joyant and finally to Manzi, Joyant & Cie. They also acquired the Boussod et Valadon galleries at 19, Boulevard Montmartre and 24, Boulevard des Capucines.

385: 'quite execrable ...': Joyant 1926, I, p. 173, tr. in Thomson et al. 1991, p. 533.

385–6: 'beat Whistler ...'/'purely English': Joyant 1926, I, p. 174.

386: an abandoned fox-terrier ... named Tommy: Letters 360, 368.

386: dedicating one of the lithographs to Chéret: Wittrock and Castleman 1985, no. 82.

386: chain of violence: For a detailed account of anarchist bombings in 1892–4 in France, see Halperin, pp. 271ff.

386: 'tawdry banners ...': Letter 365 (tr. revised by Frey).

386: 'all this ...': Letter 368 (tr. Frey).

387: accused of bombing the Restaurant Fayot: See Halperin, pp. 272ff. She believes that Fénéon probably did commit this anarchist act, saying that he admitted as much to the widow of another anarchist in the 1920s.

387: fruit and sweets: Halperin, p. 284.

387: Although three of the defendants: Halperin, pp. 292–4.

387: 'Everything here ...': Letter 365.

387: 'It's hot ...': Letter 368 (tr. Frey).

387: Yvette Guilbert album: Letter 367.

387: 'get complete ...': Letter 370 (tr. Frey).

387: Henry Van de Velde: See Joyant 1926, I, pp. 167–9.

388: peacock feathers: Letter 375.

388: 'furniture ... tilting it': Gauzi 1954a, pp. 124–5.

388: bearskin quilt: Gauzi 1954a, pp. 66ff.

388: bare of his own work: Joyant 1926, I, pp. 167–8.

388: a book in 1899: Bernier 1985, p. 18.

388: 'Menelik's tent ...': Joyant 1926, I, p. 168. Menelik II, (1842–1913), Negus of Abyssinia, ascended to the throne in 1889. His name is used today primarily to identify the Menelik dollar, a silver coin minted during his reign.

389: 'When we were ...': Rebell, pp. 44–6.

389: 'Perdriel ...': Rebell, pp. 49–50.

389: on Tuesdays: Gauzi 1954a, pp. 168–9.

390: Irish and American Bar: Letter 435.

390: *The Chap Book*: Wittrock P18.

390: not be admitted: Leclercq 1958, p. 59.

390: These apparently ... Félix Fénéon: Halperin, p. 168.

390: Le Cosmopolitain: Perruchot 1958, p. 197.

390: a glowing review: In *Paris*, a Republican journal. See Thomson et al. 1991, p. 314.

390: 'There's no mistaking it ...': Quoted in Brécourt-Villars, p. 154.

390: a well-known *mauvaise langue*: Brécourt-Villars, p. 149.

390–1: 'No one has ...': Quoted in Adhémar 1965, p. xxi. Tr. somewhat corrected by Frey.

391: 'birdy shits': *'merderies oisonneuses'*, quoted in Brécourt-Villars, p. 149.

391: 'be drawn ...': Quoted in Perruchot 1958, p. 278.

391: *'Cher ami ...'*: Quoted in Knapp and Chipman, p. 143.

391: a painting by Van Rysselberghe: Letter 365.

391: done for André Marty: Letter 381, misdated August 1894, but must have been July since Marty's answer is dated July 28.

391: to learn from Marty: ALS (Musée d'Albi) André Marty to HTL, 28 July 1894.

392: Henry, who hoped ... multiples existed: A most interesting discussion of the commercialization of Lautrec's lithographs may be found in Antony Griffiths, 'The Prints of Toulouse-Lautrec' in Wittrock 1985, I, pp. 35–49.

392: share of the family fortune: Alphonse did, at one point, suggest that Henry himself take on the management of the Ricardelle vineyards. See Letter 201.

393: Ricardelle: See Letter 371. Letter 373 states that 10,000 hectares of Ricardelle had been sold. All logic would indicate that this is a typographical error for 1,000, as an estate that size would be an immense property. This interpretation is supported by Coquiot 1921, p. 6, who asserts that the entire estate amounted to 1500 hectares at the end of the eighteenth century, and by Magné and Dizel 1992, p. 379 n.

393: 43,000 francs: Beaute 1988, p. 132. This is partially confirmed by Letter 229, in which Henry states that 20,000 francs would allow him to live for part of a year. In the 1990s 43,000 francs would be the approximate equivalent of £100,000 per year.

393: Albi that summer: Letter 349, misdated March 1894, but as it mentions the pregnancy of Raoul Tapié de Celeyran's wife, is most likely summer at the earliest, for the child was born in 1895. Lautrec was in the South in the summer and almost certainly stopped in Albi on his way back to Paris.

393: For reasons ... animal species: Toussaint 1943, pp. 235 ff. A slightly different version of this anecdote was published in his memoirs, 1945, 24–27.

394: 'to protect ...': Toussaint, op. cit.

394: 'One Sunday ...': Ibid. Another account of this event is provided in Perruchot 1958, p. 320.

394: 'You can stop ...': Ibid. Lautrec's young cousin, Robert de Montcabrier later denied that this could have happened, saying that the story had been invented by people Lautrec had insulted. Cf. Beaute 1988, 121.

394: 'funeral relations'/'the family honour': Cf. Sagne 1988, 29. I have misplaced the original source for this information, and he gives none.

395: from a parent's misbehaviour: Beverley Conrad, M.A. suggested this theory to me in a telephone conversation, February 12, 1993.

395: a permanent outsider: A most interesting discussion of the effects of the Dreyfus Affair on art and literature may be found in Kleeblatt, ed.

396: 'all the old Jews in Paris': ALS (Carlton Lake) AdTL to GTL, Paris, Sunday 13 January [1884]. See also ALS (Carlton Lake) AdTL to LTC, 14 January 1884.

396: 'a real nest ...': 26 January, quoted in Bernier 1991, p. 55.

398: an international incident: Desloge et al., p. 222.

398: printed privately: Adriani 1986, p. 96.

398: the value ... quadrupled: Bouret, p. 167.

398: not his style: Letter 489.

399: the Dreyfus trial: Wittrock and Castleman 1985, p. 16.

399: to introduce them: Renard 1984, I, p. 237 (8 November 1894).

399: 'A tiny blacksmith ...': Renard 1984, I, pp. 239–40, partly tr. in Thomson et al. 1991, p. 533.

399–400: 'Yesterday at Lautrec's': Renard 1984, I, p. 242, partly tr. in Thomson et al. 1991, p. 534.

400: 'nothing but marches ...': Letter 396.

400: new colour lithograph: It was in celebration of Guilbert's impending British tour, where she

sang in English, 'Linger longer, Lucy, Linger longer, Loo', and was published the same day Captain Dreyfus was sentenced for espionage, 22 December 1894.

400: only three issues: Thomson et al. 1991, p. 214.

400: advertisement for Chocolat Potin: Wittrock 86.

400–1: comic stooge act: Shattuck, p. 7.

401: Chocolat dancing: *Chocolat dansant* (Dortu D4117), 1896.

401: 'people in checks': Bernier 1991, p. 271.

401: inebriated literary types: Bouret, p. 176.

401: through the window: Unidentified clipping communicated by Jean Adhémar, quoting Franc-Nohain (composer, 1873–1934) who was writing the memoirs of George Footit.

402: Jourdain, then twenty-two years old: Adhémar 1965, p. xxiii.

403: complained loudly: Lugné-Poë 1931–46, I, p. 20, quoted in Adhémar 1965, p. xxiii.

403: 'white linen wrapping': Halperin, p. 303.

402–3: *The Little Clay Cart*: For a discussion of this play and Fénéon's influence at the Théâtre de l'Oeuvre, see Halperin, pp. 303ff.

403: 'The programme...': Quoted in Adriani 1986, p. 159.

404: two ice-skating lithos: The subject of these works has always been identified as a demi-mondaine named 'Liane de Lanc[e]y', the mistress of Espeleta and of Forain. In 1895 Liane de Pougy was much more in the public eye.

404: 'Poor Jean...': Pougy (de), p. 130.

404: 'strewing the plain': Letter 396.

404: Auguste Renoir's son: Renoir, p. 97.

404: 'Gabrielle knew...': Ibid.

405: 'He offered...': Renoir, p. 296.

405: 'He took off...': Renoir, pp. 296–7.

405: one of Henry's brothel paintings: *Femme assise* to M. Bauchy on 18 April 1895, and another painting to M. Georges Thomas on May 28, for 350 francs. See Thomson et al. 1991, pp. 535, 536.

405: 'They are frequently...': Paret, p. 40.

405: 'good, but...': Vuillard, unpublished journals, carnet 1 (November 1894).

405: 'American and other drinks': See *Invitation* (Wittrock 90).

406: 'chubby baby-face...': Gauzi 1954a, p. 91.

406: 'You mustn't...': Gauzi 1954a, p. 164.

406: 'At dawn...': Gold and Fizdale, p. 55.

406: he did the menu: *Menu Sescau* (Wittrock 94).

406: 'victims of...': Bouchot 1895, p. 207.

406–7: 'These are...they are after': Bouchot 1895, pp. 208–11.

407: furious at Bouchot: Letter 581.

407: 'The more...'/'Lautrec draws admirably': Renard 1984, I, pp. 254, 259.

408: depicting a fox: *La Revue blanche* no. 43 (15 March), p. 271 and no. 44 (1 April), p. 308.

408: a huge poster for *La Revue blanche*: Wittrock P16.

408: by Jules Roques in 1894: Adriani 1986, p. 210.

408: attack any aggressor: I am indebted for this insight to my colleague, Pamela Marcantonio, professor of Italian at the University of Colorado, Boulder.

408: first row on the left: Adhémar 1965, p. xxiv.

408: Geffroy and Guibert: Letter 406.

408: shows her famous back: *Lender de dos, dansant le boléro dans 'Chilpéric'* (Wittrock 105), 1895.

408: large oil painting of *Chilpéric*: Dortu P627.

409: to say hello: Gauzi 1954a, p. 79.

409: 'My booth . . .': Joyant 1926, I, p. 85, tr. Thomson et al. 1991, p. 270.

409: 'Booth No. 10 . . .': Quoted in Thomson et al. 1991, p. 271.

410: 'It does seem . . .': Fénéon wrote this in a letter quoted in Thomson et al. 1991, p. 276.

410: sold peanuts outside Le Moulin Rouge: See Gauzi 1954a, p. 81.

411: Maurice Denis and others: Francis Jourdain 1951, p. 164.

411: exhibited other works: See Pissarro, unpublished journals, 26 May 1895 (in Pissarro 1990, p. 76) and Adhémar 1965, p. xxxvi.

411: 'The most astonishing . . .': Blanche 1895, p. 466 quoted in Thomson et al. 1991, p. 400.

411: 'charming lad . . .'/'some friends . . .': Letter 422 (tr. Frey).

412: thirty prints dated 1895: See Wittrock P14.

412: several reproductions of this sort: See Letters 408, 454, 542, 543.

412: 'on the condition . . .': Letter 454 (tr. Frey).

412: 'with a quill pen': Thomson et al. 1991, p. 536.

412: 'that there . . .'/'wear a white . . .': Letter 414 (tr. Frey), probably to Dujardin, well known as a dandy. See also Letter 412, written a week earlier.

412: 'to a half-cocked . . .': Letter 413.

413: 'left-hand mezzanine . . .': Thomson et al. 1991, p. 536.

413: 'state of exasperation'/'Everything . . .': Letter 421 (tr. Frey).

413: 'That will make . . .': Letter 421 (tr. Frey).

413: As the story is told: See Joyant 1926, I, pp. 189ff. Joyant got the story a little wrong, but provides dramatic detail.

413: 'he's rewarding himself . . .': ALS (Carlton Lake) AdTL to GTL, Verdelais, Sunday 11 August [1895]. In this letter she mentions the name of the steamer, the *Chili*.

413: *La Passagère du 54* . . .: Wittrock P20.

414: 'an exquisite thing . . .': Joyant 1926, I, p. 189, tr. in Thomson et al. 1991, p. 384.

414: Salon des Cent used the litho: Letters 428ff. and Joyant 1927, II, p. 255.

414: in a pastel by Vuillard: See Thomson et al. 1991, p. 384, referring to J.P.L. Fine Arts, *Private View*, 23 May-14 July 1989, no. 39.

414: 'directly from Madrid . . .': ALS (Carlton Lake) AdTL to GTL, Malromé, 19 August [18]95. See drawing dated August 1895, *Dans le train de Madrid à Bordeaux*.

414: 'There is only . . .': Attems 1975, p. 89.

414: bought four of Henry's drawings: Thomson et al. 1991, p. 536.

414: colour lithograph: *Marcelle Lender en buste* (Wittrock 99).

414–15: 'a few words . . .': Letter 424 (tr. Frey).

415: complex amd expensive work: Wittrock 1985, I, p. 260 n. 1.

415: 'on a sea . . .': Letter 426 (tr. Frey).

415: *The Chap Book*: Letter 434, n. 2.

415: going by rowboat: See photograph in Beaute 1964, p. 62.

415: 'magnificent . . .': Letter 441.

415: 'that is to say . . .'/'I lead . . .': Letter 442 (tr. Frey).

416: looked unfinished: Feinblatt and Davis 1985, p. 28.

416: 'These people . . .': Gabriel Tapié de Céleyran, quoted by Coquiot 1921, in Wittrock and Castleman 1985, p. 44, translation slightly corrected.

416: edition of one hundred: Wittrock 150. See. Adhémar 1965, p. xxvi.

416: 'a fantastic satirist . . .': Frantz Jourdain, 'Les Décorés, ceux qui ne le sont pas' (1895), quoted in Adhémar 1965, p. xxiii. Ernest Maindron's review was published in *La Plume* on 15 November 1895.

416: to say hello: Natanson 1951b, p. 93.

416: as if the tapir were an old friend: Leclercq 1921, p. 71.

417: twenty-three original drawings: Gauzi 1954a, pp. 49–50.

417: 'no doubt . . .': Quoted in Thomson et al. 1991, p. 536.

417: 'Madame T[ristan] Bernard . . .': Renard 1984, I, p. 304.

417: 'home of a friend': Geffroy 1896, n.p.

417: 12 January 1896: Letter 447.

417: 'terrible documentation': Geffroy 1896, n.p.

417: 'Lautrec ought . . .': Quoted in Perruchot 1960, p. 229.

418: prices far higher: Adriani 1987, p. 318.

418: something like 1,000 francs: Letter 439, 16 November 1895. As Joyant paid Henry 500 francs for *La Clownesse Cha-U-Kao* (Dortu 580 or 581), it was presumably sold for about twice that, although Joyant himself remembered the price as 500 francs. See Joyant 1926, I, p. 26.

418: 'Clown with tits': Letter 439.

418: given to the Louvre: Cf. Joyant 1926, I, p. 26.

418: a variety of different witnesses: Including Natanson, Leclercq, Rothenstein and Gauzi.

418: fifty-one years old: Lipton 1993, p. 166. Henry drew a lithograph (Wittrock 298) with the notation 'Olympia l'unique aimie [sic]' (1898). It was a sketch of a fat, frowning woman with bare breasts and, behind her, the scales of justice.

419: 'That's how . . .': Gauzi 1954a, p. 82.

419: hospitalized for mental illness: Symons 1930, n.p.

419: the ex-king of Serbia, who had bought: Letter 449, n. 1.

419: 'basically it's just . . .': Joyant 1926, I, p. 26.

419: 'I'll be able . . .': Letter 449.

419: rue Forest gallery: Thomson et al. 1991, p. 537.

419: pressure from Geffroy: Goncourt 1956, IV, p. 909.

420: Goncourt's literary 'attic': Gustave Geffroy was named one of the original members of the Académie Goncourt in 1902. See Billy III, p. 31. See also Thomson et al. 1991, p. 537.

420: 'Perhaps it's time . . .': Letter 294 (tr. Frey).

420: 'Exhibition *chez* Jouault . . .': Goncourt 1956, IV, pp. 909, 966.

420: 'It is precious . . .': Quoted in Thomson et al. 1991, p. 364.

421: 'a sort of artist . . .': Francis Jourdain quoted in Perruchot 1960, p. 226.

421: hung one in his bathroom: Adhémar 1965, p. xxvii, quoting Coquiot 1921, p. 163.

421: Max Lebaudy: Ibid.

421: for Jane Avril in London: ALS (Musée d'Albi) Jane Avril to HTL, Hôtel des Etrangers, London, 19 January 1896.

421: left-leaning review: Adriani 1986, p. 249. I have been unable to trace the reputation of *L'Aube*. There may be some confusion in critics' minds with the Dreyfusard review *L'Aurore*, which published Emile Zola's *J'accuse!* in 1898, and for which Henry refused to do illustrations of current events (see Letter 489).

422: 'soften his end': Natanson 1951b, p. 41.

422: home-decorating objects: Desloge et al., p. 246.

422: 'spiteful in the extreme': Perruchot 1958, p. 254.

422: '*nom à renversement*': Natanson 1951b, p. 42.

422: 'produced books . . .': Letter 463 (tr. Frey).

423: 'One day . . . what might happen': Leclercq 1958, p. 10.

CHAPTER TEN: HTL
(pp. 424–93)

424: *La Plume* in May: Letter 460, n. 2. A drawing for this undone commission still exists: Dortu D4114.

424: 'after days ...': Letter 462 (tr. Frey).

424: 'in a sour atmosphere ...': Leclercq 1958, p. 59.

424: to season the port: Leclercq 1958, p. 81.

424–5: 'rather pitiful-looking ... You're telling me!': Leclercq 1958, pp. 22–3.

425: describing Henry later: Leclercq 1958, p. 47.

425: 'falsetto-voiced ...': Leclercq 1958, p. 50.

425: 'three days outdoors'/'perhaps destined ...': Letter 462 (tr. Frey).

425: an homage to Cézanne's self-portraits: Stuckey, p. 263.

426: 'Bachelorhood ...': Leclercq 1958, p. 74.

426: 'The tenant ...': Quoted in Perruchot 1960, p. 230.

426: most of the summer hiding: Letters 462, 467.

426: 'won out ...': Letter 487, misdated 1897. The reference in this letter to Avenue Frochot is to an apartment he hoped to move into in January 1897, but he planned the move several months in advance. The letter can be dated by the reference to spending All Saints' Day at Blois, which he did in 1896.

426: 'very black scapegoat': Natanson, 1951b, p. 42.

427: no luck at all: Letters 467, 468.

428: to Adèle at Malromé: Letter 466.

428: grape harvest: ALS (Carlton Lake) AdTL to GTL, Malromé, 18 October [1896].

428: Elisabeth in the garden: See photo of Henry painting (Dortu P613) in the garden at Le Bosc while other relatives play croquet. See Stuckey, p. 265 and Beaute 1964, p. 118.

428: in early October: ALS (Carlton Lake) AdTL to GTL, Malromé, 18 October [1896].

428: 'tumblers of Cognac': Pierre Devoisins 1958, p. 55.

428: through a window: Joyant 1926, I, p. 190.

428: a comic menu [crocodile]: Wittrock 175.

428: 'a little knocked out ...': Letter 488, misdated November 1897, but really 1896 (see reference to moving to Avenue Frochot, January 1897).

428–9: 'I fight every day ...': Letter 487.

429: 'Lautrec is very ...': Renard 1984, p. 383, tr. in Thomson et al. 1991, p. 537.

429: 'Lautrec [said he] ...': Renard 1984, p. 383, tr. in Thomson et al. 1991, p. 538.

430: only twelve in January 1897: Adriani 1986, p. 266.

430: *La Grande loge*: Dortu P651 and Wittrock 177.

430: magnificent frame: Perruchot 1958, p. 227.

430: Natanson was most unhappy: Bernier 1991, p. 144.

431: attacked by spiders: Gold and Fizdale, p. 68.

431: couldn't help being anti-Semitic: Dennis Cate, conversation, 19 October 1993. On this subject, see the most interesting discussion by Linda Nochlin in Kleeblatt, p. 110.

431: 'a flat for a fried flounder': Leclercq 1921, p. 37. Leclercq says Henry also described his cousin Gabriel's low-ceilinged flat in the same way.

431: more and more disturbed: Leclercq 1958, pp. 65–6.

432: country-sized kitchen: Letter 461, dated by Schimmel May-June 1896, but may have been written as late as autumn 1896.

432: the first year's lease: Thomson et al. 1991, p. 538.

432: demands for key money: Letter 461.

432: 'terrible heat': Letter 480.

432: Joseph Albert was taking: Thomson et al. 1991, p. 525.

432–3: 'Henri de Toulouse-Lautrec . . .': Letter 479. Invitation is Wittrock 183.

433: write-up in *La Vie parisienne*: Quoted in Thomson et al. 1991, p. 216.

433: making fun of it: Adhémar 1965, p. xxx.

434: *pi-pi*: Thomson et al. 1991, p. 216, citing Lapparent 1928, p. 48.

434: extensively remodelled: Letter 485.

434: supplements from Adèle: See Letters 480, 482, 485, 486.

434: pointing and cheering: This story is told in at least two different sources: Joyant 1926, I, p. 192, and Gauzi 1954a, p. 55.

434: Adèle at Malromé: ALS (Carlton Lake) AdTL to GTL, Malromé, 20 September 1897.

434: the avenue Frochot: As Henry moved there in January 1898, this work can now be dated 1898.

434–5: 'For at least . . .': Leclercq 1958, p. 115.

435: one of Henry's best portraits: *Paul Leclercq* (Dortu P645).

435: *mon premier zinc*: Wittrock 239.

435: New Year's card: Wittrock 238.

435: 'His disposition . . .': Joyant 1926, I, p. 210.

435–6: 'Lautrec was haunted . . .': Leclercq 1958, p. 81.

436: presence of ladies: Beaute 1964, p. 177.

436: 'Everybody has . . .': Beaute 1964, p. 178.

436: 'I'm not saying . . .': Letter 496.

436: 'I'm in a rare . . .': Letter 493.

436: a respectable street: Thomson et. al. 1991, p. 539. The same apartment at 9, rue de Douai in the 9th *arrondissement*, sold in 1987 for 1,120,000 francs. It measured 1,560 square feet and consisted of an entry hall, salon, dining room, three bedrooms, two baths, kitchen, basement storage and a separate maid's room on the sixth floor. According to the seller, the building, of brick covered with *crépi* (stucco), was constructed between 1860 and 1870. The composer Bizet had also lived in the same building.

436: all on one floor: Letters, V 1 and IV 1–36. Beaute 1988, p. 126, quotes Robert de Montcabrier as saying that Adèle lived on the *4e étage*, but documentation shows that this is not true.

436: 'elderly lady . . .': Leclercq 1958, pp. 85–6.

437: favourite drinking partners: Letter 291, n. 3.

437: invite Calmès and his mother: Letter 562.

437: 'he profited . . .': Sadoul and Séré de Rivières 1964, n.p.: *Sa mère était décidée à tout accepter pour garder son fils . . . le voulant heureux, [elle] lui avait dit: "Tu peux m'amener qui tu veux." Il en a profité pour lui amener des filles de la rue que ma tante recevait aimablement, et un jour, même, un homme étrange vetu d'un complet à grands carreaux jaunes et marrons et une casquette assortie sur la tête, des bagues à tous les doits, une cravate très voyante. Ma tante l'a accueilli comme elle acueillait tout le monde et on aurait pu assister à cette chose étrange: la comtesse de Toulouse-Lautrec assise en face du tenancier de la principale maison close de Paris. Je ne sais quelle conversation ils ont pu tenir, mais il a gardé la casquette sur la tête pendant tout le déjeuner.'*

438: 'refined eccentric'/'that what he wanted . . .': Quoted in Thomson et al. 1991, p. 540.

438: 'the ambassadors . . .': Letter 530.

438: invitation/litho for a menu: Wittrock 281 and Wittrock 283.

439: face to the wall: Beaute 1964, p. 178.

439: Whistler borrowed four paintings and a lithograph: Letter 533, n. 2.

440: 'A nice chap!': Perruchot 1960, p. 249. See also Leclercq 1958, p. 108.

440: 'Renoir ...': Gold and Fizdale, p. 98.

440: 'I was very fond ...': Letter 548. See also Gauzi 1954a, p. 182, and Leclercq 1958, pp. 59–60.

440: 'the intrepid publisher': Musée d'Albi, catalogue no. I.6.

441: no reason for the trip: ALS (Schimmel) ATC to AdTL, n.d. [c. 7 January 1899].

441: for her own good: ALS (Schimmel) Emilie de Toulouse-Lautrec to AdTL, 6 January 1899.

441: could no longer work: Letter 493.

441: Similar stories: Joyant 1926, I, p. 213 and Natanson 1951b, p. 135.

441: for the unpaid rent: ALS (Schimmel) Baronne Berthe d'Annelet to AdTL, 28 December 1898.

441: Adèle had difficulty: Except for one letter written about Henry's getting drunk at a friend's first communion party when he was ten years old, Adèle never mentioned her son's drinking in any of the hundreds of her letters which were preserved, even though she received many letters from others on the subject. It goes without saying that she always denied that Henry could have suffered from syphilis.

441: subject to hallucinations: Letters IV 9, 19, 26, and Natanson 1951b, p. 134.

441: prescription Bourges had given: AN (Schimmel) Dr. H. Bourges, 22 December 1898.

441: counterpart is Valium: Austin Bloch, M.D., Louisville, Kentucky, conversation, 28 January 1983.

442: 'down there ...': ALS (Schimmel) Emilie de Toulouse-Lautrec to AdTL, 6 January 1899. Although no letters written by Adèle over these weeks were found, she saved many of the letters she received. Several of them imply that she thought Henry was impossible to deal with and that she was enraged by the changes in his personality. See also ALS (Schimmel) Georges de Tanus to AdTL, 8 January 1899.

442: 'spying': Letter IV 14.

442: letters from Henry's cousin: ALS (Schimmel) Gabriel Tapié de Céleyran to AdTL, 13 and 17 January 1899.

442: 'Henri shouldn't know ...': ALS (Schimmel) Joseph Albert to AdTL, 18 January 1899.

442: put him to bed: Letter IV 1.

442: 'He told me ...': Letter IV 1.

443: went uneaten: Letter IV 2.

443: 'He had another ...': Letter IV 2.

443: 'Tonight we are having ...': Letter IV 3.

443: own studio to sleep: Letter IV 4.

443: A shopkeeper reported: Letter IV 7.

443: 'This morning ...': Letter IV 15.

443: come in a money order: Letter IV 9.

443: 'Yesterday ...': Letter IV 3.

443: painted plaster figures: Letter IV 4.

444: 'He told me ...': Letter IV 26.

444: 'I'm not always ...': Letter IV 4.

444: 'That dirty bag ...': Letter IV 17.

444: 'The shopkeepers ...': Letter IV 5.

444: 'There's nothing new ...': Letter IV 5.

444: 'I'm very much ...': Letter IV 6.

444: 'There is no need ...': ALS (Schimmel) Maurice Joyant to AdTL, n.d. [c. 20 March 1899].

444: his own works matte: Henri Perruchot, a normally reliable source, carried the description

of this behaviour one step further, saying: 'Standing before one of his canvases, Lautrec, his fly open, varnished it with his semen' (Perruchot 1958, p. 304).

444: 'This morning...': Letter IV 5.

445: he forgot to drink: Letter IV 7.

445: 'They both drink...': Letter IV 8.

445: 'It's easy to see...': Letter IV 6.

445: 'What's going...': Letter IV 8.

445: 'anything at all... cupboard': Letter IV 8.

445: 'Monsieur is...': Letter IV 9.

445: threatened to go to Albi: Letter IV 9.

446: 'to see whether...': Letter IV 9.

446: 'Monsieur keeps on...': Letter IV 7.

446: particularly in his drinking: Natanson 1951b, pp. 130ff.

446: 'good stuff': HTL quoted in Leclercq 1958, p. 82.

446: cheap rum: Natanson 1951b, p. 17.

446: gave to Spoke: Joyant1927a, II, p. 232.

447: 'He was furious...': Letter IV 11.

447: 'I had been...': ALS (Schimmel) Gabriel Tapié de Céleyran to AdTL, Friday [13 January 1899].

447: 'My dear Aunt...': ALS (Schimmel) Gabriel Tapié de Céleyran to AdTL, Tuesday [17 January 1899].

447: 'My cousin Gabriel...': Letter 558. The du Vignaud de Villefort family of Albi, direct descendants of Gabriel Tapié de Céleyran and owners of this letter, believe Henry wanted his mother to will to his cousin her château at Malromé. However, when she died in 1930, Malromé was purchased by another of Henry's cousins, Georges Séré de Rivières. Gabriel Tapié de Céleyran himself died in 1930.

448: 'send the number three...': Letter 555.

448: 'Monsieur asked me...': Letter IV 12.

448: 'He got a telegram... 500 francs a day': Letter IV 14.

448: concierge complained... happen to him: Letter IV 12.

448: account for their deeds: Letter IV 14.

448: Georges was unreceptive: The same day, Berthe ran into Georges in the street. He made no mention of the incident to her, merely saying that he thought Henry had improved and 'that he had written to Madame under the dictation of Monsieur, so that Madame should set her mind at rest'. Georges undoubtedly did not mention it to Adèle, either, although she learned of it through Berthe (Letter IV 10).

448–9: 'My father told me...': Sadoul and Séré de Rivières 1964, p. D.

449: 'They have robbed...': Letter IV 29.

449: 'yellow crust': Letter IV 26.

449: 'it's true...': Letter IV 16.

450: 'drunk as I don't dare...': Letter IV 18.

450: 'to Stern...': Catalogue of Galerie Charpentier sale, Paris, 1959.

450: her hat is monstrous: I am grateful to my colleague, Pamela Marcantonio, at the University of Colorado whose comment on the looming head visible in Jane Avril's plumed hat led me to explore Lautrec's 'monster' hats.

450: Munch had shown: Thomson et al. 1991, p. 351.

450: *The 1899 Crisis*: Natanson 1951b, p. 133.

450: childhood themes: See drawings in 1871 sketchbook belonging to the Carlton Lake

Collection of the Harry Ransom Humanities Research Center of the University of Texas at Austin.

451: like a signature: Stuckey, p. 57.

451: at least two fox-terriers: Letters 360 and IV 30.

451: 'beaten up ...': Letter IV 31.

451: 30, rue Fontaine: Letter IV 22.

451: 'I must warn ...': Letter IV 19.

451: 'All of Monsieur's ...': Letter IV 15.

452: Madame Devismes ... his son: ALS (Schimmel) Madame Devismes to AdTL, Paris, n.d. [c. 18 January 1899].

452: no one was to tell Alphonse about Henry: See ALS (Schimmel) Amédée Tapié de Céleyran to AdTL, 27 February 1899: 'Yesterday Alphonse was trying to force Alix to show him your letter. If you want to hide things from him it would be better to write them on a separate page, at least when you're writing to her. As for me, he wouldn't dare ask.'

452: 'One cannot ...': ALS (Schimmel) Madame Devismes to AdTL, 19 January 1899.

452: telegraphed his father: Letter IV 30.

452: 'staccato ...': Natanson 1951b, p. 131.

452: never worked drunk: Ibid.

452: 'He was afraid ...': Natanson 1951b, p. 135.

452: hid out at Calmès' livery stable: Sugana, p. 85.

453: 'a beast ...': Natanson 1951b, p. 135.

453: 'wearing red trousers ...': Quoted in Huisman and Dortu 1964, pp. 195–6.

453: organic psychosis: Symptoms include: decreased ability to work, impairment of concentration and judgment, delusions, loss of memory, lack of insight, apathy or violent rages, and incontinence. Alcoholic symptoms are intensified by: personality changes, violent mood-swings, physically violent behaviour, increasing paranoia, obsessive-compulsive behaviour patterns, careless personal hygiene, alienation from family and friends, irresponsibility about money, frequent geographic relocation even within the same neighbourhood, and reliance on other alcoholics for understanding. Patients can exhibit agitation, tremors, poor appetite, unpleasant and terrifying dreams, momentary disorientation, incessant, incoherent talking. The countenance is flushed. Symptoms typically abate suddenly after two or three days. (Harrison et al., pp. 1392–3). In the case of paretic syphilis, the patient shows confusion, apathy, impaired memory, defects in judgement. Concentration is poor. Grandiosity can be manifested by euphoria, overactivity, ideas of grandeur and megalomania. Auditory and visual hallucinations are not common, but delusions of wealth and prowess are frequent. As the disease progresses, paranoia, mania and euphoria recede, to be replaced by simple dementia. The patient may present tremors of the facial muscles, tongue and hands. Speech becomes slurred. Eventually patients become completely bedridden, unable to move or feed themselves. Death usually occurs within a few years after the onset of symptoms. (Harrison et al. pp. 1634–5).

453: Emilie wrote: ALS (Schimmel) Emilie de Toulouse-Lautrec to AdTL, 30 January 1899.

453: a furious letter/from Henry's landlady: Copy (in Schimmel collection) of letter from Baronne Berthe d'Annelet to AdTL, 1 February 1899. Henry had paid key money of 1,600 francs for his studio in 1897. In 1899, his rent was approximately 153 francs a month. In 1984, a nearly identical studio in the Avenue Frochot rented for 4000 francs a month, or approximately twenty-five times the price. Thus 1 franc in 1899 is worth about 25 francs, or around two pounds sterling in 1990s purchasing power.

454: 'out of fear of germs': Coquiot 1921, p. 79.

454: burned newspaper and kerosene-soaked rags: Letter IV 8.

454: 'almost asphyxiated him': Letter IV 29.

454: 'like a madman ...': Letter IV 32.

454: nearly been arrested: Letter IV 32.

454: or any family: Letter IV 28.

454: one last, incomprehensible lithograph: Wittrock 312, I.

455: a long letter: ALS (Schimmel) Amédée Tapié de Céleyran to AdTL, 10 February 1899.

455: around the clock: Schimmel collection has the bill from the Société Générale des Infirmiers et Infirmières Diplomés de Paris, 13 February 1899.

455: 'This man ...'/'I didn't dare ...': Letter IV 33.

456: a new guard for her son: Schimmel and Goldschmidt 1969, p. 53.

456: private insane asylum: Letter IV 34.

456: agreed to be taken to the clinic: ALS (Schimmel) Amédée Tapié de Céleyran to AdTL, Albi, 13 March 1899: *'Jamais je n'aurais cru qu'H. . . . se résignerait à être enfermé, et tout cela s'est réalisé sans douleur.'* ('I could never have believed H. . . . would resign himself to being locked up, and it all happened painlessly.') See also Gauzi 1954a, p. 172.

456: Dr. René Semelaigne's clinic: See Perruchot 1958, p. 251, which gives the history of the clinic. It was founded *c.* 1855 by a nephew of the 'celebrated Dr. Pinel who had done so much for lunatics' in the eighteenth century. Although the estate, now composed of a pretty yellow-painted building with gardens, can still be found at the same address, it has not been used as an asylum since 1921.

456: 'Madrid-les-Bains' and 'Saint-James Beach': Perruchot 1958, p. 282.

456: a list of suggestions: AN (Schimmel). Her list contained the following names: Dr. Semelaigne; Dupré, 46, rue Saint Georges; Garnier, Médecin inspecteur des asiles d'aliénés, 16, Boulevard Montmartre; Legras, 7, Passage Saulnier; and on a separate page, Mlle Gabrielle Guilbert, 86 rue Lemercier.

456–7: Descriptions of the clinic are from Joyant 1926, I, pp. 214–16, and Alexandre 1899.

457: 'Bring a camera ...': 17 March 1899. Cited in Joyant 1926, I, p. 216, tr. in Mack, p. 340.

457: 'on pure water': Joyant 1926, I, p. 216.

457: 'the prisoner': Joyant 1926, I, p. 215, and Alexandre 1899.

457: 'Was it always ...': Natanson 1951b, p. 135.

457: 'I was thunderstruck ...': Sert, pp. 52ff.

458: 'When his mind ...': Sert, p. 137.

458: a delicate pencil rendering: See Joyant 1927a. II, p. 239.

458: 'To the dove of the Ark': Misia, whose memory was inaccurate on many subjects, later recalled in her autobiography that Henry called her 'the swallow', but in this instance at least, the inscription can be clearly read on the drawing.

458: Their letters were supportive: The Schimmel collection contains at least six which she received between 9 and 13 March 1899.

458: preventing her mother from finding out: ALS (Schimmel) Raoul Tapié de Céleyran to AdTL, Albi, [10 March 1899].: *'elle ne se doute de rien. Ça l'aurait tuée.'* ('She doesn't suspect a thing. It would have killed her.')

458: 'You can relax ...': ALS (Schimmel) Amédée Tapié de Céleyran to AdTL, Albi, 13 March 1899. *'Tu peux être tranquille au sujet d'Alphonse au moins pour l'instant. Il a bien un peu déraisonné par moments, mais d'une façon toujours assez calme ... Il se fait à lui-même des raisonnements à haute voix pour se prouver que la situation de son fils à Neuilly est ce qu'il vaut de mieux pour son état.'*

458: subsequent letters from Alix: ALS (Schimmel) ATC to AdTL [13 March 1899]. Alph was

doubly insulted that his sister and brother-in-law, fearing one of his well-known outbursts of temper, had not dared to tell him themselves, but had asked a relation by marriage, M. de la Portalière, to break the news.

458: 'Papa, you have …': Joyant 1926, I, p. 217.

459: 'You must know …': Quoted in ALS (Schimmel) Georges de Tanus to AdTL, 9 April 1899: *'Toi, tu dois savoir la vérité, à moi on ne la dit pas. Henry est-il enfermé de force ou non?'*

459: to see for himself: ALS (Schimmel) ATC to AdTL, 13 March 1899.

460: drawing a little: Joyant 1926, I, p. 216, letter dated 12 March 1899.

460: 'Come to see me ': Joyant 1926, I, p. 216.

460: 'Send me ground …': Ibid.

460: 'on the spot …': Pierrefort quoted in Astre, p. 129.

460: 'anguished sadness'/'a lucid, calm Lautrec': Joyant 1926, I, p. 216.

460: drawing of his guard: Joyant 1926, I, p. 219.

460–1: 'The line was agitated …': Joyant 1926, I, p. 226.

461: drawing of a seated female clown: Joyant 1927a, II, p. 239.

461: locked up there permanently: Ibid.

461: 'Help': Joyant 1926, I, p. 217.

461: prevent himself being permanently committed: ALS (Schimmel) Mme Devismes to AdTL, Paris, n.d. [*c.* 12 March 1899].

461: a note to 'Uncle' Georges: ALS (Schimmel) [illegible] to Georges Séré de Rivières, 13 March 1899.

461: 'In the meantime …': ALS (Schimmel), Georges Séré de Rivières to AdTL, 16 March 1899: *'En attendant, qu'on lui fasse savoir mon affection en lui expliquant comme on voudra le retard de ma visite.'*

461: 'in an establishment …': The establishments near the Opéra, as the public well knew, were mostly elegant bordellos.

461–2: newspaper accounts: See Dortu 1971, I. The originals are in the Musée d'Albi.

462: 'The man himself …': Tr. adapted from Mack, pp. 334–5.

462: *'le grand chic'*: Ibid.

462–3: 'Even though the town …': ALS (Schimmel) ATC to AdTL, Albi, [March 1899].

462: *Gazette de France*: The best known of some 250 monarchist newspapers published in France in the 1890s, the newspaper catered to aristocratic, mostly titled readers and maintained a consistently conservative, even reactionary point of view.

464: 'I know him …': Clarétie *c.* 1899, also quoted in the autograph catalogue of *La Librairie Niçoise*, 2, rue Defly, Nice, n.d., p. 63.

464: 'It is very sad …': Rothenstein II, p. 50.

464: Conder himself would be permanently institutionalized: Symons 1930, n.p.

464: 'I had not realized …': Rothenstein II, p. 50.

464: first written reviews of Henry's art six years before: In *Le Paris* (1 August 1892).

464: 'mocking alertness': Arsène Alexandre, 'Une Guerison', *Le Figaro*, 30 March 1899.

465: 'Once, for a moment …': Ibid.

465: 'That's Quinquina, you can't have any': *'C'est du Quinquina, tu n'en auras pas.'* The line is a parody of a popular song: *'J'ai du bon tabac, tu n'en auras pas,'* which everyone present must have recognized (see Smith, p. 154). Ironically, Henry had been given doses of Quinquina, a quinine-based liqueur, as a child to improve his appetite.

465: 'Souvenir of my captivity': Joyant 1927a, II, p. 234.

466: 'The patient … ultimate release': Joyant 1926, I, pp. 218–19, tr. adapted from Mack, pp. 344–5.

466: he went each afternoon: ALS (Schimmel) Pierre Lazagne to AdTL, 29 May 1899.

466: leading his tipsy guard: Joyant 1926, I, p. 220.

466: 'He was satisfied ...': ALS (Schimmel) Emilie ['Odette'] de Toulouse-Lautrec to AdTL, 1 April 1899.

466: 'almost perfect ...': ALS (Schimmel) Madame Devismes to AdTL, Easter [2 April], 1899.

466–7: urgently summoned to Albi: ALS (Schimmel) Maurice Joyant to AdTL, n.d. [April 1899] and M. Teinturier to AdTL, 12 April 1899.

467: 'Bring me a pound ...': Letter 567.

467: Jean-Henri Latude: An adventurer convicted of machinations against Madame de Pompadour. He spent thirty-five years in prison.

467–8: 'The only completely ... theological response': ALS (Schimmel) Madame Devismes to AdTL, 14 April 1899.

468: this extremely touchy subject: Divorce, one of the liberties granted during the French Revolution, then banned under Napoleon I in 1804, had been reintroduced in France in 1884. See Zeldin I, p. 291.

468: 'To my cousin ...': Joyant 1927a, II, p. 232.

468: 'because of the medication': ALS (Schimmel) Georges Séré de Rivières to AdTL, [April 1899].

468: his friend Dr. Robert Wurtz: Almost certainly the same Dr. Robert Wurtz with whom Henry had frequently stayed at Taussat and whose portrait Henry was to paint twice two years later.

468: 'the chance, or ...': ALS (Schimmel) M. Teinturier to AdTL, 16 April 1899.

468: 'He finds ...': Letter IV 35.

468: 'He thought ...': Letter IV 36.

469: 'who will keep ...': Letter 571.

469: 'When you had left ...': ALS (Schimmel) Dr. René Semelaigne to AdTL, Neuilly, [23 April 1899].

469: for Joyant to publish the entire series: Henry himself mentioned this project to Joyant in a letter dated 12 April 1899. See Joyant 1926, I, p. 220.

469: Over fifty remain: See Joyant 1926, I, p. 223. Twenty-two drawings were reproduced in *Au Cirque* (Paris: Goupil & Cie (Manzi, Joyant & Cie, successeurs), 1905). Arsène Alexandre wrote the preface. Another 17 drawings were reproduced in *Au Cirque, 17 dessins aux crayons de couleur* (Paris: Librairie de France, 1932, English version 1952). All 39 drawings were collected in one book, *The Circus*, 1955.

470: 'the "Madrid Circus" ...': Huisman and Dortu 1964, p. 204.

470: the Cirque Molier was travelling: Perruchot 1958, p. 284.

470: easily recognizable circus acts: Joyant 1926, I, p. 224.

471: chiselled facial features: Henry Frichet, *Le Cirque et les Forains*, quoted in Mack, p. 216.

471: drawing from memory ... Ecole des Beaux Arts: Thomson et al. 1991, p. 67.

471: six weeks had passed: In his 27 April letter, Dr. Semelaigne had mentioned that he was already planning another meeting of the consulting physicians.

471: 'Still, on account ...': Joyant 1926, I, p. 222, tr. Mack, pp. 346–7.

471: 'I bought ... their benefit': Joyant 1926, I, p. 222.

472: 'shaking off that dusty cloak': See Thomas Hardy: 'You have dropped your dusty cloak and taken your wondrous wings / To another sphere, Where no pain is.'

474: Alix was particularly worried: ALS (Schimmel) ATC to AdTL, Albi, 19 May 1899.

474: 'except for the swelling ...': ALS (Schimmel) GTL to ATC, Albi, 21 May 1899.

474: 'Where he had ...': ALS (Schimmel) Emilie de Toulouse-Lautrec to AdTL, Albi, 21 May 1899.

474: 'I can't see ...': ALS (Schimmel) GTL to ATC, Le Bosc, 22 May [1899].

475: 'Lautrec out of prison': Letter 574.

475: 'the days he ...': ALS (Schimmel) GTL to AdTL, 23 May 1899.

475: 'very reasonable'/'What are the two ...': ALS (Schimmel) Emilie de Toulouse-Lautrec to AdTL, Albi, 20 May 1899.

475: 'lavishing attention ...': ALS (Schimmel) Emilie de Toulouse-Lautrec to AdTL, Albi, 24 May 1899.

475: 'absolutely the way ...': ALS (Schimmel) ATC to AdTL, Le Bosc, 23 May 1899.

475: 'He argues that ...': ALS (Schimmel) Emilie de Toulouse-Lautrec to AdTL, Albi, 24 May 1899.

476: to simplify Henry's life: See ALS (Schimmel) Louis Pascal to AdTL, 24 May 1899, in which he refers to Adèle's anger at Alphonse's arranging for Henry to travel with Viaud ['et qu'il a arrangé avec son père'].

476: 'completely well': ALS (Schimmel) ApTL to Georges Séré de Rivières, 30 May 1899.

476: 'the authors of his sequestration': Ibid.

476: 'Lautrec didn't seem ...': Quoted in Bouret, p. 230.

476: exercise his upper body: Coquiot 1921, p. 83.

477: 'He went to work ...': Gauzi 1954a, p. 156. Gauzi illustrates this anecdote with the portrait Henry painted of Madame Leclercq, but it seems unlikely that this story is about Madame Leclercq, as Paul knew exactly what Henry's work was like and would not have had the same reaction.

477: People tried to pretend: Perruchot 1958, p. 263.

477: to 'convalesce': Joyant 1926, I, p. 228.

477: 'Alexandre is ...': Ibid.

477: 'dry nurse': Joyant 1926, I, p. 226.

477: Oscar Wilde arrived: Letter 577 and Ellman, pp. 583ff.

478: lithographs of some of the performers: Joyant 1926, I, p. 228. Works Henry had done in Le Havre in previous years include: *Au Star*, *La Chanson du Matelot*, *DT Fellow*.

478: 'Let it dry ...'/'Thanks for ...': Letter 578.

478–9: The news that Joyant had sent: Joyant 1926, I, pp.227–8.

479: 1,400 francs: Perruchot 1958, p. 264 n.

480: Villa Bagatelle: See Letter 580, which gives his address as 'chez M. Fabre'.

480: 'Send me the rules ...': Letter 582.

481: *En Cabinet particulier* ...: For a most interesting discussion of this painting, see Thomson et al. 1991, p. 163.

482: interested in anything: Joyant 1926, I, p. 231.

482: '*La Gitane* ... even booing': Joyant 1926, I, p. 244.

482: 'Maybe they were ...': Ibid.

482: 'an alert squirrel': Leclercq 1921, p. 24.

483: 'sell anything ...': Letter 591.

484: 'to open the hunt': Gold and Fizdale, p. 68.

484: 'not less than seventy-five': Joyant 1926, I, p. 216.

484: '*L'art, c'est de la merde*': Quoted by Sagne 1988b, p. 380.

484: 'Old Chump'/'The Stars and other bars ...': Joyant 1926, I, p. 323.

485: 'Send the "dough"': Letter 602.

485: 'Look after them ...': Perruchot 1958, p. 229 quoting Achille Astre. See also Letters 595, 596.

485: Moving to his mother's: Joyant 1926, I, p. 232 .

486: Two atypically conventional notes: Letters 593, 594.

486: 'Have you considered . . .': Perruchot 1958, p. 268.

486: 'the Exposition de Bordeaux': Letter 604, n. 2, which calls this the Exposition d'art moderne at the Imberti Gallery.

486: 'I'm beginning . . .': Letter 603.

486: 'send the entire . . .': Letter 597.

486: several times to *Messaline*: Sagne 1988b, p. 406.

487: 'Don't make fun . . .': Letter 601A.

487: 'and from someone . . .': Letter 603.

487: 'Last month . . .': Quoted in Sagne 1988b, p. 406.

488: 'an obsession . . .': Joyant 1926, I, p. 232.

488: 'Do what I ask . . .': Sagne 1988b, p. 406. Apparently Joyant included a copy of this telegram in a letter he sent to Adèle in January 1901.

488: 'Will you be . . .': Letter 604.

488: *Nux vomica*: A herbal medication used for heart disease.

488: 'I'm living . . .': Letter 605.

488: 'very bored': Letter 606.

488: 'who rolled . . .': Ibid.

488: 'in his railway . . .': Joyant 1926, I, p. 236.

488: drawing which had been reproduced: See lithographic flyer *Au Bal des Etudiants*, done in Bordeaux in 1900 (not in Wittrock), reproduced in Feinblatt and Davis 1985, p. 34.

489: on 25 April: Perruchot 1958, p. 273, states that the Depeaux sale was held on 24 April 1901.

489–90: 'Our hearts . . .': Joyant 1926, I p.237.

490: in art magazines: Rivoire 1901, n.p.

490: The thesis: Musée d'Albi catalogue no. 166.

490: testimonial to Henry's decline: Thomson et al. 1991, p. 512.

490: 'finishing some paintings . . .': Joyant 1926, I, p. 238.

491: 'We can kiss . . .': Perruchot 1958, p. 274.

491: 'When I am dead . . .': Ibid.

491: major hit in Paris: As *Cyrano*, the movie based on Rostand's play, was a hit in Paris and the United States in 1990.

491: Each would die: Like Henry, Cyrano de Bergerac (1619–1655) died at age thirty-six.

491: 'Madame . . . and friendship. Henri': Letter 608.

492: Gabriel and Louis . . . he said: Gabriel Tapié de Céleyran apparently recounted the last hours of Henry's life to a number of friends including Thadée Natanson (1948, p. 162) and Jules Renard (1984, I, p. 501).

492–3: 'Reality had been . . .': Letter V 2.

493: Alphonse had to insist . . . to keep up: Perruchot 1960, p. 281, quoting a first-person account by a mourner, Albert Rèche.

493: to Verdelais: Mack, p. 362.

493: 'rough sketches': Letter V 3.

493: 'I have no plans . . .': Letter V 5.

INDEX